DE AFRICA ROMAQUE

Society for Libyan Studies Conference Volume 1

DE AFRICA ROMAQUE

MERGING CULTURES ACROSS NORTH AFRICA

Proceedings of the International Conference held
at the University of Leicester (26-27 October 2013)

Edited by
Niccolò Mugnai, Julia Nikolaus, Nick Ray

The Society for Libyan Studies

Society for Libyan Studies Conference Volume 1

Produced in 2016 by:
The Society for Libyan Studies
c/o The British Academy
10–11 Carlton House Terrace
London SW1Y 5AH

www.societyforlibyanstudies.org

ISBN: 978-1-900971-33-1

Cover and interior design by Chris Bell

Printed in the United Kingdom by Marston Book Services

CONTENTS

LIST OF FIGURES

LIST OF TABLES

LIST OF ABBREVIATIONS

APM	*Atlas préhistorique du Maroc*, Paris (1973).
APT	*Atlas préhistorique de la Tunisie*, Rome (1985-).
Carte	*Carte nationale des sites archéologiques et des monuments historiques de la Tunisie*, Tunis (1998-).
CIL	*Corpus Inscriptionum Latinarum*, Berlin (1862-).
IAM2	*Inscriptions antiques du Maroc, 2. Inscriptions latines*, Paris (1982).
IAM2 Suppl.	*Inscriptions antiques du Maroc, 2. Inscriptions latines. Supplément*, Paris (2003).
ILAlg	*Inscriptions latines de l'Algérie*, Paris (1922-).
ILS	*Inscriptiones Latinae Selectae*, Berlin (1892-1916).
P. Fay.	*Fayum Towns and their Papyri*, London (1900).
P. Mich.	*Papyri and Ostraca from Karanis*, Ann Arbor (1931-).
P. Ryl.	*Catalogue of the Greek and Latin Papyri in the John Rylands Library*, Manchester (1909-1938).
P. Tebt.	*The Tebtunis Papyri*, London (1902-1976).
RIL	*Recueil des inscriptions libyques*, Paris (1940-1941).
SEG	*Supplementum Epigraphicum Graecum*, Amsterdam (1923-).
The Epigraphic Survey 1930	*Medinet Habu, Volume I. Earlier Historical Records of Ramses III*, Chicago (1930).
The Epigraphic Survey 1932	*Medinet Habu, Volume II. Later Historical Records of Ramesses III*, Chicago (1932).
The Epigraphic Survey 1986	*Reliefs and Inscriptions at Karnak, Volume IV: The Battle Reliefs of King Sety I*, Chicago (1986).

ACKNOWLEDGEMENTS

The editing of this volume has been a long and engaging process, and its positive outcome would have been impossible without the kind support we received from numerous persons. Firstly, we would like to express our gratitude to all the Officers and Council Members of the Society for Libyan Studies for financing this publication and for their constant encouragement during these years. Without them, this book would simply not exist. We also want to thank all the contributors to this volume for their hard work, enthusiasm and patience throughout the editing process.

The organization of the conference in Leicester (26-27 October 2013) was made possible through the generous grants awarded to us by various institutions: the College of Arts, Humanities and Law (University of Leicester); the Graduate School Researcher Development Fund (University of Leicester); the School of Archaeology and Ancient History (University of Leicester); the Institute of Classical Studies (University of London); the Society for the Promotion of Roman Studies; the Society for Libyan Studies; and the Trans-Sahara Project.

A special acknowledgement is dedicated to those who kindly offered their help to run the conference and during the following stages of the book editing: Aurélie Cuénod; Rachel Godfrey; Sergio Gonzalez Sanchez; Crysta Rose Kaczmarek; Sharon North; Denis Sami; Giacomo Savani; Brittany Thomas; Selina Thraves; and Adam Thuraisingam.

The book has greatly benefited from the scientific support and advice of numerous scholars. To all of them goes our most sincere thanks: Lucy Audley-Miller (University of Oxford); Paolo Barresi (Università degli Studi di Enna 'Kore'); Michel Bonifay (Aix-Marseille Université, Centre Camille Jullian); Alan K. Bowman (University of Oxford); Janet DeLaine (University of Oxford); J. Clayton Fant (University of Akron); Michael Heinzelmann (Universität zu Köln); R. Bruce Hitchner (Tufts University); Philip Kenrick (Society for Libyan Studies); Victoria Leitch (Society for Libyan Studies); Anna Leone (Durham University); David J. Mattingly (University of Leicester); Emanuele Papi (Università di Siena); Patrizio Pensabene (Università di Roma 'La Sapienza'); Josephine Crawley Quinn (University of Oxford); Anna-Katharina Rieger (Universität Erfurt); Susan Walker (Society for Libyan Studies); Robin Whelan (University of Oxford); and Andrew I. Wilson (University of Oxford).

Last but not least, we owe a major debt of gratitude to David J. Mattingly, whose guidance, ongoing encouragement and never-ending patience have been invaluable in these years.

Niccolò Mugnai, Julia Nikolaus, Nick Ray
Leicester and Oxford, November 2016

PRELIMINARIES

CONTEXT AND OBJECTIVES

1

INTRODUCING
DE AFRICA ROMAQUE

Julia Nikolaus and Niccolò Mugnai

When the Roman Empire progressively expanded its influence over the North African continent, it encountered a very heterogeneous mix of peoples with a long and diverse history. The number of different groups was vast, as exemplified by Pliny who lists 516 peoples, or Strabo who mentions 300 *poleis* in the region of Carthage alone.[1] While there has been much debate on whether we can indeed identify or map the collectives mentioned by ancient authors,[2] surprisingly little research has been carried out on the survival, changes, adaptations, and negotiations of local cultures during the Roman period.

The conference *De Africa Romaque: Merging Cultures Across North Africa* (Leicester, 2013) was born out of this realization that the mutual relationships between North African societies and Rome have been generally understudied and misunderstood. The aim of the conference, and subsequently this volume, was to focus on the local peoples and their multiple cultural facets. The papers included here aim to explore the following questions: to what extent, and in what forms, did local traditions survive? How and why were they altered or revived under Roman rule? Is it possible to trace the role played by pre-Roman legacies in this long-term process? How did the impact of Rome suit local needs and vice-versa in terms of architecture, town planning, art, economy, and agriculture? Did the diverse regions of North Africa react differently to Roman imperial power?

This volume cannot answer all of these questions; instead, it is a collection of original and innovative contributions to the study of ancient North Africa, detailing the results of recent fieldwork (excavations and surveys), the study of archaeological and archival materials, and the re-analysis of written documents. Egypt is often excluded from publications about North Africa because it developed its own, very distinct, culture throughout its millenary history – from the Dynastic to Graeco-Roman periods. However, one should keep in mind that this did not happen in isolation from the rest of the continent. For this reason, we have included papers that deal with Egypt, its inhabitants, and the wider relationship with Africa and Rome. The time-frame considered focuses mainly on the Roman era, but also includes three contributions on pre-Roman North Africa to demonstrate the impact and persistence of pre-Roman legacies in the following centuries.

FROM ROMAN NORTH AFRICA TO *DE AFRICA ROMAQUE*: AFRICA *AND* ROME

The territories traditionally included within 'Roman North Africa' spread over a vast geographical area including modern Egypt, Libya, Tunisia, Algeria, and Morocco. These lands became Roman possessions at different stages, from as early as 146 BC (the end of the Third Punic War, which led to the creation of Africa Vetus, later part of Africa Proconsularis) to AD 42 (the official provincial organization of Mauretania Caesariensis and Mauretania Tingitana). By the time all of

[1] Pliny, *Historia Naturalis*, V.29; Strabo, *Geographia*, XVII.3.15.
[2] For instance: Abboudy Ibrahim 1992; Bates 1914; Brett and Fentress 1996; Brogan 1975; Desanges 1962; Mattingly 1995; 2003.

North Africa was part of the Roman Empire these regions had developed complex and intricate political, social and cultural structures. The survival of Phoenician, Punic, Numidian, Hellenistic, or Alexandrian traditions during the Roman period speaks of this complexity. But what about the indigenous contributions and influences that shaped North Africa in the Roman period? What role did they play in the development and evolution of regional societies and traditions? The compartmentalization into neat sections of the Punic, Hellenistic, Numidian, and Roman legacies in itself is problematic, since it is questionable whether such sharp categorizations ever existed amongst North African populations.[3] In contrast, elements of external influences were chosen and manipulated to suit local needs, merging, more or less seamlessly, into indigenous traditions and beliefs. The *Merging of Cultures* advocated in this book should not be understood as a random and passive process but, rather, as an active dialogue between ancestral traditions and new influences and policies from the colonizing powers.

Even before the Phoenicians arrived on the North African shores in the late second and early first millennium BC, traces of art, architecture, and the development of a distinct alphabet indicate that the inhabitants had already developed very complex cultures.[4] This complexity undoubtedly influenced the way Rome dealt with the different provinces. While Rome had a profound impact on local peoples to various degrees, the local peoples also had some influence on Rome. The ways in which the local populations recreated or reinforced their identity and dealt with the imperial power of Rome were far from uniform, as they were determined by each region's history, traditions, beliefs, and social composition.

The key theme woven into the papers within this book is an examination of the variety of societies and traditions in different parts of North Africa, from the pre-Roman period to Late Antiquity. Our intention is to shed more light on the local societies and how they manipulated and utilized external influences by incorporating them into their own culture. While many North African traditions were interconnected, the authors in this book draw attention to the local features, and to the different ways people dealt with the impact of Roman imperialism. The papers also investigate how Rome interacted with these peoples. The papers cover a vast area and a long timescale, and may ultimately raise as many questions as they can answer, but along the way they suggest new research agendas and promote new approaches.

The idea behind the initial conference was influenced by the recent shift in Roman provincial scholarship from a Rome-centred viewpoint to a more balanced approach, which takes into account local features and their contribution to the formation of the provincial societies. North Africa's long colonial history created a paradigm that strongly supported the idea of the superiority of Rome – and consequently western culture as a whole – to justify the claim by the modern colonizers that they were the rightful inheritors of North Africa.[5] During the last two decades, research has slowly moved on from perceiving indigenous peoples as 'inferior tribes',[6] to recognizing them as active contributors in the shaping of their religious, cultural, and political world. Nevertheless, the 'Roman' perspective remained a strong focus until recently. While it was acknowledged that the indigenous peoples had their own, sometimes long-lasting traditions and rituals, the primary focus was still on 'Roman' aspects, such as the assimilation and adoption of Roman art, architecture, religion, and culture, while the surviving Libyan, Phoenician or Punic legacies were classed as 'conservative'.[7] Only in recent years has the idea of the superiority of Rome over the local peoples been deconstructed.[8]

[3] Mattingly and Hitchner 1995, 186; Quinn 2013; Stone 2007. See Quinn and Vella 2014 for the problems with the term 'Punic'.

[4] Thébert 1978; Fentress 2006.

[5] Mattingly 1996a, 51-52. For example, it is only from the late 1990s and early 2000s that one can properly speak of 'Moroccan archaeology' in Morocco, thus leaving behind the country's colonial backdrop: see Hassar-Benslimane 2001; Papi 2006.

[6] Broughton 1929, 6. See Mattingly and Hitchner 1995 for a discussion of research in North Africa between 1975 and 1995.

[7] See, for instance, the traditional approaches to the history and archaeology of North Africa by Briand-Ponsart and Hugoniot 2006; Corbier and Griesheimer 2005; MacMullen 2000; Raven 1993.

[8] Quinn 2003, 7; see the review of the principal Francophone literature and scholarship on North Africa by Leveau 2014.

In the 1970s, Marcel Bénabou and Abdallah Laroui in particular drew attention to the resistance of the North African peoples against Rome, focusing on aspects previously underplayed, such as the numerous uprisings that occurred during the Roman occupation.[9] However, this view placed the argument on the other end of the scale – from acculturation to resistance – equally leading to the concept of 'us' and 'them', of 'Roman-ness' as opposed to 'reaction'.[10] North Africa has been studied against a profound ideological background – resistance is only one of many facets, and the existence of many different experiences should be taken into account.[11] It is also because of this deeply rooted colonial ideology that ethnic definitions that appear more 'politically correct', such as 'Afro-Roman', 'Mauro-Roman', or 'Roman-Numidian', are used only rarely.[12]

In recent studies, these colonial legacies have been progressively abandoned. Instead, new research tends to focus on the diverse influences that shaped the lives and characters of local inhabitants. There is also a growing interest in the inclusion and examination of the lower strata of society, such as the relationship between rural and urban communities, or the status and influence of workers.[13] Research on the Phoenician and Punic periods is undergoing a similar change. Paradigms of 'superior' Phoenician influence are being re-evaluated, and the use of the label 'Punic' for vast groups of peoples is being questioned.[14] It is now quite evident that using a single, univocal paradigm to describe the complexity of ancient societies where multiple substrata were at play is not sufficient. Concepts such as 'hybridization', 'heterogeneity', 'identities', and 'plurality' are becoming popular to describe the interactions between Rome and provincial cultures across the Empire, particularly in Anglophone scholarship.[15] Whether one agrees or not with the adoption of a given term, or label, is a matter open to academic discussion,[16] but what is important to acknowledge is that the current research in the field of Roman provincial history and archaeology is continuously advocating the abandonment of old-fashioned theories and stereotypes, in favour of more dynamic interpretative models that allow for multiple factors to be taken into account.

The present volume is much indebted to the renewed climate of research on North Africa that has developed in recent years. The various cultural relationships between North African peoples and Rome are now starting to be more fully explored through the re-examination of written evidence (literary and epigraphic sources) and new up-to-date archaeological research. Attention is being paid to the numerous regions included within the broad area referred to as 'Roman North Africa', and on how each ethnic and social group could have had a different perception of Roman dominance.[17] North Africa is starting to acquire its own autonomous space and is becoming an active topic; not merely a territory subjugated by Rome, but rather a second Rome itself – '*quasi Roma*', as advocated by the late Jean-Marie Lassère.[18] The importance of these multiple relations and interrelations between cultures is also being extended to the analysis of the Late Roman and Late Antique periods,[19] as well as the Vandal kingdom.[20] In the same vein, the recent research on the Garamantes of the Libyan desert has provided an excellent opportunity to cross the borders of the Roman Empire and to investigate the societies beyond it, together with their interconnections with the Classical Mediterranean world.[21]

[9] Bénabou 1976; 1978; Laroui 1970.

[10] Mattingly 1996, 58; Quinn 2003, 8.

[11] Mattingly and Hitchner 1995, 170. See also the recent approach to the study of military, urban, and rural communities in Britain under the Roman Empire proposed by Mattingly 2006; 2011, 236-245.

[12] Papi 2002, 703. The term 'Romano-Libyan' is more common, especially in Anglophone scholarship: see Gilbertson and Hunt 1996; Mattingly 1996b; Mattingly *et al.* 1996.

[13] Dossey 2010; Hobson 2015.

[14] Prag 2006; Quinn and Vella 2014.

[15] See, among the numerous existing references, the papers collected in Hales and Hodos 2010.

[16] For a review and useful summary: Mattingly 2014a.

[17] This variety of cultural influences in the history of North Africa is examined, for example, in Le Bohec 2013. See also the attempts to investigate North African provincial societies and identities in Briand-Ponsart and Modéran 2011 (for a critical review: Mattingly 2014b).

[18] Lassère 2015.

[19] Modéran 2003.

[20] Merrills and Miles 2010; Modéran 2014.

[21] See the contributions in Mattingly 2003; 2007; 2010; 2013.

STRUCTURE OF THE BOOK

This volume collects the proceedings of the international conference held at the University of Leicester on 26-27 October 2013. Two additional papers (those of Eleonora Gasparini and Ben Russell) are included to reflect the vibrant debate that arose during the event, together with a concluding essay by Bruce Hitchner. The five parts of the book group together papers according to the similarity of the themes they treat. However, one must be aware that each part is not to be intended as an independent, self-conclusive, section.

Part I, *North Africa before Rome: Indigenous Traditions and their Legacy*, draws attention to the period prior to the Roman conquest. It aims to shed light on the indigenous contributions that influenced the development of the North African societies later encountered by Rome.

Part II, *Planning, Developing, and Transforming the North African Townscape*, collects contributions which deal with the architectural and urban evolution of towns. Within this, the indigenous influences in this long-term process during the Hellenistic, Roman, and Late Antique periods are also considered.

Part III, *Perception and Representation of Power, Ethnic and Cultural Identities*, explores the insights we can have through the close reading of ancient texts and other sources. In particular, insights on: how North Africa was perceived by Rome; the complex interplay between local peoples and the impact of Roman imperialism; and later Christian/non-Christian identities and their relationship with the legacy of Rome in Africa.

Part IV, *Economies across North Africa: Production, Technology, and Trade*, focuses on the local contributions to the economy of the Roman Empire. Too often the importance of locally-based productions and the persistence and/or evolution of indigenous technologies are played down, or not clearly engaged with, when discussing the role of the North African economy. The principal aim of these papers is to highlight the importance of some of these local features and to analyse them within the broader framework of the Roman world.

Part V, *Creating a Lasting Impression: Architectural and Decorative Motifs*, deals with the expression of local identities and the incorporation/adaptation of external influences in art and architecture. Provincial art and architecture have long been measured against 'superior' Roman standards, thus creating an artificial dichotomy. Only more recently has the focus been shifted to the indigenous aspects of art and architecture, and how these were influenced by Roman art or vice-versa. This new approach is followed in the papers of this section, all of which engage with various aspects of this relationship.

The approaches adopted by the authors are diverse, reflecting the nature of the evidence they examined. The variety of research questions, methodological attitudes, interpretations, and conclusions is — in our opinion — one of the most significant characteristics of this book. Introducing multiple viewpoints, rather than the adoption of a single perspective, enriches our understanding of North Africa and, more broadly, the ancient world.

BIBLIOGRAPHY

Abboudy Ibrahim, M. 1992. The western desert of Egypt in the classical writings. In Pugliese Carratelli, G. (ed.), *Roma e l'Egitto nell'antichità classica. Atti del I Congresso internazionale italo-egiziano (Cairo, 6-9 febbraio 1989)*, Rome: Istituto Poligrafico e Zecca dello Stato, Libreria dello Stato, 209-217.

Bates, O. 1914. *The Eastern Libyans (Reprint 1970)*, London: F. Cass.

Brett, M. and Fentress, E. 1996. *The Berbers*, Oxford: Blackwell.

Bénabou, M. 1976. *La résistance africaine à la romanisation*, Paris: François Maspero.

Bénabou, M. 1978. Les Romains ont-ils conquis l'Afrique ?, *Annales. Économie, sociétés, civilisations*, 33: 83-88.

Briand-Ponsart, C. and Hugoniot, C. 2006. *L'Afrique romaine de l'Atlantique à la Tripolitaine. 146 av. J.-C. – 533 ap. J.-C.*, Paris: Armand Colin.

Briand-Ponsart, C. and Modéran, Y. (eds) 2011. *Provinces et identités provinciales dans l'Afrique romaine*, Caen: Publications du CRAHM.

Brogan, O. 1975. Inscriptions in the Libyan alphabet from Tripolitania and some notes on the tribes of the region. In Byon, L. and Byon, T. (eds), *Hamito-Semitica*, The Hague: Mouston, 267-289.

Broughton, T.R.S. 1929. *The Romanization of Africa Proconsularis*, Baltimore: Greenwood Press.

Corbier, P. and Griesheimer, M. 2005. *L'Afrique romaine : 146 av. J.-C. – 439 ap. J.-C.*, Paris: Ellipses.

Desanges, J. 1962. *Catalogue des tribus africaines de l'Antiquité classique à l'ouest du Nil*, Dakar: Université de Dakar.

Dossey, L. 2010. *Peasant and Empire in Christian North Africa*, Berkeley-London: University of California Press.

Fentress, E. 2006. Romanizing the Berbers, *Past and Present*, 190: 3-34.

Gilbertson, D.D. and Hunt, C.O. 1996. Romano-Libyan agriculture: walls and floodwater farming. In Barker, G. (ed.), *Farming the Desert. The UNESCO Libyan Valleys Archaeological Survey. Volume 1: Synthesis*, London: Society for Libyan Studies – Department of Antiquities, 191-225.

Hales, S. and Hodos, T. (eds) 2010. *Material Culture and Social Identities in the Ancient World*, Cambridge: Cambridge University Press.

Hassar-Benslimane, J.H. 2001. La recherche archéologique au Maroc durant deux décennies. In *Actes des 1ères journées nationales d'archéologie et du patrimoine, 2. Archéologie préislamique (Rabat, 1-4 juillet 1998)*, Rabat: Société Marocaine d'Archéologie et du Patrimoine, 7-12.

Hobson, M.S. 2015. *The North African Boom. Evaluating Economic Growth in the Roman Province of Africa Proconsularis (146 B.C. – A.D. 439)* (Journal of Roman Archaeology Supplement, 100), Portsmouth, RI: Journal of Roman Archaeology.

Laroui, A. 1970. *L'histoire du Maghreb. Un essai de synthèse*, Paris: François Maspero.

Lassère, J.-M. 2015. *Africa, quasi Roma (256 av. J.-C. – 711 apr. J.-C.)* (Études d'Antiquités Africaines), Paris: Éditions du CNRS.

Le Bohec, Y. 2013. *Histoire de l'Afrique romaine. 146 avant J.-C. – 439 après J.C. (deuxième édition revue et augmentée)*, Paris: Éditions Picard.

Leveau, Ph. 1978. La situation coloniale de l'Afrique romaine, *Annales. Économie, sociétés, civilisations*, 33: 89-92.

Leveau, Ph. 2014. *L'Afrique romaine : résistance et identité, histoire et mémoire*. In Ferdi, S. (ed.), *L'affirmation de l'identité dans l'Algérie antique et médiévale : Combats & résistances. Hommage à Kadria Fatima Kadra*, Algiers: Éditions du CNRA, 37-59.

MacMullen, R. 2000. *Romanization in the Time of Augustus*, New Haven-London: Yale University Press.

Mattingly, D.J. 1995. *Tripolitania*, London: Batsford.

Mattingly, D.J. 1996a. From one colonialism to another: imperialism and the Maghreb. In Webster, J. and Cooper, N. (eds), *Roman Imperialism: Post-Colonial Perspectives*, Leicester: School of Archaeological Studies – University of Leicester, 49-69.

Mattingly, D.J. 1996b. Romano-Libyan settlement: typology and chronology. In Barker, G. (ed.), *Farming the Desert. The UNESCO Libyan Valleys Archaeological Survey. Volume 1: Synthesis*, London: Society for Libyan Studies – Department of Antiquities, 111-158.

Mattingly, D.J. (ed.) 2003. *The Archaeology of Fazzān. Volume 1, Synthesis*, London: Society for Libyan Studies – Department of Antiquities.

Mattingly, D.J. 2006. *An Imperial Possession. Britain in the Roman Empire, 54 BC – AD 409*, London: Allen Lane, Penguin Books.

Mattingly, D.J. (ed.) 2007. *The Archaeology of Fazzān. Volume 2, Site Gazetteer, Pottery and Other Survey Finds*, London: Society for Libyan Studies – Department of Antiquities.

Mattingly, D.J. (ed.) 2010. *The Archaeology of Fazzān. Volume 3, Excavations carried out by C.M. Daniels*, London: Society for Libyan Studies – Department of Antiquities.

Mattingly, D.J. 2011. *Imperialism, Power, and Identity. Experiencing the Roman Empire*, Princeton: Princeton University Press.

Mattingly, D.J. (ed.) 2013. *The Archaeology of Fazzān. Volume 4, Survey and Excavations at Old Jarma (Ancient Garama) carried out by C.M. Daniels (1962-69) and the Fazzān Project (1997-2001)*, London: Society for Libyan Studies – Department of Antiquities.

Mattingly, D.J. 2014a. Identities in the Roman world: discrepancy, heterogeneity, hybridity, and plurality. In Brody, L.R. and Hoffman, G.L. (eds), *Roman in the Provinces. Art on the Periphery of Empire*, Chestnut Hill: McMullen Museum of Art, Boston College, 35-59.

Mattingly, D.J. 2014b. Provincial and other identities in Roman Africa, *Journal of Roman Archaeology*, 27: 819-822.

Mattingly, D.J. and Hitchner, R.B. 1995. Roman Africa: an archaeological review, *Journal of Roman Studies*, 85: 165-213.

Mattingly, D.J., Barker, G. and Jones, G.D.B. 1996. Architecture, technology and society: Romano-Libyan settlement in the Wadi Umm-el Agerem, Tripolitania. In Bacchielli, L., Bonanno Aravantinos, M. (eds), *Scritti di antichità in memoria di Sandro Stucchi, Volume 2* (Studi Miscellanei, 29), Rome: 'L'Erma' di Bretschneider, 101-114.

Merrills, A. and Miles, R. 2010. *The Vandals*, Chichester: Wiley-Blackwell.

Modéran, Y. 2003. *Les Maures et l'Afrique romaine (IV^e-VII^e siècle)* (Bibliothèque des Écoles Françaises d'Athènes et Rome, 314), Rome: École Française de Rome.

Modéran, Y. 2014. *Les Vandales et l'empire romain* (published by M.-Y. Perrin), Arles: Éditions Errance.

Papi, E. 2002. Mauretania Tingitana in epoca tardo-antica: Great Expectations, *Journal of Roman Archaeology*, 15: 703-706.

Papi, E. 2006. Archeologia marocchina in Marocco, *Journal of Roman Archaeology*, 19: 540-543.

Prag, J.R.W. 2006. Poenus plane est – but who were the 'Punickes'?, *Papers of the British School at Rome*, 74: 1-37.

Quinn, J.C. 2003. Roman Africa?. In Merryweather, A.D. and Prag, J.R.W. (eds), *'Romanization'? Proceedings of a Post-Graduate Colloquium, The Institute of Classical Studies, University of London* (Digressus Supplement, 1), Digressus: Online publication, 7-34.

Quinn, J.C. 2013. Monumental power: Numidian royal architecture in context. In Quinn, J.C. and Prag, J.R.W. (eds), *The Hellenistic West. Rethinking the Ancient Mediterranean*, Cambridge: Cambridge University Press, 179-215.

Quinn, J.C. and Vella, N.C. (eds), 2014. *The Punic Mediterranean. Identities and Identification from Phoenician Settlements to Roman Rule*, Cambridge: Cambridge University Press.

Raven, S. 1993. *Rome in Africa*, London: Routledge.

Stone, D.L. 2007. Burial, identity and local culture in North Africa. In van Dommelen, P. and Terrenato, B. (eds), *Articulating Roman Cultures: Power and Identity under the Expanding Roman Republic* (Journal of Roman Archaeology Supplement, 63), Portsmouth, RI: Journal of Roman Archaeology, 126-144.

Thébert, Y. 1978. Romanisation et déromanisation en Afrique : histoire décolonisée ou histoire inversée ?, *Annales. Économie, sociétés, civilisations*, 33: 64-82.

PART I

NORTH AFRICA BEFORE ROME: INDIGENOUS TRADITIONS AND THEIR LEGACY

2

WHO SHAPED AFRICA?
THE ORIGINS OF URBANISM AND AGRICULTURE IN MAGHREB AND SAHARA

David J. Mattingly

Abstract

This paper questions some underlying assumptions of the study of Roman Africa, first promoted in the Classical sources, but reinforced in the modern colonial era. These assumptions relate to the processes of urbanization and the development of agriculture in the Maghreb and the identity of the communities behind these innovations. The common tendency has been to link these crucial social changes to a time after the arrival of colonists on African shores – whether Greek, Phoenician or Roman. The role of indigenous African people has generally been limited to that of passive recipients or inexpert imitators. New evidence on the date of the earliest agriculture and the early stages of proto-urban development pose fundamental questions for the traditional models. The contributions of indigenous communities to the shaping of Africa under Rome need thorough re-evaluation.

INTRODUCTION

The story of Roman Africa is often constructed around two extraordinary epi-phenomena of the era. The first defining characteristic is presented as an unusually high density and magnificence of towns in the region during the Roman period. Second, there was an evident boom in agricultural output with concurrent distribution of the surplus production across Mediterranean markets.[1] I am not challenging the fundamental significance of these themes for our study, but rather I shall question the orthodox position on what the drivers of these phenomena were.[2]

The scholarly consensus view of Africa in the Roman Empire has been skewed by the agenda of modern colonialism in the region (Figure 2.1). The modern imperial regimes in North Africa (Spanish and French in Morocco, French in Algeria and Tunisia, Italian, British and French in Libya) have been fixated on a Romano-centric vision, with a particular emphasis on the notion of Romanization, and on presenting the modern colonial ventures as successors to the ancient, claiming to reprise a previous attempt at European civilization of Africa, based around the gifts of agriculture and urbanization.[3] In reaction to this model, in the first decades of post-colonial independence, some Maghrebian historians created a version of the past that was more attuned to the nationalist agenda of irreconcilable opposition to imperialism, including Bénabou's notable (and still fundamental) account of resistance to Romanization.[4]

[1] Typical of many books to embrace this duopoly is Picard 1990, whose first chapters (pages 15-100) deal with 'La révolution politique' (fundamentally urbanization) and 'La révolution économique' (fundamentally agriculture).

[2] Though I limit my comments here to the issue of urban and agrarian development, it should be apparent that there are far wider implications of this sort of investigation as David Stone's important contribution to this volume makes clear, by linking similar arguments to the question of early state formation.

[3] Mattingly 2011, 43-72, 'From one colonialism to another. Imperialism and the Maghreb'; cf. Munzi 2001; 2004.

[4] Bénabou 1976; Mattingly 2011, 59-63 summarizes this debate.

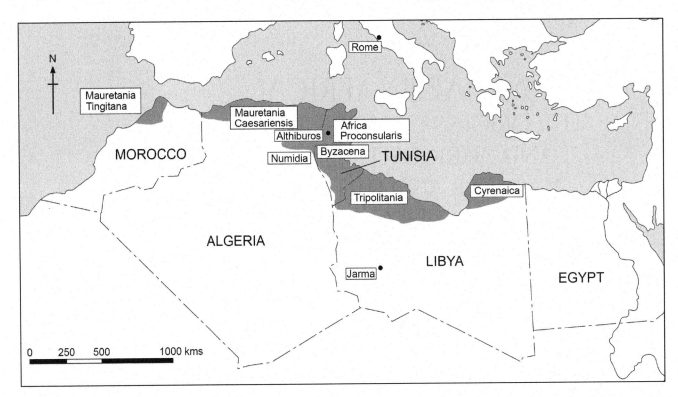

Figure 2.1. *Map of Roman provinces of Africa, with main sites mentioned in text marked (image: N. Mugnai, based on rough by D. Mattingly).*

Although the debate has moved on to the point where the middle ground between these discrepant views of Roman Africa is now well populated, my main argument here is that we have still not deconstructed the primary tenets of the old colonial models and that the future agenda of study remains compromised.[5]

A variant of the emphasis on the Roman inspiration of agrarian and urban development concerns the role of Phoenicians/Carthaginians in kick-starting these processes.[6] Both these scholarly tendencies present a paternalistic view of external civilizations bringing advanced skills and institutions for the instruction of backward and passive indigenous populations. The Libyphoenician cities along the coast are thus often hailed as key players in the introduction of cultivation and urban living.[7] In Cyrenaica (eastern Libya), Greek colonists stand in for the Phoenicians in the identical scenario.[8] The classic characterization of indigenous Africans has been that they were simple pastoralists who lacked substantial sedentary settlements and farming before colonists first visited African shores:

> '[des Gétules] [. . .] pasteurs nomades ou semi-nomades, ils entraient peu en contact avec des cités, à tel point qu'on a tendance à penser aujourd'hui que le terme Gétule désignait les peuples libyens nomades, un genre de vie plus qu'une véritable ethnie'.[9]

In a nutshell, my question concerns whether the Romans and earlier incomers to the Maghreb were ultimately responsible for the dramatic changes we witness in farming and town life and that undoubtedly represented an urban and agrarian boom by the heyday of 'Roman Africa'. Was it outsiders who shaped Africa? Or did indigenous groups have a larger role in the process than generally credited? The problem in seeking to resolve this question is that the archaeological evidence is drastically unequal – we have far more excavation of Roman and Carthaginian sites than of the proto-historic African societies in Maghreb and Sahara. At Roman cities, the presence

[5] Rather than cite the most extreme examples of the Romano-centric colonialist models, I shall illustrate this paper in part by reference to echoes of the same sort of assumptions in recently published text books (mainly in French) on Roman Africa.

[6] See, for example, Géroudet and Ménard 2005, 159: 'Rome trouve en Afrique du nord un monde déjà urbanisé et organisé. De nombreux noyaux puniques existent qui gardent longtemps leur originalité, en particulier leurs institutions'.

[7] Fantar 1993.

[8] Laronde and Golvin 2001.

[9] Briand-Ponsart and Hugoniot 2006, 23.

of major monuments impedes exploration of the earliest levels of occupation, leaving unchallenged the assumptions about their origins.

What sort of societies were the indigenous African communities of the first millennium BC? The default assumption both in antiquity and today has tended to be that they were small-scale tribes of pastoralists and that most of the vast hinterland was still essentially undeveloped prior to the arrival of Rome. Pliny talks of 516 distinct *populi* between the Ampsaga and the Greater Syrtes.[10] The more northerly peoples were coalescing into states by the late third century BC, based around two main self-identifying groups, the *Numidae* in western Tunisia and eastern Algeria and the *Maures* further to the west. The peoples living to the south of the Carthaginian, Numidian and Mauretanian heartlands were known by myriad names, but had the capacity for periodic confederated action. The Roman sources tended to refer to them in broad terms as *Gaetuli*. Beyond them lay other Libyan peoples of the deep Sahara, including the *Garamantes*, who feature later in this paper, and the *Aethiopes* (black Africans).[11] I shall now look individually at each of my themes, urbanization and agriculture, then offer a few points of general conclusion.

URBANIZATION

Towns were certainly a characteristic, even defining, feature of the African provinces of the Roman Empire.[12] The mapping of the towns and roads of the African provinces frames our conception of those spaces[13] (Figure 2.2 gives an approximation of urban densities in the Roman Empire).[14] What is immediately apparent is that Africa Proconsularis was the main focus for high-density development in the Maghreb. So densely packed were towns in northern Tunisia,

Figure 2.2. *Distribution of urban sites in the Roman Empire (image: M. Hawkes; after Russell 2013, figure 3.8).*

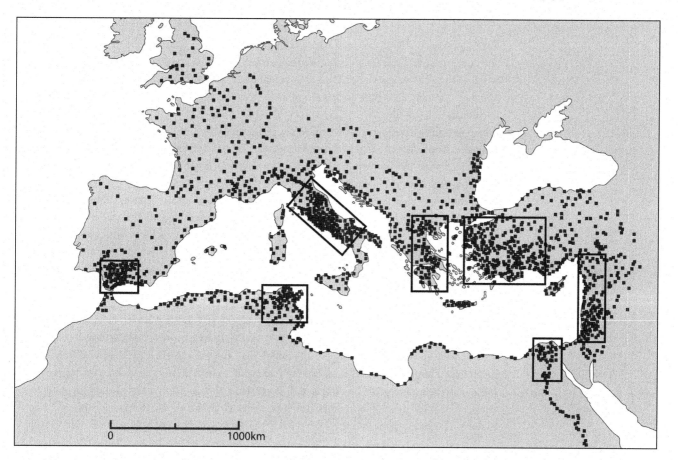

[10] Pliny, *Historia Naturalis*, V.29.

[11] On the peoples of Africa, see Desanges 1962; 1980.

[12] The classic accounts of Roman era urbanization are Gascou 1972 and Lepelley 1979; 1989. For a range of recent Romano-centric accounts of urbanism in Africa, for example, see, *inter alia*, Corbier and Griesheimer 2005, 371-417; Laronde and Golvin 2001; Le Bohec 2005, 109-131; Sears 2007; 2011.

[13] Desanges *et al.* 2010; various African maps in Talbert 2000.

[14] The map is developed from Russell 2013, which is in turn largely based on the Barrington Atlas.

for instance, that it has been estimated that the average territory of a city was only in the order of 80 sq. km.[15] Some other parts of the Maghreb and the Libyan coast had much lower levels of urbanization. It is also evident that Africa was one of seven main urban hotspots in the Roman Empire (defined by boxes on Figure 2.2), the others being Italy, Greece, Asia Minor, the Levant, the Nile Delta and south-western Spain. What these other areas share in common is the fact that Roman urbanism built on already well-established urban traditions. If we compare the success of Roman urbanism in regions of low pre-Roman urbanism and proto-urbanism, like northern Gaul and Britain, the difference in numbers, density and status promotions of towns is very striking.[16] This comparative view might thus suggest that the high urban density in Africa is most readily explicable in terms of pre-Roman developments.

Most modern commentators would accept that the Roman urban achievement did not happen *ex nihilo*, but represented rather a rapid growth in urban centres and in the size, monumentality and status of many of these. The urban progenitors are mostly identified with Carthage or Libyphoenician centres without consideration of alternatives. Can the pre-Roman development be attributed solely to the Phoenician and Carthaginian inspiration? Even where a potential African urban community is recognized, the impetus for growth is often vested in newcomers (often Roman citizens):

> 'C'est là la question cruciale : les cartes montrent [. . .] le pullulement de petites cités, auxquelles les calculs les plus optimistes donnent à peine quelques milliers d'habitants. Elles portent à peu près toutes des toponymes libyques, ou parfois puniques, et sont donc d'une ancienneté antérieure à la conquête romaine. Le début de leur intégration au monde classique est souvent le résultat de l'installation d'un petit groupe de citoyens *morantes*, résidents [. . .]'.[17]

Carthage was clearly an extraordinary urban centre, but it was also unique in Africa for its scale and development.[18] The early phases of urban evolution in Africa have been inadequately explored, whether in terms of matching up the traditional literary foundation dates for sites like Utica and Carthage, or in assessing the scale and sophistication of early sites, their economic bases and connectedness, or the identity of their inhabitants (diet, material culture, behaviours). In general, Punic specialists have found it difficult to match literary dates for foundations with archaeological evidence. At present the first archaeological traces from Carthage date to the eighth century BC (compared with the literary date of ninth century BC), at Utica the earliest published burials are late eighth century in date (compared with the literary date of the late twelfth century BC). Similarly, while the expectation is that many of the Libyphoenician emporia should date to the first half of the first millennium BC, at present the evidence suggests that the main expansion of their numbers came after 500 BC. The earliest secure archaeological evidence from Lepcis Magna is sixth-fifth century BC, at Sabratha it is late fifth century BC, at Leptiminus it is fifth century BC.[19] Part of the problem is that many early towns went on to be successful Roman towns, replete with monumental architecture and *in situ* mosaic floors, which have discouraged deeper sondages. The best-preserved Punic town at Kerkouane (with its main phase of structural development in the fourth-third centuries BC) is atypical because of its abandonment by c. 200 BC.[20] On the other hand, the extensive excavations have revealed this site to have been a small-scale settlement, lacking in public buildings and monumental architecture. It was little more than a large village and evidence for the spatial extent of other emporia also suggests that these were generally quite small in size. It is certainly the case that many of the Libyphoenician urban centres did develop into much more extensive cities during the Roman period, as at Leptiminus.[21] The investigation of Libyphoenician urbanism has thus far not fully matched expectations,

[15] Lepelley 1979, 46; 1981; Picard 1990, 25-28.

[16] Compare the relevant maps in the Barrington Atlas, Talbert 2000.

[17] Lassère 2005, 149.

[18] Fantar 1993.

[19] See Mattingly 1995, 116-127; Stone *et al.* 2011, 273-274.

[20] For the excavations, see Fantar 1984; 1985; 1986.

[21] For two recent studies of the evolution of Libyphoenician coastal towns through intensive survey, see Stone *et al.* 2011 (Leptiminus) and Fentress *et al.* 2009 (Meninx).

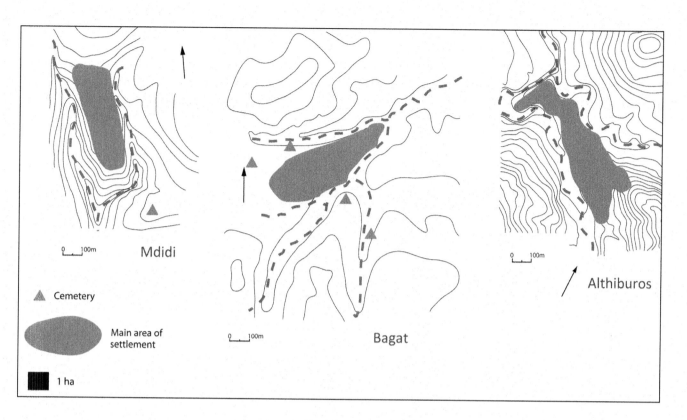

albeit with the extraordinary exception of Carthage. But did these coastal settlements provide the only model and inspiration for the emergence of towns in the hinterland – according to the orthodox interpretation first emerging under the Numidian kingdom in the latter centuries BC?

Figure 2.3. *Numidian proto-urbanism. A: Althiburos; B: Mdidi; C: Bagat (image: M. Hawkes, based on rough by D. Mattingly).*

Althiburos and 'Numidian' urbanism

Recent work at the Numidian and Roman town of Althiburos offers a new perspective on early Numidian urbanization.[22] By excavating deep trenches beneath and between the Roman remains, where most past excavators have tended to stop, this project has exposed a series of pre-Roman buildings and occupation levels which have been well dated using AMS radiocarbon determinations, in addition to stratified pottery finds.[23] A major surprise has been the identification of rectangular stone buildings dating back to the tenth-ninth centuries BC. There is also firm evidence for ironworking by the eighth century and the nature of the archaeological structures and deposits strongly supports the view that this was a sedentary settlement from the outset.

The urban model that is represented at such sites is in all probability distinctive and unlike the Phoenician and Roman creations. Figure 2.3 shows three small Numidian towns that all occupied narrow promontories defined by deeply incised wadi channels: Mdidi, Bagat and Althiburos.

In particular, Althiburos occupied a defensible spur of land between two wadis, looking out to the north towards plain lands and protected by flanking hills and a wall across the head of the valley to the south. The Roman town eventually spilled out across a larger area, but the early settlement appears to have been located on this narrow promontory c. 500 x 120 m (6 ha). The characteristic elements of all three sites are the relatively small size (5-8 ha) and the location on a narrow defensible spur, with dry streams constituting a substantial moat around much of the perimeter. Although there is greater evidence at Althiburos for subsequent monumentalizing of the core, the major public buildings were still relatively modest (a forum, two classical-style temples, an *Aesculapium*, a theatre, two arches), and the plan irregular.[24]

Bagat (Henchir Ghayadha), near Zama Regia, is another good example of the type. The walled site (8 ha only) sits on a defensible spur of land between two converging wadis. It contains limited traces of monumental constructions around a central rectangular space (forum?), probably the

[22] Kallala *et al*. 2008; Kallala and Sanmartí 2011; Sanmartí *et al*. 2012.

[23] Kallala and Sanmartí 2011, 31-38; Sanmartí *et al*. 2012, 26-36.

[24] Kallala and Sanmartí 2011, 9-28.

locality of a known temple of Tellus. The urban core is surrounded by an extensive set of cemeteries, covering at least 25 ha and incorporating pre-Roman style megaliths and bazina monuments. There was a suburban sanctuary of Baal-Hammon, later elaborated as a temple of Saturn. Saturn stelae were also recovered in relation to one of the northern cemeteries. In late Roman times Bagat appears to have been seat of a bishopric. Survey at the site has turned up Libyan, Neo-Punic and Latin inscriptions, reflecting the diverse cultural identities at play.[25] Mididi is another example of this same sort of setting, and although the Roman town eventually spread across c. 30 ha, the original Numidian core presumably lay within the c. 5 ha area on the top of the prominent plateau. Here again there was a megalith cemetery to the south of the site and numerous stelae to Baal Hammon and Saturn, including 18 neo-Punic texts.[26]

All these sites seem to represent a proto-urban tradition that initially had evolved independent of external influences. Most studies of towns in 'Roman Africa' have focused on the 'Roman' and monumental characteristics of these sites, ignoring or downplaying features that do not conform to our expectations of the Classical city. Unusual sites like Tiddis in Algeria, heavily terraced into a precipitous site and with few of the standard amenities of a Roman town, are pigeon-holed as exceptions to the 'Romanized' norm, but my suspicion is that its location on a fortified promontory has much more in common with many other towns with pre-Roman origins.[27] My conclusion is that Roman Africa was full of towns precisely because nucleated settlements had a very long prior tradition there. The hundreds of Roman towns were literally built on hundreds of indigenous villages and proto-urban settlements. What is currently uncertain, because of the lack of excavated Proto-historic sites, is the precise date at which these settlements took on a fully urban character. However, the apparent continuity of occupation at these sites, rather than their replacement by new settlements in different topographic locations under Rome, very strongly supports the view that the 'Numidian' phases of such sites were important in the eventual form of urbanism that emerged. Some at least of the Numidian centres may be suspected of having achieved what we would recognize as full urban functionality by the latter centuries BC, as suggested for example by Sallust's account of Numidian Cirta.[28] The crucial point here is that the default assumption is now changed and we cannot rule out, while we await new archaeological evidence, that proto-urban African developments may have been significant in the fashioning of Roman Africa's urban centres. In Punic and Roman times we certainly witness contact and adaptive change, but the possibility that there were African fundamentals of towns has hitherto been unexamined. Nor is this the only instance of proto-historic urban experimentation that we can observe in Proto-historic North Africa.

The *Garamantes* of the Libyan Sahara

My second archaeological case study concerns my own fieldwork in the central Sahara of southern Libya.[29] A Libyan people known from the time of Herodotus as the *Garamantes* lived here in a zone that was already hyper-arid desert before the first millennium BC.[30] The *Garamantes* can be associated with three major bands of oases in the central Sahara with smaller isolated clusters to the south-west, south-east and north-east. The central band, the Wadi al-Ajal, and the southern bands, the Murzuq basin, comprised the heartland territory and will be the main focus of attention here (Figure 2.4).

The density of nucleated settlements in this part of the central Sahara was totally unsuspected prior to my recent work and though many Garamantian sites cannot be closely dated, it is apparent that the evolution of this settlement system began about 1000 BC.

Despite a hostile hyper-arid desert environment following major climate change about 5000 years ago, it is now clear that, like the Numidians, the *Garamantes* were a largely sedentary

[25] M'Charek *et al.* 2008.
[26] Ben Baaziz 2000.
[27] Berthier 2000.
[28] Sallust, *Bellum Jugurthinum*, 21-26. Though the exact location of the site is disputed (Constantine or El Kef), it was clearly both a political and market centre for a large region, a point emphasized by the presence there of an established community of Roman grain traders. Similarly, the well-known bilingual inscriptions in Libyan and Neo-Punic from Thugga hint at urban institutions and practices there.
[29] Mattingly 2003a; 2007; 2010; 2013 for a new baseline set of studies.
[30] The ancient sources on the *Garamantes* are summarized in Mattingly 2003b, 76-90.

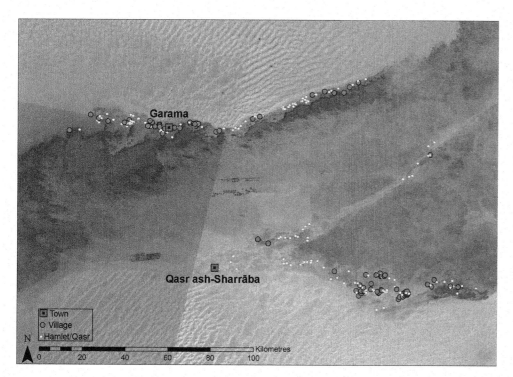

Figure 2.4. *Distribution map of Garamantian oasis settlements (image: M. Sterry).*

people by the early first millennium BC, living in permanent and well-defended settlements. By c. 400 BC these early Garamantian settlements, of which the classic example is a hillfort known as Zinkekra, were taking on an increasingly proto-urban form.[31] Through time the morphology of the best preserved Garamantian sites became increasingly sophisticated, by Late Antiquity showing some influence of Roman frontier settlements far to the north.[32] However, the underlying evolution of nucleated centres extends far back before the contact period. Jarma, the Garamantian capital, was one such site, though the Garamantian levels are here overlain by the ruins of a sequence of later towns. There were 10 phases of construction recognized, with the earliest levels dating back to the fourth century BC. As at Althiburos, the use of AMS dating and detailed study of material culture and palaeoeconomic markers have transformed our understanding of the origins and economy of the site.[33]

Jarma may have been a site of exceptional importance, but other Garamantian settlements of the Classic period are also notable for their architectural sophistication, their semi-planned nature, their density in the landscape and their scale. The largest sites are urban in scale and functional characteristics. What has become increasingly apparent in the last few years is that the settlement system merits the appellation urban from the latter centuries BC onwards and the dense nexus of permanently settled villages does not at all conform with the testimony of the ancient sources who tended to depict the *Garamantes* as barbaric nomads.[34] Moreover, the density and sophistication of oasis settlements in Garamantian territory raise question marks about the presumed start-up date of other Saharan oases. Figure 2.5 highlights some of the main groups close to the Roman frontier where the origins can be traced back to the Roman era at least. Since the dating is largely dependent on diagnostic material culture, this is more likely a question of visibility rather than foundation dates. These oases occur in many areas occupied by the people defined by the ancient sources as *Gaetuli*, who I earlier illustrated are widely represented as exclusively 'nomadic'.[35] The evidence relating to the *Garamantes* can thus be supplemented with other examples that demonstrate not only the rise of a unique Saharan state, but that supports the idea of a more generalized independent urban evolution in the Sahara pre-dating Phoenician and Roman interventions in these societies.

[31] Mattingly 2010, for the excavations at Zinkekra.

[32] Mattingly and Sterry 2013; Mattingly *et al.* 2013, 508-544; Sterry and Mattingly 2011; 2013; Sterry *et al.* 2012.

[33] Mattingly 2013, for the excavations at Jarma.

[34] For the arguments on Garamantian urbanization in detail, see Mattingly and MacDonald 2013; Mattingly and Sterry 2013; Mattingly *et al.* 2013.

[35] Briand-Ponsart and Hugoniot 2006, 23.

Figure 2.5. *North Saharan oases close to the Roman frontier with attested Roman activity and potential pre-Roman origins (image: M. Hawkes, based on rough by D. Mattingly).*

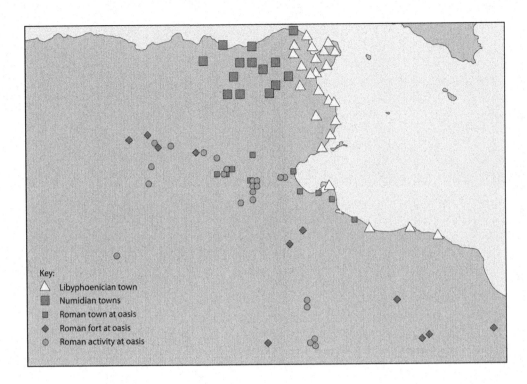

Key:
△ Libyphoenician town
■ Numidian towns
▪ Roman town at oasis
◆ Roman fort at oasis
○ Roman activity at oasis

What I am suggesting then is that there were multiple pathways to urbanism in North Africa in the first millennium BC. To summarize the evidence for urban trajectories: first, the importance of Libyphoenician sites in the urbanization of Africa has long been recognized, but also perhaps over-emphasized for want of other evidence. The coastal cities had well-developed settlements and farming systems on a Mediterranean model, tied into Mediterranean trade and cultural networks. The new evidence I have presented necessitates a re-evaluation of the significance and early origins of Numidian settlements that eventually became towns. I have suggested here that the Numidians (and other Libyans in northern and coastal regions) were developing (proto-)urbanization in parallel but possibly independently of Carthage during the first millennium BC. In addition, though, it is clear that African urbanization under Rome also built on pre-existing oasis communities, whether constituted as proper Roman towns, existing alongside occupied Roman forts, or extrapolated for other oases where we have certain indications of pre-Islamic origins. Hillforts are another important category of sites whose distribution needs to be more fully mapped and whose development and social function investigated.

AGRICULTURE

Our starting point here is that despite the unpromising arid conditions described by the ancient sources, Africa was the source of a super-abundance of cereals:

> 'La Berbérie a été un des greniers du monde antique. Elle partageait avec l'Égypte, le redoutable honneur de ravitailler Rome, et en assumait même, depuis Néron, la plus part, exactement les deux tiers. Ce fait, apparemment paradoxal, mais indéniable, doit être évidemment le point de départ de toute étude sur l'économie africaine'.[36]

More than that, archaeological evidence has long demonstrated impressive evidence for the mass production and export of olive oil and wine.[37]

How far back can we push the origins of agriculture in North Africa? Agriculture was of course present in the Nile Valley and the Western Desert oases close to the Nile from Pharaonic times, but there has been limited evidence from further west in Libya and the

[36] Picard 1990, 62.
[37] Hobson 2015; Mattingly 1988a-b; Stone et al. 2011.

Maghreb countries. Until fairly recently the common assumption has been that agriculture was an introduction of the mid-first millennium BC associated with colonists in the first instance, gradually spreading to indigenous communities under the improving encouragement of Hellenized rulers like Massinissa or the Roman state. The development of African agriculture by the Roman period is often characterized as a boom or even a miracle:

> 'Le miracle africain s'explique par plusieurs causes et en particulier par des raisons historiques, au premier rang desquelles se plaça l'héritage de Magon. Par cette expression, nous voulons dire que les Carthaginois, peuple de la mer comme on sait, sont devenus aussi un peuple de la terre. Ils ont développé une agriculture brillante, consignée dans le traité du célèbre agronome. Cependant, les Romains n'ont pas été en reste. Un de leurs apports essentiels a été de délimiter les terres des semi-nomades et de provoquer le déclin de ce genre de vie'.[38]

Some recent work in caves in Morocco has produced a startling series of AMS dates prior to 6500 cal BP for some cultivated plants (including wheat, barley and lentils). The evidence remains limited and its implications are uncertain, but the dramatically early date for agriculture in Morocco suggests that in time we shall have more Neolithic dates for cultivated crops elsewhere in the Maghreb.[39] While the recent excavations in the Haua Fteah cave in Libya have not located evidence of Neolithic agriculture in the upper sequence of deposits,[40] that does not prove that there was no agriculture in Cyrenaica in the last centuries BC, simply that it was not present at that site. As we shall see, there may be more likely places to search for it in future.

For the first millennium BC at any rate, there has been a recent breakthrough in dating. Just as the recent work at Althiburos and on the *Garamantes* have cast doubt on theories about urban origins, so these same two case studies have important new information on the origins of agriculture in North Africa.

Althiburos

At Althiburos, the rectangular stone buildings dating back to the tenth-ninth centuries BC were associated with evidence for cultivation of a range of cereals (durum and emmer wheat, barley and two species of millet), legumes (lentils, peas and beans) and viticulture from the earliest occupation and with the addition of the olive by the late eighth century, if not before (Table 2.1).[41] The first evidence for agriculture at Althiburos is thus firmly dated to the early first millennium BC and the agricultural component of the economy was consistent through all the Numidian phases.

Table 2.1. *Dates of contexts with first occurrence of range of cultivated plants in Numidian farming (data from Sanmartí et al. 2012, 30-36).*

Site	Crop	Earliest Phase	Calibrated date-range of Phase (2 sigma)
Althiburos	Durum wheat	Early Numidian 1	1020-810 cal BC
Althiburos	Emmer wheat	Early Numidian 1	1020-810 cal BC
Althiburos	Barley	Early Numidian 1	1020-810 cal BC
Althiburos	Broom-corn millet	Early Numidian 1	1020-810 cal BC
Althiburos	Italian millet	Early Numidian 1	1020-810 cal BC
Althiburos	Lentils	Early Numidian 1	1020-810 cal BC
Althiburos	Peas	Early Numidian 1	1020-810 cal BC
Althiburos	Beans	Early Numidian 1	1020-810 cal BC
Althiburos	Grape vines	Early Numidian 1	1020-810 cal BC
Althiburos	Olives	Early Numidian 3	790-760 cal BC

[38] Le Bohec 2005, 137. See Mattingly 1988a for my earlier work highlighting an olive boom under Rome.
[39] Zapata *et al.* 2013.
[40] Barker *et al.* 2012.
[41] Kallala and Sanmartí 2011, 33-38; Sanmartí *et al.* 2012, 30-34.

The range of cultivated species reveals an already developed agricultural package, suggesting that the ultimate origins of agriculture in this part of Africa may eventually prove to be much earlier still. As already noted there is a late Neolithic missing phase here.

There is also evidence of grazing animals, notably sheep and cattle, being kept by the Numidians. The handmade pottery from the site, now organized as a typology, also supports the view that these people were essentially sedentary from the earliest phases of occupation. Pastoral peoples do not generally have so wide a range of pottery forms.

The *Garamantes*

The Garamantian story is again remarkably similar, with a fully evolved agricultural package present in the Saharan oases by the very early first millennium BC (Table 2.2).[42] The ultimate origins of agriculture in the central Sahara may be earlier still as a date stone from a late Pastoral grave in the Wadi Tanzufft about 400 km south-west of Jarma has been radiocarbon dated to c. 1400-1300 BC. So far the earliest evidence from the Garamantian heartlands in the Wadi al-Ajal is from the Early Garamantian hillfort site of Zinkekra, with a series of radiometric dates in the first half of the first millennium BC. It is clear that from that point they practised advanced irrigated agriculture of cereals (bread and emmer wheat and barley), dates, vines and figs. The ultimate origins of this farming package probably lay in the oases of the Egyptian desert. By the Proto-Urban Garamantian era (500-1 BC) the first Sub-Saharan crops made an appearance in Garamantian farming – sorghum, pearl millet, cotton.[43] The Classic Garamantian era (first-fourth centuries AD) saw some further minor introductions of Mediterranean crops (durum wheat, olives, almonds, pomegranates, watermelon) though the mainstays of the farming remained as before: dates, bread and emmer wheat, sorghum and pearl millet, barley, vines and cotton. An interesting point of contrast with the Numidian agricultural package is the absence of evidence of pulses in the Garamantian samples until the Classic/Late Garamantian period.

The technology of farming the desert was certainly not due to Mediterranean influence. In the Garamantian heartlands there is evidence of the use of the *shaduf* (balance well) and lengthy

Table 2.2. *Dates of contexts with first occurrence of range of cultivated plants in Garamantian farming (data from Mattingly 2007; 2010; 2013; di Lernia and Manzi 2002).*

Site	Crop	Earliest date	Calibrated date (range)
Wadi Tanzufft	Date palm (stone)	–	1400-1300 cal BC
Zinkekra ZIN001.71	Date palm (multiple elements)	2670±70 BP	980-670 cal BC
Zinkekra ZIN001.71	Bread wheat	2670±70 BP	980-670 cal BC
Zinkekra ZIN001.71	Emmer wheat	2670±70 BP	980-670 cal BC
Zinkekra ZIN001.71	Barley	2670±70 BP	980-670 cal BC
Zinkekra ZIN001.71	Grape vine	2670±70 BP	980-670 cal BC
Zinkekra ZIN001.71	Fig	2670±70 BP	980-670 cal BC
Old Jarma GER001	Cotton	Phase 10	416-320 cal BC
Tinda TIN001	Sorghum	2180±40 BP	390-110 cal BC
Tinda TIN001	Pearl millet	2130±40 BP	360-40 cal BC
Old Jarma GER001	Pomegranate	Phase 7	cal AD 49-183
Old Jarma GER001	Almond	Phase 7	cal AD 183-353
Old Jarma GER001	Olive	Phase 6	cal AD 183-353
Old Jarma GER001	Watermelon	Phase 6	cal AD 183-353
Old Jarma GER001	Pea	Phase 6	cal AD 183-353
Old Jarma GER001	Durum wheat	Phase 6/5	cal AD 183-860
Old Jarma GER001	Bean	Phase 5	cal AD 353-860
Old Jarma GER001	Lentil	Phase 4	cal AD 860-1093

[42] Van der Veen and Westley 2010; Pelling 2013.
[43] Pelling 2013.

underground channels known as *foggaras* – both of these technologies seem to have been spread along the oasis chain running west from Egypt.[44]

CONCLUSIONS

It is worth stressing that the new evidence from Althiburos for a substantial sedentary settlement, with well-developed agriculture and iron working, predates the archaeological date for the foundation of Carthage in the late eighth century BC and is well ahead of the wider dissemination of Libyphoenician sites in Africa. So this development is not on current evidence attributable to the direct stimulus of the agencies most commonly credited for these innovations: Carthage, the Numidian king Massinissa and Rome – though that is not to deny that those connections gave further impetus to these trends. The material culture includes some Punic material, but not from the very earliest levels. If there was a Phoenician 'Prince Charming' in this story, he left little trace of awakening Numidian civilization. Althiburos was just one site among many Numidian centres that are recorded in our sources for the latter centuries BC. The demonstration that this site was a centre of sedentary agricultural people from early in the first millennium BC, rather than a development that emulated the spread of Libyphoenician urbanization and agriculture, thus represents a major revision to established models.

My identification of Numidian contributions to the spread of agriculture in North Africa during the first millennium BC in no way detracts from the remarkable achievements of the rural economy during the Roman heyday. The level of olive oil production attested in the Tunisian Dorsal and High Steppe areas indicates a significant growth in production during the Roman period, in part stimulated by the massive capital investment in major estates, but evidently emulated also at many smaller sites.[45] However, the new evidence of earlier agricultural development would suggest that this Roman boom built on Numidian foundations, with the difference being a question of increased specialization and scale of production. As with towns building on well-established sedentary communities, so Roman agriculture and arboriculture were made possible by the already widespread dissemination of agriculture and the existence of large settled farming communities.

Similarly, the *Garamantes* were remote from the Mediterranean. Their capital at Old Jarma was c. 1000 km (about a month's journey) from the nearest Libyphoenician harbour at Oea (Tripoli). Moreover, the evidence for their earliest agriculture and the initial stages of proto-urban development antedate the earliest dating evidence for the existence of the Phoenician emporia. It is not clear whether the Garamantian and Numidian pathways to urbanization and agriculture are part of a single and linked process, or whether, perhaps more likely, they are separate manifestations of the spread of new farming technologies and the need for sedentary settlements on the one hand into the Mediterranean hinterland and, on the other, into the Sahara. The differences in the agricultural packages revealed by Table 2.1 and Table 2.2 certainly suggest that they resulted from different evolutionary paths. In both cases they necessitate a significant re-dating of the adoption of agriculture by indigenous African communities, with concomitant changes to the mode of life and living spaces. For those parts of North Africa that have been presumed to have been lightly inhabited by a few wandering nomads, this requires moving the date of indigenous nucleated settlements and early agriculture back by about 500-700 years – truly a seismic shift. As noted above, there is now some evidence of extremely early agriculture in Northern Morocco, from around 7,000-6,500 years ago, but it remains to be seen whether that was an isolated early experiment with farming in the Maghreb or a first indication of a chronologically much more extended Neolithic agricultural build-up.

In conclusion, I offer two alternative models for the making of Roman Africa. The first (Figure 2.6a) represents the nineteenth- and twentieth-century vision of development dependent on colonial initiative and example, with Libyphoenicians and Romans transforming previously unsettled pastoralists into urban and village-dwelling agriculturalists. My new model (Figure 2.6b) contextualizes the Libyphoenician centres in the first millennium BC encountering a world already in transition, with agriculture and village centres well-established in the area later occupied by the Numidian and Garamantian kingdoms (and arguably beyond those areas).

[44] Mattingly *et al.* 2003, 351-544; Wilson 2006; 2009; Wilson and Mattingly 2003, 235-278.

[45] Hobson 2015; Mattingly and Hitchner 1993; Sehili 2009.

Figure 2.6. *Models of urbanization and agricultural take-up in Africa. A: the traditional colonialist model; B: proposed new model taking more account of indigenous agency in first millennium BC (image: M. Hawkes, based on rough by D. Mattingly).*

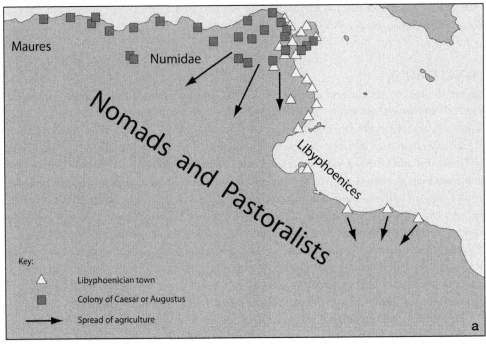

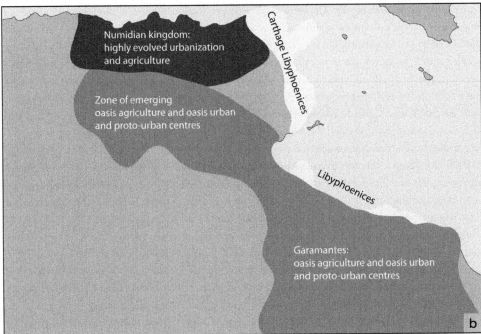

Whatever the contributions of Carthaginians and Romans, native Africans were much more active participants in the shaping of Africa in the Roman Empire. We would do well to embrace this agenda. This seems an altogether more interesting point for future research to start from, especially in the new climate following the upheavals of the Arab Spring.[46]

[46] Here I stress again the fact that many other societal developments and transformations were linked to urbanization and agriculture – metallurgy and other significant pyrotechnologies, trade, social hierarchy, identity representations, migration and state formation. These are important themes within the overall frame of the Trans-Sahara project, which I am currently directing with funding from the European Research Council. The support of the ERC is here gratefully acknowledged. The ideas explored here were first presented in my Jerome lectures during 2013 in Rome and Ann Arbor and will be elaborated in due course as a monograph. In advance of that, I am grateful to the editors of this collection for the opportunity to offer a succinct summary of some of the key issues, which are highly relevant to the theme of this volume. Two anonymous readers have encouraged me to be more explicit about the nature of African proto-urban developments, though the current state of evidence constrains discussion on many points. However, I hope at least to have convinced many readers that we need to revisit our preconceptions relating to the issues covered here. Figure 2.1 is by Niccolò Mugnai from my rough; Figures 2.2-3, 2.5-6 by Mike Hawkes also from my roughs; Figure 2.4 by Martin Sterry.

BIBLIOGRAPHY

Barker, G., Bennett, P., Farr ,L., Hill, E., Hunt, C., Lucarini, G., Morales, J., Mutri, G., Prendergast, A., Pryor, A., Rabett, R., Reynolds, T., Spry Marques, P. and Twati, M. 2012. The Cyrenaican prehistory project 2012: the fifth season of investigations of the Haua Fteah Cave, *Libyan Studies*, 43: 115-136.

Bénabou, M. 1976. *La résistance africaine à la romanisation*, Paris: François Maspero.

Ben Baaziz, S. 2000. *Rohia et le Sraa Ouertane dans l'Antiquité (Tunisie)*, Tunis: Institut National du Patrimoine.

Berthier, A. 2000. *Tiddis. Cité antique de Numidie*, Paris: De Boccard.

Briand-Ponsart, C. and Hugoniot, C. 2006. *L'Afrique romaine de l'Atlantique à la Tripolitaine. 146 av. J.-C. – 533 ap. J.-C.*, Paris: Armand Colin.

Corbier, P. and Griesheimer, M. 2005. *L'Afrique romaine 146 av. J.-C. – 439 ap. J.-C.*, Paris: Ellipses.

Desanges, J. 1962. *Catalogue des tribus africaines de l'Antiquité classique à l'ouest du Nil*, Dakar: Université de Dakar.

Desanges, J. 1980. *(Pline l'Ancien), Histoire Naturelle, Livre V 1ʳᵉ partie, 1-46 (L'Afrique du Nord)*, Paris: Les Belles Lettres.

Desanges, J., Duval, N., Lepelley, Cl. and Daint-Amans, S. 2010. *Carte des routes et des cités de l'est de l'Africa à la fin de l'Antiquité. D'après le trace de Pierre Salama* (Bibliothèque de l'Antiquité Tardive, 17), Turnhaut: Brepols.

Di Lernia, S. and Manzi, G. (eds) 2002. *Sand, Stones and Bones. The Archaeology of Death in the Wadi Tanezzuft Valley (5000-2000 BP)*, Florence: All'Insegna del Giglio.

Fantar, M. 1984. *Kerkouane : Cité punique du Cap Bon (Tunisie), Volume 1*, Tunis: Institut National d'Archéologie et d'Art.

Fantar, M. 1985. *Kerkouane : Cité punique du Cap Bon (Tunisie), Volume 2*, Architecture domestique, Tunis: Institut National d'Archéologie et d'Art.

Fantar, M. 1986. *Kerkouane : Cité punique du Cap Bon (Tunisie), Volume 3*, Sanctuaires et cultes, société, économie, Tunis: Institut National d'Archéologie et d'Art.

Fantar, M. 1993. *Carthage. Approche d'une civilisation*, Tunis: Les Éditions de la Méditerranée.

Fentress, E., Drine, A. and Holod, R. 2009. *An Island through Time: Jerba Studies, 1. The Punic and Roman Periods* (Journal of Roman Archaeology Supplement, 71), Portsmouth, RI: Journal of Roman Archaeology.

Gascou, J. 1972. *La politique municipale de l'empire romain en Afrique proconsulaire de Trajan à Septime-Sévère* (Collection de l'École Française de Rome, 8), Rome: École Française de Rome.

Géroudet, N. and Ménard, H. 2005. *L'Afrique romaine de l'Atlantique à la Tripolitaine (69-439)*, Paris: Belin.

Hobson, M.S. 2015. *The North African Boom. Evaluating Economic Growth in the Roman Province of Africa Proconsularis (146 B.C. – A.D. 439)* (Journal of Roman Archaeology Supplement, 100), Portsmouth, RI: Journal of Roman Archaeology.

Kallala, N. and Sanmartí, J. (eds) 2011. *Althiburos, I. La fouille dans l'aire du capitole et la nécropole méridionale* (Documenta, 18), Tarragona: Institut Català d'Arqueologia Clàssica.

Kallala, N., Sanmartí, J., Belarte, M.C. and Ramon, J. 2008. Recherches sur l'occupation d'Althiburos (région du Kef, Tunisie) et de ses environs à l'époque numide, *Pyrenae*, 39.1: 67-113.

Laronde, A. and Golvin, J.-C. 2001. *L'Afrique antique. Histoire et monuments*, Paris: Tallader.

Lassère, J.M. 2005. Societé et vie sociale. In Cabouret, B. (ed.), *L'Afrique romaine de 69 à 439 : Romanisation et Christianisation*, Nantes: Éditions du Temps, 144-167.

Le Bohec, Y. 2005. *Histoire de l'Afrique romaine. 146 avant J.-C. – 439 après J.C.*, Paris: Éditions Picard.

Lepelley, Cl. 1979. *Les cités de l'Afrique romaine au Bas-Empire, tome I. La permanence d'une civilisation municipal*, Paris: Études Augustiniennes.

Lepelley, Cl. 1981. *Les cités de l'Afrique romaine au Bas-Empire, tome II. Notices d'histoire municipale*, Paris: Études Augustiniennes.

Mattingly, D.J. 1988a. The olive boom. Oil surpluses, wealth and power in Roman Tripolitania, *Libyan Studies*, 19: 21-41.

Mattingly, D.J. 1988b. Oil for export: a comparative study of Roman olive oil production in Libya, Spain and Tunisia, *Journal of Roman Archaeology*, 1: 33-56.

Mattingly, D.J. 1995. *Tripolitania*, London: Batsford.

Mattingly, D.J. (ed.) 2003a. *The Archaeology of Fazzān. Volume 1, Synthesis*, London: Society for Libyan Studies – Department of Antiquities.

Mattingly, D.J. 2003b. Historical summary. In Mattingly, D.J. (ed.), *The Archaeology of Fazzān. Volume 1, Synthesis*, London: Society for Libyan Studies – Department of Antiquities, 75-106.

Mattingly, D.J. (ed.) 2007. *The Archaeology of Fazzān. Volume 2, Site Gazetteer, Pottery and Other Survey Finds*, London: Society for Libyan Studies – Department of Antiquities.

Mattingly, D.J. (ed.) 2010. *The Archaeology of Fazzān. Volume 3, Excavations carried out by C.M. Daniels*, London: Society for Libyan Studies – Department of Antiquities.

Mattingly, D.J. 2011. *Imperialism, Power, and Identity. Experiencing the Roman Empire*, Princeton: Princeton University Press.

Mattingly, D.J. (ed.) 2013. *The Archaeology of Fazzān. Volume 4, Survey and Excavations at Old Jarma (Ancient Garama) carried out by C.M. Daniels (1962-69) and the Fazzān Project (1997-2001)*, London: Society for Libyan Studies – Department of Antiquities.

Mattingly, D.J. and Hitchner, R.B. 1993. Technical specifications of some North African olive presses of Roman date. In Amouretti, M.-C. and Brun, J.-P. (eds), *La production du vin et de l'huile en Méditerranée. Actes du symposium international organisé par le Centre Camille Jullian (Université de Provence – C.N.R.S.) et le Centre archéologique du Var (Ministère de la Culture et Conseil general du Var), (Aix-en-Provence et Toulon, 20-22 novembre 1991)* (Bulletin de Correspondence Hellénique Supplement, 26), Paris-Athens: École Française d'Archéologie, 439-462.

Mattingly, D.J. and MacDonald, K. 2013. Early cities: Africa. In Clark, P. (ed.), *The Oxford Handbook of Cities in World History*, Oxford: Oxford University Press, 66-82.

Mattingly, D.J. and Sterry, M. 2013. The first towns in the Central Sahara, *Antiquity*, 87.366: 503-518.

Mattingly, D.J., Reynolds, T. and Dore, J. 2003. Synthesis of human activities in Fazzan. In Mattingly, D.J. (ed.), *The Archaeology of Fazzān. Volume 1, Synthesis*, London: Society for Libyan Studies – Department of Antiquities, 327-373.

Mattingly, D.J., Sterry, M. and Thomas, D. 2013. Jarma in its Saharan context: an urban biography. In Mattingly, D.J. (ed.), *The Archaeology of Fazzān. Volume 4, Survey and Excavations at Old Jarma (Ancient Garama) carried out by C.M. Daniels (1962-69) and the Fazzān Project (1997-2001)*, London: Society for Libyan Studies – Department of Antiquities, 505-544.

M'Charek, A., Jaïdi, H., Baklouti, H., and Sehili, S. 2008. Recherches d'archéologie et d'histoire à Henchir Ghayadha / Bagat ? (Tunisie), *Antiquités Africaines*, 44: 109-265.

Munzi, M. 2001. *L'epica del ritorno. Archeologia e politica nella Tripolitania italiana* (Saggi di Storia Antica, 17), Rome: 'L'Erma' di Bretschneider.

Munzi, M. 2004. *La decolonizzazione del passato. Archeologia e politica in Libia dall'amministrazione alleata al regno di Idris* (Saggi di Storia Antica, 22), Rome: 'L'Erma' di Bretschneider.

Pelling, R. 2013. The archaeobotanical remains. In Mattingly, D.J. (ed.), *The Archaeology of Fazzān. Volume 4, Survey and Excavations at Old Jarma (Ancient Garama) carried out by C.M. Daniels (1962-69) and the Fazzān Project (1997-2001)*, London: Society for Libyan Studies – Department of Antiquities, 473-494.

Picard, G.C. 1990. *La civilisation de l'Afrique romaine*, Paris: Études Augustiniennes.

Russell, B. 2013. *The Economics of the Roman Stone Trade* (Oxford Studies on the Roman Economy), Oxford: Oxford University Press.

Sanmartí, J., Kallala, N., Belarte. M.C., Ramon, J., Telmini, B., Jornet, R. and Miniaoui, S. 2012. Filling gaps in the protohistory of the eastern Maghreb: the Althiburos Archaeological Project (El Kef, Tunisia), *Journal of African Archaeology*, 10.1: 21-44.

Sears, G.M. 2007. *Late Roman African Urbanism: Continuity and Transformation in the City* (British Archaeological Reports, International Series, 1693), Oxford: Archaeopress.

Sears, G.M. 2011. *The Cities of Roman Africa,* Stroud: The History Press.

Sehili, S. 2009. *Huileries antiques de Jebel Semmama. Région de Kasserine*, Tunis: Centre de Publication Universitaire, Manouba.

Sterry, M. and Mattingly, D.J. 2011. DMP XIII: reconnaissance survey of archaeological sites in the Murzuq area, *Libyan Studies*, 42: 103-116.

Sterry, M., and Mattingly, D.J. 2013. Desert Migrations Project XVII: further AMS dates for historic settlements from Fazzān, south-west Libya, *Libyan Studies*, 44: 127-140.

Sterry, M., Mattingly, D.J. and Higham, T. 2012. Desert Migrations Project XVI: radiocarbon dates from the Murzuq region, southern Libya, *Libyan Studies*, 43: 137-147.

Stone, D.L., Mattingly, D.J. and Ben Lazreg, N. (eds) 2011. *Leptiminus (Lamta). Report no. 3. The Field Survey* (Journal of Roman Archaeology Supplement, 87), Porthsmouth, RI: Journal of Roman Archaeology.

Talbert, R.J.A. 2000. *Barrington Atlas of the Greek and Roman World*, Princeton: Princeton University Press.

Van der Veen, M. and Westley, B. 2010. Palaeoeconimic studies. In Mattingly, D.J. (ed.), *The Archaeology of Fazzān. Volume 3, Excavations carried out by C.M. Daniels*, London: Society for Libyan Studies – Department of Antiquities, 489-522.

Wilson, A.I. 2006. The spread of foggara-based irrigation in the ancient Sahara. In Mattingly, D.J., McLaren, S., Savage, E., al-Fasatwi, Y. and Gadgood, K. (eds), *The Libyan Desert: Natural Resources and Cultural Heritage,* London: Society for Libyan Studies, 205-216.

Wilson, A.I. 2009. Foggaras in ancient North Africa: or how to marry a Berber princess. In *Contrôle et distribution de l'eau dans le Maghreb antique et médiéval* (Collection de l'École Française de Rome, 426), Rome: École Française de Rome, 19-39.

Wilson, A.I. and Mattingly, D.J. 2003. Irrigation technologies: foggaras, wells and field systems. In Mattingly, D.J. (ed.), *The Archaeology of Fazzān. Volume 1, Synthesis*, London: Society for Libyan Studies – Department of Antiquities, 235-278.

Zapata, L., López-Sáez, J.A., Ruiz-Alonso, M., Linstädter, J., Pérez-Jordà, G., Morales, J., Kehl, M. and Peña-Chocarro, L. 2013. Holocene environmental change and human impact in NE Morocco: palaeobotanical evidence from Ifri Oudadane, *The Holocene*, 23.9: 1286-1296.

3

BEFORE GREEKS AND ROMANS
EASTERN LIBYA AND THE OASES,
A BRIEF REVIEW OF INTERCONNECTIONS
IN THE EASTERN SAHARA

Robert G. Morkot

Abstract

This paper takes a broad view, chronologically and geographically, of the evidence from the Eastern Sahara to the Nile Valley, and from the Mediterranean to the sub-Saharan routes. There has been extensive discussion of the evidence for the Libyans of the Late Bronze Age and the nature of their society: this is briefly discussed with some consideration of the implications for settlement in the oases as well as the Nile Valley. The issues of the historiography and its legacy are considered. The recent work in the Egyptian deserts and implications for understanding long-distance travel and interconnections from sub-Saharan Africa to the Mediterranean are reviewed. The existence of networks of interconnecting roads does not mean that long routes were regularly, if ever, used but shorter sections were.

THE NILE VALLEY, THE MEDITERRANEAN COAST,
THE DESERTS AND OASES

The history and archaeology of north-eastern Africa (Figure 3.1) are dominated by the cultures of the Nile Valley because of the wealth of surviving material and the intensity of research. In the Lower Nile Valley (Egypt), there is continuity in the record from Prehistoric times to the present. Although the archaeology of the Kushite and Meroitic cultures of the Middle Nile raises more questions, it too is essentially continuous from Prehistoric times onwards. Moving to the west of the Nile Valley, however, the evidence is much patchier. The archaeological material lacks the continuity of that from the Nile Valley, which is certainly partly due to the amount of survey and excavation in the oases and the deserts. There are large sites, and many are of Roman date: as a result, excavation has focused on the later phases, and earlier material of the Dynastic period is rarer. Egyptology as a discipline has also regarded ancient Egypt as an essentially Nile Valley culture, and the Egyptians as people who did not have the means, or did not like, to travel in the deserts. It was also assumed that the region to the west of the Nile Valley reached its present state of aridity by the time of Egypt's emergence as a unified state in the fourth millennium BC. The work of Rudolf Kuper and his teams throughout the Western Desert of Egypt over the past thirty years has revealed a far more complex environmental process, and also archaeological material which challenges many older assumptions. Recent work by a number of teams has specifically looked for evidence of ancient routes and begun the process of rigorous analysis of that evidence.[1]

Archaeological survey and excavation along the Mediterranean coast of the eastern part of the modern states of Libya and Egypt – ancient Marmarica – has been limited.[2] Much that

[1] Kuper 1989; most recent works of Förster 2013; Kröpelin and Kuper 2006-2007; Riemer and Förster 2013.
[2] Carter 1963; Hulin 2008; Hulin *et al.* 2009; Rieger and Möller 2012; Rieger *et al.* 2012; Snape and Wilson 2007 detail the work of Alan Rowe and others; Vetter *et al.* 2009; White 1994.

has been written about Libya before Greek colonization is acknowledged to be based on scanty archaeological evidence and a small number of written sources of non-Libyan origin (mostly Egyptian). The current, fairly generally accepted, view of Late Bronze Age Libya, which is discussed below, is that presented by Kitchen, O'Connor, Snape, and Hulin.[3] There are, of course, many points of uncertainty: the exact location of 'tribal' groups and place names; the extent to which the 'Libyans' were nomadic, settled, or a mixture; their culture; and the extent of their technologies (particularly metallurgy). Whilst the nature of the surviving evidence focuses much of the discussion on the coastal regions (Cyrenaica and Marmarica) and on the groups that eventually invaded Egypt towards the end of the Late Bronze Age (1300-1100 BC), the oases and desert routes provide scattered evidence, and were – from the perspective of Egypt – also part of the 'Libyan' world. 'Libyan' and 'Libya' are used here in the vague sense that is usual in discussions of this material.[4] Quirke and O'Connor discuss the broader problems in understanding the Egyptian evidence.[5] It cannot simply be used (as it was in the past) empirically as a quarry for 'facts'; yet all writers acknowledge that there are usable 'facts' contained within the sources.

We cannot construct a consecutive narrative of the region embracing the coastal and desert regions west of the Nile Valley from the Late Bronze Age to the Roman period. What follows attempts to highlight some of the key issues that have emerged in discussions, including ideas that have been rejected, but which still leave some residue in the (particularly 'non-academic') literature.

THE LIBYANS AND THE 'SEA PEOPLES'

The most extensive written and visual evidence for the 'Libyans' of the Late Bronze Age is that from Egypt, and it equates the Libyans with the so-called 'Sea Peoples'. Their supposed mass movements of population have been seen as the cause of the 'collapse' of the Late Bronze Empires and many cities around 1200 BC: the Hittite Empire in Asia Minor fragmented to be replaced by the 'Neo-Hittite' states; Mycenaean Greece and Crete were destroyed and entered a long 'Dark Age'; Ugarit was destroyed and never rebuilt; and other cities along the Levantine coast suffered a period of eclipse before recovery.[6] As excavations produced more and more instances of destruction levels at the end of the Late Bronze Age, so the idea of the 'Sea Peoples' grew: indeed, they could be blamed for almost anything! The 'Sea Peoples' became a mass migration of populations by land and sea, and their relentless move along the eastern coast of the Mediterranean was only halted when they reached the borders of Egypt. There they met with a strong opposition in the army of Ramesses III and were pushed back. Some of them, like the *Peleset*, stayed where they were, in Palestine; others sailed off into the sunset: the *Shardana* to Sardinia and the *Shekelesh* to Sicily. Despite more considered analyses of the evidence and the historiography,[7] the 'Sea Peoples' continue to appear in volumes on the history and archaeology of the Bronze Age as some sort of unified entity. The development of the 'Sea Peoples' theory is closely linked to the Egyptian evidence for the Libyans of the Late Bronze Age. Although the evidence is limited and open to interpretation, it allows some comment before presenting a more speculative survey of the Libyan world that stretched over the vast expanse, now desert, of the west of modern Egypt, the east of Libya and into the northern fringes of Sudan and Chad.

The Egyptian evidence for the Late Bronze Age Libyans and the groups associated with them became a focus of the nineteenth-century obsession with race. Libyans were depicted on monuments of the Egyptian New Kingdom (Eighteenth-Twentieth Dynasties, c. 1550-1070 BC), and two significant narratives recorded conflict with invading Libyan armies. One of these, with battle scenes and lengthy text, is in the temple of Ramesses III at Medinet Habu, on the east bank of the Nile in the ancient city of Thebes (modern Luxor).[8] The temple also has extensive reliefs showing a sea battle with the invaders later to be known as the 'Sea Peoples'. The other inscription, about half a century earlier in date, is from the reign of the pharaoh Merneptah

[3] Kitchen 1990; O'Connor 1990; Snape 2003; Hulin (in press).
[4] See Snape 2003, 94-95.
[5] Quirke and O'Connor 2003, especially 15-19; O'Connor 2003.
[6] Cline and O'Connor 2003.
[7] Drews 1993; Kuhrt 1995.
[8] *The Epigraphic Survey 1930*; *The Epigraphic Survey 1932*; Edgerton and Wilson 1936.

(c. 1213-1203 BC) and carved on the walls of the temple of Amun at Karnak on the east bank at Thebes.[9] Later, Flinders Petrie excavated a parallel text in Merneptah's temple on the west bank at Thebes. He misnamed this the 'Israel Stela' because it has the only reference to 'Israel' in any Egyptian text, despite being an account of the Libyan conflict. In both accounts some of the groups that make up the 'Sea Peoples' are named as invaders alongside the Libyans. These inscriptions have been extensively discussed,[10] as has the historiography,[11] and the following summary is to emphasize the issues around interpretation of the Egyptian material, and attitudes towards racial identification.

In 1855, when the Karnak inscription of Merneptah was first translated, Emmanuel de Rougé suggested that the names represented places in the northern and western Mediterranean. He identified the Lukka with Lycia, the Ekwesh with Achaea (Greece), the Tursha with Tyrsenia (= Tyrrhenia, the south and western coasts of Italy), the Shekelesh with Sicily, and the Shardana with Sardinia. De Rougé was also the first to publish the Medinet Habu scenes, and noted the presence of the Peleset, people of the coast north of Gaza (Palestine) where they were understood to have been settled for centuries. De Rougé regarded the groups as mercenary troops and hypothesized that the names of the peoples represented their place of origin.[12]

Figure 3.1. *North-east Africa with the Nile Valley, oases, and coastal regions of Marmarica and Cyrenaica (image: R. Morkot).*

A fundamental change in interpretation came with the work of Gaston Maspero, who was responsible for the idea of a mass migration of 'Sea Peoples'. Although these 'Sea Peoples' are now generally held to be responsible for the major destructions found in many sites of Greece, the Aegean and western Asia at the end of the Late Bronze Age, Maspero's thesis was *only* to explain the Medinet Habu reliefs. Maspero was writing *before* there had been excavation at Mycenae, Tiryns, Pylos, Knossos, Hattusas (the Hittite capital), Ugarit, and other Levantine cities that show major destruction levels. The attribution of the destructions to the 'Sea Peoples' is a good case of archaeology 'proving' a theory formulated for a different reason.

Maspero revised his views in 1873: he now argued that the Peleset were from the Aegean who settled Philistia *after* the conflict with Ramesses III – they may have been expelled from the Aegean by the invasions of the Dorians. He later argued that they had moved from Crete to Caria in Asia Minor, and from there to the southern Levant (because they are shown with ox-carts!). From this argument, the names now became those of peoples that were later given to the places where they settled, rather than whence they originated. The 'Libu' were not Libyan neighbours of the Egyptians, but a people from the Balkans. Rather bizarrely, Maspero argued that, instead of crossing the Mediterranean, they took the long way round via Gibraltar. Only when they were halted by Merneptah and pushed back, did they settle in Libya. Maspero argued that these peoples of Europe and Asia Minor were being pressured by other migrations even further north (such as the Dorians and the Phrygians): they started as mercenaries and raiders, and then became

[9] *The Epigraphic Survey 1986*; Manassa 2003.

[10] See O'Connor 1990; Snape 2003.

[11] Drews 1993.

[12] De Rougé 1855; 1867.

larger-scale population movements. Using Egyptian depictions, he described the Libu as 'men of tall stature and large of limb, with fair skins and light hair and blue eyes'.[13]

In his narrative history, Petrie, an obsessive collector of Egyptian images of racial types,[14] actually maintained a rather old fashioned view for the time, following de Rougé and others, rather than Maspero, and arguing that the Libyan groups were from North Africa, but further west in the Maghreb, in what is now Tunisia. He made a connection between the name 'Meshwesh' preserved in Egyptian sources, and Herodotus's Maxyes.

It was Eduard Meyer who integrated Maspero's theories with archaeological discoveries of destruction at numerous sites. In 1893 Meyer still understood the names as those of localities, but by 1928 was arguing for a true *Völkerwanderung* by land and sea and was now incorporating the archaeological evidence for destructions in Greece and Asia Minor. Therefore, Maspero's speculative hypothesis became entrenched orthodoxy: the movements of the Phrygians into Asia Minor, the Dorians into Greece, and the Latins and others into Italy were all part of the same process, pressured by other movements further north – indeed this was a movement of the Indo-Europeans to the south of the Danube.[15] Oric Bates, in his volume *The Eastern Libyans* (for a long time the major study of the subject), presented the Libyans as a branch of the 'Western Hamites'.[16] Bates located the Meshwesh in the western part of the Gebel Akhdar of Cyrenaica.

The concept of the 'Sea Peoples' has become rooted in the history and archaeology of the Late Bronze Age collapse, and the associated ideas about race and population movements still retain their influence. Specifically for the Libyans, the evidence has been reassessed in a less prejudiced way, as outlined below. The Late Bronze Age evidence presents us with an unfortunately common problem of a combination of written and visual evidence from Egypt, and (largely due to issues of survey and excavation) limited archaeological material. It does, however, even if somewhat tenuously, link with the world into which the Greek colonists arrived.

O'Connor, Kitchen, Snape, Manassa and others have discussed the earlier, rather patchy, evidence.[17] The terms Tjemeh (the place) and Tjemhu (its inhabitants) are found from an early date and understood by O'Connor to designate all inhabitants of ancient Cyrenaica and the Mediterranean coastal region westwards to the Nile Delta. Another term, Tjehenu, is also ancient. It is certain from many Egyptian sources that any people and places outside of the Nile Valley to the west were considered 'Libyan'. Terms that are new in the Egyptian New Kingdom (c. 1550-1079 BC), Meshwesh and Libu, have more specific usage, and are contemporary self-definitions.

THE EGYPTIAN EVIDENCE AND RECENT INTERPRETATIONS

An inscription of the reign of Hatshepsut (c. 1473-1458 BC) records 700 elephant tusks being captured from the Tjehenu-Libyans. Hayward suggested that this was Libyan ivory coming from further west (Tripolitania), or from further south, which was then to be traded by the Libyans with the Aegeans. Hayward's article gained considerable authority with some Aegean archaeologists, but provoked a hostile reaction from ivory specialists;[18] it is an isolated incident, as is reference to the Tjehenu at this time. It is also a very large quantity of tusks which seems to be unparalleled in near contemporary sources. The most likely explanation is that the ivory was coming from the south along the desert road through Kharga, but why it would be by-passing Egypt – surely a better source of valuable exchange goods – is impossible to say. The Egyptian records generally indicate the Middle Nile as the supplier of ivory to Egypt, even if the ivory came from further south.[19]

It is another century before Libyans are again noted in Egyptian records. Cattle 'of the Meshwesh' – the first reference to this tribal group – are referred to in documents of the reign of

[13] The development of Maspero's ideas are detailed by Drews 1993, 50-61. The most developed form appears in Maspero 1896, 430.
[14] Petrie 1922; Ashton 2003.
[15] Meyer 1928; see discussion in Drews 1993, 60-61.
[16] Bates 1914.
[17] Kitchen 1990; O'Connor 1990, with the critique of Ritner 2009; Manassa 2003; Snape 2003.
[18] Hayward 1990; Kryszkowska and Morkot 2000, 323.
[19] Kryszkowska and Morkot 2000; Morkot 1998.

Amenhotep III (c. 1370 BC).[20] Slightly later, in the reign of Akhenaten (c. 1350 BC), Libyan ambassadors are depicted alongside those of other regions, and Libyans offer 'tribute' including ostrich eggs and ostrich feathers to the king; they are also shown as soldiers in the royal body-guard.[21] A section of papyrus from Akhenaten's reign appears to depict Libyans and Mycenae-ans in conflict with Egyptian troops: are these 'mercenary' soldiers 'hired' by Libyans? This also raises the more contentious subject of the frescos from Thera, which have also been suggested to indicate Aegean-Libyan contacts.[22]

The earliest Late Bronze Age archaeological material relating to Libyans comes from the region of Marsa Matruh, where the Bates' Island site has evidence for Cypriote-Libyan exchange probably involving metals and metalwork. Evidence from the excavations by Bates at Marsa Matruh, and the excavations by White and others on Bates' Island, associates Libyan and Late Bronze Age material with Cypriot, Canaanite, Aegean and Egyptian material.[23] Cycladic and Mycenaean sherds were found in association with what has been described as a 'Neolithic' style of pottery at Cyrene.[24] Survey of the coast from Tocra to Tobruk by Pennsylvania University Museum, under Theresa Howard Carter, did not find any Minoan or Mycenaean remains, but did find microliths similar to those from Bates' Island.[25] Other evidence for pre-Greek Libyans may be represented by shelters that are known from various sites (including religious ones).[26] The archaeological evidence from Marmarica suggests that exploitation of the region may have been much the same from the Neolithic into recent times. The remains of this Capsian Tradition are difficult to locate.[27] Hulin has also noted the wide spread of 'Marmaric wares', but also the difficulty of dating them.[28]

The first major conflicts between Egyptian and Libyan forces came in the reign of Sety I (c. 1290 BC) and are depicted on the exterior walls of the Hypostyle Hall of the great temple of Amun at Karnak (Luxor). The Libyan soldiers are shown with short sharp stabbing swords of western Asiatic type, another indicator of foreign contacts. Their other weapons are the tradi-tional bows and there is no evidence for chariots or horses at this stage, although Egyptian depic-tions can present a traditional, rather than contemporary, view of opponents.

Shortly after Sety I's campaign, the Egyptians developed a defensive line of fortresses along the western edge of the Nile Delta and along the coast through Alamein to the westernmost point at Zawiyet Umm el-Rakham, near Marsa Matruh.[29] The evidence here dates from the reign of Ramesses II (c.1279-1213 BC) and suggests Egyptian attempts to control eastward migration of Libyans into Egypt: it appears to have been short-lived.

In year 44 of the reign of Ramesses II (c. 1235 BC), there is evidence from northern Nubia for the capture of Tjemehu-Libyans in one of the oases, either Dunqul or Kurkur.[30] These captives were then put to work on the construction of the temple at Wadi el-Sebua in the Nubian Nile Valley. Whether they were migrant groups, or permanently settled, is unstated in the source.

The reign of Ramesses II's son, Merneptah (c. 1213-1203 BC), saw a major invasion by Lib-yan soldiers accompanied by their families and animals. This is recorded on the misnamed 'Israel Stela' and the parallel text in the temple of Amun at Karnak. We are told that the chief of the Libu, Meryey son of Ded, brought his wife and throne, silver and gold, as well as numerous peo-ple. Famine in their homeland is specifically stated to be a cause of the movement – so here we are dealing with a migration of people rather than a purely military raid. This group had penetrated

[20] Kitchen 1990, 16.

[21] Snape 2003, 98-99. Ritner 2009 argues that these scenes show only a limited amount of contact between Egypt and the Libyans. Richardson 1999 proposes *silphium* was a commodity.

[22] Knapp 1981; Manassa 2003; Parkinson and Schofield 1995; Schofield and Parkinson 1994.

[23] White 1994, 2002.

[24] Bacchielli 1979; Barker 1996, 103-104; Boardman 1968.

[25] Carter 1963.

[26] Beltrami 1985.

[27] Barker 1996; Snape 2003, 96.

[28] Hulin 1999; 2001. For 'Shell-tempered wares', their chronology, ethnic and cultural background and distribution, see also Rieger and Möller 2012.

[29] Habachi 1980; Kitchen 1990, 18-19; Snape 2003; Snape and Wilson 2007, particularly 1-6 and earlier literature cited in note 2.

[30] Kitchen 1990, 21.

Egypt and appeared within sight of the walls of the city of Memphis. In a long and difficult battle, 6000 Libyans were killed. The Egyptian army returned from the rout driving asses laden with the uncircumcised phalluses and severed hands of the dead.

The Libyans are specified as Libu, Meshwesh and Kehek. In addition, there are other ethnic groups, named on the 'Israel Stela' and the Karnak inscription, called 'Northerners of all lands'. They comprised 2201 Ekwesh (probably the same word as Ahhiya and Ahhiyawa found in Hittite texts, generally interpreted as mainland Greece), 742 Tursha, and 222 Shekelesh who were all killed in battle. Also named are the Shardana or Lukka. These non-Libyan groups appear as elements of the so-called 'Sea Peoples' who have become central to discussions of the 'collapse' of the Late Bronze Age societies of the Near East.

The battle scenes and inscriptions from the Temple of Ramesses III (c. 1184-1153 BC) at Medinet Habu provide details of two campaigns against invading Libyans, in years 5 (1182) and 11 (1176) of the king's reign, and the major battle with the 'Sea Peoples' in year 8 (1179). The detail in texts and depictions is sufficient to show these were historical events, even if presented within the conventional Egyptian ritualized context. In year 5 Ramesses III claims to have slain 12,535 invaders; in year 11 he killed 2175 Meshwesh and captured 1200 more.

O'Connor has analysed the evidence and what it tells us about social organization, material culture and external contacts.[31] Significantly, we have evidence for the use of chariots and horses which must have been acquired originally from either Egypt or western Asia. The presence of mercenary troops also indicates wider-ranging connections than the archaeological evidence might suggest. Kitchen proposed that the Libyan invasion of Egypt was timed to be linked with a Nubian rebellion, but that the Egyptian authorities heard of this and were able to suppress the Nubians first.[32] Such a rebellion could have been co-ordinated either by representatives at the Egyptian court, or through direct correspondence. This raises further questions about contacts and communications outside the Egyptian-controlled sphere: the 'Nubians' used the Egyptian language in correspondence (having at this stage no written language of their own). With increasing external contacts, did the 'Libyans' also adopt Egyptian, or were contacts purely verbal? Long-range contacts via desert and oasis routes would have had to avoid the Egyptian desert patrols.[33]

O'Connor argued that the Libu and Meshwesh were based in Cyrenaica. Hulin suggests a broader region of occupation, with Cyrenaica as the most productive area. Hulin observes that the coastal plain of Marmarica, as far east as Marsa Matruh, is capable of seasonal pasturing, with agriculture in the wadis. Richardson also discusses pastoralism of sheep, cattle and goats in Marmarica, and seasonal movements.[34] If, as seems likely, there was a significant climatic change that contributed to the problems at the end of the Late Bronze Age, there is a possibility that, prior to that, the broader Marmarica region could have supported pastoralism with some settlement. This would seem a reasonable background to the famine that forced the Libyans to move eastwards – probably beginning in the reigns of Sety I and Ramesses II, then continuing and increasing into those of Merneptah, Ramesses III, and throughout the rest of the Twentieth Dynasty.

Faced with recurrent movements of Libyans eastwards into their territories, the Egyptians began to absorb and settle them.[35] Many were incorporated into the army, and the city of Per-Bastet (Bubastis, modern Zagazig) in the Eastern Delta became a major centre. Throughout the later Twentieth Dynasty there were incursions by Libyan groups into the Nile Valley in the region of Thebes (modern Luxor), and via the route from Kharga Oasis into the Nile Valley between Asyut and Abydos. All of this suggests populations were displaced, perhaps by a long phase of desiccation.

O'Connor has suggested that the Libyans represent an expansionist nomadic state. Ritner, however, has argued against the idea, and the evidence does not present an image of such a cohesive 'state'. I have argued that the emergence of a centralized Kushite state in the Nile Valley south of Egypt, during the late New Kingdom and following period, may too be related in part to climatic, as

[31] O'Connor 1990 and critique of Ritner 2009.
[32] Kitchen 1990; Manassa 2003.
[33] Darnell 2012.
[34] Richardson 1999; see also Vetter *et al.* 2009.
[35] Kitchen 1990, 20-21 for some of the evidence.

well as political, problems.[36] The advantages of the Nile as a continuous water source for agriculture (even if there were periods of low inundation), allied with a range of other factors, did see a process of state formation that led to the emergence of a powerful state and ultimately the Kushite conquest of Egypt. Earlier writers saw a Libyan element and influence in the emergence of the Kushite state, but this was based largely on racist ideas and minimal archaeological evidence. Nevertheless, climate change appears to have had a major impact across north-east Africa, forcing population movements into the Nile Valley at many points. Libyan movements into Egypt and the development of the Kushite state are, however, very different phenomena. The rise of Libyan political power within Egypt appears to be the ascendancy of elite groups. The difference to earlier Egyptian tradition is the maintenance of some Libyan identity expressed in names and titles.

Within a short period of the invasions of Merneptah, Libyans were rising to prominence within the Egyptian hierarchy. Libyans are attested in palace positions in the reign of Ramesses III, at a time when other Libyans posed a threat. By the reign of Ramesses XI, the extended family of one of the leading officials, Herihor, includes the Libyan names Osorkon, Mawasun, and Masaharta, indicative of some marriage alliances with the Egyptian elite. In the period following, the Libyan indigenous titles 'Chief' and 'Great Chief' of the Meshwesh (or Ma) are documented, usually with Libyan names. An Egyptian equivalent, 'Chief of Foreigners', is also found. It was not long before Egypt had Libyan pharaohs (notably the Twenty-Second, Twenty-Third and Twenty-Fourth Dynasties). The Libyan components of Egyptian culture during this phase have been the subject of recent studies.[37] The latest phase, in the second half the eighth century BC, saw Egypt divided amongst four pharaohs, all of Libyan extraction, and numerous Chiefs and Great Chiefs of the Meshwesh and of the Libu.

Ironically, the large amount of evidence from Egypt under Libyan rule (c. 1000-700 BC) tells us virtually nothing about their dealings with their former homeland. The origins of the Garamantian culture and state are attributed to the period around 1000 BC.[38] Rock art depicting horses and chariots has been dated from c. 1500 BC into the first millennium.[39] Images of wheeled vehicles drawn by four horses are generally dated later than 700 BC. Herodotus wrote that the Asbystae, a tribal group inland from Cyrene, 'are drivers of four-horse chariots to a greater extent than any other Libyans'; he also reported that the Garamantes had four-horse chariots and that 'it is from the Libyans that the Greeks have learnt to drive four-horse chariots.'[40] Certainly this is not a practice recorded in Egypt, Kush, or the Near East. Due to the nature of the surviving evidence, there is at present no clear way of understanding connections between the emerging Garamantian state in the west of Libya and Egypt under Libyan rule.[41]

The movements of Libyans through the Western Desert of Egypt in the Nineteenth and Twentieth Dynasties must have affected the oases, and possibly some Libyan groups settled there. The evidence for Egyptian control of the oases remains somewhat sporadic, largely due to the limited extent of excavation. The standing monuments and visible remains are mainly from the Twenty-Sixth Dynasty (664-525 BC), Persian, Ptolemaic and Roman periods, although the large governors' palace and tombs of late Old Kingdom date at Balat in Dakhleh show that the oasis came under Egyptian control at an early date.[42] Evidence of Egyptian New Kingdom date is also limited, although there are tombs at Bahariya Oasis. Even if under Egyptian political control, with official monuments culturally Egyptian, there is no evidence for the population and their self-identification.

THE OASES AND DESERT

Recent work on desert roads and control points from the Nile Valley to the oases of the Western Desert and through northern Nubia, have radically changed perspectives on Egyptian activities

[36] Morkot 2004.

[37] See, for example, Leahy 1985; Ritner 2009.

[38] See Mattingly in this volume, with references.

[39] Muzzolini 1982; 1991; see also Barker 1996, 106-107.

[40] Herodotus, *Historiae*, IV.170; 183; 189 [tr. Godley].

[41] Liverani 2000.

[42] Pantalacci 2013, 197-198, note 1 for recent studies.

outside the Nile Valley.[43] Excavations in Dakhleh Oasis are recovering more evidence from the Libyan period (c. 1000-700 BC), much of it recycled in later monuments.[44] From this, and two stelae acquired in 1898 (now in the Ashmolean Museum in Oxford), it is certain that the Egyptian authorities had control of Dakhleh Oasis and a governor is recorded, although he appears to have been resident in the Nile Valley. By the end of the Libyan period, Dakhleh had a governor with the Egyptian name Esdhuti, but who was depicted with a feather headdress comparable to those of the Chiefs of the Meshwesh and Libu, indicating a Libyan cultural identity. He is specified as a Chief of the Shamain, and can be dated to the late eighth century BC.

There is little Dynastic archaeological material known from Kharga Oasis earlier than the First Persian Period (525-404 BC). The main temple at Hibis was constructed under Darius I (522-486 BC), as was the small temple in the fortress of Qasr el-Ghueida, which controls access to the town of Hibis from the south.[45] There is nothing that gives any indication of the population and its self-identity at this time.

Evidence from all of the oases increases considerably for the Ptolemaic and particularly Roman periods. This appears to have been a time during which there was some considerable development of the agricultural and irrigation systems. Even the small oases connecting Bahariya and Siwa show signs of occupation during the Roman period. At Siwa itself, the earliest evidence of direct Egyptian involvement comes from the Twenty-Sixth-Dynasty core of the 'Oracle temple' at Aghurmi. The nearby temple at Umm Ubaida of the reign of Nakht-hor-heb (Nectanebo II, 360-343 BC) is conventionally Egyptian in decoration, but includes a depiction of the local Great Chief, Wenamun (an Egyptian name), with feather headdress of the type worn in New Kingdom and later images of Libyans. The tombs at Siwa have paintings which relate closely to contemporary equivalents in the Nile Valley, and the funerary customs also show strong cultural connections. The mummified bodies from Jaghbub (Giarabub) Oasis – a short distance further west – show that Egyptian cultural influence westwards, and perhaps political control, was not limited to the coastal regions.

Bagnall comments on the written evidence for the links between the Nile Valley and Dakhla Oasis in Late Antiquity, noting that some families owned land in both areas.[46] He also notes that there is good evidence of travel from Dakhla to Bahariya and on to Siwa, and argues that, on the grounds of cost, direct links and commerce with the Mediterranean coast and the regions further west were less likely: commodities and manufactures would have been moved more cheaply by sea (or the coastal roads), the Nile routes and then overland. This raises broader questions of interaction, travel and commerce throughout the region that is now the Western Desert, and the range of contacts further westwards.

LONG-DISTANCE TRAVEL AND ROUTES

Our understanding of the changing environment and of the Egyptian uses of the 'desert' roads has changed significantly since I wrote quite tentatively on the subject twenty years ago.[47] Indeed, some striking discoveries of rock inscriptions have shown that Egyptian activity was far more wide-ranging than anyone would have suspected. That the Egyptians, with their tendency to record their presence (so useful for the historian), travelled such great distances, raises questions not only about the environment, but also about the movements of the indigenous peoples of the deserts and oases, or sub-Saharan regions.

Recent work in the region of the Wadi Howar in northern Sudan has located petroglyphs indicating water, one associated with the name of the pharaoh Djedefre (c. 2560 BC). The same pharaoh is similarly attested by inscriptions 60 km south-west of Balat in Dakhla Oasis. Djedefre, his successor Khaefre (c. 2558-2532 BC), and other rulers over the next hundred years are attested by inscriptions in the diorite-gneiss quarries at Toshka, inland from the Nile in Lower

[43] Darnell 2012.
[44] Kaper 2009.
[45] Morkot 1996, 84-87.
[46] Bagnall 2012, 40.
[47] Morkot 1996; see notably Riemer and Förster 2013 for a considered approach to the subject, and other papers in Förster and Riemer 2013.

Nubia. This evidence suggests long-distance trading and prospecting activities by the Egyptians of the Fourth and Fifth Dynasties in what was probably still a dry savannah environment, but becoming increasingly arid.

The inscriptions of the official Harkhuf, who made three journeys to the land of Yam (around 2280-2260 BC) state that, on one of these expeditions, he and his caravan went on the road from Tjeny (Girga) in Upper Egypt, along the 'Oasis road' (via Kharga or Dakhla) to Yam. When they arrived in Yam, they found that the ruler had gone 'to Tjemeh-land, to smite the Tjemeh to the western corner of heaven'. After extensive discussions, consensus has placed Yam either in the Nile Valley around Kerma and the Third Cataract, or further south, perhaps near the confluence with the Atbara.[48]

An inscription of the time of Mentjuhotep II (c. 2025-2004 BC), recently found at the Gilf Kebir in the southern Libyan Desert (700 km from the Nile Valley), names the land of Yam and another, otherwise unattested, locality 'Tekhebet'.[49] The survey also identified a planned route (the 'Abu Ballas trail') with stations going south-westwards from Dakhla to the Gilf Kebir. Förster suggests that the Harkhuf expedition went from Gilf Kebir to Jebel Uweinat, before returning to the Nile Valley at the Third Cataract; the generally accepted equation of Yam with Kerma is thus retained. Even if we concur that Yam and Kerma are the same, this evidence does raise the possibility that as the Egyptians knew the route to Gilf Kebir, they could have continued towards Ennedi and Lake Chad or joined with the sub-Saharan east-west routes. This again raises the issue of the antiquity of the Darb el-Arbein route and its use.[50]

The evidence from the survey of the 'Abu Ballas trail' and the survey of the Wadi Howar, shows that Egyptian activities in this remote region were far more wide-ranging than previously expected. Irrespective of whether Yam should be identified with Kerma in the third millennium BC, the route from Kerma through Kharga Oasis was certainly used during the years of the Kushite kingdom's power (c. 1650-1550 BC). With its centre at Kerma, the kingdom of Kush controlled the Nile Valley south of Aswan, whilst Egypt was divided between the kingdom of Thebes in the south and the 'Hyksos' rulers of the Delta. The trade in luxury raw materials must have passed from the Middle Nile through the oases of Lower Nubia to Kharga, then on to Nile again, perhaps at Asyut, avoiding Theban territory.

Evidence for long-distance trade from the Middle Nile to Libya is a rather more difficult question. If the large quantity of tusks captured in the reign of Hatshepsut, referred to above, was destined for a recipient to the west of Egypt, who was it, and what was to be received in exchange? Could Libya supply commodities of sufficient value to be worth the investment in such long-distance expeditions by-passing Egypt? Manassa has drawn attention to the scenes in the tomb of Huya at Amarna, from the reign of Akhenaten, suggesting that gold was supplied by Libyans to Egypt.[51] Nubia was the major source of gold, and Egypt's tight control of production is unlikely to have seen it pass in any quantity from there to Libya.

Activities, of course, changed during the long process of desiccation of the Sahara. Nevertheless, knowledge of the routes must have continued — even if using them became more difficult, before the introduction of the camel again eased travel over longer distances. Direct north-south and east-west routes across large expanses of desert would have presented severe problems, but the shorter distances between oases were feasible.[52]

CONCLUDING REMARKS

Recent reviews of the Egyptian sources for the Libyans of the Late Bronze Age has recognized them as an indigenous African people, rather than the most extreme nineteenth-century views of them as another group of migrants of European origin. Nevertheless, as O'Connor

[48] O'Connor 1986.

[49] Förster 2013.

[50] Roe 2005-2006.

[51] Manassa 2003, 86-87.

[52] Roe 2005-2006 correctly notes that the introduction of the camel might have eased travel, but that does not necessarily mean an increase in trade.

notes,[53] the Libyan invasions of Egypt are still regarded by some writers as closely linked with the activities, and even attempted settlements, of the 'Sea Peoples' on the North African coast.

What we can say about the Libyans of the Late Bronze Age is that they were a hierarchical society for which pastoralism played a major role, although they also had settlements (the size and nature of which is disputed).[54] Wide-ranging contacts with the Aegean, western Asia and Nubia gave them access to contemporary military technologies, and mercenary soldiers, and to a wider range of cultural items and raw commodities: they were effectively brought into the Late Bronze Age world system. Desiccation of their homeland forced an eastward movement of population towards the Nile Valley. We know that significant numbers were settled within Egypt, and other groups may have taken up residence in the more southerly oases. How far any of this was connected to developments further west in Libya remains unclear. Mattingly and Wilson have written on the Garamantian irrigation technologies of foggaras and *shaduf* that originate in the Egyptian oases.[55]

The evidence we have does suggest that, from the Persian period onwards, there was development of the Egyptian oases, and with the Ptolemaic and Roman periods these were flourishing, with some substantial settlements. The role of the central government may have been significant. The fact of Ptolemaic and Roman control of the coast and Cyrenaica, as well as the oases, may have created a stable situation that facilitated communication. As already noted, long-distance bulk transport would have used the Nile and Sea routes, but the oasis routes allowed smaller-scale trading in items and commodities, peoples and ideas extending from the Meroitic kingdom in the south to the Garamantian kingdom in the west. This is not to suggest that the full length of these routes was regularly used; it is more likely that shorter stretches were. We know that desert routes ran from Meroe to Aswan, and those from the Nile Valley to the oases were in frequent use as were those between oases. There is a clear analogy with island-hopping in the Aegean.

This paper was stimulated by the questions raised by a small gold amulet, certainly from Meroe, that was reputedly acquired in Cyrene. That find-spot is now known to be incorrect – but the possibility of travel of a small object from Meroe to Cyrene is not impossible, even if over time, and by various hands. The role of the sub-Saharan Sudanic routes and their interconnection with the north-south routes can, until we have evidence, be only speculative. The significant findings of recent years, however, should encourage the investigation of those regions to explore the interconnections of sub-Saharan Africa and the Mediterranean coast.

BIBLIOGRAPHY

Ashton, S.-A. 2003. Foreigners at Memphis? Petrie's racial types. In Tait, J. (ed.), *'Never Had the Like Occurred': Egypt's View of its Past*, London: UCL Press, 187-196.

Bacchielli, L. 1979. Contatti fra 'Libya' e mondo egeo nell'età del bronzo: una conferma, *Atti dell'Accademia Nazionale dei Lincei. Classe di Scienze Morali, Storiche e Filologiche. Rendiconti*, 34: 163-168.

Bagnall, R. 2012. Dakhla and the West in Late Antiquity: framing the problem. In Guédon, S. (ed.), *Entre Afrique et Égypte : Relations et échanges entre les espaces au sud de la Méditerranée à l'époque romaine* (Scripta Antiqua, 49), Bordeaux: Ausonius Éditions, 39-44.

Barker, G. (ed.) 1996. *Farming the Desert. The UNESCO Libyan Valleys Archaeological Survey. Volume 2: Synthesis*, London: Department of Antiquities – Society for Libyan Studies.

Bates, O. 1914. *The Eastern Libyans: An Essay*, London: Macmillan.

Beltrami, V. 1985. Population of Cyrenaica and Eastern Sahara before the Greek Period. In Barker, G., Lloyd, J.A. and Reynolds, J. (eds), *Cyrenaica in Antiquity* (British Archaeological Reports, International Series, 236), Oxford: B.A.R., 135-143.

Boardman, J. 1968. Bronze Age Greece and Libya, *Annual of the British School at Athens*, 63: 41-44.

Carter, T.H. 1963. Reconnaissance in Cyrenaica, *Expedition*, 5.4: 18-27.

Cline, E.H. and O'Connor, D. 2003. The mystery of the 'Sea Peoples.' In O'Connor, D. and Quirke, S. (eds), *Mysterious Lands*, London: UCL Press, 107-138.

[53] O'Connor 1990, 92-93.

[54] See Ritner 2009.

[55] Wilson and Mattingly 2003; see also Mattingly in this volume, with further references.

Darnell, J.C. 2012. A bureaucratic challenge? Archaeology and administration in a desert environment (Second Millennium B.C.E.). In Moreno Garcia, J.C. (ed.), *Ancient Egyptian Administration*, Leiden: Brill, 785-830.

De Rougé, E. 1855. *Notice de quelques textes hiéroglyphiques récemment publiés par M. Greene*, Paris: E. Thunot.

De Rougé, E. 1867. *Extraits d'un mémoire sur les attaques dirigées contre l'Egypte par les peuples de la Méditerranée vers le XXV siècle avant notre ère*, Paris: Presses universitaires de France.

Drews, R. 1993. *The End of the Bronze Age. Changes in Warfare and the Catastrophe ca. 1200 B.C.*, Princeton: Princeton University Press.

Edgerton, W.F. and Wilson, J.A. 1936. *Historical Records of Ramses III: The Texts in Medinet Habu. Volumes 1 and 2 Translated With Explanatory Notes* (Studies in Ancient Oriental Civilization, 12), Chicago: University of Chicago Press.

Förster, F. 2013. Beyond Dakhla: the Abu Ballas trail in the Libyan Desert (SW Egypt). In Förster, F. and Riemer, H. (eds), *Desert Road Archaeology in Ancient Egypt and Beyond* (Africa Praehistorica, 27), Cologne: Heinrich Barth Institut, 297-337.

Förster, F. and Riemer, H. (eds) 2013. *Desert Road Archaeology in Ancient Egypt and Beyond* (Africa Praehistorica, 27), Cologne: Heinrich Barth Institut.

Habachi, L. 1980. The military posts of Ramesses II on the coastal road and the western part of the Delta, *Bulletin de l'Institut française d'Archéologie orientale du Caire*, 80: 13-30.

Hayward, L. 1990. The origin of the raw elephant ivory used in Greece and the Aegean during the Late Bronze Age, *Antiquity*, 64.242: 103-109.

Hulin, L. 1999. 'Marmaric' wares: some preliminary remarks, *Libyan Studies*, 30: 11-16.

Hulin, L. 2001. Marmaric wares: New Kingdom and later examples, *Libyan Studies*, 32: 67-78.

Hulin, L. 2008. The Western Marmarica coastal survey 2008: a preliminary report, *Libyan Studies*, 39: 299-314.

Hulin, L., Timby, J. and Mutri, G. 2009. The Western Marmarica coastal survey 2009: preliminary report, *Libyan Studies*, 40: 179-187.

Hulin, L. (in press). The Libyans. In Shaw, I. (ed.), *The Oxford Handbook of Ancient Egypt*.

Kaper, O.E. 2009. Epigraphic evidence from the Dakhleh Oasis in the Libyan period. In Broekman, G.P.F., Demarée, R.J. and Kaper, O.E. (eds), *The Libyan Period in Egypt, Historical and Cultural Studies into the 21st – 24th Dynasties. Proceedings of a Conference at Leiden University, 25-27 October 2007* (Egyptologische Uitgaven, 23), Leiden: Netherlands Institute for the Near East and Louvain – Peeters Publishers, 149-159.

Kitchen, K.A. 1990. The arrival of the Libyans in the Late New Kingdom. In Leahy, A. (ed.), *Libya and Egypt c. 1300-750 B.C.*, London: University of London SOAS – Society for Libyan Studies, 15-28.

Knapp, B. 1981. The Thera frescoes and the question of Aegean contact with Libya during the Late Bronze Age, *Journal of Mediterranean Anthropology and Archaeology*, 1: 249-279.

Kröpelin, S. and Kuper, R. 2006-2007. More corridors to Africa. In Gratien, B. (ed.), *Mélanges offerts à Francis Geus : Égypte-Soudan* (Cahiers de Recherches de l'Institut de Papyrologie et d'Égyptologie de Lille, 26), Villeneuve d'Ascq: Université Charles de Gaulle-Lille, 219-225.

Krzyszkowska, O. and Morkot, R.G. 2000. Ivory and related materials. In Nicholson, P. and Shaw, I. (eds), *Ancient Egyptian Materials and Technology*, Cambridge: Cambridge University Press, 320-331.

Kuhrt, A. 1995. *The Ancient Near East*, London: Routledge.

Kuper, R. 1989. *Forschungen zur Umweltgeschichte der Ostsahara* (Africa Praehistorica, 2), Cologne: Heinrich Barth Institut.

Leahy, M. 1985. The Libyan period in Egypt, *Libyan Studies*, 16: 51-65.

Liverani, M. 2000. The Garamantes: a fresh approach, *Libyan Studies*, 31: 17-28.

Manassa, C. 2003. *The Great Karnak Inscription of Merneptah: Grand Strategy in the 13th Century B.C.* (Yale Egyptological Studies, 5), New Haven, Connecticut: Yale University.

Maspero, G. 1896. *Histoire ancienne des peuples de l'Orient classique. Volume 2 : Les premières mêlées des peuples*, Paris: Hachette.

Meyer, E. 1928. *Geschichte des Altertums. Zweiter Band, Erste Abteilung: die Zeit der ägyptischen Großmacht*, Berlin: J.G. Cotta'sche Buchhandlung.

Morkot, R.G. 1996. The Darb el-Arbain, the Kharga Oasis and its forts, and other desert routes. In Bailey, D. (ed.), *Archaeological Research in Roman Egypt* (Journal of Roman Archaeology Supplement, 19), Ann Arbor: Journal of Roman Archaeology, 82-94.

Morkot, R.G. 1998. 'There are no elephants in Dongola'; notes on Nubian ivory. In *Actes de la VIIIe Conférence Internationale des Études Nubiennes, Lille 11-17 septembre 1994* (Cahiers de Recherches de l'Institut de Papyrologie et d'Égyptologie de Lille, 17), Villeneuve d'Ascq: Université Charles de Gaulle-Lille, 147-154.

Morkot, R.G. 2004. Le origini del regno di Kush. In Einaudi, S. and Tiradritti, F. (eds), *L'Enigma di Harwa. Alla scoperta di un capolavoro del rinascimento egizio*, Milan: Anthelios Edizioni, 19-41.

Muzzolini, A. 1982. La « période des chars » au Sahara. L'hypothèse de l'origine égyptienne du cheval et du char. In Camps, G. and Gast, M. (eds), *Les chars préhistoriques du Sahara*, Aix-en-Provence: Université de Provence, 445-456.

Muzzolini, A. 1991. The technological evolution from Biga to Quadriga in the eastern Mediterranean, the Maghreb and the Sahara: when and why? In Waldren, W.H. and Ensenyat, J.A. (eds), *Recent Developments in Western Mediterranean Prehistory: Archaeological Techniques, Technology and Theory* (British Archaeological Reports, International Series, 574), Oxford: Tempus Reparatum, 307-320.

O'Connor, D. 1986. The locations of Yam and Kush and their historical implications, *Journal of the American Research Center in Egypt*, 23: 27-50.

O'Connor, D. 1990. The nature of Tjehemu (Libyan) society in the later New Kingdom. In Leahy, A. (ed.), *Libya and Egypt c. 1300-750 B.C.*, London: University of London SOAS – Society for Libyan Studies, 15-28.

O'Connor, D. 2003. Egypt's view of others. In Tait, J. (ed.), *'Never Had the Like Occurred': Egypt's View of its Past*, London: UCL Press, 155-185.

Pantalacci, L. 2013. Balat, a frontier town and its archive. In Moreno Garcia, J.C. (ed.), *Ancient Egyptian Administration*, Leiden: Brill, 197-214.

Parkinson, R. and Schofield, L. 1995. Images of Mycenaeans: a recently acquired painted papyrus from el-Amarna. In Davies, W.V. and Schofield, L. (eds), *Egypt, the Aegean and the Levant: Interconnections in the Second Millennium BC*, London: British Museum Publications, 125-126.

Petrie, W.M.F. 1922. *A History of Egypt* (Tenth Edition, Revised), London: Methuen.

Quirke, S. and O'Connor, D. 2003. Introduction: mapping the unknown in ancient Egypt. In O'Connor, D. and Quirke, S. (eds), *Mysterious Lands*, London: UCL Press, 1-21.

Richardson, S. 1999. Libya domestica, *Journal of the American Research Center in Egypt*, 36: 149-164.

Rieger, A.-K. and Möller, H. 2012. Northern Libyan Desert ware: new thoughts on 'Shell-tempered Ware' and other handmade pottery from the Eastern Marmarica (north-west Egypt), *Libyan Studies*, 43: 11-31.

Rieger, A.-K., Vetter, T. and Möller, H. 2012. The Desert dwellers of Marmarica, Western Desert: Second Millennium BCE to First Millennium CE. In Barnard, H. and Duistermaat, K. (eds), *The History of the Peoples of the Eastern Desert*, Los Angeles: Cotsen Institute of Archaeology, University of California, 156-174.

Riemer, H. and Förster, F. 2013. Ancient desert roads: towards establishing a new field of archaeological research. In Förster, F. and Riemer, H. (eds), *Desert Road Archaeology in Ancient Egypt and Beyond* (Africa Praehistorica, 27), Cologne: Heinrich Barth Institut, 19-58.

Ritner, R.K. 2009. Fragmentation and re-integration in the Third Intermediate Period. In Broekman, G.P.F., Demarée, R.J. and Kaper, O.E. (eds), *The Libyan Period in Egypt, Historical and Cultural Studies into the 21st – 24th Dynasties. Proceedings of a Conference at Leiden University, 25-27 October 2007* (Egyptologische Uitgaven, 23), Leiden: Netherlands Institute for the Near East and Louvain – Peeters Publishers, 327-340.

Roe, A. 2005-2006. The old 'Darb al Arbein' caravan route and Kharga Oasis in antiquity, *Journal of the American Research Center in Egypt*, 42: 119-129.

Schofield, L. and Parkinson, R.B. 1994. Of helmets and heretics: a possible Egyptian representation of Mycenaean warriors on a papyrus from El-Amarna, *Annual of the British School at Athens*, 89: 163-169.

Snape, S. 2003. The emergence of Libya on the horizon of Egypt. In O'Connor, D. and Quirke, S. (eds), *Mysterious Lands*, London: UCL Press, 93-106.

Snape, S. and Wilson, P. 2007. *Zawiyet Umm el-Rakham, I: The Temple and Chapels*, Bolton: Rutherford Press.

Vetter, T., Rieger, A.-K. and Nicolay, A. 2009. Ancient rainwater harvesting systems in the north-eastern Marmarica (north-western Egypt), *Libyan Studies*, 40: 9-23.

White, D. 1994. Before the Greeks came: a survey of the current archaeological evidence for the pre-Greek Libyans, *Libyan Studies*, 25: 31-44.

White, D. 2002. *Marsa Matruh. The University of Pennsylvania Museum of Archaeology and Anthropology's Excavations on Bates' Island, Marsa Matruh, Egypt 1985-1989 (Volume I: The Excavation; Volume II: The Objects)*, Philadelphia: INSTAP Academic Press.

Wilson, A.I. and Mattingly, D.J. 2003. Irrigation technologies: foggaras, wells and field systems. In Mattingly, D.J. (ed.), *The Archaeology of Fazzān. Volume 1, Synthesis*, London: Society for Libyan Studies – Department of Antiquities, 235-278.

4

BURIAL MOUNDS AND STATE FORMATION IN NORTH AFRICA
A VOLUMETRIC AND ENERGETIC APPROACH

David L. Stone

Abstract

This paper explores issues of state formation in North Africa through a volumetric and energetic analysis of earthen burial mounds dating to the second half of the first millennium BC. More than 300 have been discovered in the eastern (Tunisia) and western (Morocco) Maghreb, 47 have been recorded with sufficient dimensions for analysis, and three have been excavated. Previous studies have largely considered these burial mounds through stylistic classification, neglecting to consider the social systems which produced them. This paper proposes a model for the labour systems in which burial mounds were constructed and argues that they constitute key evidence for the emerging complexity of indigenous North African societies during this period.

INTRODUCTION

When thinking about the phrase '*de Africa Romaque*', it is important to ask what we mean by '*de Africa*'? That question is not easy to answer. Some of the difficulty has been caused by the essentializing nature of culture-historical studies, which attempted to isolate ancient artefacts and practices as Phoenician, Punic, Roman, Numidian, Berber, etc. To pigeonhole identity in this fashion has been proven unreliable and irresponsible. To take one example, recent analyses of the African-born Latin author Apuleius have shown the negotiation of identity to be highly complex.[1] No less a source of the problem may be the research agendas of past archaeologists which have fallen squarely on urban architecture, Latin epigraphy, and elite artworks, rather than on rural settlements and utilitarian artefacts. With the bias of European scholars towards material associated with Phoenician, Punic, Roman, and Byzantine civilizations, much attention has been given to what we might call 'the 1 per cent', while little has addressed 'the 99 per cent'.[2]

Today we are not bound to conceive of '*de Africa*' in the same ways that previous scholars have. To build a new definition, we will have to examine the entire population, we will need to look carefully at North Africa both before and during its colonization first by Greeks and Phoenicians, and then by Rome, and we will have to be aware of complex and concurrent developments. Several studies have recently considered different North African locales in these periods, and have made important strides towards improving our knowledge. In the Fazzan region,

[1] Lee *et al.* 2014.

[2] Studies which have pointed out these priorities of past research include: Février 1989; Mattingly 1996; Munzi 2001; Oulebsir 2004.

two archaeological projects have led to the identification of Garamantian civilization as an early African state.[3] Aspects of the Garamantian state now revealed to have been present in Fazzan include: the development of urbanism; the evolution of a hierarchical society; the adoption of a written Libyan language; the use of irrigation agriculture for intensive cultivation of agricultural surpluses; the introduction of horses, camels, and wheeled transport; the creation of commercial relations with Mediterranean and sub-Saharan Africa; and population growth to a level not reached at any time other than in the last 40 years.[4] A second project at Lixus has shed light on levels crucial to understanding the city's early development as a Phoenician colony.[5] Evidence of food preparation and consumption by large groups of people dating to the seventh century BC, according to the researchers, indicates the beginnings of a system which administered food for redistribution. This early phase at Lixus has thus been said to have contained hybrid practices and cultural heterogeneity that reflected the origins of inhabitants from multiple backgrounds.[6] The third important development has been the excavations at Althiburos, where a nearly continuous sequence from the tenth century BC to the seventh century AD has been documented. Here the excavators argue that cultivation of vines and olives (and probably metallurgy, too) developed independently of Phoenicians. Significant population growth was also detected.[7] Although no clear consensus about the nature of North African settlements in the first millennium BC has emerged from these three areas, we can now base our assessments of the period on more concrete data.

In this paper I concentrate on conspicuous features of North African landscapes that have the potential to contribute to a better understanding of indigenous peoples in the first millennium BC. In particular, I examine monumental burials, which offer some of the most visible and best preserved evidence of state formation in North Africa at this time. Yet, they too suffer from the narrow agendas of earlier archaeologists. The approach of almost all previous studies to these structures has been to classify them stylistically, according to their shapes, materials, and decoration. During the colonial era of the late nineteenth and early twentieth centuries, one aim of the stylistic classifications was to document the influence of 'advanced' Oriental or European cultures on African ones, through migration, diffusion, or other contact. While this goal was not always stated in detail, there are numerous explicit references, such as a pair of articles in the same volume of *Revue d'Anthropologie* by Charles Tissot and Paul Broca, entitled, respectively, '*Sur les monuments mégalithiques et les populations blondes du Maroc*' and '*Les peuples blondes et les monuments mégalithiques dans l'Afrique septentrionale*'.[8] Another goal of classification was to show the diachronic advance of technological skills. This evolutionary perspective was stated clearly by Stèphane Gsell:

> 'On peut admettre, croyons-nous, qu'avec le temps, des Africains jugèrent le tertre superflu. Par un épais lit de cailloux ou par un dallage solide, par une profondeur plus grande donnée à la fosse, par un fort couvercle au-dessus du réduit funéraire, on assurait suffisamment la défense des morts [...] Les tumulus construits en pierre, – soit en morceaux de rocher, soit en gros cailloux en galets, – ont naturellement mieux résisté au temps que les tertres. Ils avaient l'avantage de défendre mieux leurs hôtes, celui aussi de les enfermer dans une prison plus sûre'.[9]

There is, however, no evidence to support Gsell's view that ancient North Africans experimented with the construction materials to offer better protection to the dead, rather than to accomplish a range of other goals.

In the middle of the twentieth century, typologies were deployed to indicate the presence of both indigenous African and imported features in tomb monuments, invalidating, among other

[3] Liverani 2000; 2006; Mattingly 2001; 2003; 2007; 2010; 2013.
[4] All points made in Mattingly 2001, 58.
[5] Aranegui Gascó 2001; 2005; Aranegui Gascó and Hassini 2010.
[6] Cañete and Vives-Ferrándiz 2011.
[7] Kallala and Sanmartí 2011; Sanmartí *et al.* 2012. See also Mattingly's paper in this volume.
[8] Broca 1876; Tissot 1876. On the question of migration, see especially Broca 1876, 394-395.
[9] Gsell 1929, 184. See also Gsell 1929, 74-92 on Oriental and European influences on tombs and other aspects of material culture.

things, the notion that a race of blond megalith-building peoples had migrated from Europe.[10] Gabriel Camps constructed elaborate typologies to classify North African burial mounds: allées couvertes, antenna tombs, bazinas, chouchets, djahel, djedars, dolmens, kerkour, megaliths, red- jem, tertres, and tumuli. In Camps' typology, important distinctions among the main types are made: a tumulus is an 'amoncellement de pierres de dimensions ou de nature diverses', while a tertre is a 'tumulus constitués par un amoncellement de terre, même si des pierres entrent pour une faible proportion dans leur construction', and bazinas are 'tumulus qui ont une disposition architecturale quelconque et non pas simplement ceux qui présentent extérieurement des degrés concentriques'.[11] Within the main types, Camps also classified a bewildering array of subtypes. Bazinas, for example, were subdivided into six groups: 'bazinas à enceintes concentriques non appareillées'; 'bazinas à carapace'; 'bazinas à degrés'; 'bazinas à degrés quadrangulaires'; 'bazinas à base cylindrique'; and 'bazinas à sépultures multiples'.[12]

Considering the number of these monuments which have survived, along with the great vari- ety of informative approaches which could have been taken, this emphasis on classifications and typologies above all other aspects of research is disappointing. There is almost no absolute dating of these tombs, little attention to their place in the landscape, a paucity of osteological informa- tion about the individuals buried within them, an absence of studies of the amount of effort nec- essary to create them, and a dearth of faunal or botanical remains for feasts or grave goods.[13] Such endeavours are essential if we want to understand what becomes 'de Africa'. It would obviously be impossible to address all of these desiderata at once; this paper makes progress by estimating the amount of labour involved in constructing certain tombs, and by using this information to consider the role of monumental burials in North African societies during the second half of the first millennium BC. One reason for focusing on the amount of labour involved in constructing monumental burials is to emphasize the way that state formation in North Africa can be com- pared to that in other places. In undertaking a broader comparison, it will be useful to look first at the variety of theoretical approaches used to explain monumental burials.

THEORETICAL APPROACHES

Processual archaeologists have expressed the view that the emergence of conspicuous, formal, delimited burial grounds occurred due to competition over critical resources. According to this position, known as 'Saxe-Goldstein Hypothesis 8', after the archaeologists who developed it, societies with bounded cemeteries recognize corporate groups based on lineal descent, and those groups likely create and maintain cemeteries in order to legitimize their use of important resources, such as land.[14] Cemeteries, in other words, proclaim 'we were here first, these are our ancestors, this is our land'. In contexts of early urbanism and state formation, monumental tombs have been especially well studied. A common argument is that elaborate architectural monuments, exotic grave goods, and extensive ritual procedures associated with burials are means by which elites establish their legitimacy. Thus, it has been thought that such structures were built during the early stages of state formation when elites were consolidating power. This explanation has been offered for a large number of societies which built 'pyramids for the dead', both close in time and place to North Africa in the first millennium BC as well as much removed.[15]

Alternatively, post-processual archaeologists have suggested that prehistoric peoples may have demarcated the landscape for other purposes, placing tombs to designate prominent land- marks, or to orient viewers towards paths. Rather than signifying power or prestige, they propose

[10] Camps 1961.

[11] Camps 1961, 66 (tumulus), 76 (tertre), and 159 (bazina).

[12] Camps 1961, 158-170; 1991.

[13] Kallala et al. 2014, which appeared after the initial submission of this paper, is a very important recent exception. The author is grateful for the suggestion of an anonymous reviewer that this article be considered at the time of revision. It is encouraging to note the attention of the research project at Althiburos was devoted to many of these questions.

[14] Goldstein 1981; Saxe 1970, 119-121.

[15] See Trigger 2003, 564-582 for further discussion and references.

that burials of ancestors may be of cosmological importance. They were foci of religious activities and symbols of the cosmic order, where divine powers were thought to manifest themselves. Holders of these positions have also argued that Saxe-Goldstein Hypothesis 8 has been applied to societies in which competition has not been adequately demonstrated.[16]

Conspicuous, formal, delimited burial grounds emerged throughout North Africa in the first millennium BC.[17] Connections between tombs and state formation in North Africa have infrequently been drawn, but there are some precedents worthy of citation. Most of these have evaluated the series of monumental tombs collectively known as 'Numidian royal architecture'. This is a group of seven tombs, all made of dressed stone, of varying shape, size, and elaboration. All were found in the region that modern scholars associate with ancient Numidia and probably date between the fourth and second centuries BC. They have traditionally been associated with the rulers of the Numidian kingdoms, despite clear evidence in only one case.[18] Filippo Coarelli and Yvon Thébert saw these tombs as emblematic of the ways in which North African rulers partook of the wider currents of the Hellenistic world, perhaps filtered through the medium of Carthage.[19] Lisa Fentress has argued that the tombs are one way that Numidian rulers communicated with other Mediterranean elites and simultaneously distinguished themselves from the lower classes, following Ernest Gellner's model of the social structure of agrarian societies.[20] Josephine Quinn has seen the structures as designed for multiple purposes, not only reflecting foreign influences, but also articulating power and prestige on a local stage, precisely at a time when social and political structures in the region were in flux.[21] Some of my own work has focused on *haouanet*, rock-cut tombs of a less elite nature, and regarded them as an index of the way in which local inhabitants negotiated their position among competing Punic, Numidian, and Roman powers.[22] While none of these studies has overtly appealed to cross-cultural theories of state formation, they have all shown an awareness of theoretical arguments of this nature. But theoretical frameworks have still had relatively little influence on the study of North African funerary monuments.

DATA

My analysis draws on burial mounds from across the Maghreb. Thousands of these are known, created with a variety of materials, including earth, cobbles, boulders, dressed stone, and sculpted stone. Most have been dated to the mid to late first millennium BC, with the exception of a few later monuments.[23] I have restricted my study to circular burial mounds constructed of earth, or predominantly of earth, with the addition of some clay, stone or wood. I have done so for three reasons. First, since these monuments are primarily of one material and have a similar shape, they may be treated as a group representing a diagnostic burial tradition. Second, where sufficient data have been recorded, they are susceptible to the approaches of volumetrics and energetics. Third, they are relatively understudied in comparison to other funerary monuments of this period, such as *haouanet* and 'Numidian royal architecture'. I acknowledge that earthen burial mounds are not nearly as common as those comprised of cobbles, boulders, or dressed stone, and that these are also in need of more detailed examination.[24]

[16] Hodder 1982, 195-201 and Tilley 1994. See Morris 1991 for an attempt to reconcile the opposing positions.

[17] This does not exclude the fact that earlier burials have occasionally been discovered.

[18] Kbour er-Roumia, which Pomponius Mela (*De situ orbis*, I.31) identified as '*monumentum commune regiae gentis*'.

[19] Coarelli and Thébert 1988.

[20] Brett and Fentress 1996, 33; Gellner 1983, 9. I thank Lisa Fentress for drawing this point to my attention in the discussion after my paper.

[21] Quinn 2013.

[22] Stone 2007a.

[23] On dating burial mounds, see now the comments of Kallala *et al.* 2014, 54-56. Using radiocarbon analyses, they have dated two dolmens to the sixth-fifth and fifth-fourth centuries BC, respectively, providing some of the clearest evidence yet available for North African burial mounds, and showing that these largely predate the influence of Carthage. The recent excavation of a dolmen at Mididi has provided radiocarbon dates between the eighth and fifth centuries BC: Tanda *et al.* 2009, 188.

[24] I thank the anonymous reviewer for pointing out the larger number of stone monuments. These monuments also deserve study, and although two recent studies that focused mainly on dolmens have made important strides toward their understanding (Kallala *et al.* 2014; Tanda *et al.* 2009), more work remains.

In addition to the works of classification discussed above, the *Atlas préhistorique du Maroc*,[25] the *Atlas préhistorique de la Tunisie*,[26] and the *Carte nationale des sites archéologiques et des monuments historiques de la Tunisie*[27] each produced large regional inventories of burial mounds, focusing on their number, geographic coordinates, toponyms, and rough measurements. They did not apply the classificatory schemes of Camps with the same rigor, sometimes using terms such as 'tertre', 'tumulus' and 'bazina' interchangeably.[28] Naïde Ferchiou's survey of 62 burial monuments to the south and west of Carthage is another example of a regional inventory, though it was not undertaken as part of a national program. Ferchiou's approach may be described as somewhere between the rigid typology of Camps, and the flexible one of the national atlases. She explained it as the difference between the 'sens courant' in which many North African archaeologists worked and the 'sens précis' in which detailed typologies were constructed.[29] Similar studies have not been made in Algeria and Libya, though investigators in the late nineteenth and early twentieth centuries noted many earthen burial mounds in Algeria.[30]

I draw largely on the records of regional inventories in this study. They contain the latest and most accurate information, as well as the most accessible presentation of the data. I consider all earthen (or predominantly earthen) burial mounds for which sufficient dimensions have been recorded for volumetric and energetic analyses, on the grounds that a large sample will provide greater geographic diversity and reliability. It is true that, given the number of researchers and the variety of approaches undertaken during the last 50 years, it is impossible to standardize the data in the regional inventories, as is possible with classifications undertaken by a single person. Nonetheless, we must also recognize that very few of the monuments have been excavated. Evidence of their composition is based on surface observation, and its accuracy is limited to information visible above ground. Indeed, this is the main reason further precision and standardization are impossible, and therefore we should utilize the large samples in the national atlases. More than 300 burial mounds predominantly composed of earth are known in these regional inventories of North Africa (Table 4.1).

Table 4.1. *Sources of information about earthen burial mounds.*

Regional inventory	Mounds	Diameter; height recorded	Excavated
Ferchiou (north-east Tunisia)	49	20	0
Atlas préhistorique (Tunisia)	94+	14	0
Atlas préhistorique (Morocco)	47	10	3
Carte nationale (Tunisia)	140+	5	0
Total (excluding duplicates)	**327+**	**47**	**3**

Ferchiou = Ferchiou 1987, Types I-VI. The number of earthen mounds listed in the *Atlas préhistorique* (Tunisia) and the *Carte nationale* (Tunisia) is a minimum estimate, as all designations of 'plusieurs' were counted as two.

A + indicates that the number could be higher.

Measurements of both the diameter and height of earthen burial mounds have been made in only 47 of the more than 327 cases (10 in Morocco, 37 in Tunisia). Many of the regional inventories recorded measurements for the diameter of burial mounds but omitted the height, perhaps because it is more difficult to measure. It was also uncommon for ceramics and other dating evidence in the vicinity of these tombs to have been recorded in a consistent manner; when

[25] *APM*.

[26] *APT*: published in 13 volumes of the *Collection de l'École Française de Rome* (no. 81), and available at www.persee.fr (volumes 1-2) and www.inp.rnrt.tn (volumes 3-13).

[27] *Carte*: published in print (16 fascicules) and online (all 16 print fascicules plus five additional ones) at http://www.inp.rnrt.tn/Carte_archeo/html/ipamed_index_fr.htm.

[28] For example, *Carte nationale des sites archéologiques et des monuments historiques de la Tunisie*, Fascicule 068, Site 3, page 11, and Fascicule 157, Site 46, pages 29-30.

[29] Ferchiou 1987, 14.

[30] See Gsell 1911; 1929. The height and diameter of many of these tombs have not been recorded.

examined, these were generally characteristic of the fourth, third and second centuries BC.[31] It is important to note, however, that in the absence of detailed studies on indigenous handmade pottery, dating should not be made on the basis of recognizable pottery of later periods alone.[32] The recording of numeric and ceramic data in a detailed and consistent fashion at North African tombs should be primary aims of future research.

Let us now turn to the best analysed earthen burial mounds. Excavations have been conducted at only three of these – all more than 50 years ago. Publications of these mounds have given us much important information, and it is worth summarizing what we have learned from them.

Sidi Slimane

A burial mound at Sidi Slimane, dismantled in the 1930s to make way for the expansion of the modern town, is one of the few completely excavated funerary monuments in North Africa.[33] It measured 47 m in diameter and 6 m high, with a total volume of 5,318 m³ of earth (Figure 4.1). This mound contained four burials, all in a large structure situated off-centre within the south-east quarter of the mound. The structure was 5.50 x 13.25 x 2.00 m, and contained three rooms, known as the entrance chamber, antechamber and funerary chamber. Most of its walls were comprised of mud brick. Floors had large paving stones, the entrance chamber was marked by stone walls packed with earth mortar, and the funerary chamber was roofed with six large tree trunks. The funerary chamber held two burials, both beneath heavy stones which damaged them. One burial was found in the antechamber, also beneath stones. The fourth burial was placed in the entrance chamber, without a layer of stones above. Grave goods, including vessels, worked bone objects, and a wooden chest, were placed with the graves in the antechamber and entrance chamber; no grave goods were found in the funerary chamber. After all burials had been placed in the chambers, the mound was erected, and was not opened again in antiquity.

A Libyan inscription found 30 m from the mound mentioned a father and son, and the excavator (Armand Ruhlmann) suggested that it referred to the two burials in the funerary chamber. Ruhlmann concluded that the other two burials may have been servants for the after-life or tomb guardians sacrificed at the death of the two individuals mentioned in the inscription.[34] Although Ruhlmann's theory is attractive, since retainer sacrifice is a recognized feature of early states in which rulers were equated with supernatural power,[35] it remains hypothetical. The quality and extent of recording and publication at Sidi Slimane are inadequate, and the absence of evidence for adult human sacrifice elsewhere in the Maghreb provides no opportunity for comparison.

Figure 4.1. *Cross-section of burial mound at Sidi Slimane (after Souville 1959b, figure 6).*

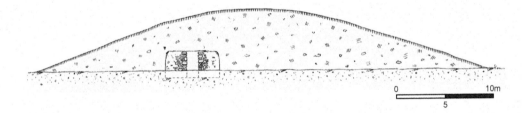

Sidi Allal al Bahraoui

The earthen burial mound at Sidi Allal al Bahraoui was excavated in 1957.[36] The mound had a diameter of 30 m, a height of 2.3 m, and a volume of 819 m³. It contained one skeleton in a pit 0.8 m below the centre of the mound.[37] This excavation was conducted more carefully than

[31] On dating evidence, see especially Ferchiou 1987, 61.

[32] The radiocarbon dates from Mididi and Althiburos mentioned above (note 23) indicate the importance of utilizing non-ceramic means for dating purposes, as well as the need for further study of handmade pottery.

[33] The following summary of the finds at Sidi Slimane is based on Ruhlmann 1939.

[34] Ruhlmann 1939, 55-56.

[35] Trigger 2003, 88-89.

[36] Souville 1959a, on which the following summary is based.

[37] About 30 skeletons were uncovered on the right side of the tumulus; their emplacement was dated by coins of Hassan I (1873-1894). At Sidi Slimane, three modern burials were found: Ruhlmann 1939, 39-40.

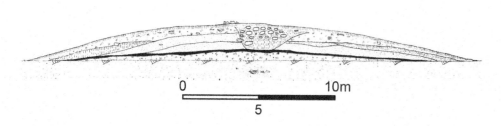

that at Sidi Slimane, and the six different layers which comprised the mound are interesting features of the stratigraphic detail recorded (Figure 4.2). Several of these layers are identified as irregular deposits of sand, red clay, and yellow clay 'coming from different sources'.[38] A thin layer of tightly packed unworked clay was found 1.7 m from the top. This layer protected the burial, and helped to maintain the shape of the mound, showing that some consideration was given to its composition. Numerous chipped stone tools and ceramic artefacts were discovered, but it was not possible to determine whether they had been deliberately included or simply arrived with the fill.

Mezora

The burial mound at Mezora, 54 x 58 x 6 m and 7,502 m[3] in size, is one of the largest in North Africa. A small retaining wall of dressed blocks without mortar at the base helped the mound to hold its shape. Ringing the circumference were 167 monoliths standing vertically. These stones averaged 1.5 m in height. Two very large monoliths, approximately 4.2 m and 5 m tall, were placed a short distance to the west. Although no detailed report on these excavations was published, subsequent studies have presented evidence in some detail.[39]

The monument has also been connected with an anecdote reported by Plutarch. According to him, the Roman general Quintus Sertorius (126-73 BC) visited the Mauretanian kingdom in 82 BC, and was shown a large tomb, which he proceeded to excavate:

'In this city [Tingis] the Libyans say that Antaeus is buried; and Sertorius had his tomb dug open, the great size of which made him disbelieve the Barbarians. But when he came upon the body and found it to be sixty cubits long, as they tell us, he was dumbfounded, and after performing a sacrifice filled up the tomb again, and joined in magnifying its traditions and honours. Now, the people of Tingis have a myth that after the death of Antaeus, his wife, Tinga, consorted with Heracles, and that Sophax was the fruit of this union, who became king of the country and named a city which he founded after his mother; also that Sophax had a son, Diodorus, to whom many of the Libyan peoples became subject, since he had a Greek army composed of the Olbians and Mycenaeans who were settled in those parts by Heracles. But this tale must be ascribed to a desire to gratify Juba, of all kings the most devoted to historical enquiry; for his ancestors are said to have been descendants of Sophax and Diodorus'.[40]

It is impossible to ascertain whether Sertorius opened the tomb at Mezora, or another, or even excavated any grave. But we can draw inferences about monumental tombs from Plutarch's presentation of the passage. Most importantly, it fits very well with evidence for ancestor worship at tombs in North Africa. Plutarch mentioned Sertorius making an 'offering' (σφάγιον) and adding 'honours' (τιμήν) to the tomb, which imply some sort of cult practice at the site. Such practices have been noted at a number of other North African tombs, particularly those connected with Numidian royalty.[41] In this respect, it is significant that Plutarch claimed to have included the anecdote to highlight the tomb's connection to Juba II, King of Mauretania (25 BC – AD 23). The story also provides a good example of the veneration of much earlier

[38] Souville 1959a, 251.

[39] Camps 1961, 76-78; Gozalbes Cravioto 2006; Tarradell 1952. The mound was excavated by César Luis de Montalbán in 1935-1936.

[40] Plutarch, *Sertorius*, IX.3-5 [tr. Perrin, 1919].

[41] Camps 1986; Stone and Stirling 2007, 22-25.

graves in the Roman era. This sort of 'tomb cult' (as it is sometimes known) has been well documented in Greece in the Roman period, and it is likely that Plutarch, who was born in Chaeronea, may have found it familiar.[42]

METHODOLOGY

All inhabitants of ancient North Africa engaged in burying the dead, so funerary monuments offer an opportunity to examine the labour they performed during mortuary practices. I draw on 'volumetric' and 'energetic' approaches to obtain numeric data to compare labour involved in the construction of North African burial mounds. Volumetrics is the term commonly used for evaluations of the size of monuments, while estimations of the energy required for the production, distribution, and consumption of materials within a cultural system are referred to as energetics.[43] These approaches to assessing the labour required for the construction of large monuments have been applied in many archaeological contexts, from residential buildings to temples and pyramids, and from Stonehenge to Easter Island and the Great Wall of China. Well-known results include those made at the Pyramid of Khufu at Giza, Monk's Mound at Cahokia, and the Pyramid of the Sun at Teotihuacán. These monuments have been measured at 2,433,400, 622,000, and 1,441,600 m³, and are estimated to have required 13,000,000, 370,000 and 11,719,500 person-days of labour, respectively.[44] Although in the first instance my aim in utilizing volumetrics and energetics is to compare burial mounds within North Africa, it could also offer an opportunity to compare them to other areas of the world.

Both volumetrics and energetics first involve measuring the dimensions of a structure and using solid geometry or topographic contours to calculate its size. Next, to understand how much labour was involved, the materials employed in construction must be identified. Then, calculations are usually derived from modern experimental studies, which have estimated the amount of labour required to obtain, transport, and work with those materials. Assessments based on ancient data are uncommon, since such data rarely survive.[45]

In North Africa, almost all earthen burial mounds are circular, or near-circular, in shape.[46] To calculate the volumes of the mounds, it is necessary to use solid geometry, since precise topographic contour maps, which have more mensurations and thus enable greater accuracy, are not available.[47] The mounds resemble a number of geometric shapes, including cones, prisms, frustums, and spherical caps. They may be best approximated to spherical caps (cf. Figures 4.1-3), and indeed appear similar to other mounds which have been evaluated in this fashion.[48] One must keep in mind, however, that a solid geometric shape cannot take into account irregularities in the base, slope, or summit of the built structure. This is one of several 'known unknowns' (that is, factors which we know were important, but which we cannot assess in quantitative terms)[49] that make precise volumetric and energetic assessments of North African burial mounds impossible. It will affect the comparison of mounds, but probably not in a significant way, as the known dimensions should provide a good estimate of total volume.

The next step is to assess the construction materials. I have made calculations on the assumption that earth was the sole material in all of these burial mounds, although in fact it was only the main component. Mounds frequently included other materials – generally clay,

[42] Alcock 2002.
[43] Lacquement 2009, 5. See also, Abrams 1994, 1-2: 'Architectural energetics involves the quantification of the cost of construction of architecture into a common unit of comparison – energy in the form of labour-time expenditure'.
[44] Detailed volume and labour estimates for each site, respectively, can be found in Lehner 1997, 108-109 and 224-225; Milner 1998, 144-147; Murakami 2015, 274.
[45] For exceptions using ancient data, see Burford 1969; De Angelis 2003, 163-166.
[46] The 30 x 90 m mound at Sidi Khili has not been included in this analysis due to its pronounced oval shape: Souville 1973, 51.
[47] Lacquement 2010 has shown that topographic contour methods produced more accurate size estimates of mounds at Moundville, Alabama than solid geometry ones. Nonetheless, Lacquement 2009, 48 advocated the use of solid geometry when topographic contours were unavailable.
[48] Lacquement 2010, 342-344.
[49] I refer here to the phrase made famous by Donald Rumsfeld, US Secretary of Defense (2001-2006) under President George W. Bush, in a press briefing (Rumsfeld 2011).

cobbles, or dressed stone – but published reports do not specify the percentage of these materials. This is a second 'known unknown'. The acquisition of stone or clay in almost all cases will have been more time-consuming and required greater energy than that of earth, since these materials are heavier. Studies of quarrying stone, for instance, show that the amount which can be obtained per day is one-third or less than that of earth.[50] Thus, by considering earth as the sole material in the mounds, the calculations of labour made in this analysis should produce minimum estimates. Another reason that the estimates are low is that no allowance for mound compaction has been made, yet it seems probable that mounds would have been compacted to prevent their disaggregation.

Finally, how much earth could one person procure for a mound in a single day? In experimental studies in the village of Las Bocas, Mexico, Charles Erasmus determined that one man could excavate 2.6 m³ of earth in one day with a digging stick, and 7.2 m³ with a metal spade.[51] A variety of other estimates based on modern experimental data exist.[52] All of these studies have substantial comparative value for Maghrebi archaeologists, although it is necessary to exercise some caution when applying their results, since further 'known unknowns' must be considered. First, to understand the amount of labour necessary to extract earth, it is important to know what sort of tools were used. Iron working has been documented as early as the sixth century BC in the Maghreb, well before the earliest burial mounds were constructed here, and is evident during the main period of their construction.[53] Thus, it is probable, but not certain, that metal implements were in use. Second, one needs to know the distance between the mound and the source of its construction materials in order to obtain transport costs. In the case of North African burial mounds, it is difficult to know where soil has originated, as this has infrequently been recorded.[54] Transport over less than 500 m may have been common, as the material in North African burial mounds appears to have been acquired in the vicinity. Erasmus' studies nevertheless indicated that the amount of earth or stone acquired each day decreased by roughly one-half as the transport distance doubled.[55] Use of draught animals, rather than human labour, for transport of earth and stone in the Mediterranean may be expected to have limited transport costs, by comparison to those in Mesoamerica, however.[56]

It remains to explain how the assumptions I have detailed relate to the quantification procedures I use in the next section. Since I consider North African burial mounds similar to spherical caps, I determine their volumes by applying the formula $Volume = \frac{\pi h^2(3r-h)}{3}$, where h is equal to the height of the cap and r to the sphere's radius (Figure 4.3). The radius of the sphere may be calculated from the radius and height of the cap, as $Sphere\ radius = \frac{a^2+h^2}{2h}$. Thus, the key measurements needed for these calculations are the height and radius (or diameter, as it is most commonly listed) of the burial mound. In North Africa, recording of burial mounds has provided dimensions for height and diameter in 47 examples (Table 4.2).[57]

An energetic approach calculates the number of person-days necessary for the construction of North African burial mounds; this method requires additional explanation. I settled on two

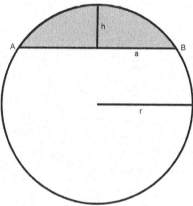

Figure 4.3. *Spherical cap (image: D. Stone).*

[50] Abrams 1994, 44-52; Erasmus 1965, 289.

[51] Erasmus 1965, 285.

[52] See Lacquement 2009, 4-5, 16-21 for discussion of many of these.

[53] Sanmartí *et al.* 2012, 36-38.

[54] An exception is Ruhlmann's suggestion that earth for the Sidi Slimane tumulus came from the bank of the Oued Beth, about 100 m away (Ruhlmann 1939, 40-41). Ferchiou 1987 occasionally hypothesized the transport of earth over short distances, but to my knowledge the subject has not been mentioned elsewhere.

[55] Erasmus 1965, 284-289.

[56] See, for example, estimates made by Coulton (1993, 52-56) concerning the tenth-century BC burial mound at Lefkandi, Greece, which show that oxen transport earth at about twice the speed of humans. Separate calculations must of course be made to determine costs of fodder for draught animals.

[57] In only seven instances, has recording provided both upper and lower diameters as well as height. A frustum equation might more closely estimate volume in these cases. I chose to use the formula for a spherical cap on 47 mounds in my analysis due to the larger sample size.

Table 4.2. *Volumetric and energetic assessment of burial mounds in North Africa.*

Toponym	Diameter (m)	Height (m)	Volume (m³)	P-D1	P-D2	Reference
El Ouiba	2.5	1	3	0.5	1	*APT* 11, 122
Bir Erroumi	6.2	0.5	8	1	2	*APT* 9, 30-32
Henchir el Ksar	5	0.8	8	1	2	*Carte* 49, 98-99
Sidi Smech	8	0.75	19	3	5	*APT* 9, 38-41
Sidi Smech	8	0.75	19	3	5	*APT* 9, 38-41
Sidi Smech	8.5	1	29	4	8	*APT* 9, 38-41
Sidi Smech	11	0.75	36	5	10	*APT* 9, 38-41
Chiniava	12.2	1.1	65	9	18	Ferchiou, 19
Vazari	12.6	1.1	69	10	19	Ferchiou, 30
Henchir Sidi Amara	11	1.5	73	10	20	Ferchiou, 27
Apisa Maius	12	1.5	87	12	24	Ferchiou, 18-19
Kef Ezzahi	11.2	2	103	14	29	*APT* 11, 157-158
Abthugni	9.6	2.7	108	15	30	Ferchiou, 31
Sidi Medien	13	1.7	115	16	32	*APT* 5, 70
Avioccala	14	2	158	22	44	Ferchiou, 21-23
Chiniava	15.4	1.9	181	25	50	Ferchiou, 29
Sidi Bou Khouzba	12	3.5	220	31	61	*APM*, 110
Seressi	16.5	2.1	229	32	64	Ferchiou, 19
Henchir el Haouam	16.4	2.3	249	35	69	Ferchiou, 31-32
Sidi Galouzi	19.5	1.7	256	36	71	*APT* 11, 153-154
Henchir Debbik	19.5	1.775	268	37	74	Ferchiou, 27-28
Thignica	20	1.7	270	38	75	Ferchiou, 26
Oued el Ain	15	3	279	39	78	*APM*, 58
Sidi Smech	15	3	279	39	78	*APT* 9, 38-41
Sidi Smech	22	2	384	53	107	*APT* 9, 38-41
Henchir Kern el Kebch	18	3	396	55	110	*APT* 5, 66
Suo	21	2.3	405	56	113	Ferchiou, 28
Henchir Guennara	23.15	2.05	436	61	121	Ferchiou, 47
Jama	22.5	2.2	443	62	123	Ferchiou, 25
Saradi	23	2.6	549	76	153	Ferchiou, 24-25
El Herigue	30	2	711	99	198	*Carte* 74, 55
Garaet Smara	21.5	4	760	106	211	*APT* 19, 7-11
Sidi Allal al Bahraoui	30	2.3	819	114	228	*APM*, 145-147
Aïn Rchine	20	5.1	871	121	242	Ferchiou, 42-43
Henchir Romana	29	2.7	902	125	251	Ferchiou, 33
Sululos	26	3.7	1009	140	280	Ferchiou, 33-34
Koudia Haj Larbi	20	6	1056	147	293	*APM*, 136
Sutunurca	26	4	1095	152	304	Ferchiou, 40-41; *APT* 5, 41
Turris-Furnos Minus	40	3	1899	264	528	Ferchiou, 26-27
El Herigue	37	4	2184	303	607	*Carte* 74, 55
Volubilis	40	6	3883	539	1079	*APM*, 141
Djebel Fedja	40	6.5	4228	587	1174	Ferchiou, 36-37; *APT* 5, 37-39
Sidi Slimane	47	6	5318	739	1477	*APM*, 130-133
Nouillat el Kebira	41	8	5549	771	1541	*APM*, 136
Mezora	56	6	7502	1042	2084	*APM*, 32-36
Sidi Bachir	60	8	11,578	1608	3216	*APM*, 58
Koudia Bou Mimoun	70	6	11,658	1619	3238	*APM*, 127

P-D1 = Person-Days, 7.2 m³ of material per day. P-D2 = Person-Days, 3.6 m³ of material per day.

APM = Atlas préhistorique du Maroc. APT = Atlas préhistorique de la Tunisie. Ferchiou = Ferchiou 1987. *Carte = Carte nationale des sites archéologiques et des monuments historiques de la Tunisie.*

figures for material procured per person per day (Table 4.2, columns P-D1 and P-D2). I arrived at these figures by considering some of the 'known unknowns' – how heavy was the material, how far did it have to be moved, which tools were used, and whether oxen or other animals contributed labour. In the first instance, I chose a figure which negated the effect of these variables, estimating 7.2 m³ of earth produced per day, equivalent to Erasmus' figure for earth procured by metal spade per day, excluding transport. In the second, I gave greater weight to these variables, recognizing that metal may not have been used, that both earth and cobbles are found in North African burial mounds, and that many of these are located on hills, to which materials may have had to be transported. My estimate here was 3.6 m³ of earth produced per day; this figure takes into account that conditions (tools, transport, weight of materials) may not have been ideal, but is perhaps still relatively high. Both figures are heuristic. Their value lies in the allocation of person-days to the construction process; in this way an energetic approach may provide a better sense of the human requirements of construction than a simple volumetric measure. To obtain the figures for the number of person-days required, one must divide the volume of the mound by the amount of earth procured per day.

RESULTS

The volumetric and energetic analyses have indicated a large range in both the size of, and labour required for, earthen burial mounds in North Africa. The volume extended from 3 m³ for the smallest tomb in the sample to 11,658 m³ for the largest. The number of person-days suggested for construction stretched between 1 and 3,238, according to the higher, but perhaps more realistic, labour estimate (Table 4.2).

Volumetric and energetic assessments are commonly utilized to shed light on the organization of labour. Elliot Abrams has performed such an analysis on domestic buildings at the Maya site of Copán in the Late Classic period (c. AD 600-900).[58] Although Maya centres of this period were arguably more advanced than North African ones in the second half of the first millennium BC, both locations may be regarded as places where hierarchies were being established and social complexity was emerging. Furthermore, while houses and tombs have different social and architectural requirements, scholarship frequently considers both structures as illustrative of status differences in these and similar societies. Abrams has sketched a model for labour organization at Copán that includes interactions among equals and between people of different social status. He has proposed the existence of five categories of labour: 'familial reciprocal', 'familial contractual', 'community contractual', 'festive custodial', and 'corvée'.[59] The first three describe exchanges among equals, whether members of a family, members of equal families, or members of an equal community. The last two involve labour provided for a socially more powerful person, either in return for a feast, or as tribute. Abrams considered the data from Copán to reflect the simultaneous existence of these categories of labour, with specific domestic structures indicative of different categories.

Abrams' model is useful for considering how the size of earthen burial mounds in North Africa might correlate to the type of labour system under which they were built. The substantial variation between the low and high figures suggests several possible – though admittedly speculative – sources of labour for the construction of the tombs. A family, or extended family group, is the most likely source of labour for the construction of small tombs. Since families varied in size and the emphasis they placed on tombs, we must proceed cautiously, but might suggest that a burial mound which required fewer than 100 person-days to construct could be ascribed to family reciprocal or family contractual systems. A small community in which members negotiated to obtain each other's labour may be regarded as capable of creating larger mounds. We might speculate that a community contractual system could have produced tombs requiring fewer than 500 person-days. Alternatively, payment for labour may have been given in the form of a feast when the work had been completed. When the member of society offering the feast is of higher social rank than the labourers and does not participate in the labour, the system may be described

[58] Abrams 1994.
[59] Abrams 1994, 96-103.

as festive custodial. Such feasting arrangements are plausible for tombs requiring more than 200 person-days.[60] Social inferiors who are obliged to work for their superiors as a form of tribute participate in a corvée labour system. Burial mounds from North Africa requiring more than 500 person-days would almost certainly have been built by non-family members in an unequal labour system. Defining a boundary between festive custodial and corvée systems is difficult, but tombs requiring more than 1,000 person-days for construction may be reasonably attributed to a corvée labour system. This model for the construction of earthen burial mounds is a hypothetical one, but is not without basis in ancient evidence. It derives in part from the distribution of mound volume and suggested person-days needed for construction, in part from North African evidence for feasting and labour contracts,[61] and in part from the comparative evidence of Abrams' study. The model offers a credible way of considering how multiple labour systems were in operation for tomb construction in ancient North Africa.

The distribution patterns of the tombs by size are revealing. Six of the seven largest earthen burial mounds, all of which were greater than 3,000 m³ in size and required more than 1,000 person-days to construct, lie in the western Maghreb (Morocco). Excavations at two of these, Mezora and Sidi Slimane, have strongly indicated that privileged elites were buried there, and it seems likely that this conclusion applies to the other five. Other burial mounds, like the well-excavated example from Sidi Allal al Bahraoui, were smaller, and less obviously elite. A number of small stone mounds are also known from this region.[62] When we examine the western Maghreb as a whole, earthen burial mounds are the most conspicuous funerary monuments of the second half of the first millennium BC, and it appears that the development of hierarchy and a prestige economy was strongly linked to the construction of these tombs. The picture in the eastern Maghreb (Tunisia) is more complex. Here, there are a handful of earthen burial mounds, such as those at Djebel Fedja, El Herigue, Turris-Furnos Minus, and Sutunurca, which were greater than 1,000 m in size and required more than 280 person-days to complete. It is probably reasonable to consider these as elite tombs. A range of smaller earthen burial mounds have also been recorded, which cannot be considered elite. In the eastern Maghreb between the fourth to second centuries BC there was also a much greater variety of funerary monuments constructed, and earthen burial mounds, while numerous, must be considered alongside dolmens, *haouanet*, and Numidian royal tombs.[63] Very little emphasis has been placed on cultural differences between the indigenous peoples of the eastern and western regions of the ancient Maghreb, but this analysis highlights the existence of such differences, and perhaps points towards avenues that future studies could take.

CONCLUSIONS

This volumetric and energetic analysis has interpreted North African earthen burial mounds of the second half of the first millennium BC in a novel fashion. Instead of classifying their style, or searching for indigenous African or wider Mediterranean influences on their construction, it has sought to consider the social systems under which they might have been built, through a study of their volume and the number of days required for construction. It is clear that many burial mounds were simple structures that could have been completed by a small number of individuals working for a few days. Others were monumental, and required the labour of many individuals working in a dependent relationship towards persons of higher social status. A model incorporating several categories of labour has been proposed as a means of explaining this evidence. Although it would be possible to debate the boundaries of these categories, or to suggest alternative ones, it is hoped that the model will stimulate a more rigorous analysis of the effort expended on burials, and the probable relationship of such effort to the emergence of more complex social systems.

[60] The number of person-days in labour system categories may overlap, and it is not necessary to have a precise boundary between these.

[61] Feasting and tombs in Roman period North Africa: Stirling 2004; feasting and labour contracts in Roman period North Africa: Shaw 2013, 77; feasting at Lixus and Althiburos: Cañete and Vives-Ferrándiz 2011; Sanmartí *et al.* 2012; corvée labour in Roman period North Africa: Kehoe 1988, 45-46.

[62] Cf. Souville 1959b.

[63] Cf. Stone 2007a, 2007b, Quinn 2013.

Monumental burials are recognized as especially conspicuous during periods of state formation, when comparative studies suggest that elites maintained socio-political power through important symbols of social hierarchy. To return to the issue of state formation raised at the beginning of this paper, current research in North Africa has documented evidence of this process through redistribution and feasting (Lixus), metallurgy, agricultural intensification and population growth (Althiburos), and urbanism, hierarchy, written language, agricultural intensification, commercial relations, population growth, and the introduction of horses, camels, and wheeled transport (Fazzan). The monumental earthen burial mounds studied above are broadly contemporary with those developments at Lixus, Althiburos, and in Fazzan, and add an important feature of the state formation process that has been less clearly identified in those places to date: the control of labour. Control of the labour of others by elites for economic and political purposes is a well-established feature of incipient states.[64] Such labour control is evident in the Numidian kingdoms at the time of Masinissa, Micipsa, and Jugurtha (as is apparent from ancient sources), but the monumental earthen burials may offer a window onto an earlier period, when such control was becoming established. Excavating some of these tombs with modern field techniques would be one way to develop this analysis further. Another would be to conduct a volumetric and energetic analysis of the many large stone tombs, of the sort excavated recently at Althiburos, where the data have been sufficiently recorded to enable quantification. A third method would be to pursue an examination of elite control of labour in agriculture, craft production, or other areas. The excavation and survey projects at Lixus, Althiburos, and in Fazzan seem well positioned to offer further evidence in these regards. Further research in any of these areas will enable an improved understanding of 'what was '*de Africa*'?' at the time it came into contact with Greece, Carthage, Rome, and other Mediterranean civilizations.

BIBLIOGRAPHY

Abrams, E. 1994. *How the Maya Built Their World: Energetics and Ancient Architecture*, Austin: University of Texas Press.

Alcock, S.E. 2002. *Archaeologies of the Greek Past: Landscape, Monuments, and Memories*, Cambridge: Cambridge University Press.

Aranegui Gascó, C. (ed.) 2001. *Lixus. Colonia fenicia y ciudad púnico-mauritana. Anotaciones sobre su ocupación medieval* (Saguntum Supplement, 4), València: Universitat de València.

Aranegui Gascó, C. (ed.) 2005. *Lixus, 2. Ladera sur: excavaciones arqueológicas morroco-españolas en la colonia fenicia, campañas 2000-2003* (Saguntum Supplement, 6), València: Universitat de València.

Aranegui Gascó, C. and Hassini, H. (eds) 2010. *Lixus, 3. Área suroeste del sector monumental (cámaras Montalbán) 2005-2009* (Saguntum Supplement, 8), València: Universitat de València.

Brett, M. and Fentress, E. 1996. *The Berbers*, Oxford: Blackwell.

Broca, P. 1876. Les peuples blondes et les monuments mégalithiques dans l'Afrique septentrionale, *Revue d'Anthropologie*, 5: 393-404.

Burford, A. 1969. *The Greek Temple Builders at Epidauros*, Toronto: University of Toronto Press.

Camps, G. 1961. *Aux Origines de la Berbèrie : Rites et Monuments Funéraires*, Paris: Arts et Metièrs Graphiques.

Camps, G. 1986. Funerary monuments with attached chapels from the Northern Sahara, *African Archaeological Review*, 4: 151-164.

Camps, G. 1991. s.v. Bazinas. In Camps, G. (ed.), *Encyclopédie berbère*, 9, Aix-en-Provence: Édisud, 1400-1407.

Cañete, C. and Vives-Ferrándiz, J. 2011. 'Almost the same': dynamic domination and hybrid contexts in Iron Age Lixus, Larache, Morocco, *World Archaeology*, 43: 124-143.

Coarelli, F. and Thébert, Y. 1988. Architecture funéraire et pouvoir : réflexions sur l'hellénisme numide, *Mélanges de l'École Française de Rome. Antiquité*, 100: 761-818.

Coulton, J. 1993. The Toumba building: its architecture. In Popham, M., Calligas, P. and Sackett, L. (eds), *Lefkandi II: The Protogeometric Building at Toumba. Part 2. The Excavation, Architecture and Finds*, London: British School at Athens, 33-70.

De Angelis, F. 2003. *Megara Hyblaia and Selinous: The Development of Two Greek City-states in Archaic Sicily*, Oxford: Oxford University Press.

Erasmus, C. 1965. Monument building: some field experiments, *Southwestern Journal of Anthropology*, 21: 277-301.

[64] Trigger 2003; Yoffee 2005.

Ferchiou, N. 1987. Le paysage funéraire préromain dans deux régions céréalières de Tunisie antique (Fahs-Bou Arada et Tebourba-Mateur) : les tombeaux monumentaux, *Antiquités Africaines*, 23: 13-70.

Février, P.-A. 1989. *Approches du Maghreb Romain : Pouvoirs, Différences, et Conflits*, Aix-en-Provence: Édisud.

Gellner, E. 1983. *Nations and Nationalism*, Oxford: Blackwell.

Goldstein, L. 1981. One-dimensional archaeology and multi-dimensional people: spatial organization and mortuary analysis. In Chapman, R., Kinnes, I. and Randsborg, K. (eds), *The Archaeology of Death*, Cambridge: Cambridge University Press, 53-69.

Gozalbes Cravioto, E. 2006. El monumento protohistorico de Mezora (Arcila, Marruecos), *Archivo de Prehistoria Levantina*, 36: 323-348.

Gsell, S. 1911. *Atlas Archéologique de l'Algérie*, Paris: Hachette.

Gsell, S. 1929. *Histoire ancienne de l'Afrique du Nord, Volume 6. Les royaumes indigènes, vie matérielle et morale*, Paris: Hachette.

Hodder, I. 1982. *Symbols in Action: Ethnoarchaeological Studies of Material Culture*, Cambridge: Cambridge University Press.

Kallala, N. and Sanmartí, J. (eds) 2011. *Althiburos, I. La fouille dans l'aire du capitole et la nécropole méridionale* (Documenta, 18), Tarragona: Institut Català d'Arqueologia Clàssica.

Kallala, N., Sanmartí, J., Jornet, R., Belarte, M. C., Chérif, S., Campillo, J., Montanero, D., Miniaoui, S., Bermúdez, X., Fadrique, T., Revilla, V., Ramon, J. and Ben Moussa, M. 2014. La nécropole mégalithique de la région d'Althiburos, dans le massif du Ksour (Gouvernorat du Kef, Tunisie). Fouille de trois monuments, *Antiquités Africaines*, 50: 19-60.

Kehoe, D.P. 1988. *The Economics of Agriculture on Roman Imperial Estates in North Africa* (Hypomnemata, 89), Göttingen: Vandenhoeck & Ruprecht.

Lacquement, C. 2009. *Landscape Modification at Moundville: An Energetics Assessment of a Mississipian Polity*, Unpublished PhD Thesis, University of Alabama.

Lacquement, C. 2010. Recalculating mound volume at Moundville, *Southeastern Archaeology*, 29: 341-354.

Lee, B., Finkelpearl, E. and Graverini, L. (eds) 2014. *Apuleius and Africa*, London: Routledge.

Lehner, M. 1997. *The Complete Pyramids*, New York: Thames and Hudson.

Liverani, M. 2000. The Garamantes: a fresh approach, *Libyan Studies*, 31: 17-28.

Liverani, M. (ed.) 2006. *Aghram Nadharif: The Barkat Oasis (Sha'abiya of Ghat, Libyan Sahara) in Garamantian Times* (Arid Zone Archaeology Monographs, 5), Florence: All'Insegna del Giglio.

Mattingly, D.J. 1996. From one colonialism to another: imperialism and the Maghreb. In Webster, J. and Cooper, N. (eds), *Roman Imperialism: Post-Colonial Perspectives*, Leicester: University of Leicester, 49-69.

Mattingly, D.J. 2001. Nouveaux aperçus sur les Garamantes : un état saharien, *Antiquités Africaines*, 37: 45-61.

Mattingly, D.J. (ed.) 2003. *The Archaeology of Fazzān. Volume 1, Synthesis*, London: Society for Libyan Studies – Department of Antiquities.

Mattingly, D.J. (ed.) 2007. *The Archaeology of Fazzān. Volume 2, Site Gazetteer, Pottery and Other Survey Finds*, London: Society for Libyan Studies – Department of Antiquities.

Mattingly, D.J. (ed.) 2010. *The Archaeology of Fazzān. Volume 3, Excavations carried out by C.M. Daniels*, London: Society for Libyan Studies – Department of Antiquities.

Mattingly, D.J. (ed.) 2013. *The Archaeology of Fazzān. Volume 4, Survey and Excavations at Old Jarma (Ancient Garama) carried out by C.M. Daniels (1962-69) and the Fazzān Project (1997-2001)*, London: Society for Libyan Studies – Department of Antiquities.

Milner, G. 1998. *The Cahokia Chiefdom: The Archaeology of a Mississippian Society*, Washington: Smithsonian Institution Press.

Morris, I. 1991. The archaeology of ancestors: the Saxe/Goldstein hypothesis revisited, *Cambridge Archaeological Journal*, 1: 147-169.

Munzi, M. 2001. *L'epica del ritorno. Archeologia e politica nella Tripolitania Italiana* (Saggi di storia antica, 17), Rome: 'L'Erma' di Bretschneider.

Murakami, T. 2015. Replicative construction experiments at Teotihuacán, Mexico: assessing the duration and timing of monumental construction, *Journal of Field Archaeology*, 40: 263-282.

Oulebsir, N. 2004. *Les usages du patrimoine : Monuments, musées et politique coloniale en Algérie, 1830-1930*, Paris: Maison des Sciences de l'Homme.

Quinn, J.C. 2013. Monumental power: 'Numidian royal architecture' in context. In Prag, J. and Quinn, J.C. (eds), *The Hellenistic West: Rethinking the Ancient Mediterranean*, Cambridge: Cambridge University Press, 179-215.

Ruhlmann, A. 1939. Le tumulus de Sidi Slimane (Rharb), *Bulletin de la Société de Préhistoire du Maroc*, 13: 37-70.

Rumsfeld, D. 2011. *Known and Unknown: A Memoir*, New York: Sentinel.

Sanmartí, J., Kallala, N., Carme Belarte, M., Ramon, J., Maraoui Telmini, B., Jornet, R. and Miniaoui, S. 2012. Filling gaps in the protohistory of the Eastern Maghreb: the Althiburos archaeological project (El Kef, Tunisia), *Journal of African Archaeology*, 10: 21-44.

Saxe, A. 1970. *Social Dimensions of Mortuary Practices*, Unpublished PhD Thesis, University of Michigan.

Shaw, B. 2013. *Bringing in the Sheaves: Economy and Metaphor in the Roman World*, Toronto: University of Toronto Press.

Souville, G. 1959a. Le tumulus de Si Allal el Bahraoui, *Libyca*, 6-7: 243-259.

Souville, G. 1959b. Principaux types de tumulus marocains, *Bulletin de la Société Préhistorique de France*, 56: 394-402.

Stirling, L. 2004. Archaeological evidence for food offerings in the graves of Roman North Africa. In Joyal, M. and Egan, R. (eds), *Daimonopylai: Essays in Classics and the Classical Tradition Presented to Edmund G. Berry*, Winnipeg: University of Manitoba, 427-451.

Stone, D.L. 2007a. Monuments on the margins: interpreting the late first millennium B.C.E. rock-cut tombs (haouanet) of North Africa. In Stone, D.L. and Stirling, L.M. (eds), *Mortuary Landscapes of North Africa*, Toronto: University of Toronto Press, 43-74.

Stone, D.L. 2007b. Burial, identity, and local culture in North Africa. In Van Dommelen, P. and Terrenato, N. (eds), *Articulating Local Cultures: Power and Identity under the Expanding Roman Republic* (Journal of Roman Archaeology Supplement, 63), Portsmouth, RI: Journal of Roman Archaeology, 126-144.

Stone, D.L. and Stirling, L.M. 2007. Funerary monuments and mortuary practices in the landscapes of North Africa. In Stone, D.L. and Stirling, L.M. (eds), *Mortuary Landscapes of North Africa*, Toronto: University of Toronto Press, 3-31.

Tanda, G., Ghaki, M. and Cicilloni, R. (eds.) 2009. *Storia dei paesaggi preistorici e protostorici nell'Alto Tell tunisino: missioni 2002-2003*, Cagliari: Università di Cagliari.

Tarradell, M. 1952. El tumulo de Mezora (Marruecos), *Archivo de Prehistoria Levantina*, 3: 229-240.

Tilley, C. 1994. *A Phenomenology of Landscape*, Oxford: Bcrg.

Tissot, C. 1876. Sur les monuments mégalithiques et les populations blondes du Maroc, *Revue d'Anthropologie*, 5: 385-392.

Trigger, B.G. 2003. *Understanding Early Civilizations: A Comparative Study*, Cambridge: Cambridge University Press.

Yoffee, N. 2005. *Myths of the Archaic State: Evolution of the Earliest Cities, States and Civilizations*, Cambridge: Cambridge University Press.

PART II

PLANNING, DEVELOPING, AND TRANSFORMING THE NORTH AFRICAN TOWNSCAPE

5

MERGING TECHNOLOGIES IN NORTH AFRICAN ANCIENT ARCHITECTURE
OPUS QUADRATUM AND *OPUS AFRICANUM* FROM THE PHOENICIANS TO THE ROMANS

Stefano Camporeale

Abstract

Using the examples of *opus quadratum* and *opus africanum*, this study discusses the interconnection between traditions and techniques of construction which typifies the architecture of North Africa between the second century BC and the early Imperial period. To understand how the Hellenistic and Roman traditions are grafted onto their predecessors, the analysis begins with the Phoenician period. New hypotheses are also proposed about the two techniques, based on typology and the construction process. The analysis does not confirm earlier hypotheses about their Phoenician origin. *Opus quadratum* was used at Carthage in the fifth century BC and spread from there during the second century BC, as exemplified by the mausoleum at Thugga. *Opus africanum* appears at Carthage in the seventh century BC, but the more complex versions are found both at Bulla Regia and at Carthage from the second century BC. The reasons for using this technique are clarified, starting from its diffusion in Morocco and by analysis of the *Capitolium* at Sala.

INTRODUCTION

In 1982, Friedrich Rakob gave the first overview of the construction techniques and traditions of North Africa between the second century BC and the early Imperial period. His starting point was Hellenistic architecture, transmitted to the Maghreb via the Punic world, which had in turn received it through the influence of Alexandria and through contact with Magna Graecia and Sicily. Rakob argued for the intertwining in this period of Punic-Hellenistic, Italian, and more specifically North African cultures and their different building techniques. Within this picture he considered various techniques: reticulate, *opus africanum*, pisé and sun-dried brick, concrete, terracotta vaulting tubes, and *opus testaceum* – all during a period of particular expansion of urbanism in North Africa when the introduction of monumental building types brought innovations in building technologies. Since Rakob, no study of North African building techniques on the same lines has been attempted. By following his example (that is, by observing the interconnections between the diverse building traditions), we can better understand how the innovations in technology came about in the Maghreb. Using the same long-term perspective adopted by Rakob, this paper will consider in particular the typology and the spread of two techniques: *opus quadratum*, in which the whole wall is built of squared blocks, and *opus africanum*, characterized by a skeleton of ashlar piers. I will also go even further back, starting from the period of Phoenician colonization around the middle of the eighth century BC, to see if it is true that the Phoenicians

played a primary role in the transfer of high-level technologies previously unknown in the western Mediterranean. Phoenician technologies would have been inherited by the Punic world and further developed following the diffusion first of Hellenistic and then of Roman technology. Therefore *opus quadratum* and *opus africanum* should form the most representative examples of survival in North Africa of building techniques in the Phoenician and Punic traditions. Through the use of new data, this general interpretation can be further elaborated.

Firstly, by analysing the evidence for the techniques over time, I will try to verify their Phoenician origins and better understand how the Hellenistic and Roman traditions are grafted onto their predecessors. Secondly, I will attempt to explain the reasons why, in certain periods, some techniques were preferred to others in specific regions or for individual buildings. Particular attention will be paid to the context which determines the choice of specific building types and the techniques most suitable for their creation.

After having traced the origins of the two techniques and having followed their transformations, local traditions of construction will emerge more clearly. In this way the character of North African architecture of the Roman period will be seen not only as a result of the importation of building technologies and types, but also of numerous adaptations of these techniques in the different regions of the Maghreb. Through case studies I will seek to understand how these adaptations came about; for *opus quadratum* we will refer to some better known examples, while for *opus africanum* the results of new research conducted in Morocco in the Mauretanian and Roman periods will be used (Figure 5.1).[1]

OPUS QUADRATUM

The problem of origin

According to Fantar, *opus quadratum* was known and used by the Phoenicians in their homeland and in their western colonies, where it is found from the eighth century BC, as shown in particular by some tombs at Carthage and Utica in Tunisia, and at Trayamar in Spain.[2] *Opus quadratum* should therefore have spread into southern Spain and the Maghreb well before the Hellenistic period. This picture, however, merges different examples known from the Levant and the west by presupposing that *opus quadratum* is a generic category without internal distinctions. An alternative interpretation was proposed a little later in Sharon's study of Phoenician building techniques at Tel Dor (Israel), where it was shown that none of the Levantine techniques are really similar to those of the western colonies.[3] Sharon concentrated specifically on *opus quadratum* and *opus africanum*, proposing a typology of these techniques based on the arrangement of the blocks in walls and piers. This analysis showed that different techniques were in use from the tenth to the second centuries BC, and have no precise parallels either in the surrounding regions (Anatolia, Persia, Greece, Egypt) or in the Phoenician colonies.

If we exclude the hypothesis of a Phoenician origin, then according to Sharon's work we should consider that *opus quadratum* was introduced into Phoenician colonies after their foundation. In any case, we have confirmation of the use of squared blocks from before the arrival of the Hellenistic technique, as Fantar had already hypothesized. The time frame for this has recently been reconsidered in the light of new C14 analyses carried out in some Phoenician contexts in Spain, Sardinia, Portugal and Carthage. These analyses show that the foundation of the first colonies was at the end of the ninth century and therefore earlier than that suggested using the ceramic evidence (middle of the eighth century BC).[4]

[1] This research was financed by a Marie Curie IEF Fellowship, 2011-2013, at the École normale supérieure de Paris, Laboratoire AOROC. My thanks go to the board of the Patrimoine du Ministère de la Culture du Maroc for permission to pursue this research, and to the site conservators Abdelkader Chergui (Sala-Chellah), Rachid Arharbi (Banasa) and Mustapha Atki (Volubilis). A particular vote of thanks goes to Naïma Khatib-Boujibar and Brahim Mlilou for permission to record the *opus africanum* in the temple at Zilil. My research at Sala was carried out in collaboration with Abdelkader Chergui and Layla Es-Saadra (Université de Rabat-Souissi). Finally I am grateful to Carla Amici, Pierre Gros, Mark Wilson Jones, Lynne Lancaster, Cynthia Mascione, Emanuele Papi for their useful comments on the reconstruction of the *Capitolium* at Sala.
[2] Fantar 1984, 326-330.
[3] Sharon 1987.
[4] Sagona 2008.

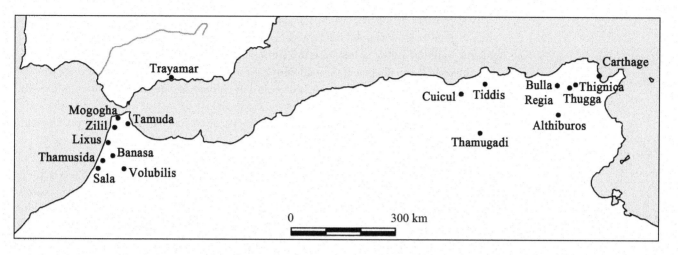

Figure 5.1. *Map with
principal sites mentioned in
the text (image: S. Camporeale).*

Recent excavations at Althiburos (Tunisia) enable us to compare what took place in the Phoenician colonies with the process that, in the same period, characterized the formation of indigenous centres in the hinterland. The first permanent settlement of Althiburos is also dated, by C14, as contemporary with that of Carthage, and the authors of the publication propose a spontaneous change to sedentary living on the part of the pre-Roman populations. In this period *opus quadratum* was not used in either the first phase of Phoenician settlement at Carthage, nor at Althiburos. In the latter, a technique with small roughly-squared stones used only in the facing – more like a type of *opus vittatum* – only appears in the fourth century BC.[5] At Carthage, however, *opus quadratum* is documented in the middle of the fifth century BC when it was used for the construction of the first city walls, uncovered by excavations in the maritime quarter.[6] The fortifications were constructed in large blocks of sandstone (up to 11 tonnes in weight) arranged in two faces with a core of stones and earth and linked by transverse walls. In the same area squared blocks were used also in the houses, especially in the corners and in some boundary walls.

In addition, at Carthage, the inhabited area excavated under the *decumanus maximus*, with occupation phases from the eighth century BC, still shows no use of *opus quadratum* (see below).[7] Earlier examples of *opus quadratum* in Phoenician colonies come only from some chambered tombs. A well-known example is that of the necropolis of Trayamar on the southern coast of Spain, especially Tomb Four from the mid-seventh century BC. The funerary chamber (3.8 x 2.9 m) is built of unequal blocks, arranged in rows of different thicknesses and set at heights which do not always match between the four walls.[8] Since its publication, this tomb has been paralleled with examples of similar type and building technique from Carthage and Utica, of unknown date,[9] and from Mogogha. The latter, about five kilometres from Tangiers, is composed of two funerary chambers, one (2 x 1.78 m) constructed in *opus quadratum* and the other (1.75 x 1 m), apparently built against the first, with small, more roughly-worked blocks. The only grave goods were three vessels found in the second chamber and dated to the third century BC.[10] There is nothing to date the older tomb, which is constructed of accurately worked blocks, particularly the slabs which form the stone carpentry of the sloping roof with ridge pole.

On the basis of the examples analysed I would suggest, for two main reasons, that *opus quadratum* was not imported into the west by the Phoenicians. The first is that it does not seem to appear in the first phases of construction in the colonies; the second being that the typology changes radically from the Levantine world to that of the west, which implies that the capacity of the skilled workers and their work habits change, or in other words their whole tradition, which therefore cannot be defined as Phoenician.

[5] Kallala and Sanmartí 2011, 164-167, figures 4.131, 4.133, walls MR 27002, 270408. On the earliest phases of occupation at Althiburos see also Mattingly's paper in this volume.
[6] Holst *et al.* 1991, 165-189, 211-214.
[7] Niemeyer *et al.* 2007.
[8] Schubart and Niemeyer 1976.
[9] Cintas 1950, 117-126 (Utica); Fantar 1984, 327-328 (with earlier bibliography for the tombs of Carthage).
[10] Jodin 1960.

The problem of the origins of *opus quadratum* in the west still remains difficult to resolve, given that only a few examples can be assigned to the older period of its use. As discussed above, only the tombs of Trayamar have a secure chronology (mid-seventh century BC). We are therefore not yet able to understand through what experimentation and cultural contacts the masons acquired squared stone construction, and even the context of reuse is difficult to pin down. Through the example of funerary architecture we can only propose that the elites used this technique to express their authority and that therefore *opus quadratum* was perfected in parallel with the strengthening of group hegemonies.

In North Africa the first example of monumental use of *opus quadratum* is the city walls of Carthage of the fifth century BC. Their construction, however, falls into a period in which the technique was already widespread in the Mediterranean, due to the growth of large urban centres and the circulation of techniques and skills between Greece, the Italian peninsula, and the rest of the Mediterranean. It is probable, however, that the technique was perfected in the Punic world by way of cultural and commercial contacts between these areas. In the same way, it is likely that *opus quadratum* spread in the west of North Africa because of the intervention of Carthage, as is clearer for the succeeding period.

The Hellenistic period and the Berber kingdoms

In order to explain how the diverse traditions intersected in North Africa, and how this contributed to local construction techniques, it is important to understand who the builders were. That means reconstructing their geographic and social origins and their technical culture; in other words, the totality of the technical knowledge inherited and transmitted from one generation to another. According to Leroi-Gourhan, this knowledge forms the technical environment, which can remain unchanged for a long time or undergo modification following contact with more evolved environments.[11]

However, as I have already shown, the available material evidence is distributed over a broad area and has chronological discontinuities. Only for the Hellenistic period can we understand better the variations in the types of *opus quadratum* and observe its use in individual categories of monuments. For the Punic area, these aspects are best analysed in the town walls of the Iberian peninsula (fourth to third centuries BC) where *opus quadratum* is both isodomic and pseudo-isodomic.[12] This latter is characterized by the use of blocks of different dimensions and coursing of unequal height. The horizontal beds of the blocks are however corrected, using stepped cuttings. Similar examples are found in the Maghreb, such as those at Lixus and Tamuda in Morocco.

Various buildings at Lixus were built in pseudo-isodomic masonry; in particular, a rectangular structure of the second half of the second century BC[13] (Figure 5.2) was integrated into the wall circuit of the early Imperial period (the so-called 'sector of the big blocks'). Its original function is uncertain and it may have been a defensive bastion in the walls of the Moorish period or the basement of a building which no longer survives.

At Tamuda, on the other hand, there is a town plan of an irregular orthogonal grid (Figure 5.3). In the foundation phase of the city (first half of the second century BC), pseudo-isodomic *opus quadratum* was used in civil constructions, perhaps residential or commercial.[14]

Figure 5.2. *Fortifications of Lixus: western side of the 'sector of the big blocks', orthorectification (image: C. Mascione).*

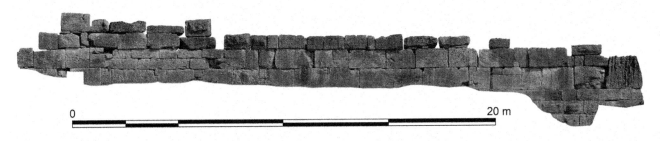

0 20 m

[11] Leroi-Gourhan 1994, 230-270.

[12] Bendala and Blánquez 2002-2003; Prados Martínez 2007, 20-21.

[13] Tarradell 1960, 162.

[14] No public buildings have in fact been found. The dating derives from the excavations by Tarradell (1956, 73, figure 1) and has been confirmed by more recent investigations (Sáez Romero *et al.* 2013, 209-213).

The creation of this small centre in western Mauretania should probably be related to what was happening in the kingdom of Numidia in the same period. As will be shown, due to the growing Carthaginian and Roman hegemonies, even the Numidian kingdoms underwent a transformation of statehood that accompanied the success of the local elites and the formation of larger and more structured urban centres.

Tamuda was destroyed and abandoned following the disorder which broke out with the annexation of Mauretania (AD 40)[15] but, as a result, this the site offers the possibility of observing a Berber city which had adopted models and techniques inspired by the Hellenistic world.[16] In the territories of the Numidian kings, however, the tombs of the Kings and local rulers, which are classified as Numidian royal architecture, are better known. This class of monument comprises monumental tumuli, tower tombs, and sanctuaries constructed during the second century BC in the immediate periphery of urban centres or in prominent, isolated positions in the countryside. In a recent paper, Quinn has reconsidered the significance of these monuments in their historical and cultural context.[17] Diverse cultural traditions (Hellenistic, Oriental, Punic, North African) are intertwined in the development of architectural models and their decoration mixed into an eclectic language, typical of the

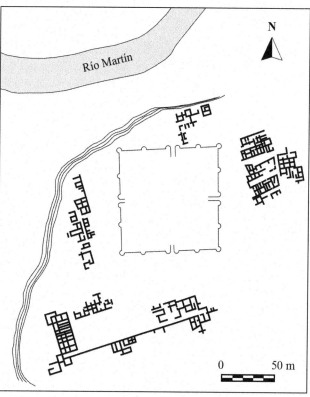

Figure 5.3. *Plan of Tamuda: Hellenistic-period settlement (c. second century BC) and Roman fort (c. second century AD) (after Euzennat 1965, figure 2).*

Hellenistic period. Elements such as the cavetto cornice, Aeolian, Ionic or Doric columns, and archaizing sculpture are put together in different ways. It was a language rich in external references to different symbols of power derived from numerous sources, such as Pharaonic and Ptolemaic Egypt, the Levant, and Greece. The development of this language, together with an impressive monumental typology, had the scope to legitimize the power of the monarchy and the elites who were asserting themselves in that period. Numidian royal architecture is also interesting for its building techniques, including isodomic or pseudo-isodomic *opus quadratum* at a more advanced technical level than the examples analysed earlier. Evidently these techniques were also used symbolically because they helped to convey the message built into the construction.

I will now turn to the tower tomb at Thugga, to understand the organization of its construction site, as well as the identity of its builders and their level of expertise. Using this example I can also try to understand how Hellenistic techniques spread through the territory of Carthage and the Berber kingdoms.

The mausoleum of Thugga bore a bilingual inscription in Libyan and Punic,[18] which was removed from the monument in 1842 and transferred to the British Museum. This is one of the rare monumental inscriptions of this period and many scholars have worked on its interpretation. The generally accepted translation was performed by Ferron, who also hypothesized about the inscription's original location on the monument.[19] Within the text are the names of the workmen used in the construction: a team of 11 men under the direction of an architect or contractor, whose name, Atban, appears in the first line. The names of two stonecutters (line 2) are followed by that of Mengi (line 3) who brings with him three workmen, who are not given any professional title and were probably his slaves (line 6). Finally there are two carpenters and two smiths (line 7). There is no unanimously agreed interpretation and according to some Atban is the patron, and therefore a local prince, while according to Ferron the patron would have been named in another inscription that is now lost. Whatever the correct interpretation, the tomb inscription throws light on the organization of the construction as the list of names seems to

[15] Only in the second century AD did the Romans found a military fort, obliterating part of the Mauretanian town.
[16] Euzennat 1965, 264.
[17] Quinn 2013.
[18] *RIL* 1.
[19] Ferron 1969–1970.

follow a hierarchy: in first place Atban, probably the architect; then two stonecutters and in third place Mengi, who brings three labourers to the site. Thus there are three free specialists and three non-specialized workers. Then there are two carpenters responsible for works such as scaffolding and lifting machinery, and the two smiths, who make the metal clamps and repair the tools.

The role of Mengi could be further explained, in that he seems to have procured a general workforce and co-ordinated their work. He thus seems to have taken the role of a foreman who ran the construction works. These hypotheses could be confirmed from observing the building technique: a pseudo-isodomic *opus quadratum* in which the elements were cut to predetermined measurements and therefore planned in advance of the construction. This implies that the work of the two stonecutters took place on the ground, so that Mengi would have been responsible for the construction true and proper, helped by the less-skilled workmen. The building technique shares all the characteristics of Hellenistic architecture widespread in the Mediterranean in the same period. The pseudo-isodomic masonry is characterized by alternate courses of thicker and thinner blocks. The thicker courses are formed by two vertical slabs worked only on the outer face, and with a fill of rubble bound together by earth and stone chips; the internal face is sometimes built in small blocks. The thin slabs, passing from one side of the wall to the other, act to stabilize the courses, just as the metal swallow-tail clamps tie the stone blocks together. This type of technique could also have been chosen to save cost by limiting the use of larger blocks to specific parts of the monument such as the roofing of the inner chambers.[20] The example of the mausoleum of Thugga shows the importance that the organization of the construction had, to such an extent that it merited description in a monumental inscription. The authority of the patron is made evident through the structure itself but also by demonstrating his economic capability and social prestige through his deployment of human and material resources to create such a monumental funerary structure.

Finally, the names of Atban's team are Numidian and, in the absence of new research on *opus quadratum* in the Berber and Carthaginian territories, we can only speculate how these craftsmen learnt the specialized techniques.[21] The local rulers, in the climate of competition which characterized the period, chose the building types together with the techniques most suitable for their construction, as well as the most symbolic. Otherwise the craftsmen were able to acquire the necessary technical competence in two ways: either following a long period of development which took place locally – which we are not yet able to follow in all its phases – or due to contact with groups of more specialized craftsmen, perhaps Punic. The intervention of Punic craftsmen has for example been suggested for the construction of the Medracen, one of the largest monumental tumuli in Numidia.[22] A more detailed analysis of the working techniques of the stone, as well as of the marks left by the tools used by the artisans, would help our understanding of the diffusion of this technology in this period. *Opus quadratum* seems to have been used in the Punic areas from the fifth century BC, as it is shown by the city walls of Carthage, and only with the Hellenistic era did it spread into the Berber kingdoms, where it was adopted for monumental and the most symbolic buildings, as in the case of Numidian royal architecture.

OPUS AFRICANUM

Origins, typology and chronology in North Africa

Research into the origins of *opus africanum* has occupied a significant part of previous studies of the technique, to an even greater extent than is the case for *opus quadratum*. According to the most recent hypotheses this was a Phoenician technique, later spread through the Mediterranean by western colonies.[23] Adopted in the Punic world, it spread in North Africa but also in Spain, Southern France, Sicily, Campania, Sardinia, and among the Etruscans.[24]

[20] The internal structure of the mausoleum is described by Poinssot and Salomonson (1959). The technique was observed in the photographs taken before the restoration, and now held in the Bibliothèque Nationale de France, in Paris.
[21] Rakob 1983, 334-335.
[22] Rakob 1983, 330.
[23] Fantar 1984, 335-344.
[24] Di Luca and Cristilli 2011.

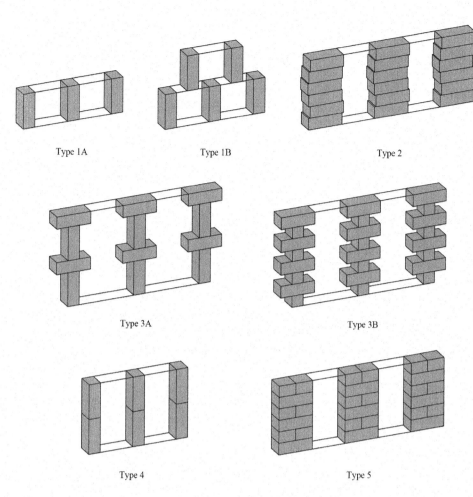

Figure 5.4. *Typology of* opus africanum *(after Camporeale 2014, figure 3).*

Type 1A Type 1B Type 2

Type 3A Type 3B

Type 4 Type 5

Through my new typological analysis of *opus africanum*, I have been able to demonstrate that, in reality, this term covers different techniques, with their own chronologies and areas of diffusion.[25] The types, outlined below and in Figure 5.4, have been distinguished on the basis of the constructional and structural characteristics of the piers, while the intermediate stretches of the walls have not been taken into consideration, given that they can vary widely in terms of both the material used (stone, mud brick, etc.) and the technique (squared blocks, reticulate, irregular rubble, etc.). The piers are always made of large blocks of the same thickness as that of the wall.

Type 1: individual blocks. In the simplest type, with two variants, the framework comprises individual isolated blocks, vertical or horizontal, usually placed at irregular intervals. Type 1A is used for the sockle of walls where the elevation is made in another technique. Type 1B is peculiar to the Etruscan world and comprises walls made in superimposed lifts, each of which has a framework of blocks of Type 1A.

Type 2: piers with superimposed stretchers. In this case the blocks often do not have homogeneous dimensions and they are not always aligned vertically.

Type 3: piers of superimposed headers and stretchers. The piers are keyed into the rest of the wall and are not structurally independent. This type has two variants. Type 3A has alternating stretchers and vertical blocks, while Type 3B has alternating stretchers and headers.

Type 4: piers of superimposed vertical blocks. The blocks form structurally independent piers and are squared to make the surfaces in contact horizontal, while the side faces are vertically aligned. This type requires accurate working of the individual blocks which implies a greater level of specialization in the workmen compared with the preceding types.

Type 5: piers of coursed blocks. The piers are formed from squared or even irregular blocks laid in courses which may or may not be keyed into the wall.

[25] Camporeale 2014, with earlier bibliography.

The earliest evidence for the use of *opus africanum* in North Africa seems to be in a residential quarter of Carthage (Type 1A) in the mid-seventh century BC, when some structures built in the preceding phase (eighth century BC) in earth, were enlarged.[26] The blocks are arranged vertically, very close together, and at irregular intervals; the infill is of mud brick or stone rubble. The technique is therefore an innovation compared to the first phase of construction and is used to reinforce the walls which would perhaps have supported the weight of an upper floor. Type 1A continues to be widespread in later periods. In fact, beyond being very simple to construct, it represents one of the most common methods of using elements of different dimensions in construction. For this reason it is often used with second-hand materials, as in the case of the reconstruction of Carthage in the Julio-Claudian period:[27] in the maritime quarter, the Punic buildings were progressively demolished as the new city blocks were being built alongside their predecessors. Type 2 also seems adapted to the reuse of mixed materials, but few examples are yet known. Types 3 and 4, however, require a more sophisticated level of stone working and are only found from the second century BC onwards in the territories of Carthage and Numidia. Type 4 is known in the Punic world, for example in the houses on the slopes of the Byrsa attributed to the phase preceding the destruction of Carthage in 146 BC.[28] In the Imperial period, Type 4 spread widely in North Africa becoming the form most commonly used, including whole settlements such as Thamugadi, Tiddis and Cuicul. On the contrary, Type 3 seems to be restricted to particular areas and categories of buildings. The oldest examples of Type 3 *opus africanum* are those at Bulla Regia in the Numidian period. Under the Baths of Julia Memmia, a building of the second half of the second century BC has been identified, with foundations in pseudo-isodomic *opus quadratum* reinforced by piers of Type 3A. The facing stones are squared on the outer face but trapezoidal behind; the core is of clay and the piers act as ties between the external faces.[29] At Bulla Regia there is another example of *opus quadratum* with piers of Type 3A in a terrace wall built in the second century BC and extended in the first century AD.[30]

At Thugga, however, Type 3A is found in the Imperial period.[31] The *Capitolium* (AD 166-167), the example par excellence of the technique in the African region, has the façade in *opus quadratum* while the rest consists of piers of Type 3A inserted in walls of small blocks. In this case, the *opus africanum* appears to be a more economical but structurally equally effective alternative for more monumental structures.

In other examples the piers are inserted into reticulate walling: at Bulla Regia in a building perhaps of the first century AD (Type 3A);[32] at Thignica, in the Temple of Dis and Saturn, first century AD (probably Type 2);[33] and in a rural structure near Thugga (Type 3A).[34] Given the irregularity of the reticulate, this is attributed to a local workforce who mixed an Italian tradition with one that is more properly African – a merging of different techniques which will be discussed in the conclusion. Lastly, the piers of Type 3A continued to be used into Late Antiquity and during the early Islamic period.[35]

With regard to the origins of the technique, as for *opus quadratum*, analysis of the oldest examples does not seem to confirm the hypothesis of a Phoenician origin. On the other hand *opus africanum* was certainly widely used in the Punic world, even if this does not signify that all the examples distributed around the Mediterranean should be attributed to Carthaginian or indeed Phoenician workmen. Memory of a technologically more advanced past does not seem sufficient to explain the spread of the technique in different areas. Above all, the simpler versions (such as the piers of Type 1A) could represent local spontaneous innovations. Indeed, *opus africanum* does not seem to derive from a cultural model, but has a structural and construction-based origin,

[26] Niemeyer *et al.* 2007, 188-195, plates 12-15.
[27] Holst *et al.* 1991, 111-115, plates 32f, 33f, 34a, 34e, 35g; Rakob 1982.
[28] Lancel 1992, 172-192.
[29] Broise and Thébert 1993, 204-205, 209-216.
[30] Hanoune 1990.
[31] Stutz 2002.
[32] Beschaouch *et al.* 1977, 18-21.
[33] Ben Hassen 2006.
[34] De Vos 2008, 281.
[35] Hanoune 2009.

similar to that of a simple hut supported by a frame of wooden posts — a fundamental principle common to the technical repertoire of any good builder.

The structural function of the piers helps therefore to clarify the difference between the types of *opus africanum*, but also leads to a better understanding of their diffusion. As has been specified in the description of the typology of this technique, the earliest type is used in the sockles of the walls and is not characterized by true piers, but rather by individual blocks which act to contain parts of the wall which are structurally less resistant. In most cases the sections between a pair of blocks are actually made with rough stones and earth (or no) mortar. This type of technique creates lateral thrusts which are countered by the blocks.

In the more complex types, however, the piers, of superimposed blocks, occupy the full height of the wall and their structural role is radically different, as is the construction process. The introduction and development of these types in North Africa can be explained in a way which blurs the 'African' origin and points to more complex cultural contacts with the rest of the Mediterranean. The first examples of Type 3A are actually found in Campania and Sicily. At Pompeii this type was used in the construction of aristocratic atrium houses in the third century BC.[36] In Sicily the same type is even earlier and is found in the Greek sector of the island between the fifth and third centuries BC.[37] On the basis of these examples, it would appear that the spread of Type 3 occurred in the Hellenistic period along a north-south axis which linked Campania, Sicily and North Africa. The importance of this axis for the exchange of goods, architectural styles and decorative techniques in this period has already been underlined by Fentress,[38] and this hypothesis might also explain the spread of Type 3A *opus africanum* and its adoption in North Africa. In the Maghreb, however, the early examples are few and it is not possible to understand their context fully, though the technique seems to have been first adopted in Numidian territory. This shows its active role in adopting and elaborating the technologies then circulating in the Mediterranean.

We should also remember the structural principle that underlies *opus africanum*, which I have described to justify the inclusion of the earliest examples of piers of Type 1. Even in the case of the types that we find from the Hellenistic period, the structural principle remains simple and its development in different contexts could depend on spontaneous local innovations. This might be the case with Type 4, evidenced at Carthage in the second century BC, but which is also found in the Iberian peninsula, both in the zone already under Punic domination, such as Seville (first century BC),[39] and in the more northerly areas such as at Clunia and Uxama (Imperial period).[40] A more detailed study of the spread of this technique in the Iberian peninsula might better explain its presence in different contexts and the cultural contacts which may have determined its transmission.

In the Roman period, *opus africanum* Types 3 and 4 spread throughout North Africa, becoming characteristic of local craftsmen, for reasons which I will try to explain in the concluding paragraphs. First though it is useful to understand the function of the piers better, by observing their use in ancient Morocco and by analysing in more detail the example of the *Capitolium* of Sala.

Opus africanum in Roman Morocco and the *Capitolium* of Sala

Walls with piers were not used in Morocco before the Roman period, but during it they are found in all the major urban centres: Thamusida, Banasa, Sala, Volubilis and Zilil.[41] At Volubilis, all types were used in different categories of buildings. There are numerous examples and in many cases different types were used in different phases of the same building. The site, however, was excavated from the start of the twentieth century and the chronology of many buildings is uncertain. Nevertheless, it seems that Types 2, 3, and 4 were initially used. Type 1 is only widespread in reconstruction phases of buildings, particularly domestic and commercial structures, and was used apparently when a large amount of second-hand material was available.

Among the earliest types used at Volubilis, the piers of Type 2 seem particularly common in walls built with or without mortar. The public buildings of Mauretania Tingitana have a

[36] Peterse 1999; see also Camporeale 2014.

[37] Karlsson 1992.

[38] Fentress 2013.

[39] Tabales Rodríguez 2010.

[40] Pers. comm. by Antonio Pizzo (CSIC, Mérida).

[41] Camporeale 2008, 145-146.

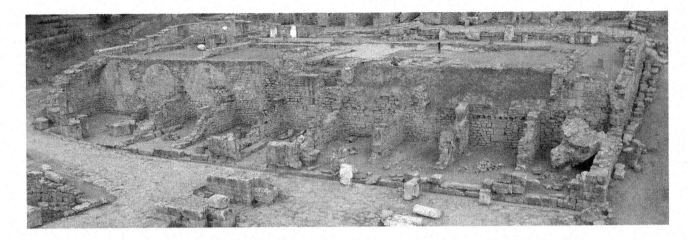

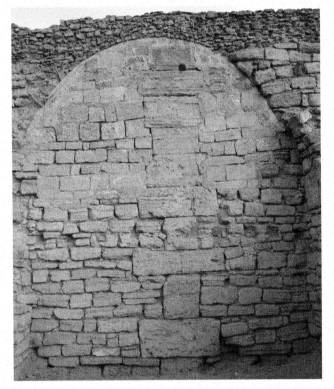

peculiar variant, namely Type 3B piers. The first examples are all dated between the first and the beginning of the second century AD: the *Capitolium* at Sala (Trajanic/Hadrianic); the precinct wall of the forum and the basilica at Banasa (end of the first to the beginning of the second century AD);[42] and the temple at Zilil (first century AD).[43] Later it was also used in the *Capitolium* of Volubilis, built under Macrinus (AD 217).[44]

The *Capitolium* of Sala (Figure 5.5) was paid for by C. Hosidius Severus, a soldier originally from Sala.[45] For this project the builders developed *ad hoc* techniques. Walls of small blocks of stone – used previously at Sala but in a less systematic way – were reinforced by piers, something previously unknown locally (Figure 5.6). We might imagine that because of his position Hosidius Severus hired military builders who brought *opus africanum*, already used in other parts of North Africa, to Tingitana for the first time. Alternatively, if the examples of Banasa and Zilil were earlier, the technique would have already been used in the province, but even in this case the intervention of the army would explain its importance in this territory.

At Banasa the piers were spaced irregularly, while at Zilil and Sala they were laid out with greater accuracy. At Zilil there are three separate temples, two with rectangular plans of the same dimensions. The piers are set in the centre of the short sides and every 10 feet on the long sides (Figure 5.7). The plan and the arrangement of the piers are different in the southern temple. However, looking at the three temples it seems that the piers also served as reference points during construction, perhaps because the project was planned to embrace the simultaneous construction of the three buildings. The fill of the walls is of unworked pebbles from the Atlantic shore, not far away. The use of piers therefore allowed for a solid structure while using more economical material in the fill.

A more sophisticated system of construction was used in the *Capitolium* of Sala. The structure is arranged on two terraces with a five metre difference in height. On the lower level, at the same level as the forum, are nine *tabernae* covered by barrel vaults, which also support the south side of the upper terrace. On this is the temple, positioned at the centre of a piazza flanked by porticoes on three sides,[46] of which only the foundations of the northern and eastern ones are preserved (Figure 5.8).

Figure 5.5. (above) *Capitolium of Sala:* tabernae *on lower south side (photo: S. Camporeale).*

Figure 5.6. (below) *Capitolium of Sala: building technique in one of the* tabernae *on the lower level (photo: S. Camporeale).*

[42] Brouquier-Reddé *et al.* 2004, 1891-1897.

[43] Lenoir 2005.

[44] The remains of the piers are visible in the back wall of the temple below modern restorations.

[45] Boube 1990.

[46] An overview of the architectural decoration of the *Capitolium* is presented in this volume by Mugnai.

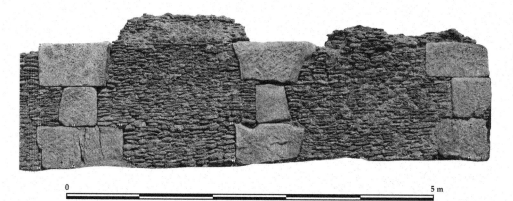

0 5 m

Figure 5.7. *Temple of Zilil:* opus africanum *wall, orthorectification (image: C. Mascione).*

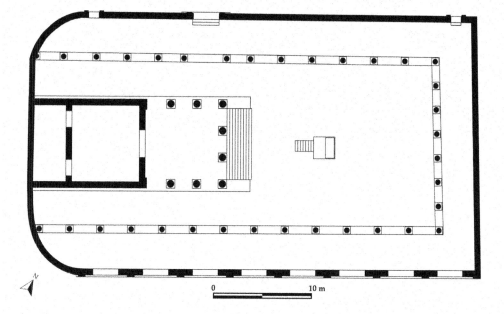

0 10 m

Figure 5.8. Capitolium *of Sala: one of the hypothetical reconstructions of the plan (image: S. Camporeale).*

The positions of the piers were accurately planned in order to serve diverse functions: as reinforcement of the walls (Figure 5.5); as links between perpendicular walls (Figure 5.9a); and as points where the weight of the south colonnade discharged on the vaults of the *tabernae* (Figure 5.9b). In order to construct the vaults three stone voussoir arches were first erected and then the rest was added in mortared rubble. The arches at the centre of the vaults corresponded to a pier of *opus africanum* positioned at the centre of the walls dividing the *tabernae*. The south portico of the upper terrace ran along the line of the central arches, so that its weight was discharged onto the piers of *opus africanum* (Figure 5.10).

Figure 5.9. Capitolium *of Sala: position and function of the piers. A: links between perpendicular walls; B: points where the weight of the south colonnade discharged on the vaults of the* tabernae *(photos: S. Camporeale).*

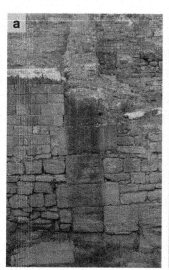
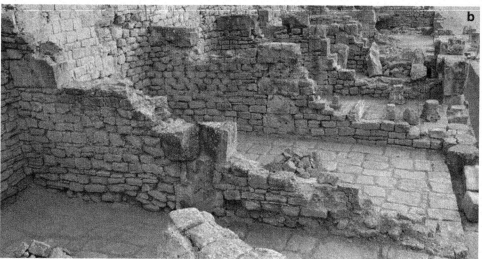

Figure 5.10. Capitolium *of
Sala: 3D reconstruction of the
southern side of the complex
(image: R. Pansini).*

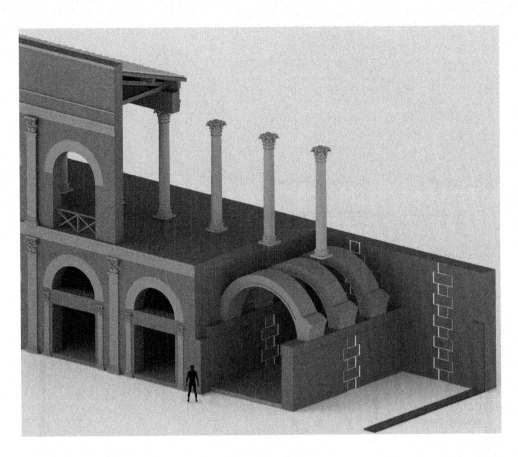

The use of *opus quadratum* was limited to the southern monumental façade, which would have had two levels: at ground level, the entrance to the *tabernae*, and at the first floor probably a series of openings which looked out onto the forum from the south portico. As in the case of the *Capitolium* of Thugga, *opus africanum* at Sala was used not only for structural reasons, but also to save money compared to the more expensive technique limited to the more visible part of the monument.

Mauretania Tingitana is the most westerly province of North Africa where walls with piers seem to be unknown before the period of Roman domination. The arrival of *opus africanum* in this area, however, seems to depend on the new possibilities offered by this technique and by its particular structural and constructional characteristics, which become clear from its use in monumental structures. But the documentation of *opus africanum* in five different urban centres has also shown how the builders adapted it to the local context and the available materials. At Sala and Banasa there is only a type of sandstone and the technique has very similar characteristics: piers of Type 3B are inserted in walls of roughly squared small blocks. At Zilil, a local limestone is used for the blocks of the piers, which act to contain a wall made of small un-worked sandstone pebbles. At Volubilis, the picture is more complex because there is a greater variety of material. For the most part an oolitic limestone, very compact and heavy, was used for the piers, while irregular stones of a lighter limestone were used for the rest of the wall. But, when second-hand blocks were available and Type 1 piers were mainly employed, the material was used in a different way in each case.

OPUS QUADRATUM AND *OPUS AFRICANUM* IN ROMAN-PERIOD NORTH AFRICA

The mausoleum at Thugga and the *Capitolium* of Sala have served as the main case studies to reconstruct the contexts of *opus quadratum* and *opus africanum* and their processes of construction. These examples have also shown the local adaptations of building techniques and the crucial role of the workforce in their transmission. At Thugga, the monumental inscription reveals the composition of the building team, while at Sala direct analysis of the monument has shown the technical system adopted here to respond to the specific needs of the building project.

The observation of the monuments and of the building techniques over the course of time shows how the different construction traditions intersect in the region of the Maghreb. As far as *opus africanum* is concerned, the more complex types, made with piers of superimposed blocks, appear in the second century BC both at Bulla Regia in Numidia and at Carthage. In this case the indigenous culture does not appear as a passive recipient of more advanced technologies, but as an active participant in the formation of a building tradition which, from then on, characterized the architecture of North Africa.

The interweaving of different traditions emerges even more clearly from the early Imperial period, and is exemplified by the use of the two techniques analysed in this study. In fact, in time the North African craftsmen worked out how to use *opus quadratum* and *opus africanum* as alternatives or in combination with each other.

The factors which seem to have determined the fortune of *opus africanum* are displayed by the construction scheme of the *Capitolium* of Sala: the possibility of using the available material in different ways; its structural resistance; and its economy with respect to other techniques, in particular *opus quadratum*. *Opus africanum* thus shows itself to be a very flexible technique, well-adapted for the use of second-hand material. The use of *opus quadratum* is on the other hand justified above all by its symbolic value – and therefore by the cultural references it implies – which goes with its higher costs and greater specialization of the workforce.

The picture outlined so far allows some further observations on the transformation of the construction traditions and techniques of North Africa produced by Roman domination. In particular, the diffusion of *opus africanum*, from the age of Augustus and above all during the first centuries of the Imperial period, shows how the workforce acquired competence with the combined use of materials of different size and quality, understanding their structural properties. The technique was already known, but in the Roman period it underwent further development for use in construction of different types, from innumerable farms spread through Libya and Mauretania, to the *domus* of the urban elite such as those of Thugga and Cuicul, and finally to the more monumental temples, such as the *Capitolia* of Thugga and Sala.

The innovation consisted of the combination of *opus africanum* with the new technologies imported by the Romans, particularly mortared rubble, which gave the technique even greater strength and adaptability. Other examples of the hybrid technology which characterizes this period are those already mentioned in which *opus africanum* acted as the framework for reticulate, and which recalls Roman *opus mixtum* with its piers of brick and panels of reticulate. This similarity, however, does not presuppose that the African examples must derive from the Italian ones or vice versa, but seems to demonstrate that a similar level of knowledge of structures and properties of materials was diffused through the Empire. Therefore, new solutions were also tried in the regions of North Africa: centre and periphery of the Empire engaged in dialogue with each other in an interconnected world where ideas did not go only from Rome towards the provinces. On the contrary, the more distant regions also played an active role in the elaboration of their own constructional – or more broadly cultural – traditions, defined through a complex system of relationships with the local context, with neighbouring regions, with the Mediterranean and with Rome.

On the other hand, in the centre of the Empire, the variable static resistance of the materials and of the technique had long been recognized, as Vitruvius shows. He is the only ancient author who describes a technique – which we call *opus africanum* – used to construct buildings '*pilis lapideis, structuris testaceis, parietibus caementiciis*'.[47] The use of *pilae lapideae* inserted in walls of mortared rubble and brick is considered a way of giving greater strength to buildings and of allowing an increase in height.

Some of the more monumental buildings exemplify how, in the Roman period, in relation to an equivalent static resistance, the different strengths of the two techniques was clearly recognized. In the examples of the *Capitolia* of Thugga and Sala, as we have seen, *opus quadratum* was used in the façade while the rest of the structure was finished in *opus africanum*. These buildings therefore best represent the local characteristics of Roman architecture that I have sought to outline. Through this it also becomes clear how the rational organization of the construction process, the economic criteria of the construction and the symbolic value of the building are crucial factors for understanding the spread of constructional traditions and techniques.

[47] Vitruvius, *De Architectura*, II.8.17.

BIBLIOGRAPHY

Bendala, M. and Blánquez, J. 2002-2003. Arquitectura militar púnico-helenística en Hispania, *Cuadernos de Prehistoria y Arqueología*, 28-29: 145-158.

Ben Hassen, H. 2006. *Thignica (Aïn Tounga). Son histoire et ses monuments*, Ortacesus: Nuove grafiche Puddu.

Beschaouch, A., Hanoune, R. and Thébert, Y. 1977. *Les ruines de Bulla Regia* (Collection de l'École Française de Rome, 28), Rome: École Française de Rome.

Boube, J. 1990. La dédicace du capitole de Sala (Maroc) et la base honorifique de C. Hosidius Severus, *Mélanges de l'École Française de Rome. Antiquité*, 102: 213-246.

Broise, H. and Thébert, Y. 1993. *Recherches archéologiques franco-tunisiennes à Bulla Regia, II. Les architectures, 1. Les thermes memmiens : Étude architecturale et histoire urbaine* (Collection de l'École Française de Rome, 28.2), Rome: École Française de Rome.

Brouquier-Reddé, V., El Khayari, A. and Ichkhakh, A. 2004. Le temple du forum de Banasa : nouvelles données archéologiques. In Khanoussi, M., Ruggeri, P. and Vismara, C. (eds), *L'Africa Romana. Ai confini dell'Impero: contatti, scambi, conflitti. Atti del XV convegno di studio (Tozeur, 11-15 dicembre 2002)*, Rome: Carocci, 1885-1898.

Camporeale, S. 2008. Materiali e tecniche delle costruzioni. In Akerraz, A. and Papi, E. (eds), *Sidi Ali ben Ahmed – Thamusida, 1. I contesti*, Rome: Quasar, 62-178.

Camporeale, S. 2014. Opus Africanum e tecniche a telaio litico in Etruria e Campania (VI a.C.-VI d.C.), *Archeologia dell'Architettura*, 18: 194-211.

Camps, G. 1989. s.v. Ateban. In Camps, G. (ed.), *Encyclopédie berbère*, 7, Aix-en-Provence: Édisud, 1008-1011.

Cintas, P. 1950. Nouvelles recherches à Utique, *Karthago*, 5: 89-154.

De Vos, M. 2008. Caratteristiche della costruzione degli impianti produttivi rurali nell'Africa Proconsularis. In Camporeale, S., Dessales, H. and Pizzo, A. (eds), *Arqueología de la construcción, 1. Los procesos constructivos en el mundo romano: Italia y provincias occidentales, Mérida 2007*, Mérida: CSIC, 269-284.

Di Luca, G. and Cristilli, A. 2011. Origine ed evoluzione dell'opera a telaio: le attestazioni campane. In Coralini, A. (ed.), *DHER. Domus Herculanensis rationes. Sito, archivio, museo*, Bologna: Ante Quem, 455-478.

Euzennat, M. 1965. Héritage punique et influences gréco-romaines au Maroc à la veille de la conquête romaine. In *Le rayonnement des civilisations grecque et romaine sur les cultures périphériques. Huitième congrès international d'archéologie classique, Paris 1963*, Paris: De Boccard, 261-278.

Fantar, M. 1984. *Kerkouane : Cité punique du Cap Bon (Tunisie), Volume 1*, Tunis: Institut National d'Archéologie et d'Art.

Fentress, E. 2013. Strangers in the city: elite communication in the Hellenistic central Mediterranean. In Quinn, J.C. and Prag, J.R.W. (eds), *The Hellenistic West. Rethinking the Ancient Mediterranean*, Cambridge: Cambridge University Press, 157-178.

Ferron, J. 1969-1970. L'inscription du mausolée de Dougga, *Africa*, 3-4: 83-110.

Hanoune, R. 1990. Opus africanum à Bulla Regia (Tunisie). In Mastino, A. (ed.), *L'Africa romana, Atti del VII Convegno di studio (Sassari, 15-17 dicembre 1989)*, Sassari: Gallizzi, 409-414.

Hanoune, R. 2009. La construction romaine en « opus africanum » et ses renaissances : innovation technique ? Continuité accidentelle ?. In Gaborit, J.R. (ed.), *Tradition et innovation en histoire de l'art. Actes du 131ᵉ Congrès national des sociétés savantes historiques et scientifiques (Grenoble, 2006)*, Paris: CTHS, 29-39.

Holst, J., Kraus, T., Mackensen, M., Rakob, F., Rheidt, K., Stanzl, G., Teschauer, O., Vegas, M., Wiblé, F. and Wolff, A. 1991. *Die deutsche Ausgrabungen in Karthago*, Mainz: Philipp von Zabern.

Jodin, A. 1960. Le tombeau de Moghoga Es Srira (Tanger), *Bulletin d'Archéologie Marocaine*, 4: 27-46.

Kallala, N. and Sanmartí, J. (eds) 2011. *Althiburos, I. La fouille dans l'aire du capitole et la nécropole méridionale* (Documenta, 18), Tarragona: Institut Català d'Arqueologia Clàssica.

Karlsson, L. 1992. *Fortification Towers and Masonry Techniques in the Hegemony of Syracuse, 405-211 B.C.*, Stockholm: P. Aströms.

Lancel, S. 1992. *Carthage*, Paris: Fayard.

Lenoir, E. 2005. La ville romaine de Zilil du Iᵉʳ siècle av. J.-C. au Iᵛᵉ siècle ap. J.-C., *Pallas*, 68: 65-76.

Leroi-Gourhan, A. 1994. *Evoluzione e tecniche, 2. Ambiente e tecniche*, Milano: Jaca Book.

Niemeyer, H.G., Docter, R.F., Schmidt, K. and Bechtold B. 2007. *Karthago. Die Ergebnisse der Hamburger Grabung unter dem Decumanus Maximus*, Mainz: Philipp von Zabern.

Peterse, K. 1999. *Steinfachwerk in Pompeji. Bautechnik und Architektur*, Amsterdam: J.C. Gieben.

Poinssot, C. and Salomonson, J.W. 1959. Le mausolée lybico-punique de Dougga et les papiers du comte Borgia, *Comptes Rendus de Séances de l'Académie des Inscriptions et Belles-Lettres*: 141-149.

Prados Martínez, F. 2007. La edilicia púnica y su reflejo en la arquitectura ibérica: materiales, aparejos y técnicas constructivas, *Pallas*, 75: 9-35.

Quinn, J.C. 2013. Monumental power: 'Numidian royal architecture' in context. In Quinn, J.C. and Prag, J.R.W. (eds), *The Hellenistic West. Rethinking the Ancient Mediterranean*, Cambridge: Cambridge University Press, 179-215.

Rakob, F. 1982. Römische Architektur in Nordafrika. Bautechnik und Bautradition. In *150-Jahr-Feier Deutsches Archäologisches Institut Rom. Ansprachen und Vorträge (4.-7. Dezember 1979)* (Mitteilungen des Deutschen Archäologischen Instituts. Römische Abteilung Supplement, 25), Mainz: Philipp von Zabern, 107-115.

Rakob, F. 1983. Architecture royale numide. In *Architecture et société de l'archaïsme grec à la fin de la République romaine. Actes du Colloque international organisé par le Centre National de la Recherche Scientifique et l'École française de Rome, Rome 2-4 décembre 1980* (Collection de l'École Française de Rome, 66), Rome: École Française de Rome, 325-348.

Sáez Romero, A.M., Bernal Casasola, D., Raissouni, B. and Lara Medina, M. 2013. El Sondeo 7 y la cronología de la ciudad mauritana: estratigrafía en la «Casa de la pilastra» del barrio septentrional. In Bernal Casasola, D., Raissouni, B., Verdugo, J. and Zouak, M. (eds), *Tamuda. Cronosecuencia de la ciudad mauritana y del castellum romano. Resultados arqueológicos del Plan de Investigación del PET (2008-2010)*, Cádiz: Universidad de Cádiz, 139-233.

Sagona, C. (ed.) 2008. *Beyond the Homeland: Markers in Phoenician Chronology*, Leuven: Peeters.

Schubart, H. and Niemeyer, H.G. 1976. *Trayamar. Los hipogeos fenicios y el asentamiento en la desembocadura del río Algarrobo* (Excavaciones arqueológicas en España, 90), Madrid: Servicio de publicaciones del Ministerio de Educación y Ciencia.

Sharon, I. 1987. Phoenician and Greek ashlar construction techniques at Tel Dor, Israel, *Bulletin of the American Schools of Oriental Research*, 267: 21-42.

Stutz, R. 2002. Zur Städtebaulichen Entwicklung Thuggas. In Khanoussi, M. and Strocka, V.M. (eds), *Thugga, 1. Grundlagen und Berichte*, Mainz: Philipp von Zabern, 113-127.

Tabales Rodríguez, M.Á. 2010. La transformación del Alcázar de Sevilla y sus implicaciones urbanas, *Archeologia dell'architettura*, 15: 71-84.

Tarradell, M. 1956. Las excavaciones de Tamuda de 1949 a 1955, *Tamuda*, 4: 71-85.

Tarradell, M. 1960. *Marruecos púnico*, Tetuán: Cremades.

6

CONTINUITY AND CHANGE IN HELLENISTIC TOWN PLANNING IN FAYUM (EGYPT)
BETWEEN TRADITION AND INNOVATION

Gabriella Carpentiero

Abstract

Recent research involving the use of remote sensing techniques and geophysical prospection has enabled the reconstruction of the layout and urban organization of Dionysias, a Hellenistic city of Fayum founded in the third century BC. This has provided data allowing the investigation of how a traditional Greek urban plan was transformed and adapted during the Hellenistic, and later Roman, domination. Although the city was built following an orthogonal grid, various aspects of Dionysias' layout attest to the influence of Egyptian urban traditions – particularly visible in the main temple of the city. Built according to local principles and through the use of Egyptian length-units, this temple demonstrates that native traditions had an important role in the foundation of Graeco-Roman urban centres in Egypt.

The arrival of the Greeks in Egypt at the end of the fourth century BC signalled contact between two different cultural traditions. The archaeological record provides ample evidence to investigate the interaction between Greek and Egyptian cultures, and to understand the implications of this phenomenon during the Roman period. Through the analysis of artefacts, as well as epigraphic and papyrological evidence, it is possible to identify the various results of this process. The study of the architectural design of buildings and urban planning is a particularly effective tool for investigating this bicultural interaction, allowing us to explore the evidence of continuing traditions and/or innovation.

A recent programme of remote sensing and geophysical analysis conducted at Dionysias – a Hellenistic city in Fayum (Figure 6.1) with phases of occupation from the third century BC to the fourth or fifth centuries AD – has provided a set of new data. This research has revealed the presence of an urban plan arranged according to an orthogonal grid, probably datable to the Hellenistic period. This layout, however, was adapted to local traditions, thus differing from the Hippodamian cities of mainland Greece and from the colonies in the western Mediterranean. Provincial cultures and transitional periods are often characterized by the interaction between indigenous and external cultural models. The outcome is the appearance of hybridized forms generated by the interaction of various cultural elements.[1] Dionysias represents an important example for the investigation of the manner in which the Greek urban design could be changed to fit a different cultural context.

[1] See the semiotic approach in Hammad 2006, 91-108.

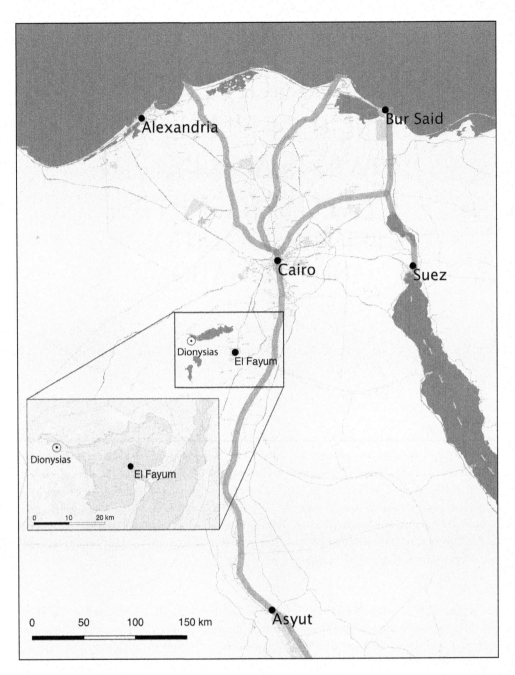

The aim of the project at Dionysias was to analyse the earliest phases of the city's urban plan and, in doing so, consider the following questions: Is it possible to understand whether aspects of both Egyptian and Greek urbanism were incorporated in the layout of this settlement? Or was Dionysias – like many Greek colonies across the Mediterranean – a town built strictly according to Greek urban traditions? And, finally, how did Roman architectural principles and design interact with this cross-cultural background?

PRELIMINARIES

The period spanning from the arrival of Alexander the Great to the Arab conquest of Egypt represents a long period of innovation both for the Egyptian culture and for the Classical (Greek and Roman) world. Egypt was an advanced provincial society under Roman rule – an excellent context for analysing the interaction between different cultures. This period is exceptionally well-documented thanks to the amount of written sources, allowing us to reconstruct some aspects of the local culture otherwise impossible to investigate in other areas. The research is further facilitated by the natural environment and climate of the region, which has guaranteed good preservation of archaeological artefacts and architectural remains, as well as thousands of

papyri. The study of more traditional epigraphic and papyrological sources (mostly written in Greek), however, has cast light only on certain aspects of the society, not sufficient to understand the complex cultural elements involved. The tradition of studies has so far approached this period of transition, and the penetration of external influences in Egypt, mostly from the standpoint of the Graeco-Roman cultures, while the importance of Egyptian traditions has been partially neglected.

Considering that the cultural components of a city do not always reflect its ethnic composition,[2] written evidence and archaeological data should be combined with the study of architecture and urbanism – a direct source of information that could change our perception of the city and its society. Through the shape of the urban layout and the architecture of the buildings, the local culture expressed its identity in a non-verbal way, demonstrating the different elements involved, their specific areas of manifestation, and their respective importance. Moreover, urbanism and architecture are the result of a political project, attesting to a precise ideological message within and outside the city.

URBANISM IN EGYPT

Ancient Egyptian town planning

The evolution of the characteristics of urban layout in ancient Egypt can only be roughly outlined, despite the interest that has been recently directed to the study of urbanism, even in the field of Egyptology. Our understanding of urbanism and domestic architecture during the pre-Classical and Classical era is still incomplete, in particular for the Old Kingdom and in part for the Middle and New Kingdom, while in contrast, we have a better picture of the Graeco-Roman period. This lack of information is partially due to the damage suffered by many archaeological sites between the late nineteenth and the early twentieth centuries, caused mainly by the activity of papyrus hunters, like the famous expedition of the Egypt Exploration Fund led by Grenfell, Hunt and Hogarth,[3] and by *sebakhin*, who destroyed ancient constructions in search of *sebakh* (ancient mud-bricks reused as a fertilizer). At present, archaeological sites are still endangered or threatened by modern soil exploitation and, more generally, by the current political instability in Egypt.

According to traditional studies there is a dichotomy between natural or 'organically' developed cities and planned cities. Cities of the first type were developed and enlarged gradually without a planned urban design;[4] while those of the second type were organized following a precise design and/or a geometric urban grid. Regular-planned cities, with an orthogonal or pseudo-orthogonal plan, date back to the earliest phases of Egyptian history, at least from the Fourth Dynasty,[5] long before the introduction of the so-called Hippodamian urban scheme. In the second millennium BC, Sesostris II (c. 1895 BC) founded a large-scale example of a regular-grid village at Kahun, which served as a residential area for the workers involved in the construction of the temple – therefore planned and designed specifically as a 'workers' city'. Similar examples are Qasr el-Sagha, a recently excavated settlement on the northern shore of the Birket Qarun,[6] and Deir el-Medina, near el-Amarna (1506-1493 BC).[7] In the Pharaonic era, settlements or villages with a regular urban organization were founded in a relatively short time, according to a process of internal colonization of the country.[8] The function of this specific kind of urban planning was to create a settlement of a certain density and size as rapidly and economically as possible.[9] For this reason, the orthogonal layout and its symmetry did not have any aesthetic meaning, but simply a functional value.

[2] Hammad 2006, 91.

[3] Grenfell *et al.* 1900.

[4] Davoli 1994, 24.

[5] Fairman 1949, 31-51.

[6] Müller 2006, 106.

[7] Davoli 1994, 83.

[8] Müller 2006, 107.

[9] Kemp 1972, 661.

The Graeco-Roman city

New Hellenistic colonies in Egypt in the fourth and third centuries BC adopted an orthogonal layout taking Alexandria as a model. Even if only little is known about its original plan, the city founded by Alexander the Great was organized following a network of parallel streets with a regular grid system of blocks of 300 metres (277 x 310 m).[10] In this case the Greek architect exploited the local know-how in designing and building the city, as attested by the choice of the site itself and by the orientation of the streets that had to adapt to the local environmental and climatic conditions.[11]

During the Graeco-Roman period, the orthogonal urban layout became a characteristic of new foundations and of new constructions within pre-existing cities. New settlements reflected their 'Greekness' and, at the same time, had to take into consideration local architectural principles and building traditions. Newly-founded cities had different economic, social and climatic needs compared to the Greek cities (*poleis*) of the mainland.[12] On the other hand, these cities had to adapt to concepts of Greek politics and society, such as independence and self-governance – all characteristics that were not relevant in the Egyptian context. In its original form, the so-called Hippodamian urban scheme was interrelated with the political background of the city. However, such an innovation should not be identified with the orthogonality of the street networks, but rather with the modulation of symmetry and the arrangement of blocks, which shaped the urban space following the models of the society that inhabited it.[13]

The repetition of standard patterns and traditions in designing a new provincial settlement involved a standardized scheme and a functional organization of the space.[14] The orthogonal layout thus became an opportunity for space manipulation and for the creation of a complete 'built environment'. Therefore, the orthogonal layout can be described as a 'routinization of daily life',[15] a distinctive element of Greekness exported into Hellenistic provinces, as well as an element of self-representation of the central power.

The Graeco-Roman city in Fayum

In the third century BC, Fayum – ancient *Arsinoite nomos* – was the region of Ptolemaic Egypt most directly influenced by the Hellenic culture. It represents an ideal research ground for Graeco-Roman archaeology in the country, and is a particularly significant case study for analysing the influence of both Greek and Roman cultures within the local background.

Fayum lies about 100 km south-west of Cairo, and extends for about 18,000 sq. km. Located west of the Nile valley, it is fed by the Bahr Youssef, a tributary of the Nile, and the whole region was originally occupied by a lake (Figure 6.2). In the second millennium BC the lake was already regulated by a massive drainage and canal system constructed by Sesostris II (Twelfth Dynasty, c. 1800 BC). With the creation of a large artificial oasis, Fayum became the richest agricultural land of the country. Many centuries later Ptolemy II (283-246 BC) undertook a second extensive land reclamation in Egypt that substantially enlarged the surface of the arable land, thus creating new space for incoming Greek colonies. The extent of the lake was reduced to approximately its current size[16] and new cities were founded in the area formerly occupied by the lake. At the end of 259 BC, Ptolemy Philadelphus changed the name of the province from *Limne* ('lake district')[17] to *Arsinoite*, named after his second wife. In the dynast's mind, this was meant not only to symbolize his control over the Egyptian territories, but also to highlight the importance attributed to the region in the administrative and economic organization of his power.

Graeco-Roman settlements, new foundations, and pre-existing cities were established all over the region around the Moeris lake (now called Birket Qarun), in particular along the shore

[10] Müller 2010, 227.
[11] McKenzie 2007, 38.
[12] Giuliano 1966, 147.
[13] Fabiani 2014, 29.
[14] Müller 2006, 135.
[15] Müller 2010, 221.
[16] Clarysse and Thompson 2006, 342-345; Davoli 2010, 353.
[17] Calderini and Daris 1978, 202.

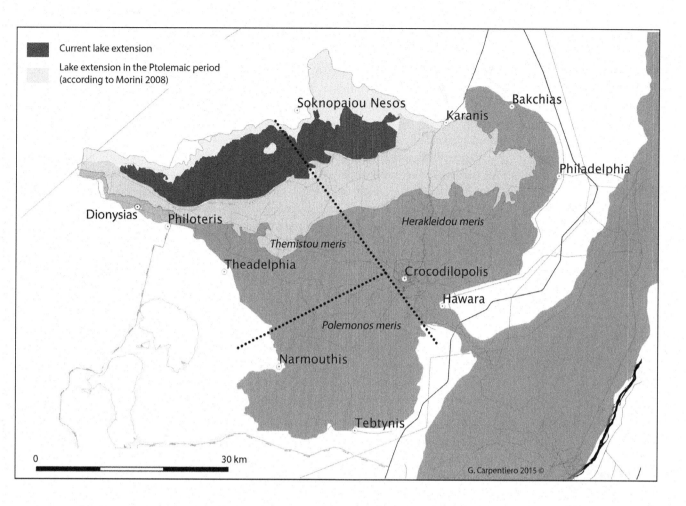

or close to the main canals,[18] as well as around a second smaller lake in the El-Gorak el-Sultan depression to the south-west.[19] According to papyrological sources, during the Ptolemaic period there were 134 villages in the region.[20] Other sources record more than 200 names of settlements, 40 of which are also known archaeologically.[21] Among these about 30 toponyms have a Greek origin and can be associated with the Ptolemaic dynasty (probably all cities or villages of new foundation). Other names are either Demotic or Egyptian written in Greek, or are local Egyptian variations of Greek names.[22]

Figure 6.2. *Main settlements in Fayum and extent of the lake in the Ptolemaic period (image: G. Carpentiero).*

Unfortunately, very little is known archaeologically about the 134 (or maybe 200) settlements in Fayum, and their urban and architectural layout has not yet been clearly identified. Recent excavations have focused mainly on religious areas, structures and/or public buildings (such as the typical Hellenistic baths), while the study of domestic architecture and its layout has often been neglected. In contrast, there are many other written sources available, in particular papyri, preserved by the favourable climatic conditions of this region and because many villages were built at the edge of cultivated lands, and thus were not endangered by floods, irrigation and the progressive development of later constructions.

It seems clear from the urban layout that there was a project of the Ptolemaic dynasty involving the creation of urbanized centres in the new land as expression of the central power. Even if a politically-driven creation of urban settlements is clear and attested by epigraphic and papyrological evidence, it is not confirmed by archaeological remains, except in the case of Philadelphia — the sole known example of this phenomenon so far.[23]

[18] Morini 2008, 115.

[19] Rathbone 2001, 1113.

[20] Clarysse 2007, 70-71. See also the Leuven Fayum Project 'Trismegistos': http://www.trismegistos.org/fayum/index.php.

[21] Davoli 2010, 354.

[22] Müller 2006, 27-30.

[23] Marouard 2012, 121-122.

URBAN TOWN PLANNING AT DIONYSIAS

Methodology of the new research: data integration and remote sensing

The settlement of Dionysias lies on the western end of Fayum, 3.5 km from the Birket Qarun, the salt lake located to the north of the region. It is located near the modern village of Qasr Qarun, named after the well-preserved Ptolemaic temple, believed to be connected to the Islamic legend of the Korah/Qarun castle.

Since 2009, as part of the *Dionysias Archaeological Project*,[24] different kinds of remote sensing techniques have been employed for the study of the urban complex, with a mixed approach involving both macro-scale and close-range analyses. The newly-acquired digital data were initially integrated with pre-existing maps, resulting in the creation of new topographic maps. The remote sensing survey was organized following three steps:

1. The elaboration of a Digital Terrain Model (DTM) of approximately 66 ha, through the use of a Differential GPS (DGPS), resulted in the recording of 72,000 points, with a 0.5/1 m step inside the urban area, and a 2 m step in the extra-urban area (*suburbium*).[25] This DTM was then integrated with the Global ASTER DEM of the whole Fayum region. The analysis of these preliminary data has revealed remarkable features, such as two pathways running from the southern corner of the city to the extra-urban district, some canal works, and the original extension of the areas destroyed by the *sebakhin*. The whole archaeological site covers an area of 50 ha (850 x 610 m) and calculations suggest that the urban area should have reached a total of approximately 33 ha (760 x 460 m), oriented north-west/south-east.

2. The acquisition and processing of a GeoEye-1 satellite image (MS and PAN) provided supplementary information, and allowed us to produce a detailed plan of the settlement.[26] This image was added to the Google Earth image already available on the web (accessed on 23 December 2002). Both images gave us the ability to detect detailed features within the site, such as walls, streets, blocks, and some of the areas dug by *sebakhin*.

3. The third phase of the research involved a geomagnetic prospection of the site, undertaken during three fieldwork seasons in 2009,[27] 2010, and 2012. The instruments employed for this analysis were a Fluxgate Gradiometer FM36 and a Fluxgate Gradiometer FM256 (Geoscan Research ltd). During eight weeks of fieldwork, 16 ha were prospected, divided into a grid of 20 x 20 m squares, and georeferenced with a Total Station. The image-outcome resolution of the Fluxgate FM36 was set at 800 points per square (traverse interval 1 m, sample interval 0.5 m), increased to 1,600 points per square (traverse interval 1 m, sample interval 0.25 m) when the Fluxgate FM256 was used.

All the information was recorded in a database connected to a GIS platform, where it was possible to reconstruct the lines of magnetic anomalies and the marks of the satellite image. The software used for this operation was QGis (QGiS 2.6.1 Brighton), an open-source geographic information system. Different thematic layers were created for the GeoEye satellite image: the Google Earth picture, the shade-plot grey-scale map of the magnetometric prospection, the magnetic anomalies, the contour lines of the DTM, and the data of the surface survey. The GIS platform also allowed different kinds of spatial analyses to be performed.

The results of the remote sensing yielded a more comprehensive understanding of the settlement as a whole, including the city walls, the street network, the disposition of blocks, and, in some cases, also the internal organization of each district. Given the lack of any data from excavations, these results are particularly significant for attempting a detailed reconstruction of the settlement. This is even more important considering the fact that no more than a small fraction of the Graeco-Roman cities of Egypt have been excavated.

[24] The project is directed by Emanuele Papi (Università di Siena).

[25] The DTM was created by Emanuele Mariotti: see Papi *et al.* 2010, 239-241, figure C.

[26] GeoEye-1 (PAN and MS), recorded on 24 July 2010. Cloud cover percentage 0; 56 sq. km. Ground Sample Distance 0.48 m (PAN), 2 m (MS). UTM zone 33 WGS 84.

[27] Papi *et al.* 2010, 244-246.

Results

The geophysical prospections and their integration with high-resolution, remotely sensed data demonstrate that the urban settlement of Dionysias was organized according to a regular orthogonal grid, and that the temple and processional road (*dromos*) were located at the very centre of the city (Figure 6.3). The inner organization of each *insula* is not entirely clear, but we can hypothesize the presence of some tower houses, visible from the magnetic map, as well as the absence of an *agora*. Furthermore, in the eastern end of the settlement, there was a regular chessboard scheme of an orthogonal road network and square blocks of c. 50 m. The variation in the size of the blocks followed a mathematical proportion (some blocks were 1.3, 1.5, or 1.6 times larger than the original square block). The regularity of this scheme, however, was not followed in the western part of the urban area. We hypothesize a process of expansion of the original nucleus and a putative chronological development of the settlement, divided into three main phases of occupation and progressive enlargement.[28]

Through the analysis of these data we have attempted to investigate the different cultural elements involved in the construction of Dionysias – the most western site of Fayum – during the Ptolemaic and Roman periods, in an attempt to answer some general questions about the overall layout of settlements in Egypt in the Graeco-Roman era. Dionysias was one of the latest settlements built in the area reclaimed by the Ptolemaic king, as is also evident from its name. The toponym is a typical example of a Greek name associated with an Egyptian descriptive formulation. A Demotic/Egyptian text refers to this settlement as 'the new village which is called Dionysias' (*P3 '.wj Tjwnss*),[29] while further on within the same text it is called only 'the new village'.

In this 'new village' there were many features typical of the Egyptian tradition – more than we would normally expect in a Ptolemaic foundation, according to traditional assumptions. Even if originally the blocks were perhaps arranged following a precise chessboard scheme, local

Figure 6.3. *Dionysias, map of the site with the graphic digitization of the satellite image analysis and the results of the geomagnetic prospections (image: G. Carpentiero).*

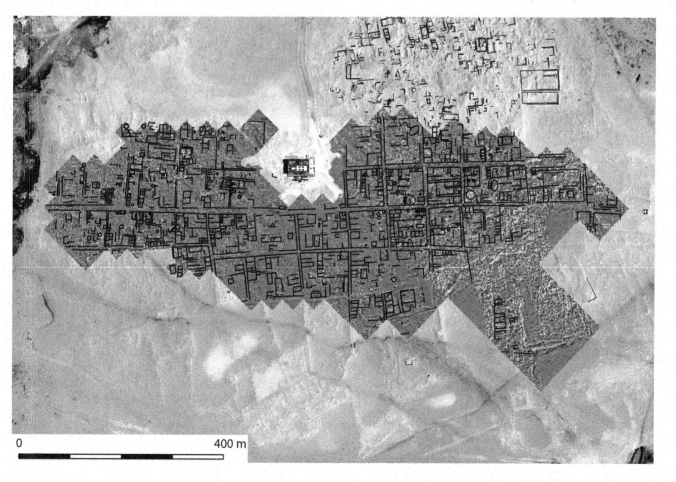

0 400 m

[28] Further details will be presented in the forthcoming volumes of the *Dionysias Archaeological Project*.

[29] P.dem.Lille 110 v. I.i; Müller 2006, 31.

design-sets and techniques were also adopted. Local workers took part in the creation of the design scheme and, afterwards, in the construction of all the main structures of the settlement. It is interesting to note, for instance, that the length-unit employed was not the Alexandrine foot of 30.8 cm, adopted at Alexandria and other settlements (like Oxyrhynchos),[30] but rather a local unit. The preliminary study of building materials used for the construction of the temple and further observations on the city plan allowed us to identify this length-unit with the *khet* (a multiple of the Royal Egyptian cubit of 52.3 cm).[31] Furthermore, the intersection between the extension of the *dromos* and the central north-south road corresponds exactly to the entrance of the *cella* of the temple – considered as the very centre of the settlement and the point from which the town planning originated.

The orthogonal layout was therefore one of the external cultural features that occurred in the design and construction of a settlement like Dionysias – as well as in other Hellenistic villages and cities in Egypt, such as Philadelphia, and probably Antinopolis and Hermopolis. However, this was not a characteristic completely extraneous to the local culture.

To define more precisely the different cultural elements involved in the urban layout of Dionysias, I will follow here the approach proposed by Smith,[32] which involves a combination of different components in the analysis of ancient urban planning: (1) co-ordinated arrangement of buildings and space; (2) formality and monumentality; (3) orthogonal layouts or other forms of geometric order; (4) access and visibility.

1. *Co-ordinated arrangement of buildings and space.* The most distinctive element at Dionysias is certainly the temple-*dromos*-*komasterion* system, attested elsewhere in Graeco-Roman Egypt, particularly in Fayum (for instance at Tebtynis, Soknopaiou Nesos, and in part also at Narmouthis). In the Pharaonic era, and later in the Hellenistic foundations in Egypt, places of worship represented the fulcrum for the planning of the urban design. The relation between the temple and the city had a fundamental role within local society. The temple represented the main architectural complex of the settlement,[33] unlike in the cities of the Greek mainland where cult places were often located in smaller areas, distant from the centre, even if they had a major importance for the culture and economy of the city.[34] The central role played by the Egyptian temple is also connected to its importance in the economic organization as well as the administrative and social functions of the city; many commercial and administrative activities took place in the temple. During the Ptolemaic period, the temple continued to own lands and their associated income. Also during the Roman era many productive, commercial, financial and administrative activities continued to take place inside the sacred enclosure, and the priests and other (non-religious) persons were housed in the *temenos*.[35] Even the *dromos* (a typical element of the Egyptian cult, even if the name is Greek) had a crucial function in the organization of the settlement, considering that associations, or *deipnateria*, and public auction rooms were placed along this road.[36] Moreover, in the Ptolemaic period the cult of the rulers and of their family was incorporated into the local Egyptian tradition.

Furthermore, the inner organization of the *insulae* and the typology of some houses was directly connected to Egyptian design (for example, the tower houses) all elements highlighting the local character of this settlement.

2. *Formality and monumentality.* With regard to the parameter of formality, the disposition of buildings and spaces represents a strong mark of organization and co-ordination. It refers to the presence of architectural complexes arranged according to a specific order and, therefore, suggesting the existence of a planned layout. Monumentality is instead related to buildings

[30] Casanova 2011, 121-126.
[31] The identification of the length-unit has been possible through the study of the construction process and design of the temple. I would like to thank Luca Passalacqua for allowing me to use these results from his research.
[32] Smith 2007.
[33] Kemp 1972, 657.
[34] Giuliano 1966, 130.
[35] Pensabene 1995, 207-208.
[36] Pensabene 1995, 208.

that are larger than necessary, and also to a specific arrangement of the space to emphasize particular buildings or architectural features. At Dionysias numerous features are directly related to local Egyptian elements: the axial and symmetric disposition of buildings around the worship complex; the importance of the temple being enhanced by its central position and its dimensions; the presence of an area of limited access enclosed within the walls of the *temenos*, provided with a putative monumental gate (visible in the magnetometry and also highlighted in the plan by Schwartz and Wild);[37] and, finally, the lack of a typical Greek *agora*, or a public square.

3. *Orthogonality*. The orthogonal layout is a distinctive feature to describe the Ptolemaic foundation of Dionysias, as well as other Hellenistic villages and cities in Egypt, although it is not an element completely extraneous to the local building tradition, as already observed above. If compared with its function in the Greek cities of the mainland, this feature of co-ordination and standardization in Fayum lost its original associations with political and social organization, related instead to the representation of power. In the Greek colonies, the arrangement of spaces could not represent the best form of social order as it was conceived by Hippodamus of Miletus.[38] Its political value was far from being relevant in non-democratic countries like Egypt. Therefore, Hellenistic foundations in the Ptolemaic kingdom could have used the orthogonal layout as a form of representation of the central power and as a distinctive element of cultural identity. It is not difficult to read in this feature a political project according to which the layout of the new city was directly linked with the new foreign kings. The adoption and modification of Hippodamian planning by the Ptolemies in this case is an indication of the degree to which Greek-style town planning had become institutionalized as a model in the Hellenistic world.

The orthogonal layout is generally described as an exclusive feature of planned cities,[39] an idea that assumes non-orthogonal cities did not have any form of planning, and are therefore classifiable as 'un-planned'. Many scholars have adopted this dichotomy between planned cities, with an axial grid or an orthogonal layout, and un-planned cities, with a so-called 'organic' development. However, there are various elements to consider with regard to urban design. In the case of cities that followed an 'organic' development, one should not just assume the absence of any kind of spatial organization. The idea of a dichotomy between planned and un-planned cities should be regarded as an artificial concept. In contrast, there are different degrees of urban planning that can be identified in ancient cities: from a low-degree planning, such as in cities with an 'organic' development, to a more elaborate and standard type of planning, as attested in Hippodamian cities. There are also different degrees of orthogonality, as well as different types of co-ordination and formality, and in fact some cities can be considered 'more planned' than others. In conclusion, the principle of orthogonality cannot be reduced to the presence or absence of a certain scheme,[40] and, in the case of Dionysias, it cannot be identified with certainty as a representation of the Lagid urban tradition.

4. *Access and visibility*. The position itself of Dionysias attests to the importance of the idea of access and visibility – being the last settlement at the western edge of the region, located at the beginning of the caravan routes leading to the desert oases. In particular the east-west road, placed south and parallel to the *dromos*, probably corresponded to an original pathway running towards the copper mines, Quta and the Bahria oasis,[41] or along the east route that connected Philoteris, Theadelphia and Euhemeria to the desert route and the oases. Nevertheless, the creation of areas of limited access and visibility is a feature connected to the construction of a great *temenos*, encircling the temple and occupying four square blocks, which could have been even 12 metres tall, like at Soknopaiou Nesos. This structure protected the sacred area, and housed ritual and administrative functions accessible only by the elites or the priests.

[37] Schwartz and Wild 1950, plate 2.
[38] Aristotle, *Ta politika*, II.1267b.22-30.
[39] Among others, see Laurence *et al.* 2011, 115.
[40] Smith 2007, 5.
[41] Pensabene 1995, 211.

Later constructions, from the first to the fourth centuries AD, have characteristics typical of the Roman building tradition, such as the so-called mausoleum at the eastern edge of the settlement, the military *castra* at the north-western corner, and a suburban road (visible in the magnetic map) that probably led to a monumental necropolis. In contrast, private architecture does not seem to differ from the local tradition or show any substantial changes even in later periods.

FINAL REMARKS

The recent research at Dionysias has given us the possibility to achieve a more comprehensive understanding of the urban layout of the settlement, to define its limits and inner organization, and to analyse the different cultural elements (endogenous and external) involved in its construction. The results bring into question some of the previous studies and provide a background for further research in the same area and in other parts of Fayum.

In the case of Dionysias, it is likely that the Hellenistic scheme and orthogonal layout were adopted only as a formal structure to highlight the Ptolemaic identity of the settlement and the power of the rulers. This idea of 'Greekness' is connected only to the overall appearance and to a few other architectural features. The orthogonal plan is certainly an element of partition and functional organization of the urban area, as well as what was thought to be the best practice at the time, and a reflection of the central power. It is therefore not sufficient to prove a Greek character of the settlement.

The function of the urban design in a new foundation was not intended to shape an ideal townscape, but rather to create a low-cost settlement as quickly as possible.[42] The pragmatism of the Lagides is well known and probably involved the adaptation of an ideal and functional Hellenistic settlement to local contexts.[43] Two important elements should not be underestimated: the ideology conveyed by the image of the city, and the process of cultural identification with an external (politically dominant) culture, which had created the model of an ideal city based on that scheme. While recent studies on Fayum have argued that an effective central organization in the Ptolemaic urban planning did not exist,[44] the present research has instead tried to demonstrate the presence of a central design project that intended to reflect the political power of the Lagides. In the ideology of the Ptolemies, Fayum (and every newly founded village or city) was conceived as a means to demonstrate the strength of their colonization process and of their government. However, such a desire of self-representation in a land only recently reclaimed by a foreign king – and inhabited by a local population – had to coexist with pragmatism and adaptation to the local cultural background.

Moreover the analysis of Dionysias' urban layout has allowed us to reassess the traditional assumption of the dominance of the Hellenistic culture on the local Egyptian tradition, and, at the same time, the idea of an opposition of the local culture against the foreign one. In Ptolemaic Egypt, the Graeco-Roman domination was not an automatic process or an imposition of an alternative cultural model, even if a Greek and Roman influence is clearly recognizable. There was, rather, a negotiation process originating from a cultural encounter, thanks to which the external elements could contribute to modify some aspects of the cultural background, but the local culture could also coexist with the dominant culture by maintaining its own ideology and identity.

The analysis undertaken so far has clearly shown that, even if the urban settlement was organized following a regular and orthogonal grid system (essentially Hellenistic), and some important constructions were later built according to Roman architectural principles, many other characteristics (know-how, man-power, and cultural values) should be associated with the local Egyptian background and endogenous culture. This is confirmed by the peculiar features and position of the main worship complexes, and by the length-unit (*khet*) employed in the construction of the temple and of the city as a whole.

[42] Kemp 1972, 661.
[43] Marouard 2012, 131.
[44] Davoli 2011, 81.

BIBLIOGRAPHY

Calderini, A. and Daris, S. (eds) 1978. *Dizionario dei nomi geografici e topografici dell'Egitto greco-romano, volume III*, Milan: Istituto editoriale Cisalpino – La Goliardica.

Casanova, N.G. 2011. Appendix. Methodological contribution to the land parcelling study. The case of Oxyrhynchos. In Subías, E., Azara, P., Carruesco, J., Fiz, I. and Cuesta, R. (eds), *The Space of the City in Graeco-Roman Egypt* (Documenta, 22), Tarragona: Institut Català d'Arqueologia Clàssica, 117-128.

Clarysse, W. 2007. Toponymy of Fayum villages in the Ptolemaic period. In Capasso, M. and Davoli, P. (eds), *New Archaeological and Papyrological Researches on the Fayum. Proceedings of the International Meeting of Egyptology and Papyrology (Lecce, June 8-10 2005)*, Lecce: Congedo, 69-81.

Clarysse, W. and Thompson, D.J. 2006. *Counting the People in Hellenistic Egypt, Volume 2. Historical Studies*, Cambridge: Cambridge University Press.

Davoli, P. 1994. *Città e villaggi dell'antico Egitto*, Imola: Editrice La Mandragora.

Davoli, P. 2010. Settlements – distribution, structure, architecture: Graeco-Roman. In Lloyd, A.B. (ed.), *A Companion to Ancient Egypt*, Chichester-Malden: Wiley-Blackwell, 350-369.

Davoli, P. 2011. Reflections on urbanism in Graeco-Roman Egypt: a historical and regional perspective. In Subías, E., Azara, P., Carruesco, J., Fiz, I. and Cuesta, R. (eds), *The Space of the City in Graeco-Roman Egypt* (Documenta, 22), Tarragona: Institut Català d'Arqueologia Clàssica, 69-92.

Fabiani, F. 2014. *L'urbanistica: città e paesaggi*, Rome: Carocci.

Fairman, H.W. 1949. *Town planning in Pharaonic Egypt*, Town Planning Review, 20: 31-51.

Giuliano, A. 1966. *Urbanistica delle città greche*, Milano: Il Saggiatore.

Grenfell, B.P., Hunt, A.S. and Hoghart, D.G. 1900. *Fayum Towns and their Papyri*, London: Offices of the Egypt Exploration Fund.

Hammad, M. 2006. Palmyre, le sens des transformations urbaines. Présupposés et énonciation. In Marrone, G. and Pezzini, I. (eds), *Senso e metropoli, per una semiotica della città*, Rome: Meltemi, 91-108.

Kemp, B.J. 1972. Temple and town in ancient Egypt. In Ucko, P.J., Tringham, R. and Dimbleby, G.W. (eds), *Man, Settlement and Urbanism. Proceedings of a Meeting of the Research Seminar in Archaeology and Related Subjects held at the Institute of Archaeology, London University*, London: Duckworth, 657-680.

Laurence, R., Cleary, S. and Sears, G.M. 2011. *The City in the Roman West, c. 250 BC – c. AD 250*, Cambridge: Cambridge University Press.

Marouard, G. 2012. Les quartiers d'habitat dans les fondations et refondations lagides de la chôra égyptienne. Une révision archéologique. In Ballet, P. (ed.), *Grecs et Romains en Égypte. Territoires, espaces de la vie et de la mort, objets de prestige et du quotidien* (Bibliothèque d'étude, 157), Cairo: Institut Français d'Archéologie Orientale du Caire, 121-140.

McKenzie, J. 2007. *The Architecture of Alexandria and Egypt, c. 300 BC to AD 700*, London: Yale University Press.

Morini, A. 2008. Templi e canali del Fayum: alcune osservazioni. In Pernigotti, S. and Zecchi, M. (eds), *Sacerdozio e società civile nell'Egitto antico. Atti del terzo colloquio (Bologna, 30-31 maggio 2007)*, Imola: Editrice La Mandragora, 115-119.

Müller, K. 2006. *Settlements of the Ptolemies. City Foundations and New Settlement in the Hellenistic World* (Studia Hellenistica, 43), Leuven: Peeters.

Müller, W. 2010. Urbanism in Graeco-Roman Egypt. In Bietak, M., Czerny, E. and Forstner-Müller, I. (eds), *Cities and Urbanism in Ancient Egypt. Papers from a Workshop in November 2006 at the Austrian Academy of Sciences*, Wien: Verlag der Österreichischen Akademie der Wissenschaften, 217-256.

Papi, E., Bigi, L., Camporeale, S., Carpentiero, G., D'Aco, D., Kenawi, M., Mariotti, E. and Passalacqua, L. 2010. La missione dell'Università di Siena a Qasr Qaroun-Dionysias (2009-10). In Pirelli, R. (ed.), *Ricerche italiane e scavi in Egitto*, Cairo: Centro Archeologico Italiano, 239-255.

Pensabene, P. 1995. Il tempio di tradizione faraonica e il dromos nell'urbanistica dell'Egitto greco-romano. In *Alessandria e il mondo ellenistico-romano. Atti del II Congresso Internazionale Italo-Egiziano (Alessandria, 23-27 Novembre 1992)*, Rome: 'L'Erma' di Bretschneider, 205-219.

Rathbone, D.W. 2001. Mapping the south-west Fayum: sites and texts. In Andorlini, I., Bastianini, G., Manfredi, M. and Menci, G. (eds), *Atti del XXII Congresso Internazionale di Papirologia, Volume II (Firenze, 23-29 agosto 1998)*, Florence: Istituto Papirologico G. Vitelli, 110-117.

Schwartz, J. and Wild, H. 1950. *Qasr-Qarun/Dionysias 1948. Fouilles franco-suisses. Rapports, I*, Cairo: Institut Français d'Archéologie Orientale du Caire.

Smith, M. 2007. Form and meaning in the earliest cities: a new approach to ancient urban planning, *Journal of Planning History*, 6.1: 3-47.

7

QUARTIERI RESIDENZIALI E AREE PUBBLICHE
L'AGORÀ ED IL GINNASIO DI CIRENE NELLA TARDA ANTICHITÀ[1]

Eleonora Gasparini

Abstract

The city of Cyrene represents a significant case study for evaluating the evolution and transformation of the North African cityscape in the transition from the Roman Imperial to Late Antique eras. This process involved a shift of the local residential spaces to the areas previously occupied by public buildings, as already highlighted by Stucchi, Bacchielli and Luni, who documented the presence of Late Antique constructions in the Agora and Gymnasium. Through a re-analysis of these works and the study of partially published archive documents, this paper describes the typology, function and internal organization of these buildings. Data obtained from the study of decorative elements, especially mosaics, and other archaeological finds are also taken into account. The period considered spans from the second half of the third century AD to the seventh century, investigating the beginning, development and ending of this particular phenomenon of urban occupation.

INTRODUZIONE

Nell'ambito degli studi sull'evoluzione topografica e sul cambio del paesaggio urbano dall'età imperiale alla tarda antichità, la città di Cirene costituisce uno degli esempi della dinamica insediativa che prevede una trasformazione dei luoghi dell'abitare attraverso il parziale spostamento dei quartieri residenziali nelle aree in precedenza occupate da edifici pubblici. Il fenomeno è parte delle trasformazioni urbanistiche intervenute in città in un momento precoce rispetto alla serie di numerosi esempi di tale dinamica nel Mediterraneo: già a partire dalla metà del III sec. d.C. vari edifici pubblici cadono in disuso rendendo disponibili spazi e materiale da costruzione per la nascita di nuovi quartieri residenziali, la cui genesi forse si lega anche all'inurbamento di parte della popolazione della *chora*.

Il tema della presente analisi ci permette dunque di guardare alla città di Cirene nel più ampio contesto del Mediterraneo tardoantico e di confrontarne le dinamiche insediative con

[1] Il presente lavoro ha preso le mosse dalla mia partecipazione alla Missione Archeologica a Cirene dell'Università di Urbino negli anni 2008-2010, sotto la direzione del Prof. Mario Luni. Alla sua memoria desidero dedicare questo contributo: tale studio non sarebbe potuto avvenire senza i dati da lui raccolti in più di quarant'anni di ricerca sul campo, poi confluiti in molteplici contributi dedicati al Ginnasio-Cesareo ed al quartiere dell'Agorà. Il progresso delle indagini sui monumenti della città, proprio negli ultimi momenti della sua attività, si è accompagnato ad un altrettanto importante sforzo di raccolta e pubblicazione della documentazione di archivio, che riveste un enorme valore in particolare per lo studio degli edifici di età tardoantica smantellati al tempo delle prime indagini. Per le numerose discussioni sulle questioni archeologiche cirenee i miei ringraziamenti vanno a Oscar Mei e Filippo Venturini. Infine ringrazio il Prof. Gianfranco Paci e Silvia Forti per l'utile supporto presso gli Archivi dell'Università di Macerata (Fondo Pernier) e del CAS (Fondo Caputo). Attraverso la consultazione preliminare di questi archivi ho potuto visionare direttamente svariati documenti qui di seguito citati.

quanto avviene nelle province orientali e occidentali, incluse le trasformazioni urbanistiche delle aree pubbliche di Roma.

Per Cirene già i lavori di Stucchi, Bacchielli e Luni hanno affrontato la problematica della conversione degli spazi pubblici in quartieri residenziali, parlando dei numerosi edifici che in forme e tempi diversi si installarono nelle due grandi piazze dell'Agorà e del Ginnasio. Ma se per l'Agorà molta documentazione è edita, per il Ginnasio è soprattutto il materiale d'archivio (parzialmente pubblicato di recente) a consentire un esame del quartiere.[2] A partire dunque dal meglio noto quartiere dell'Agorà e, in seguito, per il caso del Ginnasio, verrà analizzata la tipologia di questi edifici in riferimento alle forme, alla distribuzione ed al numero degli ambienti, alla loro funzione, al tipo di percorsi interni ed esterni generati dai nuovi quartieri, prendendo in considerazione, ove possibile, elementi decorativi come pavimentazioni musive e dati sui reperti.

Rivedendo la storia dei due nuclei urbani nel contesto delle trasformazioni avvenute a Cirene dalla seconda metà del III alla metà del VII sec. d.C., la disamina affronta dunque in maniera complessiva la problematica cronologica della nascita, lo sviluppo e la fine di tale fenomeno occupazionale in rapporto con le dinamiche dell'abitare nella città in età tardo-imperiale.

ANTEFATTO STORICO

I centri urbani della Cirenaica, dalla metà del III sec. d.C., sono protagonisti di vari rivolgimenti, che spesso portano a nuovi assetti nel panorama urbanistico delle città. Al sisma che colpì la regione nel 262 d.C.[3] si aggiunsero le incursioni operate dalla tribù nomade dei Marmaridi, testimoniate dai documenti epigrafici in cui si celebra l'intervento imperiale a difesa di Cirene e la rifondazione della città con il nome di Claudiopolis in onore di Claudio il Gotico (268-270 d.C.). Pur non esistendo alcuna testimonianza diretta inerente la Cirenaica, si può inoltre supporre che la regione sia stata colpita anche dalla "Peste di Cipriano", pandemia che sconvolse l'Impero nei territori confinanti dell'Africa e dell'Egitto.[4] Altro fattore che pure determinò un impoverimento fu una notevole variazione climatica, con un progressivo inaridimento a partire dal I sec. d.C. Nel III sec. d.C. per la prima volta gli autori fanno riferimento alla Cirenaica come regione secca, in contrasto con tutte le notizie delle epoche precedenti, che sempre parlavano di un paese eccezionalmente felice per clima e reddito agricolo.

Infine non possiamo trascurare il ruolo giocato dal più generale quadro storico della seconda metà del III sec. d.C., che coinvolse tutto l'Impero in conseguenza del prolungato periodo di instabilità politico-militare, causando anche un calo dei commerci su grande scala.[5] Nonostante il debole tentativo di rilancio operato con Claudio il Gotico, la spinta partecipativa nei confronti del potere centrale, che ancora all'inizio del III sec. d.C. caratterizza l'atteggiamento delle élites municipali, sembra in quel momento segnare una battuta di arresto e la storia della città piegare decisamente verso un percorso dettato da dinamiche locali.

L'ordinamento dioclezianeo apporterà ulteriori ed ancor più netti cambiamenti politico-territoriali: fu infatti applicato anche alla Cirenaica il principio di frazionamento delle vecchie province con la creazione di due nuovi organismi, la Libya Superior o Pentapolis, corrispondente alla Cirenaica vera e propria, e la Libya Inferior o Sicca, che coincideva con la Marmarica, con capitali rispettivamente a Tolemaide e a Paraetonium (Marsa Matruh). Le due nuove province fecero parte, con l'Egitto, della diocesi d'Oriente.

[2] Fondamentale è a questo proposito Luni 2014a. Al suo interno la bibliografia principale sui vari periodi che hanno caratterizzato la ricerca archeologica a Cirene è riassunta da M. Gasparini alle pagine 78-79; 154-156; 263-264; 363-364. Sebbene lo studio dei documenti ivi pubblicati consenta di ricostruire la sequenza dei lavori nelle varie aree archeologiche della città, tra cui Agorà e Ginnasio, scarse risultano le informazioni specifiche relative alle strutture abitative rinvenute e poi smantellate nelle due piazze. Durante la presente trattazione verranno di volta in volta citati i riferimenti agli elementi significativi rinvenuti, ma ci si propone di ampliare i dati noti attraverso una ricerca mirata all'edilizia domestica tardoantica da svolgersi all'interno degli archivi. Altri recenti studi che esaminano la storia delle prime indagini in Cirenaica sono in Rekowska 2013, 9-26; Santucci 2012, 88-106 e in Balice 2010. Per l'attività tra gli anni '20 e '30 si segnala l'articolo di Stucchi dedicato all'operato di Carlo Anti (Stucchi 1992, 49-128).

[3] White 1996, 317-325.

[4] Tiradritti 2014a, 15-18; 2014b, 40-51.

[5] Lloyd 1990, 41-53; Wilson 2001, 28-43; 2004, 143-154.

In maniera sempre più incisiva intervennero inoltre in quel periodo cause di turbamento legate alle incursioni dei popoli del deserto: tra la fine del IV e l'inizio del V sec. d.C. si rilevano plurimi assalti compiuti ai danni dei presidi di frontiera, delle campagne e persino della città, fino ad arrivare ai centri costieri:[6] nonostante i tentativi messi in atto dal potere centrale di regolare i rapporti con le tribù nomadi, le incursioni ed il malgoverno continuarono a minare la sicurezza e la stabilità del territorio. A ciò si aggiunsero i gravissimi danni causati da un violento terremoto nel 365 d.C.

L'opera di Giustiniano in Cirenaica determina la penetrazione del cristianesimo, attestata dai resti delle varie basiliche che i siti delle città ancora conservano.[7] L'imperatore rivolse soprattutto le sue cure al restauro o alla creazione di fortezze e cinte murarie, allo scopo di rinforzare le difese della regione, a riprova di quanto instabili ancora fossero le sue condizioni, sia per la costante minaccia dei popoli dell'interno, sia per le rivolte dei capi militari. Ma, come per l'Egitto, anche per la Cirenaica si avvicinava ormai, sotto la pressione degli Arabi, il momento del definitivo distacco dall'Impero.

L'AGORÀ

Gli scavi nell'Agorà hanno inizio nei convulsi anni 1914-1915, quando Ettore Ghislanzoni dovette operare in condizioni di emergenza, in concomitanza con la costruzione delle opere difensive dei militari nell'area della città antica. Nel diario di scavo dell'assistente Sinesio Catani si segnala che nello strato superficiale erano presenti "case e botteghe tarde crollate in un unico periodo [...] che si fondavano sul lastricato delle piazza".[8] La problematica della conservazione o demolizione di tali edifici fu oggetto di un dibattito tra gli archeologi che operavano a quel tempo a Cirene e, nonostante Ghislanzoni volesse preservarle, per lo meno sino alla fine degli scavi estensivi, la demolizione ebbe poi luogo nel 1929 dopo i rilievi grafici.[9] Di questa attività del 1929 resta in effetti testimonianza in alcune fotografie (Figura 7.1), ma soprattutto nella pianta del Gismondi, redatta nel 1926[10] (poi ampliata nel 1928[11] e nel 1929[12]), che includeva una numerazione delle unità abitative (Figura 7.2).

I dati furono poi arricchiti da ulteriori sondaggi di limitata estensione, a cui seguirono anche dei restauri, con il ritorno a Cirene della Missione Archeologica Italiana nel 1957 sotto la direzione di Sandro Stucchi.[13] I risultati furono elaborati in quattro pubblicazioni dedicate alla cosiddetta Platea Inferiore, ovvero lo spazio dell'Agorà vera e propria, e rispettivamente ai suoi lati nord e est,[14] al settore nord del lato ovest,[15] al lato sud e a quello nord della Terrazza Superiore[16] ed infine al settore sud del lato ovest.[17] Le descrizioni delle case vennero effettuate in modo particolareggiato seguendo la distinzione delle singole unità e la relativa numerazione proposta dal Gismondi nella sua pianta del quartiere. Stucchi, che per primo avviò tale ricerca, impostò uno studio diacronico, ove possibile basato sulle cronologie dei materiali,[18] e tale metodo fu poi seguito

[6] Sinesio, *Epistolae*.

[7] Procopio, *De Aedificiis*, VI.2.

[8] Luni 2014b, 51-52.

[9] Luni 2014b, 51-52, 68 (nota 33), 132, figura 11, relativa al 1932.

[10] Luni 2014c, 132, figura 12.

[11] Invernizzi 2014, 187, figura 11.

[12] Invernizzi 2014, 188-191, figure 13-15.

[13] Bacchielli 1981, 16-17.

[14] Stucchi 1965.

[15] Bacchielli 1981.

[16] Stucchi, Bacchielli 1983.

[17] Purcaro 2000.

[18] Oltre alla ceramica presentata da Pandolfi, un ruolo importante rivestono le monete. Come *terminus ante quem* è stato possibile basarsi sulla notizia di un tesoretto rinvenuto all'interno di una delle case che sorsero sul lato sud, che tuttavia in seguito andò disperso (Stucchi, Bacchielli 1983, 11, 113). Esso era composto da 243 monete in bronzo per la maggior parte datate al IV sec. d.C. e in particolare all'epoca di Costanzo II (335-337 d.C.) e di Costanzo Gallo (352-354 d.C.): Stucchi 1965, 293; Spagnulo 1997, 344. Un altro tesoro relativo allo stesso periodo fu ritrovato presso il teatro romano all'interno del Santuario di Asclepio a Beida: in questo caso furono rinvenute 259 monete in bronzo datate tra gli anni 350 e 361 e in un caso al 364 (Goodchild 1971, 203-205, n. 16). Ricordiamo anche un secondo tesoretto rinvenuto nella zona dell'Agorà – in questo caso presso il lato est, ossia all'interno di un edificio che identifichiamo con la Casa di Esichio – con le indagini condotte da Evaristo Breccia, benché in questo caso si tratti di monete di età traianea: Spagnulo 1996, 203-210.

Figura 7.1. (in alto a destra) *Strutture tardoantiche nell'Agorà documentate nel 1929, dall'angolo nord-orientale della piazza (da Invernizzi 2014, figura 15).*

Figura 7.2. (in basso a destra) *Pianta dell'Agorà con rappresentazione delle case eseguita nel 1929 da I. Gismondi (da Invernizzi 2014, figura 13).*

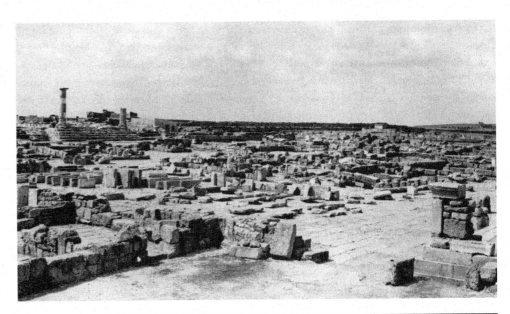

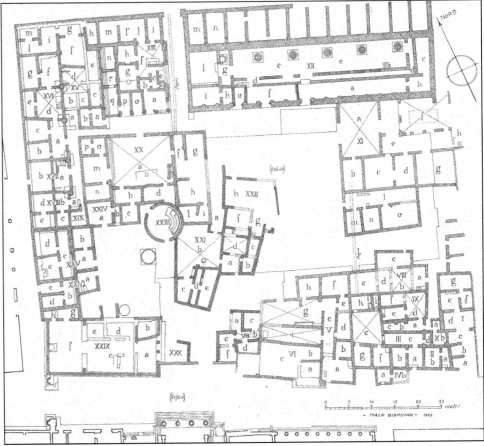

anche nelle successive pubblicazioni. Per ciò che riguarda l'edilizia residenziale, si giunse dunque all'individuazione di quattro distinte fasi:[19] la prima, che vide la trasformazione dei portici perimetrali, sarebbe relativa agli anni successivi al sisma del 262 d.C. e verrebbe attribuita al rilancio di Cirene all'epoca di Claudio il Gotico (268-270 d.C.), quando la città venne ribattezzata Claudiopolis.[20] La seconda fase, invece, durante la quale ancora le case sembrerebbero mantenersi entro i limiti degli edifici greci e romani, durerebbe dal terremoto del 365 al 395 d.C., anno delle

[19] In Bacchielli (1981, 183, 191) la periodizzazione si riduce a due fasi, una precedente e una successiva al terremoto del 365 d.C. Si precisa altresì come spesso si ponga una difficoltà nella datazione delle strutture murarie, che presentano una tecnica molto simile in entrambe le fasi.

[20] Stucchi 1965, 293-294.

incursioni degli Austuriani e dell'ambasceria del vescovo Sinesio a Costantinopoli.[21] In questa fase vari edifici che occupavano la Terrazza Superiore dell'Agorà, tra cui il Tempio di Zeus, a seguito dei danni del terremoto vennero abbandonati per non essere più ricostruiti.[22] Il terzo momento invece si collocherebbe tra la fine del IV e l'inizio del V sec. d.C., in coincidenza con l'età di Sinesio e con gli esiti positivi del suo operato al fine di portare la città all'attenzione del governo centrale. Tale fase, definita di rinascita, vede la creazione di edifici nella parte centrale della piazza, l'aggiunta di nuovi ambienti alle costruzioni precedenti e l'accorpamento di edifici.[23] Da ultimo, un quarto momento segna la fine di tale sviluppo e di esso sarebbero rimasti, sul piano architettonico, i numerosi tamponamenti di porte che testimonierebbero non solo un impoverimento, ma anche un'esigenza difensiva da collegare alle nuove incursioni degli Austuriani (405 d.C. e anni seguenti). La cessazione dei dati ceramici alla metà del V sec. d.C. si accompagnerebbe ai danni dovuti ad un nuovo evento sismico a cui si attribuiscono alcuni scheletri sigillati dai crolli presso il lato nord della piazza, ma è dibattuta una prosecuzione fino alla metà del VI sec. d.C.[24]

Alle quattro fasi illustrate corrispondono due diverse dinamiche nell'occupazione degli spazi, che consistono, per il primo momento, nell'edificazione del perimetro della piazza, con il riutilizzo dei portici e degli altri edifici preesistenti lungo i margini dello spazio aperto,[25] mentre con il momento della "rinascita sinesiana", seguendo uno sviluppo definito "centripeto",[26] si assisterebbe all'invasione dello spazio centrale e all'accorpamento di alcune precedenti unità, con l'esito di nuclei residenziali di maggiori dimensioni, con planimetrie più articolate e, in un caso, con l'impiego di decorazioni musive per alcuni pavimenti.

Osservando la documentazione grafica prodotta per tali lavori emerge innanzitutto come, da un punto di vista urbanistico, il quartiere non si caratterizzi per una pianificazione delle infrastrutture: mancò la creazione di una nuova rete fognaria, mentre dove possibile furono riutilizzate le cloache antiche.[27] Anche il sistema viario interno al quartiere si riduce in angusti e tortuosi passaggi tra gli edifici,[28] mentre la Skyrotà sembra aver continuato a costituire il principale asse di comunicazione della zona fino alla seconda metà del IV sec. d.C.,[29] quando almeno quattro unità ne ingombrano una porzione.[30]

La destinazione dell'area, sin dalla prima rioccupazione, si connota nettamente in senso residenziale, ma va sottolineata la presenza di poche altre tipologie di edifici, in parte collegabili alle stesse esigenze dell'abitare:[31] ci riferiamo ad esempio ad una latrina pubblica sul lato est della piazza[32] e ad un ipotetico mercato sorto all'interno dell'originario portico nord.[33]

La caratteristica che maggiormente ricorre in questi edifici, sin dalla loro prima comparsa, è l'ampio impiego di *spolia*, che si accompagna ad una tecnica edilizia che prevede l'impiego di murature a sacco o a telaio, con l'inserimento di piedritti monolitici di rinforzo.

Le pavimentazioni sono per la maggior parte costituite da battuti di terra, da blocchi calcarei di reimpiego o dallo stesso lastricato originario. Mentre alcuni cocciopesti sono impiegati soprattutto in settori scoperti, pavimenti a mosaico sono documentati nella sola Casa XI e degli intonaci

[21] Stucchi 1965, 307.

[22] Ensoli 2003, 62, 77.

[23] Stucchi 1965, 323-324.

[24] Bacchielli 1981, 193; Stucchi, Bacchielli 1983, 118.

[25] Vogliamo ricordare anche la conversione in abitazione (Casa XLIII), del Tempio E6 o delle Basi Ottagone, presso l'angolo sud-est dell'Agorà (Stucchi 1965, figure 207, 227; 1975, 245-248, 324; Venturini 2013, 41).

[26] Bacchielli 1981, 183.

[27] Stucchi 1965, 339.

[28] Bacchielli 1981, 183, 187-188, 192-195; Stucchi 1965, 323-324.

[29] Stucchi, Bacchielli 1983, 111.

[30] Case XLIII, IV, V e VI: Stucchi, Bacchielli 1983, 111-113, 118.

[31] Tra questi, per la prima fase di occupazione tra 262 e 365, annoveriamo anche la cosiddetta costruzione E2, formata da cinque ambienti, nella porzione centrale del portico E1, sul lato est della piazza, di cui non appare chiara la funzione (Stucchi 1965, 297-298). Nella fase successiva anche questo spazio fu riadattato per scopi abitativi (Stucchi 1965, 307) e lo stesso dicasi per l'edificio O5, nel portico ovest, il cui colonnato fu sostituito da una muratura piena. Anche in questo caso resta sconosciuto l'utilizzo dell'edificio che, dalla ceramica negli strati in connessione con le fondazioni, viene attribuito alla prima fase (262-365 d.C.). La sua obliterazione sarebbe in seguito avvenuta con la nascita della grande Casa XX all'epoca di Sinesio (Bacchielli 1981, 184-185, 192-193).

[32] Stucchi 1965, 302-303.

[33] B6, B7 e B8: Stucchi 1965, 294, 311, 324-327.

Figura 7.3. *Agorà, Casa XI, dettaglio del pavimento a mosaico dell'ala nord-sud del corridoio (foto: E. Gasparini).*

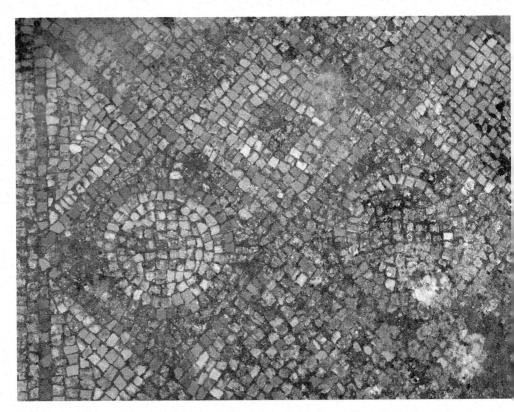

di rivestimento parietale non restano che scarse tracce.[34] Spesso le case sono dotate di scale ed anche dove non sono state rinvenute si è proposto di ipotizzare la presenza di strutture in legno, oppure miste, con solo i primi gradini in pietra: l'altezza media degli edifici, in base ai segni delle travature, è stata calcolata di circa 5 m.[35]

Da un punto di vista planimetrico, Stucchi individua due tipi principali: la casa con vani allineati e quella, meno comune, incentrata attorno ad un atrio, ma con pianta disorganica e percorsi non rettilinei tra gli ambienti.[36]

Svolgendo un'analisi del quartiere al momento della sua massima estensione, emerge come, tra le 35 unità che occupavano l'Agorà, 17 presentano più di quattro ambienti e sempre 17 sono dotate di cortile. Le scale, intese come evidenza di un secondo piano, compaiono in otto casi. I pavimenti, nella forma di cocciopesti, lastricati o mosaici, rivestono quattro unità (solo in due casi si tratta di mosaici: Figura 7.3) a cui aggiungiamo tre ulteriori case che presentano degli acciottolati nei cortili. Quattro infine sono le dimore dotate di cisterne, mentre, delle 35 totali, 13 non rispondono a nessuno dei criteri indagati.

IL GINNASIO

Per il Ginnasio le prime notizie, assai limitate, si riferiscono al 1934, durante i lavori di Luigi Pernier,[37] Evaristo Breccia[38] e Pasquale Carbonara.[39] Sterri sono menzionati poi nella Relazione del 1935[40] insieme all'avvio del restauro del muro sud del Cesareo[41] (Figura 7.4). Vi si legge:

[34] Stucchi 1965, 337-342.

[35] Stucchi 1965, 338.

[36] Bacchielli 1981, 196; Stucchi 1965, 339.

[37] Vd. Luni, Lanari 2014, 246, figura 11, in cui si osserva una porzione del muro sud prima dello scavo e del restauro. Per l'attività del Pernier a Cirene vd. Catani 2003, 235-258.

[38] Evaristo Breccia (1876-1967) diresse il Museo greco-romano di Alessandria dal 1904 al 1931. Lavorò a Cirene dal 1934 al 1936, periodo in cui era passato alla docenza presso l'Università di Pisa, di cui fu anche rettore tra il 1939 e il 1941.

[39] Bartolini 2014, 172; Invernizzi 2014, 201-202, figura 29; Luni 2014c, 145.

[40] Invernizzi 2014, 202; Luni 2014c, 149-153.

[41] Vd. anche la bella foto datata al 1935 in Luni, Lanari 2014, 246, figura 12, in cui si osserva il crollo dei blocchi dell'edificio ancora *in situ* e l'avvio del restauro, con un ponteggio attorno alla muratura dell'angolo sud-est. Sui lavori del 1935 nel Ginnasio vd. anche Forti 2014, 268 e Luni, Lanari 2014, 247-248.

"L'edificio, a quel che si può dire, ha subito varie trasformazioni – portico, tempietto e costruzioni del lato settentrionale; poi il portico fu diviso con muriccioli in una serie di stanzette e casette, ed altre case furono addossate al tempio, e piccole costruzioni sorsero di qua e di là nel cortile; poi il muro perimetrale ha dovuto costituire una specie di fortezza, giacché si vedono bene le feritoie tagliate nei blocchi nella parte orientale".[42]

Nell'autunno del 1938 si giunse alla fase decisiva di smontaggio del quartiere tardoantico su decisione finale di Giacomo Caputo che scriveva: "In questo modo si è potuto tranquillamente recuperare il materiale architettonico necessario per il restauro, senza tuttavia venire meno ai doveri della documentazione archeologica, e non si è inutilmente infastidita la visione del monumento con l'impaccio delle tardissime abitazioni che vi si erano annidate usurpandone la superficie e gli elementi".[43]

Esiste un elaborato del 1938 che si conserva in copia presso il Fondo Caputo del CAS di Macerata,[44] consistente in una preziosa pianta di dettaglio del quartiere realizzata dall'architetto Buonomo[45] (Figura 7.5). Tale documento precede la pianta dell'area di Gismondi dello stesso anno, poiché in quest'ultima il quartiere tardoromano sembra già essere stato smantellato.[46]

Dal 1939 in poi si possono seguire nella documentazione i lavori di restauro nell'area, ad opera di Gennaro Pesce e Giacomo Caputo[47] o i lavori di analisi sulla basilica,[48] ma al quartiere tardoantico si dedicano solo sintetiche analisi. Mario Luni parla di modeste abitazioni su di un unico piano costruite in fretta con materiale eterogeneo di spoglio raccolto tra i ruderi del quadriportico e della basilica.[49] Egli si sofferma su quest'ultimo edificio, individuando due serie di piccoli ambienti disposti al fianco di una stretta strada che attraversava longitudinalmente l'aula. Anche l'abside nel suo resoconto risulta suddivisa in vari ambienti[50] e, circa l'isolato che ha occupato l'area della basilica, egli fa cenno ad un'ipotesi sulla presenza di un'aula di culto paleocristiana,[51] che potrebbe coincidere con un ambiente che occupava trasversalmente la navata centrale e settentrionale, all'incirca in corrispondenza dell'asse mediano dell'edificio, i cui resti consistono in porzioni dei due muri di chiusura ed in un pavimento in lastrame marmoreo di riutilizzo, che attesta una certa rilevanza del vano.[52] Anche Ward-Perkins fornisce alcune informazioni ed in particolare evidenzia che il colonnato del quadriportico sarebbe stato smantellato ed i muri perimetrali utilizzati per addossarvi muri e coperture delle abitazioni, come dimostrato dagli svariati fori per l'incasso delle travi visibili al loro interno.[53] Egli segnala inoltre nuove modulazioni nelle aperture, attraverso restringimenti determinati da stipiti con blocchi di reimpiego anche iscritti.[54] Infine osserva la creazione di un nuovo sistema idrico di adduzione e smaltimento delle acque ad una quota più alta, determinata dal nuovo piano di calpestio, che si evince anche dall'innalzamento delle soglie.[55]

Gli studi di Mario Luni sul Ginnasio individuano due distinti momenti di gravi crolli, che coincidono cronologicamente con i due terremoti disastrosi del 262 e del 365 d.C.[56] Se il primo segna la conversione in senso residenziale dell'area, come contemporaneamente cominciava ad

[42] Luni 2014c, 152.

[43] Forti 2014, 266; Luni, Lanari 2014, 252.

[44] CAS 15.9. Vd. anche Luni 2007, 397, figura 11 e Ward-Perkins et al. 1958, tavola 26.

[45] La dicitura sul retro della pianta recita: "Soprintendenza Antichità Libia, Soprintendente Caputo. Il Cesareo (con ruderi tardi e stradina tarda) a cura di A. Buonomo – Architetto Responsabile dell'Ufficio di Cirene, con l'aiuto di Nino Calabrò. (Copia presso Caputo che la passa a S. Stucchi per lui al Centro di Documentazione). Firenze, 2/03/1969".

[46] Invernizzi 2014, 204-205, 208; Stucchi 1967, 13 e tavola fuori testo.

[47] Forti 2009, 171-177; 2014, 277-281; Invernizzi 2014, 206; Luni, Lanari 2014, 245, 253-256, 262-263, figura 5.

[48] Ward-Perkins et al. 1958, 138-194.

[49] Luni 1987, 41-46; 1988, 274-275; 1994, 209; 1998, 319-321; 2007, 394-396; Luni, Cellini 1999, 28-29.

[50] Ma questo non risulta dalla pianta di Buonomo.

[51] Luni 1988, 273.

[52] Ward-Perkins et al. 1958, 192.

[53] Ward-Perkins et al. 1958, 146, 149.

[54] Ward-Perkins et al. 1958, 140, 146, 162.

[55] Ward-Perkins et al. 1958, 146.

[56] Di Vita 1982, 127-139; Di Vita, Livadiotti 2005; Goodchild 1961, 83-95; 1966-1967, 203-212; Goodchild, Barr 1968, 41-44; Reynolds 1977, 53-58; Stucchi 1975, 234, 353 (terremoto del 262 d.C.), 257 (terremoto del 365 d.C.); Traina 1989, 449-451.

Figura 7.4. (in alto a destra)
*Strutture tardoantiche nel
Ginnasio documentate nel
1935, dall'angolo sud-orientale
della piazza (da Forti 2014,
figura 3).*

Figura 7.5. (in basso a
destra) *Pianta del Ginnasio
con rappresentazione delle
case eseguita nel 1938 da
A. Buonomo (CAS 15.9).*

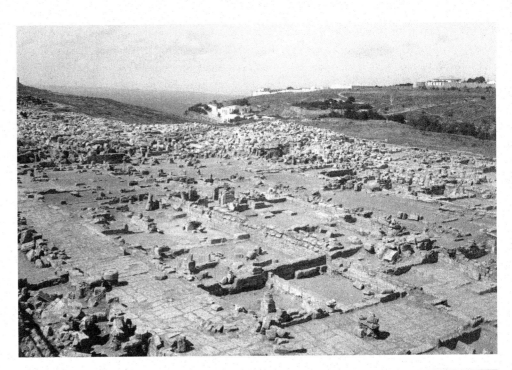

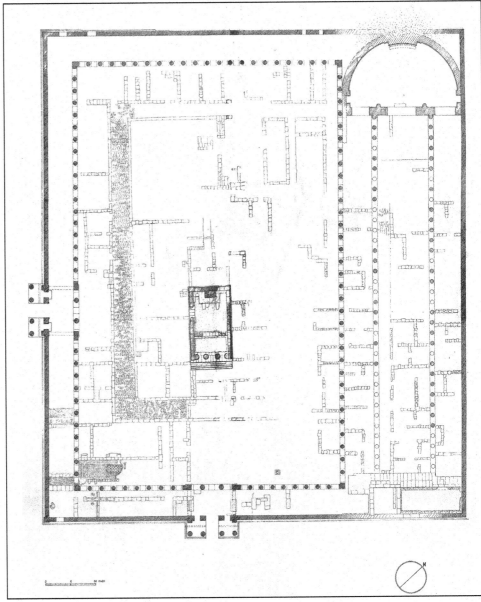

avvenire nell'Agorà, il secondo arreca pesanti danni al quartiere stesso, come sarebbe provato dal ritrovamento di strumenti, vasellame, suppellettili e monete di IV sec. d.C., nonché di uno scheletro umano, sepolti sotto cumuli di blocchi,[57] pur non segnando ancora tale evento la scomparsa totale del quartiere.

Dopo aver osservato i caratteri del quartiere abitativo dell'Agorà è possibile affrontare un'analisi di quello del Ginnasio mettendo a fuoco similitudini e differenze tra le due aree. Va innanzitutto rimarcata la diversità del contesto in cui i due quartieri si inseriscono: se nell'Agorà l'area era in precedenza molto edificata, nel Ginnasio le strutture originarie erano poche, ossia i portici, la basilica e il tempio. Non a caso, in questo secondo esempio, gli edifici successivi si addensano in corrispondenza di tali preesistenze, in particolare all'interno e intorno alla basilica, a ridosso del tempio ed in una fascia tra i portici est, sud e ovest. Una strada a questi parallela sembrerebbe aver conservato la pavimentazione nel suo tratto meridionale e parzialmente in quello orientale. Infine un ultimo nucleo edificato, apparentemente privo di connessioni con strutture precedenti, si individua nel settore centro-occidentale della piazza, ma anche in questo caso rilevante risulta il rapporto con la strada citata e in particolare con il suo tratto occidentale.

La mancanza di un numero consistente di edifici nel caso del Ginnasio sembra d'altra parte aver facilitato uno sviluppo più regolare del quartiere, che si organizza in funzione della viabilità sia nel caso dello spazio aperto che in quello della basilica, attraversata da un percorso in senso est-ovest in corrispondenza della metà sud della navata centrale.

L'individuazione di una griglia e di una forma di pianificazione differenzia il quartiere del Ginnasio da quello dell'Agorà, dove abbiamo visto come l'accrescimento progressivo delle unità abbia determinato uno sviluppo più disordinato, con frequenti casi di edifici addossati gli uni agli altri e con accessi spesso tortuosi tramite angusti spazi di risulta. Pur mancando dati precisi sulle murature, queste considerazioni ci portano a proporre, nel caso del Ginnasio, una nascita in grandi linee simultanea, con sviluppo omogeneo delle case, che previde la programmazione della viabilità e delle infrastrutture. L'assenza di una dinamica occupazionale dal perimetro al centro parrebbe inoltre dimostrata dal fatto che le due unità che più risultano assimilabili, anche per la presenza di simili pavimentazioni musive, si collocano, nel caso dell'Agorà, al centro della piazza, mentre nel caso del Ginnasio, lungo il suo perimetro (Figura 7.6).

La conclusione cui giungiamo sulla base della planimetria dell'area non implica che, anche nel caso del Ginnasio, non si sia dinanzi ad una storia occupazionale pluristratificata, come anzi

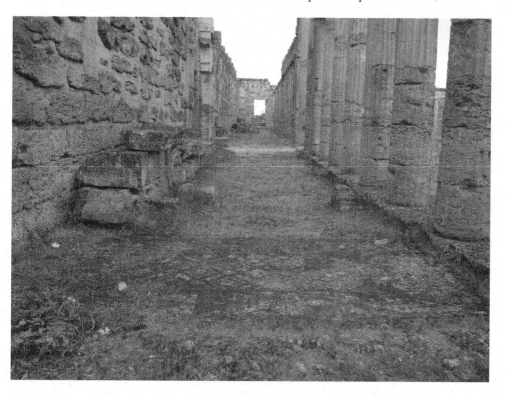

Figura 7.6. *Ginnasio, Casa I, sale con pavimentazione musiva nel portico sud (foto: E. Gasparini).*

[57] Luni 1987, 41-46; Stucchi 1975, 331-335.

sembrerebbero indicare i dati ceramici, che, seguendo le considerazioni di Luni, portano a fissare la nascita del quartiere alla metà del III sec. d.C., in coincidenza con le prime case dell'Agorà. Riteniamo tuttavia che non si trattò in questo caso di un'espansione graduale a partire da un nucleo primitivo, quanto piuttosto di ristrutturazioni e cambiamenti di un impianto sorto nello stesso momento sull'intera superficie disponibile.

Se infine nell'Agorà poche erano le eccezioni ad una destinazione residenziale, nel Ginnasio la presenza di un atelier di lucerne posto presso il suo angolo sud-occidentale, dimostra l'esistenza anche di un comparto artigianale. L'officina, costituita da cinque stanze aperte su di un cortile, con estensione non superiore a 250 mq,[58] ha restituito attrezzi per la lavorazione dell'argilla oltre a numerose matrici.[59] A ciò possiamo affiancare anche una probabile zona commerciale, che potrebbe coincidere con una sequenza di 11 vani – forse delle *tabernae* – posti tra la strada interna ed il colonnato ovest.

LA QUESTIONE CRONOLOGICA: I DATI DEI MOSAICI, DELLA CERAMICA E DELLE MONETE

Il fatto che all'interno dei quartieri dell'Agorà e del Ginnasio due case presentassero pavimenti a mosaico può fornire alcune indicazioni cronologiche. Tali mosaici geometrici sono realizzati con marmi ricavati dal reimpiego di più grandi elementi tagliati ad hoc, col risultato di tessere di grandi dimensioni e forme irregolari, che potrebbero rimandare al tardo IV o al V sec. d.C., pur se in altre zone dell'Impero vi sono esempi sia più antichi che più tardi di tali tipologie.[60] Il recente studio di Venturini evidenzia come tali pavimenti possano essere accostati da un punto di vista stilistico e collocati nel IV sec. d.C.[61]

Tale conclusione comporta una rimessa in discussione – ma non un drastico cambiamento – della scansione in fasi proposta da Stucchi per il quartiere dell'Agorà, che prevedeva, per i grandi complessi che invadono il centro della piazza, un'attribuzione alla fase di fine IV-inizio V sec. d.C., detta della rinascita sinesiana.[62]

La documentazione archeologica fornita a Cirene dalle recenti revisioni dei reperti ceramici del Ginnasio, dell'Agorà e di zone limitrofe[63] mostrerebbe che i cambiamenti che portarono alla nascita dei quartieri abitativi ebbero inizio già prima della fine del III sec. d.C. e che l'affermazione di Stucchi, che collocava la fine della vita dei quartieri stessi alla metà del V, nonostante piccole eccezioni,[64] possa essere ancora ritenuta valida.[65] La grande importanza che con tali studi ha acquisito la fase edificatoria della seconda metà del III sec. d.C. si riflette anche sulla cronologia dell'atelier di lucerne rinvenuto presso l'angolo sud-ovest del Ginnasio, che Luni collocò in principio tra fine IV e metà V sec. d.C.,[66] ma che, alla luce di tali revisioni, sembra potersi anticipare già alla seconda metà del III.[67]

Passando infine alla documentazione numismatica, recenti studi condotti da Michele Asolati sulla Cirenaica tardoantica e bizantina contribuiscono in modo decisivo a riscrivere

[58] Luni 1985, 268.

[59] Luni 1985, 259-276; Monacchi 1996, 227-236.

[60] Si tratta del "mosaico marmoreo a grandi tessere" della classificazione di Guidobaldi, Guiglia Guidobaldi 1983, 198-199.

[61] Venturini 2013, 41-42, 57-58; 2014, 259-261; diversamente in Stucchi 1965, 330-336, 341-342; 1975, 495.

[62] Stucchi 1965, 323-324.

[63] Una sintesi sugli ultimi studi è in Leone 2014, 289-290; nel dettaglio vd.: Ermeti 2006, 107-117; 2010, 295-304; Massa 2006, 103-106; 2010, 169-185; Panico 2006, 93-97.

[64] Ermeti 2010, 298.

[65] Ermeti 2010, 297, 300; vd. Stucchi 1965; 1967, 149-163.

[66] Luni 1985, 259-276. Sebbene Luni dichiari di non aver terminato lo studio del materiale, tuttavia egli asserisce che il tipo di lucerne trovi confronto con quello denominato comunemente Efeso-Mileto: in particolare le matrici rinvenute nel Cesareo di Cirene sarebbero state assimilabili sia per tipologia che per elementi decorativi con le lucerne del Cimitero dei Sette Dormienti di Efeso, soprattutto del tipo 1 e 6, databili nella seconda metà del IV sec. d.C. e talvolta fino anche agli inizi del V. Egli aggiunge che anche a Sabratha sono state recuperate alcune lucerne del tipo microasiatico, che, per la loro diversità dai prodotti locali, sono state considerate merce di importazione e riferite alla presenza di Bizantini (Joly 1974, 52-53). Sul tema vd. anche Massa 2006, 103-106; 2010, 169-185.

[67] Panico 2014, 285.

la storia economica e sociale della provincia rispetto all'immagine depressa tradizionalmente prospettata nella storia degli studi: proprio nel IV sec. d.C. emerge come la Cirenaica si inserisca in un circuito monetario mediterraneo, con attestazioni da ben 14 atelier di area non solo orientale – che comunque prevale, come ad esempio nel caso dell'officina di Alessandria – ma anche occidentale. Questo trend di inizio IV cresce ancora alla metà del secolo per poi calare a partire dal 364.[68]

IL CONTESTO URBANO

La documentazione archeologica raccolta negli ultimi quindici anni a Cirene consente di ampliare notevolmente la conoscenza delle ultime fasi di vita dell'area centrale della città grazie alla revisione di vecchi dati e soprattutto grazie ai nuovi scavi condotti in vari edifici, evidenziando l'uniformità residenziale e artigianale anche al di fuori delle due piazze esaminate, sia a nord che a sud della Skyrotà.[69]

A questo quadro possiamo aggiungere una torre che ingombrava il tracciato della Skyrotà e la cui presenza rimanda all'ipotesi formulata da Goodchild e Ward-Perkins, ma già accennata da Pernier,[70] della creazione di un sistema di fortificazione che si addossava ed includeva il Ginnasio. Ma viste le notizie del restauro dell'Arco Orientale sulla Skyrotà ad opera di Claudio il Gotico nella seconda metà del III sec. d.C., e forse nuovamente nella seconda metà del IV sec. d.C., il quartiere del Ginnasio, così come quello immediatamente a sud di esso, sarebbe sorto già prima convivendo con attività edilizie di committenza imperiale, per poi continuare a vivere grazie alla realizzazione di un sistema difensivo da cui sarebbe rimasto fuori il settore a sud della Skyrotà, forse da quel momento destinato a scopi più artigianali che residenziali, come recenti studi sull'area sembrano dimostrare.[71]

Lo stesso tuttavia non traspare per l'area dell'Agorà, a cui va aggregata la presenza, immediatamente a est, della Casa di Esichio, la dimora aristocratica meglio nota della Cirene tardoantica, che certamente non sarebbe potuta rimanere sguarnita in un contesto in cui l'abitare si fosse raccolto in spazi ristretti: siamo di fronte ad una carenza della documentazione o ad una diversa tipologia di insediamento?

CONCLUSIONI

In età tardoantica il fenomeno dell'invasione di precedenti spazi pubblici ad opera di quartieri abitativi o artigianali si può osservare in numerosi siti dell'Impero:[72] la dismissione di complessi monumentali con funzioni civili o religiose forniva infatti spazi e materiali per la creazione di nuovi edifici che rispondessero alle esigenze di abitati più concentrati.

Di grande rilevanza sono gli studi che negli ultimi anni sono stati dedicati alla legislazione che regolava i fenomeni dell'occupazione di edifici pubblici civili o religiosi, nonché al reimpiego dei loro materiali.[73] Nonostante i molti cambiamenti in tale ambito, in generale, la legislazione sembra indicare grande attenzione per il tentativo di controllare gli spazi pubblici venduti o affittati a membri dell'aristocrazia, i quali li avrebbero occupati o a loro volta affittati a clienti, riutilizzando poi in contesti privati i materiali da costruzione, specie se decorati.[74]

Il fenomeno urbanistico analizzato per Cirene, pur riscontrandosi in molti altri centri, non rappresenta una norma, come mostra la città di Tolemaide, dove il cosiddetto Piazzale delle Cisterne, il vecchio Ginnasio della città ellenistica, vive un esito diverso, con il mantenimento

[68] Asolati 2006, 181-186; 2010, 305-315; 2014, 311-332.

[69] Luni, Mei 2007, 35. Va ricordata a questo proposito anche l'occupazione a scopi domestici del Teatro 2, secondo quanto segnalato da Goodchild 1966-1967, 208 e poi ripreso da Lloyd 1990, 45.

[70] Relazione di scavo del 1935: Invernizzi 2014, 202; Luni 2014c, 149-153.

[71] Ringrazio Filippo Venturini per la condivisione di dati ancora inediti sulle attività produttive che si sarebbero installate nella vecchia area sacra tra i templi del Mosaico a Meandro e di Cibele presso il c.d. *Castellum Aquae*, nonché nell'Edificio a Sud dell'Insula di Giasone Magno. Su quest'ultimo contesto alcune informazioni sono già pubblicate in Venturini 2013, 39-40, 42, 60.

[72] Vd. anche Venturini 2013, 40-41; 2014, 259-261.

[73] Per una recente sintesi su tali questioni vd. Baldini Lippolis 2007, 197-238.

[74] Ellis 1998, 233-239; da ultimo vd. Leone 2013, 81-82.

di una funzione pubblica dello spazio.[75] Ma basta rivolgersi poco più ad ovest per riscontrare come nella seconda metà del IV sec. d.C., probabilmente ancora in conseguenza dei danni del terremoto del 365 d.C., a Leptis Magna vari spazi pubblici vengano riutilizzati per scopi abitativi. Le evidenze del fenomeno si hanno nel Foro Vecchio, nel Mercato, nel Teatro.[76] Gli stessi dati sono stati osservati a Sabratha nell'area del Tempio di Ercole,[77] mentre altre città africane, come Djemila e Thamugadi, testimoniano come l'area, se non interna, almeno intorno al foro, venga spesso preferita per impiantare quartieri residenziali.

Nel settore centro-occidentale dell'Impero dobbiamo rimarcare fenomeni di destrutturazione e discontinuità culturale maggiore e più precoce rispetto alle province orientali, con esiti diversi in vari contesti, tra cui ad esempio Luni, Cosa o Ostia.[78] A Roma le abitazioni di maggiore impegno si concentrano in quartieri tradizionalmente residenziali, sovrapponendosi spesso ad impianti precedenti non necessariamente di analoga funzione. Dal *Codex Theodosianus* tuttavia apprendiamo del divieto, relativo al 397 d.C., di costruire *casas seu tuguria* in Campo Marzio.[79] Ancora nei primi anni del VI sec. d.C. la richiesta di un privato di ampliare la propria dimora sopra la *Porticus Absidata*, all'estremità del Foro Transitorio, mostra come nelle grandi città le invasioni delle aree pubbliche fossero soggette ad un controllo da parte delle autorità.[80] Forme di occupazione, a partire dall'inizio del IV sec. d.C., del settore monumentale della città sono tuttavia evidenti, sebbene non solo con finalità residenziali, nel Templum Pacis, dove si impiantano attività commerciali, nel Foro di Cesare e in quello di Traiano, dove nel V sec. d.C. sorgono attività produttive.

In sintesi, il quadro tracciato per Cirene permette di inquadrare due diverse tipologie del fenomeno di occupazione di aree pubbliche. In un primo momento, dalla seconda metà del III alla fine del IV sec. d.C., si assisterebbe ad una forma di ripiegamento dell'abitato,[81] che per varie cause sia locali che generali, mostra segni di contrazione e impoverimento, mentre in un secondo momento, tra la fine del IV ed il V sec. d.C., saremmo dinanzi ad una riconversione più profonda delle aree, la cui primigenia funzione appare ormai privata di ogni significato.

Soffermandoci su questa seconda fase, osserviamo come l'esempio di Cirene mostri con chiarezza la complessità della rifunzionalizzazione di spazi, la cui nuova decorazione costituisce l'indicatore di un livello sociale elevato e permette di ripensare all'occupazione delle aree pubbliche in termini più articolati. Sembra dunque da ridiscutere, per gli esempi che ricadono in questa seconda tipologia, un'interpretazione del fenomeno come segno di decadenza.[82] La continuità di vita della città, testimoniata a Cirene anche dalle basiliche cristiane dislocate nel Quartiere Centrale e nel Quartiere Orientale,[83] andrebbe riconsiderata non solo attraverso la lettura delle dinamiche storiche, ma anche all'interno di un fenomeno di trasferimento delle funzioni pubbliche e politiche, che genera nuovi spazi e favorisce la trasformazione di altri, giungendo ad uno sviluppo policentrico della città.

Se all'origine di questi cambiamenti del tessuto urbano possiamo intravedere un allontanamento, seppure non volontario, dalle forme di adesione al potere centrale, osserviamo allo stesso tempo come gli esiti di tale allontanamento rientrino in un percorso ampiamente diffuso sui territori dell'Impero, che finisce col segnare la storia della stessa Roma.

[75] Caputo 1954, 33-66.

[76] Vd. Leone 2013, 103-105, per una discussione sulla sorte degli edifici pagani nell'Africa tardoantica; vd. anche Pentiricci 2010, 97-171. In generale, sulle trasformazioni delle città nell'Africa in età tardoantica vd. Leone 2007; Lepelley 1992, 50-76.

[77] Aiosa 2012, 23.

[78] Gering 2011a, 301-316; 2011b, 409-509.

[79] *Codex Theodosianus*, XII.14.1; vd. Manacorda 1993, 96; Venturini 2013, 41.

[80] Baldini Lippolis 2007, 102.

[81] Sul fenomeno, che investe in modo complessivo la regione e che è stato osservato in modo particolare a Berenice, vd. Jones 1985, 27-41; Lloyd 1985, 49-66; Lloyd 1989, 77-90.

[82] Del Moro 2013, 69; Ermeti 2010, 243-254.

[83] Alcuni dati ceramici che testimoniano un'occupazione del Quartiere Centrale sino al VI-VII sec. d.C. sono pubblicati in Del Moro 2010, 667-680.

BIBLIOGRAFIA

Aiosa, S. 2012. Cristiani fra le rovine. Ipotesi sul riuso del Tempio di Ercole a Sabratha. In Bonacasa Carra, R.M. (a cura di), *Pagani e Cristiani a Sabratha e Leptis Magna tra III e VI secolo d.C. Monumenti e reperti, tradizioni e immagini*, Palermo: Antipodes, 13-30.

Asolati, M. 2006. La documentazione numismatica a Cirene. In Luni, M. (a cura di), *Cirene "Atene d'Africa", I* (Monografie d'Archeologia Libica, 28), Roma: "L'Erma" di Bretschneider, 181-186.

Asolati, M. 2010. Cirene tardo antica e bizantina: un approccio numismatico. In Luni, M. (a cura di), *Cirene "Atene d'Africa", II. Cirene nell'Antichità* (Monografie d'Archeologia Libica, 29), Roma: "L'Erma" di Bretschneider, 305-315.

Asolati, M. 2014. Scoperte, riscoperte... dispersioni: tesori monetali a Cirene e in Cirenaica dall'attività di ricerca della Missione Archeologica di Urbino. In Luni, M. (a cura di), *Cirene "Atene d'Africa", VII. Cirene greca e romana* (Monografie d'Archeologia Libica, 36), Roma: "L'Erma" di Bretschneider, 311-332.

Bacchielli, L. 1981. *L'Agorà di Cirene, II.1. L'area settentrionale del lato ovest della Platea Inferiore* (Monografie d'Archeologia Libica, 15), Roma: "L'Erma" di Bretschneider.

Baldini Lippolis, I. 2007. Private spaces in Late Antique cities: laws and building procedures. In Lavan, L., Ozgenel, L., Sarantis, A. (a cura di), *Housing in Late Antiquity. From Palaces to Shops*, Leiden: Brill, 197-238.

Balice, M. 2010. *Libia. Gli scavi italiani, 1922-1933: restauro, ricostruzione o propaganda?* (Studia Archaeologica, 174), Roma: "L'Erma" di Bretschneider.

Bartolini, I.M. 2014. Luigi Pernier a Cirene (1925-1936). In Luni, M. (a cura di), *Cirene "Atene d'Africa", VIII. La scoperta di Cirene, un secolo di scavi (1913-2013)* (Monografie d'Archeologia Libica, 37), Roma: "L'Erma" di Bretschneider, 157-176.

Caputo, G. 1954. La protezione dei monumenti di Tolemaide negli anni 1935-1942, *Quaderni di Archeologia della Libia*, 3: 33-66.

Catani, E. 2003. L'attività archeologica di Luigi Pernier a Cirene dal 1925 al 1936, *Quaderni di Archeologia della Libia*, 18: 235-258.

Del Moro, M.P. 2010. Le produzioni a Cirene in età tardoantica. I contenitori di derrate alimentari dal Quartiere Centrale. In Milanese, M., Ruggeri, P., Vismara, C. (a cura di), *L'Africa Romana. I luoghi e le forme dei mestieri e della produzione nelle province africane. Atti del XVIII convegno di studio (Olbia, 11-14 dicembre 2008)*, Roma: Carocci, 667-680.

Del Moro, M.P. 2013. La cristianizzazione del Quartiere Centrale di Cirene. Problemi topografici, urbanistici e monumentali. In Cresci, S., Lopez Quiroga, J., Brandt, O., Pappalardo, C. (a cura di), *Atti del XV Congresso Internazionale di Archeologia Cristiana (Toledo 8-12.9 2008), Episcopus, civitas, territorium* (Studi di Antichità Cristiane, 65), Città del Vaticano: Arbor Sapientiae, 63-82.

Di Vita, A. 1982. Evidenza dei terremoti del 306-310 e del 365 in monumenti e scavi di Tunisia, Sicilia, Roma e Cirenaica, *Africa*, 7-8: 127-139.

Di Vita, A., Livadiotti, M. (a cura di) 2005. *I tre templi del lato nord-ovest del Foro Vecchio a Leptis Magna* (Monografie d'Archeologia Libica, 12), Roma: "L'Erma" di Bretschneider.

Ellis, S. 1998. Power-broking and the reuse of public buildings in Late Antiquity. In Cambi, N., Marin, E. (a cura di), *Radovi. XIII. Medunarodnog kongresa za starokršćansku arheologiju (Split – Poreń 1994). Acta XIII Congressus Internationalis Archaeologiae Christianae, pars III* (Studi di Antichità Cristiane, 54), Spalato: PIAC, 233-239.

Ensoli, S. 2003. La terrazza superiore dell'Agorà di Cirene. Il Tempio di Zeus e l'Arco Occidentale della Skyrotà, *Quaderni di Archeologia della Libia*, 18: 47-91.

Ermeti, A.L. 2006. Importazioni di vasellame fine da mensa tra tarda età ellenistica e fine età imperiale. In Luni, M. (a cura di), *Cirene "Atene d'Africa", I* (Monografie d'Archeologia Libica, 28), Roma: "L'Erma" di Bretschneider, 107-117.

Ermeti, A.L. 2010. Le ultime fasi di vita e l'abbandono del quartiere dell'Agorà di Cirene: l'evidenza della ceramica. In Luni, M. (a cura di), *Cirene "Atene d'Africa", II. Cirene nell'Antichità* (Monografie d'Archeologia Libica, 29), Roma: "L'Erma" di Bretschneider, 295-304.

Forti, S. 2009. Il contributo della documentazione del Fondo Caputo per la ricostruzione dell'attività archeologica italiana in Libia, *Quaderni di Archeologia della Libia*, 20: 171-177.

Forti, S. 2014. Giacomo Caputo e Gennaro Pesce a Cirene negli anni 1935-1942: due «archeologi militanti». In Luni, M. (a cura di), *Cirene "Atene d'Africa", VIII. La scoperta di Cirene, un secolo di scavi (1913-2013)* (Monografie d'Archeologia Libica, 37), Roma: "L'Erma" di Bretschneider, 265-286.

Gering, A. 2011a. Krise, Kontinuität, Auflassung und Aufschwung in Ostia seit der Mitte des 3. Jahrhunderts. In Schatzmann, R., Martin-Kilcher, S. (a cura di), *L'Empire romain en mutation : Répercussions sur les villes romaines dans la deuxième moitié du 3ᵉ siècle. Colloque international, Bern / Augst (Suisse), 3-5 décembre 2009*, Montagnac: Éditions Monique Mergoil, 301-316.

Gering, A. 2011b. Das Stadtzentrum von Ostia in der Spätantike. Vorbericht zu den Ausgrabungen 2008-2011, *Mitteilungen des Deutschen Archäologischen Instituts. Römische Abteilung*, 117: 409-509.

Goodchild, R.G. 1961. The decline of Cyrene and the rise of Ptolemais: two new inscriptions, *Quaderni di Archeologia della Libia*, 6: 83-95.

Goodchild, R.G. 1966-1967. A coin-hoard from Balagrae (El Beida) and the earthquake of AD 365, *Libya Antiqua*, 3-4: 203-212.

Goodchild, R.G. 1971. *Kyrene und Apollonia*, Zürich: Raggi Verlag.

Goodchild, R.G., Barr, F. 1968. *Geology and Archaeology of Northern Cyrenaica*, Amsterdam: Holland Braumelhof.

Guidobaldi, F., Guiglia Guidobaldi, A. 1983. *Pavimenti marmorei di Roma dal IV al IX secolo* (Studi di Antichità Cristiane, 36), Città del Vaticano: Pontificio Istituto di Archeologia Cristiana.

Invernizzi, L. 2014. Italo Gismondi a Cirene (1925-1938/1957). In Luni, M. (a cura di), *Cirene "Atene d'Africa",VIII. La scoperta di Cirene, un secolo di scavi (1913-2013)* (Monografie d'Archeologia Libica, 37), Roma: "L'Erma" di Bretschneider, 177-210.

Joly, E. 1974. *Lucerne del Museo di Sabratha* (Monografie d'Archeologia Libica, 11), Roma: "L'Erma" di Bretschneider.

Jones, B. 1985. Beginning and endings in Cyrenaican cities. In Barker, G., Lloyd, J.A., Reynolds, J. (a cura di), *Cyrenaica in Antiquity* (British Archaeological Reports, International Series, 236), Oxford: B.A.R., 27-41.

Leone, A. 2007. *Changing Townscapes in North Africa from Late Antiquity to the Arab Conquest*, Bari: Edipuglia.

Leone, A. 2013. *The End of the Pagan City: Religion, Economy, and Urbanism in Late Antique North Africa*, Oxford: Oxford University Press.

Leone, R. 2014, La ceramica a Cirene ed in Cirenaica (1913-2013). In Luni, M. (a cura di), *Cirene "Atene d'Africa",VIII. La scoperta di Cirene, un secolo di scavi (1913-2013)* (Monografie d'Archeologia Libica, 37), Roma: "L'Erma" di Bretschneider, 389-390.

Lepelley, Cl. 1992. The survival and fall of the classical city in Late Roman Africa. In Rich, J. (a cura di), *The City in Late Antiquity* (Leicester-Nottingham Studies in Ancient Society, 3), London: Routledge, 50-76.

Lloyd, J.A. 1985. Some aspects of urban development at Euesperides/Berenice. In Barker, G., Lloyd, J.A., Reynolds, J. (a cura di), *Cyrenaica in Antiquity* (British Archaeological Reports, International Series, 236), Oxford: B.A.R., 49-66.

Lloyd, J.A. 1989. Urban archaeology in Cyrenaica 1969-1989: the Hellenistic, Roman and Byzantine periods, *Libyan Studies*, 20: 77-90.

Lloyd, J.A. 1990. The cities of Cyrenaica in the third century AD. In Stucchi, S. (a cura di), *Giornata lincea sulla Archeologia Cirenaica (Roma, 3 novembre 1987)* (Atti dei convegni lincei, 87), Roma: Accademia Nazionale dei Lincei, 41-53.

Luni, M. 1985. Atelier di lucerne a Cirene. In Barker, G., Lloyd, J.A., Reynolds, J. (a cura di), *Cyrenaica in Antiquity* (British Archaeological Reports, International Series, 236), Oxford: B.A.R., 259-276.

Luni, M. 1987. Il Ginnasio-Caesareo nel Quartiere Monumentale dell'Agorà. In *Da Batto Aristotele a Ibn al – 'As: introduzione alla mostra*, Roma: "L'Erma" di Bretschneider, 41-46.

Luni, M. 1988. Il foro di Cirene tra secondo e terzo secolo. In Mastino, A. (a cura di), *L'Africa Romana. Atti del V convegno di studio (Sassari, 11-13 dicembre 1987)*, Sassari: Dipartimento di Storia – Università degli Studi di Sassari, 271-277.

Luni, M. 1994. Il Forum-Caesareum di Cirene e la moderna riscoperta, *Libyan Studies*, 25: 191-210.

Luni, M. 1998. La scoperta di Cirene – Atene d'Africa. In Catani, E., Marengo, S.M. (a cura di), *La Cirenaica in età antica. Atti del Convegno Internazionale di Studi, Macerata 18-20/05/95*, Pisa: Istituti editoriali e poligrafici internazionali, 319-350.

Luni, M. 2007. La Basilica nel Foro di Cirene. In Gasperini, L., Marengo, S.M. (a cura di), *Cirene e la Cirenaica nell'Antichità. Atti del Convegno Internazionale di Studi, Roma-Frascati 18-21 dicembre 1996*, Macerata: Edizioni Tored, 377-400.

Luni, M. (a cura di) 2014a. *Cirene "Atene d'Africa", VIII. La scoperta di Cirene, un secolo di scavi (1913-2013)* (Monografie d'Archeologia Libica, 37), Roma: "L'Erma" di Bretschneider.

Luni, M. 2014b. Il primo decennio di scavi a Cirene. Ettore Ghislanzoni (1913-1923). In Luni, M. (a cura di), *Cirene "Atene d'Africa",VIII. La scoperta di Cirene, un secolo di scavi (1913-2013)* (Monografie d'Archeologia Libica, 37), Roma: "L'Erma" di Bretschneider, 43-80.

Luni, M. 2014c. Attività di Carlo Anti, Luigi Pernier e Gaspare Oliverio (1923-1938). In Luni, M. (a cura di), *Cirene "Atene d'Africa",VIII. La scoperta di Cirene, un secolo di scavi (1913-2013)* (Monografie d'Archeologia Libica, 37), Roma: "L'Erma" di Bretschneider, 123-156.

Luni, M., Cellini, G.A. 1999. L'abside della Basilica nel Foro di Cirene ed i due gruppi di sculture, *Karthago*, 24: 27-73.

Luni, M., Lanari, E. 2014. Da G. Pesce a R. Goodchild e S. Stucchi (1939-1957). In Luni, M. (a cura di), *Cirene "Atene d'Africa", VIII. La scoperta di Cirene, un secolo di scavi (1913-2013)* (Monografie d'Archeologia Libica, 37), Roma: "L'Erma" di Bretschneider, 233-264.

Luni, M., Mei, O. 2007. Tempio con arco siriaco "delle Muse" presso l'Agorà di Cirene, *Karthago*, 27: 31-77.

Manacorda, D. 1993. Roma: i monumenti cadono in rovina. In Carandini, A., Cracco Ruggini, L., Giardina, A. (a cura di), *Storia di Roma, 3. L'età tardoantica, 2. I luoghi e le culture*, Torino: Giulio Einaudi Editore, 93-104.

Massa, S. 2006. Il vasellame d'uso comune a Cirene tra l'età ellenistica e la fine dell'età romana. In Luni, M. (a cura di), *Cirene "Atene d'Africa", I* (Monografie d'Archeologia Libica, 28), Roma: "L'Erma" di Bretschneider, 103-106.

Massa, S. 2010. Tradizioni quotidiane a Cirene tra l'età ellenistica e il tardo antico: il vasellame d'uso comune. In Luni, M. (a cura di), *Cirene "Atene d'Africa", II. Cirene nell'Antichità* (Monografie d'Archeologia Libica, 29), Roma: "L'Erma" di Bretschneider, 169-185.

Monacchi, W. 1996. Tracce di abbandono nel quartiere del Foro di Cirene. In Bacchielli, L., Bonanno Aravantinos, M. (a cura di), *Scritti di antichità in memoria di Sandro Stucchi, Volume 1* (Studi Miscellanei, 29), Roma: "L'Erma" di Bretschneider, 227-236.

Panico, C. 2006. Le lucerne. In Luni, M. (a cura di), *Cirene "Atene d'Africa", I* (Monografie d'Archeologia Libica, 28), Roma: "L'Erma" di Bretschneider, 93-97.

Panico, C. 2014. Importazioni e produzione locale di lucerne in età romana a Cirene. In Luni, M. (a cura di), *Cirene "Atene d'Africa", VII. Cirene greca e romana* (Monografie d'Archeologia Libica, 36), Roma: "L'Erma" di Bretschneider, 269-294.

Pentiricci, M. 2010. L'attività edilizia a Leptis Magna tra l'età tetrarchica e il V secolo: una messa a punto. In Tantillo, I., Bigi, F. (a cura di), *Leptis Magna. Una città e le sue iscrizioni in età tardoromana*, Cassino: Università degli Studi di Cassino, 97-171.

Purcaro, V. 2000. *L'agorà di Cirene, II.3. L'area meridionale del lato ovest* (Monografie d'Archeologia Libica, 24), Roma: "L'Erma" di Bretschneider.

Rekowska, M. 2013. Dangerous liaisons? Archaeology in Libya 1911-1943 and its political background, *Światowit*, 11 (52)/A: 9-26.

Reynolds, J. 1977. The cities of Cyrenaica in decline. In *Thèmes de recherche sur les villes antiques d'Occident. Actes du colloque, Strasbourg, 1er-4 octobre 1971* (Colloques internationaux du Centre national de la recherche scientifique, 542), Parigi: Éditions du CNRS, 53-58.

Santucci, A. 2012. Antichità Cirenaiche e propaganda politica del primo Novecento (1911-1943), *Revista de Historiographía*, 17/9.2: 88-106.

Spagnulo, F. 1996. Documenti dell'archivio Breccia relativi alla Cirenaica, *Studi Ellenistici*, 8: 203-219.

Spagnulo, F. 1997. Ripostiglio di Cirene in un manoscritto dell'Archivio Breccia, *Annali dell'Istituto Italiano di Numismatica*, 44: 323-348.

Stucchi, S. 1965. *L'Agorà di Cirene, I. I lati nord ed est della platea inferiore* (Monografie d'Archeologia Libica, 7), Roma: "L'Erma" di Bretschneider.

Stucchi, S. 1967. *Cirene 1957-1966. Un decennio dell'attività della Missione Archeologica Italiana a Cirene*, Tripoli: Istituto Italiano di Cultura.

Stucchi, S. 1975. *Architettura Cirenaica* (Monografie d'Archeologia Libica, 9), Roma: "L'Erma" di Bretschneider.

Stucchi, S. 1992. Gli anni di Carlo Anti a Cirene. In *Giornate di studio su Carlo Anti nel centenario della nascita (Verona – Padova – Venezia, 6-8 marzo 1990)*, Trieste: Lint Editoriale, 49-128.

Stucchi, S., Bacchielli, L. 1983. *L'Agorà di Cirene, II.4. Il lato sud della platea inferiore ed il lato nord della terrazza superiore* (Monografie d'Archeologia Libica, 17), Roma: "L'Erma" di Bretschneider.

Tiradritti, F. 2014a. Of kilns and corpses: Theban plague victims, *Egyptian Archaeology*, 45: 15-18.

Tiradritti, F. 2014b. Epidemia di Cipriano: le prove sono in Egitto, *Archeologia Viva*, 168: 40-51.

Traina, G. 1989. Fra archeologia, storia e sismologia: il caso emblematico del 21 luglio 365 d.C. In Guidoboni, E. (a cura di), *I terremoti prima del Mille in Italia e nell'area mediterranea*, Bologna: SGA, 449-451.

Venturini, F. 2013. *Cirene "Atene d'Africa", V. I mosaici di Cirene di età ellenistica e romana* (Monografie d'Archeologia Libica, 34), Roma: "L'Erma" di Bretschneider.

Venturini, F. 2014. La produzione musiva cirenea nel Mediterraneo alla luce di nuovi dati. In Luni, M. (a cura di), *Cirene "Atene d'Africa", VII. Cirene greca e romana* (Monografie d'Archeologia Libica, 36), Roma: "L'Erma" di Bretschneider, 241-267.

Ward-Perkins, J.B., Ballance, M., Reynolds, J.M. 1958. The Caesareum at Cyrene and the Basilica at Cremna, with a note on the inscriptions of the Caesareum, *Papers of the British School at Rome*, 26: 137-194.

White, D. 1996. Fresh reverberations from Cyrene's later antique earthquakes. In Bacchielli, L., Bonanno Aravantinos, M. (a cura di), *Scritti di antichità in memoria di Sandro Stucchi, Volume 1* (Studi Miscellanei, 29), Roma: "L'Erma" di Bretschneider, 317-325.

Wilson, A.I. 2001. Urban economies of Late Antique Cyrenaica. In Kingsley, S., Decker, M. (a cura di), *Economy and Exchange in the East Mediterranean during Late Antiquity. Proceedings of a Conference at Somerville College, Oxford, 29th May, 1999*, Oxford: Oxbow Books, 28-43.

Wilson, A.I. 2004. Cyrenaica and the Late Antique economy, *Ancient West and East*, 3.1: 143-154.

PART III

PERCEPTION AND REPRESENTATION OF POWER, ETHNIC AND CULTURAL IDENTITIES

8

ROMAN IMPERIALISM IN AFRICA FROM THE THIRD PUNIC WAR TO THE BATTLE OF THAPSUS (146-46 BC)

Matthew Simon Hobson

Abstract

This paper attempts to use literary, archaeological and epigraphic evidence to tackle the issue of Roman imperialism in North Africa in the decades before the destruction of Carthage and in the century which followed. Specific attention is paid to coin and ceramic distributions, the *Lex agraria* of 111 BC, and the relationship between the northern centuriation group and the founding of the Gracchan colony. The conclusion is that there was a greater level of interest and activity in former Carthaginian territory in the decades immediately following 146 BC than is often assumed.[1]

'The Romans held fast the territory which Carthage had possessed at its fall, but less in order to develop it for their own benefit than to prevent its benefiting others, not to awaken new life there, but to watch the dead body [...] The land was, as a matter of course, turned to full account by Roman speculation; but neither might the destroyed great city rise up afresh, nor might a neighbouring town develop into a similar prosperity.'

(Mommsen 1886, 306-307)

How much do we know about the motivations and consequences of Roman imperialism in North Africa from the outbreak of the Third Punic War to the close of the civil war between Caesar and Pompey?[2] Some classical authors saw the destruction of Carthage as a crucial turning point in the development of the Roman state, after which only moral degradation and decline followed.[3] Our evidence base for this period is fragmentary, and consequently there remains disagreement about the level of interest Rome initially showed in its newly gained lands in North Africa. There is some distance, for example, between the account of the post-146 BC situation in Africa given above by Mommsen and that of Whittaker. In an article which has been particularly influential, Whittaker used insights derived from ethnographic work of the nineteenth and twentieth centuries to play down the impact of the Roman conquest. Neither the Carthaginians nor the Romans,

[1] I would like to thank D.J. and H.B. Mattingly for bringing to my attention to some of the recent work on the *Lex agraria* and L. de Ligt and A. Lintott, for answering a number of my questions regarding the African section. P.H.A. Houten and B.L. Noordervliet made the creation of Figure 8.1 possible. I am also grateful to E. Fentress for offering useful comments on an earlier version of this paper, and to K. Pazmany and S. Penders for their invaluable proof reading. Finally, I thank the conference organizers and participants for a stimulating conference.
[2] On Roman imperialism, in chronological order: Mommsen 1901; Frank 1914; Badian 1968; Harris 1979; North 1981; Crawford 1992; Sidebottom 2005.
[3] Polybius, *Historiai*, XVIII.35; Sallust, *De Catilinae coniuratione*, X.1-2; *Bellum Iugurthinum*, XLI.2-3; *Historiae*, I.12; Harris 1979, 127-128; Wood 1995, 176-182.

nor later the Arabs, he maintained, had the power to transform the relations of land and labour which had existed for some centuries before the Second Punic War, which were the result of the basic geographical prerequisites of the North African territories, and which had only begun to be altered in the modern era by French colonial intervention[4] Today such environmental determinism finds fewer supporters but, even in the many works which allow for a little more social and economic change, the founding of official Roman communities by Caesar and Octavian-Augustus is often seen as marking the real beginning of 'Roman' North Africa.[5] Indeed, the one hundred years between the destruction of Carthage in 146 BC and Caesar's victory over the remainder of the Pompeian forces at Thapsus in 46 BC, which will be the focus of this paper, are sometimes argued to have seen almost no Roman intervention of any kind.[6] In attempting to grapple with both the intentions and consequences of Roman actions, this paper begins by examining the literary evidence outlining the reasons for the outbreak of the Third Punic War and the Roman decision to destroy Carthage, before moving on to focus a little more closely on the possible contributions which archaeology and epigraphy can make to the interpretation of the aftermath. Geographically the focus is restricted to the region of Carthage's former territory and to some broader stretches of the North African coastline.

ROMAN AND CARTHAGINIAN INTENTIONS AT THE OUTBREAK OF THE THIRD PUNIC WAR

Appian, for a long time viewed as a mere compiler,[7] provides the only complete extant narrative of the Third Punic War and Carthage's final destruction.[8] His account breaks off abruptly in 146 BC and there has been a voluminous body of literature produced, mainly by ancient historians, which attempts to divine not only the real causes that lay behind Rome's declaration of war but also the precise opinions of the ancient writers regarding its onset.[9] Unfortunately this endeavour has never been particularly fruitful. The accounts of Livy and Polybius have survived only partially: a few meagre fragments of the relevant books of Polybius and extremely concise summaries of Livy which are missing most of the detailed argumentation once contained.[10] A larger problem concerns whether or not it is possible to ascribe a uniform system of desires and motivations to Roman foreign policy during this period. Modern scholars have noted that victory in the Hannibalic War marked something of a watershed; the accumulation of a Mediterranean empire qualitatively altered both the internal functioning of the Roman oligarchy and the way in which that oligarchy managed its relations with foreign powers.[11] Certainly between the end of the Hannibalic War and 146 BC there was consistency in terms of a general Roman hostility towards Carthage. Control of the Roman state was however being fought over by conflicting oligarchic factions whose political goals with regard to foreign policy shifted rapidly in accordance with the altering fortunes of both their political allies and opponents. Particularly after 146 BC, Roman aristocrats became increasingly entangled in an expanding socio-political sphere, in which new strategies for acquiring political support through networks of foreign *clientelae* were being developed, and in which actual military force and violence became ever more frequently used.[12] Alliances with various disenfranchised groups, Italian or otherwise, and even use

[4] Whittaker 1978, 331.

[5] Stone (2013, 507-511) provides a brief historiographical overview. See also, in order: Gsell 1928, 120; Le Glay 1968, 202; Bénabou 1976, 25-26; Lassère 1977, 142; Février 1989, 93-98; Quinn 2003; 2004; Briand-Ponsart 2005, 96; Fentress 2006.

[6] Fentress 2006, 22; Quinn 2003, 32.

[7] Smith 1913, 338.

[8] Appian, *Punica*. Appian's account does have its own originality and agenda.

[9] In chronological order: Duruy 1883, 201, note 1; Frank 1914, 234-237; Gelzer 1931; Saumagne 1931; Adcock 1946; Hoffman 1960; Marotti 1983; Vogel-Weidemann 1989; Baronowski 1995; Limonier 1999; O'Gorman 2004.

[10] The difficulties of recovering the essence of Polybius are compounded by the fact that the first 36 books of Cassius Dio only survive in fragments. This leaves us reliant upon the twelfth-century Byzantine chronicler Zonaras (*Epitome Historiarum*, IX.26-30).

[11] Crawford 1992, 68-79.

[12] Marius' veterans in North Africa, to which he fled, being a prime example (Appian, *Bellum Civile*, I.62). More generally, Appian *Bellum Civile*, I-II; Badian 1958; Brunt 1971.

of the legions in open civil war became common, making the pursuance of a consistent policy towards North Africa extremely difficult, if not impossible.[13] Nonetheless, at various stages in the political struggle between *optimates* and *populares*, the different factions would have had clear ideas about what they wanted to achieve, even if their efforts were frustrated by their political opponents or by other unforeseen circumstances. Appian's account does include a debate in the senate in which Scipio Nasica argues that Carthage should be allowed to exist in order that Roman discipline might be preserved through continued fear of her, but it has been impossible to arrive at agreement about whether or not this story is a later, anachronistic addition.[14]

Fear in general has for too long taken pride of place among modern explanations for Rome's decision to utterly destroy her old enemy. Yann le Bohec has recently pointed out that the Third Punic War was a military conflict of completely different nature to the First and Second Punic wars. Indeed, to describe it as a 'war' in the same terms as those which came before is really a serious misrepresentation of the facts.[15] In the middle of the second century BC Carthage could not hope to compete with Rome in terms of military strength. Appian informs us that before the beginning of the siege there was a general rush of both Roman citizens and allies to join the forces crossing from Sicily to Utica, so certain were they of the successful outcome of the war, and no doubt of the possible riches to be won in connecting themselves with the right people once landed in North Africa.[16] Although after Scipio Aemilianus received command most of the profiteering element was supposedly removed from the military camps,[17] one can imagine the sorts of deals being struck between the local aristocracy at Utica and those seeking to make or increase their fortunes in the aftermath of the invasion. There must have been sufficient connections among the important men of Utica and the Roman aristocracy to convince the town to throw in its lot with Rome and offer its harbours and numerous good landing places to the invasion fleet.[18] That the Carthaginians felt that they could not hope to emerge successfully from any kind of open conflict with Rome is indicated by the readiness of the Carthaginian people and their envoys to submit themselves entirely to Rome's conditions following their recent defeat by Massinissa. Carthage had no allies, no fleet, and had lost many thousands of men in this most recent conflict.

Why the Carthaginians had chosen so disastrously to attempt to settle their old territorial disputes with the wily Numidian king at this precise juncture is unclear. For nineteenth-century scholars such as Niebuhr and Mommsen an explanation lay in the fact that Carthage had become a wild democracy in the post-Hannibalic age, incapable of reforming her military practices or of formulating and carrying out an appropriate foreign policy.[19] Polybius is the main source of this opinion, but the sycophancy of his statements cannot be doubted, and since the passage appears in the context of a rigidly formulaic system which sees all states achieving a period of growth, apogee, and decline, we cannot be certain that Carthage had become any more democratic than it had been in earlier periods.[20] Appian certainly describes the development of a democratic faction prior to the outbreak of war, but his comments, perhaps drawn from and in the same vein as those of Polybius, flavour of a sycophantic desire to appeal to the strong distaste which the Roman aristocracy continued to hold for democratic forms of government.[21] It must be significant that the war with Massinissa came after the fifty-year period during which Carthage had to pay the annual indemnity of silver talents to Rome had elapsed. Could it be that the Carthaginians also envisaged that other conditions of the post-Hannibalic war treaty should also be lifted at this time? Whether or not leading Carthaginians were tricked into thinking a military expedition against Massinissa would now be viewed as acceptable in Rome, or whether popular support for a war against the

[13] Broughton 1929, 44.

[14] Appian, *Punica*, 69.

[15] Le Bohec 2011.

[16] Appian, *Punica*, 75.

[17] Appian, *Punica*, 115-116. Some appear to have been allowed to remain.

[18] Appian, *Punica*, 75. Significantly Caesar chose Utica as the place to sell off the African estates he had confiscated from the defeated Pompeian officers (*Bellum Africum*, 97).

[19] Mommsen 1870, 36, 41; Niebuhr 1852-1853, 232; 1875, 230-231.

[20] Polybius, *Historiai*, VI.2.

[21] Appian, *Punica*, 68 and 70.

Numidian king became uncontrollable, is impossible to tell. For Rome's part it certainly seems more than suspicious that war was declared more or less as soon as Carthage had stopped providing her this significant annual revenue.

Whatever the truth of the matter, the Roman senate clearly represented the military action by Carthage as a serious break from the terms of the treaty, and many later scholars have seen this as a more than adequate juridical reason for Rome to declare war.[22] But in the surviving fragments we do have of Polybius' account he is relatively unequivocal about the fact that the Roman state, or a certain faction amongst the ruling aristocracy, had been determined to destroy Carthage long before the calamity of the war with Massinissa. He states that many years before the events which provided the eventual pretext occurred, war had been resolved upon; the only hesitation being caused by a concern not to go to war without a justifiable pretext.[23] Appian states much the same, and Livy concurs that the Roman senate was already generally hostile towards Carthage.[24]

That the Roman aristocracy was both fearful of a resurgence of Carthaginian power and eager to profit more directly from such diligently cultivated lands has found some support in previous accounts,[25] but there is also a long tradition denying that there was any strong greed or desire for profit connected with the decision to destroy the city.[26] Some possible early intentions towards the appropriation of Carthaginian land, however, may be gleaned from the fact that child hostages of Carthaginian nobles were taken before the crossing of the invasion fleet from Lilybaeum. While this no doubt secured an unmolested landing on North African shores,[27] it may also be taken to indicate awareness that indigenous nobles, brought up to be multilingual and sympathetic to the Roman cause, would be potentially useful in the later management of Carthaginian territory. This was certainly the way Rome later dealt with the creation of friendly kings, particularly in the case of Juba II, who was brought up at Rome before later being implanted as king of Mauretania by Augustus.[28] The senate's decision to commission the translation of a Carthaginian agricultural manual written by Mago has often been taken to indicate the high esteem in which Carthaginian agriculture was held, and that there was an interest among the Roman aristocracy in applying its precepts to Italian soils.[29] A more straightforward conclusion is that the senate wished to aid prospective buyers of African land in becoming acquainted with the agricultural potential of the region, and this argument indeed has also often been put forward.[30] Precisely where the reality lies between Mommsen's full Roman speculation and Whittaker's seamless continuity, therefore, remains open to question.

ROMAN AIMS FOLLOWING 146 BC: AN ARCHAEOLOGICAL APPROACH

After the destruction of Carthage the seven cities which had taken the Roman side in the Third Punic War retained their territories and their municipal freedom, while four cities that had remained loyal to Carthage were destroyed.[31] A part of the new territory was given to a couple of thousand deserters from the Carthaginian cause, and to members of the Numidian royal houses.[32] With regard to the active settlement of Roman citizens in Africa, the Gracchan colony of the 120s has often been represented as a total failure and the evidence for the viritane

[22] Saumagne 1931.

[23] Polybius, *Historiai*, XXXVI.2.

[24] Appian, *Punica*, 69; Livy, *Periochae*, 48.

[25] Carcopino 1929, 92-93; Rostovtzeff 1957, 316-317.

[26] In order: Frank 1914, 237; Broughton 1929, 14-15; Haywood 1938, 3; Thompson 1969, 133; Desanges 1978, 628.

[27] Smith 1913, 358.

[28] Braund 1984; Creighton 2006, 14-19.

[29] Translation: Pliny, *Historia Naturalis*, XVIII.22; cf. Varro, *De Re Rustica*, I.10; Heurgon 1976. For use in Italian agriculture: Harris 1989, 148; Heitland 1918, 36; Toynbee 1965, 164, note 3.

[30] Broughton 1929, 27, note 65; Desanges 1978, 627-628; Haywood 1938, 5; Wilson 1966, 51.

[31] The free cities of Utica, Hadrumetum, Thapsus, Leptis (Minor), Acholla, Uzalis, and Teudalis are mentioned in *Lex agraria*, l.79 (Crawford 1996, 121). Those destroyed, Tunis, Neapolis, Clupea, and Neferis are listed by Strabo (*Geographia*, XVII.3.16).

[32] Appian, *Punica*, 100 and 108; Livy, *Periochae*, 50; *Lex agraria*, l.76. After 111 BC we hear no more of significance of the Carthaginians in the sources. One significant exception is in Cicero's writings (*Disputationes Tusculanae*, III.22). Nicolet 1966 discusses other enigmatic literary references at the time of the Social War.

settlement of Marius' Gaetulian veterans two decades later is often seen as questionable.[33] Few Roman troops, if any, appear to have been stationed in Africa at the outbreak of the Jugurthine War (112 BC)[34] and the lack of Roman coins minted there before the beginning of the civil war between Caesar and Pompey has been seen as suggesting a generally low administrative presence. A mere five Latin inscriptions predating 46 BC have been found in North Africa, and they have a restricted distribution between Cap Bon and Utica.[35] These are the traditional arguments of what I will loosely term here the minimalist position.[36]

The most forceful statements in support of this school of thought were provided a little over a decade ago by Josephine Quinn, who, in examining the archaeological evidence available for the period of the first hundred years after the conquest, stated that a lack of evidence for Roman influence may be beginning to confirm the traditional attitude of ancient historians that Roman Africa was initially 'abandoned to decline' after 146 BC.[37] While the introduction of archaeological evidence into a sphere of research which has traditionally been dominated by works drawing almost exclusively on literary and epigraphic sources is most certainly to be welcomed,[38] one of the disappointing aspects of Quinn's analysis is that it is for the most part an *argumentum ex silentio*. In other words it is the absence of a range of different material culture forms that leads Quinn to the conclusion that there was very little direct Roman intervention in North Africa until much later.[39] Quinn makes her argument in the context of a critique of the paradigm of Romanization, although – it has to be said – more by arguing away Roman influence entirely than by adopting a self-consciously postcolonial perspective.

There is however more to Quinn's arguments than a reassessment of outmoded models of the colonial period, or a simple rehearsal of the old minimalist arguments. For in arguing both that the *Fossa Regia* may not have constituted any kind of real juridical boundary at all immediately following 146 BC, and that the *Lex agraria* of 111 BC indicates a lack of any organized intervention in the region before its enactment, she takes the argument to a new level.[40] The most questionable of her assertions is that the bulk of the northern centuriation group is likely to be Augustan in date.[41] Here Quinn rather brusquely dismisses the arguments made by Chevalier and Caillemer in the 1950s that this programme of land survey should be dated to the period of the Gracchan colony, and passes over more recent work which argues quite plausibly that the vast majority of the centuriation work may have taken place during the second half of the second century BC.[42] I shall attempt here to argue for a slightly different view of Rome's early influence in North Africa, focusing on Roman imperialism rather than on the processes of cultural transformation or on the impact of modern identity politics. I argue that it is necessary to rethink the implications of the repeal of the *Lex Rubria*, the law which was intended to establish a Roman colony in former Carthaginian territory during the late 120s BC.[43] Recent discussion of the fragmentary epigraphic *Lex agraria* of 111 BC,[44] in combination with the current thinking on the centuriation schemes of northern Tunisia, provides a new context for this discussion.[45] The idea is put forward that the Gracchan colony, far from

[33] Badian (1958, 199) describes the evidence as 'abundant', while Brunt (1987) minimizes it. For a discussion of the evidence, see Hobson 2015, 44-49.

[34] Sallust, *Bellum Iugurthinum*, XXVII.5. Calpurnius gathered an army before transporting it to Africa – not necessarily proof that there was no Roman standing force in Africa. Orosius (*Historiarum adversum Paganos*, V.11) mentions at least 30,000 soldiers who died while stationed at Utica in 124/125 BC.

[35] Quinn 2003, 16, 30.

[36] Such arguments developed as a counterpoint to the works of Mesnage (1913, 35-40), Rostovtzeff (1957, 554, note 32), and others, who assumed large-scale Italian emigration to Africa during the Republic.

[37] Quinn 2003, 15.

[38] Shaw 1980, 33.

[39] Quinn 2003, 32.

[40] Quinn 2004, 1598 and 1601.

[41] Quinn 2003, 30; 2004, 1601.

[42] Caillemer and Chevalier 1957; 1959; Chevalier 1958; Peyras 1998; 1999; Ouni and Peyras 2002. Earlier discussion in Carcopino (1929, 92; 1967, 295, note 60) and Saumagne (1929, 308-309).

[43] Appian, *Bellum Civile*, I.24; Plutarch, *Caius Gracchus*, 10; Velleius Paterculus, *Historiae*, II.7. *Lex agraria*, ll. 55, 59, 60, 61 and 79.

[44] Crawford 1996, 113-180; De Ligt 2003; 2007b; Lintott 1992.

[45] Ouni and Peyras 2002.

being an almost total failure which had little impact on the region, was in fact instrumental in the development of the pattern of landholding in the province and which later made Africa famous for its incredibly wealthy landowners. Before moving on to discuss the issues of centuriation and colonization, I will first deal with some of the archaeological evidence for the economic condition of North Africa during this period.

PRODUCTION AND TRADE

One of the newer elements in the minimalist argument has been the attempt to use knowledge of ceramic production and distribution to suggest that following the city's destruction there was a major collapse of economic activity, and that this economic vacuum was of particular benefit to the coastal towns of the Tunisian Sahel.[46] The main evidence marshalled in support of this model was that the van der Werff 1 amphora type, made around Carthage from the fourth century BC, may have ceased production around the time of the Third Punic War; the coastal sites of the Tunisian Sahel by contrast continued to produce amphorae of the van der Werff 2 type throughout the first century BC.[47] While archaeological survey work conducted on the isle of Djerba certainly has found evidence for a thriving villa economy during this period,[48] it has also been clear for some time that later variants of the van der Werff 1 demonstrate continuity of production in the Carthage area perhaps into the first century AD.[49] Recent excavation work at Utica also suggests the continued production of variants there throughout the first century BC.[50] Even more significant is the recent discovery that the African republican amphora type, produced from the mid-second century BC and continuing throughout the first century BC, once called 'Tripolitana antica', in fact seems to have had its production centres in the Carthage-Utica region and not in Tripolitania.[51] The supporting evidence comes from a dump of amphora and coarseware sherds associated with a pottery workshop at Mnihla, not far from Tunis,[52] and from fabric analysis conducted on what are probably residual sherds of the same amphora form in layers of the first century AD recovered during the recent Nuovo Mercato Testaccio excavations in Rome.[53] The dump at Mnihla is made up of approximately 80 per cent van der Werff 1 (Maña C2) and about 19 per cent of the amphora type now suggested to be called 'Africana antica'.

Another part of the minimalist argument based on archaeology has been the observation that the limited amount of survey work conducted in the region of Carthage's former territory, in the bay of Utica, on Cap Bon and in the Segermes valley, has recorded few sites with black gloss wares datable between 146-46 BC.[54] The argument was always rather ambivalent.[55] Quinn noted a significant decline in the number of occupied sites after 146 BC in the Tunisian-French survey conducted in the bay of Utica, but at the same time bemoaned the problems associated with attempting to draw such fine chronological conclusions from poorly dated black gloss wares.[56] One might also add that the complex processes of alluviation at work in that region probably also make quantitative exercises based on the number of sites problematic (Utica, once a port, now lies several kilometres inland). Clearly advances in the understanding of amphora and coarseware production are beginning to demonstrate that the region continued to be actively involved in production and export.[57] Both van der Werff 2 and 'Africana antica' amphora types have been found in shipwrecks associated with Italian amphora forms Lamboglia 2 and Dressel 1.[58] Regardless of whether or not this demonstrates

[46] Van der Werff 1977-1978; 1982; Baldassari and Fontana 2002, 975; Quinn 2003, 31, note 125; Pasa 2009, 273.
[47] Callegarin 2005, 177-178.
[48] Fentress 2000; 2001; Fentress *et al.* 2009. Survey around Thugga (De Vos Raaijmakers and Attoui 2013) records fewer late republican than early imperial sites, but the ceramics are not yet published (Hobson 2014).
[49] Freed 1998, 33-35.
[50] Anastasi and Leitch 2012, 25.
[51] Capelli and Contino 2013.
[52] Ben Jerbania 2013, 179-180.
[53] Capelli and Contino 2013.
[54] Quinn 2003, 12, note 25; 15, note 44.
[55] See, for example, Dossey 2010, 41-43.
[56] Our understanding of the 'imitation' black gloss wares is embryonic (Bridoux 2008).
[57] Leitch 2008; 2010; 2011; 2013.
[58] Callegarin 2005, 178; Fontana *et al.* 2009, 277; Ben Jerbania 2013, 189.

the channelling of African products through Italian *negotiatores*, it indicates a vibrant level of activity across the entirety of the newly conquered territory and not just amongst the ports of the Sahel.

The evidence of the bronze coinage also seems to give an indication of continued trade between North Africa and other parts of the Mediterranean. In the former Carthaginian territory a huge mass of previously minted local coins continued in circulation after 146 BC. An assemblage of 277 coins from recent excavations at the sanctuary of Henchir el Hami, thought to have been deposited for the most part between 100 BC and AD 100, indicates that Carthaginian bronze coins minted even before the beginning of the second century BC continued to circulate for a long period and in large numbers. Alongside these was an even greater number of bronze coins of Massinissa, which had been produced on an enormous scale from around 200 BC onwards, and which continued to be produced in similar forms under his immediate successors.[59] Potentially more significant is the smaller number of coins plausibly, although not definitely, produced at Utica from sometime after the battle of Zama, which also formed part of the inherited bronze coinage of this period.[60]

Other cities of the North African littoral including Hadrumetum, Iol, Icosium, Lixus, and Tingi also appear to have struck coinage from the time of the Second Punic War onwards (Lepcis Magna possibly from c. 108 BC)[61] and this is perhaps one of the clearest indications of the breaking up of Carthaginian hegemony in the region, alongside the influx of Campanian black gloss ware to the coastal towns which also began at that time.[62] The imagery on the 'Utican' coinage just mentioned is of the Dioscures, Castor and Pollux, possibly. According to Alexandropoulos, this may further demonstrate the newly established foothold of Roman power in North Africa through this symbolic shift in coin motif. The issues of Massinissa and his successors are found widely distributed in the western Mediterranean but this is not the case with the city coinages.[63] These municipal issues were produced in smaller volumes and are not so often found in other parts of the Mediterranean.[64] What is interesting, however, is the significant amount of coins minted on the Iberian Peninsula which are found in Mauretania, further demonstrating direct trade links across the Mediterranean (Figure 8.1). Any conclusions drawn have to be preliminary but it appears that more coins from Gades reached Atlantic Morocco and the region of the Straits of Gibraltar than the more eastern parts of North Africa, whereas coins from Ebusus on Ibiza are comparatively well represented at Iol. North African coins are also found on the Iberian Peninsula, but in smaller quantities.[65] In terms of the internal circulation of the North African coinages, it seems that coins struck in western Mauretania rarely reached the central and eastern parts of North Africa and the same was true vice versa.[66]

Coins of a specifically Roman type were not minted in Africa until the time of the civil war between Caesar and Pompey, and very few Republican bronzes appear to have seen contemporary use in Africa.[67] Dossey has argued for a longer period of economic decline based on the greater number of coins datable to the third-first centuries BC compared to those of the first and second centuries AD from the excavations at the fortified village of Castellum Tidditanorum.[68] True municipal coin striking on the Roman model existed in North Africa only briefly, beginning under Augustus in a number of towns in Proconsularis and being discontinued during the reign of Tiberius.[69] Thereafter, North Africa was reliant upon imports for any new bronze coinage. The evidence is very slim but significant quantities of Roman coin probably did not arrive until the reign of Domitian,[70] and Dossey argues that it was not until the fourth century AD that the supply became sufficiently large to truly monetize the countryside.[71] Clearly the economic situation in

[59] Alexandropoulos 2007a, 441-444; *contra* Crawford 1985, 141.

[60] Alexandropoulos 2007a, 434-444; 2007b, 347; Burnett *et al.* 1992, 190-192.

[61] Alexandropoulos 2007b, 363-483; Callegarin 2008, 306.

[62] Bridoux 2005.

[63] Burnett *et al.* 1992, 182.

[64] Alexandropoulos 2007b, 251-253; Callegarin 2008.

[65] Callegarin 2008, 313. The current ratio is 1 : 4.

[66] Callegarin 2008, 315.

[67] Alexandropoulos 2005, 203-205; 2007a, 443 and 449; 2007b, 352.

[68] Dossey 2010, 43.

[69] Burnett *et al.* 1992, 182-185.

[70] Alexandropoulos 2005, 212-214; Munzi 2013, 70. Claudian coins found in western Mauretania appear to be imitations struck on the Iberian Peninsula.

[71] Dossey 2010, 84-88.

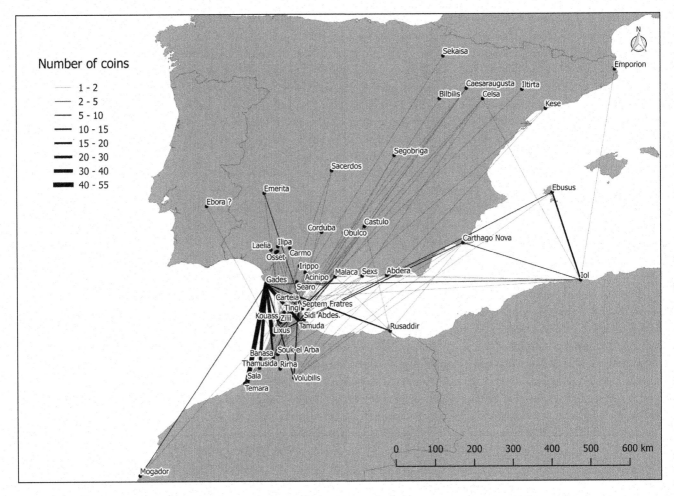

Figure 8.1. *Coins struck at mints of the Iberian Peninsula before AD 40 and found in Mauretania (data from Callegarin 2008, table 5).*

North Africa in the last two centuries BC was very different from that of the fourth century AD. The rate at which the large mass of Carthaginian and Numidian bronze coinage which remained in circulation gradually became more and more depleted and deficient for everyday purposes is difficult to gauge. The contrast between the presence of Italian ceramics and the absence of Roman Republican coinage in North Africa is interesting. Coins from Ebusus are found in Campania as well as in Algeria,[72] and this makes it tempting to see something like the collection of import taxes behind some of these coin distributions.

The situation is slightly different with the precious metal coinage. Carthage, it appears, had been the only power to mint precious metal coins in the region, and in the period following its destruction down to the reign of Juba I no precious metal coins were minted by the Numidian or Mauretanian royal houses. Unfortunately far too few precious metal coin hoards have been recovered to gain an accurate impression of the situation, but a hoard buried around 150 BC on the island of Cani, located about 10 km off the north-Tunisian shore, may indicate that Roman silver coins already made up a significant proportion of the precious metal coinage in circulation in Africa even before the fall of Carthage. One can only speculate, but perhaps Roman bribes payed in the form of precious metal coins played a part in the desertion of the seven free cities from the Carthaginian side. The hoard was made up of 18 Punic *dishekels* and 132 Roman *denarii*, the Roman coins making up 70 per cent of the weight of the hoard. Additionally, a hoard from Cirta buried sometime after 79 BC provides an indication of the types and relative proportions of the silver coinage circulating later on: 136 Roman *denarii*, 75 Celtiberian *denarii*, 14 new-style Athenian *tetradrachmas*, and 12 Massaliote *drachmas*.[73] When taken together with the other ceramic and coin distributions the eclectic collection of coins here appears to demonstrate the continued involvement of North Africa in networks of Mediterranean trade and communication.

[72] Callegarin 2008, 317.

[73] Alexandropoulos 2005, 204; Burnett *et al.* 1992, 182; Crawford 1985, 133-142.

CENTURIATION AND CARTHAGE'S FORMER TERRITORY

As we have seen the archaeology indicates that a significant level of population still existed in this part of North Africa. Indeed the region of former Carthaginian territory may even have benefited from its geographic situation as trade increased between the thriving Numidian and Mauretanian kingdoms and other Roman-controlled territories. Part of the problem in understanding precisely how Rome dealt with the local population who remained living within the area of Carthage's former hinterland, who must have numbered in their thousands, is that the literary record is very scanty indeed. Of the Carthaginians we learn merely that those who had remained in the city to the bitter end either died in the fire and destruction during the sack of the city, were subsequently executed, or were sold into slavery.[74] The *Lex agraria* of 111 BC appears to indicate that some lands were sold off or leased out very soon after 146,[75] perhaps because the state was in need of immediate funds.[76] Two decades later, after being elected as *tribunus plebis* in 124 BC, Gaius Sempronius Gracchus began an ambitious programme of reform enacted through a series of tribunician laws.[77] One of these laws, passed by his colleague Rubrius, proposed the founding of a new colony within the former territory of Carthage. There was strong opposition to the colony among the *optimates*, perhaps partly because there was conservative feeling against transmarine colonies of Roman citizens,[78] and partly due to the fact that Gracchus was attempting to use the colony as a way of enrolling a large number of Italians in the Roman citizenship.[79] After Gracchus' violent death a few years later, the Rubrian law was repealed, and the colonists lost their right to official municipal organization. This is surely a large part of the reason why one finds so few physical traces of normal Roman administrative activity during this period. We do have abundant evidence, however, that a vast project of surveying and of allocating land was carried out, both from land divisions visible on aerial photographs and from the fragmentary remains of the *Lex agraria*.

The territory of Carthage that fell into Roman hands in 146 BC covered an area of around 25,000 km² east of the *Fossa Regia*, or royal ditch, which Pliny the Elder tells us was cut by Scipio Aemilianus and the Numidian kings to separate Roman and Numidian lands.[80] Aerial photographs of this region, which today corresponds to a substantial portion of north-east Tunisia, indicate that around 16,000 km² was centuriated at the order of the Roman state. Three main alignments of centuriation have been identified. A northern group, by far the largest, covers an area of approximately 12,500 km² stretching from Cap Bon to Teboursouk east to west and from Bizerte to Enfida north to south. A smaller centre-east group, which can be seen to cut the earlier northern group, occupies an area of about 2,500 km² in a region just east of El-Djem. Immediately south of this another even less extensive south-eastern group is located covering less than 1,000 km².[81]

The probable line of the *Fossa Regia* fits very well with the western limit of the observed centuriation schemes. This should be taken as a strong indication that the majority of the centuriation in north-east Tunisia took place before the creation of Africa Nova by Caesar in 46 BC. Over and above this, it supports the idea that the *Fossa Regia* really did form some real kind of juridical boundary between Roman public lands and the Numidian kingdom from the second half of the second century BC down to Caesar's annexation of Africa Nova.[82] The argument that all of the observable centuriation schemes in Tunisia may date to the second half of the second century BC has recently been made

[74] Orosius, *Historiarum adversum Paganos*, IV.23.7; Cicero, *Disputationes Tusculanae*, III.22.53. A plague of locusts in the region of Carthage is also recorded in 125/124 BC (Orosius, *Historiarum adversum Paganos*, V.11; Livy, *Periochae*, 60).
[75] *Lex agraria*, l. 45. These are called *ager privatus vectigalisque*. There is disagreement over whether or not the phrase *publice venire* referred to the leasing out of land, as Crawford (1996, 56-57) would have it, or genuine sales, advocated by De Ligt (2001, 187-188; 2003, 152).
[76] Frank 1914, 241, note 29.
[77] Appian, *Bellum Civile*, I.3.
[78] Velleius Paterculus, *Historiae*, II.7; Broadhead 2007, 157.
[79] Appian, *Bellum Civile*, I.24; Piper 1987, 41. Plutarch (*Caius Gracchus*, IX.1-2) states that Gracchus intended to draw the colonists from the most respectable of citizens. A clause in the *Lex agraria* appears to assume that that colonial plots were only allocated to Roman citizens (Crawford 1996, 175, commentary on ll. 76-77), although this may not prove concretely that Italians had not been intended to be enfranchised in the colony.
[80] Pliny, *Historia Naturalis*, V.25. How much of this boundary already had existed as the so-called 'Phoenician trenches' (Appian, *Punica*, 32) is unclear.
[81] Caillemer and Chevalier 1957, 275.
[82] *Contra* Quinn 2004.

by Ouni and Peyras.[83] They have argued that other forms of land division, visible on satellite imagery and based on the Punic cubit, were present in the regions of the free cities of Thapsus, Leptiminus and Acholla. While not proving the case conclusively, this observation removes one of the original arguments of Chevalier and Caillemer, that the Roman centre-east and south-east centuriation schemes must have post-dated the civil war. There is no longer any compelling reason to believe that there was a link between the inland region around El-Djem being centuriated and the lands of these once-free cities being confiscated following the battle of Thapsus.[84] Instead it appears that the territories of the free cities remained clear of Roman centuriation.[85] The inland centuriation could therefore be of a much earlier date. One can, of course, accept that some surveying work is likely to have happened in Africa in the decade or so following Caesar's assassination. More veterans were clearly settled within the former province of Africa Vetus by Octavian, and there is reference both to centuriation and *subseciva* on inscriptions from the imperial estates west of the *Fossa Regia*.[86] It remains distinctly improbable, however, that the majority of the vast scheme of Roman survey work was carried out during this later period.

THE *LEX AGRARIA* OF 111 BC

One more piece of evidence is of vital significance. Inscribed on one side of a bronze tablet, several fragments of which were found near Urbino in the late fifteenth century, the *Lex agraria* has often been identified with legislation mentioned by Appian in Book 1 of his *Bellum Civile* and is therefore often referred to in earlier scholarly work as the *Lex Thoria*. The law inscribed on the tablet is divided into three sections covering Italy, Greece and Africa, and contains clauses relating to the allocation, sale and taxation of land in those regions. Quinn has asserted that the impression given by the African section of the law is that 'there had been very little organization or exploitation of African land until this point'.[87] In my view the *Lex agraria* can assuredly be taken as an indication that a degree of administrative chaos resulted from the repeal of the *Lex Rubria*, but we should read this rather as proof of the interest in, and political struggle over, how lands in Africa were to be distributed and managed.

The story of the Gracchan colony is related to us by Appian in the context of political struggle over land rights between the *populares* faction, represented by demagogic leaders such as Gaius and Tiberius Gracchus, and the rich oligarchic faction. The plots of land which had been assigned to the urban poor in Italy under the *Lex Sempronia agraria*, enacted by Tiberius Gracchus in 133 BC, had been inalienable, with the intention of protecting this newly created group of small-holders from pressure to sell up to rich landowners.[88] If the same was true of plots allocated in Africa under the *Lex Rubria*, this would have created a legal grey area when the law was repealed. Evidently some colonists had sold their plots of land privately, without the state having a record of the transactions. The inalienability of the colonial plots would also explain what the rich oligarchic faction in Rome hoped to gain from their actions. With Gaius Gracchus and the law which set up the colony removed, there would be no further obstacle to buying up considerable swathes of this public land and farming it out to tenants.

Why should one accept the association of the Gracchan colonization and a political struggle over the ownership of land with the northern centuriation group? Simply to demonstrate the realms of possibility, Figure 8.2 shows a square with an area equal to 6,000 allotments[89] of 200 *iugera*.[90] What is immediately striking is the huge scale of the Iunonian colonization, especially

[83] Ouni and Peyras 2002.

[84] *Pace* Chevalier 1958; Lintott 1994, 27-28; Trousset 1977, 190.

[85] This is also the case in the region of the northern centuriation around the free city of Uzalis (Peyras 1998).

[86] Gsell 1928, 13.

[87] Quinn 2004, 1601.

[88] The scenario is taken by ancient writers to be axiomatic: Sallust, *Bellum Iugurthinum*, XLI.8; Seneca, *Epistulae morales ad Lucilium*, XC.39; Juvenal, *Satires*, XIV.140-55; XVI.36-39; Apuleius, *Metamorphoses*, IX.35-38.

[89] Appian, *Bellum Civile*, I.24.

[90] The size of 200 *iugera* mentioned in *Lex agraria*, l.60, corresponded to the size of one *centuria* (about 50 ha). This may have been either the standard size of an allotment, or the maximum size. Lacunae in this part of the tablet leave the matter open to question. Individual allotments in earlier Roman colonies had been far smaller (Salmon 1969, 72, note 111).

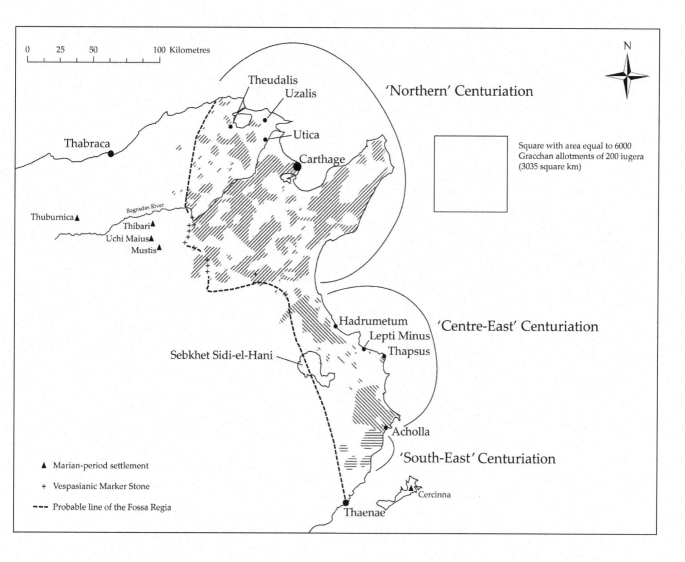

Figure 8.2. *The main regions of centuriation in Tunisia in relation to the seven free cities, the* Fossa Regia, *the Marian settlements, and the possible aggregate size of the Gracchan colonization (image: M.S. Hobson).*

when one conisders that the dimensions of this illustration would have to be drastically increased to account for the unusable land within the centuries: the wooded, marshy or mountainous areas.[91] The area of land surveyed, implied by Appian's claim that there were 6,000 colonists drawn from all over Italy,[92] and the indication from line 60 of the *Lex agraria* that the allotments may each have been 200 *iugera* in size, fit extremely well with the scale of the northern centuriation scheme known to us from the study of aerial photographs. This in turn implies that the extent of land being sold off or leased out under the terms of the *Lex agraria* was a vast area extending between the *Fossa Regia* in the west to the territories of the free cities of the coast in the east. It has also been pointed out that the scheme may even antedate the *Lex Rubria*, as surveying may have begun almost immediately, connected with the sale or leasing out of land which the *Lex agraria* attests had occurred previously.[93]

Although the colony was denied its official status, recent discussion of the law generally agrees that certain colonists were to be confirmed in the possession of their allotments. In 111 BC it is evident that problems had been caused by the state having sold off or leased out plots which some of the original colonists had already sold on to others.[94] The law stipulates that the *duumvir* is responsible for deciding which individuals can take rightful possession of the land. Compensation in the form of an equal amount of public land subject to a vectigal appears to have been given to those individuals who found that the state had already promised their lands

[91] Peyras 1998, 8.

[92] Appian, *Bellum Civile*, I.24.

[93] Haywood 1938, 6; Lintott 1993, 30; 1994, 28. Our earliest evidence for this is in the *Lex agraria* (ll. 85-86) during 115 BC, but it may well have been going on since 146.

[94] Crawford 1996; De Ligt 2001; 2003; 2007a; 2007b; 2008; Lintott 1992.

to others. So the law established a hierarchy of claims, the original colonist having the strongest claim, followed by those who had leased or bought land directly from the state, with those who had bought land privately from other individuals having the weakest claim.[95] A possible explanation for this situation is that, in a similar manner to the Gracchan allotments in Italy allocated under the *Lex Sempronia*, prior to the repeal of the *Lex Rubria* the colonists in Africa were not allowed to sell their plots.[96]

Whatever the taxation system imposed on Libyan and Carthaginian peasants of the old province was, it is likely that with such large allotments Gracchus and Rubrius may have intended the situation to be similar to that which emerged under the later successfully established colony of Carthage, in which important magistrates and priests of the colony resided at various urban and semi-urban foci within the vast *pertica* of the colony, closer to where their estates were located. This part of northern Tunisia was dotted with small but well-established communities, which in the later life of the Empire were presided over by town councils of roughly a hundred individuals of just this sort of 'good' men.[97] One can estimate that if the Gracchan colony had achieved a distribution of one moderately important landowner per 50 ha (200 *iugera*), it would have furnished these small communities with the correct number of this class of individual to form just such a municipal council in each of the subordinate semi-urban villages within the newly conquered territory. One can see the pattern of landownership most clearly in Marian territory, just west of the *Fossa Regia*, which was annexed officially by Caesar following the battle of Thapsus.

As we have seen, some lands, presumably for the most part within the old province, were confiscated at this time from the Pompeians.[98] Other lands, west of the *Fossa Regia*, became part of the large *pertica* given to Carthage during the course of its refounding over the next decade or so. There is evidence that in the region of Thugga Octavian awarded estates to ambitious equestrians whom he wished to promote to senatorial rank. A boundary marker of his general and proconsul of Africa T. Statilius Taurus, found in this area, must relate in some way to this process.[99] The periphery of Thugga appears to have been characterized by large estates covering several square kilometres each, which may have been imperial properties ceded as gift-estates to Roman nobles.[100] Closer to the town, epitaphs reveal estates of a more modest size belonging to the resident municipal elites of the imperial period. The very large estates appear to have remained in practical terms to be privately controlled under the Julio-Claudians, until Nero's confiscations brought them under the tighter control of the imperial fisc.[101] Supporting evidence is provided by the great agrarian inscriptions of the Bagradas valley and from surveying operations undertaken during the reign of Vespasian, remarking the route of the *Fossa Regia*, which appears to have formed the eastern border of some of the estates.[102] The western boundary of one of the estates was also redefined perhaps at this same time where it touched the adjacent territory of the *civitas* of Thugga.[103] The presence of such huge estates in this region no doubt meant that the level of absentee landlordism was higher than it would have been if the Gracchan scheme had been successfully brought to fruition. The two-tiered system of tenancy, which developed as a result, meant that for some time to come contracting head tenants (*conductores*) formed an important part of the social structure of this region, alongside the resident owners of more modest estates.

[95] De Ligt 2003, 157.

[96] Crawford (1996, 57) does not support this view, but see the opposing arguments of De Ligt (2003, 152; 2007b, 91).

[97] A town charter formally establishing this type of organization exists in Spain, at Urso, (the *Lex coloniae Genetivae Iuliae seu Ursonensis*), dating to shortly after Caesar's murder: Crawford 1996, 393-454.

[98] *Bellum Africum*, 97.

[99] De Vos Raaijmakers 2013, 146-47, 183-84, 193-200.

[100] Rathbone 2014, 294.

[101] Pliny, *Historia Naturalis*, XVIII.35.

[102] Hobson 2015, 37-39, 146.

[103] Abid 2014, 411-418; Christol 2014.

CONCLUSION

In the above I have tried to put forward arguments about the earlier stages of the Roman conquest and assimilation of North Africa which, while not radically different from the traditional view, depart from it in certain key areas. In the hundred-year period following Carthage's destruction the evidence of ceramics, coins and centuriation neither implies smooth continuity indicative of a low level of intervention, nor catastrophic economic disruption. Rather than a land left utterly barren and desolate with a small population in which the Roman state had little interest, one finds a region significantly reorganized with large-scale surveying and land division backed up by military might and by significant allotments of land to Numidian nobles and to former Carthaginian deserters. There are clear indications of continued agricultural production and of urban centres teeming with both indigenous artisans and foreign *negotiatores*. Rather than passing over the intended Gracchan colony as a total failure, I have tried to demonstrate how the repeal of the *Lex Rubria* could be seen as resulting from an intense level of interest in the acquisition of African land among certain elements of the Roman aristocracy. The greed and power of a rich minority pervades the story at almost every level, but they did not make their gains without political opposition. Ultimately one has to conclude that it was far easier to gain consensus on the decision to destroy the city of Carthage than it was to share amicably in the management of its former lands in the decades that followed. To pursue any kind of consistent policy of 'provincialization' in the political turmoil which surrounded the vigorous attempt to exercise tribunician power against senatorial corruption and excess would have been asking a great deal. However, the designation of vast swathes of land as *ager privatus vectigalisque* within Carthage's former territory may well have had a larger impact on the pre-existing communities than some authors have acknowledged.

Well before the time of the Third Punic War many of the towns of the North African coastline had become vibrant multicultural centres of commerce.[104] It is for this reason a false exercise to try to quantify the number of newly arriving Italian immigrants but there is literary attestation of the presence of Italian *negotiatores* at Carthage before the destruction of the city, and we find ample reference to them in Sallust's *Bellum Iugurthinum* as well as in other sources.[105] Following the Social War and the enfranchisement of Italy in 90-89 BC, these migrant Italian communities may well have felt that they also had a legitimate claim to Roman citizenship.[106] Opinion remained sharply divided about how Roman political power should be exerted over its subjects and this contributed in no small measure to the Republic's quickening descent into civil war. Inevitably the destruction of Carthage came to be seen as a milestone in the onset of instability in the Roman system of government. It was precisely because of the altered political situation, and because of the dictatorial power they were able to wield as a result, that Caesar and Octavian-Augustus managed to found so many official colonies in Africa and elsewhere in the process of demobilizing their large numbers of troops.[107] A contributing factor in North Africa was that no small amount of foundation in terms of communities of Roman citizens able to support the new colonial towns had been laid in the preceding century.

BIBLIOGRAPHY

Abid, H. 2014. Le tracé de la Fossa Regia dans la vallée de l'oued Siliana. Précisions et réflexions. In Briand-Ponsart, C. (ed.), *Centres de pouvoir et organisation de l'espace. Actes du X^e colloque international sur l'histoire et l'archéologie de l'Afrique du Nord préhistorique, antique et médiévale (Caen, 25-28 mai 2009)*, Caen: Presses universitaires de Caen, 401-418.

Adcock, F.E. 1946. Delenda est Carthago, *Cambridge Historical Journal*, 8.3: 117-128.

[104] Cicero, *De Re Publica*, II.9.

[105] At Carthage: Appian, *Punica*, 92. At other towns: Sallust, *Bellum Iugurthinum*, XXI.3, XXVI.3, XL.1, LXIV.5; Cicero, *in Verrem*, II.1.70; Valerius Maximus, *Factorum et dictorum memorabilium libri*, IX.10.2; Caesar, *Bellum Civile*, II.36; *Bellum Africum*, XXXVI.87-88, 90, 97. The elder Pliny's *oppida civium Romanorum* have been shown to be native towns containing communities of Roman citizens (Shaw 1981; Teutsch 1962, 27 ff.). Significance of Italian immigration: Sherwin-White 1973, 227, note 6, 228, 270 and 344-346.

[106] Thompson 1969, 135, note 4.

[107] Briand-Ponsart 2005, 96-99.

Alexandropoulos, J. 2005. Monnaie et romanisation en Afrique antique, I^{er} siècle av. J.-C. – II^e siècle ap. J.-C., *Pallas*, 68: 203-216.

Alexandropoulos, J. 2007a. Les monnaies. In Ferjaoui, A. (ed.), *Le sanctuaire de Henchir el-Hami : De Ba'al Hammon au Saturne africain (I^{er} siècle avant J.-C. – IV^e siècle après J.-C.)*, Tunis: Institut National du Patrimoine, 434-449.

Alexandropoulos, J. 2007b. *Les monnaies de l'Afrique antique (400 av. J.-C. - 40 ap. J.-C.)*, Toulouse: Presses Universitaires du Mirail.

Anastasi, M. and Leitch, V. 2012. Pottery report. In Fentress, E., Ghozzi, F., Quinn, J.C. and Wilson, A.I. (eds), *Excavations at Utica by the Tunisian-British Utica Project 2012*, Oxford: Annual Report of the Tunisian-British Utica Project, 22-27.

Badian, E. 1958. *Foreign Clientelae (264-70 B.C.)*, Oxford: Clarendon Press.

Badian, E. 1968. *Roman Imperialism in the Late Republic*, Chichester: Blackwell.

Baldassari, R. and Fontana, S. 2002. Anfore a Pantelleria: appunti per una storia economica dell'economia dell'isola nell'antichità. In Khanoussi, M., Ruggeri, P. and Vismara, C. (eds), *L'Africa Romana. Lo spazio marittimo del Mediterraneo occidentale: geografia storica ed economia. Atti del XIV convegno di studio (Sassari, 7-10 dicembre 2000)*, Rome: Carocci, 953-989.

Baronowski, D.W. 1995. Polybius on the causes of the Third Punic War, *Classical Philology*, 90: 16-31.

Ben Jerbania, I. 2013. Observations sur les amphores de tradition punique d'après une nouvelle découverte près de Tunis, *Antiquités Africaines*, 49: 179-192.

Bénabou, M. 1976. *La résistance africaine à la romanisation*, Paris: François Maspero.

Braund, D. 1984. *Rome and the Friendly King: The Character of Client Kinship*, London: Croom Helm.

Briand-Ponsart, C. 2005. Le statut des communautés en Afrique Proconsulaire aux I^{er} et II^e siècles, *Pallas*, 68: 93-116.

Bridoux, V. 2005. À propos de la pénétration des produits italiques sur trois sites numido-maurétaniens. In Briand-Ponsart, C. (ed.), *Identités et cultures dans l'Algérie antique*, Rouen: Presses universitaires de Rouen et du Havre, 45-58.

Bridoux, V. 2008. Les « imitations » de céramiques à vernis noir en Numidie et en Maurétanie (III^e-I^{er} siècles av. J.-C.) : état des recherches. In Gonzáles, J., Ruggeri, P., Vismara, C. and Zucca, R. (eds), *L'Africa Romana. Le ricchezze dell'Africa. Risorse, produzioni, scambi. Atti del XVII convegno di studio (Sevilla, 14-17 dicembre 2006)*, Rome: Carocci, 609-636.

Broadhead, W. 2007. Colonization, land distribution, and veteran settlement. In Erdkamp, P. (ed.), *A Companion to the Roman Army*, Chichester: Blackwell, 148-163.

Broughton, T.R.S. 1929. *The Romanization of Africa Proconsularis*, London: Humphrey Milford-Oxford University Press.

Brunt, P.A. 1971. *Social Conflicts in the Roman Republic*, London: Chatto & Windus.

Brunt, P.A. 1987. *Italian Manpower*, Oxford: Clarenden Press.

Burnett, A., Amandry, M. and Ripollès, P.P. (eds) 1992. *Roman Provincial Coinage, Volume 1: From the Death of Caesar to the Death of Vitellius (44 BC – AD 69)*, London: British Museum Press.

Caillemer, A. and Chevalier, R. 1957. Les centuriations romaines de Tunisie, *Annales. Économie, sociétés, civilisations*, 12: 275-286.

Caillemer, A. and Chevalier, R. 1959. *Atlas des centuriations romaines de Tunisie*, Paris: I.G.N.

Callegarin, L. 2005. Productions et exportations africaines en Méditerranée occidentale (I^{er} siècle av. – II^e siècle de n. è.), *Pallas*, 68: 171-201.

Callegarin, L. 2008. La côte Maurétanienne et ses relations avec le littoral de la Betique (fin du III^e siècle A.C. – Ier siècle P.C.), *Mainake*, 30: 289-328.

Capelli, C. and Contino, A. 2013. Amphores tripolitaines anciennes ou amphores africaines anciennes ?, *Antiquités Africaines*, 49: 199-208.

Carcopino, J. 1929. L'Afrique au dernier siècle de la Republique romaine, *Revue Historique*, 162: 86-95.

Carcopino, J. 1967. *Autour des Gracques*, Paris: Les Belles Lettres.

Chevalier, R. 1958. Essai de chronologie des centuriations romaines de Tunisie, *Mélanges de l'École Française de Rome. Antiquité*, 70: 61-128.

Christol, M. 2014. La cité et le domaine impérial : à propos de Thugga. In Briand-Ponsart, C. (ed.), *Centres du pouvoir et organisation de l'espace. Actes du X^e colloque international sur l'histoire et l'archéologie de l'Afrique du Nord préhistorique, antique et médiévale (Caen, 25-28 mai 2009)*, Caen: Presses universitaires de Caen, 333-347.

Crawford, M.H. 1985. *Coinage and Money under the Roman Republic: Italy and the Mediterranean Economy*, London: Methuen.

Crawford, M.H. 1992. *The Roman Republic*, Cambridge, MA: Harvard University Press.

Crawford, M.H. (ed.) 1996. *Roman Statutes, Volume 1* (Bulletin of the Institute of Classical Studies Supplement, 64), London: Institute of Classical Studies.

Creighton, J. 2006. *Britannia: The Creation of a Roman Province*, London: Routledge.

De Ligt, L. 2001. Studies in legal and agrarian history IV: Roman Africa in 111 B.C., *Mnemosyne*, 54: 182-217.

De Ligt, L. 2003. Colonists and buyers in Lex agr. 52-69. In Defosse, P. (ed.), *Hommages à Carl Deroux, III : Histoire et épigraphie, droit*, Bruxelles: Éditions Latomus, 146-157.

De Ligt, L. 2007a. Mancipes, pecunia, praedes and praedia in the epigraphic lex agraria of 111 BC, *The Legal History Review*, 75: 3-16.

De Ligt, L. 2007b. The problem of ager privatus vectigalisque in the epigraphic lex agraria, *Epigraphica*, 69: 87-98.

De Ligt, L. 2008. Provincial dediticii in the epigraphic 'lex agraria' of 111 B.C.?, *Classical Quarterly*, 58: 356-362.

De Vos Raaijmakers, M. 2013. The rural landscape of Thugga: farms, presses, mills, and transport. In Bowman, A. and Wilson, A.I. (eds), *The Roman Agricultural Economy. Organization, Investment, and Production*, Oxford: Oxford University Press, 143-218.

De Vos Raaijmakers, M. and Attoui, R. 2013. *Rus Africum, Tome I. Le paysage rural antique autour de Dougga et Téboursouk : Cartographie, relevés et chronologie des établissements*, Bari: Edipuglia.

Desanges, J. 1978. L'Afrique romaine et libyco-berbère. In Nicolet, C. (ed.), *Rome et la conquête du monde méditerranéen, 2. Genèse d'un empire*, Vendôme: Presses universitaires de France, 627-656.

Dossey, L. 2010. *Peasant and Empire in Christian North Africa*, London: University of California Press.

Duruy, J.V. 1883. *History of Rome and of the Roman People from its Origin to the Invasion of the Barbarians* (translated by M.M. Ripley and W.J. Clarke), Boston: C.F. Jewett.

Fentress, E. 2000. Jerba Survey: settlement in the Punic and Roman periods. In Khanoussi, M., Ruggeri, P. and Vismara, C. (eds), *L'Africa Romana. Geografi, viaggiatori, militari nel Maghreb: alle origini dell'archeologia nel Nord Africa. Atti del XIII convegno di studio (Djerba, 10-13 dicembre 1998)*, Rome: Carocci, 73-85.

Fentress, E. 2001. Villas, wine and kilns: the landscape of Jerba in the late Hellenistic period, *Journal of Roman Archaeology*, 14: 249-268.

Fentress, E. 2006. Romanizing the Berbers, *Past and Present*, 190: 3-33.

Fentress, E., Drine, A. and Holod, R. (eds) 2009. *An Island through Time: Jerba Studies. Volume 1, The Punic and Roman Periods* (Journal of Roman Archaeology Supplement, 71), Portsmouth, RI: Journal of Roman Archaeology.

Février, P.-A. 1989. *Approches du Maghreb romain : Pouvoirs, différences et conflits, Volume 1*, Aix-en-Provence: Édisud.

Fontana, S., Ben Tahar, S., and Capelli, C. 2009. La ceramica tra l'età punica e la tarda antichità. In Fentress, E., Drine, A. and Holod, R. (eds) 2009. *An Island through Time: Jerba Studies. Volume 1, The Punic and Roman Periods* (Journal of Roman Archaeology Supplement, 71), Portsmouth, RI: Journal of Roman Archaeology, 241-327.

Frank, T. 1914. *Roman Imperialism*, New York: Macmillan.

Freed, J. 1998. Pottery report (C. Wells *et al.* 'The construction of decumanus VI N and the economy of the early colony of Carthage'). In *Carthage Papers: The Early Colony's Economy, Water Supply, a Public Bath, and the Mobilization of State Olive Oil* (Journal of Roman Archaeology Supplement, 28), Portsmouth, RI: Journal of Roman Archaeology, 18-63.

Gelzer, M. 1931. Nasicas Widerspruch gegen die Zerstörung Karthagos, *Philologus*, 56: 261-299.

Gsell, S. 1928. *Histoire ancienne de l'Afrique du Nord, Volume 7. La République romaine et les rois indigènes*, Paris: Hachette.

Harris, W.V. 1979. *War and Imperialism in Republican Rome*, Oxford: Clarendon Press.

Harris, W.V. 1989. Roman expansion in the west, IV: Rome and Carthage. In Astin, A.E., Walbank, F.W. and Frederiksen, M.W. (eds), *The Cambridge Ancient History, Volume 8: Rome and the Mediterranean to 133 B.C.*, Cambridge: Cambridge University Press, 142-162.

Haywood, R.M. 1938. Roman Africa. In Frank, T. (ed.), *An Economic Survey of Ancient Rome, Volume 4*, Baltimore: The John Hopkins Press, 3-119.

Heitland, W.E. 1918. A great agricultural emigration from Italy?, *Journal of Roman Studies*, 8: 34-52.

Heurgon, J. 1976. L'agronome carthaginois Magon et ses traducteurs en latin et en grec, *Comptes Rendus de Séances de l'Académie des Inscriptions et Belles-Lettres*: 441-456.

Hobson, M.S. 2014. Review of De Vos Raaijmakers and Attoui 2013, *Libyan Studies*, 45: 177-178.

Hobson, M.S. 2015. *The North African Boom. Evaluating Economic Growth in the Roman Province of Africa Proconsularis (146 B.C. – A.D. 439)* (Journal of Roman Archaeology Supplement, 100), Portsmouth, RI: Journal of Roman Archaeology.

Hoffman, W. 1960. Die römische Politik des 2. Jahrhunderts und das Ende Karthagos, *Historia*, 9: 309-364.

Lassère, J.-M. 1977. *Ubique populus. Peuplement et mouvements de population dans l'Afrique romaine de la chute de Carthage à la fin de la dynastie des Sévères (146 a.C. – 235 p.C.)*, Paris: Éditions du CNRS.

Le Bohec, Y. 2011. The 'Third Punic War': the siege of Carthage (148-146 BC). In Hoyos, D. (ed.), *A Companion to the Punic Wars*, Chichester: Blackwell, 430-445.

Le Glay, M. 1968. Les Flaviens et l'Afrique, *Mélanges d'Archéologie et d'Histoire de l'École Française de Rome*, 80: 201-246.

Leitch, V. 2008. Trade in Roman North African cookwares. In Dalla Riva, M. (ed.), *Meetings between Cultures in the Ancient Mediterranean. Proceedings of the 17th International Congress of Classical Archaeology (Rome, 22-26 September 2008)*, Rome: Bollettino di Archeologia Online, 11-23.

Leitch, V. 2010. *Production and Trade of Roman and Late Roman African Cookwares*, Unpublished PhD Thesis, University of Oxford.

Leitch, V. 2011. Location, location, location: characterizing coastal and inland production and distribution of Roman African cooking wares. In Robinson, D., Wilson, A. (eds), *Maritime Archaeology and Ancient Trade in the Mediterranean* (Oxford Centre for Maritime Archaeology Monograph, 6), Oxford: Oxford Centre for Maritime Archaeology, 169-195.

Leitch, V. 2013. Reconstructing history through pottery: the contribution of Roman N African cookwares, *Journal of Roman Archaeology*, 26: 281-306.

Limonier, F. 1999. Rome et la destruction de Carthage : un crime gratuit?, *Revue des Études Anciennes*, 101: 405-411.

Lintott, A. 1992. *Judicial Reform and Land Reform in the Roman Republic: A New Edition, with Translation and Commentary, of the Laws from Urbino*, Cambridge: Cambridge University Press.

Lintott, A. 1993. *Imperium Romanum. Politics and Administration*, London: Routledge.

Lintott, A. 1994. The Roman empire and its problems in the late second century. In Crook, J.A., Lintott, A. and Rawson, E. (eds), *The Cambridge Ancient History, Volume 9: The Last Age of the Roman Republic, 146-43 B.C.*, Cambridge: Cambridge University Press, 16-39.

Marotti, E. 1983. On the causes of Carthage's destruction, *Oikumene*, 4: 223-231.

Mesnage, P.J. 1913. *Romanisation de l'Afrique : Tunisie, Algérie, Maroc*, Paris: Pères Blancs.

Mommsen, T. 1870. *The History of Rome, Volume 3* (translated by W.P. Dickson), New York: Charles Scribner & Co.

Mommsen, T. 1886. *The History of Rome. The Provinces, from Caesar to Diocletion. Part II* (translated by W.P. Dickson), London: Richard Bentley & Son.

Mommsen, T. 1901. *The History of Rome* (translated by W.P. Dickson), London: Macmillan & Co.

Munzi, M. 2013. The Tripolitanian countryside and a monetary economy: data from the archaeological survey of the territory of Leptis Magna (Libya), *The Journal of Archaeological Numismatics*, 3: 67-88.

Nicolet, C. 1966. Mithridate et les « ambassadeurs de Carthage ». In Chevallier, R. (ed.), *Mélanges d'archéologie et d'histoire offerts à André Piganiol*, Paris: Sevpen, 807-814.

Niebuhr, B.G. 1852-1853. *The Collected Lectures of B.G. Niebuhr, Volume 2* (translated by L. Schmitz), London: Walton and Maberly.

Niebuhr, B.G. 1875. *Niebuhr's Lectures on Roman History, Volume 2* (translated by H.M. Chepmell and F. Demmler), London: Chatto & Windus.

North, J.A. 1981. The development of Roman imperialism, *Journal of Roman Studies*, 71: 1-9.

O'Gorman, E. 2004. Cato the Elder and the destruction of Carthage, *Helios*, 31: 99-125.

Ouni, K. and Peyras, J. 2002. Centuriation et cadastres du Centre-Est tunisien. In Clavel-Lévêque, M. and Orejas, A. (eds), *Atlas historique des cadastres d'Europe, II*, Luxembourg: Office des Publications des Communautés Européennes, 1-10.

Pasa, B. 2009. La place de l'Africa dans le bassin méditerranéen au lendemain de la troisième guerre punique : province romaine et traditions africaines, *Pallas*, 79: 269-280.

Peyras, J. 1998. Centuriation et cadastres du Tell nord-est tunisien. In Clavel-Lévêque, M., Vignot, A. and Navarro Caballero, M. (eds), *Atlas historique des cadastres d'Europe*, Luxembourg: Office des Publications des Communautés Européennes, sheet 3.

Peyras, J. 1999. Statut et cadastres des cités libres du centre-est tunisien. In Mrabet, A. (ed.), *Du Byzacium au Sahel : Itinéraire historique d'une région Tunisienne. Actes du colloque sur le Sahel tenu à Sousse en décembre 1996*, Tunis: L'Or du Temps, 71-82.

Piper, D.J. 1987. Latins and the Roman citizenship in Roman colonies: Livy 34, 42.5-6; revisited, *Historia*, 36: 38-50.

Quinn, J.C. 2003. Roman Africa? In Merryweather, A.D. and Prag, J.R.W. (eds), *'Romanization'? Proceedings of a Post-Graduate Colloquium, The Institute of Classical Studies, University of London* (Digressus Supplement, 1), Digressus: Online publication, 7-34.

Quinn, J.C. 2004. The role of the settlement of 146 in the provincialization of Africa. In Khanoussi, M., Ruggeri, P. and Vismara, C. (eds), *L'Africa Romana. Ai confini dell'Impero: contatti, scambi, conflitti. Atti del XV convegno di studio (Tozeur, 11-15 dicembre 2002)*, Rome: Carocci, 1593-1601.

Rathbone, D. 2014. Review of A. Bowman and A. Wilson (eds) 2013. The Roman Agricultural Economy. Organization, investment and production. Oxford: Oxford University Press, *Journal of Roman Studies*, 104: 294-295.

Rostovtzeff, M.I. 1957. *The Social and Economic History of the Roman Empire*, Oxford: Clarendon Press.

Salmon, E.T. 1969. *Roman Colonization under the Republic*, London: Thames and Hudson.

Saumagne, C. 1929. Les vestiges d'une centuriation romaine à l'est d'El-Djem, *Comptes Rendus de Séances de l'Académie des Inscriptions et Belles-Lettres*: 307-313.

Saumagne, C. 1931. Les prétextes juridiques de la troisième guerre punique, *Revue Historique*, 167: 1-42, 225-253.

Shaw, B.D. 1980. Archaeology and knowledge: the history of the African provinces of the Roman empire, *Florilegium*, 2: 28-60.

Shaw, B.D. 1981. The Elder Pliny's African Geography, *Historia*, 30: 424-471.

Sherwin-White, A.N. 1973. *The Roman Citizenship*, Oxford: Clarendon Press.

Sidebottom, H. 2005. Roman imperialism: the changed outward trajectory of the Roman Empire, *Historia*, 54: 315-330.

Smith, R.B. 1913. *Carthage and the Carthaginians*, London: Longmans, Green, and Co.

Stone, D.L. 2013. The archaeology of Africa in the Roman republic. In DeRose-Evans, J. (ed.), *A Companion to the Archaeology of the Roman Republic*, Chichester: Blackwell, 505-521.

Teutsch, L. 1962. *Das Römische Städtewesen in Nordafrika in der Zeit von C. Gracchus bis zum Tode des Kaisers Augustus*, Berlin: De Gruyter.

Thompson, L.A. 1969. Settler and native in the urban centres of Roman Africa. In Thompson, L.A. and Ferguson, J. (eds), *Africa in Classical Antiquity*, Ibadan: Ibadan University Press, 132-181.

Toynbee, A.J. 1965. *Hannibal's Legacy: The Hannibalic War's Effects on Roman Life*, London: Oxford University Press.

Trousset, P. 1977. Nouvelles observations sur la centuriation à l'est d'El Jem, *Antiquités Africaines*, 11: 175-207.

Van der Werff, J.H. 1982. Amphores de tradition punique : mise en cause de la datation. In *Actes du colloque sur la céramique antique (Carthage, 23-24 juin 1980)*, Carthage: CEDAC, 213-218.

Van der Werff, J.H. 1977-1978. Amphores de tradition punique à Uzita, *Babesch*, 52-53: 181-183.

Vogel-Weidemann, U. 1989. Carthago delenda est: aitia and prophasis, *Acta Classica*, 32: 79-95.

Whittaker, C.R. 1978. Land and labour in North Africa, *Klio*, 60: 331-362.

Wilson, A.J.N. 1966. *Emigration from Italy in the Republican Age of Rome*, Manchester: Manchester University Press.

Wood, N. 1995. Sallust's theorem: a comment on 'fear' in western political thought, *History of Political Thought*, 16.2: 174-189.

9

AFRICAN GEOGRAPHY IN THE TRIUMPH OF CORNELIUS BALBUS

Andy Merrills

Abstract

This paper examines Pliny's presentation of the triumph of Cornelius Balbus in 19 BC, particularly as it relates to Roman geographical understanding. It argues that confusion surrounding the presentation of conquered regions and peoples is a reflection of modern cartographic modes of conceptualizing space, which would have been unfamiliar to Cornelius Balbus, Pliny and their contemporaries. It is suggested that some geographical trophies were distinguished for their particular importance, but most were intended simply to demonstrate the breadth of Roman conquest. This pattern of public display was an important mode of authentication: geographical material presented in this form was much more trustworthy than information from many other sources.

In 19 BC, Cornelius Balbus was granted a triumph for his military victories in North Africa. In keeping with tradition, the *triumphator* was welcomed back into Rome in an elaborate ceremony: a long procession of booty, captives and symbols of conquest wound its way from the Campus Martius to the Capitoline Hill, and formally recognized the general's successes and the reintegration of his army into civic society.[1] Balbus' was not the most important triumph of the first century BC, or even of the previous decade: the magnificent parades of the triumvirs, and Octavian's famous triple triumph of 29 BC were well-remembered for the scale of the conquests that they celebrated, and for the spectacular plunder on display.[2] But the triumph of 19 BC is of particular interest to historians, and there are two reasons for this. The first, of course, is that Balbus' represented the last in a long sequence of triumphs to be celebrated by aristocrats, rather than members of the imperial family. As proconsul of Africa in 21-20 BC Balbus had command over one of the few senatorial provinces to have a substantial military presence, and seems to have made the most of this opportunity.[3] From what we can gather, he engaged in at least two campaigns during that period, and won plaudits for his victories in both. After the ceremonial recognition of this success in the procession of 19 BC though, the Republican tradition of aristocratic triumph was quietly shelved, and it became a prerogative exclusive to the imperial house. Balbus was the last aristocratic *triumphator*, and his is the final entry on the Capitoline *fasti Triumphales*, his victory *ex Africa* the last to be so commemorated.[4]

For a relatively small minority of ancient historians, Balbus' triumph has a second significance, namely for the light that it casts on North African geography in the latter part of the

[1] See especially Beard 2007; Hölscher 2006; Itgenhorst 2005, for important reappraisals.
[2] On the lingering impact of the triple triumph in particular, see Gurval 1998.
[3] Desanges 1980, 394-395; see also Desanges 1978, 189-195 for the context.
[4] Degrassi 1954.

first century BC. Among the plunder and prisoners that the victorious general paraded through the city were representations (or written placards) commemorating the settlements, mountains, rivers and peoples who had been defeated on campaign. By happy chance, a list of these trophies was preserved in the fifth book of Pliny's *Historia Naturalis*, and this text in turn has been plundered by later generations of historians and archaeologists. Records of Balbus' parade allowed Pliny to populate his geography of the Libyan interior with plausible sounding toponyms, and it is thanks to his preservation of this material that we can start to do the same. What I wish to do here is to look again at this peculiar passage and reconsider what it can tell us about how Romans of the first centuries BC and AD really knew about the North African interior, and how this reflected their understanding of the emerging empire more broadly.

Our starting point must be Pliny's text. The passage appears in the fifth book of the *Historia Naturalis*, as part of his long opening geography. Pliny drew upon an impressive range of source materials in constructing his geographical chapters, and cheerfully flitted between them as he saw fit. In this section, however, his debts are clear enough:

> 'There is also this remarkable circumstance, that our writers have handed down the names of the towns mentioned above as being taken by him [Cornelius Balbus], and have stated that in his own triumphal procession beside Cydamum and Garama were carried the names and images [*nomina ac simulacra*] of all other peoples and cities, which went in this order: the *oppidum* of Tabudium, the *natio* of Niteris, the *oppidum* of Milgis Gemella, the *natio* or *oppidum* of Bubeium, the *natio* of the Enipi, the *oppidum* of Tuben, the mountain known as the Niger, the <*natio* of the> Nitibrum, the *oppidum* of Rapsa, the *natio* of Viscera, the *oppidum* of Decri, the river Nathabur, the *oppidum* of Thapsagum, the *natio* of Tamiagi, the *oppidum* of Boin, the *oppidum* of Pege, the river Dasibari; then a series of *oppida*, Baracum, Bulba, Halasit, Galsa, Balla, Maxalla, Cizania; and *mons* Gyri, preceded by a *titulus* saying that it was a place where precious stones were produced'.[5]

This is the basic text for our understanding of both Balbus' triumph and the campaigns that lay behind it, and initially it makes for somewhat confusing reading.

Some of Pliny's toponyms are straightforward. Cydamum (Gadames) and Garama are familiar enough, of course, and recent archaeological work in southern Libya has brought both into vivid focus.[6] But thereafter, things become rather more opaque. One or two other names sound somewhat familiar, but none of them is too obvious, and toponyms can frequently be false friends. Invaluable here are the copious notes of Jehan Desanges' excellent Budé edition, his discussion of the episode in *Recherches sur l'activité des méditerranéens aux confins de l'Afrique*, and David Mattingly's thorough treatment of the same territory on Map 36 of the *Barrington Atlas*. After some cross referencing, and some vain scouring of (relatively) unfamiliar maps, the broad pattern comes into focus. Desanges and Mattingly generally agree in their interpretations of the toponyms and their historical significance, and this provides us with an important starting point for understanding this text, if not a conclusion.

Through careful comparison with Ptolemy and extensive scrutiny of medieval and modern toponyms, several of the places paraded by Balbus and recorded by Pliny can be identified (Figure 9.1). We can state confidently that this parade of names was not organized according to geographical location. Decri and Baracum we can place in Fazzan and its immediate environs – probably between Garama and Cydamum.[7] The *oppidum* Boin seems to have been located in Tripolitania, perhaps near Gholaia.[8] The mountains Niger and Gyris are very difficult to locate: they both incorporate the Berber stem Ger ('water'), and have been tentatively placed in the highlands

[5] Pliny, *Historia Naturalis*, V. 36-37: '*et hoc mirum, supra dicta oppida ab eo capta auctores nostros prodidisse, ipsum in triumpho praeter Cydamum et Garamam omnium aliarum gentium urbiumque nomina ac simulacra duxisse, quae iere hoc ordine: Tabudium oppidum, Niteris natio, Milgis Gemella oppidum, Bubeium natio vel oppidum, Enipi natio, Thuben oppidum, mons nomine Niger, Nitibrum <natio>, Rapsa oppidum, Viscera natio, Decri oppidum, flumen Nathabur, Thapsagum oppidum, Tamiagi natio, Boin oppidum, flumen Dasibari; mox oppida continua Baracum, Bulba, Halasit, Galsa, Balla, Maxalla, Cizania; mons Gyri in quo gemmas nasci titulus praecessit*' [tr. Rackham (with modifications)].
[6] Herodotus, *Historiae*, IV. 183-184; Mattingly 2007; 2010; 2013.
[7] Desanges 1980, 404-407.
[8] Desanges 1980, 406-407; cf. Mattingly 2000, 549.

of Fazzan, but without a great deal of confidence.[9] Mattingly suggests that the River Dasibari might be identified with the Wadi al-Ajal in central Libya, but Desanges is less confident.[10] Tabudium and Milgis Gemella, the Enipi and Viscera peoples and the River Nathbares have been most convincingly located elsewhere on the African frontier, in the area around the Chotts and in the Wadi Djedi region of Algeria.[11] None of the other names can be located with any confidence, but may also have been in the Mauretanias rather than in the regions to the south of Tripolitania. We can thus conclude that the list must have come from the conflation of two or more military campaigns, one in Fazzan and the others elsewhere on the African frontier, primarily in southern Numidia.[12]

Some sense may be made of the toponyms within the text, then, but the way in which this information was presented seems bizarre to say the least. Pliny can be a frustrating source, and can try the patience of even the most patient scholar. In his 1995 book *Tripolitania*, for example, Mattingly writes:

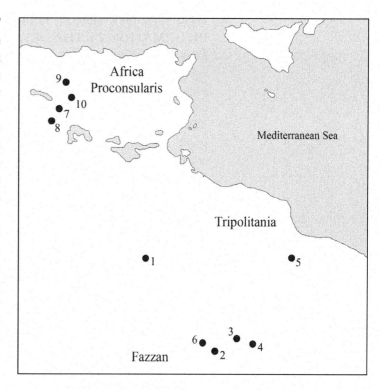

Figure 9.1. *Map showing the likely origins of identified toponyms in Balbus' triumph. 1: Cydamum; 2: Garama; 3: Decri; 4: Baracum; 5: Boin; 6: Flumen Dasibari (?); 7: Tabudium; 8: Milgis Gemella; 9: Enipi natio; 10: Viscera natio. (image: N. Mugnai, based on rough by A. Merrills).*

> 'That Pliny did not always understand the significance and geographical indications of his own sources is clear from his account of the campaign of Cornelius Balbus c. 20 BC'.[13]

And elsewhere in the same volume:

> '[...] disappointingly, Mela and Pliny give no up-to-date information although it must have existed following the campaigns of Balbus'[14].

These comments are fairly typical of modern scholarly responses to the text, and may serve as a jumping-off point. Pliny's is the fullest description of the human geography of the African interior in this period, and one of the few sources available to us, and yet the ordering of his material seems peculiar. The account in the *Historia Naturalis* is explicit that this information came from the triumphal parade of Cornelius Balbus, as it was noted down by observers at the time. Pliny remarks with surprise that such records exist (he terms it a *mirum* – wonder), and states explicitly that his account preserves the order of the original triumph. Consequently Mattingly's lament can (I think) be formulated into two connected questions:

1. Why did the triumph present this information in the way that it did?
2. Given this chaotic form, why did Pliny defer to the *triumph*, in his description of this region, rather than to *other military records* which must (at one time) have been available?

It is these questions which I would like to address briefly here.

To answer these questions, we need to think about two connected points: first the peculiar choreography of military triumphs, and second the *authority* of these triumphs, particularly in comparison with other sources of information on military campaigns.

[9] Desanges 1980, 403, 409-410; Mattingly 2000, 548.

[10] Mattingly 2000, 549; cf. Desanges 1980, 407. On other interpretations, cf. Camps 1995, 2233-2234.

[11] Desanges 1980, 400-410.

[12] Mattingly 1995, 18, 70.

[13] Mattingly 1995, 18.

[14] Mattingly 1995, 35.

WHY DID THE TRIUMPH PRESENT ITS GEOGRAPHICAL INFORMATION IN THIS WAY?

It has been something of a commonplace to assert that Roman triumphs were the 'native geography lessons' for the populace of the city,[15] or that 'the ritually recurrent and visually emphatic triumphal processions both conveyed and constructed Roman views of self and other, and [...] can be studied as formative expressions of such conceptions'.[16] We know from the accounts of Plutarch or Livy, as well as the Augustan poets, that representations of cities, rivers and captured provinces were a familiar part of this ritual choreography, that paintings or dioramas depicted crucial moments in campaigns, and – most importantly for our purposes – that *tituli* (placards) were borne through the streets as a central part of the ceremony, literally rendering this display legible to those of the audience who could read.[17] As Ovid said, imagining a triumph from his chilled exile in Tomi:

> 'So then all the people will be able to view the triumph, reading the names of captured towns and the titles of leaders [...]'[18].

Or as Propertius put it, imagining himself in rather more congenial surroundings:

> 'And resting on a dear girl's bosom I start to watch
> And from their labels read the captured towns,
> The flying horse's missiles, the trousered soldiers' bows,
> And captive leaders sitting under armour'.[19]

While the precise ceremony of the triumphal parades has been the matter of extensive recent dispute – and probably changed considerably over time – it is clear that there was at least some discrimination when it came to the parading of geographical symbols within the display.[20] Our sources for this are frustratingly elusive, and most of our detailed accounts – like Josephus on the Flavian Jewish triumph – were more interested in treasure and captives than the specifics of geographical information.[21] Nevertheless, the passing summaries in the historians are revealing. The accounts of Plutarch, Appian and Pliny on Pompey's third triumph all distinguish between the most prominent geographical trophies – Pontus, Armenia, Cappadocia, Paphlagonia, and so on – and the smaller conquests that filled out the list. In Plutarch's words:

> 'Among these peoples no less than a thousand strongholds had been captured, according to the inscriptions, and cities not much under nine hundred in number, besides eight hundred piratical ships [...]'.[22]

We see similar rhetoric in Livy's account of the 134 *oppidorum simulacra* carried in Lucius Scipio Asiaticus' triumph of 189 BC, which he does not list, and in innumerable other descriptions of triumphs.[23] It seems clear from these accounts that there was a clear distinction between the 'headline' victories of the triumphs – the conquest of large regions or prominent rivers, which might be commemorated on the *Fasti triumphales* – and the other *tituli*, sculptures and personifications that filled out the parade.[24]

[15] Murphy 2004, 160.

[16] Östenberg 2009, 2. Cf. Holliday 2002, 29-30.

[17] Cf. Pliny, *Historia Naturalis*, XXXIII.54; Ovid, *Consolatio ad Liviam*, 456-464 and the examples below.

[18] Ovid, *Tristia* IV.2.19-20: '*ergo omnis populus poterit spectare triumphos, / cumque ducum titulis oppida capta leget*' [tr. Wheeler].

[19] Propertius, *Elegiae*, III.4.15-18: '*tela fugacis equi et bracati militis arcus / ad vulgi plausus saepe resistere equos, / inque sinu carae nixus spectare puellae / incipiam et titulis oppida capta legam!*' [tr. Lee].

[20] Beard 2007 discusses the changing emphases of scholarship on the triumph.

[21] Josephus, *Bellum Judaicum*, VII.123-157; on which see Beard 2003.

[22] Plutarch, *Pompeius*, 45.2 [tr. Perrin].

[23] Livy, *Historiae*, XXXVII.59.3-5.

[24] This point is developed more fully in Merrills 2017, 78-86.

Here we come back to Pliny's account of the triumph of Cornelius Balbus in 19 BC. Looking at it again, we can see clearly that Pliny derived his account from two distinct sources, and that these correspond to the common discrimination within the triumph.[25] First, we have the 'headline' provinces – Garama and Cydamum. We may assume that these places may have been at least dimly familiar to at least some of the audience, either from their reading of Herodotus or (more probably) from political gossip in the weeks after news of Balbus' victories began to circulate in Rome. After these two prominent places comes the chaotic parade of smaller places, which we can only assume would have been utterly alien to everyone present, with the possible exception of those soldiers who fought on the campaign and themselves were participants in the triumph. As we have seen, Pliny expresses surprise that someone saw fit to record this list, and this partly explains his inclusion of it: in the normal scheme of things this parade of the obscure and the arcane would simply have passed on into obscurity. But somebody did record it, and Pliny dutifully took this information down, and this shared tradition reveals what we might otherwise have assumed – that these miscellaneous places were paraded without reference to geographical order, or even to the types of places that were being commemorated: Numidian sites are mixed among those in Tripolitania, rivers appear alongside towns and mountains and some – like Bubeium, 'a *natio* or an *oppidum*' – may not have been clearly identified by type.

We might still ask why the triumphs presented the wider world in this chaotic and indistinct manner, but the more pertinent response would be to ask why they should not. After all, these rituals were not intended to provide a cartographic approximation of the world, or to illustrate the relative locations of places with respect to one another. They were not 'geography lessons' in that sense. Instead, they sought to demonstrate in emphatic terms the simple *scale* of Roman conquest. They did this in part by revealing the familiar (or semi-familiar) places that had been brought under the Roman aegis – the Pontuses and Armenias, as well as the Garamas – but also through the superabundance of other places in a kind of chaotic pile. Rome ruled *everywhere* it was implied. And that was the only important thing to know.[26]

AUTHORITY

This brings us back to the second question, but also hints at an answer. Given the 'uncartographic' nature of these displays – given their introduction of a new imperial geographical syntax, and a wilful distain from showing the world *as it actually was* – why on earth did Pliny defer to the triumphal order, rather than the other forms of information that must have been available? Why refer to the jumbled triumph, rather than the ordered campaign narratives which we assume existed? Why would a writer of geography wilfully ignore some of the sources that must have been available to him, in preference to visibly inferior material? Was this simply a reflection of Pliny's magpie-like mania for collection, or does it tell us something else?[27]

Pliny did use military reports, of course, and recognized their importance in broad terms for the understanding of the world. In his discussion of the Nile sources, for example, he states:

'The sources from which the Nile rises have not yet been ascertained, proceeding as it does through scorching deserts for an enormously long distance and only having been explored by unarmed investigators, without the wars that have discovered all other countries'.[28]

Similarly, he alludes at different points to military *depicti* (plans) sent back from the Caucasus, and the *forma Aethiopiae* produced by the expedition that Nero sent to Sudan in the early 60s AD.[29] These reports are unlikely to have taken the form of maps as we would understand them today – there is good reason, for example, to conclude that the *forma Aethiopiae* was an annotated itinerary

[25] Desanges 1980, 398.

[26] My thinking on this point has been particularly influenced by Veyne 2005, 379-418 (on the friezes of Trajan's column).

[27] On Pliny's self-presentation as an omnivorous collector, see especially Henderson 2011.

[28] Pliny, *Historia Naturalis*, V. 51 : '*Nilus incertis ortus fontibus, ut per deserta et ardentia et inmenso longitudinis spatio ambulans famaque tantum inermi quaesitus sine bellis quae ceteras omnis terras invenere*' [tr. Rackham].

[29] Pliny, *Historia Naturalis*, VI. 40 (Caucasus maps); VI. 184-185 (Ethiopian expedition).

of the Nile between Syene and Meroe – but this was important geographical data for scholars like Pliny, regardless of the form that it took.[30] But while Pliny was aware of the existence of this information, he was rarely completely confident when using it. He draws little information from the 'maps' of the Caucasus beyond confirming a local toponym, and only discusses the *forma Aethiopiae* alongside other sources: it is never simply taken on trust as an authoritative account in its own right. More importantly, he also explicitly casts doubt upon campaign narratives in his treatment of explorations in the Atlas mountains:

> 'Upon trial [the accessibility of the region] is discovered to be for the most part exceedingly fallacious, because persons of high position, although not inclined to search for the truth, are ashamed of ignorance and consequently are not reluctant to tell falsehoods, as credulity is never more easily let down than when a false statement is attested by an authority of weight'.[31]

Here we encounter a fundamental question in the study of Roman geography – the issue of authority, and what made descriptions of the world trustworthy.[32] Reading Pliny, Mela and the other Latin geographers we can see that military narratives had a certain value, but they were rarely taken entirely on trust, and consequently they needed to be read with caution. In itself, this should not surprise us: records from the East India Company in the eighteenth century show that much the same was true of maritime mapping practice during that period of rapid British commercial expansion: individual ships' reports of their observations and discoveries had some anecdotal value, but could only contribute to the archival geographical knowledge of the navy (and hence the empire), once this information had been assessed, processed and authenticated by a central authority.[33] Without this, such information might be interesting – noteworthy even – but it would not be authoritative. This discourse of archiving and the consolidation of power is a constitutive feature of Foucauldian models of knowledge and power, of course, and has been applied more or less successfully to the study of the early Roman Empire in the work of Claude Nicolet, but Pliny and the case of Cornelius Balbus allow us to think more carefully about how this actually seems to have worked on the ground.[34]

In the twenty-first century, authoritative archival knowledge is located in a variety of places, but we tend to privilege cartographic modes for comprehending the physical world. Here, trusted media for the dissemination of geographical information have shaped our cognitive responses to it. As ancient historians or archaeologists, when we think about North Africa (even ancient North Africa), we do so in part through the more or less invisible lenses of the *Barrington Atlas* or *Google Earth*. We convince ourselves that such media represent an accurate approximation of the world as it actually is (or was) and, crucially, that the cartographic location of places is the natural (and inevitable) ontology by which they should be understood. When we want to understand how Tabudium (say) relates to Milgis Gemella, we know precisely where to turn. As I mentioned earlier in this paper, my own first port of call in making sense of Balbus' triumphal geography was indeed the *Barrington Atlas*. While Jehan Desanges and David Mattingly did not have this resource to hand when they first examined this passage, the similar cartographic assumptions implicit in their approaches are clear – in both cases they comprehend the mysterious list of toponyms through reference to known, named (and mapped) locations. This is not a criticism of their methodologies, of course, simply a recognition of the prevalence of the cartographic mindset in certain forms of knowledge production (and reproduction) in the contemporary world.

For Pliny, this self-evidently was not the case. Part of our frustration with Pliny and his contemporaries arises from the fact that they not only had no access to materials of this kind, but it would not have occurred to them to use them if they did. When the choreographers of

[30] On which see Merrills (2017), 206-215.

[31] Pliny, *Historia Naturalis*, V. 12: '*Sed id plerumque fallacissumum experimento deprehenditur, quia dignitates, cum indagare vera pigeat, haut alio fidei proniore lapsu quam ubi falsae rei gravis auctor existit*' [tr. Rackham].

[32] Jacob 2006 is fundamental here.

[33] Cook 2006 on the example of the East India Company. On this process of archival authentication more broadly, see especially Driver 2001.

[34] Nicolet 1988; 1991. On Nicolet's scholarship, and some of the issues arising from it, see now Merrills 2017, 6-15.

Balbus' triumph determined the order of the ceremony then, or Pliny tried to make sense of it from the notes of observers, neither party was particularly concerned with understanding the spatial relations between these places, or had the means to determine what these might have been. Over the last generation or so, there has been an intense debate about levels of cartographic practice and map-literacy in the Classical world, whether 'maps' as we understand them today were a common sight in Athens or Rome, and about the possible cognitive relations between different modes of spatial understanding.[35] Pliny's treatment of Balbus' triumphal geography allows us to contribute to this discussion in some small way. First, it is clear that Pliny and his audience appreciated the importance of the spatial organization of geographical material; after all the author systematically works his way around the known world throughout Books III-VI of the *Historia Naturalis*. But on the more regional level, this spatial arrangement of material – what we might call a 'cartographic' organization, regardless of whether Pliny's contemporaries used maps in the way we understand them today – became less important than other factors.

Here we need to address the issue of contested geographical authority in early imperial Rome, and the different forms of spatial cognition that competing sources of information demanded. As an important starting point, we need to acknowledge that there was no single source of authoritative geographical knowledge in early imperial Rome, whether map, inscription, textual description or otherwise. Pliny had some very important sources, to be sure – he refers to the writings of Cornelius Nepos and Varro, and the Agrippa 'Map' (whatever that was). In fact, Pliny spends much of the first book of his *Historia Naturalis* doing nothing *but* listing the sources that he used, but this sheer proliferation tells its own story.[36] If the 'Map' of Agrippa had created a definitive image of the world, authenticated by imperial power, as is often assumed, then this work might have provided the foundation upon which Pliny could create his own text. But while Pliny referred multiple times to the great survey, he rarely took its account on trust, often contradicted its findings, and never referred to it at all for vast tracts of his own world geography.[37] In the absence of a single, definitive survey of the world, Pliny attempted to make one of his own. In truth he probably failed – and the fact that he makes little reference in his text to the attempts of predecessors like Strabo and Mela suggests that they failed too – but his very attempt is crucial to our understanding of the manner in which he presents his information.

Within this vacuum, triumphs and monumental displays represented an important source of trustworthy geographical information for Pliny and his contemporaries. They were not the only source, and they sat uncomfortably alongside information derived from itineraries, histories, poetry or *fabulae*, but they were important and they were treated with respect. This is evident in Pliny's concern to reproduce this material faithfully, even when it referred explicitly to settlements that had been destroyed and abandoned (and hence had little relevance within a geographical survey as we might think of it today).[38] Equally significant, perhaps, is the testimony of Pliny's predecessor Pomponius Mela, who composed his own prose description of the world in the months before Claudius' British triumph, and who confidently declared that Roman knowledge of the northern island would be revolutionized by this ceremony.[39]

[35] The bibliography here is enormous (and ever expanding). Cf. the recent collections edited by Talbert 2012; Talbert and Unger 2007. Rathmann 2013 provides a helpful overview of this scholarship. Janni 1984 and Brodersen 1995 are fundamental. For an interesting recent appraisal of different modes of spatial understanding in the Empire, see Salway 2012.

[36] On Pliny's methodology in Book I of the *Historia Naturalis*, see especially Beagon 1992, 26-52; Doody 2009; Henderson 2011. On the question of the Agrippa 'Map', see especially the summary in Arnaud 2007-08, 45-51. Cf. also Brodersen 1995, 284-285; Nicolet 1991, 95-97; Tierney 1963 and (on the foundational German scholarship of the nineteenth century) Sallmann 1971.

[37] Pliny cites Agrippa by name at *Historia Naturalis*, III.8, 16-17, 37, 86, 96, 150; IV.45, 60, 77, 83, 91, 98, 103, 105, 118; V.9, 40, 65, 102; VI.3, 36-37, 39, 57, 136, 163-164, 196, 207, 209.

[38] Monuments: Pliny, *Historia Naturalis*, III.136-138; VII.96. At VI.160 Pliny refers to Aelius Gallus' expedition in Arabia and lists hitherto unknown towns that had been destroyed. And cf. VI.184-185 (on abandoned towns in Nubia).

[39] Pomponius Mela, *De situ orbis*, III.49: '*Britannia qualis sit qualesque progeneret mox certiora et magis explorata dicentur. Quippe tamdiu clausam aperit ecce principium maximus, nec indomitarum modo ante se verum ingotarum quoque gentium victor, propriarum rerum fidem ut bello affectavit, ita triumpho declaraturus portat*'.

As we have seen, triumphs did not present their geographies in a spatially-ordered manner, but they remained authoritative sources of information in spite of this. Instead it was inclusion within the Empire, and more importantly the formal performance of this inclusion through public display, which provided the basic ontology within which individual places might be comprehended. The *oppidum* of Tabudium, or the *natio* of Niteris were not to be defined primarily by their location in space, then – by how far they were from Garama or Carthage or Lepcis – but rather by their ceremonial passage before the authenticating eyes of Rome. Once they were brought into the imperial city, and their presence was recorded, their original 'cartographic' context was secondary to their new imperial identity.

It is worth emphasizing again that the value of triumphal or monumental sources did not derive from their close dependence upon military reports: the authority of the ceremony far surpassed the more limited importance of the material on which it was based. Pliny, Mela and their contemporaries had a bewildering variety of geographical information available to them (and exploited much of it), but the form in which this material appeared was just as important. Triumphal ceremonies, or the inscription of the names of conquered peoples onto monuments and columns, was one way in which the Roman world created its own geography. Other administrative sources also had a place – and Pliny readily appropriated this material in his discussion of the Italian *regiones*, or the urban foundations of North Africa – but here too the authority of the source was independent of its correspondence to spatial clarity.[40] When viewed through the lenses of modern cartographic understanding, the result is a confusing mess. Viewed within his own first-century *Weltbild*, Pliny's imperial geography was entirely comprehensible.

This brings us back to the two questions with which we opened, and to the peculiar choreography of Balbus' triumph as it is preserved in Pliny's *Historia Naturalis*. On the precise ordering of the triumph we can say little. Judging from this passage, and scattering of allusions elsewhere, it seems likely that captured towns, provinces, peoples and rivers were divided into two unequal categories: on the one hand we see the 'headline' victories – relatively well-known locations which were a particular focus of triumphal pride, and which were often commemorated on the triumphal *fasti*. On the other, we see the great mass of other places, the principal function of which seems to have been to impress the audience with the scale of military conquest. Triumphs were not ordered geographically because they never had been, because none of the audience would have appreciated this, and because the means to effect such a system were utterly lacking. Balbus' triumph provided a geographical and an ontological authority at one and the same time: it both supplied information, and a framework in which it could be understood. Frustrating as it may be to read Pliny's account today, his description of the Libyan interior was not the chaotic jumble it might at first seem.

BIBLIOGRAPHY

Arnaud, P. 2007-08. Texte et carte de Marcus Agrippa : historiographie et données textuelles, *Geographia Antiqua*, 16-17: 45-97.

Beagon, M. 1982. *Roman Nature. The Thought of Pliny the Elder*, Oxford: Oxford University Press.

Beard, M. 2003. The triumph of Flavius Josephus. In Boyle, A.J. and Dominik, W.J. (eds), *Flavian Rome: Culture, Image, Text*, Leiden: Brill, 543-558.

Beard, M. 2007. *The Roman Triumph*, Cambridge MA: Harvard University Press.

Bispham, E. 2007. Pliny the Elder's Italy. In Bispham, E. and Rowe, G. with Matthews, E. (eds), *Vita Vigilia Est. Essays in Honour of Barbara Levick*, London: Institute of Classical Studies, 41-67.

Brodersen, K. 1995. *Terra Cognita. Studien zur römischen Raumerfassung* (Spudasmata, 59), Hildesheim: Olms.

Camps, G. 1995. s.v. Dasibari. In Camps, G. (ed.), *Encyclopédie berbère*, 15, Aix-en-Provence: Édisud, 2233-2234.

Cook, A.S. 2006. Surveying the seas. Establishing the sea routes to the East Indies. In Akerman, J.J. (ed.), *Cartographies of Travel and Navigation*, Chicago: Chicago University Press, 69-96.

Degrassi, A. (ed.) 1954. *Fasti Capitolini*, Turin: G.B. Paravia.

Desanges, J. 1978. *Recherches sur l'activité des méditerranéens aux confins de l'Afrique* (Collection de l'École Française de Rome, 38), Rome: École Française de Rome.

[40] On Pliny's deference to this material throughout Book IV, see Bispham 2007.

Desanges, J. 1980. *(Pline l'Ancien), Histoire Naturelle, Livre V 1ʳᵉ partie, 1-46 (L'Afrique du Nord)*, Paris: Les Belles Lettres.

Doody, A. 2009. Pliny's Natural History: Enkuklios Paideia and the ancient encyclopedia, *Journal of the History of Ideas*, 70.1: 1-22.

Driver, F. 2001. *Geography Militant. Cultures of Exploration and Empire*, Oxford: Oxford University Press.

Gurval, R.A. 1998. *Actium and Augustus. The Politics and Emotions of Civil War*, Ann Arbor: University of Michigan Press.

Henderson, J. 2011. The nature of man: Pliny, Historia Naturalis as cosmogram, *Materiali e Discussioni*, 66: 139-171.

Holliday, P.J. 2002. *The Origins of Roman Historical Commemoration in the Visual Arts*, Cambridge: Cambridge University Press.

Hölscher, T. 2006. The transformation of victory into power: from event to structure. In Dillon, S. and Welch, K.E. (eds), *Representations of War in Ancient Rome*, Cambridge: Cambridge University Press: 27-48.

Itgenhorst, T. 2005. *Tota illa pompa: der Triumph in der römischen Republik*, Göttingen: Vandenhoeck & Ruprecht.

Jacob, C. 2006. *The Sovereign Map. Theoretical Approaches in Cartography throughout History* (translation T. Conley), Chicago: Chicago University Press.

Janni, P. 1984. *La mappa e il periplo. Cartografia antica e spazio odologico* (Università di Macerata, Pubblicazioni della Facoltà di Lettere e Filosofia, 19), Macerata: Università di Macerata.

Mattingly, D.J. 1995. *Tripolitania*, London: Batsford.

Mattingly, D.J. 2000. Map 36 Garama. In Talbert, R.J.A. (ed.), *The Barrington Atlas of the Greek and Roman World. Map-by-Map Directory, Volume 1*, Princeton: Princeton University Press, 545-551.

Mattingly, D.J. (ed.) 2007. *The Archaeology of Fazzān. Volume 2, Site Gazetteer, Pottery and Other Survey Finds*, London: Society for Libyan Studies – Department of Antiquities.

Mattingly, D.J. (ed.) 2010. *The Archaeology of Fazzān. Volume 3, Excavations carried out by C.M. Daniels*, London: Society for Libyan Studies – Department of Antiquities.

Mattingly, D.J. (ed.) 2013. *The Archaeology of Fazzān. Volume 4, Survey and Excavations at Old Jarma (Ancient Garama) carried out by C.M. Daniels (1962-69) and the Fazzān Project (1997-2001)*, London: Society for Libyan Studies – Department of Antiquities.

Merrills, A. 2017. *Roman Geographies of the Nile. From the Late Republic to the Early Empire*, Cambridge: Cambridge University Press.

Murphy, T. 2004. *Pliny the Elder's Natural History. The Empire in the Encyclopedia*, Oxford: Oxford University Press.

Nicolet, C. 1988. *L'inventaire du monde : Geographie et politique aux origines de l'empire romain*, Paris: Fayard.

Nicolet, C. 1991. *Space, Geography and Politics in the Early Roman Empire* (Thomas Spencer Jerome Lectures, 19), Ann Arbor: University of Michigan Press.

Östenberg, I. 2009. *Staging the World. Spoils, Captives, and Representations in the Roman Triumphal Procession* (Oxford Studies in Ancient Culture and Representation), Oxford: Oxford University Press.

Rathmann, M. 2013. Kartographie in der Antike. Überlieferte Fakten, bekannte Fragen, neue Perspektiven. In Boschung, D., Greub, T. and Hammerstaedt, J. (eds), *Geographische Kenntnisse und ihre konkreten Ausformungen* (Morphomata, 5), Munich: Wilhelm Fink Verlag: 11-49.

Sallman, K.G. 1971. *Die Geographie des älteren Plinius in ihrem Verhältnis zu Varro. Versuch einer Quellenanalyse*, Berlin: Walter De Gruyter.

Salway, B. 2012. Putting the world in order: mapping in Roman texts. In Talbert, R.J. (ed.), *Ancient Perspectives. Maps and their Place in Mesopotamia, Egypt, Greece and Rome*, Chicago: Chicago University Press, 193-234.

Talbert, R.J. (ed.) 2012. *Ancient Perspectives. Maps and their Place in Mesopotamia, Egypt, Greece and Rome*, Chicago: Chicago University Press.

Talbert, R.J. and Unger, R.W. (eds) 2008. *Cartography in Antiquity and the Middle Ages: Fresh Perspectives, New Methods*, Leiden: Brill.

Tierney, J.J. 1963. The Map of Agrippa, *Proceedings of the Royal Irish Academy*, 63C: 151-163.

Veyne, P. 2005. *L'Empire Gréco-Romain*, Paris: Le Seuil.

10

A CATHOLIC STRONGHOLD? RELIGIOUS AND ETHNIC IDENTITIES AT TIPASA[1]

Gareth Sears

Abstract

It is difficult to examine the multiple religious or ethnic identities of a particular African community and its interactions with external power over the long term in Late Antiquity. One of the few communities where we are presented with multiple texts purportedly showing us a clearly defined religious identity over a century is Tipasa in Mauretania Caesariensis. Here, a Christian-'Catholic' identity forged in persecution by both Donatists and Arians has been interpreted from the evidence and has been used to help create, through antithesis, a Donatist-native nexus. This paper will examine the hagiographic and polemical texts that comprise our evidence and will conclude that in reality the standard picture of Tipasa as a 'Catholic' stronghold is impossible to substantiate. Furthermore, extrapolating from these sources to create pictures of religious belief in the city, the wider province and amongst native communities who appear in the text is fraught with difficulties.

INTRODUCTION

The relationship between individual African religious communities and the Roman and Vandal states is very difficult to track, and fraught with problems, because of the limited and partisan nature of our source material. The local-state relationship and the religious and ethnic identities of urban populations are frequently used by our literary sources to score points in ecclesiastical and state politics. Despite these problems scholars have used moments of violence at particular cities to characterize a location as being loyal to Donatism or Catholicism or to chart conversion from paganism to Christianity.[2]

One city where academics have felt able to make statements about religious affiliation over the long term is Tipasa in Mauretania Caesariensis, where, during the fourth and fifth centuries AD, three texts – Optatus of Milevis' *De schismate Donatistarum contra Parmenianum*, the *Passio Sanctae ac Beatissimae Salsae*, and Victor of Vita's *Historia persecutionis Africanae provinciae* – have been used to characterize the city as a Catholic stronghold.[3] This paper will argue

[1] I would like to thank the editors and the anonymous reviewer for their very helpful suggestions.

[2] For example, Frend 1952, 73; Gsell 1894, 315.

[3] Optatus' *De schismate Donatistarum contra Parmenianum* was created to repudiate Donatist accusations of Catholic complicity during the Great Persecution. It is unclear how influential it was within Africa; many of its arguments, which later influenced Augustine's anti-Donatist works, may have been ignored by Donatists as the work of a descendant of those who 'betrayed' the Christian community in the early fourth century AD. See Edwards 1997, xvi-xxix and Labrousse 1975, 9-56 for general detail about Optatus and his work. The *Passio Sanctae ac Beatissimae Salsae* purports to tell the story of a teenage idol destroyer and her subsequent murder by the Tipasan community. Its dramatic date is not clear but the extant version of the story must at least postdate the 370s AD (see below and Piredda 2002 for background detail). Victor's *Historia persecutionis Africanae provinciae* is a partisan account of the measures that the Vandal kings and their agents took against the Catholic clergy during the fifth century AD. His hostile presentation of Vandal rule seeks to emphasize conflict and persecution; see below and Merrills and Miles 2010.

Figure 10.1. *Map of Late Antique Africa (after Sears 2011a, map 5).*

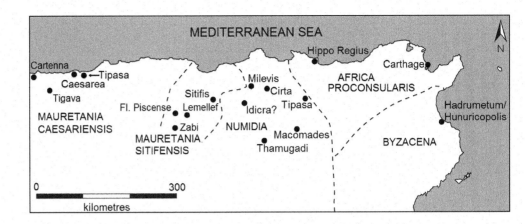

that the nature of our literary evidence cannot easily support the weight of this argument. It will argue that for the most part, as one might expect, the sources are uninformative about the numerical strength of the religious communities but they do show moments of strife when religious and ethnic identities became important. They also show the impact that Roman and Vandal 'outsiders' could have on a city and, in the case of the *Passio Salsae*, the way that an author could use the presentation of violence to establish his community's relationship to Roman power, the 'non-Roman', and to emphasize its own importance. These texts allow the examination of the interaction of the religious identities of African communities and Roman and Vandal policy and power; 'African-ness'; and debates over the relationship between Roman and non-Roman ethnicities and religious belief in Late Antique Africa. The paper also demonstrates the importance of analysis of the 'local' when examining African societies and their relationships with the state. The examination will help to clarify what might be said about religious identities and culture at a particular place but also provides an insight into the presentation of urban religious identities across Africa.

EXAMINING RELIGIOUS IDENTITY

Tracing the religious identities of a particular Late Antique African community, and its interactions with external power over the long term, is problematic. Some elements of local identity might be evoked in our literary material but for the most part we have to interpret moments of religious turmoil, which may be unrepresentative of wider attitudes within communities or longer-term relationships.[4] Alternatively we might look at a patchwork of instances from across a region to understand a more general process but that might not tell us about the experience across time in a particular community. Archaeologically we might examine the construction of churches or the abandonment and destruction of temples but these events are often very badly dated, and the extent to which such work might show specific attitudes to the pagan heritage or demonstrate a particular Christian identity can be unclear.[5]

Unlike other frequently cited examples of religious conflict from Late Antique Africa,[6] where discussion surrounds a single moment of violence, for Tipasa we do at least have several texts from across more than a century that inform us about multiple moments of religious tension.[7] The city has also seen considerable archaeological excavation, particularly of the churches, including the basilica of Saint Salsa (Figure 10.2).[8] The literary material has been used to create a 'Catholic' Christian religious identity across the fourth and fifth centuries, maintained despite persecution by religious rivals and the opposition of 'secular' powers. This 'Catholic' Tipasa has,

[4] See Leone 2013, 235-243; Rebillard 2012, 62 for recent work on the 'secular' and toleration in North Africa, pointing to a generally tolerant relationship between urban inhabitants. See Rebillard 2012, 61-91 for Christian and other identities.

[5] See Leone 2013; Sears 2007, 2011a.

[6] For instance Calama (Augustine, *Epistolae*, 90-91, 103-104) and Sufes (Augustine, *Epistolae*, 100), see Hermanowicz 2008, 156-159, 167; Rebillard 2012, 86-91.

[7] Carthage would be another exception to the general rule of opacity.

[8] See Sears 2007, 66-70 for a brief description and assessment of the late Roman city and its churches.

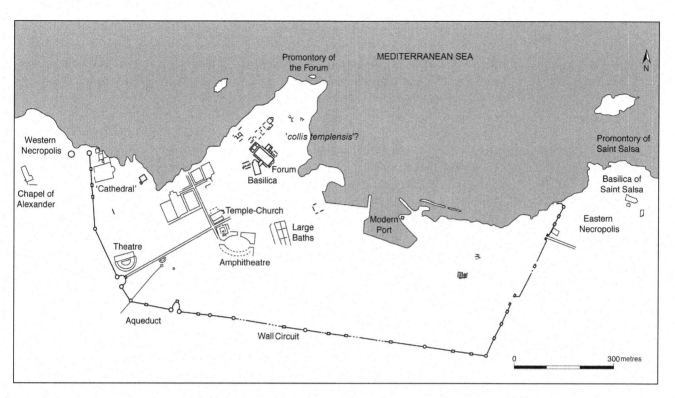

Figure 10.2. *Plan of Tipasa (after Lancel 1982, figure 17).*

without much discussion, been the dominant paradigm for the city in academic and popular writing. Frend's description of the city as a 'Catholic stronghold' is typical.[9] However, beyond an implication that this helps to explain why the city held out in the 370s against the rebel leader Firmus, a scion of a native family who Frend characterizes as a Donatist or Donatist sympathizer, arguments as to the reliability of this picture remain undeveloped. More generally, the literary material on which reconstructions of wider Mauretanian religious attitudes are based is perhaps even less substantial than that for Tipasa, and depends disproportionately on material derived from the city. A detailed re-examination of the three texts is therefore essential not only for deconstructing the standard view of Tipasan Christianity and the population's relationship with external power but also to allow for the re-examination of identity in the region more generally. The analysis will also demonstrate the implausibility of a city population ever having a single religious viewpoint.

OPTATUS OF MILEVIS

Optatus, probably writing in the mid-380s or later,[10] presents Tipasa as having a Catholic population in AD 363 that was important enough to be singled out for retribution by Donatists returning from exile under the Emperor Julian. According to Optatus, the Numidian Donatist bishops Urban of Forma and Felix of Idicra (Figure 10.1), in conjunction with the Mauretanian *praeses* Athenius,[11] attacked the large Catholic community of Tipasa in Mauretania Caesariensis,[12] turning them out of their churches, their *sedes*.[13] The attack seems to have been intended to seize those churches confiscated from the Donatists under Constans.[14] Optatus turns from specific complaints about the churches to list generic complaints about evildoers: foetuses ripped from wombs, children killed, virgins raped. Whether these claims bear any relationship to reality is

[9] Frend 1952, 73.

[10] Edwards 1997, xvi-xviii; Optatus, *De schismate Donatistarum contra Parmenianum*, II.18.

[11] Optatus, *De schismate Donatistarum contra Parmenianum*, II.18-19.

[12] Optatus, *De schismate Donatistarum contra Parmenianum*, II.18: '*catholica frequentia*'.

[13] Optatus, *De schismate Donatistarum contra Parmenianum*, II.18.5. Following Shaw 2011, 155 and Labrousse 1995 rather than Edwards 1997 who translates *sedes* as homes. 'Churches' works better given the context of the rest of the passage which focuses on the eucharist being thrown out of churches for the dogs. The only other specific attack mentioned in this context, at Lemellef (see below), was on a church.

[14] Shaw 2011, 155.

impossible to say but, as Gaddis has argued, such violent images were designed to shock, and to characterize the perpetrators as un-Christian.[15] The most specific charges that Optatus levels at the Numidian bishops, and his most believable claims, are that the eucharist and the chrismation were abused.[16] Optatus particularly cared about the violence done to the sacraments; the rhetorical claims about personal violence provided human drama.

One might argue that the fact that Tipasa was attacked in this way shows that the city was considered by contemporaries to be the home of an important Catholic community. The two Donatist bishops who were involved were apparently active over 300 km from their sees, suggesting that the city could attract antagonists from some distance. This assault is also one of the few specific instances that Optatus records of a Catholic community losing its basilicas to the Donatists at this time. Optatus reports that 'Mauretanian cities' in general were attacked, which if this is anything more than hyperbole, might suggest that the events at Tipasa were particularly memorable either in the violence employed or because Tipasa was important enough to have a particular impact on Optatus' readers. 'Mauretanian cities' may also illustrate the fact that Optatus was operating at the very edge of his knowledge and that the city or the event's fame had led to the story having a wide circulation; Tipasa is the most westerly place in Africa mentioned by Optatus.

An alternative explanation for the inclusion of this information about Tipasa in Optatus' work has been suggested by Brent Shaw. Whilst most academics accept Optatus' presentation, Shaw has wondered if Optatus might have wrongly attributed the event to Mauretanian Tipasa – Numidian Tipasa being a more likely target for the bishops of Idicra and Forma; a journey of around 160 km from Idicra rather than over 320 km (in the contemporary attack on the Catholics at Lemellef, the bishops of Zabi and *Piscence flumen* had travelled only around 35 km – see Figure 10.1 for locations).[17] In addition one might argue that Optatus was far more likely to have received word of events at a city located near his own. Perhaps some support for Shaw might be sought in the fact that the events of the 360s did not leave an impression in the *Passio Salsae* when an event only a decade later, Firmus' siege of the city, did. However, we might easily explain this omission. Whilst Saint Salsa protected her devotees during Firmus' revolt (see below), she conspicuously failed to protect Catholics in the 360s; we might expect a hagiography to ignore such an inconvenient 'truth'. Alternatively, whilst Optatus' text focused on Donatist-Catholic divisions, the *Passio* was concerned with creating/popularizing a martyr cult for all of Tipasa and advertising the city's success against a 'non-Roman' enemy; a text focused on the success of the saint against an 'external' enemy did not need to re-emphasize internal divisions. Victor of Vita's later anecdote about the Arian persecution of Catholics at the city (see below) might also be employed to support Shaw, as again the event of the 360s left no trace in his text despite the fact that a clear parallel might have been made. However, as with Optatus, Tipasa was at the very western limits of Victor's knowledge and the memory of an event in the Donatist-Catholic dispute may have been forgotten or deemed unimportant.

Despite the attractiveness of Shaw's proposal the traditional attribution of the events to Mauretanian Tipasa would seem to be correct. Optatus was a contemporary and could have investigated the matter; presumably the events would have been reasonably well known and if it had taken place at Numidian Tipasa, Optatus' relative proximity to the city should have saved him from making the mistake. He was also accurate when it came to Athenius' rank. All governors of Caesariensis were *praesides* (Numidian governors were *consulares*) and no other *praeses* of Mauretania is known from Julian's reign. Although Mauretanian Tipasa was outside the area of Optatus' primary focus, its status as one of the larger African cities may have prompted its inclusion as one of the clear examples of Donatist outrages in the 360s. A large Catholic community might have attracted Donatist and Optatus' attention but it may be as simple as the city's fame leading to stories of events there having a greater cachet, longevity and diffusion, than those at smaller towns.

[15] See Gaddis 2005, 81-88 for a range of examples, especially the Donatist *De passione sancti Donati episcopus Advocatensis*, 5.

[16] See Shaw 2011, 156-157 on the ritual elements to these actions.

[17] The Donatist bishops of Zabi and *Piscence flumen* only travelled 35 and 20 km respectively to get to Lemellef.

Optatus' Tipasa is a frustratingly indistinct place. He actually provides us with little detail about the Catholic community's size. The fact that Donatist bishops had to come from some distance away and needed military support might suggest that the Donatists were not locally strong enough to enforce their will or that the Catholic community was particularly large; Optatus' lack of specificity does not help us. Were the troops used? Shaw argues that they were just there to make sure that things did not get out of hand but, if so, who composed the forces that evicted the Catholics? If violence really was employed, even if it was not on the scale that Optatus suggests, either the troops were used or the Donatists relied on their own forces. Optatus suggests that multiple Mauretanian Catholic communities were attacked, so perhaps Tipasa was not actually singled out by Athenius, but by Optatus. Optatus also tells us little about the other religious communities at the city or about inter-sect relations but it does imply, although this is often overlooked in modern writing about the city, that there was a Donatist community who were given the churches. Perhaps most importantly Optatus shows that one Numidian bishop of the 380s could conceive of the city as having a substantial Catholic population in the 360s and this might testify to the fame of Mauretanian Tipasa and, possibly, to that of its Catholic community.

SAINT SALSA[18]

The *Passio Sanctae ac Beatissimae Salsae* details the undated killing of a young girl for her destruction of the bronze idol of 'Draco' located in the god's temple on the '*collis templensis*' (see Figure 10.2) who then, as a saint, thwarted the siege of Tipasa by the rebel Firmus;[19] other nearby cities were not so fortunate. The text is problematic but I will not rehearse the various debates here as they largely do not impinge on my argument.[20] The *Passio* post-dates AD 375 and Firmus' death and probably pre-dates the Vandal invasion on the grounds that otherwise some mention would have been made of the conquest;[21] although, given what else the *Passio* ignored about Tipasan history (see above) it is possible that the inconvenient truth of the Vandal invasion might also have been ignored. The power of the cult of Salsa can be seen in the size, complexity and longevity of the basilica of the saint at the city (see Figure 10.2); the story clearly resonated with the community.

Despite Salsa's popularity at Tipasa her *Passio* is the only literary mention of her cult apart from martyrological calendars. Tipasa's marginality with regard to the cultural centres of Numidia and Africa might be responsible for this. Certainly, in terms of Augustine's corpus, the region of Tipasa and Caesarea features less regularly than Proconsularis, Byzacena or Numidia.[22] He received information and letters from people in Caesariensis but mostly after his one journey to Caesariensis, to Caesarea itself, in AD 418.[23] It is unclear to what extent Augustine's relatively limited communication with the west was typical of other 'easterners', although we have already seen Optatus' lack of interest or knowledge about the region. Although Sotinel has doubted that the Mauretaniae were 'at the mercy of chance information reaching them' because of the regular turnover of imperial officials, this does not mean that eastern African prelates had as good communications with Caesarea as they did with sees elsewhere, nor that they regarded it in the same way.[24] A further mark of Tipasa's peripheral nature and its great distance from Carthage is that the city sent neither a Donatist nor a Catholic bishop to the Council of Carthage in AD 411 and indeed the province as a whole was rather

[18] This paper was written before the publication of Fialon and Meyers 2015. I have not been able to incorporate all of the chapters into this text but their conclusions rarely impinge on, and do not alter, my argument.

[19] Monceaux 1905, 167; Piredda 2002; *Passio Sanctae Salsae*, 3.

[20] On Salsa's historicity: for, Monceaux 1905, 163-168; against, Grégoire 1937. See also Duval 1982, 697-700.

[21] Monceaux 1905, 168; Piredda 2002, 37-38.

[22] See Shaw 2011, 10-11 for the region's peripheral-ness. Augustine's letters addressed to correspondents or about events in Mauretania: pre-418, *Epistolae*, 84, 87, 93 and 28*; *Epistola*, 236 is undated; post-418, *Epistolae*, 22*, 23* and 23A*. *Epistolae*, 190 and 202 are to a 'Spanish' bishop but he may have been from Tingitana; *Epistola*, 250 may be to a Mauretanian (Sotinel 2012, 133).

[23] Lancel 2002b, 347-355; Perler 1969, 57-61, 345-350; Shaw 2011, 10.

[24] Sotinel 2012, 126.

under-represented.[25] At the same time, absence from the event should not suggest an absence of either Donatist or Catholic communities from the city.

The specific Christian community that produced the text, Donatist or Catholic, is unclear but has long been assumed to be the latter. Gaggero for instance argued that it showed explicit condemnation by the Catholic community of the usurper Firmus, who is often presented as a native potentate ('*la più esplicita condanna, di parte cattolica*').[26] This argument appears to be largely on the basis of the treatment of Firmus, but possibly the lack of rhetoric about *traditores* and false Christians, common to the Donatist martyr texts, and the apparent continuous power of the cult of Salsa at Tipasa throughout Late Antiquity – and thus corresponding assumptions about the cult's Catholicity – have played a part in this argument.[27]

Many academics have accepted Augustine's picture of Donatists allying with Firmus, and native peoples, against the Roman state and the Catholics. Monceaux, for instance, argued that Firmus was an '*allié des Donatistes*' and Frend repeated this picture arguing that the Donatists had supported Firmus and that in return he had repressed their own schismatics, the so-called Rogatists.[28] This position, based on a handful of texts, still dominates scholarly opinion.[29] In *Letter* 87, for example, to the Donatist Bishop Emeritus of Caesarea, Augustine stated (in response to complaints about Catholic persecution): 'Remember that I have not said anything about the Rogatists who call you Firmiani, just as you call us Macariani'.[30] The only independent evidence that might be used to establish Firmus' Donatism, or an alliance with Donatists, is that Ammianus tells us that Firmus sent Christian bishops to negotiate with Count Theodosius on his behalf.[31] Augustine's texts give Frend and others the support they need to see Donatists in these bishops: 'Augustine leaves no doubt that these bishops were Donatists'.[32]

Shaw has disputed whether Firmus was a Donatist or particularly favoured them at all. He points out that the Firmus-Donatist construction is solely based on Augustine's texts; for Shaw it is a construct to undermine the Donatists.[33] He argues that other material suggests that the family were not Donatists and concludes that it is extremely unlikely that Firmus would have sent Donatists to parley with the orthodox Count Theodosius, as this would have risked offending him.[34] Whilst, in general, he is right to be cautious, and Monceaux, Frend, and others may well have over-stated the link between Donatists and Firmus – and certainly between Donatism and 'native' thought – Shaw's argument is not definitive. Theodosius' Christianity, rather than the exact form of Christianity he espoused, may have been the crucial element in sending bishops to negotiate with him. Firmus may not have been aware of Theodosius' exact religious position and Theodosius may not have been able to identify a Donatist given the similarity of Donatist and Catholic theology and his unfamiliarity with the region. Additionally, Augustine's statements might also be true in general even if he is presenting the detail for the benefit of the Catholics. Some Donatists and Firmus may have helped each other without Firmus being a Donatist, or this making all Donatists, *Firmiani*. Firmus may well have been a Christian on the basis of his father Nubel's gift of a fragment of the true cross to a basilica in Rusicade, his niece Salvina being married into the imperial family, and possibly his visit to the shrine of Salsa, but these elements might

[25] See Lancel 1972a-b; 1975; 1991 for the proceedings of the Council of Carthage, and in particular Lancel 1972a, 143-190 for the composition of the Council.

[26] Gaggero 1994, 1114; Piredda 2002, 20. See Ammianus, *Res Gestae*, XXIX.5.

[27] See Christern 1968 for the complex.

[28] Frend 1952, 171, 198-199; Monceaux 1912, 450.

[29] See, for instance Gaggero 1994, 1114-1115; Gsell 1894, 316; Lancel 2002b, 169; Piredda 2002, 20; 2015, 107; Tilley 1997, 94. See Blackurst 2004 for a more nuanced view of the activities of Firmus; he does not, however, consider the *Passio*.

[30] Augustine, *Epistolae*, 87.10: '*Memento quod de Rogatensibus non dixerim, qui vos Firmianos appellare dicuntur, sicut nos Macarianos appellatis*'. See in a similar fashion: *Contra litteras Petiliani*, II.83.184; *Contra epistolam Parmeniani*, I.10.16; *Epistolae*, 87.10 also alleges that the Donatist bishop of Rucatensi opened the city gates to Firmus surrendering the Catholics to slaughter and pillage. This is extrapolated by Camps (1984, 187) to: 'et à faire appel aux Donatistes qui lui ouvrent les portes des villes'.

[31] Ammianus, *Res Gestae*, XXIX.5.12, 25 and 39.

[32] Frend 1952, 73.

[33] Shaw 2011, 45, 54-58.

[34] Shaw 2011, 45-46.

make him a Catholic, a Donatist, or even a more free-floating adherent of Christianity.[35] Shaw's position that the link between Firmus and the Donatists was entirely a product of Augustine's propaganda is perhaps too absolute and does not allow for the fluidity of belief and the need to compromise when exercising power.

In the *Passio*, Firmus' Christianity is largely ignored except to be denied. The Saint and God punish his 'impiety under the guise of faith'.[36] Piredda has suggested that this passage is an attack on Donatism.[37] However, the rest of the section that details Firmus' and Salsa's inter-action appears concerned to establish the power of the saint against a non-Roman barbarian enemy of Tipasa, not against the schismatic community. Despite the fact that Donatism was a live issue at the time the text was probably written, it does not refer to him as a Donatist nor, indeed, mention the Donatists at all. One might argue that Catholicism was so dominant in the city, and the community for whom this was being produced so aware of Firmus' religious leanings, that there was no need to remind the reader of his beliefs; alternatively, in Tipasa, Donatism was not a particular concern so that, again, Firmus' religion was not stressed. In other words the absence of an explicit accusation of Donatism might either show the population of Tipasa (or at least the readership of the text) as being very interested, or not at all interested, in Donatism. However, I would point out that the Tipasans were also presumably aware of his ethnic identity and, as we shall see, that was comprehensively stressed. At the same time, if Augustine was correct about Firmus' persecution of Rogatists in Mauretania, then we should probably imagine contemporary religious debates to be as live and contested in Tipasa as elsewhere; that the writer of the *Passio* chose not to use Donatism but barbarity as his weapon of choice tells us about his priorities.

The text exults in a sacrilegious barbarian being thrown down after going to the Saint's shrine during the siege of Tipasa.[38] I would not go quite as far as concluding that the author of the *Passio* did not recognize the Christianity of Firmus at all. Instead he works to argue it away. There is substantial evidence of devotion in the text but his faith is presented as warped and false as part of the agenda to present him as the 'enemy'.[39] He becomes a blasphemous and degenerate barbarian and is presented as trying to get Salsa's help '*contra Romanam et Christianam plebem*'; which implies that he was neither a proper Christian nor Roman but clearly he was aware of the power of the saint and God.[40] A Christian being brought low by a Saint would be problematic, so true faith is denied to him. In general, the nuances of Firmus' religious position are neither evident, nor important, for the author and we should not expect them to be accurately presented – the only element that we can really accept is Firmus' presence at Salsa's shrine.

Whilst the text tells us little about the subtleties of religious identity in the city it reminds us that there were more rhetorical strategies for a Late-Roman African to employ than an accusation of Donatism. It might also suggest that the Tipasans had a heightened awareness of the 'barbarousness' of the tribes besieging the city (despite the fact that Firmus controlled reg-ular army units as well). For the inhabitants of Tipasa on a narrow coastal plain with recently hostile tribal groups to the south it is unsurprising that a text like the *Passio* would focus on the barbarity of the enemy, their non-Roman-ness, especially as the picture also chimed with the official propaganda of the Roman state towards 'native' rebels.[41]

Salsa's *Passio* should also be considered as one among several late fourth- to early fifth-century texts about Mauretanian martyrs. Others include Typasius of Tigava and Fabius of Caesarea, both executed in Caesarea, with Fabius being buried in Cartenna.[42] Perhaps in the

[35] Nubel: *CIL* VIII 9255; Salvina: Jerome, *Epistolae*, 79.2; Firmus and Salsa: *Passio Sanctae Salsae*, 13; Blackhurst 2004; Camps 1984, 185-190.

[36] *Passio Sanctae Salsae*, 13.

[37] Gaggero 1994, 1114-1115; Piredda 2002, 38.

[38] See now Piredda 2015, 107-108.

[39] *Passio Sanctae Salsae*, 13.

[40] *Passio Sanctae Salsae*, 13.

[41] Cf. Claudian's presentation of Firmus' brother Gildo in the *Bellum Gildonicum*.

[42] Duval 1982, 350-417, 720-724; Monceaux 1905, 124-131. See *Socii Bollandiani* 1890 for the competing martyr stories of Typasius and Fabius.

aftermath of Firmus' revolt, amid the financial troubles and possible rebuilding of Caesarea following its sack by Firmus, there were particular concerns about divine protection, the intercession of the saints and opportunities to improve a city's relative status through an effective protector.[43] Monceaux, for example, suggested that part of the purpose of the *Passio Fabii* was to establish primacy between Caesarea, where he was martyred, and Cartenna, where he was buried, in favour of the latter.[44] Perhaps one of the important messages of Salsa's *Passio* was that she was able to hold back Firmus, when the protectors of the neighbouring cities were not. In this context a focus on Firmus as a barbarian is unsurprising.

The *Passio*, along with the physical remains of the saint's basilica and cemetery, demonstrate the emergence of a locally important cult. The community now had a text as well as a location to rally around and the text made a powerful statement about the saint and Tipasa's place in recent events. However, the *Passio* actually does little to demonstrate that Tipasa was a Catholic, as opposed to a Donatist or more generically Christian, 'stronghold'. The Donatist-Catholic schism is absent and unless we believe that Firmus automatically meant 'Donatist' for those reading or hearing the Passion there is no sense of his defeat being a triumph for the Catholics. Instead, the focus is on Salsa and, in section 13, the Christianity/Roman-ness of Salsa and Tipasa versus the false Christianity/non-Roman-ness of Firmus.

VICTOR OF VITA

The preservation of manuscripts of the *Passio Salsae* in Spain and the Saint's presence in Spanish calendars and hymnaries has been linked to an episode in the final text concerning religious violence at Tipasa.[45] In his *Historia persecutionis Africanae provinciae* (III.29-30), Victor of Vita describes the population sailing to Spain in response to an attempt by Huneric's new 'Arian'/Homoian bishop of Tipasa to convert them, probably in AD 484. Only those who were unable to travel remained in the city. Uncowed, meeting together in a house, they were subsequently persecuted for not converting. The confessors had their tongues cut out and eventually ended up in Constantinople where they were miraculously still able to talk. As we have already noted, at no point does Victor compare this persecution with the pagan persecution of Salsa or Donatist persecution in Optatus' text.

The violence at Tipasa is unusual for its inclusion in the *Historia persecutionis* because Mauretania Caesariensis was even further outside Victor's comfort zone than it was Augustine's. It was possibly outside the main area of Vandal control and one of only a few points occupied along the coast.[46] Support for Victor's story has been seen in the presence of a coin of Thrasamund and local bronze imitations of late Roman coinage in two hoards, which have been interpreted as confirming the presence of Vandal troops.[47] Morrisson has argued that the small number of coins actually demonstrates how peripheral Tipasa was to the Vandal realm.[48] One reading of this evidence could suggest that Tipasa's peripheral nature in relation to the Vandal kingdom, and the apparent garrisoning of the town with Vandal troops, might have made identity crucial within the city, and that intensified conflict with representatives of royal power – the bishop and the troops. The situation in Tipasa may have led to questions of religious and even ethnic affiliation, between the local population and the occupiers, and between central authority and local power, which appeared more 'live' than in other regions of the kingdom and at other times. Alternatively we might see the events of AD 484 as being no more than a limited spasm of violence occasioned by the appointment of a new bishop bringing religious affiliation into sharp focus, with issues of core

[43] See Ammianus, *Res Gestae*, XXIX.5.18; Orosius, *Historiae adversus Paganos*, VII.33.5-7; Symmachus, *Epistolae*, 1.64 for the impact on Caesarea. Caesarean coin-hoards: Salama 1988. See Lepelley 1981, 515-517; Leveau 1984, 503 and Potter 1995, 16-17, 35-36 for a less catastrophic interpretation of the evidence of the archaeology.

[44] It would be interesting if Monceaux's hypothesis (1905, 153-158) that the author of the *Passio Salsae* was the author of the *Passio Fabii* – so, a roving writer of Passions – was correct. Fialon 2015, 191-216 has recently examined the issue again and argues for different authors working within the same cultural milieu.

[45] For example, Piredda 2002, 28-29, 52-53; Vallejo Girvés 2007, 329-334, but see Conant 2010, 35.

[46] Courtois 1955, 177, 181.

[47] Turcan 1961, 207-226; Merrills and Miles 2010, 66, 168.

[48] Morrisson 2003, 80; see also Merrills and Miles 2010, 65-66, 168-175; Modéran 2006, 179-180.

and periphery not playing a part. The coin of Thrasamund, far from being a sign of peripherality might actually show its importance to the state given that there are actually relatively few examples of Vandal coins, as opposed to Vandal era coins, in Africa outside the heart of the kingdom in Proconsularis, Numidia and Byzacena. Either reading is possible although the latter would seem to fit with the wider picture of toleration in Late Antique Africa.

Victor's general statement about persecution and emigration to escape Arianism has often been accepted as accurate.[49] Frend's characterization of Tipasa as a Catholic stronghold 'throughout the fifth century' is presumably based on this event.[50] Possibly the inclusion of the bishop of Tipasa, Reparatus, in the *Notitia provinciarum et civitatum Africae* and his possible participation in Huneric's Council of Carthage in AD 484 may have played a part in his thinking but 119 other bishops from Mauretania Caesariensis were also listed; being on the roll was hardly a mark of an unusual adherence to Catholicism on Reparatus or his congregation's part.[51]

Victor clearly felt he could present Tipasa as having one religious identity and it is obviously possible that there was a reaction against forced conversion to Arianism but does this allow us to view the city as a Catholic 'stronghold' across time? Quite apart from the limited materials from which we have to work regarding Donatism's survival, or otherwise, into the Vandal period, we have no way of knowing whether any non-Vandal inhabitants of the city converted to Arianism nor how accurate Victor's picture is of uniform hostility to the Vandal mission.[52] Even if Victor was completely correct about Tipasan fidelity to Catholicism in AD 484 it would be rash to backdate that picture to the fourth century.

CONCLUSION

This contribution has demonstrated the value of a close reading of a series of texts about one community when examining local identities and the interplay of ideas of Roman-ness and African-ness, Christian and non-Christian, over time. It has not reconstructed a religious history of Tipasa, nor argued that Tipasa did not have a large Catholic population. It has, however, pointed to the inadequacy of an approach that accepts the narratives of a few, partial texts, to reconstruct Catholic dominance. What can we say about Tipasan religious identities, the interaction between state power and local community, or ethnic identities in and around the city after examining these three texts? Clearly Optatus and Victor, as external sources, are less concerned with accuracy about Tipasa than presenting incidents of martyrdom and persecution as part of general polemics against rival interpretations of Christianity. The *Passio Salsae* is hardly more detailed about Tipasan religious identity; the focus is on Saint Salsa and her cult with the smiting of the explicitly non-Roman and less clearly non-Christian Firmus as the proof of her efficacy. The absence of Tipasan Donatists, apart from the barest hint, in Optatus and the *Passio* should not necessarily indicate the lack of a Donatist community and therefore be taken as evidence of the city being particularly Catholic; the Donatist community are largely missing because of their lack of an extant voice and the rhetorical needs of the authors.

What is notable is that the Tipasan Catholic community was not only referred to but also (probably) produced its own writing, that it was felt important enough to create a statement about local 'history', 'faith' and 'identity'. The texts hint at other elements of the religious makeup of the city: the killing of Salsa suggests pagan dominance in the early fourth century and the *De schismate Donatistarum* suggests a Donatist community from whom the Catholics had taken churches in the fourth century and to whom they were presumably returned in the 360s. The *Passio Salsae* mentions a Jewish community who converted the Temple of Draco into a synagogue, which was then later transformed into a church; although this might be a synagogue, created by the writer of the Passion in order to put a break between temple and church at a time when converting temples for Christian

[49] Piredda 2002, 28-29, 52-53; Vallejo Girvés 2007, 329-334.

[50] Cf. Gsell 1894, 315 writing about the aftermath of the siege of Firmus: 'Le catholicisme régna désormais en maitre à Tipasa'.

[51] *Notitia provinciarum et civitatum Africae, Nomina episcoporum Mauretania Caesariensis*, 99; Lancel 2002a, 237-243; Modéran 2006.

[52] See Merrills and Miles 2010, 192-203 for Arian successes in Africa under Thrasamund.

use was unusual and problematic.[53] These other religious beliefs might remain ephemeral but they remind us that no urban population would ever have had a single religious viewpoint. Tipasa might have had a Catholic majority in the fifth century (although even 'Catholic' would hide a multiplicity of nuanced religious beliefs) but the texts that are used to examine religious (or ethnic) identities, either those of the city or Firmus, are so limited that we cannot rely on them nor use them to establish wider patterns of religious domination in Mauretania Caesariensis.

BIBLIOGRAPHY

Blackhurst, A. 2004. The house of Nubel: rebels or players? In Merrills, A. (ed.), *Vandals, Romans and Berbers*, Aldershot: Ashgate, 59-75.

Camps, G. 1984. Rex gentium Maurorum et Romanorum. Recherches sur les royaumes de Maurétanie des VIᵉ et VIIᵉ siècles, *Antiquités Africaines*, 20: 183-218.

Christern, J. 1968. Basilika und Memorie der Heiligen Salsa in Tipasa, *Bulletin d'Archéologie Algérienne*, 3: 193-258.

Conant, J. 2010. Europe and the African cult of saints, circa 350-900: an essay in Mediterranean communications, *Speculum*, 85.1: 1-46.

Courtois, C. 1955. *Les Vandales et l'Afrique*, Paris: Arts et Métiers Graphiques.

Duval, Y. 1982. *Loca sanctorum Africae : Le culte des martyrs en Afrique du IVᵉ au VIIᵉ siècle* (Collection de l'École Française de Rome, 58), Rome: École Française de Rome.

Edwards, M. 1997. *Optatus: Against the Donatists*, Liverpool: Liverpool University Press.

Fialon, S. 2015. L'auteur de la Passio sanctae Salsae a-t-il aussi écrit la Passio sancti Fabii ?. In Fialon, S. and Meyers, J. (eds), *La Passio sanctae Salsae (BHL 7467) : Recherches sur une passion tardive d'Afrique du Nord*, Bordeaux: Ausonius, 191-216.

Fialon, S. and Meyers, J. (eds) 2015. *La Passio sanctae Salsae (BHL 7467) : Recherches sur une passion tardive d'Afrique du Nord*, Bordeaux: Ausonius.

Frend, W.H.C. 1952. *The Donatist Church: A Movement of Protest in Roman North Africa*, Oxford: Clarendon Press.

Gaddis, M. 2005. *There is no Crime for Those who have Christ: Religious Violence in the Christian Roman Empire*, Berkeley-Los Angeles: University of California Press.

Gaggero, G. 1994. Le usurpazioni africane del IV secolo d.C. nella testimonianza degli scrittori cristiani. In Mastino, A. and Ruggeri, P. (eds), *L'Africa Romana. Atti del X convegno di studio (Oristano, 11-13 dicembre 1992)*, Sassari: Gallizzi, 1111-1127.

Grégoire, H. 1937. Sainte Salsa, roman épigraphique, *Byzantion*, 12: 213-224.

Gsell, S. 1894. Tipasa, ville de la Maurétanie Césarienne, *Mélanges d'archéologie et d'histoire*, 14: 291-450.

Hermanowicz, E.T. 2008. *Possidius of Calama*, Oxford: Oxford University Press.

Labrousse, M. 1995. *Optat de Milève : Traité contre les donatistes, vol. 1* (Sources Chrétiennes, 412), Paris: Les Éditions du Cerf.

Lancel, S. 1972a. *Actes de la conférence de Carthage en 411, tome I : Introduction général* (Sources Chrétiennes, 194), Paris: Les Éditions du Cerf.

Lancel, S. 1972b. *Actes de la conférence de Carthage en 411, tome II : Texte et traduction de la Capitulation générale et des actes de la première séance* (Sources Chrétiennes, 195), Paris: Les Éditions du Cerf.

Lancel, S. 1975. *Actes de la conférence de Carthage en 411, tome III : Texte et traduction des actes de la deuxième et de la troisième séance* (Sources Chrétiennes, 224), Paris: Les Éditions du Cerf.

Lancel, S. 1982. Tipasa de Maurétanie : histoire et archéologie, I. État des questions des origines préromaines à la fin du IIIᵉᵐᵉ siècle. In *Aufstieg und Niedergang der römischen Welt, II: Prinzipat*, 10.2, Berlin: Walter De Gruyter, 739-786.

Lancel, S. 1991. *Actes de la conférence de Carthage en 411, tome IV : Additamentum criticum, notices sur les sièges et les toponymes, notes complémentaires et index* (Sources Chrétiennes, 373), Paris: Les Éditions du Cerf.

Lancel, S. 2002a. *Victor de Vita. Histoire de la persécution Vandale en Afrique suivie de la Passion des Sept Martyrs et registre des provinces et des cités d'Afrique*, Paris: Les Éditions du Cerf.

Lancel, S. 2002b. *St Augustine* (translation by A. Nevill), London: SCM Press.

Leone, A. 2013. *The End of the Pagan City: Religion, Economy, and Urbanism in Late Antique North Africa*. Oxford: Oxford University Press.

Lepelley, Cl. 1981. *Les cités de l'Afrique romaine au Bas-Empire, tome II. Notices d'histoire municipale*, Paris: Études Augustiniennes.

[53] See Sears 2011b on temple conversion.

Leveau, P. 1984. *Caesarea de Maurétanie. Une ville romaine et ses campagnes* (Collection de l'École Française de Rome, 70), Rome: École Française de Rome.

Merrills, A. and Miles, R. 2010. *The Vandals*, Chichester: Wiley-Blackwell.

Modéran, Y. 2006. La Notitia Provinciarum Civitatum Africae et l'histoire du royaume Vandale, *Antiquité Tardive*, 14: 165-185.

Monceaux, P. 1905. *Histoire littéraire de l'Afrique chrétienne depuis les origines jusqu'à l'invasion Arabe, volume 3 : Le IV^e siècle, d'Arnobe a Victorin*, Paris: Leroux.

Monceaux, P. 1912. *Histoire littéraire de l'Afrique chrétienne depuis les origines jusqu'à l'invasion Arabe, volume 4 : Le Donatisme*, Paris: Leroux.

Morrisson, C. 2003. L'atelier de Carthage et la diffusion de la monnaie frappée dans l'Afrique Vandale et Byzantine (439-695), *Antiquité Tardive*, 11: 65-84.

Perler, O. 1969. *Les voyages de saint Augustin*, Paris: Études Augustiniennes.

Piredda, A.M.G. 2002. *Passio Sanctae Salsae: testo critico con introduzione e traduzione italiana* (Quaderni di Sandalion, 10), Sassari: Edizioni Gallizzi.

Piredda, A.M.G. 2015. Les monologues de sainte Salsa. In Fialon, S. and Meyers, J. (eds), *La Passio sanctae Salsae (BHL 7467) : Recherches sur une passion tardive d'Afrique du Nord*, Bordeaux: Ausonius, 97-108.

Potter, T.W. 1995. *Towns in Late Antiquity: Iol Caesarea and its Context*, Sheffield: University of Sheffield.

Rebillard, É. 2012. *Christians and Their Many Identities in Late Antiquity, North Africa, 200-450 CE*, Ithaca-London: Cornell University Press.

Salama, P. 1988. Vulnérabilité d'une capitale : Caesarea de Maurétanie. In Mastino, A. (ed.), *L'Africa Romana. Atti del V convegno di studio (Sassari, 11-13 dicembre 1987)*, Sassari: Dipartimento di Storia – Università degli Studi di Sassari, 253-269.

Sears, G.M. 2007. *Late Roman African Urbanism: Continuity and Transformation in the City* (British Archaeological Reports, International Series, 1693), Oxford: Archaeopress.

Sears, G.M. 2011a. *The Cities of Roman Africa*, Stroud: The History Press.

Sears, G.M. 2011b. The fate of the temples in North Africa. In Lavan, L. and Mulryan, M. (eds), *The Archaeology of Late Antique Paganism* (Late Antique Archaeology Series, 7), Leiden: Brill: 229-259.

Shaw, B.D. 2011. *Sacred Violence: African Christians and Sectarian Hatred in the Age of Augustine*, Cambridge: Cambridge University Press.

Socii Bollandiani. 1890. Passiones tres martyrum Africanorum: SS. Maximae, Donatillae et Secundae, S. Typasii Vcterani ct S. Fabii Vexillieferi, *Analecta Bollandiana*, 9: 107-134.

Sotinel, C. 2012. Augustine's information circuits. In Vessey, M. (ed.), *A Companion to Augustine*, Oxford: Wiley-Blackwell, 125-137.

Tilley, M. 1997. *The Bible in Christian North Africa; the Donatist World*, Minneapolis, MN: Fortress Press.

Turcan, R. 1961. Trésors monétaires à Tipasa : la circulation de bronze en Afrique romaine et vandale aux V^e et VI^e siècles après J.-C., *Libyca*, 9: 203-257.

Vallejo Girvés, M. 2007. Dos casos de comunidades cristianas en el exilio: Tipasa, Durostorum y el traslado de sus reliquias, *Vetera Christianorum*, 44: 323-341.

PART IV

ECONOMIES ACROSS NORTH AFRICA: PRODUCTION, TECHNOLOGY, AND TRADE

11

OIL PRODUCTION AT DIONYSIAS AND IN FAYUM
TRADITION AND TECHNOLOGICAL INNOVATION ACROSS THE PTOLEMAIC AND ROMAN PERIODS

Leonardo Bigi

Abstract

The aim of this paper is to provide an outline of the technological changes in oil production in the Fayum oasis (Egypt) following the Roman conquest. Archaeological records have been reinterpreted in the light of new research conducted at the site of Dionysias. A multidisciplinary approach has been adopted in the choice of sources accessed. Additionally, attention is focused on the various oil plants grown for specific purposes in different periods. What emerges from this analysis is the existence of a local material culture composed of elements belonging to: the Egyptian tradition, innovations and technological progress that took place in the Ptolemaic era to solve specific production requirements, and new devices imported by the Romans and adapted to local needs.

INTRODUCTION

Egypt, and in particular the Fayum oasis, represents a unique context for the study of oil production in antiquity. Three main elements contribute to this uniqueness: industry specialization in the region occurring after the Greek conquest (especially due to the land reclamation started in the third century BC), and further developed during the Roman period (31 BC onwards); production based on various oil plants, in addition to the olive tree; the ability for us to integrate archaeological information with papyri (private correspondence, receipts, contracts, rents, taxes, tariffs, etc.).

The starting point of this study is the recent surface analysis conducted by the University of Siena at the site of Dionysias,[1] one of the most important manufacturing centres of the oasis. The research represents an opportunity to enhance the collection of archaeological data in this region. This paper will focus on the evidence of different cultural traditions from the Dynastic to the Roman period through the factors that determined the selection of oil plants. An important contribution is represented by the combination of information drawn from ancient sources and studies in chemistry and botany. This interdisciplinary approach is useful to understand the properties and employment of oils, as well as the procedures necessary for their extraction. Subsequently, I will concentrate on the instruments and different stages of seed processing, attempting to reconstruct the history of Egyptian technology from archaeological records, information available from ancient authors or papyri dealing with tax and fiscal administration, and from results of scientific analyses. A complex and multi-faceted technological landscape emerges. The impact of the Roman conquest on the local economy is demonstrated by the importation of new

[1] The project is directed by Emanuele Papi (Università di Siena).

instruments to enhance the production process. At the same time, however, local productive traditions in this region had already been influenced by innovations introduced in the Hellenistic period. In this context the local material culture was influenced by market trends and economics, by the spaces and organization of production, and by the direct and indirect intervention of the state in the fiscal, economic and cultural sphere.

THE FIELD RESEARCH AT DIONYSIAS (QASR QARUN)

Dionysias is located in the western side of the Fayum oasis, 4 km from the shore of Lake Qarun, between the cultivated area and the desert covering an area of approximately 40 ha.[2] Some ancient buildings have been preserved, including the still-standing main temple of the city, dedicated to Sobek, the crocodile god. The site was probably founded after the second reclamation started by Ptolemy II Philadelphus around 280 BC, and was completed by his son Ptolemy III Euergetes.[3] After the Roman conquest, the city seems to have experienced a period of great economic and urban development. In the fourth century AD, a military fort was built within the city (the cause of its name change to *Castra Dionysiados*) and was where the *ala V Praelectorum* was garrisoned.[4] The final abandonment of the site is dated to around the seventh-eighth centuries AD. Due to the progressive advance of the desert zone, Dionysias was almost inaccessible until the end of the nineteenth century.

Over 255 artefacts related to oil production were documented during the survey of the site (Figure 11.1).[5] They can be grouped into three categories: *molae oleariae*, composed of millstones (69) and mill mortars (58); mortars (88); and swing millstones (40). All of these objects are almost exclusively made of local limestone (light beige in colour).

The *molae oleariae* (Figure 11.2) were originally placed above cylindrical pedestals (height 60-80 cm), made from mud and roughly worked stones. Some wooden elements, in particular the vertical axis of rotation, were inserted with metal joints inside a quadrangular hole located in the middle of the mill mortar. The other end was probably inserted into beams located on the ceiling.

Figure 11.1. *Satellite image of Dionysias and distribution of the artefacts identified during the survey (image: L. Bigi).*

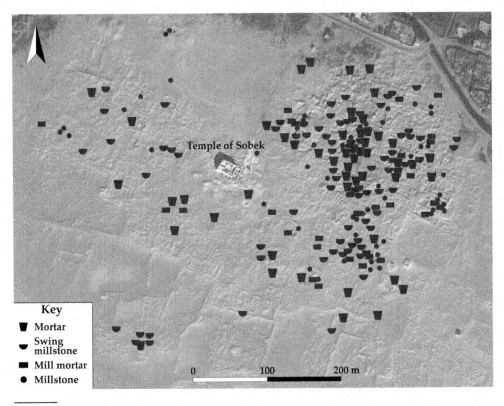

Temple of Sobek

Key
- ▼ Mortar
- ⏷ Swing millstone
- ■ Mill mortar
- ● Millstone

0 100 200 m

[2] The urban layout of Dionysias is discussed by Carpentiero in this volume.
[3] Pernigotti 2007, 20-23.
[4] Calderini 1987, 109. The military fort was excavated in 1950: see Schwartz 1969.
[5] Papi *et al.* 2010, 239-255.

Mortars (Figure 11.3), with a truncated conical shape and double semi-circular handles, had multiple functions and were also associated with beer and bread production. The common element between these implements was the need to decorticate seeds of cereals and oil plants for subsequent grinding. Large mortars could also be used as catchment basins for the oil spilled from the press (see below).

The swing millstone (Figure 11.4) is a very common artefact in the sites of Fayum, although only a few studies have been dedicated to this topic.[6] These millstones have a semi-spherical shape, with a diameter of approximately 50 cm, characterized by a convex and a smooth surface. They are frequently identified in proximity to mortars and *molae oleariae*, as well as circular stone bases with a flat or slightly concave work surface (Figure 11.5). The friction generated by rubbing the millstone on the base would turn olives and seeds into oily paste.

The survey also led to the identification of basins, some of which are likely to be interpreted as vats for oil catchment and decantation (Figure 11.6). They have a rectangular shape, often with rounded corners, and their dimensions are: width 80-100 cm; length 100-150 cm; depth 70-80 cm. The walls are approximately 20 cm thick, made of mudbrick or brick and mortar with a layer of plaster covering the inner and outer surfaces.

In many cases different stages of reconstruction are clearly visible. It is necessary to say that there is great uncertainty about the interpretation of these structures, due

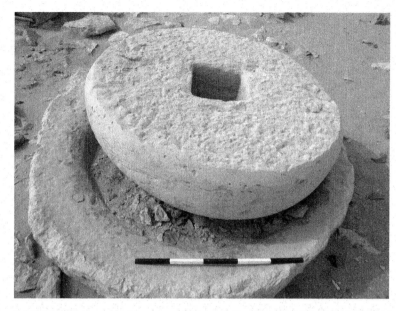

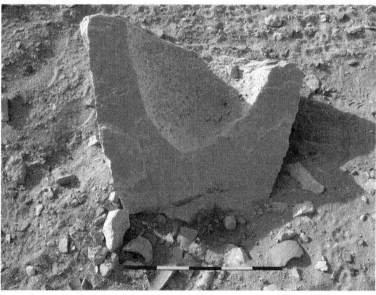

to the lack of archaeological records from excavations at Dionysias, as with the other settlements in Fayum. The few published studies on Karanis demonstrate that the production facilities were not equipped with catchment basins, but rather with large mortars set into the floor at the point of the outflow of oil from the press.[7] When compared to this site, the presence of basins at Dionysias may seem to be contradictory evidence; however, the low visibility of the structures does not allow us to understand whether these vats were indeed employed as decanting devices in response to particular productive needs in the city of Dionysias. Schwarz and Wild described three similar basins that were interpreted as 'reservoirs', probably built in a late period, at some private domestic structures at Qasr Qarun.[8] In addition to being found at other sites of Fayum, such as Tebtynis, similar installations seem to have been used as 'reservoirs' for domestic use.[9] We can exclude the production of wine from the potential industries that could have employed similar structures at Dionysias, since this is rarely mentioned in Fayum papyri. Furthermore, the dimensions of basins found at

Figure 11.2. (above) *Example of* mola olearia *found at Dionysias (photo: L. Bigi).*

Figure 11.3. (below) *Fragmentary example of mortar from Dionysias (photo: L. Bigi).*

[6] The term 'swing millstone' is the result of a personal analysis and does not appear in other publications. The only known example is described as 'pressing stone': Husselman and Peterson 1979, 54, plate 93b.

[7] At the site of Karanis, three presses have been identified *in situ*: in building C86 (Husselman and Peterson 1979, 48-54, plate 93a), in building B75b, and another example found by the *sebakhin* (Boak and Peterson 1931, 37, figures 56-57, plates 28-29).

[8] Schwartz and Wild 1950, 16-19, figure 5. In these cases traces of plaster seem absent.

[9] They are described as banquettes and are found in service rooms or storage spaces: Hadji-Minaglou 2007, 194-195.

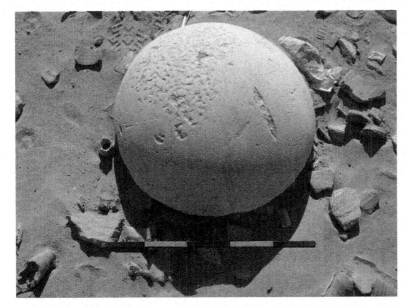

a winery at Theadelphia, as at similar contexts in the Delta region,[10] were substantially greater (about 4 m wide and 5 m long).[11]

If we compare Dionysias to the other sites of Fayum, it is possible to identify another discordant feature: no blocks for screw presses have been identified during the field research.[12] These stone elements usually have a parallelepiped shape, with two quadrangular holes, separated by a press bed delimited by the drainage channel (Figure 11.7). Wooden uprights would have been inserted into the two cavities, surmounted by a wooden beam. The latter was perforated to allow the rotation of the screw which applied pressure on the oil pulp inside circular wicker bags (known as *fisci*).[13] The absence of press blocks on the surface at the site may be the consequence of recycling in antiquity, or even in modern times.[14]

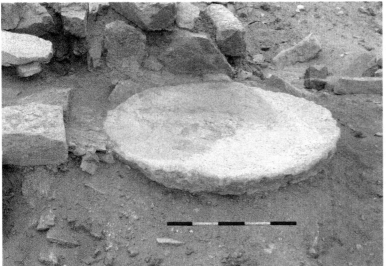

From the distribution of artefacts across the site it is possible to locate concentrations of objects interpreted as oil mills (approximately 25 examples, 18 of which are located in the northern and eastern districts). This higher concentration is due exclusively to the modern *sebakhin* excavations that destroyed many architectural remains, making it impossible to reconstruct plans or to understand the function of the spaces. It is likely that a greater number of oil mills were located across the city, especially in the southern and western parts. We can thus attempt a hypothetical, proportional calculation of the number of oil mills per hectare (based on

Figure 11.4. (above) *Swing millstone (photo: L. Bigi).*

Figure 11.5. (below)*Working surface for the swing millstone found at Dionysias (photo: L. Bigi).*

Figure 11.6. (right) *'Reservoir'/basin probably used as a catchment vat for oil (photo: L. Bigi).*

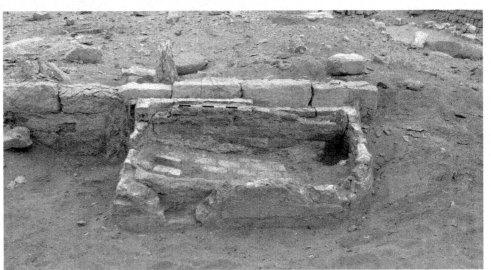

[10] See Brun 2004b, 151-158.

[11] Cf. Davoli 1998, 283.

[12] These artefacts are known at other sites such as Karanis, Bakchias (for both see Brun 2004b, 177-178), and Philoteris (one isolated and fragmentary example).

[13] Some well-preserved *fisci* have been found at Narmouthis: Bresciani 1976, 7, figure 15.

[14] Cf. Bailey 1999, 211-218; Davoli 2012, 155-161.

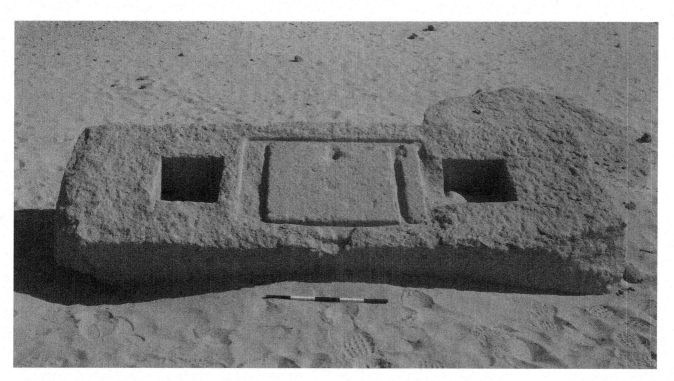

the more visible districts) which would give a result of approximately 48 oil mills across the whole site (45 ha). This can give an idea of the importance of oil production for the economy of the city in the Roman and late Roman periods.

Figure 11.7. *Screw-press block found at Bakchias (photo: L. Bigi).*

SELECTION OF PLANTS IN THE DYNASTIC, PTOLEMAIC AND ROMAN ERAS

Unlike in many other regions of the Mediterranean, oil production in Egypt involved the cultivation of a rather heterogeneous set of plants – in addition to the olive tree – whose seeds were processed. The choice of plants changed over time from the Dynastic to the Roman period, and was mainly determined by the following features: (1) personal taste and demand of the foreign settlers or rulers; (2) local presence of species or, in the case of non-native species, their adaptability to the local climatic conditions; (3) quality and chemical composition of oils; (4) yield of plants and the ease of their cultivation and harvesting.

With the exception of the Dynastic period, for which we do not have sufficient information, it is necessary to indicate which plants were destined for 'primary' production (oils for frequent use: fuel for lamps/cooking), and which belonged to 'secondary' production, characterized by a lower quantity and a different market demand (drugs, cosmetics, perfumes, and ointments). For the Dynastic age we have only references to castor oil from *Ricinus communis*,[15] safflower oil from *Carthamus tinctorius*,[16] and oil of ben from the tree of *Moringa oleifera* or *Moringa peregrina*.[17]

In the Ptolemaic period, lands obtained through the second reclamation of the Fayum oasis witnessed the establishment of new settlements and the introduction of new crops, some of which represented imported species.[18] In terms of oil production, the cultivation of oil plants increased. The olive tree, already known in the Egyptian territory before the Greek conquest,[19] was subject to a more widespread and intensive cultivation in this period due to the presence of Greek inhabitants and their increasing demand.[20] Production increased gradually from the third century BC, but the slow rate of growth of olive trees and the poor quality of crops

[15] Dawson 1929, 52-55; Dubois 1925, 64.
[16] Dubois 1925, 64.
[17] Dubois 1925, 63.
[18] Crawford 1979, 140.
[19] Meeks 1993, 4-5.
[20] Morini 2007, 119.

caused Egyptian olive oil to have a less favourable reputation.[21] In this period, among the primary products one finds castor, sesame, and safflower oil. As secondary products there were olive,[22] ben, and linseed oil.[23] In reference to sesame oil, it is likely that its production was intensified during Persian rule, given the widespread use of this product in the Near East.[24]

During the second and first centuries BC, the overall production of oil shrank due to the increasing need for cereals that likely replaced the extensive cultivation of oil plants.[25] In contrast, after the Roman conquest the cultivation of olive trees was intensified.[26] Papyri mentioning olive oil production increased from the first to the second century AD.[27] Archaeological evidence from Karanis and Narmouthis confirms this trend,[28] explained by the possibility of higher profits offered by olive oil production, which better suited the habits and needs of the new conquerors than other oils. As primary production products we find olive oil and radish oil, extracted from the seeds of *Raphanus sativus* or other varieties of *Brassica napus*. It is possible that the attribution of radish to the radish plant (*Raphanus sativus*) or similar vegetables is erroneous, due to fact that Pliny reports secondhand information originally mentioned by Theophrastus.[29] Perhaps radish oil was obtained from other *Brassicaceae*, such as rutabaga (*Brassica napobrassica*) or, more likely, from *Brassica napus* ssp. *oleifera*, a herbaceous plant more suitable for oil production because of the greater ease in harvesting seeds, which are enclosed in pods.[30] There are no references to this plant, however, before the Roman conquest.[31] In a passage from Pliny we learn that the choice of this oil was determined by the possibility of higher returns, guaranteed by the absence of taxes on its manufacture.[32] The great success of this oil is confirmed by its mention in Diocletian's edict, as well as in many documents from the Middle Ages.[33] Among the secondary products, castor, sesame, safflower, and ben oil continued to be manufactured, although a gradual disappearance of sesame and castor oil occurred around the second century AD,[34] probably replaced by olive and radish oil respectively. A radical economic change occurred in Fayum at the end of the second century AD: references in the papyri to oil workshops (*elaiourghion*) become rare,[35] but we still find references to leases of olive fields in the third century. On one hand, the archaeological record seems to show that the manufacture of oil was taking place in domestic spaces – in the so-called 'courtyard' (*aule*), where other domestic activities were carried out, such as food preparation and cooking, and even the breeding of small animals. On the other hand, the presence of imported oil is documented by the discovery of Tripolitanian amphorae. It is likely that the cultivation of olive trees was aimed at the export of olives,[36] while oil was largely imported from abroad or produced domestically for household consumption.

[21] This information is confirmed by papyri and authors such as Theophrastus (*Historia plantarum*, IV.2.8-9) and Strabo (*Geographia*, XVII.1.35). Theophrastus, almost contemporary with the early stages of the second reclamation in Fayum initiated by Ptolemy II, writes that the olive tree was already cultivated in Egypt, with particular reference to the Thebaid region, though the oil was characterized by an unpleasant smell. Strabo, who writes between the end of the Ptolemaic kingdom and the Roman conquest, reports that the olive tree was located only in the *Arsinoite nomos* and in the vicinity of Alexandria. Plants were large and very productive, but the unpleasant organoleptic aspect is confirmed by Strabo as well. As to the papyri of the Ptolemaic period, mentions of olive oil (about 50 in total) are relatively few when compared to those of other oils and other periods (see Sandy 1989, 113-115).

[22] Olive oil is not listed among those subjected to the State monopoly, probably in order to encourage the initiation of production: Dubois 1925, 75-79.

[23] Other plants and oils like lettuce oil, colocynth, almond, etc. are less known and more rarely mentioned: Lucas and Harris 1962, 327-337; Sandy 1989, 3-6; Serpico and White 2000, 390-408.

[24] Herodotus, *Historiae*, I.193; Xenophon, *Anabasis*, IV.4.13; Bedigian and Harlan 1986, 143-146.

[25] Dubois 1927, 8.

[26] See Sandy 1989, 82.

[27] Dubois 1927, 8.

[28] Karanis: Papi *et al.* 2010, 239-255; Narmouthis: Bresciani 1976, 7-8.

[29] Pliny, *Historia Naturalis*, XIX.26; see Lechi 1984, 860-861.

[30] The seed oil of *Brassica napus oleifera* is still produced in large quantities with the name of rapeseed oil. For the assumptions on the varieties of brassicas see Serpico and White 2000, 401-402.

[31] Mayerson 2001, 109.

[32] Pliny, *Historia Naturalis*, XIX.26.

[33] Gil 1975, 65-66.

[34] Mayerson 2001, 110; Sandy 1989, 53.

[35] *P. Mich.* 11 620 (AD 240), *P. Ryl.* 2 236 (AD 253-256), both from unknown locations.

[36] Pliny (*Historia Naturalis*, XV.4) states that Egyptian and Syrian olives were preferred to Italian olives for table consumption.

SEEDS AND OILS: PROPERTIES AND FEATURES

The abundance of references about the names of different oils in the papyri contrasts with the limited literary and archaeological information on their use (such as fuel, or as products for cooking, cosmetic or medicinal purposes) and on the tools employed in the extraction process, especially for grinding. Consequently, botanical studies are taken into consideration to provide more specific information on the quality and chemical composition of oils, and on both macroscopic and microscopic characteristics of the seeds (Table 11.1). This will also help in determining the shape and type of tools needed for oil production.

Table 11.1. *Characteristics of oils and plants, and their use in antiquity.*

Oil/Plant	Seed size	Oil percentage	Components and their properties	Use
Castor *(Ricinus communis)*	9-11 mm	40-60%	Ricinoleic acid, ricina (toxic)	Fuel
Sesame *(Sesamum indicum)*	4-5 mm	50%	E vitamin, phosphorus, calcium, proteins, natural antioxidants	Cooking
Safflower *(Carthamus tinctorius)*	8-10 mm	50%	Hypoallergenic, cutaneous tissue oxygenation, no smoke when heated	Fuel, cooking, cosmetic (?)
Radish *(Raphanus sativus/ Brassica napobrassica/ Brassica napus oleifera)*	4-5 mm	60%	Unpleasant odour, Erucic acid (toxic)	Fuel
Ben *(Moringa oleifera)*	9-11 mm	60%	Oleic acid, low viscosity, low rate of oxidation, good excipient	Cosmetic

FROM SEEDS TO OIL: TECHNOLOGY OF PRODUCTION PROCESSES

Starting phases of production

The variety of artefacts identified at Dionysias and in Fayum is the result of different choices linked to practical, economic and social aspects. In order to understand how the equipment was progressively selected over a long time frame, it is necessary to combine a variety of source types: iconographical, papyrological, historical and scientific.

The extraction of oil from the seeds of the oil-plants described above required some necessary preliminary steps. Firstly, hulling could take place outside the mill, straight after the harvest.[37] The microscopic structure of seeds is formed by an outer layer of variable thickness (the testa), and by an inner part (the endosperm), which encloses the embryo. The oil and nutrient are located in the endosperm, in a structure consisting of small cells. In order to extract the oil, the first necessary step was pounding, aimed at removing the testa. Afterwards, sieving was carried out in order to isolate the oily part from the waste. At this point, as described by Herodotus, two methods could be employed: (i) boiling the seeds and collecting the oil coming to the surface; or (ii) grinding and pressing them.[38] In both cases, the structure of the micro cells had to be broken to allow the removal and thickening of the oily liquid.

With regard to the Dynastic era, stone mortars were found in the village of Amarna, and were depicted in wall paintings from funerary contexts.[39] In these cases the use of mortars is related to bread or beer manufacturing for which a decortication of the cereal was necessary, similar to the procedure used for the seeds of oil plants.[40] In the same period another well-known instrument was used, the saddle quern.[41] This was very effective for grinding grains

[37] Sandy 1989, 15.

[38] Herodotus, *Historiae*, II.94.

[39] Curtis 2001, 124-131.

[40] Curtis 2001, 114-115; Darby *et al.* 1977, 515-517. Seeds could also be soaked in water and left to dry in the open air (Dioscorides, *De materia medica*, I.32).

[41] Moritz 1958, 29-33.

of dry cereals through friction, but it was unsuitable for seeds with a high percentage of oil and fat components. Unfortunately, there is no information for this period that can help reconstruct which method was used to gather oil after milling (boiling versus grinding and pressing).

For the following periods, it is possible that Persian rule (fifth century BC) contributed to the development of local technical knowledge.[42] In terms of the Hellenistic-period papyri, explicit references to millstones employed in oil-seed manufacture are absent.[43] Other terms are mentioned, such as *olmos* (a mortar – or, more generally, an instrument used to pound), as well as words like *strobilos*, the meaning of which is uncertain.[44] If we look at archaeological contexts from Israel or Greece dating to the same period,[45] the presence of the *trapetum* – a crushing device that has not been identified in Fayum nor in the rest of Egypt – is frequently attested.

Ancient authors provide interesting information on the Roman period. Dioscorides and Pliny described the two methods of oil gathering (regarding castor oil in particular).[46] Taking into consideration the archaeological records from Dionysias and Fayum in this period until the late Roman age, a significant number of *molae oleariae*, mortars, swing millstones, blocks for screw presses, and imported amphorae (especially from Tripolitania) are attested. Through the study of the papyri, we can observe an increasing trend in olive tree cultivation and olive oil manufacture, in which an important role was played by military veterans who had become local landowners.[47]

To summarize, the available local Egyptian technological substratum was represented mainly by mortars. The lack of information about grinding tools would lead us to assume that further processing steps consisted of boiling the seeds in water. Mortars continued to be a key tool in the production process during the Ptolemaic period, but only scant evidence of crushing devices can be found. It is possible, however, that the term *strobilos* was related to a particular object and to the movement necessary for its operation,[48] likely referring to the swing millstone. In this way small seeds, like those of sesame, could be easily turned into an oily pulp ready to be pressed.[49] This kind of instrument, identified only in Fayum, resembles other local grinding devices strictly connected to indigenous substrata.[50] Therefore, it cannot be rejected that this peculiar type of millstone was already known before the Greek conquest.

Following the Roman conquest, the production of fundamental goods, like oil, had to be adapted to a new regime where the widespread exploitation of olive trees and oil plants had to meet the needs of a growing population. Production processes and instruments employed until that time belonged to the indigenous tradition. The *mola olearia* was perhaps introduced due to the inadequate nature of local tools. This was the best solution, since it was a familiar tool which also allowed a larger quantity of oil to be produced.[51] Moreover, it also proved to be a suitable expedient for grinding seeds. As a matter of fact, Dioscorides writes that, in Egypt the *mola* was employed due to the locally abundant production of castor oil.[52] Seeds of castor, like those of safflower, have a similar shape and size and it is likely that the *mola* was also used in these cases. The oscillatory mill continued to be employed for grinding small seeds, such as those of sesame and radish. Some examples, probably dating to the late Roman period, show traces of reuse that would confirm a progressively diminishing need for these tools.

[42] Levey 1959, 90-91.

[43] Cf. Sandy 1989, 14. The term *strobilos* is listed in the papyri of the Roman period, although it is also mentioned in some Ptolemaic papyri.

[44] Sandy 1989, 14.

[45] Kloner and Sagiv 1993, 119-135.

[46] Dioscorides, *De materia medica*, I.33; Pliny, *Historia Naturalis*, XV.7.

[47] Bowman 1988, 145.

[48] The term seems to describe something curved (from *streblos*) or driven by a fast and swirling movement.

[49] In some rural regions of modern Turkey and India there are mills where castor and safflower seeds are processed. Metal rollers perform the same function of the oscillatory millstones turning the seed into oily pulp: Knowles 1967, 156-162.

[50] A very similar artefact has been identified in the countryside of Methana, Greece, and is described by Foxhall (1993, 193-194) as 'roll and bed' type, considered as part of the local substratum also known in the Classical period. With regard to North Africa, Camps-Fabrer (1953, 53-54) reports some information about similar tools used by the Berbers.

[51] The *mola olearia* was the most common grinding tool in North Africa during the Roman period: Mattingly 1996, 578-579.

[52] Dioscorides, *De materia medica*, I.33.

Further phases of production: the screw press and the fortune of a technological innovation

The screw technology employed in oil presses entirely changed the production system in Roman Egypt, as well as in the rest of the Empire. The introduction of this invention required specific conditions that could have arisen only in the Ptolemaic period of Egypt. I will now focus on those aspects of the Ptolemaic period that favoured technical innovations and the development of production tools. This technology is the same as that found by the Romans after the conquest of Egypt, which they decided to maintain at the local level and also to export abroad.

After the conquest by Alexander the Great, Egypt lacked a technological level suitable for the type of economy the Greeks wanted to establish in the new territories. The only pressing device of the Dynastic age, employed exclusively for the production of wine, consisted of squeezing a sack filled with crushed grapes. Thanks to iconographic evidence we can see how complicated this operation was, for it required the participation of three to five men who had to adopt strange and unnatural positions.[53] Some Greek written sources have been interpreted as evidence for the use of this pressing system for oil production also in later periods.[54] In archaeological sites of Syria, Lebanon, and Israel dating to between the late Bronze and Iron Ages, the use of pressing devices (lever-type press,[55] with mobile counterweights) is attested. The Hellenistic period, especially in Greece, witnessed the adoption of innovative tools and their widespread diffusion, such as the windlass-lever press,[56] and the *trapetum*.[57] The latter was probably adopted in Palestine and Lebanon after Alexander's conquest.[58] If this was the case, one could understand how strong the impact of foreign conquerors was on the local economy in terms of incentives for production investments. Egypt was a particular context, however, where the Greeks combined their own scientific and engineering knowledge with local traditions. All these aspects contributed to a sort of 'technological revolution' (impossible to date with precision) as a consequence of a complex system of social, economic, and political factors.

With regard to the social factors, we can point out that population growth was recorded in Egypt following the conquest and the increasing power of the Ptolemaic dynasty. This was due to the arrival of Greek colonists who quickly became a local elite and were appointed to important offices in the public administration, as well as in economic and production sectors.[59]

In the economic field, the government of the Ptolemies inaugurated a period of stability and growth, supporting scientific and cultural research.[60] In this context, a reclamation was required to increase the amount of cultivable land (subject to taxes) and to meet the need of food for a rapidly growing population.

The small quantity of archaeological evidence for wooden screw presses belongs either to the Roman period or is not possible to date.[61] The attempt to advance hypotheses on the chronology through ancient sources, notably Heron of Alexandria and Pliny, already subjects of debate, contrasts with the reliability of these authors in this regard.[62] In particular, it seems that the mechanical description of the screw press, about which we are informed by Heron,

[53] Amouretti 1986, 159; Darby *et al.* 1977, 560-565, figures 14.3-14.6.

[54] In particular Herodotus, *Historiae*, IV.23 and Hippocrates, *Corpus Hippocraticum*, I.104: see Brun 1993, 539-540.

[55] Type A0-A1: Amouretti 1986, 166; Brun 1986, 86-87; 2004a, 131-149.

[56] Archaeological evidence of this tool, especially from ancient Greece, has been found at sites such as Isthmia (Anderson-Stojanović 1996, 57-98), Sifnos (Hohmann 1983, 27-38), and Delos (Brun 2004a, 108-113).

[57] The earliest archaeological evidence of the use of *trapetum* in Greece (fifth century BC) comes from Chios (Boardman 1958-1959, 295-309) and Olynthus (Robinson and Graham 1938, 337-339).

[58] Brun 1993, 541.

[59] Bowman 1988, 139.

[60] Bowman 1988, 246-248.

[61] Some sporadic screw-press blocks are visible in some sites of Fayum, such as Bakchias, Karanis, and Philoteris, datable to the Roman period. Another block from Antinoupolis in the Nile Valley is dated to the late Roman period (Empereur and Picon 1989, 244, figure 30). A fragment of a wooden screw is probably datable to the second century AD (Brun 1993, 545; 2004b, 164).

[62] Heron, *Mechanica*, III.2.13-20; Pliny, *Historia Naturalis*, XVIII.317. Pliny describes the lever press with screw and counterweight; this is not an example of a direct-screw press but, nevertheless, it attests to the presence of screw technology adopted 'within the last one hundred years' (first century BC). A technological comparison between Greek and Roman technology has been attempted by Drachmann 1932 and White 1984, 67-70.

belongs to a more ancient technology dating back to the third century BC.[63] The occurrence of presses (*organon*) in the so-called 'Revenue Laws' papyrus (dated to the reign of Ptolemy Philadelphus, first half of the third century BC) is more plausible. The mechanism of the screw – also called the 'Archimedean Screw' – was likely already known by the Assyrians who had discovered the advantages of this invention as an irrigation device in the palace of Nineveh.[64] We do not know with precision when the first 'Archimedean Screw' was installed in Egypt; perhaps already under Persian rule, or following the Greek conquest of the Near East, when the Greeks could have directly observed the use of this device and had access to workers accustomed to the use of these instruments.

The need for a new production regime and the assimilation of the technological knowledge from the heterogeneous cultures coexisting in the same country were the basis for technological development. This was achieved through the adaptation of what was already known. Moreover, we should consider a further decisive element: the role played by the central government in the production of oil. The Ptolemaic administration established a monopoly, about which it is essential to specify at least two aspects. The first concerns the protectionism secured by taxes on imported foreign oils (from Syria and the Greek islands), charged at 50 per cent of their value.[65] The second was the imposition of minimum quantities of oil that producers had to provide (which were, in fact, quite high), perhaps to be able to meet the market demand. Each mortar in every mill had to work a minimum of six artabs of seeds per day, around 200 kg.[66] Furthermore, we should consider an additional quantity of oil destined for the black market, a phenomenon about which we have little information,[67] which allowed some producers to earn more beyond state fiscal control.

The benefits of a more efficient tool for oil pressing also concerned practical issues. The direct-screw press potentially allowed one or two men to carry out the pressing activities, an important aspect if one also considers the space available for production. In Ptolemaic and Roman Fayum, production took place in densely populated urban areas where domestic buildings and manufacturing environments were relatively small in size. When we look at the plans of the structures discovered at sites such as Dionysias or Tebtynis, rooms were almost never wider than 6 m,[68] thus making it impossible to install long presses, such as the beam-and-windlass ones.[69] One should also keep in mind that the absence of large trees in the Fayum oasis is another factor to take into account to explain the absence of these types of press, which were instead widespread in the other regions of the Mediterranean.

During the Roman period, the practice of oil production in small urban spaces is still attested, but we can now identify some other interesting aspects in terms of the organization of work. Some papyri mention lists of workers paid by the day for some periods of harvesting.[70] Given the 'delocalized' character of the industry, it is likely that oil producers found this form of employment more convenient compared to a slavery-based system. As it seems clear from the correspondence of some 'entrepreneurs', we can understand that they were conductors or owners of many plots of land in different centres all over Fayum.[71] This would probably have resulted in a great amount of expense and issues with the maintenance and control of slave labour.

The Roman conquest drastically changed local economic life. The monopoly in oil production was likely substituted by a heavy regime of taxation on every aspect of oil production: from the harvest of olives to the ownership of spaces.[72] Moreover the local production had to face the increasing importation of better-quality oil, made possible by the new administration. The

[63] Russo 2010, 156-164.
[64] Dalley and Oleson 2003.
[65] Sandy 1989, 26-28.
[66] Sandy 1989, 14.
[67] *P. Tebt.* 4 1094 (113 BC).
[68] Cf. Hadji-Minaglou 2007; Schwarz and Wild 1950, 10-20.
[69] Vitruvius writes that the length of an oil mill with a windlass-lever press should not measure less than 40 feet (11.6 m), in order to make its use easier (*De Architectura*, VI.6.3).
[70] *P. Fay.* 102 (AD 103-104).
[71] Dubois 1927, 16-17.
[72] Wallace 1938, 49-62.

material evidence of the Roman period (the screw-press blocks) was the result of a Greek innovation at the local level, determined by the economic, social, and administrative factors demonstrated above. The new Roman conquerors could take advantage of the new pressing system, which was then adapted and imitated in the western provinces.[73] However, they also needed to improve the set of productive tools through the introduction of an instrument, the *mola olearia*, belonging to their technological background. This would also enable them to increase the rate of production. Past innovations and new traditions can be considered as the two sides of Roman Egyptian economic and technological life.

BIBLIOGRAPHY

Amouretti, M.-C. 1986. *Le pain et l'huile dans la Grèce antique. De l'araire au moulin*, Paris: Annales Littéraires de l'Université de Besançon.

Anderson-Stojanovič, V. 1996. The University of Chicago excavations in the Rachi settlement at Isthmia, 1989, *Hesperia*, 65: 57-98.

Bailey, D.M. 1999. Society, sebakh, sherds, *The Journal of Egyptian Archaeology*, 85: 211-218.

Bedigian, D. and Harlan, J.R. 1986. Evidence for cultivation of sesame in the ancient world, *Economic Botany*, 40.2: 137-154.

Boak, A.E.R. and Peterson, E.E. 1931. *Karanis. Topographical and Architectural Report of Excavations during the Seasons 1924-28*, Ann Arbor: University of Michigan Press.

Boardman, J. 1958-1959. Excavations at Pindakas in Chios, *Annual of the British School at Athens*, 53-54: 295-309.

Bowman, A.K. 1988. *L'Egitto dopo i faraoni. Da Alessandro Magno alla conquista araba, 332 a.C. – 642 d.C.* (traduzione di B. Draghi), Florence: Giunti.

Bresciani, E. 1976. *Missione di scavo a Medinet Madi (Fayum – Egitto). Rapporto preliminare delle campagne di scavo 1968 e 1969*, Milan: Istituto editoriale Cisalpino – La Goliardica.

Brun, J.-P. 1986. *L'oléiculture antique en Provence. Les huileries du département du Var* (Revue archéologique de Narbonnaise Supplement, 15), Paris: Éditions du CNRS.

Brun, J.-P. 1993. Les innovations techniques et leur diffusion dans les pressoirs. In Amouretti, M.-C. and Brun, J.-P. (eds), *La production du vin et de l'huile en Méditerranée. Actes du symposium international organisé par le Centre Camille Jullian (Université de Provence – C.N.R.S.) et le Centre archéologique du Var (Ministère de la Culture et Conseil general du Var), (Aix-en-Provence et Toulon, 20-22 novembre 1991)* (Bulletin de Correspondence Hellénique Supplement, 26), Paris-Athens: École Française d'Archéologie, 539-550.

Brun, J.-P. 1997. L'introduction des moulins dans les huileries antiques. In Meeks, D. and Garcia, D. (eds), *Techniques et économie antiques et médiévales : Les temps de l'innovation. Colloque international (C.N.R.S.), Aix-en-Provence, 21-23 Mai 1996*, Paris: Éditions Errance.

Brun, J.-P. 2004a. *Archéologie du vin et de l'huile. De la préhistoire à l'époque hellénistique*, Paris: Éditions Errance.

Brun, J.-P. 2004b. *Archéologie du vin et de l'huile dans l'Empire romain*, Paris: Éditions Errance.

Calderini, A. 1987. *Dizionario dei nomi geografici e topografici dell'Egitto greco-romano, volume 5*, Milan: Istituto editoriale Cisalpino – La Goliardica.

Camps-Fabrer, H. 1953. *L'olivier et l'huile dans l'Afrique Romaine*, Alger: Imprimerie Officielle.

Crawford, D.J. 1979. Food: tradition and change in Hellenistic Egypt, *World Archaeology*, 11.2: 136-146.

Curtis, R.I. 2001. *Ancient Food Technology*, Leiden: Brill.

Dalley, S. and Oleson, J.P. 2003. Sennacherib, Archimedes, and the water screw: the context of invention in the Ancient World, *Technology and Culture*, 44.1: 1-26.

Darby, W.J., Ghalioungui, P. and Grivetti, L. 1977. *Food: The Gift of Osiris, Volume 2*, London: Academic Press.

Davoli, P. 1998. *L'archeologia urbana nel Fayyum di età ellenistica e romana*, Napoli: G. Procaccini.

Davoli, P. 2012. The archaeology of the Fayum. In Riggs, Ch. (ed.), *The Oxford Handbook of Roman Egypt*, Oxford: Oxford University Press.

Dawson, W.R. 1929. Studies in medical history: (a) the origin of the herbal; (b) castor-oil in antiquity, *Aegyptus*, 10: 47-72.

Drachmann, A.G. 1932. *Ancient Oil Mills and Presses*, Copenaghen: Levin & Munksgaard.

Dubois, C. 1925. L'olivier et l'huile d'olive dans l'ancien Égypte, I. Époque pharaonique et ptolémaïque, *Revue de philologie, littérature et d'histoire anciennes*, 49: 60-83.

Dubois, C. 1927. L'olivier et l'huile d'olive dans l'ancienne Égypte, II. Époque romaine, *Revue de philologie, littérature et d'histoire anciennes*, 53: 7-49.

[73] Mattingly 1996, 585.

Empereur, J.Y. and Picon, M. 1989. Les régions de production d'amphores impériales en Méditerranée orientale. In *Amphores romaines et histoire économique : Dix ans de recherche. Actes du colloque de Sienne, 22-24 mai 1986* (Collection de l'École Française de Rome, 114), Rome: École Française de Rome, 223-248.

Foxhall, L. 1993. Oil extraction and processing equipment in Classical Greece, In Amouretti, M.-C. and Brun, J.-P. (eds), *La production du vin et de l'huile en Méditerranée. Actes du symposium international organisé par le Centre Camille Jullian (Université de Provence – C.N.R.S.) et le Centre archéologique du Var (Ministère de la Culture et Conseil general du Var), (Aix-en-Provence et Toulon, 20-22 novembre 1991)* (Bulletin de Correspondence Hellénique Supplement, 26), Paris-Athens: École Française d'Archéologie, 183-200.

Gil, M. 1975. Supplies of oil in Medieval Egypt: a Geniza study, *Journal of Near Eastern Studies*, 34.1: 63-73.

Hadji-Minaglou, G. 2007. *Tebtynis, IV. Les habitations à l'est du temple de Soknebtynis*, Cairo: Imprimerie de l'Institut Français d'Archéologie Orientale.

Hohmann, H. 1983. Ein Rundbau auf Sifnos Aspros Pirgos, *Antike Welt: Zeitschrift für Archäologie und Kulturgeschichte*, 14: 27-38.

Husselman, E.M. and Peterson, E.E. 1979. *Karanis Excavations of the University of Michigan in Egypt, 1928-1935. Topography and Architecture: A Summary of the Reports of the Director, Enoch E. Peterson*, Ann Arbor: University of Michigan Press.

Kloner, A. and Sagiv, N. 1993. The olive presses of Hellenistic Maresha, Israel. In Amouretti, M.-C. and Brun, J.-P. (eds), *La production du vin et de l'huile en Méditerranée. Actes du symposium international organisé par le Centre Camille Jullian (Université de Provence – C.N.R.S.) et le Centre archéologique du Var (Ministère de la Culture et Conseil general du Var), (Aix-en-Provence et Toulon, 20-22 novembre 1991)* (Bulletin de Correspondence Hellénique Supplement, 26), Paris-Athens: École Française d'Archéologie, 119-135.

Knowles, P.F. 1967. Processing seeds for oil in towns and villages of Turkey, India and Egypt, *Economic Botany*, 21.2: 156-162.

Lechi, F. 1984. Libro diciannovesimo. Gli ortaggi. In Conte, G.B. and Ranucci, G. (eds.), *Gaio Plinio Secondo. Storia Naturale*, 3, 1, Turin: Giulio Einaudi Editore, 859-967.

Levey, M. 1959. *Chemistry and Chemical Technology in Ancient Mesopotamia*, Amsterdam: Elsevier.

Lucas, A. and Harris, J.R. 1962. *Ancient Egyptian Materials and Industries*, New York: Dover Publications Inc.

Mattingly, D.J. 1996. Olive presses in Roman Africa: technical evolution or stagnation?. In Khanoussi, M., Ruggeri, P. and Vismara, C. (eds), *L'Africa Romana. Atti dell'XI convegno di studio (Cartagine, 15-18 dicembre 1994)*, Ozieri: Il Torchietto, 577-595.

Mayerson, P. 2001. Radish oil. A phenomenon in Roman Egypt, *Bulletin of the American Society of Papyrologists*, 37: 109-117.

Meeks, D. 1993. Oléiculture et viticulture dans l'Égypte pharaonique, In Amouretti, M.-C. and Brun, J.-P. (eds), *La production du vin et de l'huile en Méditerranée. Actes du symposium international organisé par le Centre Camille Jullian (Université de Provence – C.N.R.S.) et le Centre archéologique du Var (Ministère de la Culture et Conseil general du Var), (Aix-en-Provence et Toulon, 20-22 novembre 1991)* (Bulletin de Correspondence Hellénique Supplement, 26), Paris-Athens: École Française d'Archéologie, 3-38.

Morini, A. 2007. La nuova gestione idrica del Fayyum tolemaico. In Pernigotti, S. and Zecchi, M. (eds), *La terra, gli uomini e gli dèi: il paesaggio agricolo dell'antico Egitto. Atti del secondo colloquio (Bologna, 22/23 maggio 2006)*, Imola: Editrice La Mandragora, 111-120.

Moritz, L.A. 1958. *Grain-mills and Flour in Classical Antiquity*, Oxford: Clarendon Press.

Papi, E., Bigi, L., Camporeale, S., Carpentiero, G., D'Aco, D., Kenawi, M., Mariotti, E. and Passalacqua, L. 2010. La missione dell'Università di Siena a Qasr Qaroun-Dionysias (2009-10). In Pirelli, R. (ed.), *Ricerche italiane e scavi in Egitto*, Cairo: Centro Archeologico Italiano, 239-255.

Pernigotti, S. 2007. Fondazioni e rifondazioni di centri urbani nel Fayyum di età tolemaica e romana. In Pernigotti, S. and Zecchi, M. (eds), *La terra, gli uomini e gli dèi: il paesaggio agricolo dell'antico Egitto. Atti del secondo colloquio (Bologna, 22/23 maggio 2006)*, Imola: Editrice La Mandragora, 13-26.

Robinson, D.M. and Graham, J.W. 1938. *Excavations at Olynthos, Part VIII: The Hellenic House*, Baltimore: Johns Hopkins Press.

Russo, L. 2010. *La rivoluzione dimenticata. Il pensiero scientifico greco e la scienza moderna*, Milan: Feltrinelli.

Sandy, D.B. 1989. *The Production and Use of Vegetable Oils in Ptolemaic Egypt*, Atlanta: Scholars Press.

Schwartz, J. and Wild, H. 1950. *Qasr-Qarun/Dionysias 1948. Fouilles franco-suisses. Rapports, I*, Cairo: Institut Français d'Archéologie Orientale du Caire.

Schwartz, J. 1969. *Qasr Qarun/Dionysias 1950. Fouilles franco-suisses. Rapports, II*, Cairo: Imprimerie de l'Institut Français d'Archéologie Orientale.

Serpico, M. and White, R. 2000. Oil, fat and wax. In Nicholson, P.T. and Shaw, I. (eds), *Ancient Egyptian Materials and Technology*, Cambridge: Cambridge University Press, 390-429.

Wallace, S.L. 1938. *Taxation in Egypt from Augustus to Diocletian*, Princeton: Princeton University Press.

White, K.D. 1984. *Greek and Roman Technology*, Ithaca-New York: Cornell University Press.

12

LES ATELIERS D'AMPHORES DE ZITHA ET LE POTENTIEL ÉCONOMIQUE DE LA TRIPOLITAINE TUNISIENNE

Elyssa Jerray

Abstract

This paper focuses on the pottery produced by the ateliers discovered at Zitha since the late 1990s. This site is located in the southern part of Tunisia, c. 10 km west of Zarzis. A first typological study of local pottery was undertaken in the early 2000s. Thanks to the discovery of new pottery kilns in the suburb of the town, this study will allow us to outline some peculiar characteristics of these ateliers and to distinguish their products from the other types of amphorae found across the Mediterranean. At a broader level, the paper will also provide an overview of pottery production in this specific region of Tunisian Tripolitania, highlighting its economic potential.

Nos connaissances sur les lieux de production des céramiques africaines ont considérablement progressé ces dernières années en Tunisie. De nouveaux fours sont encore régulièrement mis au jour, dans le cadre de fouilles, de prospections ou lors de découvertes fortuites. Certaines études récentes ont permis de caractériser la production de quelques-uns d'entre eux mais celles-ci demeurent ponctuelles et concernent majoritairement les fours découverts dans les régions du Cap Bon et du Sahel.[1] Elles ont néanmoins permis de mettre en évidence les intenses relations économiques et commerciales qui reliaient l'Afrique à Rome ainsi qu'à d'autres régions de l'Empire. Outre cet aspect purement économique et commercial, l'étude de la céramique, de ses lieux de production et de sa diffusion, témoigne également de la mise en place ou de l'intensification en Afrique d'activités agricoles et artisanales correspondant aux besoins, aux habitudes alimentaires et au « goût » romain. L'importation massive d'amphores à huile, à vin ou à *salsamenta* à Rome, constitue un des multiples exemples illustrant cette interdépendance entre la province et la capitale romaine.

La découverte à la fin des années 1990 d'importants ateliers d'amphores à Zitha a permis de supposer l'implication de cette cité du sud tunisien dans ces différents réseaux d'échanges commerciaux méditerranéens et de mettre en évidence le potentiel économique d'une région souvent considérée comme marginale.

NATURE DES VESTIGES ET HISTORIQUE DES RECHERCHES

Zitha est une petite cité romaine localisée à une dizaine de kilomètres à l'ouest de la ville de Zarzis en Tunisie méridionale (Figure 12.1). Dès la fin du XIXème siècle, les premiers explorateurs proposèrent d'identifier les ruines d'Henchir Zian à la station de *Ponte Zita municipium* de

[1] Voir notamment à Salakta : Nacef 2007 ; 2009 ; à Leptiminus : Opait 2000 ; Stirling *et al.* 2001 ; Stone *et al.* 2011 ; à Nabeul : Ben Moussa, Mrabet 2007 ; Bonifay *et al.* 2010.

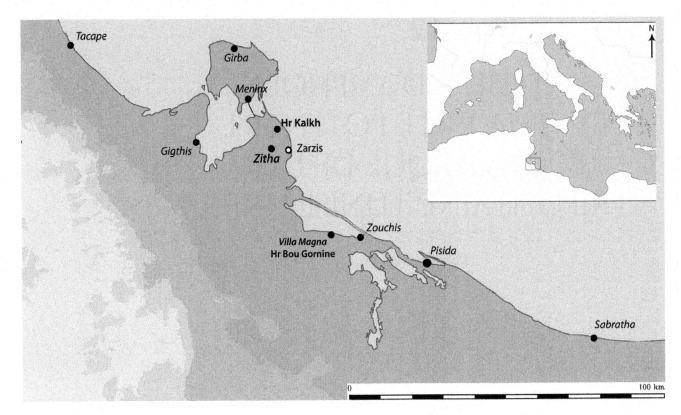

Figure 12.1. *Zone d'étude et principaux sites mentionnés dans le texte (dessin : E. Jerray).*

l'Itinéraire d'Antonin et *Liha municipium* de la Table de Peutinger. Cette hypothèse fut établie de façon définitive après la découverte de deux bornes milliaires, établissant définitivement la localisation de Zitha ainsi que son orthographe.[2]

Le site antique de Zitha s'étend sur près de 37 ha. L'ampleur des vestiges, bien que modeste comparée à celle des cités du Nord de la Tunisie, retint l'attention de plusieurs chercheurs dès le milieu du XIXème siècle. À cette époque, ce sont essentiellement les statues qui attirèrent l'attention des visiteurs. Leur finesse et leur qualité d'exécution laissaient déjà supposer à leurs découvreurs l'existence d'un site important. Hormis le signalement de ce groupe statuaire, les informations relatives à l'occupation de Zitha s'avèrent en revanche relativement maigres. Ce n'est qu'en 1884, avec les fouilles de Salomon Reinach et Ernest Babelon, que de nouveaux éléments furent portés à notre connaissance.[3] Bien que ces fouilles ne durèrent que neuf jours et qu'elles aient porté exclusivement sur le forum, elles fournirent de précieuses indications qui constituent aujourd'hui encore l'essentiel de nos connaissances sur la ville de Zitha. L'ensemble de cette documentation archéologique suggère une période d'occupation romaine précoce et fait essentiellement référence à l'époque julio-claudienne (inscriptions, statues, architecture).

Suite à ces différentes phases de recherches, la cité tomba quelque peu dans l'oubli. Il faut attendre les années 1990 et les travaux d'Ali Drine pour que de nouvelles études et campagnes de prospections soient menées sur le site.[4] Hormis la découverte des fours, un nombre considérable de stèles ou de fragments de stèles néo-puniques fut mis au jour dans ce qui fut identifié comme un *tophet*, à environ cinq cent mètres au sud-est de la ville.[5] Cette découverte, ainsi que celle de fragments de vaisselles puniques aux abords du centre de la cité, mettent en lumière son occupation préromaine.

Aujourd'hui, ces vestiges sont fortement arasés et en partie dissimulés sous les ronces et la végétation. L'ensemble de la cité antique a laissé place à une oliveraie importante ainsi qu'à une culture d'amandiers. Il est par conséquent difficile d'identifier les diverses structures mentionnées dans les différentes descriptions et rapports de fouilles. Certaines pierres de taille ainsi que certaines bases de colonne dégagées par des pilleurs laissent néanmoins présager de

[2] Constans 1915, 342, n° 34 ; Donau 1920, 35-54.
[3] Reinach, Babelon 1886.
[4] Drine 1991.
[5] Drine 1991, 17-30.

l'emplacement de l'espace du forum et des thermes. En outre, plusieurs tertres épargnés par l'agriculture correspondent aux monuments les plus importants de la cité, plusieurs pierres de grand appareil affleurant à leur sommet.

LES FOURS DE ZITHA

La découverte à la fin des années 1990 d'un atelier de production de céramiques relativement important, en contrebas du centre de la cité antique, suscita un nouvel intérêt pour ce site.[6] Un pan de l'histoire de la ville lié à sa dimension productive et économique est alors mis en lumière. Le site étant soumis à des labourages réguliers, il ne reste cependant aujourd'hui plus aucune structure visible des différents fours. Leur présence se traduit sur le terrain essentiellement par des traces cendreuses de forme circulaire. Les importantes jonchées de céramiques et les nombreux ratés de cuisson contribuent également à marquer leur emplacement (Figure 12.2).

Les diverses prospections réalisées sur le site nous ont permis de dégager deux zones de fours distinctes (Figure 12.3) :

- la zone A (fours 1 à 5) correspond aux témoignages de fours situés à proximité de la route moderne, au sud de la cité antique. Les études précédentes consacrées aux productions des ateliers ont jusqu'à présent concerné uniquement cet ensemble.[7]

- la zone B (fours 6 à 9) se situe plus au nord, à l'ouest de la cité antique, et forme un ensemble bien distinct de la première. Les fours y sont plus épars et la céramique au sol y est beaucoup plus dense. Souvent circonscrits en limite de parcelles, les fours de cet ensemble semblent avoir subi moins de dommages que ceux de la première zone (présence de plusieurs blocs d'argile correspondant à de probables éléments de four).

Ces découvertes portent à neuf le nombre total de fours à Zitha. Les amphores assimilées aux formes tripolitaines y sont majoritaires et constituent sur chacun d'eux près de 90% du matériel récolté. Le four 7 constitue cependant un cas à part et sa production se distingue très nettement de celle des autres fours étudiés sur le site, par son emplacement (à proximité du centre de la cité) mais surtout par la céramique récoltée dans ce secteur. Si nous retrouvons plusieurs amphores

Figure 12.2. *Les ateliers de Zitha : vue sur le four n° 9 (a) et ratés de cuisson (b : four 6 ; c : four 8) (clichés : E. Jerray).*

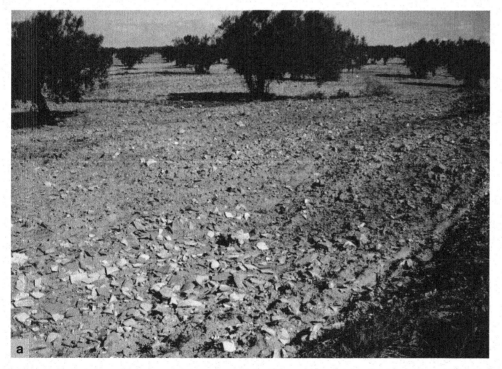

[6] Bonifay 2004 ; Drine 1999.

[7] Bonifay 2004 ; Bonifay *et al.* 2010 ; Capelli, Bonifay 2007.

Figure 12.3. *Emplacement des différents fours découverts à Zitha (dessin : E. Jerray).*

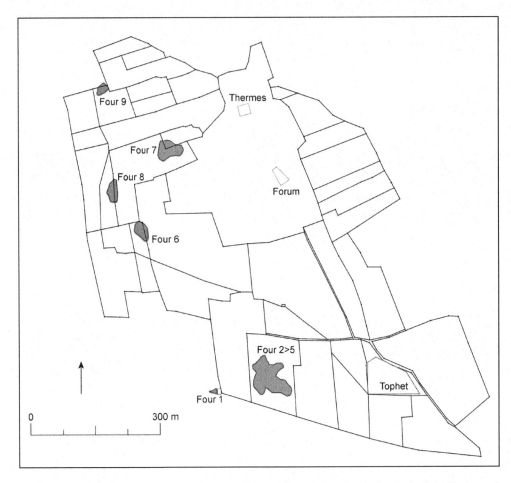

tripolitaines, elles sont ici nettement minoritaires (environ 20% du matériel récolté), l'essentiel du mobilier étant composé de céramiques communes et culinaires, traduisant la spécialisation de ce four dans la production de ces deux catégories de céramiques. Les analyses pétrographiques réalisées par Claudio Capelli confirment qu'une partie de la céramique commune et culinaire récoltée sur le site fut en effet produite sur place.[8] Ce constat n'a en soit rien de surprenant : plusieurs sites ont attesté cette production conjointe d'amphores et de céramiques communes et/ou culinaires.[9] En revanche, cela laisse supposer qu'au sein d'un même atelier, certains fours étaient peut-être plus habilités à la production d'un type de céramiques plutôt qu'à un autre.

TYPOLOGIE DES AMPHORES PRODUITES À ZITHA

Les productions amphoriques des fours firent l'objet de premières caractérisations céramologiques et pétrographiques dont Michel Bonifay est le principal contributeur. Il s'est ainsi attaché à définir les principaux types produits sur le site à partir de tessons récoltés *in situ*. Dès le début des années 2000, la présence d'un centre de production d'amphores tripolitaines (Tripolitaine I et III, absence du type Tripolitaine II) et d'amphores imitant le type Dressel 2-4 fut ainsi bien identifiée.

Si cette première caractérisation typologique a permis de définir en partie à quel faciès céramique rattacher ces ateliers, il convient cependant aujourd'hui d'être plus précis au vu des données croissantes sur les différents ateliers africains et notamment tripolitains. Les typologies de

[8] Analyses réalisées par Claudio Capelli sur des fragments de céramiques culinaires des types Hayes 181.1, Hayes 182 et Hayes 197. La présence de ratés de cuisson de céramiques culinaires et les résultats de ces analyses semblent montrer que seule une variante régionale du type Hayes 183 fut bien produite sur place.

[9] Bonifay 2004, 44 : « On observe par ailleurs que ces ateliers se limitent rarement à la production des seules amphores. Cette production principale est très souvent associée à une production de céramiques communes (Zitha, Oued el-Akarit, Sidi Aoun, Sidi Zahruni) et/ou de céramiques culinaires (Oued el-Akarit, Thaenae, Leptiminus). L'association des amphores à une production de céramiques sigillées est plus rare (Sidi Zahruni) ». Pour une vision d'ensemble des sites de production connus ayant produit des amphores avec de la céramique commune et/ou culinaire voir Leitch 2011, 170-171, table 10.2.

référence, souvent établies loin des centres de production, ne peuvent en effet traduire les spécificités de chaque atelier. À travers cette démarche, il s'agit non pas de remettre en cause ces typologies, établies pour la plupart à Ostie, mais de compléter et de préciser cette classification à travers l'étude systématique des ateliers eux-mêmes, à l'image de travaux récemment réalisés dans le Sahel.

Une des premières difficultés lors de cette phase de travail est l'absence d'exemplaires complets permettant d'établir une typologie à partir de la morphologie générale des amphores. Cet état de fait est souvent inhérent au fait d'étudier un atelier de production, le matériel y étant souvent fragmentaire.[10] Il s'agit par conséquent d'une typologie essentiellement basée sur une morphologie de bords et de fonds, ce qui constitue néanmoins une première étape de travail permettant d'isoler la production des fours qui font l'objet de cette étude.[11] Ce travail a ainsi permis d'identifier à Zitha près de 30 types au total dont nous présenterons ici les plus significatifs.

Les amphores tripolitaines

Les types distingués à Zitha sont en majeure partie assimilables aux amphores Tripolitaine I ou III (Figure 12.4). C'est ainsi le cas des bords massifs Zitha 1 et Zitha 2 (Tripolitaine I) qui figurent parmi les types les plus anciens produits sur le site (Figure 12.4, n° 1-2). Alors que le type Zitha 1, caractérisé par un gradin inférieur proéminent et un profil en S, évoque certains bords découverts à Ostie (*Ostia III*, 252) datés de la fin du Ier – milieu IIème siècle, le second est probablement plus ancien. Le bord droit et peu mouluré du type Zitha 2 évoque en effet certains fragments découverts dans des contextes de la 1ère moitié du Ier siècle après J.-C. en Libye ou plus récemment en Égypte.[12] La production de ces deux types se poursuit jusqu'au milieu du IIème siècle.

Les formes Zitha 6, Zitha 8 et Zitha 10 sont quant à elles plus tardives et sont à assimiler à l'amphore Tripolitaine III. Les différences morphologiques entre ces trois types traduisent une évolution chronologique évidente. L'aspect massif du type Zitha 6 et la transition entre le bord et le col encore bien marquée correspondent probablement à une production plus ancienne, à situer dans les décennies centrales du IIème siècle. Les types Zitha 8 et Zitha 10 présentent quant à eux certaines similitudes avec des profils découverts à Ostie[13] et au Monte Testaccio,[14] caractérisés par un amoindrissement du gradin inférieur et un bord plus aminci (fin IIème – première moitié IIIème siècle).

Certaines formes sont en revanche plus difficiles à attribuer avec certitude à l'un ou l'autre de ces deux types (exemples : Zitha 13, Zitha 14 – Figure 12.4, n° 6-7). Si les amphores massives du Ier et de la première moitié du IIème siècle sont faciles à distinguer du type III plus tardif, une série de ces bords échappe en effet à cette classification. C'est souvent le cas des fragments datés du milieu du IIème siècle – début du IIIème siècle, période qui correspond traditionnellement au passage entre ces deux types. Nous manquons en effet de références typologiques précises concernant les productions de cette période.

À l'amphore tripolitaine correspond à Zitha deux différents fonds : le premier (Zitha A), d'aspect conique, évoque les fonds traditionnels les plus courants de cette forme. Les exemplaires produits sur les ateliers présentent néanmoins la particularité d'être pleins et de disposer d'une sorte de petit bouton à leur extrémité. Le second en revanche (Zitha B) s'éloigne de la typologie traditionnelle des amphores tripolitaines : de forme tronconique à renflement annulaire arrondi et à base généralement aplatie, cette forme semble spécifique à ces ateliers et à cette région du sud tunisien. Les exemplaires de ce type sont rares dans la bibliographie mais certains fragments découverts au Monte Testaccio et en Sicile semblent démontrer qu'il s'agit d'une forme produite à partir du IIIème siècle.

Cette première approche permet ainsi de distinguer, à travers les principales formes dégagées à Zitha, différentes variantes ou « sous-types » au sein des amphores Tripolitaine I et III qui ont jusqu'à présent peu fait l'objet d'études visant à aborder les questions de leur développement morphologique et de la périodisation de ses différents types.[15]

[10] Arthur 1982, 70-71.

[11] Travail réalisé dans le cadre de notre thèse intitulée *La production d'amphores romaines en Tripolitaine occidentale : Les ateliers de Zitha et de sa région en Tunisie méridionale*, soutenue en mars 2015 à Aix-en-Provence.

[12] Riley 1979 ; information Stefanie Martin-Kilcher.

[13] Panella 1973, figure 204.

[14] Revilla 2007, figure 10.4.

[15] À propos de l'évolution morphologique des types Tripolitaine II et Tripolitaine III, voir récemment Bonifay, Capelli 2013.

Figure 12.4. *Quelques types d'amphores produits à Zitha : les amphores tripolitaines (dessin : E. Jerray).*

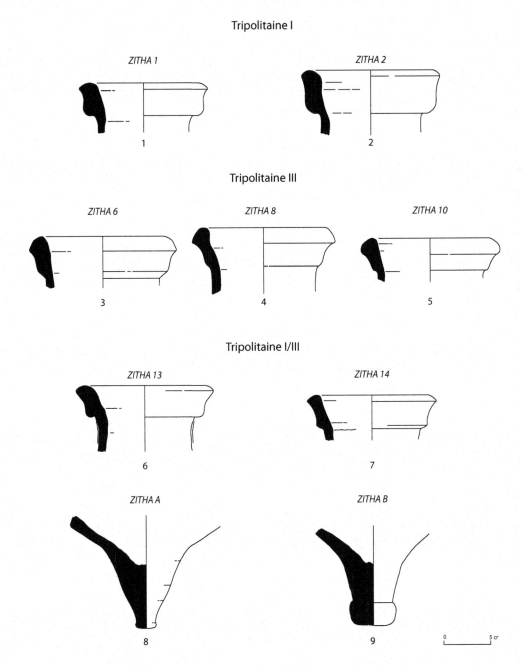

Figure 12.4. *Quelques types d'amphores produits à Zitha : les amphores tripolitaines (dessin : E. Jerray).*

Les amphores Dressel 2-4 africaines

À côté de cette production nettement majoritaire, les ateliers ont également produit une série de bords à bourrelet simple correspondant à une imitation africaine de l'amphore Dressel 2-4 (Zitha 25). Le matériel récolté sur les ateliers étant fragmentaire, il demeure cependant délicat d'être davantage précis quant à la forme générale de ces amphores (Figure 12.5). La présence d'exemplaires complets similaires aujourd'hui exposés dans le musée de Zarzis nous permet cependant d'appréhender la morphologie générale de ces amphores. Il semble ainsi que cette forme soit clairement à distinguer d'une autre amphore africaine imitant le type originaire de l'île de Cos : l'amphore Schöne-Mau XXXV. Si les anses bifides de ces conteneurs nous incitent à les regrouper sous une même appellation, leur morphologie générale laisse présager l'existence de plusieurs types à part entière, impliquant divers ateliers dont certains sont déjà bien connus.[16] Les différents exemplaires complets aujourd'hui à notre disposition semblent en effet indiquer des amphores aux dimensions et à la morphologie générale bien différentes. Les dimensions des productions du sud tunisien sont plus importantes : la hauteur moyenne de ces amphores est de 80 cm, se rapprochant en cela

[16] Faraj Shakshuki, Shebani 1998, 279-282 ; Preece 2011.

Dressel 2-4 africaines
ZITHA 24

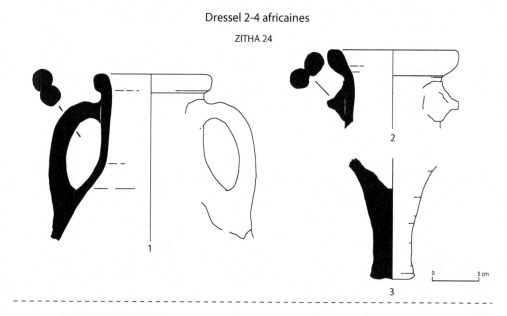

Figure 12.5. *Les amphores Dressel 2-4 africaines. 1-3 : productions de Zitha ; 4 : amphore exposée au musée de Zarzis ; 5-6 : amphores Schöne-Mau XXXV – à gauche : Pompéi ; à droite : Arles (Bonifay, Piton 2008, figure 3).*

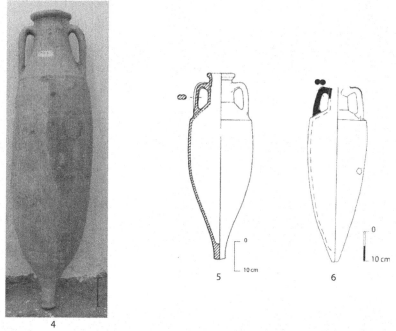

des amphores italiques. Le corps est généralement plus allongé, les anses rarement coudées et la carène caractéristique du type Schöne-Mau XXXV au niveau de l'épaulement est ici quasi-inexistante.

Une production régionale d'amphores africaines

Si la production de ces deux types évoque celle des ateliers libyens, Zitha a également produit des amphores faisant référence à des formes plus spécifiques à d'autres ateliers découverts dans le Sahel ou le Cap Bon (Figure 12.6, n° 1-2). Dès 2008 fut en effet identifiée une production d'amphores imitant les types Africaine IIA (Zitha 20) et Africaine I (Zitha 24). Il est ainsi possible de faire des parallèles satisfaisants entre plusieurs fragments produits à Zitha et certaines amphores Africaine IIA identifiées sur d'autres sites de production (Salakta par exemple) et de consommation, traduisant une volonté d'imiter deux des types parmi les plus diffusés à travers le bassin méditerranéen. Ces productions sont néanmoins nettement minoritaires et constituent chacune à peine 1% du matériel total récolté sur le site.

Face à ces productions que l'on peut rattacher sans grandes difficultés aux principales classifications de la typologie actuelle, d'autres bords sont plus difficiles à identifier. C'est le cas d'une série de fragments, que nous avons en partie interprétée comme étant de possibles imitations

Figure 12.6. *Quelques types d'amphores produits à Zitha : types mineurs (dessin : E. Jerray).*

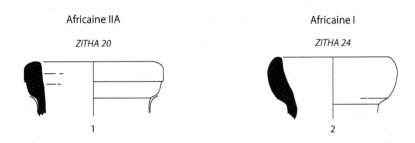

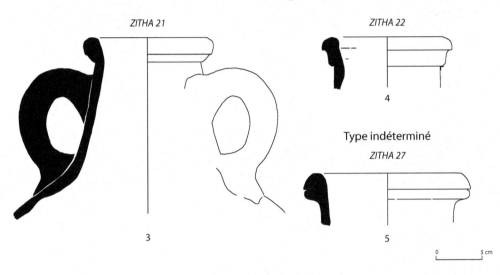

régionales de l'amphore Africaine IIA. Les anses « en oreilles » et le profil général du type Zitha 21 rappellent en effet ce type malgré un bord plus court (Figure 12.6, n° 3). Le type Zitha 22, qui figure parmi les types les mieux diffusés dans la région, présente également quelques similitudes avec certains bords de cette amphore (Figure 12.6, n° 4). Son absence dans les principaux contextes libyens insiste sur son caractère régional.

Enfin, certaines formes demeurent non répertoriées, à l'image du type Zitha 27, et constituent probablement des types locaux ayant bénéficié d'une faible diffusion (Figure 12.6, n° 5). Elles sont peut-être à mettre en relation avec une utilisation ou des contenus différents (stockage par exemple).

Chronologie du site et période d'activité des fours

Les chronologies proposées pour chacune de ces formes sont relatives. Notre matériel étant issu uniquement d'un ramassage de surface, nous ne disposons d'aucun contexte permettant de proposer une datation sûre quant à ces productions. L'absence dans le sud tunisien de stratigraphies régionales et d'études céramologiques détaillées empêche en effet de remettre en contexte les différentes formes dégagées.[17] Rares sont les fouilles en Tunisie et encore moins dans le sud tunisien permettant d'établir des parallèles avec le matériel récolté sur les fours de Zitha.[18] Nous avons été par conséquent obligés de nous référer pour l'essentiel à la typologie établie à Ostie mais ainsi qu'au matériel découvert sur d'autres sites de consommation. Ces parallèles ne servent que de références approximatives, le matériel de comparaison n'étant pas forcément du matériel produit à Zitha.

En parallèle au travail d'identification des fours et de la céramique produite à Zitha, l'étude de la céramique d'occupation, récoltée dans le secteur du forum, a néanmoins permis de compléter les principales phases d'occupation du site que semblaient mettre en lumière les résultats

[17] Nos connaissances sur cette région du sud tunisien s'appuient généralement sur les recherches réalisées sur l'île de Jerba : Ben Tahar 2010-12 ; Fentress *et al.* 2009.

[18] Le site de Zitha fait cependant depuis peu l'objet d'un nouveau projet de recherches associant l'Institut National du Patrimoine de Tunis et le Cotsen Institute of Archaeology (UCLA).

des recherches antérieures. Le mobilier recueilli à cet emplacement est essentiellement composé de vaisselles fines et de céramiques d'importation. Si les quelques fragments de céramiques attiques ou à vernis noir démontrent une certaine continuité dans son occupation depuis une époque assez haute, la présence limitée de fragments de céramiques tardives laisse supposer un déclin (voire un abandon ?) à partir du début du IV^{ème} siècle : les fragments de sigillées africaines D sont extrêmement rares alors que les catégories C et E sont quant à elles inexistantes. Cette hypothèse d'un déclin de la cité fut déjà proposée par David Mattingly qui parle au sujet de Zitha d'un *failed municipium*.[19] Il s'appuie pour illustrer son hypothèse sur les dimensions réduites du forum et sur le fait qu'il n'ait guère subit de modifications ou de travaux d'agrandissement après l'époque julio-claudienne, à l'inverse des cités voisines de Gigthis ou de Sabratha.

Face à ce constat, nous pouvons nous interroger sur la période d'activité de nos fours : est-elle à inscrire dans cet arc chronologique limité ? La comparaison entre le matériel issu des zones de fours A et B semble démontrer que ces derniers ont fonctionné plus ou moins simultanément. L'essentiel des types dégagés a en effet été découvert sur les deux zones de fours. Peut-être peut-on néanmoins deviner une intensité de production différente selon les époques. Les types Zitha 1, et surtout Zitha 2, sont en effet plus fréquents dans la zone A alors qu'ils apparaissent de façon éparse dans la zone B. Dans ce dernier secteur en revanche, les types correspondant aux amphores Tripolitaine III sont morphologiquement plus homogènes. Néanmoins, la présence dans des proportions plus ou moins équivalentes du type Dressel 2-4 sur ces deux zones de fours suggère un début de production à la même époque. Les ateliers produisaient et exportaient probablement outre-mer une partie de ces amphores jusque dans la première moitié du III^{ème} siècle comme en témoigne la présence du type Zitha B au Monte Testaccio.[20] Le type Zitha 8 rappelle quant à lui certaines formes qui semblent caractéristiques de cette même période. Ces différents éléments semblent ainsi démontrer une certaine continuité de cette activité artisanale du début du I^{er} siècle jusqu'au milieu du III^{ème} siècle après J.-C.

Les témoignages allant au-delà du milieu du III^{ème} siècle après J.-C. sont en revanche moins assurés. Nous pouvons d'ores et déjà noter l'absence à Zitha des formes les plus tardives « à casquette » caractéristiques des décennies centrales du IV^{ème} siècle mais qu'on retrouve dès le III^{ème} siècle au Monte Testaccio.[21] Ces formes sont caractérisées par une hypertrophie du gradin supérieur et la quasi-disparition du gradin inférieur. Certains fragments présentent à Zitha une morphologie similaire mais ils sont relativement rares et très dissemblables, attestant d'une production nettement minoritaire et peu standardisée.[22] L'absence à Zitha de ce type ne suffit pas cependant à témoigner en faveur d'un arrêt de l'activité de ses fours à cette époque. Rien ne nous empêche en effet de penser que les variantes tardives aujourd'hui reconnues soient propres à un autre atelier ou à une région comme Leptis Magna et que Zitha ait continué à produire des formes moins courantes. L'hypothèse d'un déclin de ces productions dans la deuxième moitié du III^{ème} siècle semble néanmoins fortement probable.

LA TRIPOLITAINE TUNISIENNE :
UN FACIÈS CÉRAMIQUE RÉGIONAL ORIGINAL

À travers cette étude, un des premiers constats est, sans surprise, la domination des amphores de tradition tripolitaine parmi le matériel récolté à Zitha. La production conjointe d'amphores tripolitaines et d'amphores imitant le type Dressel 2-4 souligne le faciès résolument tripolitain de cet atelier. La présence en Tunisie méridionale de fours ayant produit en majorité des amphores dont l'essentiel des ateliers connus se situe en Libye, permet de passer outre les frontières modernes et d'élargir quelque peu à l'ouest l'aire de production de ces deux conteneurs. Cette production d'amphores tunisiennes, qui débute dès le I^{er} siècle après J.-C, insiste sur les traditions et les influences communes de l'ensemble de ce territoire et ce, bien avant la création de la province de Tripolitaine au début du IV^{ème} siècle.

[19] Mattingly 1995, 215-216.

[20] Revilla 2007, figure 12.12.

[21] Bonifay, Capelli 2013, 34-36, figure 10 ; Manacorda 1977, figure 118 ; Revilla 2001, figure 89, n° 92/775.

[22] Bonifay 2004, figure 13.9.

L'étude exhaustive des différents types produits sur les ateliers nous a permis cependant de déceler certaines spécificités typologiques propres à cette partie tunisienne de la Tripolitaine. C'est le cas notamment des fonds d'amphores tripolitaines (Zitha A, Zitha B) mais également des exemplaires complets d'amphores Dressel 2-4 qui ont permis de distinguer très nettement cette production tunisienne des imitations de plus petites dimensions (Schöne-Mau XXXV) produites dans la région de Tripoli (Figure 12.5, n° 4-6).

Autre élément à prendre en considération pour dégager un faciès céramique propre à la région de Zitha : l'absence de l'amphore Tripolitaine II, type pourtant produit sur l'ensemble du territoire libyen, de la région de l'actuelle Tripoli à celle de Leptis Magna. L'absence de cette forme à Zitha nous a mené à lui opposer la présence d'un type mieux connu dans les ateliers du Sahel et du Cap Bon, l'amphore Africaine IIA, et à nous interroger, *in extenso*, sur les questions de leur contenu. Nous avons déjà eu l'occasion en effet de revenir récemment sur la production de ce type à Zitha et de le mettre en relation avec les divers témoignages de production de *salsamenta* dans cette région du littoral tunisien.[23] Si les amphores Tripolitaine I, III et Dressel 2-4 mettent en lumière une production oléicole et vinicole régionale, une imitation régionale du type Africaine IIA, conjuguée à l'absence de l'amphore Tripolitaine II, pourrait en effet supposer un autre contenu, dont les *salsamenta*. Si les indices convergent vers cette plaisante hypothèse, le contenu de ces deux amphores n'est pour autant jusqu'à aujourd'hui pas définitivement établi.

POTENTIEL ÉCONOMIQUE DE LA TRIPOLITAINE TUNISIENNE

Nos connaissances sur les fours de Tripolitaine ont considérablement progressé ces dernières années. En Tunisie, l'essentiel de notre documentation repose sur les campagnes de prospections réalisées dans le cadre du projet tuniso-américain dans les années 2000 à Jerba. L'île totalise ainsi 16 ateliers d'amphores romaines. Les types produits rejoignent en partie ceux dégagés à Zitha : Tripolitaine I (absence du type Tripolitaine III ?), Dressel 2-4/Mau XXXV[24] et une production d'amphores Africaine II et Keay 25. Quinze de ces ateliers semblent voués à la production du type Dressel 2-4/Mau XXXV, traduisant une véritable spécialisation de l'île dans la production de ce type.[25] Les autres amphores sont en effet produites dans des proportions moindres : seuls trois sites ont par exemple produit le type Tripolitaine I (Table 12.1).

Table 12.1. *Ateliers d'amphores découverts à Jerba.*

Lieu	Amphores de tradition punique	Mau XXXV Dressel 2-4	Tripolitaine I	Africaine II	Keay XXV
Bani Maghzel (K006)	x	x	x		
Bahbah (G056)	x	x			
Mahbubin (G087)	x	x			
Guellala (K048)	x	x		x	
Bani Maghzel (K056)	x	x			
Aghir (L006)	x	x			
K182	x	x			
Mihri (K032)	x		x		
K021		x	x		
Meninx (O005)		x		x	x
Ghazi Mustapha (K008)		x			
Al Wilhi (J014)		x			
Haribus (J034)		x			
Suq al Qibli (K050)		x			
Suq al Qibli (K019)		x			
Gmir (K144)		x		x	x

[23] Drine, Jerray 2014.
[24] Sergio Fontana n'établit pas de réelle distinction au sein des amphores Dressel 2-4 africaines qu'il regroupe sous l'appellation Schöne-Mau XXXV : Fentress *et al.* 2009, 280-282.
[25] Fentress 2001, 261-264 ; Fentress *et al.* 2009, 280-282.

Une économie locale et régionale ?

Afin de renouveler nos connaissances sur les attestations de production dans cette région, nous avons récemment eu l'occasion de nous intéresser à deux ateliers encore inédits découverts à Henchir Kalkh et Henchir Bou Gornine.[26] Alors que le premier, situé à une dizaine de kilomètres du site de Zitha, s'apparente à un établissement agricole antique, le second fut identifié comme étant la *Villa Magna* de l'Itinéraire d'Antonin.[27]

En plus de la présence d'importantes jonchées de céramiques ainsi que de zones de terre très cendreuses, c'est essentiellement la découverte de plusieurs ratés de cuisson à proximité qui confirme la production de céramiques sur ces deux sites. La densité de fragments au sol y reste cependant très en deçà de celle de Zitha, ce qui n'est guère surprenant lorsque l'on prend en considération la nature et les dimensions des sites. Il s'agit probablement davantage de productions attenantes à ces deux établissements que d'ateliers spécialisés dans la fabrication de céramiques à plus grande échelle, les fours ne dépassant probablement pas le nombre de deux.

Il a été plus délicat de dégager les types produits sur ces deux ateliers. La céramique y est en effet beaucoup plus hétérogène qu'à Zitha, où dominaient très nettement les amphores produites sur les ateliers, et la période d'occupation plus longue. Cette difficulté est probablement liée en partie aux contextes de production différents : nous retrouvons en effet à Zitha (site de production péri-urbain) des types plus standardisés, probablement voués à l'exportation et rappelant les types dégagés à Ostie, alors que la situation est plus complexe sur les deux ateliers ruraux d'Henchir Kalkh et Henchir Bou Gornine, dont les productions ont bénéficié d'une diffusion plus limitée.

Fours tripolitains et spécialisations régionales : le témoignage des amphores

L'essentiel de nos connaissances sur les fours tripolitains se trouve par conséquent en Libye. Jusqu'à 2010, les recherches faisaient état de huit sites ayant révélé la présence d'un ou plusieurs fours à céramiques. Les travaux récents de Mftah Ahmed accroissent considérablement ce chiffre.[28] Suite à de multiples prospections réalisées sur le plateau de Tarhuna, il révèle en effet l'existence de 17 nouveaux ateliers et pas moins de 35 nouveaux fours.

Ces différentes attestations de production se répartissent ainsi suivant trois principales zones :

- Les ateliers côtiers de la région de Tripoli, découverts notamment à Gargaresh,[29] Hai el Andalus[30] et plus récemment Janzur.[31]
- Les ateliers de la région de Leptis Magna, dont une partie est située sur la route reliant la ville antique à celle de Tripoli (km 102,[32] Wadi Psis[33]) et les sites découverts lors des prospections réalisées aux abords du Wadi Caam-Taraglat, plus à l'ouest.[34]
- Enfin, les ateliers du plateau de Tarhuna où de nombreux fours furent notamment récemment découverts (Figure 12.7).[35]

Le panorama général des types produits sur ces différents ateliers permet de dégager certains degrés de spécialisation selon les régions. Les types produits sur le plateau de Tarhuna et dans les environs de Leptis Magna (essentiellement Tripolitaine I et III) renforcent l'aspect de véritable « capitale oléicole » de cette région de l'Empire et de son rôle joué dans l'approvisionnement de la capitale en huile. Les amphores produites dans les régions de Tripoli et de Zitha présentent à l'inverse des productions plus diversifiées, notamment grâce à la présence d'amphores vinaires dont certaines ont par ailleurs bénéficié d'une bonne diffusion au sein de la province mais aussi

[26] Nous remercions Ali Drine et Sami Ben Tahar pour nous avoir indiqué la présence de ces deux ateliers découverts lors de leurs prospections respectives.

[27] Drine 2002.

[28] Ahmed 2010, 248-287.

[29] Bakir 1966-1967.

[30] Faraj Shakshuki, Shebani 1998.

[31] Preece 2011.

[32] Goodchild 1951.

[33] Capelli, Leitch 2011.

[34] Felici, Pentiricci 2002.

[35] Ahmed 2010; Goodchild 1951 ; Oates 1953.

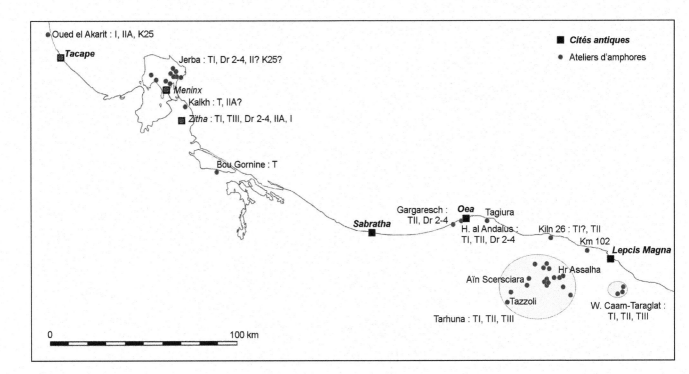

Figure 12.7. *Ateliers d'amphores romaines de Tripolitaine (dessin : E. Jerray).*

en Italie. La production conjointe d'amphores à huile et d'amphores à vin dans ces deux régions atteste ainsi d'une agriculture plus variée. Le témoignage des amphores permet ainsi d'avoir un premier aperçu sur les différentes denrées produites sur ce territoire. Ce tableau ne peut cependant être complet sans la question non résolue du contenu de l'amphore Tripolitaine II, qui semble produite tant sur les ateliers côtiers (Hai al Andalous, Gargaresh, Psis, Wadi Taraglat-site 47) qu'à l'intérieur des terres (Aïn Scersciara, Tazzoli, Tarhuna). Bien que les indices convergent vers les *salsamenta* (présence de poix, ateliers situés à proximité d'usines à salaisons, absence au Monte Testaccio) rien n'exclut totalement un contenu vinaire.

La question se pose différemment dans le sud tunisien qui nous intéresse dans la mesure où la production de ce type y est jusqu'à présent non avérée mais où nous disposons, en revanche, de plusieurs attestations de bassins et de sites spécialisés dans l'exploitation des ressources maritimes, à l'image de l'usine de salaisons d'Henchir el Mdeina (Zouchis). La démarche s'est ainsi trouvée inversée : il n'a plus été question de s'interroger sur le contenu d'un type mais de rechercher un contenant à une production bien avérée.

Ce constat illustre la nécessité d'inscrire toute étude typologique dans un cadre régional et de la mettre en relation avec d'autres témoignages de productions. Ainsi, l'étude exhaustive de la production amphorique de Zitha, outre l'intérêt typologique, mène fatalement à nous interroger sur l'intégration de cet atelier au sein d'un réseau économique et commercial régional et extra-régional. Si la production d'amphores implique le plus souvent une commercialisation outre-mer, la comparaison entre cet atelier péri-urbain et les petits ateliers ruraux d'Henchir Kalkh et Henchir Bou Gornine met en évidence les différentes étapes et échelles de commercialisation de ces conteneurs. La présence conjointe sur l'Itinéraire d'Antonin de la cité de Zitha et du *fundus* romain d'Henchir Bou Gornine-Villa Magna suggère en effet que ces différents sites et établissements fonctionnaient ensemble et participaient au même effort économique. Si les amphores nous permettent d'obtenir un aperçu et de reconstituer en partie ce « paysage » agricole et commercial, elles ne constituent qu'une fraction de celui-ci. D'autres denrées ou marchandises, non conditionnées en amphores, ont également participé à l'essor et au maintien économique de la région. C'est notamment le cas de la pourpre dont les productions de cette région, et notamment de Meninx, étaient réputées.[36]

L'ensemble de ces témoignages permet ainsi de mettre en évidence la diversité des productions de cette région du sud tunisien, la Tripolitaine tunisienne, qui passe trop souvent pour être infertile, et « importeuse ». À travers cette étude, nous avons souhaité montrer au contraire

[36] Drine 2008.

comment l'étude d'un atelier d'amphores permet de mettre en lumière les spécificités et le potentiel économique d'une région à première vue marginale. La mise en relation entre ces ateliers et les divers témoignages de productions connus dans cette région permet en outre d'insister sur son implication au sein des grands réseaux d'échanges méditerranéens. Au même titre que les régions du Cap Bon ou du Sahel, celle de la Jeffara tunisienne a très probablement participé activement à l'approvisionnement en huile, en vin ou en *salsamenta* de Rome et d'autres cités méditerranéennes. La production de types « standards » découverts sur les grands sites de consommation romains et produits dans toute la province de Tripolitaine, et ce bien avant la création de cette dernière, insistent sur l'intégration de cette région du sud tunisien au sein des grands circuits commerciaux méditerranéens.

BIBLIOGRAPHIE

Ahmed, A. 2010. *Rural Settlement and Economic Activity: Olive Oil and Amphorae Production on the Tarhuna Plateau during the Roman Period*, Thèse de Doctorat, Université de Leicester.

Arthur, P. 1982. Amphora production in the Tripolitanian Gebel, *Libyan Studies*, 13: 61-72.

Bakir, T. 1966-1967. Archaeological news, *Libya Antiqua*, 3-4: 242-243.

Ben Moussa, M., Mrabet, A. 2007. Nouvelles données sur la production d'amphores dans le territoire de l'antique Neapolis. In Remesal Rodríguez, J., Mrabet, A. (éds), *In Africa et in Hispania : Études sur l'huile africaine* (Instrumenta, 25), Barcelone: Publicacions i Edicions Universitat de Barcelona, 13-40.

Ben Tahar, S. 2010-2012. Une tombe monumentale d'époque républicaine à Marguène (île de Jerba, Tunisie), *Antiquités Africaines*, 46-48: 55-86.

Bonifay, M. 2004. *Études sur la céramique romaine tardive d'Afrique* (British Archaeological Reports, International Series, 1301), Oxford: Archaeopress.

Bonifay, M., Capelli, C. 2013. Les thermes du Levant à Leptis Magna : quatre contextes céramiques des IIIème et IVème siècles, *Antiquités Africaines*, 49: 67-150.

Bonifay, M., Capelli, C., Drine, A., Ghalia, T. 2010. Les productions d'amphores romaines sur le littoral tunisien. Archéologie et archéométrie, *Rei Cretariae Romanae Fautores. Acta*, 41: 319-327.

Bonifay, M., Piton, J. 2008. Amphores africaines du musée d'Arles (Bouches-du-Rhône). In Brochier, J-.E., Guilcher, A., Pagni, M. (éds), *Archéologies de Provence et d'ailleurs : Mélanges offerts à Gaëtan Congés et Gérarde Sauzade* (Bulletin Archéologique de Provence Supplément, 5), Aix-en-Provence: Éditions de l'APA, 585-595.

Capelli, C., Bonifay, M. 2007. Archéométrie et archéologie des céramiques africaines : une approche pluridisciplinaire. In Bonifay, M., Tréglia, J.-C. (éds), *LRCW 2. Late Roman Coarse Wares, Cooking Wares and Amphorae in the Mediterranean, Archaeology and Archaeometry* (British Archaeological Reports, International Series, 1662), Oxford: Archaeopress, 551-568.

Capelli, C., Leitch, V. 2011. A Roman amphora production site near Lepcis Magna: petrographic analyses of the fabrics, *Libyan Studies*, 42: 69-72.

Constans, L.A. 1915. Inscriptions de Gigthis (Tunisie) (suite), *Mélanges d'Archéologie et d'Histoire*, 35: 327-344.

Donau, C. 1920. Autour de Gightis. Feuilles de la carte de Tunisie au 1/100.000 : Marek, Adjim, Chemmarek, Matmata, Médénine, Zarzis, *Bulletin Archéologique du Comité des Travaux Historiques et Scientifiques*: 35-54.

Drine, A 1991. Note sur le site de Zitha (Hr Zian) à Zarzis, *Reppal*, 6: 17-30.

Drine, A. 1999. Restes de pressoirs à huile et à vin à Gigthi et à Zarzis, *Africa*, 17: 47-68.

Drine, A. 2002. Autour du lac El Bibèn, les sites d'El Mdeina et de Bou Garnin. In Khanoussi, M., Ruggeri, P., Vismara, C. (éds), *L'Africa Romana. Lo spazio marittimo del Mediterraneo occidentale: geografia storica ed economia. Atti del XIV convegno di studio (Sassari, 7-10 dicembre 2000)*, Rome: Carocci, 2001-2014.

Drine, A. 2008. Témoignages archéologiques sur les activités halieutiques de Meninx. In Napoli, J. (éd.), *Ressources et activités maritimes des peuples de l'Antiquité : Actes du Colloque international de Boulogne-sur-Mer (12-14 mai 2005)*, Boulogne: Cahiers du Littoral, 127-137.

Drine, A., Jerray, E. 2014. Exploitation et commercialisation des ressources maritimes de la Petite Syrte : témoignages archéologiques et spécificités régionales. In Botte, E., Leitch, V. (éds), *Fish & Ships, Production et commerce des salsamenta durant l'Antiquité* (Bibliothèque d'Archéologie Méditerranéenne et Africaine, 17), Aix-en-Provence: Errance-Actes Sud, 103-114.

Faraj Shakshuki, M., Shebani, R. 1998. Archaeological news 1997, *Libya Antiqua (New Series)*, 4: 279-282.

Felici, F., Pentiricci, M. 2002. Per una definizione delle dinamiche economiche e commerciali del territorio di Leptis Magna. In Khanoussi, M., Ruggeri, P., Vismara, C. (éds), *L'Africa Romana. Lo spazio*

marittimo del Mediterraneo occidentale: geografia storica ed economia. Atti del XIV convegno di studio (Sassari, 7-10 dicembre 2000), Rome: Carocci, 1875-1900.

Fentress, E. 2001. Villas, wine and kilns: the landscape of Jerba in the late Hellenistic period, *Journal of Roman Archaeology*, 14: 249-268.

Fentress, E., Drine, A., Holod, R. 2009. *An Island through Time: Jerba Studies. Volume 1, The Punic and Roman Periods* (Journal of Roman Archaeology Supplément, 71), Portsmouth, RI: Journal of Roman Archaeology.

Goodchild, R. 1951. Roman sites on the Tarhuna plateau of Tripolitania, *Papers of the British School at Rome*, 19: 43-77.

Leitch, V. 2011. Location, location, location: characterizing coastal and inland production and distribution of Roman African cooking wares. In Robinson, D., Wilson, A. (éds), *Maritime Archaeology and Ancient Trade in the Mediterranean* (Oxford Centre for Maritime Archaeology Monograph, 6), Oxford: Oxford Centre for Maritime Archaeology, 169-195.

Manacorda, D. 1977. Le anfore. In Carandini, A., Panella, C. (éds), *Ostia, IV* (Studi Miscellanei, 23), Rome: 'L'Erma' di Bretschneider, 117-285.

Mattingly, D.J. 1995. *Tripolitania*, Londre: Batsford.

Mrabet, A. 2011. Identité de la Tripolitaine occidentale : de quelques signalements archéologiques. In Briand-Ponsart, C., Modéran, Y. (éds), *Provinces et identités provinciales dans l'Afrique romaine*, Caen: Publications du CRAHM, 221-240.

Nacef, J. 2007. Nouvelles données sur l'atelier de potiers de Henchir ech Chekaf (Ksour Essef, Tunisie). In Bonifay, M., Tréglia, J.-C. (éds), *LRCW 2. Late Roman Coarse Wares, Cooking Wares and Amphorae in the Mediterranean, Archaeology and Archaeometry* (British Archaeological Reports, International Series, 1662), Oxford: Archaeopress, 581-591.

Nacef, J. 2009. *Production de la céramique antique et ateliers dans la région de Salakta et Ksour Essef*, Thèse de Doctorat, Université de Tunis.

Nacef, J. 2010. Les récentes données sur l'atelier de potiers de Henchir ech Chekaf (Ksour Essef, Tunisie) : dépotoir 2. In Menchelli, S., Santoro, S., Pasquinucci, M., Guiducci, G. (éds), *LRCW 3. Late Roman Coarse Wares, Cooking Wares and Amphorae in the Mediterranean, Archaeology and Archaeometry, Comparison between Western and Eastern Mediterranean* (British Archaeological Reports, International Series, 2185), Oxford: Archaeopress, 531-538.

Oates, D. 1953. The Tripolitanian Gebel: settlement of the Roman period around Gasr Ed-Dauun, *Papers of the British School at Rome*, 21: 81-117.

Opait, A. 2000. Early Roman amphorae from Leptiminus, *Rei Cretariae Romanae Fautores. Acta*, 36: 439-442.

Panella, C. 1973. Le anfore. In Carandini, A., Panella, C. (éds), *Ostia, III* (Studi Miscellanei, 21), Rome: 'L'Erma' di Bretschneider, 463-633.

Preece, C. 2011. Janzur: anchorage, trade, industry and development on the Tripolitanian littoral, *Libyan Studies*, 42: 47-58.

Reinach, S., Babelon, E. 1886. Recherches archéologiques en Tunisie, *Bulletin Archéologique du Comité des Travaux Historiques et Scientifiques*: 4-78.

Revilla, V. 2001. Las ánforas tunecinas y tripolitanas de los siglos II y III d. C. : tipología y circulación. In Blázquez Martínez, J., Remesal Rodríguez, J. (éds), *Estudios sobre el Monte Testaccio (Roma), II* (Instrumenta, 10), Barcelone: Publicacions i Edicions Universitat de Barcelona, 367-378.

Revilla, V. 2007. Les amphores africaines du IIème et IIIème siècle du Monte Testaccio. In Mrabet, A., Remesal Rodríguez, J., (éds), *In Africa et in Hispania : Études sur l'huile africaine* (Instrumenta, 25), Barcelone: Publicacions i Edicions Universitat de Barcelona, 269-297.

Riley, J.A. 1979. The coarse pottery of Berenice. In Lloyd, J.A. (éd.), *Excavations at Sidi Khrebish, Benghazi (Berenice), II* (Libya Antiqua Supplément, 2), Tripoli: Libya Antiqua, 91-465.

Stirling, L., Mattingly, D.J., Ben Lazreg, N. (éds) 2001. *Leptiminus (Lamta). Report no. 2. The East Baths, Cemeteries, Kilns, Venus Mosaic, Site Museum and Other Studies* (Journal of Roman Archaeology Supplément, 41), Portsmouth, RI: Journal of Roman Archaeology.

Stone, D.L., Mattingly, D.J., Ben Lazreg, N. (éds) 2011. *Leptiminus (Lamta). Report no. 3. The Field Survey* (Journal of Roman Archaeology Supplément, 87), Portshmouth, RI: Journal of Roman Archaeology.

13

IMPORTED BUILDING MATERIALS IN NORTH AFRICA
BRICK, STONE AND THE ROLE OF RETURN CARGOES

Ben Russell

Abstract

This paper examines what imported building materials – brick, tile and decorative stones – can add to our understanding of the commercial connections between North African urban centres, the wider Mediterranean, and especially Italy. Although assemblages of Italian brick and tile in North Africa have usually been explained as the remnants of ballast cargoes, there are good reasons to think that these objects were highly valued and imported for specific jobs. In this sense, the import of brick and tile and the import of decorative stone should be considered together. The desire to (re)create Roman-style buildings, especially baths and large roofed structures like basilicas, while at the same time engaging with wider currents of architectural display, underpinned the demand for these materials in North Africa.

INTRODUCTION

Africa was one of the great exporting regions of the Roman Empire and the direction of the bulk of its trade, at least in the first two centuries AD, was towards Rome. Grain, oil, *garum*, finewares and cookwares went out, but what came back? The number of imported ceramics, especially amphorae, at African port cities is typically low.[1] The usual explanation for this is that North Africa produced so many of the products habitually transported in amphorae that it did not need to import them.[2] When imported amphorae are found they tend to be for wine, from Italy or the eastern Mediterranean.[3] But other commodities were certainly also imported. Timber must have figured prominently, as must certain types of textiles. Among non-perishable materials, metal ores seem to have been imported, as well as Italian finewares and lamps[4] Building materials, however, especially stone and ceramic building material (brick and tile, hereafter CBM) are perhaps the most ubiquitous imported commodities in African cities. Despite this, building materials are rarely given much attention in studies of the economy of the region and, when they are, are often discussed separately, with imported stone being treated as a high-status, decorative commodity, and brick and tile often dismissed as simply 'ballast cargo'. With this in mind, this paper aims to examine what the distribution and use of imported building materials in North Africa adds to our understanding of the commercial links existing between this region and Italy, Rome in particular. Were these heavy materials simply imported as ballast on ships that had unloaded their primary cargoes at Rome or were they valued commodities in their own right? And, thinking more generally about the theme of

[1] On Carthage: Fulford 1987, 60; Rice 2011, 85-86.
[2] Fulford 1984.
[3] On the amphorae from the housing blocks at Carthage: Martin-Kilcher 2005, 211; also Rice 2012, 28-31, 45.
[4] For imports at Leptiminus: Mattingly *et al.* 2011, 254-261.

this volume, what role did the North African builders who used these materials have in this traffic? Were they simply passive recipients of ballast cargoes or did they actively engage with the overseas trade in building materials to acquire specific items for particular projects? For reasons of space this paper will focus on the province of Africa Proconsularis.

IMPORTED CBM

Brick stamps and petrographic analysis show that the import of Italian brick and tile in North Africa was firmly established by the first century AD, even if brick construction was never widespread.[5] Carthage contains the largest concentration of stamped Italian bricks outside Italy: Zucca catalogued 39 examples from first- and at least 80 from second-century AD contexts;[6] more recently, second-century stamped bricks have been found in the baths at Bir el Jebbana on the city's outskirts.[7] But imports were not limited to Carthage. Six different stamps of Hadrianic date were recorded in the Hadrianic Baths at Lepcis Magna, while 69 stamped *sesquipedales* were catalogued in the villa at Tagiura near Tripoli, all datable to AD 145-160.[8] Handfuls have also been identified at Hadrumentum (four), Utica (seven), Battaria (one) and inland Bulla Regia (three) and Vallis (one), as well as Caesarea (one), Rusicade (four), Saldae (four) and Cirta (two) to the west. Thébert has catalogued further examples at Tubernuc, as well as numerous *bipedales* from the *figlina* of Ti. Claudius Felix in the large northern baths at Hippo Regius.[9] This *figlina* was located near Salerno and its bricks have also been identified at Leptiminus, Hadrumentum, Thapsus, Themetra, Carthage, Salerno itself and in the Baths of Caracalla in Rome.[10] Claudius Felix was operating in the Severan period, probably at the end of the heyday of imported brick and tile, which appears to have occurred in the mid-second century AD.[11]

Since only a small number of bricks in any shipment would have been stamped (somewhere between 1 in 3 to 1 in 15),[12] petrographic analysis has a key role to play in augmenting our understanding of these imports. At Carthage, three studies of these materials have been carried out and, to some extent, these confirm the picture provided by the stamps. Peacock's analysis of 125 bricks identified 14% as local products (fabric C), 32% as from elsewhere in Tunisia (B and D), and 44% as imported (A, E and F); 9% came from an unknown source (G).[13] Among the imports, 75% appeared to be of Campanian origin (A). While most of these bricks came from fifth- and sixth-century contexts, it is probable that they were originally imported in the first and second centuries. These findings were largely confirmed by Tomber's later study, which again highlighted Campanian imports.[14] Most recently, focusing on material from a different area of the city, Mills found that Campanian brick was again the dominant import, even if the bulk of the material analysed was local.[15] At Utica, large quantities of brick and tile have been recovered by the Tunisian-British project from a major public building, probably a basilica, in the centre of the city (Area II).[16] The fabrics of these objects have not been microscopically analysed yet but initial inspection suggests that Campanian fabrics are again common; around 30 per cent by weight of the material examined was of a material similar to Peacock's fabric A.[17] A small amount might also be from the Tiber valley, though this has yet to be confirmed.

Where petrographic analysis has been carried out, Campanian material dominates and it has been argued, consequently, that these bricks were funnelled primarily through Puteoli.[18]

[5] Helen 1975, 18.
[6] Zucca 1986, 660-661; also Steinby 1981, 244-245.
[7] Rossiter 1998, 110-111.
[8] Bartoccini 1929, 77; Zucca 1986, 661-662.
[9] Thébert 2000, 348.
[10] Wilson 2001, 25-27.
[11] Rico 1995, 791, figure 7.
[12] Steinby 1981, 245.
[13] Peacock 1984, 243.
[14] Tomber 1987.
[15] Mills 2013, 69, table 4.2.
[16] For the reports, see http://utica.classics.ox.ac.uk.
[17] Pers. comm. V. Leitch.
[18] On this point, see Mills 2013, 39; Peacock 1984, 246; Rico 1995, 782-783.

However, many of the stamped bricks come from *figlinae* in the Tiber valley and were presumably shipped through Ostia and Portus. Fewer of the Campanian bricks imported into North Africa appear to have been stamped but combining petrographic results and brick stamp analysis shows that African cities acquired materials from multiple sources.

'BALLAST CARGOES'

Italian bricks and tiles are an unusual import and the traditional explanation of these seemingly anomalous assemblages is that they constitute the remnants of ballast cargoes. Steinby and Zucca concurred: the traffic in brick and tile was a 'secondary commerce'; these materials were employed as ballast and their use was neither widespread nor substantial.[19] Shippers loaded these materials in Italy, once they had unloaded their main cargoes of African agricultural produce, in order to manage the stability of their vessels on the return trip. Imported brick and tile, in other words, were effectively a by-product of North Africa's role as an exporter and, while a limited profit could be made on it, these were largely speculative cargoes.

It is certainly true that ships could not have returned from Italy empty. While an over-loaded ship is slow and risks being swamped, an under-loaded ship, with a light draught and excessive freeboard, is unsteady and difficult to handle.[20] One of the most common forms of ballast was sand. A *corpus* of *saborrarii*, probably responsible for loading ballast sand (*sabbia*) on to outbound vessels, existed at Ostia in the second century AD; another inscription delimits where sand can be dug from around Portus.[21] Beach sand was widely used as ballast in the Medieval period.[22] Gravel was another option and seems to have been used in Atlantic shipping.[23] Rough blocks of stone or boulders were also employed and were routinely reused. Piles of jettisoned stones have been found on the seabed off Caesarea Maritima, while others originating in Yemen have been found at the Red Sea ports of Quseir and Berenike.[24] These ballast materials had little commercial value and were probably discarded after use; Medieval ports even enforced regulations governing where ballast could be dumped.[25] Stone blocks, however, could be used for local building; at La Rochelle and Brouage analysis has shown that Cornish and Irish granite boulders were often used for this purpose.[26]

The argument that bricks and tiles were also used as ballast rests on the assumption that it was heavy, could be acquired cheaply by shippers and eventually sold on at a profit, however slight.[27] And it is not just for the Roman period that this argument has been advanced. The bulk of bricks used in England in the late thirteenth and early fourteenth century were imported, and largely Flemish.[28] These imports are concentrated in south-east England (London, Essex, Suffolk and Norfolk), where their use has encouraged the view that they arrived, initially at least, as ballast on returning ships involved in the export of English wool to the Low Countries.[29]

Brick and tile were different from other ballast options, however, for several reasons. First, they were manufactured products that could not be picked up for free. The shipper had to invest capital in these materials from the outset; for them to function as 'saleable'/'payable' ballast there had to be a known market for them.[30] Second, CBM is different in terms of weight and form to other ballast options. As McGrail has pointed out, shippers consider not just the weight or volume of their cargo but the relationship between these variables, the cargo density (tonne/m^3).[31] The inverse of cargo density is referred to as the stowage factor (m^3/tonne) and is used to calculate how much space a tonne of a particular cargo will take up. Water has a stowage factor

[19] Steinby 1981, 245; Zucca 1986, 664.

[20] McGrail 1989, 354.

[21] *CIL* XIV 102 (= *ILS* 6177); Cébeillac-Gervasoni 1979.

[22] Ansorge *et al.* 2011.

[23] Taylor 1998.

[24] Boyce *et al.* 2009; Peacock *et al.* 2007.

[25] Ansorge *et al.* 2011, 161.

[26] Lazareth and Mercier 1999.

[27] Mills 2013, 1.

[28] Salzman 1952, 140-142.

[29] Clifton Taylor 1972, 211-212.

[30] Hartley 1973.

[31] McGrail 1989, 356.

of 1.00. Cargoes with a stowage factor lower than this include metal ingots and ore (0.22-0.39), stone blocks or slabs (0.42-0.56), sand (0.53-0.56) and gravel (c. 0.65).[32] Most of the products that African shippers were exporting had a higher stowage factor: McGrail gives figures for wheat of 1.34-1.50, for 'casks' of wine of 1.62-1.78, and for olive oil of 1.67-1.73. In comparison, modern bricks and floor tiles usually have a stowage factor of around 1.10-1.50. Roman roof tiles would also have a much higher stowage factor, however, since the flanges on *tegulae* and the curvature of *imbrices* would mean they took up more space per tonne; for these items McGrail's figure of 2.13-2.27 is probably about right. What these stowage factors show is that if a shipper wanted to return from Rome 'in ballast' alone then bricks or tiles were not an ideal choice. Even if a shipper decided to undertake the return leg at a third maximum capacity to ensure reasonable stability, this might equate to 75-100 tonnes of ballast for a largish freighter. In the case of bricks, this would mean filling 110-150 m³ of the hold, equivalent to roughly 9,000-12,500 *sesquipedales* or 3,500-4,900 *bipedales*; a similar weight of roof tiles, consisting of approximately 3,500-4,800 *tegulae* and the same number of *imbrices*, would fill 150-230 m³ of space.[33]

BRICKS AND TILES AS A PROFITABLE CARGO

These are good reasons, therefore, to doubt that bricks and tiles were only moved long distances as ballast. Indeed even the evidence from Medieval England, so often highlighted in discussion of ballast cargoes, is far from clear-cut. As Kennett has demonstrated, in most cases imported bricks were used in England for very specific purposes and single parts of a building; when used in churches, for example, bricks are usually employed for towers.[34] Bricks might initially have arrived as speculative cargoes but their use was soon appreciated. In fact, as early as 1278, 202,500 Flemish bricks were imported for the construction of the Tower of London, followed by a further 101,350 in 1283.[35] The transport of the first shipment of these bricks cost far more than the bricks themselves (£32. 5s. compared to £20. 4s.). Bricks were not shipped simply as ballast, then, but as consignments of commodities, which either already had a buyer or at least a defined market.

Could the Italian brick and tile found in North Africa also constitute specific orders? Bricks and tiles were certainly used in a very targeted way. Most stamped bricks come from bath complexes, and indeed other large bricks, probably imported, are known from the baths at Membressa, Utica and Uthina.[36] In the case of Leptiminus, Dodge suggests that bricks were employed only for buildings where their use was essential, notably in baths and kilns, 'where durability and fire-proofing were important considerations'.[37] In baths, *sesquipedales* and *bipedales* were used especially for hypocaust flooring, but imported *tegulae* and *imbrices* are also associated with structures that required large pitched roofs, such as basilicas. This is the case at both Carthage and Utica.[38] Pitched-roof buildings are rare in North Africa, where flat or vaulted roofs made out of mortared rubble are more common.[39] In addition to the targeted use of imported brick and tile in specific building types, it is also possible to identify concentrations of these materials that might be connected to individual orders. The villa at Tagiura in Libya, with its large number of stamped *sesquipedales*, is a case in point.[40] At this site, but also within single structures at large urban sites, the stamped bricks originate at a limited range of *figlinae* and can be dated to a narrow timeframe. These were not materials that had either been accumulated from a range of ballast cargoes or held in stock at a depot for a long time.[41] Comparable concentrations have been identified at various sites, including several villas in Sardinia and at the Ca l'Andreu villa at Tiana near Barcelona.[42]

[32] McGrail 1989, 356 (table 1), supplemented with data from various online shipping company lists.
[33] Mills (2013, 29-33) gives weights for *tegulae* (14-16 kg), *sesquipedales* (8 kg), and *bipedales* (20.5 kg); 6 kg for an *imbrex* is from Royal 2012, 424.
[34] Kennett 2008, 64.
[35] Salzman 1952, 140.
[36] Thébert 2000, 349; Wilson 2001, 27.
[37] Dodge 1992, 159.
[38] At Utica, the building in Area II is probably a basilica; on the late basilica at Carthage, Mills 2013, 12.
[39] On this point, Dodge 1992, 160; 2011, 476; Hurst 1994, 57, 306-307.
[40] Zucca 1986, 661-662.
[41] Thébert 2000, 349-350.
[42] Rico 1995, 786-787; Zucca 1986, 662-665.

Why import brick and tile at all, though? Petrographic analysis at Carthage has shown that most of the brick and tile used was produced locally or regionally. The necessary raw materials, kilns, fuel and craftsmanship were present in North Africa, and indeed several producers specialized in the production of a very specific type of ceramic building material, vaulting tubes, which even appear to have been exported.[43] Italian bricks and tiles, then, were not imported because local production was unfeasible. One possibility is that these Italian materials had unique qualities that made them viable commodities for trade. Size might have been one factor. Thébert notes that many of the imported CBM in North Africa consist of *sesquipedales*, *bipedales* and *tegulae*, and queries whether local brickworks were able to produce items as large as these.[44] The robustness of Italian materials might also have affected their value. In his analysis of the Tiber valley brick industry, Graham has suggested that the volcanic materials in the clay exploited by these brickworks could have increased the strength of the end product.[45] Italian bricks and tiles could, then, simply have been more suited to the jobs on which they were used than local products.

Social ties should also be factored into this discussion. A significant portion of the stamped bricks recovered from North Africa came from *figlinae* owned by the *gens Domitii*; Thébert estimates as much as 50 per cent.[46] Four generations of this family are attested on brick stamps from North Africa and Setälä argues that they dominated the brick market in the region.[47] Cn. Domitius Lucanus and his brother Cn. Domitius Tullus even spent much of their public careers in North Africa in the Flavian period; they seem to have owned land in the Medjerda valley.[48] Perhaps this family used its ties in the region to secure contracts for the supply of building materials. Other brick producers certainly moved from Italy to North Africa: C. Iulius Antimachos, a brick producer named on stamps at Rome, is attested on two stamps from Carthage with P. Perelius Hedulus, a resident of the city and one of the few North African producers to stamp his bricks; these individuals appear to have gone into business together.[49]

While personal ties of this kind have to be acknowledged, it is important to note that it was not only North African builders who imported bricks from overseas. Stamped Italian bricks are found in southern France and eastern Spain.[50] Large quantities of bricks produced in northeastern Italy were imported into Dalmatia; Wilkes has suggested that the *figlina* of Q. Granius Priscus near Aquileia produced bricks entirely for the export market.[51] Mills' work at Beirut has shown that roof tiles were routinely imported from Cilicia, to be used with local bricks.[52] In none of these cases can it be argued that these materials were simply imported as low-value ballast cargoes. No special commercial relationship comparable to that between North Africa and Italy existed between any of the regions listed above. Good bricks and tiles seem to have been sought-after commodities.

Some support for the idea that these materials constituted a profitable cargo in their own right can also be gleaned from the shipwreck evidence. Parker catalogued 40 shipwrecks containing bricks and/or tiles.[53] Some of these were very large: 5,000 tiles were found on the Late Roman wreck in the Kerme Gulk, for example.[54] A cargo comprising 1,200 *tegulae* and probably the same number of *imbrices* was recently discovered at the site of the Boka Kotorska 1 wreck off Montenegro, dated to the late first century BC or early first century AD. The size and consistency of the cargo, Royal argues, suggest that 'tile offered a saleable cargo to generate profits and was not simply a convenient ballast option'.[55] Parker draws a similar conclusion for the

[43] Lancaster 2012, 151-160. A cargo of c. 100 vaulting tubes, seemingly North African and travelling alongside amphorae was recovered from the Levanzo I wreck off eastern Sicily: Royal and Tusa 2012, 44.

[44] Thébert 2000, 355.

[45] Graham 2006, 69-70.

[46] Thébert 2000, 350-351.

[47] Setälä 1977, 34-37; also Graham 2011, 481-484.

[48] Kehoe 1988, 51-53.

[49] Rives 1995, 55.

[50] Hartley 1973; Rico 1995.

[51] Wilkes 1979, 69; Parker 2008, 185-187.

[52] Mills 2013, 70-2.

[53] Parker 1992, 18; also Mills 2013, 6-8.

[54] Parker 1992, 226, no. 543.

[55] Royal 2012, 447.

cargo of bricks on the Punta Scario A wreck that he identifies as 'certainly not 'ballast' but a real consignment'.[56] This wreck is apposite since, although this ship sank off western Sicily, it was probably heading for Africa. It was carrying bricks and roof tiles, and at least one of the bricks carried the stamp of Ti. Claudius Felix, identical to the ones recovered at Leptiminus, Hadrumentum, Thapsus, Themetra and Carthage.[57]

IMPORTED STONE

Bricks and tiles were by no means the only building materials imported into North Africa. Many of the same cities that contain imported bricks and tiles also used large quantities of non-African decorative stones. Like CBM, decorative stones are concentrated in major public buildings, and particularly baths, and their import peaks in the mid-second century AD.

However, while Italy was the main source for imported bricks and tiles, North African builders drew on a wider range of sources for decorative stones, in keeping with the fashion for polychrome marble display. Carthage and Lepcis Magna were equipped with the full spread of imports that by the second century AD had become popular in most Mediterranean cities. Columns in *cipollino*, pink Aswan granite, grey granite from the Troad and Kozak Dağ were used in large numbers, combined with bases, capitals and entablatures in white Proconnesian or Pentelic marble.[58] In flooring and wall revetment, a wider range of Asian, Greek and Egyptian stones have been recovered.[59] Comparable assemblages have been found in other cities.[60] A particularly rich collection of imported stones has been identified at Uthina, including large numbers of granite and marble columns.[61] Initial results from the Tunisian-British excavations at Utica show some similarities: in Area II, over 40 fragments of monolithic columns have been found, with diameters of between 50 and 80 cm, carved in grey and pink granite, the former certainly Troad, the latter probably Aswan.

In the same way that imported bricks and tiles were used alongside local products, these foreign stones were combined with African materials. Of these, the most widely distributed was *giallo antico* from Chemtou. This is the most common decorative stone at Utica, where it was used for both columns and revetment; to date, 37 per cent of the revetment recovered from Area II is *giallo antico*. It is also found in significant quantities at both Uthina and Leptiminus, at the former alongside the black limestone from the nearby Djebel Aziz and the red alabaster from the Djebel Oust.[62] At both of these sites, as well as at Carthage, the grey-white streaked marble from the Cap de Garde in Algeria is found in abundance; at Leptiminus, in fact, this was the most common white marble used.[63] The white marble from the Gebel Filfila in Algeria was also used at Carthage for fine architectural carvings.[64] The substantial trade in stone from regional quarries was in aggregate terms probably more significant than the import of material from outside North Africa, lending support to the suggestion that there was a high degree of economic integration within this region in the Roman period.[65] These decorative stones, like those from overseas, however, were prestigious and expensive materials; for ordinary buildings North African cities relied on sandstone and limestone from local quarries.[66]

Among the various assemblages from North African cities examined to date, decorative stones from Italy are scarce. Luna marble is not found in large quantities in North Africa, except at Cherchel.[67] At Uthina, however, four column fragments of Sardinian granite were identified.[68] This

[56] Parker 2008, 187.

[57] Graham 2011, 483; Parker 1992, 360, no. 961.

[58] Lazzarini 2004. On Lepcis Magna, see Bianchi 2009; Bianchi *et al*. 2009; Bruno and Bianchi 2012; Pensabene 2001; Ward-Perkins 1993. On Carthage, Ros 2006.

[59] Bullard 1978.

[60] On Leptiminus: Dodge 1992, 157-162; 2001, 104-106; 2011, 463-475.

[61] Agus *et al*. 2007, 376.

[62] Agus *et al*. 2007, 377; Dodge 2011, 463-475.

[63] Dodge 2011, 463-475.

[64] Herrmann *et al*. 2012, 304-305.

[65] Fulford 1987, 87; Hobson 2012, 219.

[66] Russell 2013, 71, figure 3.11.

[67] Pensabene 1995, 15.

[68] Agus *et al*. 2007, 375-376.

pinkish-grey granite was certainly exported from Sardinia to Rome and it has also been found at Ostia, but outside of Italy it has been identified in primary use only at Carthage and Lepcis Magna, and then only in small quantities.[69] Three of the four Sardinian granite columns found at Uthina have diameters of between 60 and 70 cm, corresponding to approximate lengths of 4.2-5 m, and were evidently intended for a major building. Interestingly, these granite columns are not the only Sardinian building materials found in North Africa. A recent study of lightweight volcanic stones used in various vaulting structures in Tunisia has shown that the *scoria* in the vaulting of the Antonine Baths at Carthage is Sardinian.[70] Sardinia was also a major source of grain mills, examples of which have been found at Carthage, Gigthis, Mustis and Utica (with another preserved in the Sousse museum).[71] Pantelleria was also an important source of volcanic materials: the builders of the vault of the *frigidarium* of the East Baths at Leptiminus sourced pumice from the island and Pantellerian grain mills turn up at Carthage, Celibia, El Maklouba, Thapsus, Thuburbo Maius and Utica.[72]

How were these materials imported? It could be argued that *scoria* simply travelled as a 'spacefiller' alongside grain mills, but such large quantities of this material were used in the Antonine Baths that it must have been ordered in especially for this job.[73] The same is probably true of the bulk of decorative stones imported into North Africa. As with bricks and tiles, it has been suggested that this material could have arrived as part of 'ballast cargoes' but decorative stones, particularly when already shaped into monolithic columns, were expensive and heavy items that made little sense as speculative cargoes.[74] These stones were imported, not in the absence of local alternatives, but because they were appreciated for their unique decorative and structural qualities. There are parallels here with what has already been said about Italian brick and tile. What DeLaine describes as 'the desire – indeed we might say the social and political imperative – to reproduce' Roman-style buildings away from Rome was a major driver for innovation, both in terms of construction techniques and the materials employed, across the Roman world.[75] In the case of brick and tile, as Graham puts it, 'an Italian building required 'Italian' materials'.[76]

Exactly how the supply system for the imported stone worked is not clear. In the case of major building projects, like those at Lepcis Magna, which employed craftsmen from all across the Mediterranean, the contractors responsible would probably have sourced the necessary materials directly from the quarries.[77] Major harbours, like Ostia and Portus, also acted as important marketplaces. In the case of floor or wall schemes involving wide spreads of materials it is highly unlikely that customers approached each quarry individually. Specialist dealers (*marmorarii* or *redemptores marmorarii*) in stones instead probably dealt in bundles of mixed materials that could be put to use in a range of ways. Assortments of pre-cut panels in various stones have been recovered from the Torre Sgaratta and the Punto Novo shipwrecks, alongside primary cargoes of marble sarcophagi and blocks respectively.[78] The range and quantity of imports in North Africa closely echo what is found in central Italy, both in imperial building projects and non-elite contexts, and this raises the possibility that many of the decorative stones used for flooring and wall revetment in North Africa were actually shipped there via Italy.[79]

RETURN CARGOES

A distinction needs to be drawn, then, between 'ballast cargoes' (high bulk, low value cargoes) and 'return cargoes' containing commodities intended for a defined market on which profit could be made. As Scheidel has observed, 'finding return cargo – i.e., filling ships on both legs

[69] Lazzarini 2004, 116, figure 25.

[70] Lancaster *et al.* 2010.

[71] Antonelli and Lazzarini 2010; Williams-Thorpe 1988; Williams-Thorpe and Thorpe 1989.

[72] Dodge 1992, 157; Wilson 2001, 27.

[73] Lancaster *et al.* 2010, 958.

[74] Buckland and Sadler 1990, 115; on the logistics of shipping stone, Russell 2013, 131-139.

[75] DeLaine 2006, 238.

[76] Graham 2006, 70.

[77] Russell 2013, 202-214.

[78] Russell 2013, 134.

[79] For distribution maps, Lazzarini 2004. On non-elite marble use at Pompeii, Fant *et al.* 2013; on imperial projects at Rome, Russell 2013, 185-187.

of a round-trip journey – was particularly important, as was the ability to create a profitable mix of lightweight but valuable alongside cheap and heavier commodities'.[80] Lightweight commodities from Italy for which there is likely to have been a market in North Africa include textiles, tablewares and lamps, perhaps even more unusual materials like *scoria* and pumice. Decorative stones would have been a good option for a heavy cargo, though they would not have been cheap. Brick and tile would have been cheaper than stone, but as discussed above they had a relatively high stowage factor. There evidently existed a ready market in the coastal cities of North Africa for both of these materials, however. With regard to imported brick and tile in North Africa, Wilson has suggested that 'the long-distance trade in these apparently low-profit items would be explained if they formed the return cargoes of ships exporting oil and fish products, the profit on the outward trip permitting the shipment of a return cargo which might be sold at little more than cost.'[81] While it is true that North African shippers could probably have made substantial profits on the goods they were exporting, and that the cost of their outbound voyages would in some cases have been covered by state subsidies, there is no reason to assume that they would not also have sought to make a reasonable profit on the return leg as well. Loading and unloading thousands of bricks or tiles would have taken time and cost money, and would hardly have been worth the trouble if the profits were insignificant. The targeted use of brick and tile in certain public buildings and the occasional major private residence might also indicate that suppliers to the building industry, perhaps even architects or public curators themselves, contracted shippers heading to Italy to carry certain cargoes back for them.

The potential value of return cargoes can be appreciated from a much earlier document, Demosthenes' *Against Lakritos*.[82] In this case, the return cargo acted as security on the loan the shippers had initially received and was to be handed over to the lenders should the original loan and the interest accumulated not be repaid within twenty days. It was of such concern to the lenders that a reasonable return cargo be brought back to Athens that they even specified in the contract which products should be bought and sold en route to ensure maximum profit.

The trade in bricks and tiles has been largely overlooked until recently but the data emerging from both shipwrecks and sites on land shows that particular types of brick and tile, like certain stone varieties, were profitable commodities in their own right. There was evidently a market for these specialist materials (as well as *scoria* and pumice) in North Africa, which shippers returning from Italy to North African ports supplied. North African builders seem to have been well aware of the relative qualities of different types of building materials, both local and imported. Rather than simply making do with whatever materials happened to turn up as ballast cargoes, they actively sought out the best brick, tile and decorative stone in what was an increasingly interregional marketplace.

BIBLIOGRAPHY

Agus, M., Cara, S., Lazzarini, L. and Corda, A.M. 2007. I marmi colorati di Uthina. In Sotgiu, G., Ben Hassen, H. and Corda, A.M. (eds), *Scavi archeologici ad Uthina (2001-2007). Rapporto preliminare dell'attività di ricerca dell'Institut National du Patrimoine di Tunisi e dell'Università di Cagliari, Italia. 2. Lo scavo e le ricerche in corso*, Cagliari: Nuove Grafiche Puddu, 375-394.

Ansorge, J., Frenzel, P. and Thomas, M. 2011. Cog, sand and beer – a palaeontological analysis of medieval ballast sand in the harbour of Wismar (southwestern Baltic Sea coast, Germany). In Bork, H.-R., Meller, H. and Gerlach, R. (eds), *Umweltarchäologie – Naturkatastrophen und Umweltwandel im archäologischen Befund*, Halle: Landesmuseums für Vorgeschichte Halle (Saale), 161-173.

Antonelli, F. and Lazzarini, L. 2010. Mediterranean trade of the most widespread Roman volcanic millstones from Italy and petrochemical markers of their raw materials, *Journal of Archaeological Science*, 37: 2081-2092.

Bartoccini, R. 1929. *Le terme di Leptis*, Bergamo: Istituto italiano d'arti grafiche.

Bianchi, F. 2009. Su alcuni aspetti della decorazione architettonica in marmo a Leptis Magna in età imperiale, *Marmora*, 5: 45-70.

[80] Scheidel 2011, 30.

[81] Wilson 2001, 27.

[82] Demosthenes, *Logoi*, XXXV.10-11.

Bianchi, F., Bruno, M., Gorgoni, C., Pallante, P. and Ponti, G. 2009. The pilasters of the Severan Basilica at Leptis Magna and the School of Aphrodisias: new archaeometric and archaeological data. In Jockey, P. (ed.), *Leukos lithos. Marbres et autres roches de la Méditerranée antique : Études interdisciplinaries. ASMOSIA VIII. Actes du huitième Colloque international de l'Association for the Study of Marble and Other Stone used in Antiquity (Aix-en-Provence, 12-18 juin 2006)*, Paris: Maisonneuve & Larose, 329-349.

Boyce, J.I., Reinhardt, E.G. and Goodman, B.N. 2009. Magnetic detection of ship ballast deposits and anchorage sites in King Herod's Roman harbour, Caesarea Maritime, Israel, *Journal of Archaeological Science*, 36: 1516-1526.

Bruno, M. and Bianchi, F. 2012. Uso e distribuzione dei marmi policromi nell'architettura pubblica di età imperiale a Leptis Magna. In Cocco, M.B., Gavini, A. and Ibba, A. (eds), *L'Africa Romana. Trasformazione dei paesaggi del potere nell'Africa settentrionale fino alla fine del mondo antico. Atti del XIX convegno di studio (Sassari, 16-19 dicembre 2010)*, Rome: Carocci, 295-310.

Buckland, P.C. and Sadler, J. 1990. Ballast and building stone: a discussion. In Parsons, D. (ed.), *Stone: Quarrying and Building in England, AD 43-1525*, Chichester: Phillimore, 114-125.

Bullard, R.G. 1978. The marbles of the opus sectile floor. In Humphrey, J.H. (ed.), *Excavations at Carthage, 1975, conducted by the University of Michigan, Volume 2*, Ann Arbor: University of Michigan Press, 167-188.

Cébeillac-Gervasoni, M. 1979. Apostilles à une inscription de Portus. T. Messius Extricatus et les saborrarii, *Parola del Passato*, 34: 267-277.

Clifton-Taylor, A. 1972. *The Pattern of English Building*, London: Faber and Faber.

DeLaine, J. 2006. The cost of creation: technology at the service of construction. In Lo Cascio, E. (ed.), *Innovazione tecnica e progresso economico nel mondo romano. Atti degli incontri capresi di storia dell'economia antica (Capri, 13-16/4/2003)*, Bari: Edipuglia, 237-252.

Dodge, H. 1992. Construction techniques and building materials. In Ben Lazreg, N. and Mattingly, D.J. (eds), *Leptiminus (Lamta). A Roman Port City in Tunisia, Report no. 1* (Journal of Roman Archaeology Supplement, 4), Ann Arbor: Journal of Roman Archaeology, 157-162.

Dodge, H. 2001. The building materials from the East Baths. In Stirling, L.M., Mattingly, D.J. and Ben Lazreg, N. (eds), *Leptiminus (Lamta). Report no. 2. The East Baths, Cemeteries, Kilns, Venus Mosaic, Site Museum, and Other Studies* (Journal of Roman Archaeology Supplement, 41), Portsmouth, RI: Journal of Roman Archaeology, 104-106.

Dodge, H. 2011. Building materials and decorative stones. In Stone, D.L., Mattingly, D.J. and Ben Lazreg, N. (eds), *Leptiminus (Lamta). Report no. 3. The Field Survey* (Journal of Roman Archaeology Supplement, 87), Portsmouth, RI: Journal of Roman Archaeology, 463-478.

Fant, J.C., Russell, B. and Barker, S.J. 2013. Marble use and reuse at Pompeii and Herculaneum: the evidence from the bars, *Papers of the British School at Rome*, 81: 181-209.

Fulford, M.G. 1984. The long distance trade and communications of Carthage, c. AD 400 to c. AD 650. In Fulford, M.G. and Peacock, D.P.S. (eds), *Excavations at Carthage: The British Mission, Volume 1, 2. The Avenue du President Habib Bourguiba, Salammbo: The Pottery and Other Ceramic Objects from the Site*, Sheffield: University of Sheffield, 255-262.

Fulford, M.G. 1987. Economic interdependence among urban communities of the Roman Mediterranean, *World Archaeology*, 19.1: 58-75.

Graham, S. 2006. *Ex Figlinis: The Network Dynamics of the Tiber Valley Brick Industry in the Hinterland of Rome* (British Archaeological Reports, International Series, 1486), Oxford: John and Erica Hedges.

Graham, S. 2011. A brick stamp of Agathobulus. In Stone, D.L., Mattingly, D.J. and Ben Lazreg, N. (eds), *Leptiminus (Lamta). Report no. 3. The Field Survey* (Journal of Roman Archaeology Supplement, 87), Portsmouth, RI: Journal of Roman Archaeology, 481-484.

Hartley, K.F. 1973. La diffusion de mortiers, tuiles et autres produits en provenance des fabriques italiennes, *Cahiers d'Archéologie Subaquatique*, 2: 49-60.

Helen, T. 1975. *Organization of Roman Brick Production in the First and Second Centuries AD. An Interpretation of Roman Brick Stamps, Volume 1*, Helsinki: Academia Scientiarum Fennica.

Herrmann, J.J., Attanasio, D., Tykot, R.H. and van den Hoek, A. 2012. Characterization and distribution of marble from Cap de Garde and Mt. Filfila, Algeria. In Gutiérrez, A., Lapuente, P. and Rodà, I. (eds), *Interdisciplinary Studies on Ancient Stone. Proceedings of the IX ASMOSIA Conference (Tarragona 2009)* (Documenta, 23), Tarragona: Institut Català d'Arqueologia Clàssica, 300-309.

Hobson, M.S. 2015. *The North African Boom. Evaluating Economic Growth in the Roman Province of Africa Proconsularis (146 B.C. – A.D. 439)* (Journal of Roman Archaeology Supplement, 100), Portsmouth, RI: Journal of Roman Archaeology.

Hurst, H.R. 1994. *Excavations at Carthage: The British Mission, Volume 2,1. The Circular Harbour, North Side: The Site and Finds other than Pottery*, Oxford: Oxford University Press.

Kehoe, D. 1988. *The Economics of Agriculture on Roman Imperial Estates in North Africa*, Göttingen: Vandenhoeck and Ruprecht.

Kennett, D.H. 2008. Caister Castle, Norfolk, and the transport of brick and other building materials in the Middle Ages. In Bork, R. and Kann, A. (eds), *The Art, Science and Technology of Medieval Travel*, Aldershot: Ashgate, 55-68.

Lancaster, L.C. 2012. Ash mortar and vaulting tubes: agricultural production and the building industry in North Africa. In Camporeale, S., Dessales, H. and Pizzo, A. (eds), *Arqueología de la construcción, 3. Los procesos constructivos en el mundo romano: la economía de las obras (Parigi, École Normale Supérieure, 10-11 de Diciembre de 2009)* (Anejos de Archivo Español de Aqueología, 64), Madrid: CSIC, 145-160.

Lancaster, L.C., Sottili, G., Marra, F. and Ventura, G. 2010. Provenancing of lightweight volcanic stones used in ancient Roman concrete vaulting: evidence from Turkey and Tunisia, *Archaeometry*, 52.6: 949-961.

Lazareth, C.E. and Mercier, J.-C.C. 1999. Geochemistry of ballast granites from Brouage and La Rochelle, France: evidence for medieval to post-medieval trade with Falmouth, Cornwall, and Donegal, Ireland. In Pollard, A.M. (ed.), *Geoarchaeology: Exploration, Environments, Resources*, London: The Geological Society, 123-139.

Lazzarini, L. 2004. *Pietre e marmi antichi. Natura, caratterizzazione, origine, storia d'uso, diffusione, collezionismo*, Padua: CEDAM.

Martin-Kilcher, S. 2005. Carthage: imported eastern amphorae in the Roman Colonia Iulia. In Briese, M.B. and Vaag, L.E. (eds), *Trade Relations in the Eastern Mediterranean from the Late Hellenistic Period to Late Antiquity: The Ceramic Evidence*, Odense: University Press of Southern Denmark, 202-220.

Mattingly, D.J., Stone, D.L., Stirling, L.M., Moore, J.P., Wilson, A.I., Dore, J.N. and Ben Lazreg, N. 2011. Economy. In Stone, D.L., Mattingly, D.J. and Ben Lazreg, N. (eds), *Leptiminus (Lamta). Report no. 3. The Field Survey* (Journal of Roman Archaeology Supplement, 87), Portsmouth, RI: Journal of Roman Archaeology, 205-272.

McGrail, S. 1989. The shipment of traded goods and of ballast in antiquity, *Oxford Journal of Archaeology*, 8.3: 353-358.

Mills, P. 2013. *The Ancient Mediterranean Trade in Ceramic Building Materials: A Case Study in Carthage and Beirut* (Roman and Late Antique Mediterranean Pottery, 2), Oxford: Archaeopress.

Parker, A.J. 1992. *Ancient Shipwrecks of the Mediterranean and Roman Provinces* (British Archaeological Reports, International Series, 580), Oxford: Tempus Reparatum.

Parker, A.J. 2008. Artifact distributions and wreck locations: the archaeology of Roman commerce. In Hohlfelder, R.L. (ed.), *The Maritime World of Ancient Rome*, Ann Arbor: University of Michigan Press, 177-196.

Peacock, D.P.S. 1984. Ceramic building materials. In Fulford, M.G. and Peacock, D.P.S. (eds), *Excavations at Carthage: The British Mission, Volume 1, 2. The Avenue du President Habib Bourguiba, Salammbo: The Pottery and Other Ceramic Objects from the Site*, Sheffield: University of Sheffield, 242-246.

Peacock, D.P.S, Williams, D. and James, S. 2007. Basalt as ships' ballast and the Roman incense trade. In Peacock, D.P.S. and Williams, D. (eds), *Food for the Gods: New Light on the Ancient Incense Trade*, Oxford: Oxbow Books, 28-70.

Pensabene, P. 1995. Some problems related to the use of Luna marble in Rome and western provinces during the first century AD. In Maniatis, Y., Herz, N. and Basiakos, Y. (eds), *The Study of Marble and Other Stones Used in Antiquity. ASMOSIA III*, London: Archetype, 13-16.

Pensabene, P. 2001. Pentelico e proconnesio in Tripolitania: coordinamento o concorrenza nella distribuzione?, *Archeologia Classica*, 52: 63-127.

Rice, C. 2011. Ceramic assemblages and ports. In Robinson, D. and Wilson, A.I. (eds), *Maritime Archaeology and Ancient Trade in the Mediterranean*, Oxford: Oxford Centre for Maritime Archaeology, 81-92.

Rice, C. 2012. *Port Economies and Maritime Trade in the Roman Mediterranean: 166 BC to AD 300*, D.Phil. Thesis, University of Oxford.

Rico, C. 1995. La diffusion par mer des matériaux de construction en terre cuite : un aspect mal connu du commerce antique en Méditerranée occidentale, *Mélanges de l'École Française de Rome. Antiquité*, 107: 767-800.

Rives, J.B. 1995. *Religion and Authority in Roman Carthage from Augustus to Constantine*, Oxford: Oxford University Press.

Ros, K.E. 2006. The Roman theatre at Carthage, *American Journal of Archaeology*, 100.3: 449-489.

Rossiter, J.J. 1998. A Roman bath-house at Bir el Jebbana: preliminary report on the excavations (1994-1997). In *Carthage Papers: The Early Colony's Economy, Water Supply, a Public Bath, and the Mobilization of State Olive Oil* (Journal of Roman Archaeology Supplement, 28), Portsmouth, RI: Journal of Roman Archaeology, 103-116.

Royal, J.G. 2012. Illyrian coastal exploration program (2007-2009): the Roman and Late Roman finds and their contexts, *American Journal of Archaeology*, 116.3: 405-460.

Royal, J.G. and Tusa, S. 2012. The Levanzo I wreck, Sicily: a 4th-century AD merchantman in the service of the annona?, *The International Journal of Nautical Archaeology*, 41.1: 26-55.

Russell, B. 2013. *The Economics of the Roman Stone Trade* (Oxford Studies on the Roman Economy), Oxford: Oxford University Press.

Salzman, L.F. 1952. *Building in England down to 1540. A Documentary History.* Oxford: Oxford University Press.

Scheidel, W. 2011. A comparative perspective on the determinants of the scale and productivity of maritime trade in the Roman Mediterranean. In Harris, W.V. and Iara, K. (eds), *Maritime Technology in the Ancient Economy: Ship-Design and Navigation* (Journal of Roman Archaeology Supplement, 84), Portsmouth, RI: Journal of Roman Archaeology, 21-37.

Setälä, P. 1977. *Private Domini in Roman Brick Stamps of the Empire: A Historical and Prosopographical Study of Landowners in the District of Rome,* Helsinki: Suomalainen Tiedakatemia.

Steinby, M. 1981. La diffusione dell'opus doliare urbano. In Giardina, A. and Schiavone, A. (eds), *Società romana e produzione schiavistica, II. Merci, mercati e scambi nel Mediterraneo*, Rome-Bari: Laterza, 237-245.

Taylor, J. 1998. Late Iron Age ballast-quarries at Hengistbury Head, Dorset, *Oxford Journal of Archaeology*, 17.1: 113-119.

Thébert, Y. 2000. Transport à grande distance et magasinage de briques dans l'empire romain. Quelques remarques sur les relations entre production et consommation. In Boucheron, P., Broise, H. and Thébert, Y. (eds), *La brique antique et médiévale. Production et commercialisation* (Collection de l'École Française de Rome, 272), Rome: École Française de Rome, 341-356.

Tomber, R. 1987. Evidence for long-distance commerce. Imported bricks and tiles at Carthage, *Rei Cretariae Romanae Fautorum Acta*, 25-26: 161-174.

Ward-Perkins, J.B. 1993. *The Severan Buildings of Lepcis Magna: An Architectural Survey* (published by Ph. Kenrick) (Society for Libyan Studies Monograph, 2), London: Society for Libyan Studies.

Wilkes, J.J. 1979. Importation and manufacture of stamped bricks and tiles in the Roman province of Dalmatia. In McWhirr, A. (ed.), *Roman Brick and Tile* (British Archaeological Reports, International Series, 68), Oxford: B.A.R., 65-72.

Williams-Thorpe, O. 1988. Provenancing and archaeology of Roman millstones from the Mediterranean area, *Journal of Archaeological Science*, 15: 253-305.

Williams-Thorpe, O. and Thorpe, R.S. 1989. Provenancing and archaeology of Roman millstones from Sardinia (Italy), *Oxford Journal of Archaeology*, 8.1: 89-113.

Wilson, A.I. 2001. Construction techniques and building materials. In Stirling, L.M., Mattingly, D.J. and Ben Lazreg, N. (eds), *Leptiminus (Lamta). Report no. 2. The East Baths, Cemeteries, Kilns, Venus Mosaic, Site Museum, and Other Studies* (Journal of Roman Archaeology Supplement, 41), Portsmouth, RI: Journal of Roman Archaeology, 25-28.

Zucca, R. 1986. L'opus doliare urbano in Africa ed in Sardinia. In Mastino, A. (ed.), *L'Africa Romana. Atti del IV convegno di studio (Sassari, 12-14 dicembre 1986)*, Sassari: Università degli Studi di Sassari, 659-676.

PART V

CREATING A LASTING IMPRESSION: ARCHITECTURAL AND DECORATIVE MOTIFS

14

STONES OF MEMORY
THE PRESENTATION OF THE INDIVIDUAL IN THE CEMETERIES OF CYRENE

Meseret Oldjira and Susan Walker

Abstract

This paper briefly explores the context of a major change in the focus of funerary practice at Cyrene, from the representation of busts or half-figures of goddesses, current from the archaic to Hellenistic Greek periods, to bust-length portraits of individuals favoured by Roman users of the cemeteries at Cyrene.

INTRODUCTION

Since the nineteenth century the vast necropolis of Cyrene has attracted the admiration and curiosity of both travellers and scholars.[1] Much of the scholarship devoted to its study has focused on establishing the typology and morphology of the tombs.[2] However, individual funerary sculptures (portrait busts, in particular) found near the tombs have been shipped to museums or sold onto the art market without systematic documentation or study of their context. Nevertheless, the well-documented archaeological setting provides valuable information for the study of the development of Cyrenaican funerary sculpture over time.

One of the most distinctive and numerous types of Cyrenaican funerary sculpture is the portrait bust, displayed inside a tight niche on the façade of rock-cut tombs. These busts, widely used for much of the duration of the Roman occupation of the area, illustrate a new form of funerary representation that differs from earlier funerary monuments in Cyrenaica. The portrait busts should be examined together with the niches and the tombs that once housed them in order to enrich our knowledge of both monument and context. Unlike previous studies, which consider Cyrenaican funerary busts as a genre with little discussion of their settings,[3] we will use data provided by the archaeological study of the tombs to place the funerary busts within their original context so that we may understand better their function and meaning within the culture and society of Roman Cyrenaica. We will first examine the development and later modification and reuse of rock-cut tombs; we will then analyse the relationship between particular features of these tombs and the major shift in funerary practice and representation in Roman Cyrenaica.

THE CEMETERIES OF CYRENE: LOCATION AND DEVELOPMENT

The city of Cyrene is located some 600 m above sea level on the upper slopes of the fertile Jebel al-Akhdar in eastern Libya. The mountain takes its name from its fertile and temperate

[1] For the nineteenth-century expedition see Smith and Porcher 1864.

[2] Synthesized in Dent 1985; Thorn 2005.

[3] For instance, Bonanno 1976; Huskinson 1975. Rosenbaum 1960 did attempt in her introduction to place the portraits in context; this paper takes note of more recent archaeological survey.

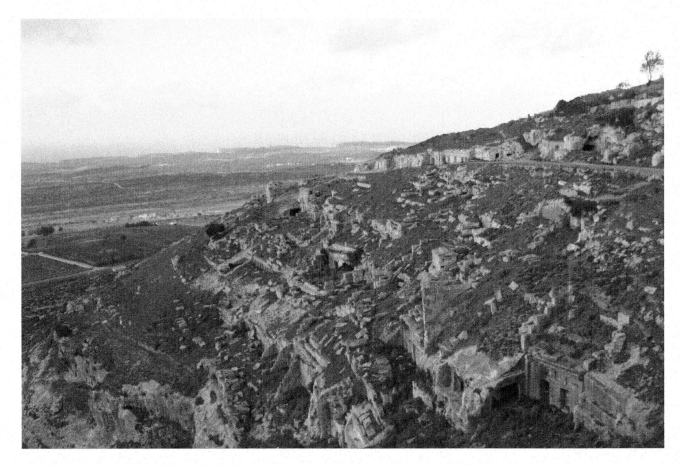

Figure 14.1. *View of the North Necropolis at Cyrene (photo: P. Kenrick).*

Mediterranean climate, more similar to that of Greece and Asia Minor than that of Tripolitania or other parts of North Africa.[4] The region served as a key point of Greek settlement in North Africa and, for much of its history, Cyrenaica maintained closer cultural and economic ties with Crete and Greece than with the remaining regions of Africa.

The city of Cyrene is surrounded by cities of the dead, whose living relatives created often elaborate tombs cut into the limestone rock, some of which remained in use for centuries. The imposing extent of the necropolis indicates that the legendary origins and long-standing Greek heritage of the city must have attracted Cyrenaicans throughout the region to seek burial space there.[5] Even as late as the fifth century AD, Bishop Synesius, whose family had ancient origin in Cyrene, lamented tribal attacks on the city, fearing that he would not find rest in the tombs of his Doric ancestors.[6]

The natural setting creates two types of landscape for the necropolis. The north-western cemeteries are located where the steep cliffs of the uppermost Jebel fall towards a plain several hundred metres below. Here rock-cut tombs are organized in tight terraces, one above the other. The North Necropolis (Figure 14.1) occupies the highly visible slopes beside the road to Apollonia and thus contains some of the most elaborate tombs with large and remarkable façades.[7] The West Necropolis, located in the Wadi bel Ghadir and its tributary the Halag Stawat, also contains rock-cut tombs. Limestone sarcophagi are also numerous, but built tombs are few.[8] Most tombs have been robbed of their contents and stones but not to the extent of those in the south-eastern plain.

The south-eastern cemeteries are located on the plain directly above the Jebel step. Here there are fewer rock-cut and more built tombs, the latter better suited to flat areas.[9] On the plain there is clear evidence for the development of cemeteries in association with rural sanctuaries,

[4] Kenrick 2013, 1.

[5] For the extent of the necropolis see Cherstich 2008a, 4.

[6] Synesius, *Catastasis*, II.5.303A.

[7] Cassels 1955, 3.

[8] Cherstich 2008a, 5.

[9] Cherstich 2008a, 78.

with early and later elite tombs sited on agriculturally marginal land near to sacred areas.[10] There is much modern habitation, with a long history of stone robbing and reuse of tombs as dwellings and stables; hence the south-eastern cemeteries are less well preserved than the north-west.

EVIDENCE FOR CONTINUITY OF TOMB USE AND CHANGES IN THE DESIGN OF BURIAL CHAMBERS

The considerable variety of available tombs allowed families to select and construct the most appropriate type depending on their social status and financial means. The Classical and Hellenistic periods witnessed the greatest expansion of the Cyrenean necropolis.[11] In particular, Ptolemaic control of Cyrenaica, with the presence of Ptolemy VIII and IX in Cyrene, brought considerable wealth to some leading families of the later Hellenistic city: for example Klearchos, who commissioned the magnificent tomb with false façade S1, and traced his ancestry back to such early figures as Aladeir and Battus.[12] The construction of monumental tombs implies a considerable expenditure of resources, associated with urban prosperity. After Cyrenaica became a Roman province, very little space remained in the necropolis for the building of new tombs, so subsequent burials necessitated the modification and reuse of pre-existing tombs.[13] Though rock-cut tombs are the most extensively studied type of tomb in Cyrene, it is difficult to securely assign the building of new tombs to the Roman period.[14] Some tomb construction continued in the second century along with urban building and rebuilding in Cyrene, but with no evidence for significant expansion of the existing cemeteries it is likely that elaborate burial became confined to a smaller elite of landowners in the countryside. Within the cemeteries of Cyrene (if we follow Synesius), in some cases burial may have been restricted to descendants of the owners of existing tombs.[15]

Roman reuse of earlier tombs involved interior modifications, often increasing the size of the chambers, though a change in burial practice actually diminished capacity for individual burials. Thus old corridors with burial slots (loculi) cut in the walls were enlarged to form 'sepulchres'.[16] Another prominent Roman feature is the arcosolium, an arched niche containing a rock-cut sarcophagus decorated with garlands (a design popular in the eastern Mediterranean), the chest standing on a platform.[17] This fashion coincided with a change to inhumation at Rome in the second century AD, and a consequent major rise in the production of free-standing, marble sarcophagi.

Tomb N258 (Figure 14.2), first recorded by Smith and Porcher, presents significant evidence of Roman modifications to a tomb originally built in the Hellenistic period. A passage leads into the forecourt and the partly-built, partly-rock-cut façade of the tomb, which appears to be of Hellenistic type. Above the entrance, the upper part of the façade consists of a rock-cut recess measuring 1.25 m in height, 2.78 m in width, and 0.72 m in depth.[18] Robbing activity has uncovered a marble stele amongst the debris in the forecourt of the tomb.

During the tomb's reuse in the Roman period, one of the loculi in the right wall, and the loculus in the left wall, were both enlarged to form sepulchres.[19] A painted recess was cut into the eastern wall of the forecourt.[20] According to Thorn, this may have been used as a triclinium.[21]

The marble stele found in the forecourt provides valuable evidence for the tomb's reuse during the Roman period. The stele, believed to have fallen from the recess above the entrance to the main tomb chamber, is 0.93 m tall and measures 0.35 m wide at the top and 0.38 m at the base.

[10] Menozzi 2006, 71 notes that prominent families may have played a role in these cults.

[11] Cherstich 2008b, 78.

[12] Cherstich 2006a, 114.

[13] Cherstich 2008a, 49; Di Valerio et al. 2005, 53-54; Stucchi 1975, 227-229.

[14] Cherstich 2011, 33.

[15] Cassels 1955, 22; Stucchi 1975, 149. See Cherstich 2006b, 403 on diminished Roman occupancy of the rock-cut tombs.

[16] 'Sepulchres' is a term used by Thorn 2005, 352-355.

[17] Thorn 2005, 356-361, figures 234-238.

[18] Al Muzzeini et al. 2003, 166; Thorn 2005, 381, figure 225.

[19] Thorn 2005, figure 233.

[20] Thorn 2005, figure 235.

[21] Al Muzzeini et al. 2003, 167.

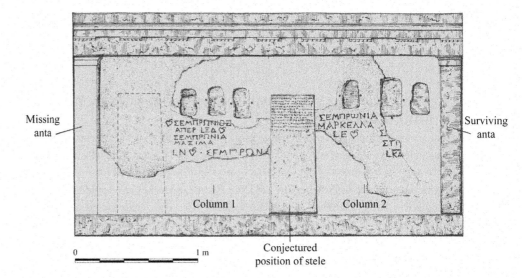

Its upper part contains a Greek inscription with well-defined and clearly-cut letters, although they are not of the highest quality. According to Reynolds, the inscribed poem, composed in commendable Greek metric verse, dates to the second half of the first century AD:[22]

> δεύτερον εἰς λυκάβαντα
> καὶ εἰκοστόν με περῶσαν,
> λυγρὸς ἀφ᾿ἱμερτῶν εἷλε
> μόρος θαλάμων
> οὐδ᾿ ὅλον εἰς πλειῶνα γά-
> μοις ἔπι γηθήσασαν,
> ἤματι δ᾿ ᾧ παστὸν καὶ
> σποδιὴν ἔλαχον,
> Στλακκίη αἰνοδάκρυτος·
> ἀμαυροτέρη δ᾿ὑπολύπῃ
> θνήσκω, τὴν μουνήν σοι,
> πόσι, παρθεμένη.

'As I was passing towards my twenty-second year, gloomy fate snatched me from my beloved bridal-chamber, when I had not rejoiced in my marriage for a full-year, but on the day on which a bridal bed was my lot so too were ashes, Stlakkia, deserving of bitter lament; and I die of a plight that brings darkness, leaving with you, my husband, this resting place'.[23]

The stele commemorates a young woman named Stlakkia, whose cremation took place on the anniversary of her wedding day. The name Stlakkia is possibly of Campanian origin.[24] Its diffusion in the eastern Mediterranean may have been due to the presence of Italian *negotiatores* in the region; from at least the early first century BC the latter are well attested in Cyrene.[25] Moreover, the second Cyrene Edict of Augustus mentions a pair of Stlacii.[26] According to Reynolds, Stlakkia's father may have had Roman citizenship.[27] Stlakkia and her Italian family wished to demonstrate their 'pretensions to Hellenic culture' by commissioning this poem.[28]

The most conspicuous feature of Roman reuse of this tomb is the exterior. Nine niches for funerary busts were cut into this tomb façade during the Roman period. Greek inscriptions give the names of the deceased commemorated by the funerary portrait busts once set in the niches

[22] Al Muzzeini *et al.* 2003, 168.

[23] Reynolds' translation; Al Muzzeini *et al.* 2003, 169.

[24] Al Muzzeini *et al.* 2003, 170.

[25] Reynolds 1962, 98; *SEG* 20, 715.

[26] *SEG* 9, 8, no. 2.

[27] Al Muzzeini *et al.* 2003, 170.

[28] Al Muzzeini *et al.* 2003, 170.

but no longer surviving. The names on the left side refer to members of a family who have Latin *cognomina* and the *nomen* Sempronius. These names strongly suggest that the people commemorated in the lost funerary busts had Roman citizenship. Sempronius is not a name associated with Italian *negotiatores*. Reynolds suggests that the family may have come from Spain, since members of the *cohors Hispanorum* were buried in Cyrene and the name Sempronius is widely attested in Spain. The inscriptions to the right of the stele again mention the Stlacii, who may have been the first Roman occupiers of the tomb, later used by the Sempronii.[29] Though the Sempronii were of Italian extraction, they used Greek as the language of commemoration. As elsewhere in the eastern Mediterranean, Greek remained the predominant written language of Cyrenaica.[30] Latin was largely used for official texts recording the activities of the proconsul, emperor and other officials; it was very rarely used for private inscriptions.[31]

Just as Tomb N258, the façades of archaic tombs N2-N9 and Tomb N10 have numerous niches that once held portrait busts.[32] Along with the round-headed niches for funerary portrait busts, the square niches may have held marble panels for inscriptions.[33] The niches were mostly cut around, and usually above the central entrance to the tomb. The façade of Tomb N10 displays the greatest number of niches – eleven in total, all clustered around the top of the entrance, ten round-headed and one square. The niches may correspond to the number of bodies buried inside the five *loculi* of the tomb. In some cases, as on the façades of N3 and N10, niches are tightly packed next to each other.

THE RELATIONSHIP BETWEEN THE NICHES AND OTHER BURIAL FEATURES

Luca Cherstich has investigated the relationship between portrait niches on the façades and the internal structure of tombs.[34] His survey of the Southern Necropolis has recorded a total of 234 rock-cut tombs and 172 built tombs; 63 rock-cut tombs have niches cut into the façades.[35] A similar statistical analysis from the other cemeteries has not been published: James and Dorothy Thorn's gazetteer of the Cyrenean necropolis provides a useful list of tombs from all four cemeteries, but does not record the interiors of most tombs.[36] The published evidence suggests a strong association between niches and certain types of burial features.

In Cherstich's sample of 53 tombs with identifiable burial features, portrait niches appear more frequently on tombs that contain both Roman sepulchres and *loculi*. Two Hellenistic tombs, N17 and N258, contain Roman sepulchres and have niches on their façades. Niches have a weak association with tombs that contain *arcosolia*, though the latter are few.[37] Cherstich argued that in most cases, the carving of portrait niches predated *arcosolia*. However, as he himself notes, the niches on the façade of Tomb S71 are large and have straight-cut bases suggesting busts dating to the second century AD, or possibly later.[38] If we accept Rosenbaum's chronology, busts with straight-cut bases do not appear before the time of Hadrian.[39] Thus, the cutting of some portrait niches may be contemporaneous with the construction of the *arcosolia* in the second century.

The development of *arcosolia* in Cyrene represents the introduction of a new funerary fashion to Cyrenaica. Cherstich has interpreted the poor association between niches and *arcosolia* he noted in the Southern Necropolis as indicative of 'two different, parallel tendencies'.[40] However, Tombs N17, N5, N8, and N226 all have both *arcosolia* and portrait niches. The incorporation of both features surely enhanced the prestige of such tombs.

[29] Al Muzzeini *et al*. 2003, 172.

[30] Dobias-Lalou 1994, 245.

[31] Reynolds 1959; 1962.

[32] Thorn 2005, 515, figure 296.

[33] Thorn 2005, 515 functionally divides the niches according to shape.

[34] Cherstich 2008a; 2011.

[35] Cherstich 2011, 36-37.

[36] Thorn and Thorn 2009.

[37] Cherstich 2011, 39.

[38] Cherstich 2011, 40.

[39] For chronology see Rosenbaum 1960, 18-19.

[40] Cherstich 2011, 40.

There is a noticeable lack of association between niches and built tombs. A recently excavated elaborate built tomb from the Ain Hofra Valley in the Eastern Necropolis has survived with some furnishings intact. In the upper level of one of the few known built tombs of Roman date, a room revealed a remarkable collection of high quality Antonine sculptures.[41] Unlike the funerary busts, the portrait heads have drilled pupils and incised irises. Although the interior was lavishly furnished, the façade has no niches for busts, and no inscriptions were found. Similar statuary has been uncovered inside a tomb in the Western Necropolis. Known as the 'Tomb of Grenna', this contained sculpture of the late second century AD.[42] Although rock-cut, this tomb had all the pretensions of a built tomb; it was partly built in masonry and its walls once covered in marble veneer.[43] It has an elaborate, Ionic columnar façade, significantly lacking portrait niches. The grandeur of the Cyrenaican built tombs attests to the wealth and high social status of the families that commissioned them. When families could afford lavish built tombs, they chose commemorative statues instead of small funerary busts.

COURTYARDS

Unlike the earlier archaic tombs N2-N10, Hellenistic tombs N17, N226, and N258 had courtyards in front of their façades. In each case, the façade served as the main focus of the courtyard, which, in many cases, was surrounded on the eastern and western sides by short, protective walls of ashlar blocks. Some Hellenistic columnar façades included representations of funerary goddesses standing on blocks inscribed with the name of the deceased. In Roman times, niches for portrait busts were added to courtyards. The courtyards highlight the emphasis placed on the exterior of tombs in the late Hellenistic and Roman periods. By architecturally defining the area in front of the façades, the courtyards drew attention to the funerary busts and statues displayed there.[44] Courtyards also provided reserved space for cremation and commemorative feasting: in the case of Tomb N258, the stele informs us that the remains of the deceased woman Stlakkia were cremated. The courtyard may have served as a site for her funerary pyre.

From the 'Windmill Tomb' at Tarhuna comes evidence of five stone couches grouped in the sunken courtyard, apparently intended for commemorative feasting by living relatives within the tomb complex.[45] In Cyrene, stone *klinai* have been discovered in the courtyard of Tomb N1.[46] In Tomb N258, the beautifully decorated recessed space in the courtyard has been interpreted as a *triclinium*. The presence of funerary busts, protective goddesses and texts naming the deceased beneath the funerary busts allowed the dead a role in the celebrations. Furthermore, the courtyards were highly visible to passers-by – anyone leaving ancient Cyrene would pass through 2-3 km of tombs bearing visual messages – and thus underscored the display strategy of the tombs' owners.[47]

The provision of areas for feasting with the dead is well attested from other areas of the Roman Empire. In Italy, family members of the deceased would gather for funerary meals at the tomb on days devoted to the commemoration of the dead such as birthdays and annual festivals.[48] Some tombs in Pompeii included funerary gardens and areas in which the living could gather to remember the dead.[49] Archaeological work at Marina el-Alamein in western Egypt has uncovered evidence of funerary feasting in a ground-level pavilion.[50] Side rooms may have served as storerooms for food and drinks.[51]

[41] Fabbricotti 2008, 219, 222-223, 226, figures 3.1-3.3; 227, figures 4-5.
[42] Thorn and Thorn 2008, 96, figures 1-2; 104-106, figures 7-8.
[43] Thorn and Thorn 2008, 102-103.
[44] See Rosenbaum 1960, plate II, 2 showing funerary busts set into niches in the North Necropolis at Cyrene.
[45] Santucci and Thorn 2003, cited with further discussion by Tomlinson 2006, 100.
[46] Cherstich and Santucci 2010, 36.
[47] Cherstich 2006b, 391-392.
[48] Fejfer 2008, 105; Toynbee 1971, 51.
[49] Cormack 2007, 594; Toynbee 1971, 122-123.
[50] Daszewski 1994, 52-53; 1998, 46-47, figure 4.
[51] Daszewski 1994, 52.

COMMEMORATING THE INDIVIDUAL IN THE CEMETERIES OF CYRENE

Elizabeth Rosenbaum's catalogue of Cyrenaican sculptures contains 117 funerary busts, including fragments. She suggests that the surviving busts represent only a small percentage of the ancient total.[52] Made of scrap marble (Figure 14.3), funerary busts were evidently affordable to most people buried in the rock-cut tombs of Cyrene, though, as noted above, the scope for burial in the tombs was dramatically reduced in the Roman period.

The Cyrenaican busts represent the head and shoulders carved in the round; very rarely do they show a larger part of the chest (Figure 14.4). In size, the busts range from about 0.15 m in height to about life-size. The backs remained unworked. All include a smooth, narrow band extending from the ears

to the shoulders, a feature unique to Cyrenaican funerary busts.[53] These 'side-strips'[54] would have blended with the surface of the wall surrounding the niche, giving the impression that the busts were cut in relief. Remaining traces of paint indicate that the side-strips were painted. Rosenbaum suggested that their main function was to make the relief portraits resemble painted Egyptian mummy portraits, thus obscuring the 'three dimensional character of the portraits'.[55] However, most mummy portraits were painted with the head frontal but the shoulders turned, so these too evoked the bust carved in the round. It is more likely that the side-strips were designed to fill the gap that remained on either side of the bust as it was placed inside its niche, thereby framing the busts, accentuating the carved image and integrating the portraits within the façade.

Cyrenaican funerary busts exhibit a remarkable level of uniformity in style and technical aspects. With the exception of four busts, which have slightly turned faces, all are strictly frontal. An overwhelming number portray youthful subjects, with very few signs of ageing. Apart from two portrait busts, none have eyes with drilled pupils and incised irises – a technique widely used in Roman Imperial portraiture from the middle of Hadrian's reign (Figure 14.5).[56] None of the portrait busts have engraved eyebrows. Although traces of paint have survived only on the side-strips, it can be assumed that the eyes of the portrait busts were also painted. It is remarkable that the workshops producing the funerary busts never adopted the technique of drilling the pupils and engraving the irises, since artists who made full-scale Cyrenaican portraits had followed this fashion.[57] The Cyrenaican funerary busts represent a noteworthy group of portrait sculptures in the Roman Empire in which the rendering of the eyes in paint persisted.[58]

Although most busts are homogeneous in appearance, some attempts at individualization have been made: for example, signs of ageing and flat hair-bands worn around the crown.[59] Rosenbaum argued that some busts display 'distinctive features of the Libyan race', which she defines as curly hair, prominent cheek-bones, and full lips.[60] She interprets the proposed pres-

Figure 14.3. *Portrait bust of a woman, early second century AD, seen from the side as a piece of scrap marble. British Museum Sculpture 1501 (photo: M. Oldjira, with permission of the British Museum).*

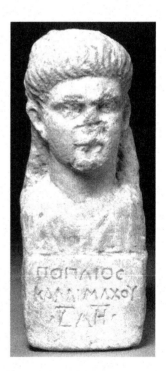

Figure 14.4. *Portrait bust of Publius, son of Kallimachos, early second century AD, frontal view showing the side-strips and a relatively small amount of draped bust above the Greek text. British Museum Sculpture 2273 (photo: M. Oldjira, with permission of the British Museum).*

[52] Rosenbaum 1960, 16. Since the publication of Rosenbaum's catalogue numerous portrait busts have come to light: see, in order: Bonanno 1975-1976; Beschi 1976; Bonanno 1976; Bacchielli 1977a; de Kersauson 1996; Bonanno Aravantinos 2007 proposes a total of 353 known busts. A fine Julio-Claudian funerary bust of a woman was recently recovered from a cache of Classical, Hellenistic, and Roman sculpture found beneath the destruction levels of the *cella* of the Temple of Cybele at Cyrene: Giovannini 2014, 67.

[53] Rosenbaum 1960, 16. See Anderson and Nista 1988 for Roman funerary busts.

[54] As called by Rosenbaum.

[55] Rosenbaum 1960, 17. For the surviving example see Rosenbaum 1960, plates CI, CII, CIII.

[56] Bonanno 1975-1976, 29.

[57] Rosenbaum 1960, 20.

[58] Cf. Rosenbaum 1960, 20.

[59] Rosenbaum 1960, no. 207, plate LXXXIV, 1-2; no. 219, plate LXXXVII, 1-2; Bonanno 1976, plate II, no.1.

[60] Rosenbaum 1960, 21. Some scholars have accepted characterization of these 'Libyan' features, see Bacchielli 1977a and 1977b. Walker (1994) interpreted similar characteristics as reflecting the origin of the sculptor of a group of early imperial portrait statues from Cyrene.

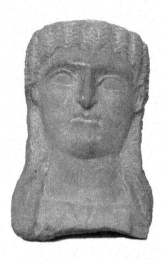

Figure 14.5. *Portrait bust of a woman with eyes left uncarved, mid-later second century AD. British Museum Sculpture 1996 (photo: M. Oldjira, with permission of the British Museum).*

ence of these features as 'proof of the mixture of [Greek and Libyan] races that had taken place.'[61] However, it is problematic to assign such specific ethnic identities based on features that, upon close inspection, not all busts exhibit.

In many cases, the original shape or function of the scrap marble can still be detected. On the left side of one bust, the original architectural moulding remains visible.[62] Some busts were re-carved from earlier sculptures.[63] Some sculptures of early 'funerary goddesses' were also re-carved into funerary busts.[64] The reuse of marble also occurs in other sculptural types at Cyrene. It has been suggested that the destruction caused by the Jewish Revolt of AD 115-117 must have made a great deal of scrap marble available.[65] Though the busts were made of scrap marble, the materiality of the imported marble still functioned as a prestigious medium.[66]

The funerary bust remained in use for more than three centuries of Cyrenaican history. However, without precise contextual information it is difficult to assign secure dates. Rosenbaum proposed a chronology based on the shape of the bust and the hairstyle of the subject: before the time of Hadrian, most Cyrenaican busts show the head, neck, and a portion of the chest; some are draped, but most are undraped; and they are rounded at the base.[67] After the time of Hadrian, the busts are always draped, and often cut straight across the base, with more of the shoulders displayed.[68] The earliest busts date from the first century BC.[69] Rosenbaum dates the majority of the busts to the first and second centuries AD. Although some busts can be dated as late as Constantine, there is a decline after the Antonine period. The number of busts assigned to the Hadrianic and Antonine periods is significant. These periods mark the extensive rebuilding and urban renewal of Cyrene that occurred after the devastation caused by the Jewish Revolt.

CULTURAL CONTEXT: THE FUNERARY BUST IN THE ROMAN EMPIRE

The freestanding bust was a distinctive feature of Roman commemoration.[70] Its use in Rome as a common form of tomb portraiture dates from about 90 BC to the beginning of the Imperial period.[71] The Tomb of the Flavii near Pompeii's Porta Nocera displays funerary busts inside individuated, framed niches on the façade of a built tomb in a similar arrangement to that of the funerary busts displayed at Cyrene.[72]

Although subject to both technical and aesthetic variations in different areas, the use of the funerary bust spread throughout the Roman world.[73] Scholars have often compared Cyrenaican funerary busts with Egyptian mummy portraits. Certainly, the two regions, due to their proximity and shared Ptolemaic history, share close cultural ties. However, an examination of Cyrenaican funerary busts with Egyptian mummy portraits in their respective contexts demonstrates that the two types of funerary portraiture represent parallel, local interpretations of a Roman art form. Mummy portraits from Roman Egypt must be seen as a component of the mummy as a whole. The embalmed mummy of Egyptian tradition incorporates the Roman commemorative bust, in this local context a painted portrait on a wooden panel inserted within the mummy wrappings. The emergence of painted mummy portraits coincides with the confirmation of privileges for city-dwellers and the descendants of Greek colonists outside Alexandria in the first half of the first century AD.[74]

[61] Rosenbaum 1960, 22.
[62] Rosenbaum 1960, plate C, 4.
[63] Rosenbaum 1960, plate LXXXII, 4; plate LXXXVIII, 3.
[64] Rosenbaum 1960, plate XCV, 6-7.
[65] Bacchielli 1977a, 83.
[66] Kane 1985, 241; Walker 1985, 101.
[67] Rosenbaum 1960, 18-19.
[68] Rosenbaum 1960, 19; cf. Bonanno 1976, three portraits with straight bases can be dated earlier than the time of Hadrian.
[69] Rosenbaum 1960, plate LXXIX, 1-2.
[70] Audley-Miller 2010, 16; Fejfer 2008, 236; Zanker 2010.
[71] Skupinska-Løvset 1983, 97.
[72] Cormack 2007, 590, figure 37.4.
[73] Audley-Miller 2010.
[74] Walker 1997, 1.

As discussed previously, the earliest busts from Cyrenaica date to the first century BC, earlier than the mummy portraits from Hawara. Thus, it is not likely that mummy portraits served as a direct inspiration for Cyrenaican busts. Rather, their close association with named individuals suggests a link to the contemporary rise of funerary portraits in Italy. Alexandrian influence in tomb design has been noted in Roman Cyrene (rather later than might be expected from the evident flourishing of the city under Ptolemaic rule).[75] However, no mummy portraits are yet known from Alexandria, where free-standing marble busts were preferred.

CULTURAL CONTEXT: FUNERARY SCULPTURES IN CYRENAICA

Since the Archaic period, Cyrenaican tombs had incorporated female half-figure statues on their façades (Figure 14.6).[76] These figures served as markers on top of, or beside, tombs or sarcophagi and, like the Roman portrait busts, represent a type of funerary monument unique to Cyrenaica. The earliest types, dated to 480-460 BC, are draped, terminate just below the shoulders, have long hair and wear a *polos* on top of unusually long heads set on cylindrical necks; there are no carved facial features or any evidence that paint had been added.[77] These figures are associated with contemporary, rock-cut and free-standing sarcophagi, set on square plinths fixed into sockets on the lids, and with tombs that contain sarcophagi,[78] where they were placed inside rock-cut niches on the façades.[79] One circular tomb set on a rectangular base (E121) had the figures set at each corner of the podium. The aniconic figures gave way to more developed and naturalistically rendered female figures in the fourth century BC.[80] This type is cut off below the waist, worked flat at the bottom and represents the woman wearing the upper part of the mantle draped over the head as a veil, some with one raised hand uncovering the veil to show, in many but not all cases, a fully represented face.[81] These figures have been found throughout the Cyrenean necropolis, albeit not *in situ*. Their prevalence increases from one half-figure per tomb in the Archaic period, to more than four in the Hellenistic period.[82]

These female figures have been variously interpreted as Ge, Demeter or Persephone, or as the soul of the deceased.[83] A recently published inscription identifies the half-figure simply as *Thea* – 'goddess'.[84] Nonetheless, the bridal gestures of the later, veiled figures, and the fact that they are always shown as half-figures, strongly support an identification as Persephone, seen here as the bride of Hades, god of the underworld, emerging from the ground. The pose and draped hands of the later figures also suggest that they mourned the deceased and/or protected the tomb.[85] From the fourth century BC onwards, funerary goddesses were placed on top of bases that had well-carved inscriptions naming the deceased, male or female.[86]

It has been widely argued that the portrait busts replaced the tradition of erecting female half-figure statues on tomb façades.[87] However, the use of funerary goddesses may have continued well into the early Roman period.[88] A half-length statue discovered in the south-western

[75] Cherstich 2006b, 403.

[76] Thorn 2005, 447, figure 253, 448; figure 254, 449; figure 255.

[77] For the typology and chronological development of the half-figures, see Beschi 1969-1970.

[78] Cherstich 2008a, 77; Thorn 2005, 417, 419, figures 253, 255.

[79] Di Valerio *et al.* 2005, figure 10.1, A1-A3.

[80] Beschi 1969-1970, 227 ff.; Di Valerio *et al.* 2005, 56.

[81] Beschi 1969-1970, figures 67, 69, no. 26; there are also aniconic (early) versions of this type, see Beschi 1969-1970, figure 68, no. 24; figure 69, no. 27.

[82] Beschi 1969-1970, 338; Cherstich 2008a, 82-83; one average-sized tomb, E140, had at least four statues on its roof, Cassels 1955, 4.

[83] Beschi 1969-1970, 335-336; Chamoux 1953, 299-300; Di Valerio *et al.* 2005, 56.

[84] Reynolds and Thorn 2005.

[85] Siciliano 2006, 411.

[86] Beschi 1969-1970, 196-201.

[87] Bacchielli 1990, 87; Cherstich 2008a, 84; Rosenbaum 1960, 15.

[88] Chamoux and Cassels suggest this possibility which is denied by Rosenbaum and Cherstich. Cf. Goodchild 1971, 167.

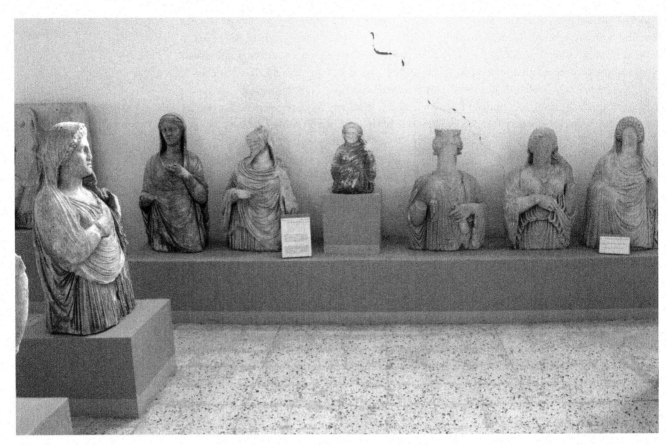

Figure 14.6. *Funerary goddesses in Cyrene Museum (photo: P. Kenrick).*

cemetery of Cyrene represents a later type.[89] The strongest evidence of the use of both funerary busts and half-length statues comes from Tomb N17. On the façade of this tomb, the portrait niches were carved alongside the image of the 'funerary-goddess'. Rather than substituting the latter, as some have argued, goddess and busts could have been coeval. Indeed, the busts perform a different function – they commemorate the deceased through individual likeness and an inscription. This contrasts sharply with the visual anonymity of the 'funerary goddesses'.

Portrait busts and funerary goddesses were also commissioned in village cemeteries of the Cyrenaican countryside. At Lamluda and Zawiya Morazigh, rows of rock-cut tombs contain niches for funerary busts. Giuseppe Oliverio's recollection of Ettore Ghislanzoni's second archaeological survey of Cyrenaica, made in 1918 at the request of the Italian colonial governor, noted at Beit Hamer, east of Cyrene on the road from Gubba to Mara 'tombe a camera scavate nella roccia, con piccoli mezzi busti ad alto rilievo incavati nella facciata...', the portraits apparently then still *in situ*.[90]

A notable feature of rural tombs are small stelae, a homogenous group of funerary monuments using both aniconic and iconic forms.[91] The limestone slabs are anthropomorphic, consisting of a roughly circular head with summarily carved features, set on top of a flat, rectangular body, with thin guide lines for a Greek inscription bearing the name of the deceased. The inscriptions provide a way of dating these stelae, which first appear in the early Imperial period.[92]

Bacchielli suggests that these stelae derive from Roman portrait busts based on their date, shape, and position in façade niches.[93] The presence of the anthropomorphic stelae and carved reliefs on the tomb façades highlights the spread of the funerary bust, of urban appearance, even

[89] Wanis 1977-1978 assigns this statue to the Flavian period, which is unlikely. A comparison with other Cyrenaican statues suggests that this 'funerary goddess' may be dated to the first century BC, which indicates the manufacture of such funerary monuments in the early years of the Roman period.

[90] Translated: 'chamber tombs excavated in the rock, with small half-busts in high relief cut into the rock face'. Sillani 2014, 82, 84, where the author notes that many of the drawings and photographs of these early expeditions were dispersed or used by later authors without acknowledgement of the accompanying architect Guastini.

[91] Bacchielli 1987, 462-463, figures 2-5.

[92] Bacchielli 1987, 461.

[93] Bacchielli 1990, 61.

to the Cyrenaican countryside. These stelae combine elements of both busts and aniconic funerary goddesses, but evidently commemorate an individual. Studies of Antonine Imperial portraits and Hadrianic statues from Cyrenaica have stressed the correspondence between these portraits and sculptures and other art of the eastern Roman provinces.[94]

Nonetheless Cyrenaican sculptures exhibit distinctive technical qualities.[95] It is remarkable that while non-funerary sculpture in the urban centre of Cyrene exhibits a technical and stylistic evolution over time, the funerary busts remained uniform for a long period of time. Here we may recall Synesius' wish to be buried with his Dorian ancestors, and in Hellenistic times Klearchos making extravagant claims of descent from the founders of Cyrene. Such consciousness of personal links to the founders of Cyrene on the part of the highly educated elite of later antiquity discouraged the adoption of changing fashions in technique and style.

CONCLUSION

The examination of Cyrenaican funerary busts within their original contexts enhances our understanding of their function. These portraits represent a new, Roman way of commemorating the dead through likeness and inscriptions, but are deeply embedded within their local setting. Before the Roman occupation, the Cyreneans already had a centuries-old, partially aniconic, regional funerary tradition. Thus, once the Roman bust form was adopted, it took on formal features peculiar to Cyrenaica. Pre-existing tombs were modified to accommodate this new form of funerary display. Within rock-cut tombs, there is a clear association of busts with sepulchres and *loculi*, which provides valuable evidence of Roman reuse of existing tombs. Busts were used in the countryside, where distinctive semi-iconic monuments to individuals were also commissioned. Busts were not used by the very wealthy, who commissioned marble sarcophagi and whole statues to furnish built tombs; nonetheless, burial in the rock-cut tombs of Cyrenaica remained a privilege for the few, as capacity within the existing tombs was reduced and the cemeteries were not enlarged.

BIBLIOGRAPHY

Adams, N. 2003. Greek and Roman sculpture and inscriptions from Cyrene: recent joins and proposed associations, including a 'new' private portrait statue, and some recent epigraphic discoveries, *Libyan Studies*, 34: 43-44.

Anderson, M.L. and Nista, L. 1988. *Roman Portraits in Context: Imperial and Private Likenesses from the Museo Nazionale Romano*, Rome: De Luca Edizioni d'Arte.

Audley-Miller, L. 2010. *Tomb Portraits under the Roman Empire: Local Contexts and Cultural Styles*, Unpublished D.Phil. Thesis, University of Oxford.

Al Muzzeini, A., Thorn, D., Thorn, J.C. and Reynolds, J. 2003. Newly discovered funerary verses at Cyrene, *Quaderni di Archeologia della Libya*, 18: 165-172.

Bacchielli, L. 1977a. Un ritratto cireneo nel Museo Nazionale Romano e alcune osservazioni sui busti funerari per nicchia, *Quaderni di Archeologia della Libia*, 9: 77-92.

Bacchielli, L. 1977b. Un ritratto cirenaico in gesso nel Museo Greco-Romano di Alessandria, *Quaderni di Archeologia della Libia*, 9: 97-110.

Bacchielli, L. 1987. La scultura libica in Cirenaica e la variabilità delle risposte al contatto culturale greco-romano, *Quaderni di Archeologia della Libia*, 12: 459-522.

Bacchielli, L. 1990. Il ritratto funerario in Cirenaica: produzione urbana e produzione della chora a confronto. In Stucchi, S. (ed.), *Giornata lincea sulla Archeologia Cirenaica (Roma, 3 novembre 1987)* (Atti dei convegni lincei, 87), Rome: Accademia Nazionale dei Lincei, 55-64.

Beschi, L. 1969-1970. Divinità funerarie Cirenaiche, *Annuario della Scuola Archeologica Italiana di Atene*, 47-48: 133-341.

Beschi, L. 1976. Un supplemento 'cretese' ai ritratti funerari romani della Cirenaica, *Quaderni di Archeologia della Libia*, 8: 385-397.

Bonanno, A. 1975-1976. Another funerary portrait from Cyrenaica in the British Museum, *Annual Report of the Society for Libyan Studies*, 6: 27-30.

[94] Adams 2003; Kane 1985; Rosenbaum 1960, 5 ff.; 1988.
[95] Rosenbaum 1960, 5, 6, 7, 60, no.54, plate XXXVII, 1-2; 67, no.74, plate XLVIII.

Bonanno, A. 1976. Cyrenaican funerary portraits in Malta, *Journal of Roman Studies*, 66: 39-44.

Bonanno Aravantinos, M. 2007. I ritratti di età romana della Cirenaica: lo stato degli studi. Considerazioni sui ritratti dal Tempio di Zeus Olimpio a Cirene. In Gasperini, L., Marengo, S.M. (eds), *Cirene e la Cirenaica nell'Antichità. Atti del Convegno Internazionale di Studi, Roma-Frascati 18-21 dicembre 1996*, Macerata: Edizioni Tored, 87-104.

Cassels, J. 1955. The cemeteries at Cyrene, *Papers of the British School at Rome*, 23: 1-43.

Chamoux, F. 1953. *Cyrène sous la monarchie des Battiades*, Paris: De Boccard.

Cherstich, L. 2006a. S4: la tomba di Klearchos di Cirene. In Fabbricotti, E. and Menozzi, O. (eds), *Cirenaica: studi, scavi e scoperte. Parte 1: nuovi dati da città e territorio. Atti del X Convegno di Archeologia Cirenaica (Chieti, 24-26 Novembre 2003)* (British Archaeological Reports, International Series, 1488), Oxford: John & Erica Hedges, 103-120.

Cherstich, L. 2006b. Ricognizione nella Necropoli Sud di Cirene: la strada per Balagrae. In Fabbricotti, E. and Menozzi, O. (eds), *Cirenaica: studi, scavi e scoperte. Parte 1: nuovi dati da città e territorio. Atti del X Convegno di Archeologia Cirenaica (Chieti, 24-26 Novembre 2003)* (British Archaeological Reports, International Series, 1488), Oxford: John & Erica Hedges, 391-408.

Cherstich, L. 2008a. *The Southern Necropolis of Cyrene*, Unpublished D.Phil. Thesis, University of Oxford.

Cherstich, L. 2008b. From looted tombs to ancient society: a survey of the Southern Necropolis of Cyrene, *Libyan Studies*, 39: 73-91.

Cherstich, L. 2011. The changing funerary world of Roman Cyrene, *Libyan Studies*, 42: 33-46.

Cherstich, L. and Santucci, A. 2010. A new discovery at Cyrene: Tomb S64 and its 'Pompeian Second Style' wall paintings. Preliminary notes, *Libyan Studies*, 41: 33-45.

Cormack, S. 2007. The tombs at Pompeii. In Dobbins, J.J. and Foss, P.W. (eds), *The World of Pompeii*, London: Routledge, 585-606.

Daszewski, W.A. 1994. The origins of Hellenistic hypogea in Alexandria. In Minas, M. and Zeidler, J. (eds), *Aspekte Spätägyptischer Kultur. Festschrift für Erich Winter zum 65 Geburtstag*, Mainz am Rhein: Philipp von Zabern, 51-68.

Daszewski, W.A. 1998. Marina el-Alamein: excavations 1998, *Polish Archaeology in the Mediterranean*, 10: 41-50.

De Kersauson, K. 1996. *Catalogue des portraits romains*, Paris: Ministère de la culture et de la communications, Éditions de la Réunion des Musées Nationaux.

Dent, J. 1985. Burial practices in Cyrenaica. In Barker, G., Lloyd, J.A. and Reynolds, J. (eds), *Cyrenaica in Antiquity* (British Archaeological Reports, International Series, 236), Oxford: B.A.R., 327-336.

Di Valerio, E., Cherstich, I., Carinci, M., Siciliano, F., D'Addazio, G. and Cinalli, A. 2005. Votive niches in funerary architecture in Cyrenaica (Libya). In Birault, C., Green, J., Kaldelis, A. and Stellatou, A. (eds) *SOMA 2003: Symposium on Mediterranean Archaeology* (British Archaeological Reports, International Series, 1391), Oxford: Archaeopress, 53-58.

Dobias-Lalou, C. 1994. Langue et politique : à quoi sert le dialecte dans la Cyrénaïque Romaine ?. In Reynolds, J. (ed.), *Cyrenaican Archaeology: An International Colloquium. Libyan Studies 25*, London: Society for Libyan Studies, 245-250.

Fabbricotti, E. 2008. New finds from a Roman tomb in Cyrenaica. The portraits. In Pochmarski, E. Franek, C. and Lamm, S. (eds), *Thiasos: Festschrift für Erwin Pochmarski zum 65 Geburtstag*, Vienna: Phoibos Verlag: 219-227.

Fejfer, J. 2008. *Roman Portraits in Context*, Berlin: Walter de Gruyter.

Giovannini, V. 2014. Le sculture dal 'Tempio di Cibele' nel santuario dei Dioscuri. In Luni, M. (ed.), *Cirene "Atene d'Africa", VIII. La scoperta di Cirene, un secolo di scavi (1913-2013)* (Monografie d'Archeologia Libica, 37), Rome: 'L'Erma' di Bretschneider, 67-89.

Goodchild, R.G. 1971. *Kyrene und Apollonia*, Zürich: Raggi Verlag.

Huskinson, J. 1975. *Corpus Signorum Imperii Romani: Roman Sculpture from Cyrenaica in the British Museum*, London: British Museum Publications.

Kane, S. 1985. Sculpture from the Cyrene Demeter Sanctuary in its Mediterranean context. In Barker, G., Lloyd, J.A. and Reynolds, J. (eds), *Cyrenaica in Antiquity* (British Archaeological Reports, International Series, 236), Oxford: B.A.R., 237-247.

Kenrick, P. 2013. *Libya Archaeological Guides. Cyrenaica*, London: Silphium Press.

Menozzi, O. 2006. Per una lettura della chora cirenea attraverso lo studio di santuari rupestri e di aree marginali della necropoli di Cirene. In Fabbricotti, E. and Menozzi, O. (eds), *Cirenaica: studi, scavi e scoperte. Parte 1: nuovi dati da città e territorio. Atti del X Convegno di Archeologia Cirenaica (Chieti, 24-26 Novembre 2003)* (British Archaeological Reports, International Series, 1488), Oxford: John & Erica Hedges, 61-84.

Reynolds, J. 1959. Four inscriptions from Roman Cyrene, *Journal of Roman Studies*, 49: 95-101.

Reynolds, J. 1962. Cyrenaica, Pompey, and Cn. Cornelius Lentulus Marcellinus, *Journal of Roman Studies*, 52: 97-103.

Reynolds, J. and Thorn, J.C. 2005. Cyrene's Thea figure discovered in the Necropolis, *Libyan Studies*, 36: 89-100.

Rosenbaum, E.A. 1960. *Cyrenaican Portrait Sculpture*, London: British Academy.

Rosenbaum, E.A. 1988. Roman portraiture in the Eastern Mediterranean: Greece, Asia Minor, Cyrenaica, *Quaderni della ricerca scientifica*, 116: 19-30.

Santucci, A. and Thorn, J.C. 2003. Tarhuna-Windmill Tomb, tomba dei due coniugi, tomba N1: la grande tomba circolare della necropoli nord di Cirene, *Quaderni di Archeologia della Libia*, 18: 183-204.

Siciliano, F. 2006. Divinità funerarie Cirenaiche. Alcuni recenti rinvenimenti. In Fabbricotti, E. and Menozzi, O. (eds), *Cirenaica: studi, scavi e scoperte. Parte 1: nuovi dati da città e territorio. Atti del X Convegno di Archeologia Cirenaica (Chieti, 24-26 Novembre 2003)* (British Archaeological Reports, International Series, 1488), Oxford: John & Erica Hedges, 409-422.

Sillani, C. 2014. Documenti inediti di E. Ghislanzoni sul territorio di Cirene (1913-1919). In Luni, M. (ed.), *Cirene "Atene d'Africa", VIII. La scoperta di Cirene, un secolo di scavi (1913-2013)* (Monografie d'Archeologia Libica, 37), Rome: 'L'Erma' di Bretschneider, 81-108.

Skupinska-Løvset, I. 1983. *Funerary Portraiture of Roman Palestine: An Analysis of the Production in its Culture–historical Context*, Gothenburg: Paul Åströms Förlag.

Smith, R.M. and Porcher, E.A. 1864. *History of the Recent Discoveries at Cyrene. Expedition to the Cyrenaica in 1860-1861*, London: Day & Son.

Stucchi, S. 1975. *Architettura Cirenaica* (Monografie d'Archeologia Libica, 9), Rome: 'L'Erma' di Bretschneider.

Thorn, J.C. 2005. *The Necropolis of Cyrene: Two Hundred Years of Exploration*, Rome: 'L'Erma' di Bretschneider.

Thorn, J.C. and Thorn, D.M. 2008. The tomb of Grenna, Cyrene, *Libyan Studies*, 39: 95-116.

Thorn, J.C. and Thorn, D.M. 2009. *A Gazetteer of the Cyrene Necropolis*, Rome: 'L'Erma' di Bretschneider.

Tomlinson, R.A. 2006. Tomb N271 and its significance for the history of Cyrene Doric. In Fabbricotti, E. and Menozzi, O. (eds), *Cirenaica: studi, scavi e scoperte. Parte 1: nuovi dati da città e territorio. Atti del X Convegno di Archeologia Cirenaica (Chieti, 24-26 Novembre 2003)* (British Archaeological Reports, International Series, 1488), Oxford: John & Erica Hedges, 97-102.

Toynbee, J.M.C. 1971. *Death and Burial in the Roman World*, London: Thames & Hudson.

Walker, S. 1985. The architecture of Cyrene and the Panhellenion. In Barker, G., Lloyd, J.A. and Reynolds, J. (eds), *Cyrenaica in Antiquity* (British Archaeological Reports, International Series, 236), Oxford: B.A.R., 327-336.

Walker, S. 1994. The Imperial Family as seen in Cyrene. In Reynolds, J. (ed.), *Cyrenaican Archaeology: An International Colloquium. Libyan Studies 25*, London: Society for Libyan Studies, 164-184.

Walker, S. 1997. Mummy portraits in their Roman context. In Bierbrier, M.L. (ed.), *Portraits and Masks: Burial Customs in Roman Egypt*, London: British Museum Press.

Wanis, S. 1977-1978. Two funerary statues at Cyrene, *Libyan Studies*, 9: 47-49.

Zanker, P. 2010. *Roman Art* (translated by H. Heitmann-Gordon), Los Angeles: J. Paul Getty Museum.

15

BEYOND GHIRZA: ROMAN-PERIOD MAUSOLEA IN TRIPOLITANIA

Julia Nikolaus

Abstract

Roman-period mausolea in Tripolitania were rich in architectural variations and stone-carved decorations. Most publications to date have concentrated on a specific site or monument, in particular the two monumental cemeteries at Ghirza. This contribution will go beyond Ghirza and provide a preliminary overview of the distribution, architecture, and decorative styles of mausolea in Tripolitania. Local preferences in figural decorations will be explored by focusing in more detail on the depictions of agriculture.

INTRODUCTION

Over 140 Roman-period mausolea once dotted the landscapes of Tripolitania. Their architectural and decorative features displayed a vivid variety of local, North African, Roman, Hellenistic, and Egyptian elements that reflected the rich cultural environment in which they were created. Previous scholarly work has predominantly focused on the cemeteries of Ghirza[1] and, to date, no coherent study of all recorded mausolea has been published. This paper will start to fill this gap by providing an overview of the distribution of mausolea in Tripolitania. Specific examples have been selected to demonstrate their varied architectural and decorative elements and to highlight the complex regional styles that developed over time.[2]

Initially, it was believed that Tripolitanian mausolea were built for Roman settlers in the late Roman period,[3] until Olwen Brogan challenged this view and subsequently demonstrated that they were, in fact, commissioned by the local Libyan elite from the first century AD onwards.[4] Despite this, scholarly attention has remained on the Roman aspects, leading to the assumption that the monuments were simply a (bad) attempt to emulate Roman styles in a desire to appear 'Roman' in the backwaters of the Tripolitanian hinterland.[5] This did not, however, explain the existence of diverse local preferences in architectural styles and stone-carved decorations.

Fontana was amongst the first who moved away from this Romano-centric view and instead focused on the message(s) that the figural reliefs conveyed. He noticed a change in the mode

[1] See, in particular, Brogan and Smith 1984.

[2] This paper presents some preliminary results of my PhD project undertaken at the University of Leicester, which is primarily concerned with stone-carved decorations that decorate many mausolea in Tripolitania. The numbers of mausolea presented in this article are conservative estimates and reflect the data collected until 2014 when this paper was written. The final number of all recorded mausolea is likely to be even higher. I would like to thank David Stone, David Mattingly, Bruce Hitchner, and Lucy Audley-Miller for their feedback on the article. Of course, all mistakes remain my own.

[3] See for instance Barth 1857; Clermont-Ganneau 1903; Coro 1928; Cowper 1896; 1897; Gentilucci 1933; Goodchild and Ward-Perkins 1949; Rae 1877; Romanelli 1925; 1930.

[4] Brogan 1964; 1975; Brogan and Smith 1984; Mattingly 2004, 6.

[5] For instance, Toynbee 1971; Zimmer 1981.

of self-representation during the third century AD, from portraiture to interactive scenes that displayed individuals exercising power over others.[6] Mattingly's work on the monumental cemeteries at Ghirza demonstrated how Roman imperial art could provide an image pool that was manipulated to represent indigenous traditions and values to support the legality of Roman power within local society.[7] Zanker drew attention to the sometimes intricate details on the reliefs at Ghirza, such as height or dress, to convey complex messages of status and accomplishment primarily aimed at the local viewer.[8] Subtle differences in dress and hairstyle on portraiture at Ghirza were explored in detail by Audley-Miller. Although the portraits are far from realistic, they actively expressed status by negotiating between local and Roman hair and dress styles.[9]

By moving beyond Ghirza, this paper will provide an overview of the distribution and architectural styles of mausolea across Tripolitania. It will demonstrate that their style and decorations were not simply passively or randomly selected by the local elite, but were part of an active process that was influenced by local and wider socio-economic circumstances.[10]

THE DISTRIBUTION OF MAUSOLEA ACROSS TRIPOLITANIA: AN OVERVIEW[11]

Tripolitania was incorporated into the Roman Empire in the mid-first century BC.[12] From the first century AD onwards, there was a sharp increase in the construction of mausolea from only three known Hellenistic examples,[13] to over 140 by the fifth century AD.[14] Their distribution can best be demonstrated by examining the broad geographical zones of the region: (1) the coastal zone is defined by a narrow coastal plain of Mediterranean climate that contained the big cities of Lepcis Magna, Sabratha and Oea (Tripoli); (2) the Gefara plain with fertile soils to the east, but much dryer towards the west; (3) the mountainous Gebel that rises up steeply from the Gefara forming a plateau with depressions filled with fertile soils; (4) the dry and arid pre-desert zone to the east and finally; (5) the desert with its big sand seas and oasis towns.

The distribution of mausolea across the different areas of Tripolitania is difficult to assess due to the reuse of their stones in more recent structures. However, some confident estimates can be made on the basis of evidence collected from nineteenth and early twentieth-century travel writings, archaeological reports, archival materials, and more recent surveys (Figure 15.1).

The coast

The evidence for mausolea is limited in the coastal areas but it seems that at least 18 mausolea once stood in this region. It is likely, however, that there were many more as the coastal region was always the most densely populated area of Tripolitania, which led to the continuous reuse of ancient building materials into newer structures over centuries. The vast majority of existing evidence for mausolea comes from Lepcis Magna, which has been subject to intense archaeological study over the last century. Monumental tombs were located in cemeteries that lined the roads in and out of the city towards Alexandria to the east, Oea to the west and Tarhuna to the south.[15] In the eastern outskirts of Lepcis Magna, the tower mausoleum of Gasr Shaddad is still preserved to some height today. Nowadays it stands in isolation, but scattered archaeological remains indicate

[6] Fontana 1997, particularly on mausolea from the pre-desert area.

[7] Mattingly 1999; 2003; 2011.

[8] Zanker 2008.

[9] Audley-Miller 2012.

[10] This paper is based on materials collected from the Society for Libyan Studies Archive and published materials by early travellers, archaeologists, and more recent published works.

[11] The numbers provided for each zone are minimum estimates based on the archival and published materials available.

[12] It is not entirely clear when exactly the region was formally added to the Roman Empire but it can be placed at some point before the battle of Thapsus in 46 BC (Mattingly 1996, 51).

[13] Hinshīr Būrgū on the island of Jerba dates to the second century BC: see Ferchiou 2009. The two mausolea at Sabratha (Mausoleum A and Mausoleum B) also date to the second century BC: see Di Vita 1976; 2010 for an extended bibliography.

[14] A sharp increase in mausolea construction can be attested across the Roman Empire, see for instance von Hesberg 1992 and Toynbee 1971.

[15] Romanelli 1925, 157-167; Squarciapino 1966, 45-47.

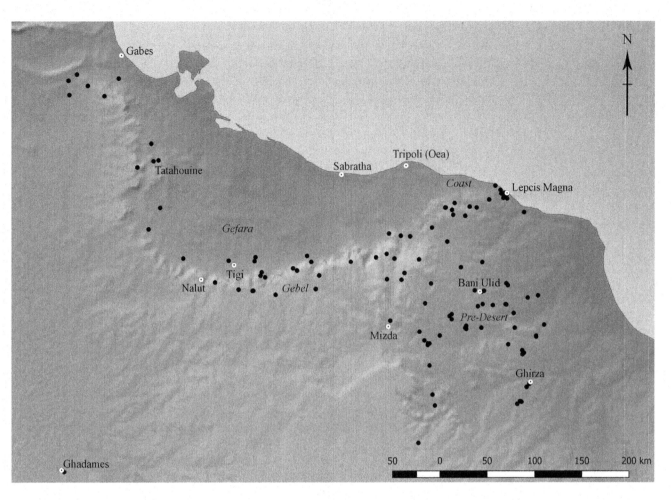

Figure 15.1. *Distribution of mausolea in Tripolitania (image: J. Nikolaus).*

that the surrounding area once held a multitude of burials, including other mausolea, hypogea, and smaller tombs.[16] A photograph taken in the late nineteenth century in the immediate outskirts of Lepcis Magna shows at least two substantial mausolea that were turned into military barracks but which are now missing.[17] Towards the west of the city along the coast, tower tombs were noted by Rae in the nineteenth century but these have now entirely disappeared.[18] Other mausolea were situated in the immediate agricultural hinterland to the south of Lepcis Magna, frequently associated with nearby farms.[19] Along the Wadi Lebda, stood the tower mausoleum of Gasr Duirat,[20] and the mausoleum of Gasr Gelda was situated further up the Wadi.[21] The mausoleum of Gasr Legbeba was located near the Wadi Lebda approximately 5 km south of the city.[22] At least one mausoleum and other types of burials were located in the Wadi er Rasaf.[23]

The evidence for mausolea elsewhere on the coast is very limited. The foundations of two mausolea were recorded at Silin, 14 km to the north-west of Lepcis Magna,[24] and a very large mausoleum was located approximately 35 km to the south-east of Lepcis Magna at Al Jumaa in the Wadi Caam.[25] The dating of the mausolea around Lepcis Magna is difficult due to their fragmented condition and the lack of a detailed study of their architecture. Fontana suggests that, according to the architectural decoration, they were built before or during the Severan period.[26]

[16] Fontana 1996, 80-81; 2001, 163; Munzi *et al.* 2010, 738-741; Musso 2010, 61; Romanelli 1925.

[17] Matoug 1997, 214, plate XCb.

[18] For the drawing of such a tower mausoleum, see Rae 1877, between pages 35 and 36.

[19] Clermont-Ganneau 1903, 341-343; for a survey of the hinterland of Lepcis Magna see, in particular, Munzi *et al.* 2004, 14; 2010.

[20] This mausoleum is now reconstructed outside the Lepcis Magna museum.

[21] Clermont-Ganneau 1903, 341-343; Munzi *et al.* 2010, 738; Romanelli 1925, 165, and figure 91.

[22] Matoug 1997, 211-214.

[23] Masturzo 1997, 284-287.

[24] Munzi *et al.* 2004.

[25] Kenrick 2009, 148-149; Merighi 1940, 157-158.

[26] Fontana 1997, 152.

The Gefara

The Gefara is still severely under-explored and sand dunes cover much of the area.[27] Most Roman-period sites were located close to the foot of the Gebel, where farms and settlements took advantage of the watershed from the escarpment, amounting to at least 18 monumental tombs.[28] Some mausolea were constructed with a mix of rubble and concrete, perhaps with ashlar facing.[29] Others, such as El Amrouni near Tatahuine were solid ashlar constructions.[30] Brogan recorded the large foundations of a mausoleum measuring 5.90 m x 5.65 m, located approximately 105 km outside Tripoli, which she called Ruderi Romani.[31] The footings of a smaller mausoleum, Henscir Schiugaff, were recorded 2 km west of Bir Aiad.[32] Above the Wadi Hagiar, dressed stones, some of which were decorated, indicated the presence of another mausoleum.[33] Coro saw three mausolea near Giosc that were already severely looted for lime burning in the 1920s. He also recorded two mausolea along the Wadi Umm Teghuf, south-east of Giosc that were, likewise, rather damaged.[34] More recently, the foundations of a mausoleum have been discovered at Rogeban, which brought to light several architectural fragments and figurative reliefs relating to agricultural activities.[35] More detailed work has been conducted in the western part of the Gefara, at the foot of the central and western Gebel. The best published example is that of El Amrouni near Tatahouine, an early second-century tower-mausoleum.[36] Others include a group of four mausolea at Beni Guedal,[37] two mausolea at Henscir el-Ausāf near Tigi,[38] the mausoleum of Oued Beni Blell,[39] and at least two mausolea at Henchir Snem.[40]

The Gebel

Many mausolea in the Gebel have now disappeared due to intense stone robbing. However, the evidence suggests that they once must have exceeded 30 in number. Coro recorded over 20 during his travels in the Gebel Nefusa in 1922, most of them already in a rather ruinous state.[41] Olwen Brogan came across over 30 during her many visits from the 1950s to the 1980s, including many of those that Coro had mentioned. She observed the remains of many more, further inland of the Gebel but in very fragmentary condition. Sadly, many of these were not recorded in detail.[42] Cowper, Oates and, more recently, Ahmed conducted surveys on the Gebel Tarhuna. Ahmed noted the remains of eight mausolea and Trousset recorded at least 12 mausolea in the western Gebel.[43]

Some mausolea on the eastern Gebel were situated in highly visible positions along the edge of the escarpment, such as Gasr Doga or Henchir Suffit south-east of Yefren, which were visible from a distance.[44] Others stood further inland where the eastern Gebel gradually merges into the pre-desert as, for example, Bir el Uaar.[45] The central Gebel bears almost no structural evidence of mausolea. However, some reused reliefs, architectural decoration, and carefully cut ashlar

[27] Coro and Merighi both visited the Gefara in the early to mid-twentieth century (Coro 1928; Merighi 1940), and Brogan conducted a brief survey in the 1960s and 70s (Brogan 1965; Brogan, unpublished notes, Society for Libyan Studies Archive). Trousset (1974) undertook a physical and literary survey of the western parts of the Gefara (now southern Tunisia). See Trousset 1974 for an extended bibliography on nineteenth and early twentieth-century travellers and archaeologists who first recorded some of the sites in the Gefara and the Gebel.

[28] Brogan, unpublished notes, Society for Libyan Studies Archive; see also Coro 1928, 95-99.

[29] For instance, Henscir Sciugaff 2 km west of Bir Aiad (Brogan, unpublished notes, Society for Libyan Studies Archive); see also Coro 1928, 65-70.

[30] Ferchiou 1989.

[31] Brogan, unpublished notes, Society for Libyan Studies Archive.

[32] Coro 1928, 7-15.

[33] El Hagiar: Brogan, unpublished notes, Society for Libyan Studies Archive.

[34] Coro 1928, 95-99.

[35] Zenati 1995, 156.

[36] Ferchiou 1989; Trousset 1974, 107-113, figure 33a.

[37] Trousset 1974, 123-126, figure 35a and b.

[38] Brogan 1965; Coro 1928, 111.

[39] Trousset 1974, 108.

[40] Trousset 1974, 109.

[41] Coro 1928.

[42] Brogan, unpublished notes, Society for Libyan Studies Archive.

[43] Ahmed 2010; Cowper 1896, 1897; Faraj et al. 1997; Oates 1953, 104-105; Trousset 1974.

[44] Kenrick 2009, 76-77.

[45] Abdussaid 1998.

masonry indicate that at least a small number once stood in this area.[46] On the western Gebel the mausolea were in a rather ruinous state. They broadly followed the line of the escarpment that also formed part of the *limes*-zone of western Tripolitania.[47] Here, they were situated close to Roman forts that dotted the *limes*, but Roman-period farms can also be associated with the mortuary monuments. Whether or not these mausolea are more closely related to forts or farmsteads has still to be established. The monumental tombs often stood in isolation or in pairs in highly visible positions.[48] An exception is presented by the now completely obliterated cemetery south-east of Cabao in the eastern Gebel mentioned by Coro, which held eight mausolea.[49] The dating of the monuments across the Gebel is difficult due to their fragmented condition, but they seemed to have been built throughout the Roman period. In the eastern Gebel, Gasr Doga near Tarhuna is the largest of the Tripolitanian mausolea dating to the early first century AD.[50] The capitals of Henshir Kebir near Biscema are of the pre-Severan period,[51] while the architectural fragments of Bir el-Uaar in the eastern Gebel have been dated to the third century AD.[52]

The pre-desert

The largest number of mausolea survive in the pre-desert region, some in a relatively good state of preservation, predominantly constructed of ashlar masonry. From the first century AD onwards, the pre-desert underwent substantial agricultural intensification with the help of water irrigation systems. As a result, the area was much more densely settled and yielded enough surplus wealth to enable the construction of these large mortuary monuments.[53] The UNESCO Libyan Valleys Survey recorded over 70 mausolea in a relatively small survey area, together with a large number of farm dwellings and small settlements.[54] Mausolea can frequently be associated with nearby settlements and farms, but are sometimes situated a considerable distance away in a highly visible position.[55] Some stand in isolation while others are surrounded by simpler burials such as cairns and cists;[56] and 20 cemeteries in this area contained at least two mausolea or more. The settlement of Ghirza is situated in this area, housing the two largest monumental cemeteries with seven mausolea each.[57] The earliest examples such as the mausolea at Mselliten in the Wadi Merdum can be dated to the mid-to-late first century AD,[58] which corresponds with the establishment of more intense agricultural activity. The building of mausolea continued throughout the Roman period: the Wadi N'f'd mausolea were most likely built in the second century,[59] while the arcaded temple mausolea at the cemetery of Ghirza are from the late third to the fifth century AD.[60]

[46] Brogan 1970-1971, 11-12; Brogan and Kenrick recorded numerous mosques that had stones integrated.

[47] Trousset 1974, Henchir Mguitla, 62; Benia Guedah Ceder, 67, Henchir Guedah ez Zehmala, 69; Sidi bel Abbas, 79-80; Henchir bel Aïd, 80, Djebel Tafechna, 81-82, figure 11; Henchir bou Guerba, 82-83; Henchir Krebita, 83-84; Henchir Oum el Abbes, 84-85; Douirat, 102-103; Si Aoun, 118.

[48] The presence of smaller burials around the mausolea in the Gebel is in need of more detailed study. This is currently being investigated by a research project by Julia Nikolaus and Nick Ray entitled 'Funerary Monuments of Tripolitania' funded by the Society for Libyan Studies.

[49] Coro 1928, 23-32. When Brogan visited the site most of the evidence of the eight mausolea had disappeared (Brogan, unpublished notes, Society for Libyan Studies Archive).

[50] This mausoleum has been recently re-studied by Bigi *et al.* 2009. The early date is based on the architectural decoration and the inscription.

[51] Brogan, unpublished notes, Society for Libyan Studies Archive.

[52] Abdussaid 1998, 154.

[53] This has been demonstrated by the UNESCO Libyan Valleys Survey: see Barker 1996; Mattingly 1996.

[54] Barker 1996; Mattingly 1996.

[55] For instance, the Ghirza South cemetery is located approximately 2 km to the south of the settlement, and the mausoleum in the Wadi Migdal stands on the opposite side of the wadi away from the associated gasr (Mattingly 1996, 200, Mg1).

[56] See Mattingly 1996 for the cemetery in the Wadi Antar (33-36, An1) or in the Wadi Umm el-Agerem (20-21, Ag2; Ag3).

[57] Brogan and Smith 1984. The so-called North Cemetery is located very close to the settlement, 350 m to the south of the nearest building, whereas the so-called South Cemetery is situated two and a half kilometres to the south (Brogan and Smith 1984, 121).

[58] Mattingly 1996, 174, Md1.

[59] Abdussaid 1996; Mattingly 1996, 261, Nf30 and Nf31.

[60] Brogan and Smith 1984.

The desert

Remarkably, Roman-period mausolea can be found even in the remote desert region. The Asnam cemetery in the oasis town of Ghadames, approximately 465 km south-west of Tripoli as the crow flies, held a minimum of six mausolea of considerable proportions, constructed of rubble and cement, perhaps with an ashlar facing. This is similar to the construction technique of the Gefara,[61] probably due to a lack of good quality limestone.[62] Their architectural style is akin to the arcaded temple tombs at Ghirza but even bigger in size.[63] This similarity suggests a date range from the late third to the fourth century AD.[64]

The dramatic rise in the number of mausolea across Tripolitania is significant and points towards the development of a larger, richer, and more influential elite. The large number of mausolea in the pre-desert stands in contrast to the smaller numbers in the rest of the region. Limited survey work along the coast and around Oea and Sabratha, as well as the extensive reuse of stones in other structures, accounts, at least in part, for the small number of mausolea in the coastal areas. Furthermore, underground burial chambers (hypogea) were an alternative mode of burial employed by the upper strata of the city's inhabitants.[65] Hypogea are evident at the coast and the Gebel and were already in use before the Roman period, representing an ancestral mode of burial that was used over generations.

Many of the landowners of the Gebel were prominent figures in the coastal cities, from where they controlled their large country estates. This is suggested by the writings of Apuleius who married a rich woman from Oea who owned a considerable amount of land. Apuleius mentions that many of the Oean elite owned large estates within the city's territory,[66] which was formed by the agricultural lands on the Gefara and the Gebel. It is conceivable that some very rich and influential landowners preferred to erect their funerary monument close to the city to display their wealth and status. The rural environment, on the other hand, provided an alternative to gain, maintain and execute considerable powers for those who did not hold a high municipal position, of which only very few were available.[67] A dedication of an *Ammonium* in the eastern Gebel shows that some estates here still belonged to local resident elite who succeeded in pursuing independent relations with the big urban centres.[68] For them, a funerary monument in a rural environment was much more effective since they did not have to compete with the monuments of the urban elite in the cities.

The pre-desert is a particularly interesting case since it was not until the first century AD that this area was more densely settled. The newly acquired land was, most likely, divided up into larger estates and allocated to a few elite leaders, similar to the Gebel area.[69] Cemeteries served as property markers and were placed on visible locations on the edge of the family land, not always closest to the nearest settlement,[70] placing more importance on their visibility than proximity.[71] This way, mausolea acted as symbolic markers to lay claim to the land and to maintain power over the region. The height of the monument was of significance since it reflected a degree of permanence and high social status[72] They were visible for miles and served as important landmarks on the otherwise often-featureless landscape, as they still do today.[73] It is also more likely that landowners were permanently resident in this area since they were situated a considerable

[61] For instance, Henscir Sciugaff 2 km west of Bir Aiad: Coro 1928, 65-70.

[62] Brogan, unpublished notes, Society for Libyan Studies Archive.

[63] Mattingly and Sterry 2010, 9.

[64] Mattingly and Sterry 2010, 9, 76. For the Balbus' campaign to Cidamus see Merrills in this volume.

[65] Fontana 2001, 162-165.

[66] Apuleius, *Apologia*, 44.6; 71.6; Mattingly 1995, 143.

[67] Haeussler 2013, 242.

[68] Ahmed 2010, 123. Translation of dedication by Levi Della Vida (1951): 'To the Lord Ammon, this (is the) beautiful (?) idol (literally: statue of a god) and the sanctuary of his temples and the porticoes, which were built and dedicated in the year of the proconsul over Africa (literally: the territory of the Libyans) Lucius Aelius Lamia by TNKAF son of Sasidwasatn son of Tnamar, who belongs to Son of Masinkaw, with their annexes, at his expense'.

[69] Mattingly 1995, 144-153.

[70] Buck *et al.* 1983, 53.

[71] Mattingly and Dore 1996, 144.

[72] Hitchner 1995, 496; Pillinger 2013, 194.

[73] Mattingly and Dore 1996, 144.

distance from the coast. This theory is supported by partial family trees that can be reconstructed from the names on inscriptions of mausolea at, for instance, the Wadi el-Amud or the Wadi Umm el-Agerem.[74] The elite families had substantial influence over local trade, agriculture, and irrigation systems that yielded substantial wealth and political authority in the region.[75]

ARCHITECTURAL TYPES

Three main architectural types are evident across Tripolitania: the tower mausoleum, the temple mausoleum, and the rectangular mausoleum. Tower and temple mausolea are the most frequent architectural form while rectangular mausolea are less prevalent. The three different types developed into a surprising array of architectural sub-styles.

Tower mausolea

Tower mausolea were already a long-established mode of elite burial in neighbouring Numidian and Punic territories from the late fourth century BC onwards,[76] but it is unclear how frequent or widespread they were in Tripolitania prior to the Roman period.[77] They were constructed of local limestone in ashlar masonry, occasionally with a rubble core and ashlar facing. Pilasters, engaged columns, and mouldings served as architectural decoration, while friezes frequently displayed animals, human figures, rosettes, vegetative scrolls or busts. The architectural types that developed over time were not merely a copy of their predecessors, but they developed into an array of architectural sub-styles: (i) the obelisk mausoleum; (ii) the multi-storey aedicula mausoleum; and (iii) the tower mausoleum with integrated open peristyle.

(i) *Obelisk mausolea:* perhaps the most striking new sub-form of tower mausolea that had evolved out of the tower mausoleum is the obelisk mausoleum. This type is taller and thinner than other North African tower tombs, and is topped with a long and slender pyramidal roof, such as the mausoleum in the Wadi N'f'd (Figure 15.2a).[78] They consist of two or three superimposed storeys that reached up to a height of 18 m above the subterranean burial chamber.[79]

(ii) *Multi-storey aedicula mausolea:* this type of mausoleum was popular across the Empire,[80] and was also present in Tripolitania, at, for instance, Henshir Suffit in the eastern Gebel or Gasr Shaddad near Lepcis Magna (Figure 15.2b). The striking development here is that the aedicula was integrated into the basic form of the tower and obelisk tomb. Ghirza South A featured two narrow vaulted aedicula that held two statues on the second storey topped by a slender pyramid (Figure 15.2c).[81] The obelisk mausoleum in the Wadi Migdal had a much deeper aedicula with three columns in the front and a cella at the back, as well as an obelisk on top (Figure 15.2d).[82]

(iii) *Tower mausolea with integrated (open) peristyle:* the obelisk tomb in the Wadi Meseuggi on the edge of the eastern Gebel had a square open peristyle over a square base and was topped by a pyramid (Figure 15.2e).[83] At Gasr Duirat near Lepcis Magna the tower tomb featured a circular

[74] Mattingly 1995, 163-166.

[75] Hitchner, 1995, 495. The importance of irrigation is also mentioned in the poem of the Julii mausoleum A53: *et nemus exorant revocatis sapius undis.* Some estates in the pre-desert were perhaps managed by *conductores* (estate managers), to whom such large mausolea could also belong (Hitchner, pers. comm); there is, however, no epigraphic evidence for this.

[76] Camps 1973, especially 499 ff. for radiocarbon dates of Medracen tomb, around 320 BC; Moore 2007, 78; Stone 2007a, 38.

[77] Only two pre-Roman examples survive at Sabratha from the late third or early second century BC (Di Vita, 1968; 1976; 2010). There may have been more monumental tombs at Sabratha, Lepcis Magna or Oea that were completely obliterated during urban expansion under the Empire (Fontana 2001, 162).

[78] The tower tombs in Africa Proconsularis had a much smaller pyramid. See Baratte 2004, 40 on North African mausolea in general, and Moore 2007 on mausolea in Tunisia.

[79] Mattingly and Dore 1996, 146.

[80] See von Hesberg 1992, 121-158.

[81] Brogan and Smith 1984, 182-189.

[82] Mattingly 1996, 200, Mg1.

[83] Brogan, unpublished notes, Society for Libyan Studies Archive.

Figure 15.2. *Sub-types of tower mausolea. A: obelisk mausoleum, Mselliten (photo: P. Kenrick); B: tower mausoleum with aedicula, Gasr Shaddad, Lepcis Magna (photo: P. Kenrick); C: obelisk mausoleum with aedicula, Ghirza South A, pre-desert (photo: G. Bauer, Society for Libyan Studies Archive); D: tower mausoleum with aedicula,Wadi Migdal, pre-desert, UNESCO Libyan Valleys Survey Mg1 (photo: Society for Libyan Studies Archive); E: obelisk mausoleum with colonnade,Wadi Meseuggi, eastern Gebel (photo: O. Brogan, Society for Libyan Studies Archive); F: mausoleum with aedicula and circular features, Gasr Duirat, Lepcis Magna (photo: D. Mattingly).*

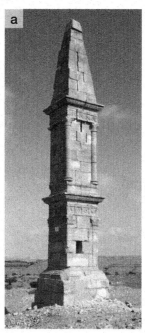
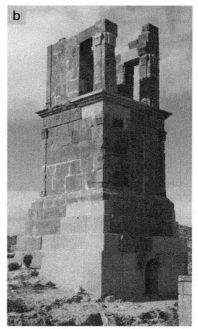
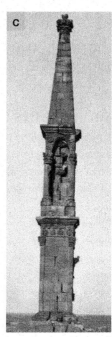
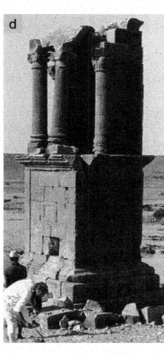
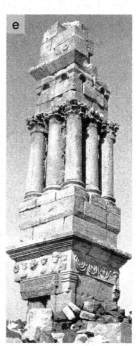
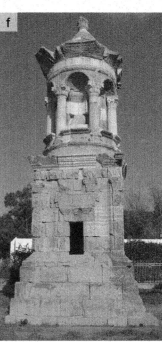

peristyle over a square solid plinth, which was topped with a conical roof, and at least one statue was displayed in the arched niches of the circular peristyle (Figure 15.2f).[84] The tower tomb at Bir el Uaar in the eastern Gebel similarly had a conical roof but featured a square open peristyle on a solid plinth, topped by an open circular peristyle.[85] The remains of a tower mausoleum at Henshir Biscema in the eastern Gebel also displayed circular features.[86]

Temple mausolea

At some point during the late second and the third century AD, temple mausolea gained in popularity in Tripolitania. Their numbers rose from one temple mausoleum at Gasr Doga at the coast built during the early first century AD to at least 25 by the fifth century AD. Similar to tower mausolea, temple mausolea developed into many different sub-types: (i) peripteral

[84] Fontana 2001, 163.
[85] Abdussaid 1998.
[86] Brogan, unpublished notes, Society for Libyan Studies Archive.

temple mausolea; (ii) arcaded temple mausolea; and (iii) 'tetrastyle' mausolea. They did not have their origins from pre-Roman North-African traditions but appear to take their inspiration from Hellenistic architecture.[87]

(i) *Peripteral temple mausolea:* free-standing columns run along all sides of the chamber in the centre which sits on a podium over the lower burial chamber. The roof is flat without a pediment but is instead decorated with roof ornaments such as palmettes, scrolls or roof statues. Four examples of this type are evident: tomb North A at Ghriza (Figure 15.3a),[88] the large mausoleum of Kasr Banat in the Wadi Sofeggin,[89] Gasr Banat in the Wadi N'f'd in the pre-desert,[90] and Gasr Doga in the eastern Gebel.[91]

(ii) *Arcaded temple mausolea:* this type of mausoleum first appeared in Tripolitania in the third century AD. A pier was located in the centre of the structure, which was often decorated with a false door in relief (Figure 15.3b). The surrounding colonnade supported monolithic arches that were placed directly on top of the columns on which the arcuate lintels and highly decorated friezes were placed.[92] The roof did not have a pediment but, like the peripteral temple tomb, it was crowned with roof ornaments. The burial chamber was placed underneath the podium. They were particularly popular at Ghirza, where 10 mausolea were of this type.[93] Two other examples can be found in close proximity to Ghirza at Bir Nesma in the Wadi Sofeggin,[94] and another in the Wadi Khanafes (Figure 15.3c).[95] Remarkably, arcaded temple mausolea were also built at Ghadames in the desert (Figure 15.3d). Their architecture, albeit in a damaged state, displayed close similarities to the arcaded temple mausolea at Ghirza, by featuring a

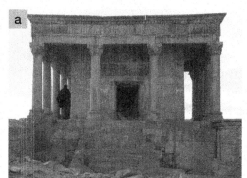
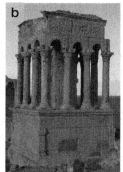
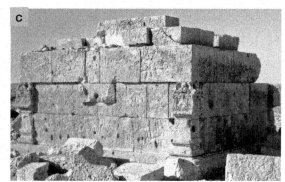

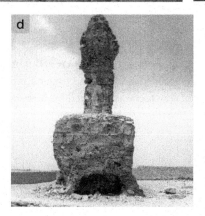
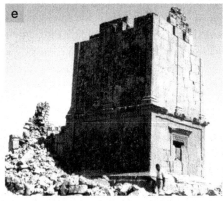

Figure 15.3. *Sub-types temple mausolea. A: peripteral temple tomb, Ghirza North A, pre-desert (photo: P. Kenrick); B: arcaded temple tomb, Ghirza North C, pre-desert (photo: S. Kenrick); C: arcaded temple tomb, Wadi Khanafes, pre-desert, UNESCO Libyan Valleys Survey Kn5 (photo: UNESCO Libyan Valleys Survey, Society for Libyan Studies Archive); D: arcaded temple mausoleum, Ghadames, true desert (photo: J. Nikolaus); E: Gasr Gebab, eastern Gebel (photo: O. Brogan, Society for Libyan Studies Archive).*

[87] Brogan and Smith 1984, 208.

[88] Brogan and Smith 1984, 121-133.

[89] Mattingly 1996 calls this mausoleum Kasr Banat (1996, 280, Sf3); Al Khadduri (1997, 220-223) calls this mausoleum Gasr al-Mekeznat.

[90] Brogan and Smith 1984, 264-265; Mattingly 1996, 263, Nf38.

[91] Bigi *et al.* 2009.

[92] The arrangement of the monolithic arch above columns can be seen at Lepcis Magna and later in early Christian and Islamic architecture (Brogan and Smith 1984, 208-209).

[93] Brogan and Smith 1984.

[94] Mattingly 1996, 287, Sf92.

[95] Mattingly 1996, 152-153, Kn5.

high podium and a solid plinth in the centre but the tombs at Ghadames were much larger.[96] Both Ghirza and Ghadames are the biggest settlements in their respective region, and the existence of the same type of tomb may point towards close trade links or family ties between the two important centres.

(iii) *Tetrastyle temple mausolea:* this type of tomb had a solid *cella* at the back that was preceded by free-standing columns. The structure was topped by a pediment roof. Tetrastyle temple mausolea were popular across Tunisia but their presence in Tripolitania is more ambiguous. Gasr Ajdab in the pre-desert may have been of this type; the large structure had tall columns lying in front of its west face which indicate that it may have featured a portico. However, no evidence of the roof structure has survived.[97]

Rectangular mausolea

Only four rectangular mausolea have been noted so far, of which three are located in the pre-desert in the Wadi Mimoun and one at the coast in the Wadi Lebda.[98] They consist of a semi-submerged chamber topped with a plain ashlar plinth above ground and a flat roof. Notably, they lack decorative friezes and have little in the way of architectural decoration such as mouldings and engaged pillars.

The architectural development of mausolea in Tripolitania demonstrates that elite burial traditions changed drastically during the Roman period. The number of mausolea rose significantly, and the elaborate monuments demonstrate that the elite invested considerable amounts of money to build substantial burial markers that commemorated themselves and their families. Arcaded temple mausolea only appear from the third century onwards, in two monumental cemeteries, Ghirza and Ghadames, and three other locations, in the Wadi Sofeggin at Bir Nesma and in the Wadi Khanafes. This type, so prevalent at Ghirza, appears not to have been favoured at the coast, the Gefara or the Gebel, reflecting a local preference for this type of funerary architecture in the pre-desert and desert regions.

Tower mausolea were the most popular form of elite burial, drawing on wider North African ancestral traditions while, at the same time, new and innovative sub-types were introduced. Within the first century AD, the obelisk tomb developed out of pre-Roman tower tombs into a more slender form, and the Hellenistic tower tomb at Sabratha already shows the tendency to a more slender shape. The style of obelisk tomb was ever changing and adaptable. There are still clear references to the basic ancestral form of the tower and obelisk tomb, but additional features were added to give the monument a very individual appearance. Their architecture reflects a strong North African component, while the detailed architectural decoration, such as capitals, incorporated aspects of Hellenistic and Roman styles. In contrast, temple mausolea represent a new and innovative style, but their vivid pictorial decorations still referred to ancestral traditions of figural representation, which will be explored below. The overall variety of architectural styles reflects a strong expression of personal taste as well as the aspirations of the commissioner and the architect or craftsmen.

The decorations

The majority of mausolea were vividly decorated with symbolic and figural relief panels. In fact, examples without any form of relief are rare.[99] The panels were placed in highly visible positions on the outside façade, typically on the first or second storey while the funerary chamber remained undecorated. Such positioning suggests that the concern was to reach a broader audience beyond immediate family members. The most common themes include portraiture, trade, hunts, combat, agricultural activities, religious imagery, animals and symbolic sculpture.

[96] Other architectural elements such as columns, carved friezes and the distinctive arches have been found throughout the town.

[97] Zenati 1997, 224-225, plate CIX; he calls this mausoleum Gasr al-Ajbar.

[98] Mimoun: Mattingly 1996, 220, Mm 91; 223, Mm123; 227, Mm209, figure 28.17; Wadi Lebda: Gasr Legbeda, Matoug 1997.

[99] For instance Mselliten A (Mattingly 1996, 173, Md1), el-Amud (Mattingly 1996,165, Lm1) and Bir Gebira (Mattingly 1996, 183, Md23) were undecorated.

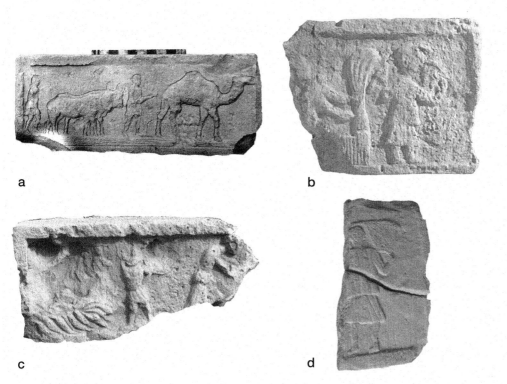

Figure 15.4. *Agricultural scenes. A: ploughing with oxen and camels, Tigi, Gefara (photo: O. Brogan, Society for Libyan Studies Archive); B: harvesting scene, Ghadames, desert (photo: O. Brogan, Society for Libyan Studies Archive); C: harvesting scene, Tabuniyah, pre-desert, UNESCO Libyan Valleys Survey Tb45 (photo: O. Brogan, Society for Libyan Studies Archive); D: person carrying basket, Ghadames, desert (photo: J. Nikolaus).*

Agricultural scenes are one of the most commonly repeated subjects on the mausolea of Ghirza. They appeared on six mausolea, representing up to 12 relief panels in total. The genre was broad and included the depiction of ploughing with camels and horses, reaping, clearing and tending the fields, sowing, basket carrying, threshing, winnowing, and grape harvesting.[100] Outside of Ghirza 22 reliefs depicted agricultural activities, of which 14 come from the pre-desert,[101] three from the coast,[102] three from the Gefara,[103] two from the Gebel,[104] and two from Ghadames in the desert. The scenes included the act of ploughing with horses, oxen or camels. The plough was driven by a person holding a stick in one hand and the plough in the other (Figure 15.4a). Less common is the process of harvesting, represented by a person cutting the wheat with a sickle: one from the Wadi Antar, and one from Ghadames (Figure 15.4b). A person carrying a basket on the shoulder is depicted at Tabuniyah (Figure 15.4c) and at Ghadames (Figure 15.4d). Other agricultural activities are represented by a figure climbing a palm tree to harvest dates in the Wadi Khanafes.

Like at Ghirza, the majority of figures that are actively involved in agriculture wear a short tunic and, in some cases, a belt. The ploughman at Ghirza South C, and possibly the reaper at Tabuniyah, wear longer garments that reach down to the ankles (Figure 15.4c).[105] The dress style in Ghadames is different to the rest of the Tripolitanian scenes; the workers appear to wear a two-piece garment consisting of a tunic and a skirt-like undergarment (Figures 15.4b and 15.4d).

Looking at the agricultural reliefs across Tripolitania in more detail shows that there was a regional distinction in type and style of carving. The reliefs from the Gefara display a more realistic style, arguably more akin to the art of the coastal cities. The outlines are precisely incised with deep grooves to increase their impact by manipulating light and shadow (Figure 15.4a).[106] The

[100] Brogan and Smith 1984: ploughing: North B (plate 64 a - b), North C (plate 77a), South C (plate 110a); sowing: North C (plate 82c); harvesting: North B (plate 66 a-c), North C (plate 79a); threshing: North B (plate 67a); tending the field: North B (plate 64a), North C (plate 79a), South C (plate 110a); cutting grapes: South F (plate 126b), South G (plate 128a).

[101] Mattingly 1996: Umm el-Agerem, 20, Ag002; Bir Scedua Basin, 55, Bs72; Khanafes, 152-153, Kn005; Mimoun, 211-213, Mm003; Tabuniyah, 301-302, Tb045.

[102] Gasr Duirat (Kenrick 2009, 135-136).

[103] El Ausaf, Tigi (Brogan 1964); Bou Guerba (Brogan 1964; Trousset 1974); Rogeban (Zenati 1995, 156).

[104] Roman-period reliefs from a mausoleum later integrated into a mosque at Buchar (Romanelli 1930, figures 13-14).

[105] Brogan and Smith 1984, plate 110a.

[106] Brogan 1964, 50.

Figure 15.5. *Different carving styles. A: camel and camel driver from mausoleum near Mizda, eastern Gebel (photo: O. Brogan, Society for Libyan Studies Archive); B: ploughing scene in high relief with multiple horizons, Wadi Khanafes, pre-desert, UNESCO Libyan Valleys Survey Kn5 (photo: UNESCO Libyan Valleys Survey, Society for Libyan Studies Archive).*

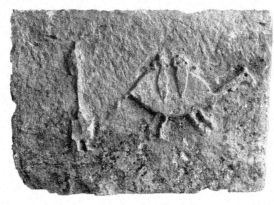 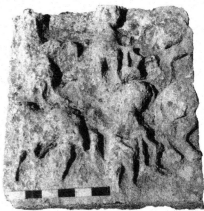

a b

closer proximity to the coastal cities probably influenced the choice of style. Some landowners resident in the city may have preferred to be buried on their country estate, and wanted a more 'classical' style to which they were more accustomed.

Artistic styles more akin to Punic art and Saturn stelae were present in the pre-desert, Ghadames, and the eastern Gebel.[107] Here, the body and head of the figures were out of proportion, and large almond-shaped eyes dominate the otherwise small facial features. Due to their schematic appearance, those images have often been reduced to represent a failed attempt to produce Roman art. It seems unlikely, however, that the elite of an entire region failed to produce anything remotely akin to classical art if this was their intention.

There is, of course, the question of the skill of the craftsmen, which must not be ignored. The commissioner may have had a more 'classical style' in mind, but he had to settle for the 'next best and closest artist available' while also considering cost.[108] Some of the pieces may have not been worked by professional sculptures, but amateurs.[109] This is, for instance, conceivable for the depiction of a camel at Mizda that was carved in a very haphazard way (Figure 15.5a). Nevertheless, it was still obvious what the stone depicted: a camel carrying two amphorae, followed by a figure, possibly the camel driver. It is, thus, conceivable that the message itself was more important than the skill of the craftsman.[110] Furthermore, the quality of the carving was influenced by the type of stone available. Soft stone is easier to carve while coarser stone produces a more impressionist effect.[111] Hence, different types of stones produced different results.[112] Indeed, many carvings do not equate to poor skills but appear to be a deliberate choice. Some depictions are carved in remarkably high relief and with great attention to detail such as the agricultural reliefs from the Wadi Antar (Figure 15.5b).

Although they are rather damaged and weathered, it is clear that a certain amount of skill was required to produce an image in such high relief. It appears that these more schematic depictions were deemed appropriate and, in fact, desired and fulfilled the expectation of the commissioner, the viewer and the artist in these areas. Seen against the background of the remote regions where figural art was rare,[113] it is more conceivable that this type of art was intentionally chosen to emphasize the link to ancestral traditions and to conform to local preferences. It is, however, questionable if the local population was aware of which artistic styles belonged to which culture.[114] By the time the mausolea were erected, what we know as Punic art was adapted and incorporated into local Libyan traditions, and would have been perceived as local art, or the art of the ancestors. To try to untangle which aspects of these reliefs belong to Punic or Libyan art is

[107] Di Vita 1964, 73-75; 1968.
[108] Johns 2003a, 16.
[109] Johns 2003a, 15; 2003b.
[110] Stewart 2010, 9.
[111] Johns 2003a, 15.
[112] Johns 2003a, 29; Russell 2013, 9.
[113] Stewart 2010.
[114] Stone 2007b, 138 argues this for first-millennium tombs in North Africa.

difficult, and becomes even more complex when we add the Roman and Hellenistic influences to the mix. In an incredibly creative and complex process, elements of ancestral, Hellenistic and Roman iconography were chosen, adapted and manipulated to suit the local setting. They reflect local needs and traditions in a manner and style the resident viewer could understand. This style of carving had a much larger impact than standardized classical art. The style was chosen because it reflected the local needs and traditions and it was deemed appropriate to display the elite's economic and political power over agriculture and water management, while, at the same time, the ancestral claim over the land was enhanced and maintained.

While the styles of carving display distinct regional differences and preferences, what they do have in common is a remarkable attention to detail in the rendering of agricultural activities.[115] These specific scenes carried a multitude of important messages: they underlined the importance of agricultural activities to the owner and to the community; they highlighted the wealth and achievements of the deceased (and the family) and they carried symbolic meanings. Amongst the North African elite, landholding was the main form of wealth. Funerary inscriptions and ancient texts from Tripolitania and Africa Proconsularis indicate that prestige and status was demonstrated by showing their involvement in rural investment, the development of land and the innovation in tools and crops.[116] The majority of agricultural scenes come from the rural areas and, in particular, from the pre-desert zone. Farming in these arid landscapes was particularly challenging, and required complex irrigation techniques. Furthermore, country life was an extremely popular scene on mosaics,[117] and the popularity of this image in the domestic sphere was perhaps transferred onto mausolea.

A further significance is represented by the symbolism that relates to agricultural scenes in a funerary context. They not only celebrated abundance and life, but they also celebrated death. They represented the circle of life, starting with the ploughing of the fields and ending with cutting the stalks of the ripe corn, so vividly depicted on the sequence of ploughing, sowing, harvesting and reaping on tomb North B at Ghirza.[118] The presence of a single agricultural scene on a mausoleum, such as ploughing or reaping, can be seen as an abbreviation of the full sequence.[119] Its meaning was well known amongst the viewers and, therefore, the representation of the whole agricultural circle was not necessary. Considering the high importance of ancestral worship in Tripolitania, the images may have also addressed future concerns by requesting the ancestors' help and protection for the continuation of prosperity and success of the family in the future.

The connections between agricultural scenes and the life/death cycle were made all over the Empire, from North Africa to Gaul and Britain. However, regional differences in the style of carving, clothing, and agricultural methods can be observed, which clearly reflect regional circumstances. For instance, ploughing with camels is a local reference and is not simply plucked from an Empire-wide image pool. Additionally, the heat of summer in North Africa required the reapers to wear light garments in the form of the short tunics,[120] which are depicted on almost all of the agricultural scenes of Tripolitania. A distinction of status amongst the workers can perhaps be made by considering the length of the garment.[121] The reaper at Tabuniyah and a ploughman at Ghirza wore longer tunics then the rest of the agricultural workers, representing the foremen who oversaw the work on the fields. The different style of garment of the agricultural workers at Ghadames, on the other hand, points towards the existence of regional traditions and preferences in dress and costume.[122]

[115] In his article about Ghirza, Zanker (2008, 217) remarks that he is unaware of any other funerary monuments in the Roman Empire that display agricultural activities in such a differentiated and detailed manner.

[116] See, for instance, Stone (1998) who investigates the funerary inscriptions of T. Flavius Secundus (*CIL* VIII, 212, 213), the harvester from Mactar (*CIL* VIII, 11824 = *ILS* 7457).

[117] Dunbabin 1978, 123.

[118] Shaw 2013, 162-163.

[119] Shaw 2013, 165.

[120] Shaw 2013, 37.

[121] Zanker 2008. See also Audley-Miller 2012 and Mattingly 1999 for status distinction in dress, with particular reference to Ghirza.

[122] Other funerary reliefs from Ghadames show a rather distinct preference in hairstyle, which is not found elsewhere in Tripolitania.

CONCLUDING REMARKS

The integration of Tripolitania into the Roman Empire in the mid-first century BC led to a profound change in elite funerary structures from cairns, cist burials and hypogea to substantial ashlar mausolea. By the fourth century AD, hundreds of mausolea stood across the Tripolitanian territory, forming an integral part of the funerary landscape. The mausolea were carefully placed within the landscape in highly visible positions, along major roadways, trade routes, major thoroughfares or land boundaries. They created an eternal resting place for future generations to visit. At the same time, these expensive and substantial burial monuments set the elite apart from the rest of the local community, which reinforced the existing gap between the elite and their local subjects.[123] By looking beyond Ghirza and by considering the variations of the numerous mausolea of Tripolitania, this overview demonstrates that the choice in architecture and decoration was not a random occurrence or a way to promote 'Roman-ness' by the Libyan elite. Instead, they reflect regional styles and preferences that developed out of cultural traditions that were influenced by the local and wider socio-political environment, as well as the geographical location. For the commissioner they were vehicles of self-representation and commemoration, while the ancestral links reflected a strong sense of identity, belonging and entitlement.

BIBLIOGRAPHY

Abdussaid, A. 1996. The restoration of the North Mausoleum of Wadi Nfed, *Libya Antiqua (New Series)*, 2: 73-78.

Abdussaid, A. 1998. Bir el-Uaar Mausoleum (Al-Urban, Djebel Garian), *Libya Antiqua (New Series)*, 4: 147-155.

Ahmed, A. 2010. *Rural Settlement and Economic Activity: Olive Oil and Amphorae Production on the Tarhuna Plateau during the Roman Period*, Unpublished PhD Thesis, University of Leicester.

Al Khadduri, A.E.1997. Wadi Sofeggin: Gasr al-Merkazant, *Libya Antiqua (New Series)*, 3: 220-223.

Audley-Miller, L. 2012. Dress to impress: the tomb sculpture of Ghirza in Tripolitania. In Caroll, M. and Wild, J.P. (eds), *Dressing the Dead in Classical Antiquity*, Stroud: Amberley Publishing, 99-114.

Barker, G. (ed.) 1996. *Farming the Desert. The UNESCO Libyan Valleys Archaeological Survey. Volume 1: Synthesis*, London: Society for Libyan Studies – Department of Antiquities.

Baratte, F. 2004. L'architecture funéraire en Afrique : identité locale ou manifeste de romanité ?. In Schmidt-Coliner, A. (ed.), *Lokale Idenditäten am Rande des Römischen Reiches. Akten des Internationalen Symposiums in Wiener Neustadt, 24.-26. April 2003*, Wien: Phoibos Verlag, 37-48.

Barth, H. 1857. *Travels and Discoveries in North and Central Africa*, London: Ward, Lock.

Ben Rabha, K.A. and Masturzo, N. 1997. Wadi al-Fani (Khoms): villa, mausoleum and gasr, *Libya Antiqua (New Series)*, 4: 214-216.

Bigi, F., Di Vita-Evrard, G., Fontana, S. and Schingo, G. 2009. The Mausoleum of Gasr Doga, *Libyan Studies*, 40: 25-46.

Brogan, O. 1964. The Roman remains in the Wadi el-Amud, *Libya Antiqua*, 1: 47-56.

Brogan, O. 1965. Henscir el-Ausâf by Tigi (Tripolitania), *Libya Antiqua*, 2: 47-56.

Brogan, O. 1970-1971. Expedition to Tripolitania, 1971, *Annual Report of the Society for Libyan Studies*, 2: 10-11.

Brogan, O. and Smith, D.J. 1984. *Ghirza. A Libyan Settlement in the Roman Period* (Libyan Antiquities Series, 1), Tripoli: Department of Antiquities.

Buck, D.J., Burns, J.R. and Mattingly D.J. 1983. Archaeological sites of the Bir Secuda Basin: settlements and cemeteries. In Jones, G.D.B and Barker, G., The UNESCO Libyan Valleys Survey IV: the 1981 season, 42-54, *Libyan Studies*, 14: 39-68.

Camps G. 1973. Nouvelles observations sur l'architecture et l'âge du Medracen, mausolée royal de Numidie, *Comptes rendus des séances de l'Académie des Inscriptions et Belles-Lettres*, 117: 470-517.

Clermont-Ganneau, C. 1903. Lepcis et Leptis Magna, *Comptes rendus des séances de l'Académie des Inscriptions et Belles Lettres*, 47: 333.

Coro, F. 1928. *Vestigia di colonie agricole romane. Gebel Nefusa*, Rome: Sindacato Italiano Arti Grafiche.

Cowper, H.S. 1896. Notes on a journey in Tarhuna and Gharian, Tripoli, *The Geographical Journal*, 7: 150-163.

Cowper, H.S. 1897. Further notes on the Tripoli Hill Range, *The Geographical Journal*, 9: 620-638.

[123] Stone 2007a, 139.

Di Vita, A. 1964. Il "limes" romano di Tripolitania, *Libya Antiqua*, 1: 65-98.

Di Vita, A. 1968. Influences grecques et tradition orientale dans l'art punique de Tripolitaine, *Mélanges d'Archéologie et d'Histoire de l'École Française de Rome*, 80: 7-83.

Di Vita A. 1976. Il mausoleo punico-ellenistico B di Sabratha, *Mitteilungen des Deutschen Archäologischen Instituts. Römische Abteilung*, 83: 273-285.

Di Vita, A. 2010. I mausolei punici di Sabratha e l'impianto urbano della città ellenistica: prodotti di un sincretismo culturale, *Bollettino di Archeologia Online*, Special Volume. Available at http://www.bollettinodiarcheologiaonline.beniculturali.it/documenti/generale/1_DiVITA.pdf [last accessed 21-05-2014].

Dunbabin, K.M.D. 1978. *The Mosaics of Roman North Africa: Studies in Iconography and Patronage*, Oxford: Clarendon Press.

Faraj, M., Asmia, M. and Al-Hadad, M. 1997. Tarhuna, Zwitina cave: hypogean tomb, *Libya Antiqua (New Series)*, 3: 217-218.

Ferchiou, N. 1989. Le mausolée de Q. Apuleus Maxssimus à El Amrouni, *Papers of the British School at Rome*, 57: 47-76.

Ferchiou, N. 2009. Recherches sur le mausolée hellénistique d'Hinshīr Būrgū. In Fentress, E., Drine A. and Holod, R. (eds), *An Island through Time: Jerba Studies, 1. The Punic and Roman Periods* (Journal of Roman Archaeology Supplement, 71), Portsmouth, RI: Journal of Roman Archaeology, 107-128.

Fontana, S. 1996. Le necropoli di Leptis Magna. Introduzione, *Libya Antiqua (New Series)*, 2: 79-84.

Fontana, S. 1997. Il predeserto tripolitano: mausolei e rappresentazione del potere, *Libya Antiqua (New Series)*, 3: 149-163.

Fontana, S. 2001. Leptis Magna. The Romanization of a major African city through burial evidence. In Key, S. and Terrenato, N. (eds), *Italy and the West: Comparative Issues in Romanization*, Oxford: Oxford University Press, 161-172.

Gentilucci, I. 1933. Resti di antichi edifici lungo l'uádi Sofeggin, *Africa Italiana*, 5: 172-187.

Goodchild, R.G. and Ward-Perkins, J.B. 1949. The limes tripolitanus in the light of recent discoveries, *Journal of Roman Studies*, 39: 81-95.

Haeussler, R. 2013. *Becoming Roman? Diverging Identities and Experiences in Ancient Northwest Italy* (Publications of the Institute of Archaeology, University College London, 57), London: Left Coast Press, Inc.

Hitchner, B. 1995. The culture of death and the invention of culture in Roman Africa, *Journal of Roman Archaeology*, 8: 493-498.

Johns, C. 2003a. Art, Romanisation and competence. In Scott, S. and Webster, J. (eds), *Roman Imperialism and Provincial Art*, Cambridge: Cambridge University Press, 9-23.

Johns, C. 2003b. Roman-British sculpture, intention and execution. In Noelke, P. (ed.), *Romanisation und Resistenz in Plastik, Architektur und Inschriften der Provinzen des Imperium Romanum. Neue Funde und Forschungen*, Mainz: Philipp von Zabern, 27-38.

Kenrick, P. 2009. *Libya Archaeological Guides. Tripolitania*, London: Silphium Press.

Levi Della Vida, G. 1951. The neo-Punic dedication of the Ammonium at Ras el-Haddagia, *Papers of the British School at Rome*, 19: 65-68.

Masturzo, N. 1997. Uadi er Rasaf: l'area nord, *Libya Antiqua (New Series)*, 3: 284-287.

Matoug, J.M. 1997. Gasr Legbeba (Wadi Lebda), *Libya Antiqua (New Series)*, 3: 211-214.

Mattingly, D.J. 1995. *Tripolitania*, London: Batsford.

Mattingly, D.J. 1996 (ed.). *Farming the Desert. The UNESCO Libyan Valleys Archaeological Survey. Volume 2: Gazetteer and Pottery*, London: Society for Libyan Studies – Department of Antiquities.

Mattingly, D.J. 1999. The art of the unexpected: Ghirza in the Libyan pre-desert. In Lancel, S. (ed.), *Numismatique, langues, écritures et arts du livre, spécificité des arts figurés. VIIᵉ colloque sur l'histoire et l'archéologie de l'Afrique du nord (Nice, 21 au 31 octobre 1996)*, Paris: Éditions du CTHS, 383-405.

Mattingly, D.J. 2003. Family values: art and power at Ghirza in the Libyan pre-desert. In Scott, S. and Webster, J. (eds), *Art and Imperialism*, Cambridge: Cambridge University Press, 153-170.

Mattingly, D.J. 2004. Olwen Brogan: from Gaul to Ghirza. In Joukowsky, M.S. and Lesko, B. (eds), *Breaking Ground: Women in Old World Archaeology*. Available at http://www.brown.edu/Research/Breaking_Ground/bios/Brogan_Olwen.pdf [last accessed 14/03/2014].

Mattingly, D.J. 2011. *Imperialism, Power, and Identity. Experiencing the Roman Empire*, Princeton: Princeton University Press.

Mattingly, D.J. and Dore, J. 1996. Romano-Libyan settlement. Typology and chronology. In Barker, G. (ed.), *Farming the Desert, the UNESO Libyan Valleys Archaeological Survey. Volume 1: Synthesis*, London: Society for Libyan Studies – Department of Antiquities, 111-158.

Mattingly, D.J. and Sterry, M. 2010. *Ghadames Archaeological Survey, Phase 1*, Unpublished Desk-top Report, University of Leicester.

Merighi, A. 1940. *La Tripolitania antica: dalle origini alla invasione degli arabi. Volume II*, Verbania: A. Airoldi Editore.

Moore, J.P. 2007. The mausoleum culture of Africa Proconsularis. In Stone, D.L. and Stirling, L.M. (eds), *Mortuary Landscapes of North Africa*, Toronto: University of Toronto Press, 75-109.

Munzi, M., Felici, F., Cifani, G., Cirelli, E., Gaudiosi, E., Lucarini, G. and Matug, J. 2004. A topographic research sample in the territory of Lepcis Magna: Silin, *Libyan Studies*, 35: 11-66.

Munzi, M., Felici, F., Cirelli, E., Schingo, G. and Zocchi, A. 2010. Il territorio di Leptis Magna: ricognizioni tra Ras el-Mergheb e Ras el-Hammam (2007). In Milanese, M., Ruggeri, P. and Vismara, C. (eds), *L'Africa Romana. I luoghi e le forme dei mestieri e della produzione nelle province africane. Atti del XVIII convegno di studio (Olbia, 11-14 dicembre 2008)*, Rome: Carocci, 723-746.

Musso, L. 2010. Missione archeologica dell'Università Roma Tre, 1998-2007, *Libya Antiqua (New Series)*, 5: 49-78.

Oates, D. 1953. The Tripolitanian Gebel: settlement of the Roman period around Gasr ed-Daun, *Papers of the British School at Rome*, 21: 81-117.

Pillinger, E. 2013. Inuenta est blandae rationis imago: visualizing the Mausoleum of the Flavii, *Transactions of the American Philological Association*, 143: 171-211.

Rae, E. 1877. *The Country of the Moors: A Journey from Tripoli in Barbary to the City of Kairwân*, London: J. Murray.

Romanelli, P. 1925. *Leptis Magna (Africana Italiana, 1)*, Rome: Società Editrice d'Arte Illustrata.

Romanelli, P. 1930. La vita agricola Tripolitana attraverso le rappresentazioni figurate, *Africa Italiana*, 3: 53-75.

Russell, B. 2013. *The Economics of the Roman Stone Trade* (Oxford Studies on the Roman Economy), Oxford: Oxford University Press.

Shaw, B. 2013. *Bringing in the Sheaves. Economy and Metaphor in the Roman World*, Toronto: University of Toronto Press.

Stewart, P. 2010. Geographies of provincialism in Roman sculpture, *RIHA Journal*, 0005: 1-32. Available at http://www.riha-journal.org/articles/2010/stewart-geographies-of-provincialism [Accessed on 03/03/2014].

Stone, D.L. 1998. Culture and investment in the rural landscape: the North African bonus agricola, *Antiquités Africaines*, 34: 103-113.

Stone, D.L. 2007a. Burial, identity and local culture in North Africa. In van Dommelen, P. and Terrenato, N. (eds), *Articulating Local Cultures: Power and Identity under the Expanding Roman Republic* (Journal of Roman Archaeology Supplement, 63), Portsmouth, RI: Journal of Roman Archaeology, 126-144.

Stone, D.L. 2007b. First millennium B.C.E. rock-cut tombs of North Africa. In Stone, D.L. and Stirling, L.M. (eds), *Mortuary Landscapes of North Africa*, Toronto: University of Toronto Press, 43-74.

Squarciapino, M.F. 1966. *Leptis Magna*, Basel: Raggi Verlag.

Toynbee, J.M.C. 1971. *Death and Burial in the Roman World*, Baltimore: John Hopkins University Press.

Trousset, P. 1974. *Recherches sur le limes tripolitanus, du chott El-Djerid à la frontière tuniso-libyenne*, Paris: Éditions du CNRS.

Von Hesberg, H. 1992. *Römische Grabbauten*, Darmstadt: Wissenschaftliche Buchgesellschaft.

Zanker, P. 2008. Selbstdarstellung am Rand der Libyschen Wüste. Die Reliefs an den Häuplings-Mausoleen in der Nordnekropole von Ghirza. In Prison, F. and Wuf-Rheidt, U. (eds), *Austausch und Inspiration. Kulturkontakt als Impuls Achitektonischer Innovation*, Mainz: Philipp von Zabern, 214-226.

Zenati, M. 1995. Archaeological news, Department of Antiquities, Sabratha, *Libya Antiqua (New Series)*, 1: 156-157.

Zenati, M. 1997. Gasr al-Ajbar, *Libya Antiqua (New Series)*, 3: 224-225.

Zimmer, G. 1981. Ghirza, Grenzsiedlung am Limes Tripolitanus, *AntikeWelt*, 12: 3-10.

16

ARCHITECTURAL DECORATION AT SALA (CHELLAH) AND IN MAURETANIA TINGITANA
PUNIC-HELLENISTIC LEGACIES, ROMAN OFFICIAL ART, AND LOCAL MOTIFS

Niccolò Mugnai

Abstract

In this paper I present some observations on a select sample of architectural decoration recorded during recent field research at Sala (Chellah, Morocco). The interrelation of different artistic traditions across the late Mauretanian and Roman eras is well reflected in the motifs adopted at this site, and in Mauretania Tingitana as a whole. The persistence of pre-Roman legacies is documented by Ionic capitals of Punic-Hellenistic tradition and Egyptian gorge cornices. At the same time, contacts with the art of the Empire are confirmed by the importation of marble Asiatic Corinthian capitals. Locally-made capitals either reproduce a simplified version of the Romano-Carthaginian models, or feature a mixture of official art and reworked motifs. Further local creations, such as pseudo-lotus capitals or Corinthian capitals with three calyces, represent peculiar types of decoration that find no parallels outside Tingitana.

INTRODUCTION

The study of architectural decoration can provide important information beyond the mere recognition of the artistic features of single architectural elements – bases, capitals, or entablatures. The choice of a specific motif was determined by several factors: the historical dynamics that led to the introduction of a particular style; the geographic location of the territory examined; the encounter of different decorative traditions; and the stonemasons' background and know-how. Ultimately, architectural decoration provides a glimpse into the social and cultural aspects of the society that adopted it. This contribution focuses on these features, looking at the decoration from a peripheral context of the Roman world: the province of Mauretania Tingitana (northern Morocco). Various points of the discussion will also offer a moment of reflection on the potential and shortcomings of using stylistic criteria for the study and dating of provincial architectural decoration.

The evidence collected here corresponds to a select group of ornament from Sala (Chellah, Rabat), particularly significant for evaluating the different stylistic trends and their interrelations within this site, and at a broader provincial level. The majority of these architectural elements are unpublished, and they were recorded for the first time during recent field research.[1] The analysis

[1] This research is part of a PhD project undertaken at the University of Leicester, which involves also the study of the decoration from Lixus, Banasa, and Volubilis. Fieldwork at Sala was carried out mainly in September 2011, funded by the 'Borsa di Studio Daniela Fusaro'. I would very much like to thank Irene, Elvio and Alessandro Fusaro for their kind support; this paper is dedicated to Daniela. Further financial assistance for the subsequent fieldwork seasons (2012-2014) was provided by the Society for Libyan Studies and the Society for the Promotion of Roman Studies. I am grateful to Emanuele Papi and Aomar Akerraz for their help in obtaining the required permissions from the Moroccan Ministry of Culture. Many thanks also to Abdelkader Chergui, curator of the site of Chellah, and to all his supportive staff. Finally, thanks to Patrizio Pensabene, Stefano Camporeale, Janet DeLaine, and David Mattingly for all their useful observations and suggestions.

will also look at parallels identified at other Moroccan sites and across North Africa. The time frame selected spans from the late first century BC to the second century AD, encompassing the late Mauretanian era, the client kingdoms of Juba II and Ptolemy, and the Roman provincial period.

The paper opens with a brief overview of the research undertaken at Sala until the present, together with an outline of the monumental district where the architectural elements are preserved. The discussion is then divided into three sections, each dealing with different groups of architectural decoration: pre-Roman (Mauretanian) ornament; Roman official art and decoration influenced by official models; and local decoration featuring very specific, provincial motifs. The final section summarizes the main characteristics of each group, providing a synthesis of the preliminary results.

ARCHAEOLOGICAL RESEARCH AT SALA: A BRIEF CHRONICLE

One of the most fascinating sites of Morocco, Sala is located on the hill of Chellah, just outside the gate of Bab Zaër in the south-east portion of the Almohad walls of Rabat. The hill is not far from the oued Bou Regreg, the ancient river Salat from which the Roman settlement took its name.[2] The ruins of the Mauretanian/Roman town (Figure 16.1) are found inside the majestic ribat built by the Marinid dynasty in the fourteenth century, which encloses a royal cemetery and a mosque with oratory, medersa and hammam.[3]

Sala was identified in the late nineteenth century by the French geographer Charles Tissot,[4] while the first excavations were undertaken during the French Protectorate in 1929-30. The works started after the mosque and minaret were reclaimed from the vegetation, under the direction of Jules Borély, head of the Service des Beaux-Arts. A large portion of the monumental district was unearthed: the so-called 'basilica/curia Ulpia'[5] and the underground nymphaeum set in the middle of the complex; the arch with three fornices; and the pseudo-isodomic masonry building directly behind it.[6] Regrettably, Borély did not leave any notes regarding the work undertaken, and a brief description of these discoveries can be drawn only from Louis Chatelain's later account.[7]

After the end of the Protectorate, excavations at Sala were resumed in 1958 thanks to Maurice Euzennat, head of the Service des Antiquités du Maroc, who appointed Jean Boube as director of the operations. The works focused on the rest of the monumental district, bringing to light all the buildings observable today, and on the Roman cemeteries outside the ribat of Chellah. The excavations were carried out during various seasons until 1996. Unfortunately, only the results of the research in the cemeteries have been published as a monograph,[8] while we must look at various reports, short articles and other miscellaneous contributions for information on the monumental district.[9] The public buildings excavated by Boube consist of: the forum area at the north-east end of the sector, with 'temple A' on its upper terrace; the putative 'temple B' and 'temple C'; the foundations of 'building D'; the baths; the *Capitolium* – with the temple and portico on the upper level, and nine vaulted chambers (*tabernae?*) on the lower level. The urban layout of the district is the outcome of transformations that took place mainly from the first century BC until the second century AD.

Finally, more research has been undertaken by the University of Siena in recent years. In particular, the analysis of building techniques carried out by Stefano Camporeale (also extended to Thamusida and Banasa) has provided new data to revise and/or refine some of Boube's old

[2] Pliny, *Historia Naturalis*, V.5: '*oppidum Sala, eiusdem nominis fluvio inpositum*'; V.13: '*indigenae tamen tradunt in ora ab Salat CL flumen Asanam*'.
[3] On the Islamic complex see Basset and Lévi-Provençal 1922a-b.
[4] Tissot 1878, 231-235. This identification had been previously suggested by F. Freihern von Augustin, H. Barth, and V. de Saint-Martin: see Boube 1999, 19.
[5] The identification of this building as a *curia* has been questioned by Balty 1991, 226.
[6] This edifice – later renamed 'building F' (Boube 1999, 17) – had been initially interpreted as a *Capitolium* (see Chatelain 1944, 88-91), until the real temple was discovered in 1960.
[7] Chatelain 1944, 81-101.
[8] Split in two volumes: Boube 1977 (plates); 1999 (main text).
[9] In particular Boube 1962; 1966a; 1967, *passim*; 1990a-b; 1999, 13-20. Other short fieldwork reports can be found in the chronicles of the *Bulletin d'Archéologie Marocaine*.

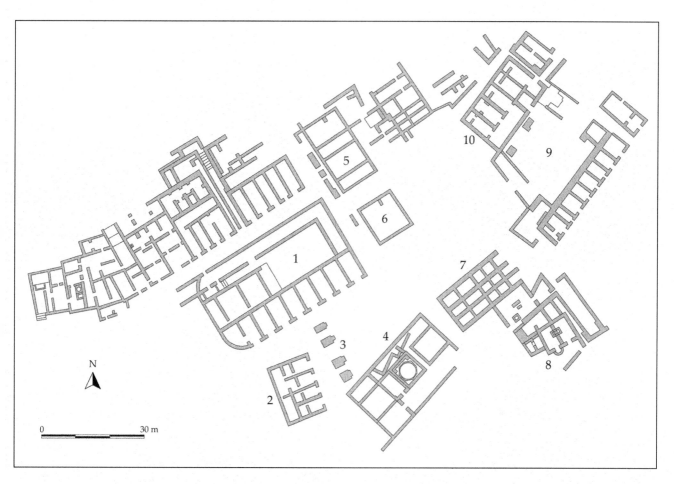

Figure 16.1. *Plan of Sala's monumental district. 1:* Capitolium*; 2: 'building F'; 3: arch; 4: 'basilica/*curia Ulpia*'; 5: 'temple B'; 6: 'temple C'; 7: 'building D'; 8: baths; 9: forum; 10: 'temple A' (after Ammar 2008, figure 1).*

hypotheses.[10] The overview of Sala's architectural decoration presented in this paper, as well as the broader project on the ornament from Tingitana, have benefited greatly from the results of this latter research.

PRE-ROMAN ARCHITECTURAL DECORATION AND ITS LEGACY

Examples of early architectural decoration – all made of local calcarenite – have been recovered at Sala, probably dating to between the late Mauretanian era and the reign of Juba II and Ptolemy. However, some remarks on this chronology must be advanced here. These pieces are in the forum area, which develops on three terraces (Figure 16.2): the lower level features a building with nine *tabernae* opening on the street; the middle terrace corresponds to a trapezoidal, paved piazza; the upper terrace is occupied by 'temple A', connected through a staircase with the piazza underneath. The main building phase of this complex is dated to between the end of the first century AD and the beginning of the second century,[11] although later restorations might be identifiable as well.[12]

A first group of architectural elements is now positioned on the ground at the south-west limit of the piazza. One piece is a Tuscan column capital (Figure 16.3a),[13] recovered during the excavation of some mud-brick structures obliterated by the *tabernae* and the piazza in the Roman period. This 'sealed' stratigraphic context reassures us on the reliability of the capital's dating to around the latter half of the first century BC, as suggested by Boube.[14] The capital has a simple design: the echinus is shaped as a reversed quarter-round, underlined by a fillet and crowned

[10] I would like to thank Stefano Camporeale for allowing me to use some data from his PhD thesis (2004-2005), which will soon be published as a monograph.

[11] Boube 1990b; 1999, 17; Camporeale 2004-2005, 239; Euzennat and Hallier 1986, 89.

[12] Two inscriptions, dated respectively to the reign of Constantine and Constantine II (?), were found in the forum (*IAM2* 304b, 305). The existence of later building phases is based on a pers. comm. by Stefano Camporeale.

[13] Boube 1967, 322-324, plate 18.2-3, figures 8b, 9; Jodin 1977, 306-307, figure 3.

[14] Boube 1967, 310-311: the chronology is confirmed by the associated pottery and coins.

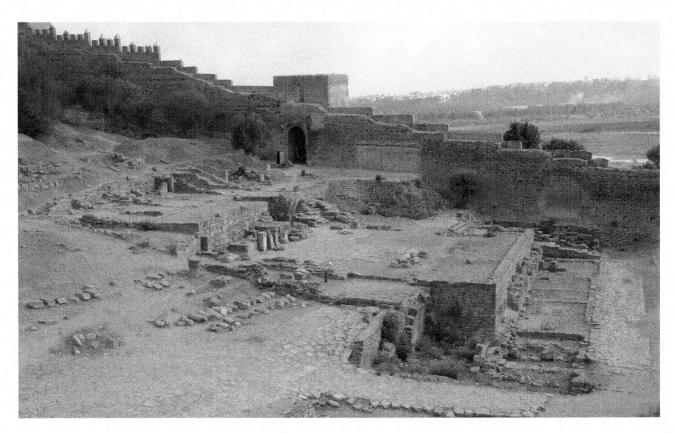

Figure 16.2. *Sala: view of the forum area (photo: S. Camporeale).*

by a square abacus, with some traces of stucco preserved on the surface. Similar examples are known in Morocco: one isolated capital was found on the island of Mogador, probably associated with a villa dated to the reign of Juba II;[15] other capitals come from various buildings at Volubilis, dated (more arbitrarily) to this same period.[16] A last group of capitals can be found at Lixus in the 'quartier des temples', seemingly belonging to the portico of 'temple F', the construction of which should be dated in the second half of the first century AD.[17]

A second Tuscan column capital (Figure 16.3b) – or single-torus base? – can be found next to the previous piece. Regrettably, we have no information about its provenance, although we cannot discard that it might belong to the same context. In this case the echinus has a torus profile, underlined by a cavetto at the bottom. The diffusion of this type of torus-shaped capital was already documented in Tunisia,[18] and other similar examples are known, for instance, at Caesarea of Mauretania[19] and Lepcis Magna,[20] with dates spanning from the first to the second century AD. This quite broad chronological range is also confirmed by the parallels in Tingitana. Capitals or bases with identical profiles can be seen in the forum at Banasa, although they are not *in situ* (Figure 16.4a). This complex was wholly rebuilt and enlarged in the early second century AD;[21] however, these elements might even be isolated surviving elements from the earlier forum of the colony (approximately dating to the second half of the first century BC).[22] Some examples from Volubilis, scattered on the ground outside the north side of the basilica, would appear to be later in date. They are made of the local Zerhoun limestone, whose quarrying is generally acknowledged to have started in the second half of the first century AD, becoming intensively exploited in the second and third centuries.[23]

[15] Jodin 1977, 304-305, figures 2, 3.

[16] Boube 1967, 324, plate 18, figure 1; Jodin 1977, 307-309, figure 4; 1987, 95, figure 8a-c.

[17] Brouquier-Reddé *et al.* 2008, 134-136, with further bibliography.

[18] Ferchiou 1989, 75, plate 12, no. III.V.19a-b; Lézine 1955, 14-15, plate 1.

[19] Pensabene 1982, 50-51, plates 45-46, nos 138-139.

[20] Mahler 2006, 171, plate 49, no. 220 TK.

[21] Arharbi *et al.* 2001, 149; Brouquier-Reddé *et al.* 2004, 1891-1896.

[22] If we accept their identification as capitals rather than bases, we should not discard the possibility that they could belong to the second-century building phase.

[23] See Jodin 1968-1972, 133, with references to previous works on the petrography of Volubilis.

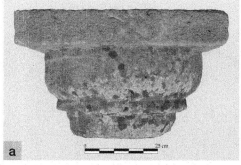 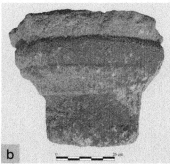 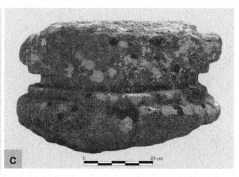

The last piece of the group is an Attic column base without plinth (Figure 16.3c), which belonged to the pre-Roman constructions underneath the forum, according to Boube's account.[24] The base has two tori of the same diameter, separated through a shallow square-cut moulding (replacing the more traditional scotia). Attic bases without plinth in North Africa were described as a typical pre-Imperial decoration by Lézine,[25] and this assumption has been accepted – often uncritically – afterwards. The particular type from Sala, with both tori having the same diameter, is quite common in Morocco (for instance at Lixus, Cotta, Banasa, and Volubilis). Jodin created the label of 'bases-trochlées' for these elements, regarding them as a recurring feature of the pre-provincial era.[26] However, one must remark that such bases are commonly associated with Roman-period buildings as well. At Banasa, for instance, they can be seen in the colonnades of the forum (Figure 16.4b), dating to the early second century AD (see above). In addition, more examples *in situ* are known at Volubilis (Figure 16.4c): on the inner pilasters of the basilica (probably dating to the early third century AD),[27] in the piazza of the *Capitolium* (c. AD 217),[28] and in various rooms of the Palace of Gordianus (rebuilt in AD 238-241),[29] to cite a few examples. Therefore, one must conclude that Attic bases without plinth were surely adopted in Morocco during the Mauretanian period, as Sala's stratigraphy would confirm.[30] However, evidence also shows that this decoration was not abandoned in the Imperial era, since its use was protracted up to the mid-third century.

The second group of architectural elements is composed of two Ionic half-column capitals (Figure 16.5a)[31] and eight blocks of an Egyptian gorge cornice (Figure 16.5b),[32] found at the base of 'temple A'. It seems reasonable to agree with Boube that the ornament belonged to this building, although its dating is debated. Boube suggested that it should be interpreted as a

Figure 16.3. *Sala: architectural decoration from the layers underneath the forum. A-B: Tuscan capitals; C: Attic base without plinth (photos: N. Mugnai).*

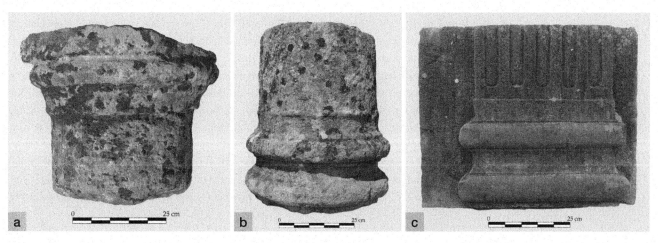

Figure 16.4. *Banasa and Volubilis: architectural decoration. A: Tuscan capital (Banasa, forum); B: Attic base without plinth (Banasa, forum); C: Attic base without plinth (Volubilis, Palace of Gordianus) (photos: N. Mugnai).*

[24] Boube 1967, 322, figure 11a.

[25] Lézine 1960, 93-96.

[26] Jodin 1987, 97-104.

[27] No inscription recording the basilica's inauguration date is preserved. However, it is generally accepted that the construction of this building was part of the works carried out under the Severans to enhance Volubilis' monumental district, together with the arch of Caracalla (AD 216/217) and the *Capitolium* (AD 217).

[28] The *Capitolium* was dedicated to Macrinus between April and December 217: see *IAM2* 355.

[29] *IAM2* 404.

[30] A pre-Roman dating is also likely for the examples from Lixus and Cotta.

[31] Boube 1967, 318-320, figure 5.

[32] Boube 1967, 326-330, plate 19.1-2, figure 8a.

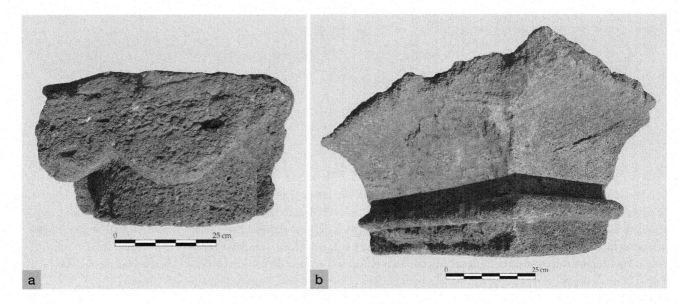

Figure 16.5. *Sala: architectural decoration of 'temple A'. A: Ionic capital of Punic-Hellenistic tradition; B: Egyptian gorge cornice (photos: N. Mugnai).*

sanctuary built around the mid-first century BC and later dedicated to the royal family of Juba II and Ptolemy.[33] According to this hypothesis, the temple would be the most ancient building in the forum. In contrast, Euzennat and Hallier rejected this chronology, arguing that the piazza and the temple were both Roman constructions of the same phase (end of the first to early second century AD).[34] It is not easy to reach a consensus, but a survey of the temple's building techniques carried out by Camporeale seems to confirm that a Mauretanian phase does exist, followed by later re-arrangements.[35]

The architectural decoration recovered could date to this early phase, judging by its stylistic features. However, a closer analysis reveals that these pre-Roman motifs survived in the Roman era. The two Ionic capitals are both undecorated, showing a flat echinus with circular volutes at the sides. The echinus and the volutes' channel are fused together – and there is no marked distinction with the upper abacus on the frontal face. The lateral *pulvini* are shaped as simple cones without any *balteus*. They were covered with stucco, of which only a few traces survive, and there is reason to believe that the volutes' spirals and the echinus' decoration were originally painted. These capitals belong to the series of Ionic capitals of Punic-Hellenistic tradition described by Lézine,[36] which also appear to show influences from the Italic-Ionic style.[37] The series is documented elsewhere in Morocco. A small, fragmentary capital was found at Volubilis, perhaps coming from the layers under the Roman forum and datable to the reign of Juba II.[38] Two more capitals come from Lixus, both featuring a circular button in the middle of the echinus, perhaps datable to within the first century AD. The first was recovered in the 'maison de Mars et Rhéa',[39] while the second capital comes from the 'quartier des temples' and might belong to one of the annexes of 'temple F'.[40] Looking at the rest of North Africa, one can easily realize that this Punic-Hellenistic legacy survived for a long period, overlapping with the influence of Rome. One of the earliest known examples comes from the mausoleum of Siga, dated to the first half of the second century BC.[41] An isolated capital recovered at Tacape might date from the end of the first century BC to the early first century AD.[42] The Ionic capitals of the 'Tombeau de la Chrétienne' may belong to the period of Juba II, although the

[33] Boube 1967, 320, 328-330, 348-352; 1990b; 1999, 16.

[34] Euzennat and Hallier 1986, 89.

[35] The existence of a pre-Roman phase would be confirmed by the absence of mortar in the temple's perimeter wall (pers. comm. by Stefano Camporeale). It is acknowledged that building techniques involving an intensive use of this material were introduced in Tingitana during the provincial era: see Camporeale 2008, 141-144, with further bibliography.

[36] Lézine 1960, 73-80.

[37] Batino 2006, 171-177.

[38] Boube 1966b.

[39] Tarradell 1959, 78, plate 40.

[40] Ponsich 1981, 62, plate 22.

[41] Rakob 1979, 149-154, figure 77.

[42] Ferchiou 1989, 140-141, 171, plate 32a, no. V.VIII.E.1.

chronology of this mausoleum is not certain.[43] The capitals found at Lepcis Magna are dated from the second half of the first century BC to the mid-first century AD,[44] while those from Gigthis may date to the late second – early third century AD.[45] Finally, the continuity of this Punic-Hellenistic tradition can be recognized in the Ionic capitals of 'Tomb North A' at Ghirza, seemingly built in the third century AD, if not even later.[46]

The Egyptian gorge cornice is provided with a large projecting cavetto, underlined by a square-cut moulding, a torus, and a fascia at the bottom. A thick layer of stucco is visible on some blocks. Again, parallels can be found elsewhere in Morocco: three blocks from Volubilis, perhaps attributed to (unidentified) pre-Roman temples;[47] one block from Lixus, recovered in a room of the so-called 'cámaras Montalbán', dated to the Augustan era;[48] and a last element from Cotta, reused in the wall of a small Roman temple.[49] The chronology of these cornices would support a date towards the late Mauretanian/Juba II period for the cornice from Sala, together with the Ionic capitals attributed to the same entablature. However, one must be cautious before drawing any definitive conclusions. When considering the other evidence from North Africa, a clear evolution and chronology of this type of cornice is difficult to assess,[50] and its use persisted in the Roman period.[51]

ROMAN-PERIOD DECORATION AND THE IMPACT OF ROMAN OFFICIAL ART

The urban layout of Sala witnessed major transformations starting from the end of the first century AD and culminating in the second century. This coincided with the peak of Roman influence in Mauretania Tingitana and North Africa. A large paved space developed in the western part of the district, flanked by public buildings: the 'basilica/curia Ulpia' on the south-west side and the Capitolium on the opposite side, with the arch set in the middle (Figure 16.6). Among the other buildings attributed to this phase are the baths near the forum, and a series of adjoining constructions (perhaps used for commercial activities) along the street on the upper level of the Capitolium.[52] It goes without saying that such an intensive building programme involved a large demand for architectural decoration.

The ornament of the Capitolium is discussed in more detail here.[53] It forms a homogeneous group with that of the 'basilica/curia Ulpia', to which the same considerations apply. In addition, the construction of the temple can be dated by fragments of the dedicatory inscription,[54] and through other epigraphic evidence.[55] The analysis of these data led Boube to suggest that the inauguration took place at the beginning of Hadrian's reign, c. AD 120.[56] On the upper level, the foundations and part of the podium are preserved, surrounded by a portico on three sides. The material used for the architectural decoration was, again, the local calcarenite.[57] Four Corinthian capitals with smooth leaves can be attributed to the colonnade of the portico, but are now located on the ground. All of them belong to the same type, although two variants can be recognized. The first variant (Figure 16.7a) is represented by three examples. The capitals feature two tiers of

[43] Christofle 1951, 21, figures 8-9. Rakob (1979, 142) suggested an earlier dating towards the first half of the first century BC.

[44] Mahler 2006, 63, 164-165, nos 161-166 IdK.

[45] Constans 1916, 111-112, figure 1. See also Lézine 1960, 76-77, figure 39, who does not discard the possibility that these could be recycled materials.

[46] Brogan and Smith 1984, 121-125, 209-210, plates 47-48.

[47] Jodin 1987, 103, plate 9, figure 1.

[48] Aranegui Gascó 2008, 47, figure 8.

[49] Ponsich 1970, 211, figure 56.2.

[50] Lézine 1960, 97-101.

[51] Fantar 1984, 458, note 117.

[52] Boube 1966a, 27; 1990b; 1999, 17-18; Camporeale 2004-2005, 239-240.

[53] The building techniques and a 3D reconstruction of the Capitolium are presented by Camporeale in this volume.

[54] IAM2 Suppl. 861.

[55] IAM2 Suppl. 859, 860.

[56] Boube 1990a, 240: the Capitolium was built and donated to the citizens of Sala by the prefect C. Hosidius Severus.

[57] The inner face of the perimeter wall was decorated with white marble slabs, a few fragments of which are still preserved.

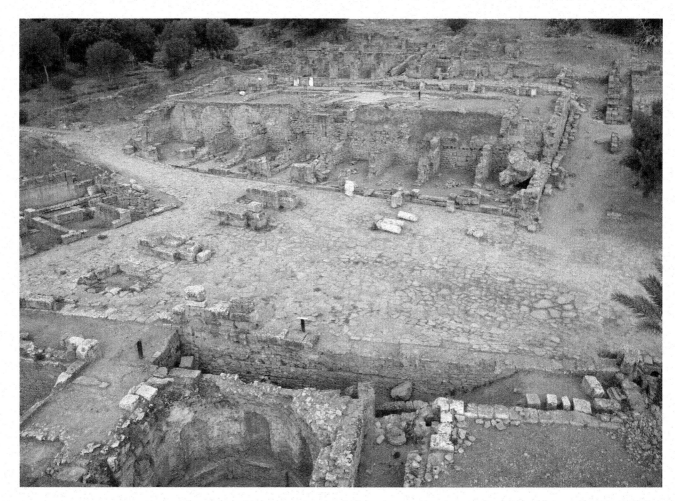

Figure 16.6. *Sala: view of the* Capitolium, *arch, and* 'basilica/curia Ulpia' *(photo: S. Camporeale).*

eight leaves, developing around the kalathos. Each leaf has a single, protruding lobe. The cauliculi are long and vertical, highlighted by a rounded collar at the top. Calyces, helices and volutes are smooth and undecorated. The upper abacus is composed of two strings of fillets, replacing the canonical cavetto and ovolo mouldings. Both the central calyx and the fleuron stem were omitted. One of these capitals shows traces of stucco on its surface. The second variant (Figure 16.7b) is represented by a single capital that is almost identical to the previous ones, were it not for the double collar at the top of the cauliculi. These capitals were associated with as many Attic bases (Figure 16.7c)[58] showing standard characteristics: square plinth, lower torus, scotia, and upper torus with a smaller diameter.[59] The same type of capital is documented by other examples: three small column capitals, of uncertain provenance, now positioned close to the portico of the *Capitolium*; two pilaster capitals of different size outside the *Capitolium*, the smaller of which perhaps belonged to one of the pilasters decorating the front of the *tabernae*; and two capitals carved on a block with attached half-column and pilaster, repositioned *in situ* at the north-east corner of the 'basilica/curia Ulpia'.

Similar capitals can be found elsewhere in Tingitana – especially at Banasa, where various pieces (with some variations in the carving) are scattered across the site. Corinthian and composite capitals with smooth leaves were largely diffused in North Africa and across the Mediterranean, made either of marble or locally-quarried stones. They were the result of an intermediate stage of workmanship of the orthodox second-century capitals, and became an autonomous decoration in the late second to early third century AD.[60] The simplification of the carving, especially the schematization of the abacus and the absence of the central calyx and fleuron stem, would normally indicate a later chronology. This is true, for instance, for a series of limestone

[58] Three bases are still *in situ* on the stylobate of the portico; the fourth base has been repositioned next to the others.
[59] Analogous bases can be observed on the front of the *tabernae*, on the central fornix of the arch, and along the façade of the 'basilica/curia Ulpia', with only minor variations of their mouldings.
[60] Pensabene 1986, 387.

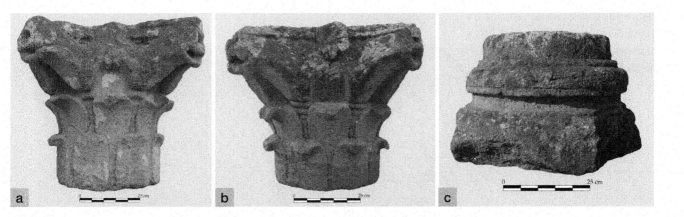

capitals from Caesarea (approximately dating to the end of the second to late third century AD), produced by local stonemasons when the Luna marble, the decorative motifs, and the carving techniques diffused during the period of Juba II were no longer in use.[61] On the other hand, the pieces from the *Capitolium* and the 'basilica/*curia Ulpia*' at Sala – that find a close parallel in one of these capitals from Caesarea[62] – would suggest that the simplifications described above were already introduced in the early second century. For this reason, stylistic criteria alone could be misleading when dating capitals with smooth leaves. In this case the provenance context proves to be the most reliable indicator of chronology.

Another architectural element from Sala that deserves attention is a small column capital, made of white limestone, currently kept in the storehouse (Figure 16.8a). Its provenance is, unfortunately, unknown. The upper part of the kalathos is damaged; the helices, volutes and abacus are not preserved. The leaves are flattened and show the typical features of the western, second-century acanthus *mollis*: they are divided in five lobes, separated through small, drop-shaped eyelets in vertical position. The mid-rib is represented by two vertical channels narrowing towards the top, flanked by two additional channels at the sides. The cauliculi run vertically, with fluted stems and highlighted by a thin collar. A central calyx, shaped as a triangular leaf or tongue, springs from the top of the second tier's frontal leaf. This isolated find is quite similar to other half-column and pilaster capitals from the 'maison à la mosaïque de Vénus' at Banasa (Figure 16.8b), built before the end of the second century AD.[63] This latter group, made of calcarenite, is characterized by a large astragal at the bottom of the kalathos, decorated with an Ionic *kymation* – an element not preserved, or, more likely, absent in the capital from Sala. The presence

Figure 16.7. *Sala: architectural decoration from the portico of the* Capitolium. *A-B: Corinthian capitals with smooth leaves; C: Attic base (photos: N. Mugnai).*

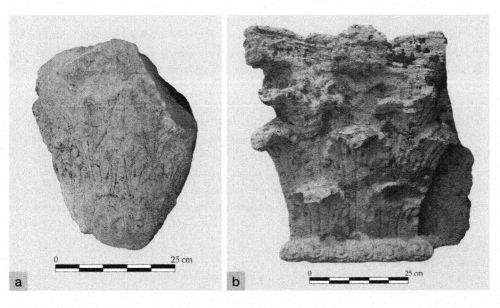

Figure 16.8. *Corinthian capitals with acanthus* mollis. *A: Sala (storehouse); B: Banasa ('maison à la mosaïque de Vénus') (photos: N. Mugnai).*

[61] Pensabene 1982, 57-59, 73, plates 54-55, nos 162-167.

[62] Pensabene 1982, 58, plate 55, no. 164.

[63] Arharbi *et al.* 2001, 148-149; Camporeale 2004-2005, 203.

Figure 16.9. *Sala: marble Asiatic Corinthian capitals. A:* tabernae *under the* Capitolium; *B-C: storehouse (photos: N. Mugnai).*

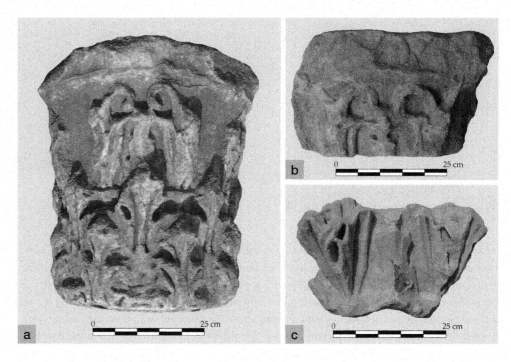

of flattened leaves with their ribs taking the form of vertical channels, combined with drop-shaped, vertical eyelets, are all elements that clearly recall Roman official decoration style. As we know, these Corinthian and composite capitals, which revived the late Flavian motifs developed at Rome,[64] were first adopted at Carthage. Afterwards, the city acted as a promoter of Roman art (and propaganda), contributing to the diffusion of this decoration in North Africa throughout the whole of the second century.[65] In this context, the stonemasons who carved the capital from Sala and those from the 'maison à la mosaïque de Vénus' at Banasa were surely influenced by the Romano-Carthaginian models. Nevertheless, their decorative style was not just a mere imitation of Roman productions, since it allowed for the presence of local reworking: this helps to explain the presence of the decorated astragal in the capitals from Banasa.

In contrast, a faithful adhesion to the official models diffused across the Empire is evident when one looks at architectural elements imported from the production centres as finished products. Such is the case of three marble column capitals from Sala. One is placed inside a *taberna* under the *Capitolium* (Figure 16.9a), although its original setting is unknown; two other fragmentary pieces are in the storehouse (Figure 16.9b-c). These capitals belong to the Asiatic Corinthian type with prickly acanthus, and are probably made of Proconnesian marble.[66] The leaves of the lower tier have five lobes; in those of the upper tier only three lobes are carved, separated by arched, drop-shaped eyelets. Two deep channels form the mid-rib of the upper leaves, covering only their upper half and leaving the portion underneath undecorated. The cauliculi are reduced to small triangular protuberances. The calyces are well-developed in height, while the helices are quite schematic. A central calyx, taking the form of a long leaf with five lobes, is visible.

These decorative features were adopted in Asia Minor in the late Flavian period, as the evidence from Ephesos shows,[67] and this tradition persisted also during Trajan's reign.[68] With regard to North Africa, the same characteristics are evident in some capitals from the Hadrianic baths (AD 137)[69] and from the temple of Rome and Augustus (mid-second-century restoration)[70] at Lepcis Magna. Although the context of provenance is unknown, a dating to within the Hadrianic period is also acceptable for the capitals at Sala. This latter group is significant because it adds information on the

[64] Pensabene 1973, 217-218, with further bibliography.
[65] Pensabene 1986, 364-373, 377-378; 1989, 432.
[66] Based on a preliminary observation of the marble macroscopic characteristics, which will need to be confirmed by archaeometric analyses.
[67] Vandeput 1997, 135, plate 84.1, with further bibliography.
[68] Vandeput 1997, 171, plate 94.3.
[69] Bianchi 2009, 49-51, figure 2a-f.
[70] Pensabene 2001, 68-69, figure 17.

presence of marble in Tingitana. A few isolated finds of marble architectural decoration come from Lixus and Tingi, while no such evidence exists in the hinterland (at Banasa, Thamusida, Zilil, or Volubilis). Sala appears to be rather exceptional, since more architectural elements made of white marble – capitals, bases, and mouldings – can be found in the storehouse, together with numerous fragments of small cornices of coloured marbles.[71] It is also worth observing that Asiatic-style decoration was widely spread across North Africa from the Severan era onwards. Corinthian capitals like those from Sala, which surely predated the mass-produced Severan ornament, have been occasionally recorded in Tripolitania (at Lepcis Magna and Sabratha), while in the rest of Africa Proconsularis the Romano-Carthaginian model was much more popular in this earlier period.[72]

LOCAL STYLES AND DECORATIVE MOTIFS: A 'PARALLEL' PRODUCTION

While the adoption of decoration inspired by Roman official models is definitely recognizable in second-century Sala (and Tingitana), one must be careful not to conclude hastily that this made a *tabula rasa* of local traditions. Some of the evidence presented above demonstrates that variation and reworking were also possible. Another contemporary phenomenon was the diffusion of local decorative motifs, for which it is very difficult – if not impossible – to find any close parallels elsewhere in North Africa. The analysis of this 'parallel' phenomenon will require further research, and the observations advanced here must be taken for the time being as a preliminary overview. In particular, two architectural elements from Sala provide interesting information that can be compared with the decoration from other centres of the province.

The first element is a calcarenite pilaster block, featuring a Corinthian capital with smooth leaves on the left-hand side and a circular lotus scroll on the other side (Figure 16.10a). It is positioned in front of the arch's east façade. The size, proportions and other features of the block suggest that it belonged to this monument. Unfortunately, only some courses of the pedestals and gateposts have survived, while the upper part of the archways, the entablature, and the attic are lost. For this reason, a precise dating is not possible. In his accounts, Boube never described the arch in detail and simply regarded it as one of the constructions that embellished the district in the late first to early decades of the second century AD.[73] On the other hand, Chatelain had previously suggested a slightly later chronology, towards the reign of Antoninus Pius, based on a fragmentary inscription that he had attributed to the arch.[74] Further comments on this topic go beyond the aim of this contribution. I should only point out that the arch was part of the second-century building activities recorded at Sala, and is likely datable to within the first half of the century. With regard to the capital, its kalathos is surrounded by two tiers of flat leaves with a marked mid-rib, and the cauliculi have long, vertical stems. In the upper portion one can observe some particular features that diverge from the normal Corinthian style. The calyces are open and provided with large scrolls at the inner and outer edges. From them spring a second and a third set of additional calyces, replacing the canonical helices and volutes. The abacus is reduced to a thin, almost invisible fillet. The combination of three calyces with a simplified abacus is a typical characteristic of the Volubilitan productions, for which no parallels elsewhere are known so far. Capitals showing such features, combined with other peculiar motifs, can be found across the whole site of Volubilis: in the piazza annexed to the *Capitolium*,[75] on the columns of the arch of Caracalla,[76] along the *decumanus* (Figure 16.10b),[77] and in many houses of the north-east district.[78] Therefore, the capital from Sala was either made by stonemasons who came from Volubilis, or it

[71] In particular Rosso Antico and Breccia di Settebasi: see Lazzarini 2011, 839-840, figures 2, 6.

[72] Pensabene 1986, 360, 394; 1989, 455; 2001, 67-69.

[73] Boube 1966a, 27; 1990b; 1999, 17-18.

[74] Chatelain 1944, 87-88: three fragments of the inscription (*IAM2* 309) are preserved, on which the name C. Fa[bius Mo]destus can be read. This person is one of the *amici* of the prefect M. Sulpicius Felix, mentioned in the honorary base dedicated in AD 144 (*IAM2* 307). However, a recent re-analysis by the University of Siena would suggest that the association of this inscription with the arch should be discarded (pers. comm. by Emanuele Papi).

[75] Pensabene 2011, 217-222, figures 13-17.

[76] Pensabene 2011, 225-226, figures 22-23.

[77] Thouvenot 1971a, 306-308, figure 10.

[78] For instance, in the 'maison de Flavius Germanus' and in the 'maison de l'Ephèbe': Pensabene 2011, 242-246, figures 41-42, 45, 48.

Figure 16.10. *Corinthian
capitals with three calyces.
A: Sala (arch); B: Volubilis
(decumanus) (photos:
N. Mugnai).*

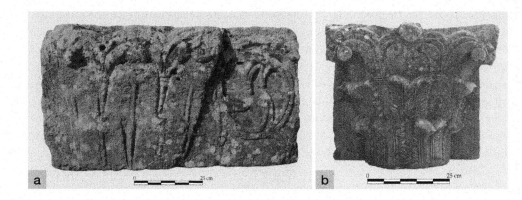

was the product of a local group of artisans influenced by Volubilitan decorative traditions. The second option may be supported by the fact that the capital is made of local calcarenite, while for the decoration at Volubilis the Zerhoun limestone was always employed.

The second element considered here is a large column capital (Figure 16.11a)[79] made of calcarenite. It is currently placed outside the western limit of the forum, but its provenance is uncertain. It is formed by two separate blocks: the lower one features a flattened torus underlined by a fillet; on the upper block, two tiers of 12 smooth leaves each are preserved, round-shaped and bowed frontally. It is likely that the upper part of the kalathos and the abacus were carved on a third (lost) block. This type is also documented by five examples from Banasa:[80] two large column capitals now positioned on the podium of the 'temple with seven *cellae*' in the forum (Figure 16.11b); another identical capital recycled in a wall of the 'maison aux quatre piliers' in the north-west district; one pilaster capital at the entrance of the so-called '*macellum*'; and a smaller capital, with the upper kalathos and abacus still preserved (Figure 16.11c), not far from the previous one. The particular shape and arrangement of the leaves led Boube to recognize a remote Egyptian influence for this decoration, hence his label of 'pseudo-lotus' style. This classification was rejected by Euzennat and Hallier, who preferred to define this type 'corinthien abâtardi'.[81] The chronology is also disputed. Boube suggested a dating in the second half of the first century BC for Sala's capital, supported by other (unspecified) pottery finds discovered with it. However, the stratigraphic context remains unclear. The capital was found during the excavation of a building concealed by the Roman paving, but Boube himself admitted that it might have fallen in that spot from the hill's upper terrace.[82] For this reason, it seems that it was recovered while digging the subsoil layers, thus excluding its provenance from a securely dated context. In reference to the capitals from Banasa, Thouvenot proposed a chronology of around the beginning of the first century AD – not supported by any precise evidence, apart from the author's own considerations.[83] In contrast, Euzennat and Hallier regarded these capitals as late Roman, arguing that the pieces from the '*macellum*' at Banasa belonged to a later phase of the building, and those in the forum might be associated with restorations carried out in the third century AD.[84]

Despite the shortcomings of a stylistic analysis, the dating advanced by Euzennat and Hallier may be supported by some decorative features evident in the smaller example from Banasa. The capital is carved as a single block and it shows an upper kalathos much reduced in height. At the same time, the helices and volutes are very schematic and atrophied, running almost horizontally. As a general rule (valid for Corinthian capitals), it is acknowledged that the height of tiers of the leaves tended to rise with time, while the upper part of the kalathos progressively shrank. In addition, from the mid-late second century AD onwards, one can observe an advancing

[79] Boube 1967, 332-334, figure 10.
[80] Boube 1967, 334-336, plates 20, 21.1; Thouvenot 1971b, 250-253, figures 5-6.
[81] Euzennat and Hallier 1986, 81-82.
[82] Boube 1967, 334.
[83] Thouvenot 1971b, 252-253.
[84] Euzennat and Hallier 1986, 82.

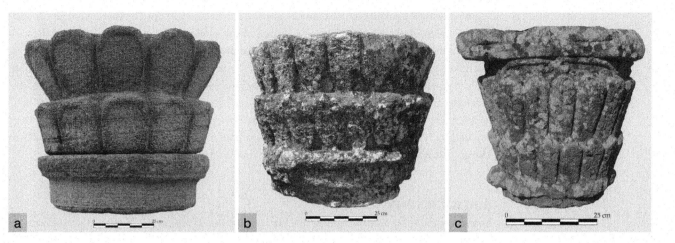

Figure 16.11. *Pseudo-lotus capitals. A: Sala (outside the forum); B: Banasa ('temple with seven cellae'); C: Banasa (outside the 'macellum') (photos: N. Mugnai).*

schematization of calyces, helices and volutes.[85] Therefore, it is possible that this particular group of Moroccan capitals followed a similar pattern, thus hinting towards a chronology not earlier than the second half of the second century AD. In terms of stylistic definitions, I would give credit to Boube for his recognition of a possible Egyptian origin of these lotus-shaped leaves – an influence which can also be recognized in other capitals from this province, provided with water plant and palm leaves (for instance, at Thamusida, Banasa, and Zilil).

FINAL REMARKS

This contribution does not aim to present definitive conclusions. The progress of this research will add more data and broaden the range of variability of the sample discussed here. As with all classifications and typologies, researchers sometimes have a tendency to create groupings that represent their own opinions more than an accurate reflection of reality. The tripartite subdivision adopted here – pre-Roman decoration; official art and ornament inspired by official art; and local motifs – may give the impression of being an artificial construct. However, one must keep in mind that these decorative trends should not be regarded as separate 'blocks', taking place independently one from the other. On the contrary, the evidence shows that different decorative styles overlapped, giving birth to very dynamic phenomena and reflecting the characteristics of the society that created them.

The importance of the Punic and Hellenistic heritage is evident when we look at the decoration generally defined as 'pre-Roman'. While these motifs were surely a feature of pre-Roman North Africa, it is also clear that they did not disappear under Roman rule – possibly even witnessing a widespread revival in Late Antiquity.[86] Both the Attic bases without plinth and the Ionic capitals of Punic-Hellenistic tradition are a case in point. This persistence also suggests a careful approach when using stylistic criteria to date such architectural elements, especially in the case of pieces not associated with a precise building or not coming from a stratigraphic context.

With regard to Roman art, it has been observed that Tingitana was involved in the diffusion of official-style decoration, although not as markedly as the neighbouring territories. For instance, unlike Africa Proconsularis or Mauretania Caesariensis, marble architectural decoration seems to have reached a few coastal sites only – and Sala is a centre where most of this evidence is preserved. These motifs are instead more easily traceable in some local productions, where the Romano-Carthaginian models were often merged with reworked motifs, as the capitals from the 'maison à la mosaïque de Vénus' at Banasa would suggest. However, the main mode of assimilation of Roman art can be identified in the production of 'simplified' decorative elements already at the beginning of the second century AD, such as the Corinthian capitals with smooth leaves from the *Capitolium* at Sala.

[85] Pensabene 1973, 207, 235-238. On the ratio of the Corinthian capital in the late first century BC see Vitruvius, *De Architectura*, IV.1.12: '*dempta abaci crassitudine dividatur reliqua pars in partes tres, e quibus una imo folio detur; secundum folium mediam altitudinem teneat*'.
[86] On this topic see Pensabene's contribution in this volume.

Finally, the circulation of local motifs across the province will need further investigation. The evidence presented here is just a small selection of the whole material – the classic 'tip of the iceberg'. In the Roman period, the well-recognizable production of Corinthian capitals at Volubilis was linked to the establishment of specialized schools of stonemasons at that site – a phenomenon that can also help to explain the limited diffusion of marble architectural decoration in the region. In reference to the pseudo-lotus (and other) capitals from Sala and Banasa, I have argued that their origin might be discovered following an Egyptian track. But how this connection between the two ends of North Africa was established and, more importantly, when these motifs first reached Morocco, are all questions that still need to be answered.

BIBLIOGRAPHY

Ammar, H. 2008. À propos du nymphée de Sala. In Gonzáles, J., Ruggeri, P., Vismara, C. and Zucca, R. (eds), *L'Africa Romana. Le ricchezze dell'Africa. Risorse, produzioni, scambi. Atti del XVII convegno di studio (Sevilla, 14-17 dicembre 2006)*, Rome: Carocci, 559-569.

Aranegui Gascó, C. 2008. Elementos arquitectónicos y decorativos de la época de Juba II en Lixus (Marruecos). In La Rocca, E., León, P. and Parisi Presicce, C. (eds), *Le due patrie acquisite. Studi di archeologia dedicati a Walter Trillmich* (Bullettino della Commissione archeologica comunale di Roma Supplement, 18), Rome: 'L'Erma' di Bretschneider, 41-49.

Arharbi, R., Kermovant, A. and Lenoir, E. 2001. Iulia Valentia Banasa : de la découverte du site aux recherches récentes. In *Actes des 1ères journées nationales d'archéologie et du patrimoine, 2. Archéologie préislamique (Rabat, 1-4 juillet 1998)*, Rabat: Société Marocaine d'Archéologie et du Patrimoine, 147-168.

Balty, J.Ch. 1991. *Curia ordinis. Recherches d'architecture et d'urbanisme antiques sur les curies provinciales du monde romain*, Bruxelles: Palais des Académies.

Basset, H. and Lévi-Provençal, E. 1922a. Chella : une nécropole mérinide, *Hespéris*, 2: 1-92.

Basset, H. and Lévi-Provençal, E. 1922b. Chella : une nécropole mérinide (suite), *Hespéris*, 2: 255-425.

Batino, S. 2006. *Genus ionicum. Forme, storia e modelli del capitello ionico-italico* (British Archaeological Reports, International Series, 1579), Oxford: John and Erica Hedges.

Bianchi, F. 2009. Su alcuni aspetti della decorazione architettonica in marmo a Leptis Magna in età imperiale, *Marmora*, 5: 45-70.

Boube, J. 1962. Découvertes récentes à Sala Colonia (Chellah), *Bulletin Archéologique du Comité des Travaux Historiques et Scientifiques*: 141-145.

Boube, J. 1966a. Fouilles archéologiques à Sala, *Hespéris-Tamuda*, 7: 23-32.

Boube, J. 1966b. Un chapiteau ionique de l'époque de Juba II découvert à Volubilis, *Bulletin d'Archéologie Marocaine*, 6: 109-114.

Boube, J. 1967. Documents d'architecture maurétanienne au Maroc, *Bulletin d'Archéologie Marocaine*, 7: 263-369.

Boube, J. 1977. *Sala, 3. Les nécropoles de Sala. Planches* (Villes et sites archéologiques du Maroc, 1), Rabat: Musée des Antiquités.

Boube, J. 1990a. La dédicace du capitole de Sala (Maroc) et la base honorifique de C. Hosidius Severus, *Mélanges de l'École Française de Rome. Antiquité*, 102: 213-246.

Boube, J. 1990b. Sala (Chella). In *De l'Empire romain aux villes impériales. 6000 ans d'art au Maroc*, Paris: Musée du Petit Palais, 29.

Boube, J. 1999. *Les nécropoles de Sala*, Paris: Éditions Recherche sur les Civilisations.

Brogan, O. and Smith, D.J. 1984. *Ghirza. A Libyan Settlement in the Roman Period* (Libyan Antiquities Series, 1), Tripoli: Department of Antiquities.

Brouquier-Reddé, V., El Khayari, A. and Ichkhakh, A. 2004. Le temple du forum de Banasa : nouvelles données archéologiques. In Khanoussi, M., Ruggeri, P. and Vismara, C. (eds), *L'Africa Romana. Ai confini dell'Impero: contatti, scambi, conflitti. Atti del XV convegno di studio (Tozeur, 11-15 dicembre 2002)*, Rome: Carocci, 1885-1898.

Brouquier-Reddé, V., El Khayari, A. and Ichkhakh, A. 2008. Les édifices religieux de Lixus (Maurétanie Tingitane). In *Les lieux de culte : Aires votives, temples, églises, mosquées. IXe colloque international sur l'histoire et l'archéologie de l'Afrique du Nord antique et médiévale, IIe colloque de la SEMPAM (Tripoli, 20-24 février 2005)*, Paris: Éditions du CNRS, 129-139.

Camporeale, S. 2004-2005. *Tecniche edilizie del Marocco antico: Thamusida, Banasa, Sala. Tipologia, maestranze, storia urbana*, Unpublished PhD Thesis, Università degli Studi di Siena.

Camporeale, S. 2008. Materiali e tecniche delle costruzioni. In Akerraz, A. and Papi, E. (eds), *Sidi Ali ben Ahmed – Thamusida, 1.1 contesti*, Rome: Quasar, 62-178.

Chatelain, L. 1944. *Le Maroc des Romains. Étude sur les centres antiques de la Maurétanie occidentale* (Bibliothèque des Écoles Françaises d'Athènes et de Rome, 160), Paris: De Boccard.

Christofle, M. 1951. *Le Tombeau de la Chrétienne*, Paris: Arts et Métiers Graphiques.

Constans, L.A. 1916. *Gigthis : Étude d'histoire et d'archéologie sur un emporium de la petite Syrte* (Nouvelles archives des Missions Scientifiques, 14), Paris: Imprimerie Nationale.

Euzennat, M. and Hallier, G. 1986. Les forums de Tingitane. Observations sur l'influence de l'architecture militaire sur les constructions civiles de l'Occident romain, *Antiquités Africaines*, 22: 73-103.

Fantar, M. 1984. *Kerkouane : Cité punique du Cap Bon (Tunisie), Volume 1*, Tunis: Institut National d'Archéologie et d'Art.

Ferchiou, N. 1989. *L'évolution du décor architectonique en Afrique proconsulaire des derniers temps de Carthage aux Antonins : L'hellénisme africain, son déclin, ses mutations et le triomphe de l'art romano-africain*, Gap: Imprimerie Louis-Jean.

Jodin, A. 1968-1972. Remarques sur la pétrographie de Volubilis, *Bulletin d'Archéologie Marocaine*, 8: 127-177.

Jodin, A. 1977. L'ordre toscan dans l'architecture du Maroc antique. In *Les pays de l'Ouest. Études archéologiques. Actes du 97ᵉ congrès National des Sociétés Savantes, section d'archéologie et d'histoire de l'art (Nantes, 1972)*, Paris: Bibliothèque Nationale, 301-321.

Jodin, A. 1987. *Volubilis regia Iubae. Contribution à l'étude des civilisations du Maroc antique préclaudien*, Paris: Éditions du CNRS.

Lazzarini, L. 2011. In limine imperii: i marmi colorati di Sala-Chellah (Rabat-Marocco). In Brandt, O. and Pergola, P. (eds), *Marmoribus vestita. Miscellanea in onore di Francesco Guidobaldi, Volume II*, Città del Vaticano: Pontificio Istituto di Archeologia Cristiana, 835-848.

Lézine, A. 1955. Chapiteaux toscans trouvés en Tunisie, *Karthago*, 6: 12-29.

Lézine, A. 1960. *Architecture punique. Recueil de documents* (Publications de l'Université de Tunis, Faculté des Lettres, 1ᵉʳ série, Archéologie, Histoire, 5), Tunis: Presses Universitaires de France.

Mahler, K.-U. 2006. *Die Architekturdekoration der frühen Kaiserzeit in Lepcis Magna* (Libya Antiqua Supplement, 8), Worms: Wernersche Verlagsgesellschaft.

Pensabene, P. 1973. *Scavi di Ostia, VII. I capitelli*, Rome: Istituto Poligrafico dello Stato – Libreria dello Stato.

Pensabene, P. 1982. *Les chapiteaux de Cherchel : Étude de la décoration architectonique* (Bulletin d'Archéologie Algérienne Supplement, 3), Alger: Bulletin d'Archéologie Algérienne.

Pensabene, P. 1986. La decorazione architettonica, l'impiego del marmo e l'importazione di manufatti orientali a Roma, in Italia e in Africa (II-VI d.C.). In Giardina, A. (ed.), *Società romana e impero tardoantico, 3. Le merci, gli insediamenti*, Rome: Laterza, 285-429.

Pensabene, P. 1989. Architettura e decorazione nell'Africa romana: osservazioni. In Mastino, A. (ed.), *L'Africa Romana. Atti del VI convegno di studio (Sassari, 16-18 dicembre 1988)*, Sassari: Editrice Democratica Sarda, 431-458.

Pensabene, P. 2001. Pentelico e proconnesio in Tripolitania: coordinamento o concorrenza nella distribuzione?, *Archeologia Classica*, 52: 63-127.

Pensabene, P. 2011. Tradizioni punico-ellenistiche a Volubilis. I capitelli corinzi e compositi, *Archeologia Classica*, 62: 203-278.

Ponsich, M. 1970. *Recherches archéologiques à Tanger et dans sa région*, Paris: Éditions du CNRS.

Ponsich, M. 1981. *Lixus : Le quartier des temples (étude préliminaire)* (Études et travaux d'archéologie marocaine, 9), Rabat: Musée des Antiquités.

Rakob, F. 1979. Numidische Königsarchitektur in Nordafrika. In Günter Horn, H. and Rüger, C.B. (eds), *Die Numider. Reiter und Könige nördlich der Sahara*, Bonn: Rudolf Habelt Verlag, 119-171.

Tarradell, M. 1959. *Lixus. Historia de la ciudad, guía de las ruinas y de la seccion de Lixus del Museo Arqueológico de Tetuán*, Tétouan: Instituto Muley El-Hasan.

Thouvenot, R. 1971a. Notes sur des chapiteaux de Volubilis, *Revue Archéologique*, 2: 299-308.

Thouvenot, R. 1971b. Sur quelques chapiteaux singuliers de Banasa, *Bulletin Archéologique du Comité des Travaux Historiques et Scientifiques*, 6: 245-253.

Tissot, C. 1878. *Recherches sur la géographie comparée de la Maurétanie Tingitane*, Paris: Imprimerie Nationale.

Vandeput, L. 1997. *The Architectural Decoration in Roman Asia Minor. Sagalassos: A Case Study* (Studies in Eastern Mediterranean Archaeology, 1), Turnhout: Brepols.

17

RIPRESA E CONTINUITÀ DI TRADIZIONI ELLENISTICHE NELL'ARCHITETTURA E NELLA DECORAZIONE ARCHITETTONICA TARDOANTICA IN AFRICA E ALTRE PROVINCE DELL'IMPERO ROMANO

Patrizio Pensabene

Abstract

Across the various regions of the Mediterranean, Late Antiquity (c. third century AD onwards) represented a period of change in the relationship between Rome and the provinces. The weakening of Rome's control is reflected in the resurfacing of pre-Roman traditions, especially those coming from Hellenistic legacies, which can be easily traced in the architecture and architectural decoration of many buildings. This phenomenon, linked with the continuity and/or revival of ancient architectural forms, gave birth to the creation of local styles. This paper aims to present an overview of the situation documented in North Africa (from Morocco to Egypt), Spain, and other provinces of the Roman Empire, while also considering the two main centres of power – Rome and Constantinople.

INTRODUZIONE

Il tema che si vuole affrontare richiede alcune considerazioni su problemi di metodo che incorrono quando si parla di riprese e continuità. La prima riguarda l'uso delle influenze per ricostruire un percorso di cultura architettonica che, inevitabilmente, si accompagna ad un metodo comparativo. Il problema si pone quando vogliamo ricostruire l'origine di una tradizione culturale di cui conosciamo le manifestazioni solo a partire da un periodo molto distante da quello in cui essa si è formata. Questo è ad esempio il caso di Volubilis, di cui non conosciamo tutti i gradini che hanno portato – forse già alla fine del I sec. d.C. e sicuramente nel corso del II – alla creazione delle nuove forme volubilitane. In questo caso è impossibile prescindere dai confronti e dal gioco delle influenze per approssimarsi almeno a delle ipotesi plausibili. Tuttavia si deve notare che le influenze non spiegano una determinata forma, se non vengono accompagnate dallo studio del contesto e delle motivazioni storiche.

Un altro problema riguarda la percezione dell'immagine architettonica. Dobbiamo chiederci se lo spettatore fosse in grado di recepire o meno se una determinata decorazione costituisse la ripresa di un motivo di origine antica, appartenente al suo sostrato culturale punico, libico o altro, quando questa era utilizzata in un contesto di architettura ufficiale, in una chiesa o in una tomba monumentale. L'interrogativo è se riconoscesse le singole decorazioni, o se esse fossero

Figura 17.1. *Urbino, Palazzo Ducale: capitello composito (foto: P. Pensabene).*

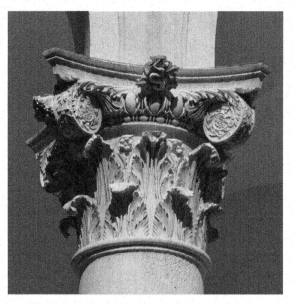

recepite in base ad un senso comune del *decor*. Anche nel caso dell'architettura e della sua decorazione siamo di fronte ad un linguaggio che viene compreso intuitivamente e non chiedendosi ogni volta l'origine di un determinato motivo; un linguaggio comunica attraverso segni e questi devono essere immediatamente comprensibili, altrimenti il significato viene perso.

Infine, parlare di continuità e ripresa è una divisione artificiale, in quanto i due fenomeni non sono separabili in modo chiaro: all'interno di una continuità di forme può avvenire l'inserimento di motivi più antichi che vengono reintrodotti nell'apparato decorativo in epoche successive. Lo stesso vale per la ripresa di forme più antiche, che si verifica dopo un periodo d'interruzione abbastanza lungo: non si tratta mai di imitazione, di copia, bensì di ispirazione all'antico. La copia apparentemente perfetta, anzi troppo perfetta e per questo autodenunciantesi, si verifica soprattutto nel rinascimento italiano: cito soltanto alcuni capitelli compositi del Palazzo Ducale di Urbino (Figura 17.1), talmente fedeli ai capitelli romani di età medio imperiale da essere facilmente confusi con essi se trovati frammentati in un contesto archeologico.

Naturalmente le situazioni descritte vanno proiettate nella storia. Non potrò qui affrontare in modo dettagliato la prospettiva storica alla base di ogni situazione particolare; dovrò contentarmi dell'osservazione generale che la crisi che si produce nell'Impero Romano a partire dal III sec. d.C., che determina il cambiamento dei rapporti tra Roma e le province, si traduce in molti casi nell'impoverimento delle élites locali e nella crescita di ricchezza di minoranze. È noto come in Italia e nelle province occidentali il concentrarsi delle proprietà terriere nelle mani di pochi proprietari crea, tra IV e prima metà del V sec. d.C., un sistema latifondistico tale da limitare le prospettive di benessere economico delle élites locali ancora costituite dai proprietari di fondi; vi si aggiungono i funzionari del governo imperiale responsabili della raccolta delle tasse, gli addetti all'amministrazione dei latifondi senatoriali e imperiali e ben presto i detentori delle cariche ecclesiastiche.[1] Sono appunto gli esponenti di queste categorie a essere spesso i committenti delle imprese edilizie del periodo tardo-imperiale, in particolare quelle cristiane: è noto come gli edifici ecclesiastici, compresi i palazzi dei vescovi e le sale di riunione per i concili, formavano ormai una delle componenti principali del paesaggio urbano tardoantico. Ma tra le élites locali vanno anche ricercati i committenti delle *domus* dell'epoca, dotate di corti porticate e chiaramente depositarie dei messaggi di prestigio dei proprietari, affidati non solo all'articolazione delle piante e ai pavimenti musivi, ma anche agli ordini architettonici adottati negli elevati (vd. ad esempio il caso di Gemila). Inoltre vanno considerati pure i *curatores* degli interventi di restauro degli stabilimenti termali e di altre costruzioni pubbliche.

Le osservazioni ora fatte servono ad inquadrare il fenomeno che si verifica nella decorazione architettonica proprio durante il periodo tardo-imperiale. Fu allora che si registra un peso maggiore delle antiche tradizioni ellenistiche: basti citare la visibilità di quelle tolemaiche in Egitto, o puniche nella Proconsolare, nella Mauretania e nella Betica, sempre più forte a partire dal III sec. d.C. Dobbiamo porre tale fenomeno in un background storico e geografico di zone caratterizzate dalla persistenza di aspetti religiosi, sociali, linguistici, artigianali risalenti a periodi precedenti alla dominazione romana, come si verificò nelle regioni africane e ispaniche che erano appartenute alla sfera politica cartaginese. Tuttavia va considerato anche il ridimensionamento dell'influenza di Roma e del ruolo dell'annona come dispensatrice di

[1] Whittow 1990, 6, 12, 18.

ricchezza fra le élites locali. Non affermo che sia l'unica causa, ma la mancanza di committenze di importanti edifici pubblici determina l'interruzione dell'attività di officine specializzate nell'architettura e nella decorazione di grandi monumenti; continua invece l'attività delle officine che intervengono nelle case, nei mausolei funerari e ben presto nelle chiese, e sono queste ad essere portatrici di tradizioni più antiche. Esemplare è il caso di Volubilis dove influenze dell'architettura ufficiale emergono solo nei monumenti pubblici più rilevanti, come la Basilica (Figura 17.2a) e il *Capitolium*, nei quali, pur avvertendosi l'intervento delle officine locali, si denota lo sforzo di adottare le forme diffuse dalle capitali e dalle città più importanti africane. Nei portici della piazza del *Capitolium* e nelle case di Volubilis, invece, come anche in antichi santuari di divinità d'origine africana,[2] continua tranquillamente nei capitelli lo stile che riteniamo marcato da tradizioni punico-ellenistiche,[3] anche se le forme createsi in età imperiale sono ormai nuove (Figura 17.2b).

In effetti il caso di Volubilis va visto all'interno di situazioni eccezionali che si verificano soprattutto nei centri interni dove si utilizzavano pietre locali anche per la decorazione, distanti dunque dal mare e quindi meno influenzabili dalle forme ufficiali dell'Impero che spesso viaggiavano insieme al marmo; o ancora si verificano in centri sul mare, ma lungo le rotte atlantiche fino allo stretto di Gibilterra o le rotte del Mar Rosso dove carichi di marmi utilizzabili per gli elementi architettonici degli elevati arrivavano con molte difficoltà. È il prezzo dei porfidi e dei graniti che ne spiega lo scarso uso per gli alzati architettonici delle città del Medio e Alto Egitto, nonostante i carichi con queste pietre passassero sul Nilo; è di nuovo il costo che spiega come a Baelo Claudia, sullo stretto di Gibilterra, si utilizzassero per i monumenti pubblici solo le pietre locali, riservando il marmo alla statuaria soprattutto imperiale.

CONTINUITÀ/RIPRESE DI ANTICHE TRADIZIONI DECORATIVE E FENOMENI DI RECUPERO DI FORME DEL PASSATO

Tornando al problema delle continuità/riprese, dobbiamo distinguere tre situazioni diverse per le città interessate dal fenomeno. La prima è quella delle località in cui erano persistite tradizioni locali risalenti al periodo pre-imperiale; vi comprendiamo molte città dell'interno della Siria, dell'Egitto (testimoniate nel medio e alto corso del Nilo, nel Fayum e nei deserti occidentali di Karga e Dekla), della Proconsolare, della Mauretania (ad esempio a Volubilis o Banasa), della Tripolitania (necropoli di Ghirza), della Lusitania (come Bracara Augusta), dell'Aquitania (come il santuario di Clos du Château), etc.

La seconda riguarda quelle città dove l'interruzione o il rallentamento delle attività di edilizia monumentale obbliga le officine ad imitare le forme del passato al momento della loro

Figura 17.2. *Volubilis: capitelli corinzi. A: basilica; B: portico del* Capitolium *(foto: P. Pensabene).*

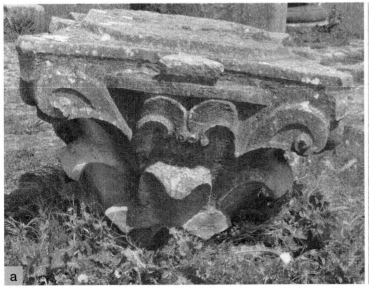
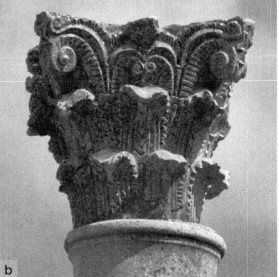

[2] Cfr. a Volubilis: Morestin 1980, 43, figura 26.
[3] Pensabene 2011.

chiamata a imprese pubbliche. Esemplare in questo senso è il caso dell'Arco di Costantino a Roma, dove le maestranze urbane chiamate a realizzare le parti nuove della decorazione dell'arco imitano – ma anche trasformano – i motivi ornamentali delle trabeazioni reimpiegate.[4] Viene così creato un nuovo stile che ha in comune con quello del pieno periodo imperiale, rappresentato dagli elementi di reimpiego, il "senso comune del *decor*" attraverso cui le nuove forme erano percepite dallo spettatore, che si aspettava un apparato decorativo nella tradizione come accompagnamento naturale alla costruzione di un importante edificio pubblico (Figura 17.3). È ovvio che questa situazione di dialettica tra materiali di reimpiego e di nuova produzione compare anche altrove: citiamo il caso del mausoleo di Thuburnica, dove in una fase di ricostruzione o costru-

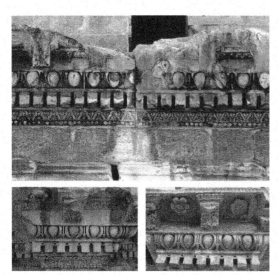

zione tarda coesistono gli elementi architettonici recenti con quelli di una fase precedente di età giulioclaudia, ma nella tradizione punico-ellenistica tipicamente africana.[5]

La terza infine riguarda le città di nuova fondazione, come Costantinopoli, dove l'aspirazione a creare un nuovo stile decorativo imperiale spinge a *revivals* di forme più antiche, anche se naturalmente interpretate secondo le mode architettoniche del tempo. Basti citare nell'ambito dei capitelli corinzi la ripresa del motivo ellenistico degli occhielli a distinguere i lobi dell'acanto spinoso (Figura 17.4a),[6] innovazione ben presto fatta propria dalle officine del Proconneso da cui sono esportati in molte altre località del Mediterraneo (come ad Alessandria: Figura 17.4b):[7] il motivo deriva in particolare da modelli ateniesi ancora ben visibili in edifici monumentali come l'*Olympieion* (Figura 17.4c). Basterebbe ancora citare per il VII sec. d.C. i primi palazzi omayyadi, come quello di Khirbat al-Mafjar presso Gerico (Figura 17.4d),[8] dove i modelli decorativi ripresi e trasformati vengono da Bisanzio.

Figura 17.3. (in alto)
Roma, Arco di Costantino: cornici. In alto: II sec. d.C.; in basso: età costantiniana (foto: P. Pensabene).

Figura 17.4. (a destra)
*Capitelli corinzi.
A: Costantinopoli, portico di Teodosio; B: Alessandria, museo; C: Atene, Olympieion; D: Gerico, presso il palazzo omayyade di Khirbat al-Mafjar (foto: P. Pensabene).*

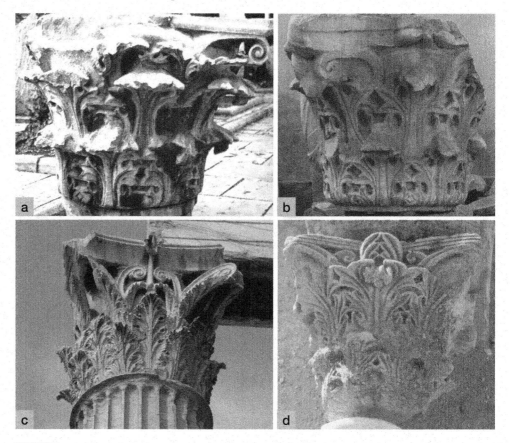

[4] Pensabene 1999.
[5] Ferchiou 1986, 670-676.
[6] Barsanti 1993, 200.
[7] Pensabene 1993, 157-160.
[8] Whitcomb, Taha 2013.

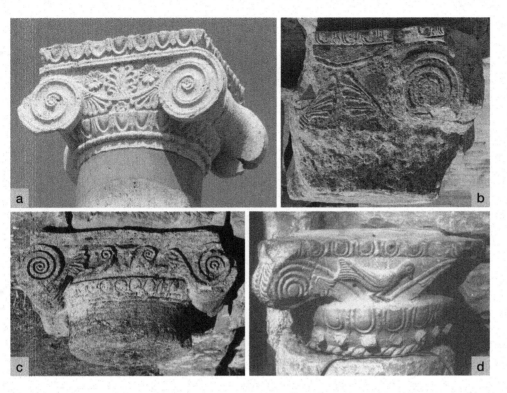

Figura 17.5. *Capitelli ionici.*
A: Leptis Magna, tempio di
Liber Pater; B: Bulla Regia,
Esplanade Est; C: Gemila, casa
di Castorio (foto: P. Pensabene);
D: Henchir Belbel (da Ferchiou
1989, tavola 48).

TRADIZIONI DECORATIVE ELLENISTICHE NEL MONDO PUNICO E LORO CONTINUITÀ IN CAPITELLI D'AFRICA E SPAGNA

Capitelli ionici

È ormai noto, anche per i lavori del Lézine[9] e della Ferchiou[10] per la Tunisia e della Gutiérrez Behemerid[11] per la Spagna, come uno dei fenomeni che caratterizza l'architettura in regioni di antico dominio punico sia la continuità d'uso dell'ordine ionico, che non segue la tradizione attica bensì quella di antica origine peloponnesiaca di IV sec. a.C.,[12] per la quale il capitello ionico appare con il canale delle volute concavo e soprattutto scisso dal *kyma* ionico e con le spirali delle volute di ridotte dimensioni, spesso sostituite da un motivo vegetale o altro. Se le manifestazioni più note si trovano nei templi del Foro Vecchio di Leptis Magna (Figura 17.5a), altri esempi, che su questa comune origine manifestano l'invenzione di nuove forme, si ritrovano in numerose località: basti citare per l'Africa i capitelli in pietra locale di Bulla Regia con il canale flesso e le semipalmette che invadono del tutto lo spazio tra le volute (Figura 17.5b), di Testour nella Proconsolare datato tra il I e il II sec. d.C.,[13] della casa di Castorio a Gemila (Figura 17.5c) con volute a doppia S affrontate che occupano l'echino sotto cui vi è il *kyma* ionico (in questo caso con l'introduzione di una protome bovina), di Henchir Belbel (Figura 17.5d) con le volute che nascono libere dietro il *kyma* ionico.

Per la Spagna vanno evidenziate due correnti con molti punti in comune con quelle africane: la prima è rappresentata dagli esempi di Baelo Claudia in calcarenite stuccata (Figura 17.6a)[14] e di Lancia,[15] di cui va notata la particolare somiglianza con quelli di Henchir Belbel e di altri capitelli tunisini;[16] la seconda, con le doppie volute ad S contrapposte che occupano lo spazio dell'echino,

[9] Lézine 1960, 51-58.

[10] Ferchiou 1989.

[11] Gutiérrez Behemerid 1992.

[12] È a partire dal IV sec. a.C. che il Lézine (1960, 43) ritiene sia stata introdotta la colonna ionica nell'architettura punica.

[13] Ferchiou 1989, 191, n.VI.III.1.

[14] Fellague 2010, 286, figura 6; Gutiérrez Behemerid 1992, nn. 760-770.

[15] Gutiérrez Behemerid 1992, n. 93.

[16] Anche in questo caso la ricerca va approfondita al sostrato ellenistico alla base di questi capitelli ionici: infatti il noto capitello figurato di Nimes, rinvenuto presso la porta di Augusto (von Mercklin 1962, n. 298), con protomi di divinità tra gli steli delle volute che nascono liberi dietro il *kyma* ionico, rimanda a forme magnogreche evidentemente assorbite dalle officine al servizio della clientela romana della città.

Figura 17.6. *Capitelli ionici.*
A: Baelo, basilica, ordine
superiore; B: Carthago Nova,
nei pressi del Foro; C: Tarragona,
museo; D: Segobriga, basilica,
ordine superiore (foto:
P. Pensabene).

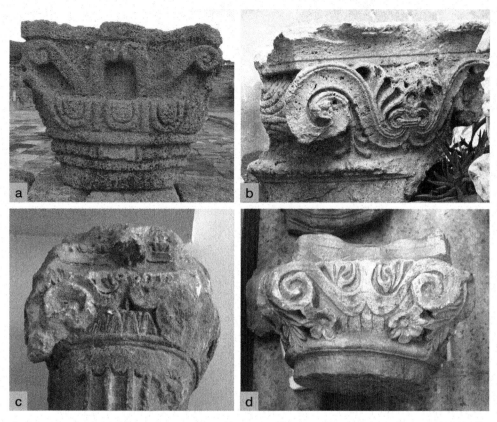

la cui sintassi è riconoscibile anche nel capitello della Casa di Castorio a Gemila. Tuttavia gli esempi ispanici si caratterizzano per una certa eleganza con soluzioni originali del motivo che implica una consuetudine di lunga data da parte delle officine locali ad affrontare questa forma decorativa: tra i più raffinati capitelli vanno menzionati quelli di Carthago Nova in travertino rosso locale (Figura 17.6b),[17] ma si possono citare anche quelli di Tarragona (Figura 17.6c) e di Segobriga in calcare (Figura 17.6d).[18]

Si può ragionevolmente collegare tale preferenza per l'ordine ionico in località dove era forte la presenza di sostrati religiosi e culturali preromani con il fatto che nel mondo punico proprio tale ordine era impiegato nei santuari, come testimonierebbero cippi architettonici di Cartagine[19] datati al II sec. a.C. con capitelli ionici dal canale delle volute flesso, così come i templi del Foro Vecchio di Leptis e il fatto che a Bulla Regia venga rappresentata Tanit al centro dei lati di capitelli ionici indica che potrebbero di nuovo provenire da un santuario. In tale ambito vanno anche citati i capitelli ionici della peristasi dei tempietti funerari di fine III sec. d.C. della necropoli di Ghirza, che riproducono piccoli luoghi di culto di divinità locali (Figura 17.7a-b), e va ricordato che presso l'abitato da cui dipendeva la necropoli si trovava un santuario di tradizione semitica con attestazioni di culto ancora nel IV e V sec. d.C.[20]

Per inciso si osserva che nell'architettura ufficiale imperiale e soprattutto in quella templare molto meno frequente del corinzio è l'uso dell'ordine ionico: a Roma è limitato al Tempio di Saturno, dove la continuità d'uso anche nella ricostruzione tardo-imperiale ne riflette l'impiego nella fase originaria; si trova ancora nel Tempio del dio Portuno sul Foro Boario, anche in questo caso con motivazioni inerenti al culto di questa divinità in epoca repubblicana; infine è documentato solo da immagini su rilievi e monete nel tempio del Divo Augusto. Tanto più è da rilevare, dunque, la specificità dell'ordine ionico in ambienti quali l'africano e l'ispanico che hanno nella loro storia un lungo periodo di dominazione e/o influenza punica.

[17] Ramallo Asensio 2004, 205, figura 49.
[18] Mar, Pensabene 2013, 25-26, figure 6-10. Il motivo è anche adottato in esemplari compositi di II sec. d.C., creando pure in questo caso tipi nuovi: vd. ad esempio un capitello in calcare di II sec. d.C. nel museo di Cuenca, dal teatro di Segobriga (Díaz Martos 1985, 181, n. 38).
[19] Lézine 1960, 46, tavola 5, figura 72; cfr. Ferchiou 1989, n. V.I.A.3.
[20] Kenrick 2009, 188, figura 96: si tratta dell'edificio 32.

Capitelli corinzi a volute libere

Altra forma comune al mondo punico-ellenistico era un tipo di capitello corinzio a volute libere, testimoniato in Tripolitania da esemplari del museo di Leptis[21] e che si conserva nei capitelli di fine III sec. d.C. dei monumenti funerari di Ghirza, dove compare anche il capitello figurato (Figura 17.7c-d). La documentazione si estende anche alla Proconsolare dove appare in diverse città interne. Si tratta di una forma che in origine s'ispirava a modelli alessandrini, ma anche sicelioti, di nuovo di lontana origine peloponnesiaca, e che in Africa aveva dato luogo a vari tipi con rese più schematiche dell'acanto, ma di cui è riconoscibile la matrice ellenistica.

Per inciso osserviamo che, nonostante l'apparente distinzione tra lo stelo dei caulicoli e i calici, in realtà nei capitelli corinzi di Volubilis proprio la lunghezza dei caulicoli mostra come all'origine vi fossero steli liberi tra le foglie che terminavano in volute, poi modificati per influsso del corinzio normale: s'introdusse una separazione tra i lunghi steli dei caulicoli e i piccoli calici,[22] adottati però in un'edizione locale che aveva messo sullo stesso piano i calici a V e un doppio motivo di elici e volute parallelo e contiguo ai calici. Tale forma, dunque, è assorbita come patrimonio di base dalle officine di Volubilis che sviluppano una tradizione propria che persiste per tutta l'epoca imperiale, non solo per la posizione ai margini dell'Impero della città, ma anche per i prestigiosi modelli offerti dai santuari di divinità africane presenti nella città (come i capitelli del tempio B).[23]

La continuità del tipo nella prima età imperiale si coglie ad esempio a Sabratha, dove ne offre una buona testimonianza il tempio di Iside di I sec. d.C.,[24] con capitelli a due corone di foglie lisce che occupano la metà inferiore del *kalathos* e due coppie per lato di steli disposti a V terminanti in piccole spirali sotto gli spigoli dell'abaco e sotto il fiore centrale (Figura 17.8a). Nel tempio di

Figura 17.7. *Ghirza: capitelli ionici e corinzi. A-B: necropoli nord, Tomba A; C: necropoli nord, Tomba B; D: necropoli sud, Tomba A (foto: P. Pensabene).*

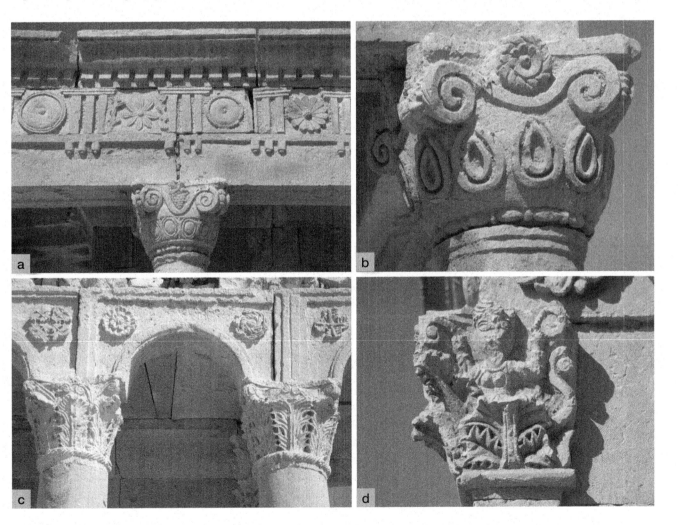

[21] Mahler 2006, 29, n. KK 23, dove s'ipotizza che in origine appartenesse ad un mausoleo.

[22] Cfr. Pensabene 2011, 262-270.

[23] Morestin 1980, 43, figura 26.

[24] Pesce 1953, 28, figura 14, attribuito al colonnato del peristilio; per la datazione cfr. Brouquier-Reddé 1992, 63.

Figura 17.8. *Capitelli corinzi e capitello con rosetta e girali. A: Sabratha, tempio di Iside; B: Tarragona, piazza; C: Baena, museo, da Torre Paredones; D: Braga, museo Pio XII (foto: P. Pensabene).*

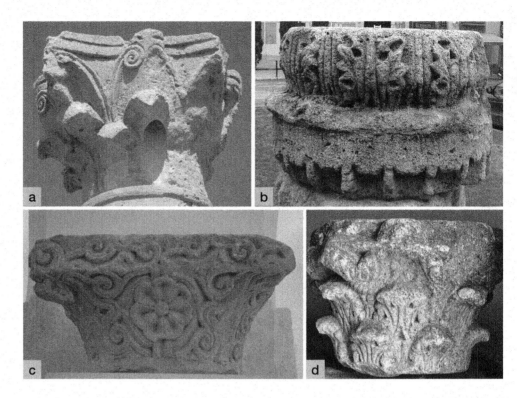

Liber Pater, sebbene nei capitelli a foglie lisce sia introdotto un piccolo calice per gli steli a V delle elici e delle volute,[25] si può riconoscere la stessa forma, modificata superficialmente su influenza del corinzio normale. Si è di fronte, dunque, al risultato di semplificazioni e trasformazioni che vanno a modificare anche la forma più consueta del *kalathos*, ma che non arrivano a interrompere la continuità di una tradizione decorativa formatasi in ambiente punico-ellenistico. La spiegazione può trovarsi nel tradizionalismo che spesso accompagna l'architettura templare di divinità di origine punica o comunque assimilate ad esse, come può essere il caso di Iside/Tanit o di *Liber Pater*, e va rilevato che, nello stesso periodo in cui si ricostruivano i due templi (seconda fase), erano già in uso in Tripolitania capitelli corinzi normali d'influsso urbano.

Nella penisola iberica la diffusione del capitello a volute libere può essere stata anche favorita dall'arrivo dei coloni romani già dal II sec. a.C. che introducono il capitello corinzio-italico, che ben presto dà luogo nelle città ispaniche ad una forma locale adottata in età tardo-repubblicana a Tarragona (Figura 17.8b). Una buona documentazione viene da Barcino, dove vi è un nutrito gruppo di capitelli corinzi in pietra locale senza caulicoli, ma con gli steli delle elici e delle volute che nascono direttamente tra le foglie della seconda corona; l'acanto ha assunto una forma rigida e spinosa derivante dai capitelli corinzi del secondo triumvirato, ma in seguito, pur mantenendo un carattere ispanico, riflette gli stili successivi.[26] In ogni caso questi capitelli sono definibili corinzio-ispanici per sottolinearne la minore esuberanza e plasticità rispetto ai capitelli corinzio-italici, con foglie d'acanto molto più rigide degli esemplari italici, come mostra un gruppo di Barcino,[27] dove solo un esemplare si presenta con foglie più carnose e plastiche.[28] I capitelli corinzio-ispanici continuano ad essere impiegati in età imperiale soprattutto in contesti privati e funerari, per riemergere di nuovo nell'architettura visigota.

Ma su questa tradizione che non segue l'ordine corinzio canonico, un ruolo devono aver avuto i santuari iberici precedenti alla dominazione punica, che già avevano subito influssi greci. In questo senso vanno citati i capitelli del santuario di Torre Paredones, che sorgeva a circa 40 km da Cordoba: datati al IV sec. a.C., essi presentano forme decorative schematiche, ma di chiara ispirazione greca, centrate nella grande rosetta al centro di girali (Figura 17.8c), che richiama una delle forme con cui era rappresentata la *potnia theron*, la divinità femminile che presiedeva alle nascite e al mondo

[25] Kenrick 1986, 61, figura 24.
[26] Un gruppo numeroso viene da Barcino e dal suo territorio: Gutiérrez Behemerid 1986, nn. 23-45.
[27] Gutiérrez Behemerid 1986, nn. 3-14.
[28] Gutiérrez Behemerid 1986, n. 2; 1992, n. 129.

dell'aldilà. Questa tradizione floreale si ritrova nei capitelli di media e tarda età imperiale di Bracara Augusta, ma solo in quelli scolpiti nel granito locale ad opera di officine locali, che conservavano le antiche tradizioni decorative con uso di grandi rosette nella parte libera del *kalathos* e con tendenze geometrizzanti nella resa dell'acanto (Figura 17.8d); in quelli di marmo bianco, invece, appare la tradizione del corinzio dell'architettura ufficiale espressa dalle capitali provinciali.

Di nuovo in tal senso va citata l'Africa romana, che è anche caratterizzata dalla presenza di capitelli ionici, corinzi e compositi in cui la voluta è del tutto occupata da una grande rosetta o da altri elementi vegetali,[29] che non possono non richiamare il simbolismo legato ai fiori come rappresentazione delle divinità con valenze anche ctonie.

IL CASO DI CAESAREA AUGUSTA/CHERCHEL IN MAURETANIA

Come altro caso africano che mette in rilievo il contrasto tra l'adozione delle forme urbane e la continuità di quelle tradizionali vorrei proporre quello di Cherchel. Abbiamo potuto osservare come il periodo di Giuba II e del figlio Tolemeo segnarono una completa adesione all'architettura e alla decorazione in voga a Roma negli stessi anni, che venne realizzata con l'impiego del marmo di Carrara e con l'arrivo di maestranze dall'Italia: la funzione è quella di qualificare la nuova capitale del regno di Mauretania come un'altra Roma, di esprimere dunque la fedeltà dei monarchi all'imperatore. Uno degli effetti di questa politica fu appunto la creazione di quegli apparati edilizi che caratterizzano le grandi capitali: tempio di culto imperiale, teatro, palazzo reale, collezioni statuarie, etc.

Ma che succede durante il periodo di Giuba e Tolemeo delle precedenti tradizioni maure, sulle quali avevano già agito proprio nella decorazione architettonica forti influenze ellenistiche mediate dalla Sicilia, da Cartagine e dal vicino regno numida? Citiamo subito come esempio paradigmatico il grande tumulo reale presso Tipasa, noto con il nome di Tombeau de la Chrétienne, probabilmente datato tra il II e gli inizi del I sec. a.C. e attribuito ad uno dei due re mauri che portano il nome di Bocco. La trabeazione del suo tamburo è liscia con *taenia* e gola rovescia, mentre quella del falso portale a est è modanata con un *kyma* ionico sotto la sima a gola egizia liscia e astragalo e dentelli stretti e ravvicinati nella sottocornice. Inoltre presenta due tipi di capitelli ionici, entrambi senza il *kyma* ionico e scolpiti insieme al sommoscapo che forma un collarino decorato con *anthemion*. Il primo è costituito dai due capitelli ai lati del portale dove l'echino è occupato da una grande palmetta con steli ondulati fioriti ai lati: sono gli stessi motivi che s'incontrano nei capitelli del tempio di *Liber Pater* a Leptis e che giustificherebbero l'uso del termine punico-ellenistico per abbracciare i vari fenomeni artistici di tutta quest'area africana. Il secondo tipo, riguardante tutti gli altri capitelli del tamburo, è caratterizzato dall'echino flesso quasi ad angolo.[30] Questa stessa forma si ritrova anche nel mausoleo di Siga, degli inizi del II sec. a.C., all'estremità occidentale del regno numida dove esercitava il potere Syphax, rivale di Massinissa;[31] esso, con la sua forma a torre coronata da una piramide, rappresenta uno dei quattro mausolei a torre della Numidia che derivano dall'accettazione di questa forma architettonica nel dominio punico (v. il mausoleo di Sabratha) su influenza della madrepatria fenicia, della Siria e dell'Asia Minore.[32] Sono simili tradizioni ellenistiche che, ancora nel regno di Numidia, avevano portato all'erezione da parte di Micipsa del santuario monumentale nelle cave di Simitthus,[33] con echi tarantini nei capitelli figurati con doppia sfinge e macedoni per il fregio con scudi alternati a loriche.

La forza di tali tradizioni, che avevano improntato di sé i regni di Numidia e di Mauretania, è tale che continua a vivere presso l'artigianato locale dedito alla decorazione architettonica, anche dopo l'episodio costituito dai monumenti di Giuba II e Tolemeo e contemporaneamente all'influenza esercitata da Cartagine sulle forme dell'architettura pubblica.

Quali manifestazioni di tradizioni più antiche si hanno, dunque, dopo la fine dell'indipendenza della Mauretania quando viene trasformata in provincia? In effetti, proprio a Cherchel,

[29] Rinvio per una più ampia casistica a Pensabene 1986, 419-422.
[30] Christofle 1951, 86-87, figure 64-66; Rakob 1979, 138-142, figure 60-64.
[31] Pensabene 1986, 414, figura 51; Rakob 1979, 151, figura 77.
[32] Rakob 1979, 145.
[33] Rakob 1979, 120.

Figura 17.9. *Cherchel.*
A: capitello ionico, lapidario
nelle terme (da Pensabene 1982,
tavola 52); B: capitello corinzio,
museo (foto: P. Pensabene).

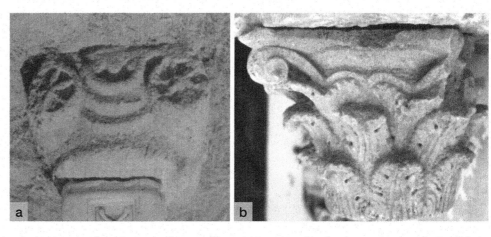

si può osservare la ricorrenza di capitelli ionici in pietra locale che negli esemplari attribuiti al II e III sec. d.C. si caratterizzano per differenti tendenze. Una partecipa alla moda africana dell'echino leggermente flesso, della mancanza del canale delle volute assorbito dal cavetto dell'abaco, dell'astragalo spesso e a perline cilindriche allungate, delle volute che tendono a ridurre il diametro,[34] riallacciandosi in tal modo ai capitelli africani di tradizione punico-ellenistica. Un'altra che alle caratteristiche ora descritte aggiunge grandi rosette che sostituiscono la spirale delle volute;[35] citiamo ancora la tipica forma ad angolo assunta dal canale delle volute,[36] che già il Lézine attribuiva a tradizioni puniche[37] e che s'incontra anche in un capitello ionico di Leptis Magna attribuito al I sec. a.C.[38] Ma una tradizione preromana è ancora più emergente in alcuni capitelli ionici del museo e del lapidario presso le terme dell'Ovest di Cherchel, databili tra il tardo IV e V sec. d.C., dove si hanno esemplari con canale delle volute accentuatamente flesso e con la spirale delle volute sostituita da uno schematico fiore a stella (Figura 17.9a),[39] oppure con rapporto "dissociato" tra le volute e gli ovuli che si pongono sotto l'echino e di nuovo con rosette che occupano le volute,[40] o ancora con un raddoppio dell'echino, nel senso che tra le volute si dispone il *kyma* ionico, mentre sotto vi sono un echino liscio e un tondino/astragalo liscio molto sporgenti[41] e, in generale, con piccole volute attaccate direttamente all'echino.

Per ciò che riguarda i capitelli corinzi va rilevato che essi, nella piena età imperiale, sono quasi sempre del tipo normale e impiegati in monumenti ufficiali (vd. ad esempio i capitelli a foglie lisce di lesena che decoravano il fronte esterno dell'ippodromo)[42] ed il richiamo è all'architettura pubblica di Cartagine: tuttavia si osserva con il III sec. d.C. la tendenza a rendere con steli sottili, quasi a V, le volute e le elici,[43] fino ad arrivare all'introduzione di una rosetta tra di esse,[44] che ha paralleli in capitelli di Banasa,[45] ma anche di Tolemaide[46] e di Barcino,[47] a dimostrare come si tratti di un'eredità ellenistica. In ogni caso gli esempi di Cherchel e di Banasa con rosette sono un'altra testimonianza della continuità di formule ellenistiche entrate a far parte del patrimonio decorativo africano del dominio punico e di quello dei regni locali. Va ricordato che in Tripolitania, ad esempio nell'Arco di Traiano in calcare a Leptis, ugualmente compaiono esemplari che apparentemente seguono il modello del corinzio normale,

[34] Pensabene 1982, 18, n. 13.
[35] Pensabene 1982, 19, n. 15.
[36] Pensabene 1982, 56, n. 159.
[37] Lézine 1960, 73.
[38] Mahler 2006, 63, n. 166 IdK, a cui si rimanda per confronti e inquadramento.
[39] Pensabene 1982, 56, n. 158.
[40] Pensabene 1982, 54, n. 154.
[41] Pensabene 1982, 55, n. 152.
[42] Pensabene 1982, 59, nn. 169-171, della prima metà del III sec. d.C.
[43] Pensabene 1982, 61, n. 174.
[44] Pensabene 1982, 61, n. 175: l'esemplare è stato genericamente attribuito al III-IV sec. d.C. e ne va notata anche la sottigliezza delle foglie dei calici che richiama i capitelli di Volubilis, anche per le spirali terminali delle elici e delle volute.
[45] Thouvenot 1971, 245, figura 2.
[46] Kraeling 1962, tavola 20B: il capitello è datato in età severiana.
[47] Gutiérrez Behemerid 1986, n. 49: l'esemplare è datato nel III-IV sec. d.C.

ma che nella mancanza di elasticità e struttura tettonica degli steli e delle volute e delle elici mostrano la persistenza di motivi più antichi.[48]

Infine, anche a Cherchel con il periodo tardoimperiale si avverte l'influenza del capitello corinzio teodosiano, visibile nelle zone d'ombra ad occhiello tra i lobi delle foglie, che s'incontra con il *revival* del corinzio normale di questo periodo (vd. oltre) e con la tradizione locale degli steli molto sottili delle elici e delle volute (Figura 17.9b).

I CAPITELLI FIGURATI

Un'altra classe di capitelli su cui va posta l'attenzione sono quelli figurati con busti o teste di divinità. Di nuovo si registra in contesti religiosi del periodo ellenistico l'utilizzazione di capitelli con un apparato vegetale prevalentemente corinzieggiante (collare alla base del kalathos decorato con un astragalo, una o due corone di foglie d'acanto, busti o protomi umane emergenti da cespi, foglie o fiori al centro dei lati nella parte lasciata libera dalle foglie): gli esempi più noti in Italia sono quelli della Magna Grecia (Taranto, Canosa, Brindisi, Padula, Paestum), ma sono diffusi anche in area centro-italica (dalle tombe etrusche di Vulci a edifici di Cori e di altri centri: gli ultimi esemplari rinvenuti di questo tipo provengono da S. Maria di Cinturelli a Caporciano presso L'Aquila: Figura 17.10a); altri esempi provengono dalla Siria e dall'Egitto tolemaico, dove è presente l'influsso del capitello hathorico,[49] e dalla Numidia, dove nei capitelli d'anta del monumento di Micipsa a Simitthus di II sec. a.C. (Figura 17.10b) è ripreso un tipo ellenistico di Taranto con sfinge alata al centro, mentre nei capitelli di una casa di Utica di I sec. a.C. (Figura 17.10c) l'ispirazione deriva dai capitelli corinzio-italici e figurati magnogreci e centro-italici. In Asia Minore e in Grecia, nei contesti santuariali, pare preferito nei capitelli figurati un motivo vegetale di tralci nascenti da un cespo tra grifi, allusivo alla divinità nella sua qualità di presiedere alla rinascita, o direttamente alla *potnia theron* nella forma di Rankengöttin – così nella cella del *Didymaion* di Mileto[50] (Figura 17.10d) – ancora

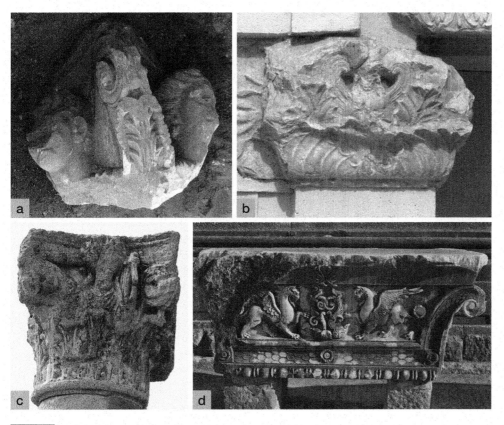

Figura 17.10. *Capitelli figurati. A: Caporcino, S. Maria di Cinturelli; B: Simitthus, monumento di Micipsa; C: Utica, casa dei capitelli istoriati; D: Didymaion di Mileto, cella (foto: P. Pensabene).*

[48] Mahler 2006, 27, n. KK 10.
[49] Cfr. LaBranche 1966, 71-75.
[50] LaBranche 1966, 80-81, da vedere per i pochi altri esemplari figurati della Grecia. Per l'Asia Minore sono da citare ancora i capitelli d'anta del tempio di Zeus Sosipolis a Magnesia sul Meandro e del tempio di Augusto ad Ankara con divinità femminili alate nascenti da elementi vegetali.

Figura 17.11. *Capitelli figurati. A: Messene, portici dell'*Asklepieion *(foto: P. Pensabene); B: Thugga (da Ferchiou 1989, tavola 54); C: Mustis, portale del tempio di Apollo; D: Siviglia, museo, da Italica (foto: P. Pensabene).*

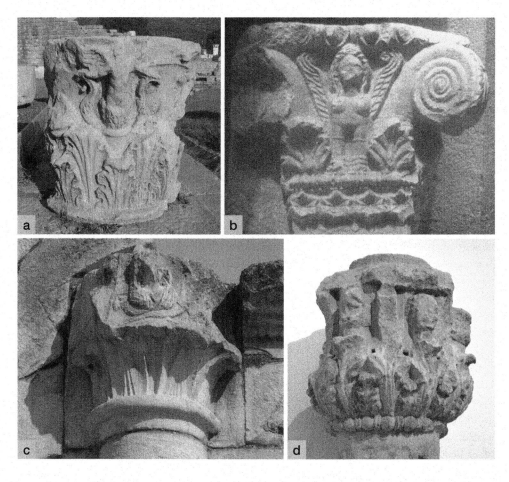

con leogrifi alati al centro dei lati, ben noto da esemplari di Atene, Eleusi, Corinto, Patrasso e dal relitto di Mahdia,[51] oppure divinità nude maschili e femminili, alate e non, di nuovo emergenti da un calice, come nei capitelli dei portici dell'*Asklepieion* di Messene (Figura 17.11a). Tenute presenti, dunque, le probabili influenze dei capitelli figurati magnogreci e alessandrini sul mondo mediterraneo di età ellenistica, vanno evidenziati quei capitelli con busti di divinità dell'età imperiale e tardoimperiale derivanti dalle trasformazioni dei prototipi più antichi, che non presentano come predominante l'influenza di tipi figurati affermati in età imperiale.

Per la Tunisia rimandiamo alla raccolta citata della Ferchiou, limitandoci a menzionare un esemplare di Thugga (Figura 17.11b) in cui ritorna il motivo della sfinge alata, insieme a grandi volute libere spiraliformi, a piccole foglie d'acanto dal contorno dentato, ad un astragalo con perline bombate e una serie di rosette dai petali a stella, motivi di chiara tradizione ellenistica, ma la cui resa rigida e schematica permette di collocare l'esemplare tra I e II sec. d.C.; anzi le tendenze geometrizzanti che si avvertono nell'ornato sono in qualche modo nella stessa corrente che porterà ai capitelli di Volubilis, tra l'altro con il fiore dell'abaco talvolta sostituito da una testina,[52] senza per questo esserci una relazione diretta tra i due centri. A Mustis, invece, nel capitello figurato (Figura 17.11c) ai lati del portale del recinto del tempio di Apollo, datato al II sec. a.C. e poi inglobato nelle mura tarde, si ha un busto di divinità femminile su due cornucopie incrociate, di chiara derivazione ellenistica, confermata anche dallo spesso astragalo liscio alla base del *kalathos* e anche dall'astragalo articolato in perline e fusarole a disco che corona l'architrave del portale. Nel mausoleo di Assuras il capitello figurato in calcare nummolitico[53] presenta al centro una testa circolare – forse un *gorgoneion* – sopra cui vi è una piccola protome di animale, forse bovina, tra steli a tralcio fioriti, ma non contrapposti simmetricamente: è evidente che la tradizione iconografica non può che essere locale.

[51] von Mercklin 1962, nn. 592-601.
[52] Pensabene 2011, 220, figura 15.
[53] Ferchiou 1989, 206, n. VIII.1.4.

In Tripolitania, invece, sono i mausolei della necropoli sud di Ghirza a presentare numerosi capitelli corinzi figurati con teste e busti di divinità locali,[54] che sembrano rinviare ad un sostrato preromano di popolazioni dell'interno venute in contatto con l'ambiente semitico delle città sul mare. Un'altra prova in tal senso viene da una tomba a piramide di Wadi Merdum da cui proviene un capitello figurato in calcare di pilastro (ora al Museo di Tripoli)[55] con sfinge e leone su due fianchi e foglie al centro, dietro cui crescono stilizzati caulicoli da cui emergono senza calici i sottili steli delle elici e delle volute disposti a V secondo formule tipiche dell'ambiente africano (vd. sopra).

Per la Spagna citiamo soltanto il capitello figurato in arenisca da una casa di Italica, ora al museo di Siviglia (Figura 17.11d), datato all'età augustea,[56] che ugualmente ripropone l'acanto carnoso tipico dell'ellenismo italico, lo spesso astragalo alla base del *kalathos* e bustini di divinità tra le volute libere: anche in questo caso siamo in un periodo in cui già sono introdotti nell'architettura ufficiale i capitelli corinzi di tradizione urbana.

IL *REVIVAL* DEL CAPITELLO CORINZIO "NORMALE" E LA PERVASIVITÀ DELLO STILE TEODOSIANO

Abbiamo volutamente introdotto Roma e soprattutto Costantinopoli nel nostro discorso perché quanto avviene nelle due città in epoca tardoimperiale entra in un continuo rapporto dialettico con le forme decorative provinciali che già documentavano una persistenza o una ripresa di forme più antiche: tali incontri si verificano sotto forma di influenze giunte in vario modo nelle province, ma soprattutto attraverso le iniziative di architettura cristiana.

Ci limitiamo a citare due casi: i capitelli in marmo di S. Paolo fuori le Mura a Roma e quelli in pietra locale di Segermes nella Proconsolare, che dimostrano la pervasività del nuovo stile teodosiano che tuttavia non soppianta le tradizioni locali, creando nuovi tipi quasi in ciascuna area dell'Impero dove era richiesta un'architettura di prestigio.

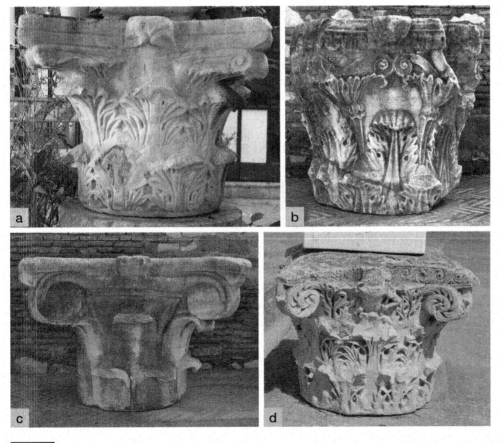

Figura 17.12. *Capitelli corinzi. A: Roma, S. Pudenziana, da San Paolo fuori le Mura; B-C: Roma, San Paolo fuori le Mura; D: Cartagine, museo della Byrsa, da Segermes (foto: P. Pensabene).*

[54] von Mercklin 1962, n. 320.
[55] von Mercklin 1962, n. 473.
[56] Díaz Martos 1985, 185, n. K1; Gutiérrez Behemerid 1992, n. 924.

A S. Paolo fuori le Mura erano presenti:[57] nell'arcone trionfale capitelli ionici d'importazione tasia, ma rifiniti da officine locali; nelle navate capitelli corinzi di reimpiego di età severiana, capitelli corinzi teodosiani d'importazione proconnesia e nello stile costantinopolitano (Figura 17.12a), capitelli corinzi di tardo IV sec. d.C. che riprendono motivi dei capitelli costantinopolitani (vd. gli occhielli tra i lobi delle foglie: Figura 17.4a), ma inserendoli nella tradizione urbana e creando di fatto un nuovo stile (Figura 17.12b). Infine si hanno capitelli compositi a foglie lisce di pieno IV sec. d.C. di produzione urbana (Figura 17.12c), che trovano una vasta risonanza nell'architettura tardoimperiale di Roma perché s'ispirano a quelli di reimpiego del transetto e delle colonne vitinee dell'edicola della basilica di S. Pietro.

A Segermes sono stati reimpiegati nella basilica cristiana due capitelli corinzi con influssi del composito nelle volute[58] (Figura 17.12d): le due corone di foglie ad acanto dentellato con grandi zone d'ombra ad occhiello mostrano chiari influssi dell'acanto teodosiano, mentre la forte riduzione in altezza della zona del *kalathos* destinata all'apparato vegetale superiore, come anche l'unica foglia del calice da cui si origina direttamente la spirale delle volute, sono da ritenere gli apporti delle officine locali; lo stesso per le piccole figure di stagioni nascenti da un cespo d'acanto che occupano la piccola zona libera del *kalathos* tra le foglie superiori e sostituiscono il fiore dell'abaco con la loro testa, o con aquile nella stessa posizione nel secondo capitello. Va sottolineato come la tradizione africana ben evidente nei capitelli ionici e compositi[59] del II e III sec. d.C. di occupare del tutto con un elemento vegetale il cerchio delle volute, o di arricchirle vegetalizzando le spirali, interagisce con tipi di capitelli compositi costantinopolitani in cui appunto la spirale delle volute è sostituita da rosette o altri elementi vegetali.

Ma questa coesistenza di tradizioni locali più antiche, influssi costantinopolitani e uso di pietre dalle cave regionali è un fenomeno che si registra in molte località anche distanti tra di loro. Proprio tra IV e V sec. d.C. è documentato abbastanza frequentemente un altro fenomeno collegato al precedente, ma che assume una sua fisionomia particolare: l'apparire cioè di capitelli in pietra locale, questa volta con una programmatica adozione della forma canonica del corinzio con caulicoli, calici e steli delle elici e delle volute, che si contrappone dunque ai tipi dominanti il periodo tardo, caratterizzati dalla riduzione o assenza dei caulicoli e dei calici, anche se la resa generale è certamente iscritta nelle mode contemporanee. Citiamo solo alcuni casi di Aquileia (Figura 17.13a) e dell'Egitto copto da Bawit e da Saqqara con acanto dentellato (Figura 17.13b-c), ma l'esemplificazione si può estendere ad altre regioni del Maghreb, come mostra un capitello in calcare, con acanto spinoso, al museo della Byrsa a Cartagine (Figura 17.13d) e quello citato di Cherchel con un acanto che richiama i capitelli di S. Paolo fuori le Mura.

TRADIZIONI ELLENISTICHE NEI CAPITELLI E DECORAZIONI DELLA SIRIA E DELL'EGITTO DI MEDIA E TARDA ETÀ IMPERIALE

Nell'oriente dell'Impero un altro caso molto noto di persistenza è costituito da alcune zone interne della Siria, in particolare nella regione sud-orientale dell'Hauran, ad As-Suwayda e Qanawat, e in quella nord-occidentale, dove nel museo di Idlib (13 km a ovest di Ebla) sono raccolti anche i materiali di età imperale e tardo-imperiale.

Nel museo di As-Suwayda si conservano capitelli corinzieggianti figurati che si riallacciano direttamente a tradizioni ellenistiche per gli steli delle volute libere e la figura di divinità al centro (Figura 17.14a) di cui è riprodotta tutta la parte superiore del corpo; anche il capitello corinzio con il fiore dell'abaco sostituito da una protome di divinità barbata e con gli steli delle volute cordiformi (Figura 17.14b) rappresenta le modalità con cui in epoca piuttosto tarda (seconda metà IV – V sec. d.C.) si è trasformato il modello ellenistico. Pure interessante è la forma assunta da un capitello ionico dove la decorazione dell'echino è costituita da un'unica grande rosetta (Figura 17.14c) che richiama le disinvolte inserzioni di fiori nei capitelli ionici

[57] Brandenburg 2009.

[58] von Mercklin 1962, n. 447; Pensabene 1986, 409. Cfr. von Mercklin 1962, n. 568. Vd. inoltre Barsanti 1990, sull'arrivo in Tunisia di capitelli e marmi costantinopolitani che hanno introdotto le nuove forme presso le officine locali.

[59] Pensabene 1986, 416-422.

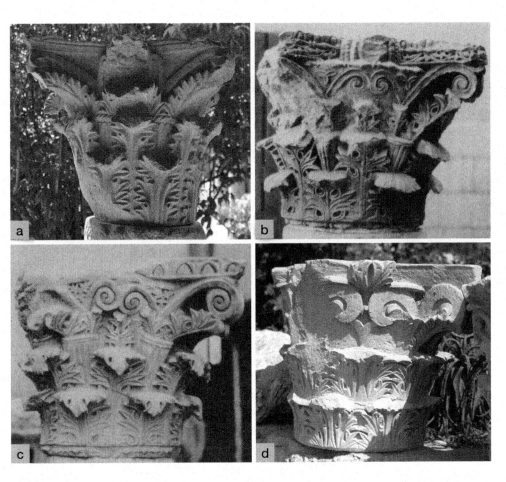

Figura 17.13. *Capitelli corinzi. A: Aquileia, museo (foto: P. Pensabene); B-C: Cairo, museo copto (da Pensabene 1993, tavola 68); D: Cartagine, museo della Byrsa (foto: P. Pensabene).*

africani. Nel museo di Idlib vi è un capitello corinzio che mostra una successione di tre stilizzati calici a V (Figura 17.14d) che richiamano la forma tipica dei capitelli di Volubilis, a cui rimanda anche l'abaco semplificato a tavoletta e il tondino/astragalo liscio alla base del kalathos: anche in questo caso non ci sono relazioni dirette tra le due località, ma le somiglianze sono dovute agli esiti di una comune ascendenza ellenistica. In Siria è evidente il netto valico che separa i capitelli e le basi in marmo da quelli in pietra locale che – quando di una qualità "tenera" facile ad essere scolpita, come a Gerasa – aveva permesso una lavorazione più esuberante e la conservazione delle tradizioni ellenistiche ad opera di officine che si erano formate lavorando le pietre del posto. Sono queste tradizioni a confluire nelle basiliche cristiane dell'interno, come Qalat Seman, dove danno luogo a manifestazioni decorative a dir poco eccentriche, in cui si mischiano anche gli influssi costantinopolitani.

Nel corso del lavoro sugli elevati architettonici di tradizione greco-romana in Egitto, ci ha colpito come molti edifici definiti "copti" fossero caratterizzati dalla presenza di elementi architettonici di tradizione tolemaica, quali ad esempio i frontoncini interrotti utilizzati come coronamenti di nicchie, o ancora capitelli corinzi che ripropongono lo schema di origine greca del corinzio con caulicoli organici e riprendono i motivi ellenistici degli occhielli a separare i lobi dell'acanto, ignorando o mescolandosi a tradizioni derivanti invece dall'architettura romana imperiale. Lo stesso vale per aspetti dell'elevato, come l'inclinazione delle pareti delle chiese e di altri edifici, ispirate ai *mastaba* di tradizione faraonica.

Si tratta di un fenomeno che si differenzia da quanto avviene a Costantinopoli in periodo teodosiano, dove si verifica la ripresa di alcune tradizioni ellenistiche, come di nuovo l'acanto ad occhielli nei capitelli e nei fregi con tralci vegetali, o la successione di *anthemia, kymatia* ionici e lesbici nelle cornici con un'esigenza di naturalismo, anche formulato nel linguaggio bizantino che ha le sue radici nell'architettura e nell'arte greca. In questi casi si tratta di scelte formali operate da officine che tuttavia circoscrivono tali ispirazioni all'antico in modo da non stravolgere la continuità delle tradizioni decorative imperiali.

Nell'Egitto copto invece si assiste al fenomeno della ripresa che non è sempre distinguibile, quando si tratti delle città dell'interno, dalla continuità di tradizioni locali. Infatti, se

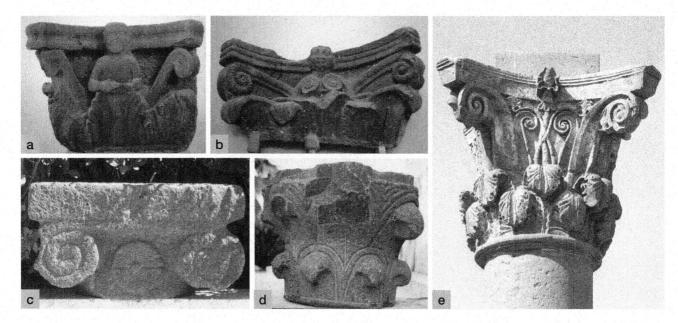

Figura 17.14. *Capitelli corin-*
zieggianti, corinzi e ionici.
A-C: As-Suwayda, museo;
D: Idlib, museo (foto:
P. Pensabene); E: Denderah,
ninfeo (da Pensabene 1993,
tavola 31).

nell'architettura pubblica di Alessandria si può parlare di uso di motivi decorativi tolemaici ancora fino all'età adrianea, come è ben visibile nelle cornici di granito di Assuan dei portali del recinto del Serapeo ingrandito in quest'epoca, tuttavia il diffondersi del marmo proprio nei monumenti pubblici a partire dal II sec. d.C. porta con sé le forme dell'architettura ufficiale romana, derivanti soprattutto dalla parte orientale dell'Impero.

Diversificata è la situazione nell'architettura privata di Alessandria, dove le necropoli di età imperiale, come quella di Kom es Shogafa, mostrano la continuità d'uso di motivi religiosi e decorativi faraonici e tolemaici nell'articolazione delle pareti e delle nicchie, per le quali tuttavia non è usato il marmo. Nelle città dell'interno, invece, monumenti come il ninfeo di Denderah, del II sec. d.C., dai capitelli corinzi con elici e volute libere, con sottili steli che s'incrociano e terminano con un piccolo fiore schematico a stella sotto l'abaco (Figura 17.14e) e, come il mausoleo di Dionysias nel Fayum e le tombe a tempietto della necropoli di Hermoupolis, testimoniano la continuità delle tradizioni tolemaiche. Lo stesso in città sul mare, come Marina el-Alamein:[60] qui, infatti, le piante e gli elevati architettonici delle case e delle tombe della media età imperiale ripropongono tradizioni egiziane e tolemaiche. Inoltre, nelle grandi cave di granito e porfido del Deserto Orientale e di Assuan, la tradizione tolemaica sembra continuare anche nei capitelli corinzi semi-rifiniti prodotti nelle cave, esportati a Roma e altrove.

Certo è che a partire dal tardo III sec. d.C., come testimonia la necropoli di Karga in uno dei deserti occidentali, e soprattutto nel IV-VI sec. d.C., proprio in centri distanti dal mare, si registra la presenza di decorazioni nella tradizione tolemaica nelle necropoli e anche nei complessi cristiani, insieme naturalmente ad altri motivi che risentono di diretti influssi dell'arte bizantina, ma con una libertà di interpretazione che permette di parlare di arte "copta", ben distinta ad esempio dalle manifestazioni architettoniche ad Abu Mina o ad Alessandria stessa, dove appunto nell'architettura pubblica (vd. le vie colonnate) predomina l'adesione all'arte ufficiale di Costantinopoli e l'importazione di manufatti marmorei dalle cave del Proconneso.

CONCLUSIONI

È con questa griglia di possibilità che abbiamo affrontato i casi specifici delle regioni citate, tentando di non isolare il fenomeno delle persistenze da quanto avveniva nell'architettura contemporanea alle loro manifestazioni. Tuttavia, se possiamo parlare di arte regionale è perché vi sono forme profondamente radicate in tradizioni preromane, che di fatto sono sempre presenti o latenti soprattutto nelle città dell'interno o periferiche, nelle quali l'uso della pietra locale, e non del marmo, favorisce il conservarsi di modalità di lavorazione e di formule decorative radicate

[60] Pensabene 2010, 206-210.

nel passato: si è visto come i monumenti funerari e gli antichi santuari di divinità locali contribuiscono al mantenimento di tali formule e rendono visibile la linea di separazione rispetto alle mode architettoniche provenienti dall'architettura ufficiale dell'Impero.

Si è però rilevato che in tutto il Mediterraneo s'individua in modo più riconoscibile il riemergere o la maggiore visibilità delle tradizioni locali e/o regionali a partire dal III sec. d.C., quando per varie ragioni storiche si allenta il rapporto con Roma e l'architettura ufficiale. Cambia parallelamente la composizione sociale della committenza e sempre maggiore è il ruolo dei vescovi e del clero nelle manifestazioni della nuova architettura cristiana. Continuano a costruirsi *domus* anche grandi, come testimoniano gli esempi di Cartagine e di Gemila, ma anche nell'ambito dell'edilizia cristiana privata si può stabilire una linea di demarcazione tra le città sul mare, più aperte alle importazioni di manufatti marmorei e alla pratica del reimpiego di elementi architettonici più antichi, e invece quelle dell'interno dove quasi per ogni centro si sviluppano stili locali: artigianati regionali, dediti alla decorazione architettonica, dove la dialettica tra tradizioni locali, arte ufficiale romana della piena età imperiale e nuove mode provenienti da Costantinopoli forniscono una delle chiavi per capire le istanze culturali della società.

BIBLIOGRAFIA

Barsanti, C. 1990. Tunisia. Indagine preliminare sulla diffusione dei manufatti di marmo proconnesio in epoca paleobizantina. In de' Maffei, F., Barsanti, C., Guiglia Guidobaldi, A. (a cura di), *Costantinopoli e l'arte delle province orientali*, Roma: Edizioni Rari Nantes, 429-436.

Barsanti, C. 1993. s.v. Capitello: area bizantina. In *Enciclopedia dell'arte medievale, IV*, Roma: Istituto della enciclopedia italiana, 200-214.

Brandenburg, H. 2009. Die Architektur und Bauskulptur von San Paolo fuori le mura. Baudekoration und Nutzung von Magazinmaterial im späteren 4. Jh., *Mitteilungen des Deutschen Archäologischen Instituts. Römische Abteilung*, 115: 143-201.

Brouquier-Reddé, V. 1992. *Temples et cultes de Tripolitaine* (Études d'Antiquités Africaines), Parigi: Éditions du CNRS.

Christofle, M. 1951. *Le Tombeau de la Chrétienne*, Parigi: Arts et Métiers Graphiques.

Díaz Martos, A. 1985. *Capiteles corintios romanos de Hispania: estudio, catálogo*, Madrid: Impenta Ideal.

Fellague, D. 2010. Le décor architectural de la basilique de Baelo Claudia : contribution à la connaissance de la chronologie de l'édifice, *Mélanges de la Casa de Velázquez, Nouvelle Série*, 40.2: 273-296.

Ferchiou, N. 1986. Le mausolée anonyme de Thuburnica, *Mélanges de l'École Française de Rome. Antiquité*, 98: 665-705.

Ferchiou, N. 1989. *L'évolution du décor architectonique en Afrique proconsulaire des derniers temps de Carthage aux Antonins : L'hellénisme africain, son déclin, ses mutations et le triomphe de l'art romano-africain*, Gap: Imprimerie Louis-Jean.

Gutiérrez Behemerid, M.A. 1986. *Capiteles de Barcino en los museos de Barcelona*, Barcellona: Universitat Autònoma de Barcelona.

Gutiérrez Behemerid, M.A. 1992. *Capiteles romanos de la península Ibérica*, Valladolid: Universidad de Valladolid.

LaBranche, C.L. 1966. The Greek figural capital, *Berytus Archaeological Studies*, 16: 71-96.

Lézine, A. 1960. *Architecture punique. Recueil de documents* (Publications de l'Université de Tunis, Faculté des Lettres, 1er série, Archéologie, Histoire, 5), Tunisi: Presses Universitaires de France.

Kenrick, P. (a cura di) 1986. *Excavations at Sabratha 1948-1951: A Report on the Excavations Conducted by K. Kenyon and J.B. Ward-Perkins* (Journal of Roman Studies Monograph, 2), Londra: Society for the Promotion of Roman Studies.

Kenrick, P. 2009. *Libya Archaeological Guides. Tripolitania*, Londra: Silphium Press.

Kraeling, C.H. 1962. *Ptolemais, City of the Libyan Pentapolis*, Chicago: The University Press.

Mahler, K.-U. 2006. *Die Architekturdekoration der frühen Kaiserzeit in Lepcis Magna* (Libya Antiqua Supplemento, 8), Worms: Wernersche Verlagsgesellschaft.

Mar, R., Pensabene, P. 2013. El Foro de Segobriga y la formación de la arquitectura imperial en la Hispania Romana: entre innovación y continuidades. In Sousa Melo, A., do Carmo Ribeiro, M. (a cura di), *História da construcão, arquiteturas e técnicas construtivas*, Braga: Candeias Artes Gráficas, 15-40.

Von Mercklin, E. 1962. *Antike Figuralkapitelle*, Berlino: Walter De Gruyter.

Morestin, H. 1980. *Le temple B de Volubilis* (Études d'Antiquités Africaines), Parigi: Éditions du CNRS.

Pensabene, P. 1982. *Les chapiteaux de Cherchel : Étude de la décoration architectonique* (Bulletin d'Archéologie Algérienne Supplemento, 3), Algeri: Bulletin d'Archéologie Algérienne.

Pensabene, P. 1986. La decorazione architettonica, l'impiego del marmo e l'importazione di manufatti orientali a Roma, in Italia e in Africa (II-VI d.C.). In Giardina, A. (a cura di), *Società romana e impero tardoantico, 3. Le merci, gli insediamenti*, Roma: Laterza, 285-429.

Pensabene, P. 1993. *Elementi architettonici di Alessandria e di altri siti egiziani* (Repertorio d'arte dell'Egitto greco-romano, Serie C, 3), Roma: "L'Erma" di Bretschneider.

Pensabene, P. 1999. Progetto unitario e reimpiego nell'Arco di Costantino. In Pensabene, P., Panella, C. (a cura di), *Arco di Costantino tra archeologia e archeometria* (Studia Archaeologica, 100), Roma: "L'Erma" di Bretschneider, 13-42.

Pensabene, P. 2010. Le abitazioni di Marina: modelli ellenistici in chiave alessandrina. In Raffaele, F., Nuzzolo, M., Incordino, I. (a cura di), *Recent Discoveries and Latest Researches in Egyptology. Proceedings of the First Neapolitan Congress of Egyptology (Naples, June 18th-20th 2008)*, Wiesbaden: Harroswitz Verlag, 201-220.

Pensabene, P. 2011. Tradizioni punico-ellenistiche a Volubilis. I capitelli corinzi e compositi, *Archeologia Classica*, 62: 203-278.

Pesce, G. 1953. *Il tempio d'Iside in Sabratha* (Monografie d'Archeologia Libica, 4), Roma: "L'Erma" di Bretschneider.

Rakob, F. 1979. Numidische Königsarchitektur in Nordafrika. In Günter Horn, H., Rüger, C.B. (a cura di), *Die Numider. Reiter und Könige nördlich der Sahara*, Bonn: Rudolf Habelt Verlag, 119-171.

Ramallo Asensio, S. 2004. Decoración arquitectónica, edilicia y desarrollo monumental en Carthago Nova. In Ramallo Asensio, S. (a cura di), *La decoración arquitectónica en las ciudades romanas de Occidente. Actas del Congreso Internacional celebrado en Cartagena entre los días 8 y 10 de octubre de 2003*, Murcia: Universidad de Murcia, 153-218.

Thouvenot, R. 1971. Sur quelques chapiteaux singuliers de Banasa, *Bulletin Archéologique du Comité des Travaux Historiques et Scientifiques*, 6: 245-253.

Whitcomb, D., Taha, H. 2013. Khirbat al-Mafjar and its place in the archaeological heritage of Palestine, *Journal of Eastern Mediterranean Archaeology and Heritage Studies*, 1.1: 54-65.

Whittow, M. 1990. Ruling the late Roman and early Byzantine city: a continuous history, *Past and Present*, 129: 3-29.

18

IMPERIAL STATUES IN URBAN CONTEXTS IN LATE ANTIQUE NORTH AFRICA

Anna Leone

Abstract

This paper focuses on the findings of imperial statues in various contexts of North African cities. From the perspective of Late Antique towns, in particular, there are some issues to consider: where were these late imperial statues to be dedicated? How did the use, function, and understanding of public spaces change? And finally, what evidence do we have to discuss the fate, use and reuse of these statues? The analysis considers dedicatory inscriptions and portraits from the Diocletianic period up to the end of the fourth century AD. Their location within the urban context provides some information on the display of these statues and the changing function of urban spaces.

INTRODUCTION

The nature, practice, and final phase of the imperial cult and its form have been the focus of increased study in recent years, which includes the reconsideration of the practice of dedicating imperial statues. The focus has been primarily on the city of Rome and the dedication, rededication and movement of statues within the urban setting.[1] The forums continued to be decorated with statues, where they were still functioning as public spaces. Imperial statues continued to be dedicated and occasionally redisplayed in the forums of the Urbs.[2] The aim of this paper is to look at the presence of imperial statues' dedications in Late Antiquity and their display in public spaces in North Africa. Although the recorded find-spots of statues are often vague and difficult to understand, a few well-dated cases allow us to point out some trends and directions that could be tested in future works.

THE IMPERIAL CULT AND PLACES OF VENERATION

Some new specific analyses and re-interpretations regarding Pagan practices have been posited in recent years, re-evaluating the quality of religious life in Late Antiquity; such revision has also taken into consideration the issue of the imperial cult. Alan Cameron, in his latest book *The Last Pagans of Rome*, argues that by the time legal prohibition of sacrifices was enacted, the practice had already formally ended.[3] A similar opinion on the weakness and purely symbolic value of cult practices in Late Antiquity has been expressed recently by Frank Trombley.[4] Focusing specifically on the imperial cult in Late Antiquity, he has suggested that the last religious practice (after the closure of temples) connected to the imperial cult was limited to incense burning in front of statues of emperors.

[1] On the analysis of the different practices, see Machado 2006. For a specific analysis of the different functions of the forums in the city of Rome in Late Antiquity, see Chenault 2012.

[2] Chenault 2012.

[3] Cameron 2011, 67.

[4] Trombley 2011.

According to Trombley, this is confirmed by the ecclesiastical historian Philostorgius, who condemned those Christians in Constantinople who offered incense and prayers in front of a statue of Constantine.[5] Trombley also points out that in the fourth century the imperial cult, and cult practices connected to it, were progressively replaced by panegyrics. This practice is also recorded in North Africa after the Roman presence, during the Vandal period, as demonstrated by several poems contained in the *Anthologia Latina*,[6] a time when the dedication of statues seems to disappear.[7] It must be noted that the continuity of Roman tradition in Vandal North Africa (fifth and early sixth century) is confirmed by inscriptions recording *flamines imperiales* and *sacerdotes provinciales* of the imperial cult.[8] In contrast, there is no evidence of statue dedications in the region during this period.

Attempts to examine evidence of the imperial cult in North Africa should also ideally go through an analysis of known cult buildings, as well as the final dedications of statues and their locations within the urban layout. However, as Trombley suggests, the presence of a statue of the emperor is not always clear evidence of his attendant cult and at the same time, unless there is a specific dedication, the locations of these cults are almost impossible to identify.[9] An attempt to recognize these complexes has been made by Pensabene,[10] who collected the data and discussed the issue from a North African perspective, beginning with the consideration that in many cases the presence of imperial statues bears evidence of the presence of cult practices and activities. He records imperial statues displayed in a number of public structures in North Africa, namely theatres, forums, civic basilicas, temples, and baths.[11] Acknowledging the impossibility of clearly identifying the effective presence or absence of the cult, this paper will concentrate specifically on the dedication of imperial statues; their locations, if known, in the urban topography and their use, meaning, and reuse with some references to the marble economy of Late Antique North Africa. In chronological terms, data discussed here date from the Diocletianic period up to at least the end of the fourth century.

STATUES AND URBAN SPACES

From the perspective of Late Antique cities there are some issues to consider: where were these late statues dedicated? How did the use, function, and understanding of public spaces change? And, finally, what evidence do we have to discuss the use, reuse, and fate of these statues? These questions have been addressed recently for the city of Rome, pointing out the continuity of dedication of statuary in the forums.[12] Although the practice continued, the way in which public statues were displayed in Late Antiquity changed, because the use of spaces changed substantially. As Roland R.R. Smith observes, honorific portraits in Late Antique Aphrodisias were increasingly displayed in the open area of the forum, in contrast to the earlier tendency to locate them in porticoes.[13] The same evidence appears also in North Africa, as at the Temple of Apollo in Bulla Regia. Some of the statues displayed in the porticoes and in the square in front of the temple were found in place. The square facing the temple was completely reorganized in the first half of the fourth century with the rededication of the

[5] Trombley 2011, 48.

[6] This collection consists of poems (signed or anonymous) of various subjects, periods, and dates. The principal corpus is the so-called *Codex Salmasianus*, dated to between the seventh and eighth centuries. Poems referring to Vandal North Africa are those of Felix (Chapter XVIII), Luxorius (Chapter XXIV), and other minor authors.

[7] By contrast, statue dedications continued for longer in the east. For a discussion on this, see Leone 2013, 116-118.

[8] For a record of all the inscriptions mentioning priests of the imperial cult in North Africa, see Leone 2013, Appendix 1.

[9] For some discussion on the processions and the location of imperial cult statues in public monuments in Rome, see Elkins 2014.

[10] Pensabene 1994, 153.

[11] For a more detailed discussion of the evidence, see Leone 2013, 193-195.

[12] It has been recently considered that forums in the city of Rome had different functions. In the fourth and fifth centuries, Trajan's Forum records dedications only to civilians: Chenault 2012.

[13] Smith 1999, 171.

inscription of a statue of a *togatus* and some bases of statues reused as column bases (Figure 18.1).[14] The statues of gods were left in place and maintained their original locations within the architectural framework, while the newly dedicated (although mostly recycled in this context) statues were displayed in the space facing the temple. A similar reconsideration of spaces is recorded in baths (see below).

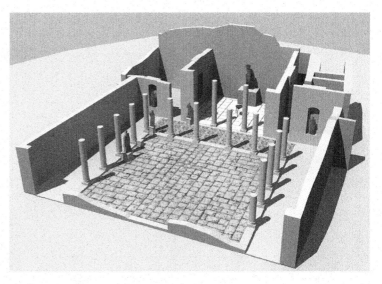

IMPERIAL STATUES IN URBAN CONTEXTS: THE ARCHAEOLOGICAL EVIDENCE FOR NORTH AFRICA

Regarding imperial statue finds in urban areas, data have been collected primarily through the *Last Statues Project* database,[15] with some additional information. Inscriptions in particular suggest that the dedication of imperial statues continued in North Africa until the end of the fourth century. Overall, inscriptions dedicated in North Africa in Late Antiquity reveal that Constantius I and Constantine I received a higher number of dedications (Figure 18.2). It is also apparent that the dedication of imperial statues continued at the same rate in both major and minor provincial centres.[16] At first glance, it appears that the majority of imperial statue dedications have been found in forums (Figure 18.3), but the situation is probably more complex.

Figure 18.1. *Reconstruction of the square in front of the temple of Apollo at Bulla Regia, with the relocation of statues found during the excavation (from Leone 2013, figure 29).*

The evidence is certainly biased by the nature of the data. First, most inscriptions were found out of context; for example, their original locations are unknown. It is therefore very difficult to make clear statements on the distribution of these statues within the urban layout. Secondly, since in the majority of these cases only the inscriptions were preserved, it is impossible to fully understand the nature of these statues (such as whether they were reused, re-carved, etc.). Thirdly, inscriptions may have been relocated in antiquity without any record of the move.

To bypass this problem of data bias, it is necessary to consider all the evidence of the latest preserved and published dedicated portraits of emperors, starting from the Diocletianic period in North Africa. In doing so it is necessary to stress that this paper does not aim to discuss stylistic interpretations or identifications, but rather consider issues of reuse and location, or relocation, of statues in urban contexts. There are a very limited number of imperial portraits that can be identified with this period with any level of certainty.

The first is a cuirassed portrait of one of the Tetrarchs, possibly Diocletian, from Utica whose original location is not known.[17] The number of such works increases at a later date and there are more references to the Constantinian period, primarily from Carthage. These include a portrait of Constantine, probably re-carved from an unidentified portrait,[18] and another possibly of Constantius II,[19] both found in the portico running to the north of the Antonine Baths. The location of these portraits offers some points of discussion on the display of Late Antique statuary. As pointed out by Yvon Thébert, it appears that the centre of propaganda shifted progressively from the forum to the baths, with the presence of statuary dedication to both private parties and emperors located in these areas.[20] The Antonine Baths were probably abandoned at the time of the

[14] Merlin 1908, 8. For a detailed discussion of statuary display in the temple, see Leone 2013, 168-176. Other statues to civilians were dedicated in the square but they have not been found or were found broken.

[15] http://laststatues.classics.ox.ac.uk/database/search3.php (last accessed 26 July 2014).

[16] Tantillo 2010, 185.

[17] Salomonson 1960; *Last Statues* 1029: http://laststatues.classics.ox.ac.uk/database/detail.php?record=1029 (last accessed 26 July 2014).

[18] *Last Statues* 1062: http://laststatues.classics.ox.ac.uk/database/detail.php?record=1062 (last accessed 26 July 2014) (Tunis, Bardo Museum, inv. no. C 77). See also Prusac 2011, 147.

[19] *Last Statues* 1061, indicated as an unknown emperor: http://laststatues.classics.ox.ac.uk/database/detail.php?record=1061 (last accessed 26 July 2014); Picard 1957.

[20] Thébert 2003, 446-447.

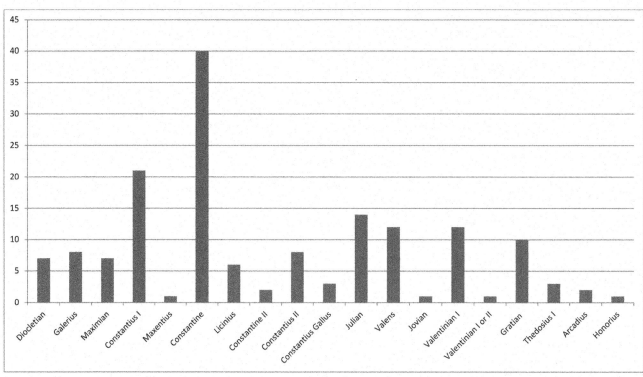

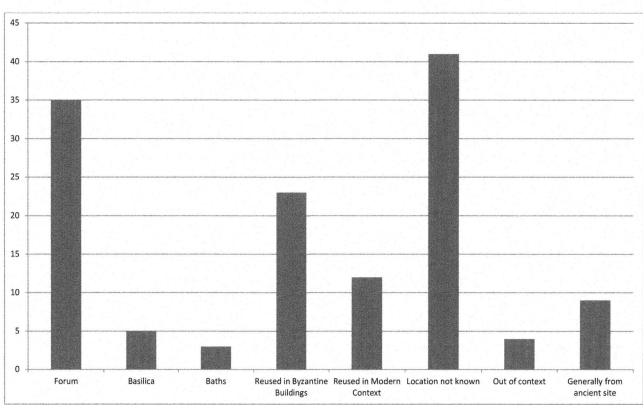

Vandal conquest, due to a structural collapse of the complex that probably occurred around AD 425.[21] Therefore, these were likely the last statues to be dedicated in the complex, which was reduced in size during its Byzantine reorganization. However, the statues of the emperors, as in the case of Aphrodisias, were not displayed within the structure but rather in the portico, filling the empty space of an open area. At Timgad, bases of statues were found in the 'Grand thermes du Sud', near the entrance, dedicated to Valerianus, his son Gallienus, Gallienus' wife

[21] The dating is suggested on the basis of a coin hoard found under a collapsed vault of the building. For a discussion on the fate of the Antonine Baths in Carthage, see Leone 2013, 160-162.

Salonina, and their sons.[22] The Baths of Julia Memmia in Bulla Regia are a case in which there is no specific reference to the imperial cult, but there was a display of honorary statues recorded at the entrance to the baths, showing the same use of the bath space.[23] The display of imperial as well as private statuary in porticoes suggests a re-interpretation of public spaces in Late Antiquity, as indicated by Thébert.[24] These displays now do not appear to be concentrated primarily in the forum area, but in other porticoes and squares within the urban context; they are not necessarily concentrated in one specific part of the city, but do exist in areas still frequented by many people. Although the number of dedicated statues is reduced in Late Antiquity, the display of these statues occurs in a much larger variety of contexts. Several inscriptions from North Africa recorded by Lepelley and Witschel attest to the movement and relocation of statues from derelict urban spaces (for example: *De Sordido Loco Translata*).[25]

Even buildings and public spaces that were not built to be decorated by statues, progressively acquired this function. This new form of display may also refer to a new interpretation of statuary and its functionality that I will reconsider later. Several statues of emperors were found in theatres in various contexts, but none that specifically date to Late Antiquity. A related find is that of an incised drawing in the theatre of Lepcis Magna, on the balustrade of the orchestra. Details of this incision have been published by Caputo who identified the subject depicted as the Emperor Julian,[26] although this identification poses numerous problems and the arguments proposed in its defence are very weak at best (the main reason given is that the figure holds a globe and therefore must be of a philosopher). He dates it to the fourth century, although does not provide any specific reason to support this suggested chronology. It should be stressed that generally theatres at the end of the fourth century were in a state of disrepair and they were mostly abandoned after the Vandal conquest of North Africa.[27]

At the same time, evidence of the late dedication of imperial statues is recorded in more traditional contexts, such as forums and sometimes in structures where a connection with the imperial cult has been made. This is the case of Carthage and its forum on the Byrsa Hill. Here, a head of an unidentified emperor dated to the fourth century was found by Ferron and Pinard in 1954.[28] They refer to the head as being found near the large apsidal structure, which is the civil basilica of the city. It has been suggested by Gros that the structure was probably also used for the imperial cult, as statues of several other earlier emperors come from the area and were probably displayed there. In proximity to this area, two altars dedicated to the *gens Augusta* have also been found. The complex was already in a state of disrepair at the end of the fourth century and it was completely abandoned in the Vandal period, to be reused in the Byzantine period and transformed into a church.[29] A similar function – as a location for the imperial cult – has also been suggested for Basilica I in Sabratha, where the place of the cult has been identified in an apsidal area within the structure.[30] The building was completely stripped of its marble decoration, probably during the fourth century. The architectural elements were collected in the basement of the *Capitolium*, while most of the statues were stored in a room of the complex that was later blocked up when the complex was transformed into a church.[31]

Figure 18.2. (opposite, top) *Evidence of dedications of imperial statues in North Africa (data from* http://laststatues.classics.ox.ac.uk/database/search3.php, *last accessed 26 July 2014).*

Figure 18.3. (opposite, bottom) *Location of imperial statues with dedicated bases (data from* http://laststatues.classics.ox.ac.uk/database/search3.php, *last accessed 26 July 2014).*

[22] The first inscription is dated to the first half of the third century: *CIL* VIII 2380; Boeswillald *et al.* 1905, 277-278: [*Imp(eratori)*]*Cae[sari P. Li/cinio Veleri]ano / [Invi]cto Pio Fel/ici Aug(usto), / pontif(ici) max(imo), Ger(manico) / Max(imo), trib(unicia) potestate / III, co(n)s(uli) III, p(atri) p(atriae), / proco(n)s(uli), / resp(ublica) col(oniae) Tha/mug(adensis) devota / numini ma/iestatiq(ue) eo/rum.* For the second inscription, see Cagnat 1894, 362, no. 75 (suggested chronology AD 255-256): *Corneliae / Saloninae / Aug(ustae), coniu/gi d(omini) n(ostri) P. Licini(i) / Gallieni, / matri / P. Corneli(i) / Licini(i) Vale/riani nobi/lissimi Caes(aris) / Aug(usti) et cas/tror[u]m se/natu[s --- / --- / ---].*
[23] For a discussion on the case of Bulla Regia, see Leone 2013, 182.
[24] See above note 15.
[25] Lepelley 1981; 1994; Witschel 2007. For a detailed consideration of all the *formulae*, see Lepelley 1994.
[26] Caputo 1971-1974.
[27] For a discussion on this see Leone 2007.
[28] Ferron and Pinard 1955. For dating of the statue head see Jucker 1967; *Last Statues* 1064: http://laststatues.classics.ox.ac.uk/database/detail.php?record=1064&_submit=Go (last accessed 26 July 2014).
[29] Gros 1985, 113-115.
[30] For a detailed discussion and further bibliography see Leone 2013, 226.
[31] These statues were found during the excavation of the building: see Leone 2013, 206-208 with further bibliography.

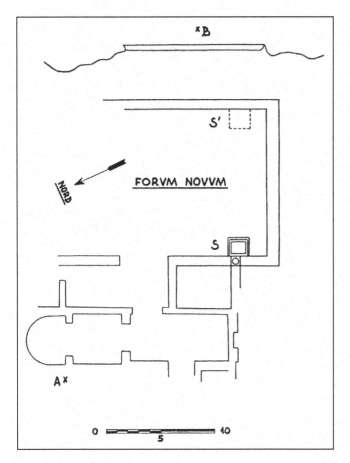

FORVM NOVVM

Figure 18.4. *Thubursicum Numidarum,* forum novum: *detail with the location of the finding of the two colossal statues (from Sassy 1953, figure 4).*

USE AND REUSE: COULD IMPERIAL STATUES BE REUSED?

The last significant case considered in this paper of a Late Antique forum displaying a range of statues of emperors is the *forum novum* of Thubursicum Numidarum, built *ex novo* in the second half of the fourth century when the old forum was abandoned, perhaps due to an earthquake. A number of recycled materials that come from the forum area deserve some consideration. This area saw a significant amount of material recycling and redecoration with statues, as indicated by an inscription. Two further inscriptions refer to the transfer of two statues – of Trajan and Constantine,[32] respectively – from the old forum to decorate the complex. Similarly, a fourth-century inscription refers to the dedication of two colossal statues (*Colossi*) with no specific reference to the figures represented by these monumental works.[33] The two bases were displayed facing each other in the *forum novum,* and the description of the excavation by Sassy indicates that two monumental statues, one representing Marcus Aurelius and one representing Lucius Verus (although only the feet are preserved), were found collapsed in close proximity (Figure 18.4).[34] The specific absence in the base inscriptions of the names of the two emperors may indicate that everyone was familiar with the portraits, or that they were displayed uniquely for their artistic value as monumental statues.[35]

A similar question related to the function and identification of statuary may be posed in the case of a portrait from North Africa representing Caracalla. The bust rests on a base in which the name of the emperor was changed to Constantine and with the inscription *Numi Constantini,* at a much later date (although the inscription refers specifically to the 'Genius of the Emperor'). Galinsky stressed that from a legal perspective it was officially prohibited to rename an existing statue of an emperor; for this reason it has been suggested that the statue may have been on display in a private context.[36] In terms of recycling, these last two cases attest to the cheapest way to reuse material for display. Evidence from statuary suggests that different levels of reuse occurred in these cities, and that these various levels also reflected various costs. Statues could have been specifically sculpted, re-carved from earlier statues, or even reused as they were and certainly transferred to different parts of the city.[37] These options had different costs, and obviously the availability of marbles and the budget played an important role in the choices that were made. Significant in this respect is the inscription recorded at Madauros, where the text specifically indicates that the dedicated statues in the public areas were imported from elsewhere.[38] Such activity suggests a market on various levels as well as the possibility of using different types of marble materials.

Bianchi, in his work on the third-century and fourth-century portraits from Lepcis Magna, highlighted that the majority of later portraits were re-carved.[39] Although systematic studies on this subject are lacking, several other examples are known from different parts of North Africa, such as the two Tetrarchs from Utica and Bulla Regia.[40] The increasingly common practice of

[32] *ILAlg* 1247 and 1274. See also Leone 2013, 112.

[33] Witschel 2007.

[34] Sassy 1953.

[35] For a more detailed discussion, see Leone 2013, 111-114.

[36] Galinsky 2008, 6. For a detailed discussion on the finding of this statue, see also Leone 2013, 118.

[37] The re-carving process was probably sometimes used to maintain aspects of the original work. One theory is that on occasion this may have been an intentional practice (Galinsky 2008, 4).

[38] *ILAlg* 4011.

[39] Bianchi 2005.

[40] Prusac 2011, 146-147.

re-cutting and re-carving recorded in Late Antiquity also implies, according to Kinney, that most of the statues removed from display were not destroyed but were probably stored instead.[41] In some buildings, such as theatres, this process may have started as early as the second half of the fourth century. This was probably the case in Carthage where a large number of statues from the theatre and the odeon were relocated to a nearby cistern. A market for reused statuary that we simply cannot follow must have existed. In support of this hypothesis is the case of Markouna (Verecunda),[42] where inscribed marble slabs and six marble portraits of the imperial family were found stored in a room in the forum. The portraits are of Young Faustina, Lucius Verus, Julia Domna, Septimius Severus, Caracalla, and Commodus. A similar case is that of Zitha/Ziane, where in one room in the forum 16 perfectly preserved statues were found. These are now at the Louvre, on the floor together with marble heads representing Tiberius, Claudius, and Lucilla.[43] It is striking that these statues were not broken but were carefully removed and deposited all together in one room. This suggests that they were not to be burnt or buried, but instead tagged for reuse. The discovery of statues in excellent condition along with marble materials all in one room of a derelict public building seems to confirm the idea that the planned dismantling of public buildings by the municipality appears to have started in the second half of the fourth century in some centres.[44] In this process statues were probably stored, as they were in the past, with the aim of being reused. This may also have been the case at the basilica of Sabratha mentioned earlier. It is possible that these storerooms were connected to marble workshops, although we know very little about local workshops and their statuary, especially in Late Antiquity. In North Africa there is only one case where the presence of a marble workshop has been suggested, at the Antonine Baths in Carthage. This identification is based on the fact that in one of the rooms of the basement were two pillars clearly cut to allow the passage of large column shafts, while in another room a large number of fragments of columns ready to be worked were found along with a number of statues. The chronology of the workshop has been placed between the fourth century (when the building was probably abandoned due to a structural collapse) and the early fifth century, in connection with the Byzantine restoration of the complex.[45]

CONCLUSIONS

In conclusion, statuary within an urban context as an element of decoration beyond veneration still appears to have been very important at least until the mid-fourth century. The availability of marbles and marble statues was still an important factor; although fewer dedications were taking place, anything that was necessary to supply decorative elements was permitted, leading also to the removal and storage of statues. It was still possible to purchase statues and this was within reach of even the most modest budget. It is difficult to say whether statues of emperors maintained a specific cult function (such as burning incense or other practices), but their reuse in some contexts, such as the depictions of Lucius Verus in Thubursicum Numidarum or that of Caracalla at Rusicade, suggests that in their last periods of functionality some of these works were seen above all as statues, beyond and irrespective of the subject of their portraiture.

BIBLIOGRAPHY

Baratte, F. 1983. Les portraits impériaux de Markouna et la sculpture officielle dans l'Afrique romaine, *Mélanges de l'École Française de Rome. Antiquité*, 95: 785-815.

Bianchi, L. 2005. Ritratti di Leptis Magna fra III e IV secolo, *Archeologia Classica*, 56: 269-301.

Boeswillald, E., Ballou, A. and Cagnat, R. 1905. *Timgad*, Paris: Leroux.

Cagnat, R. 1894. Chronique d'épigraphie africaine, *Bulletin Archéologique du Comité des Travaux Historiques et Scientifiques*: 337-363.

Cameron, A. 2011. *The Last Pagans of Rome*, Oxford: Oxford University Press.

[41] Kinney 1997.

[42] Baratte 1983.

[43] For a detailed discussion on these findings and for a complete bibliography, see Leone 2013, 148.

[44] For a detailed recording see Leone 2013, 181-185.

[45] Leone 2013, 229-232.

Caputo, G. 1971-1974. Graffiti figurati al teatro di Leptis Magna: Dea Roma e busto di Giuliano l'Apostata, *Dioniso*, 45: 193-200.

Chenault, R. 2012. Statues of senators in the Forum of Trajan and the Roman Forum in Late Antiquity, *Journal of Roman Studies*, 102: 103-132.

Elkins, N.T. 2014. The procession and the placement of imperial cult images in the Colosseum, *Papers of the British School at Rome*, 82: 73-107.

Ferron, J. and Pinard, M. 1955. Les fouilles de Byrsa : 1953-54, *Cahiers de Byrsa*, 5: 31-264.

Galinsky, K. 2008. Recarved imperial portraits, *Memoirs of the American Academy in Rome*, 53: 1-25.

Gros, P. 1985. *Mission archéologique française à Carthage. Byrsa, 3. Rapport sur les campagnes de fouilles de 1977 à 1980 : La basilique orientale et ses abords* (Collection de l'École Française de Rome, 41), Rome: École Française de Rome.

Gros, P. 1995. Le culte impérial dans la basilique judiciaire du forum de Carthage, *Karthago*, 23: 46-56.

Jucker, H. 1967. Zwei Konstantinische Porträtkopfe in Karthago. In Rohde-Liegle, M., Cahn, H.A. and Ackermann, H.C. (eds), *Gestalt und Geschichte: Festschrift Karl Schefold, zu seinem sechzigsten Geburtstag am 26. Jan. 1965*, Bern: Francke, 121-132.

Kinney, D. 1997. Spolia: damnatio and renovatio memoriae, *Memoirs of the American Academy in Rome*, 42: 117-148.

Leone, A. 2007. *Changing Townscapes in North Africa from Late Antiquity to the Arab Conquest*, Bari: Edipuglia.

Leone, A. 2013. *The End of the Pagan City: Religion, Economy, and Urbanism in Late Antique North Africa*, Oxford: Oxford University Press.

Lepelley, Cl. 1981. *Les cités de l'Afrique romaine au Bas-Empire, tome II. Notices d'histoire municipale*, Paris: Études Augustiniennes.

Lepelley, Cl. 1994. Le Musée des statues divines : la volonté de sauvegarder le patrimoine artistique païen à l'époque théodosienne, *Cahiers Archéologiques*, 42: 5-15.

Merlin, A. 1908. *Le Temple d'Apollon à Bulla Regia* (Notes et documents publiés par la Direction des Antiquités et Arts, 1), Paris: Leroux.

Machado, C. 2006. Building the past: monuments and memory in the forum Romanum. In Bowden, W., Gutteridge, A. and Machado, C. (eds), *Social and Political Life in Late Antiquity*, Leiden: Brill, 157-192.

Pensabene, P. 1994. Gli spazi del culto imperiale nell'Africa Romana. In Mastino, A. and Ruggeri, P. (eds), *L'Africa Romana. Atti del X convegno di studio (Oristano, 11-13 dicembre 1992)*, Sassari: Gallizzi, 153-168.

Picard, G. 1957. Un portrait présumé de Constance II à Carthage, *Monuments et mémoires, publiés par l'Académie des Inscriptions et Belles-Lettres (Fondation Piot)*, 49: 83-91.

Prusac, M. 2011. *From Face to Face. Re-carving of Roman Portraits and the Late Antique Portrait Art*, Leiden: Brill.

Sassy, G. 1953. Note sur une statue impériale de Thubursicum Numidarum (Khamissa), *Libyca*, 1: 109-113.

Salomonson, J.W. 1960. Ein unbekanntes Tetrarchporträt aus Nordafrika in Leiden, *Oudheidkundige mededelingen uit het Rijksmuseum van Oudheden te Leiden*, 41: 59-68.

Smith, R.R.R. 1999. Late Antique portraits in a public context: honorific statuary at Aphrodisias in Caria, AD 300-600, *Journal of Roman Studies*, 89: 155-189.

Tantillo, I. 2010. I costumi epigrafici: scritture, monumenti, pratiche. In Tantillo, I. and Bigi, F. (eds), *Leptis Magna. Una città e le sue iscrizioni in età tardoromana*, Cassino: Università degli Studi di Cassino, 173-203.

Thébert, Y. 2003. *Thermes romains d'Afrique du Nord et leur contexte méditerranéen* (Bibliothèque des Écoles Françaises d'Athènes et de Rome, 315), Rome: École Française de Rome.

Trombley, F.R. 2011. The imperial cult in Late Roman religion (ca. A.D. 244-395): observations on the epigraphy. In Hahn, J. (ed.), *Spätantiker Staat und religiöser Konflikt: imperiale und locale Verwaltung und die Gewalt gegen Heiligtümer* (Millennium Studies, 34), Berlin: Walter De Gruyter, 19-54.

Witschel, C. 2007. Statuen auf Spätantiken Platzanlagen in Italien und Afrika. In Alto Bauer, F. and Witschel, C. (eds), *Statuen in der Spätantike*, Wiesbaden: Reichert, 113-170.

CONCLUSION

19

DE AFRICA ROMAQUE: SOME CONCLUDING THOUGHTS[1]

R. Bruce Hitchner

'Concerning the original inhabitants of Africa, the settlers that afterward joined them, and the manner in which they intermingled (*aut quomodo inter se permixti sint*)'

Sallust, *Bellum Iugurthinum*, XVII[2]

Sallust's words capture succinctly a core truth about the human history of North Africa in Antiquity: it is best understood as the story of the intermingling of local and Mediterranean peoples and their cultures. For much of the late nineteenth and twentieth centuries, historians and archaeologists, writing in the shadow of European imperialism, seemed to forget 'the manner in which they intermingled' preferring instead a narrative that privileged Punic and Roman hegemony or domination over the native inhabitants. The intermingling process, to pursue Sallust's formulation, manifested itself to varying degrees in almost every aspect of life across almost two millennia, resulting in a distinctively African-Mediterranean cultural world. The papers in this volume demonstrate this repeatedly with new insights and approaches to our knowledge and understanding of ancient North Africa.

By comparison with Northern Europe and of course the Mediterranean, our knowledge of Africa during the first millennium BC is frustratingly inadequate. However, as David Mattingly's stimulating paper makes clear (Chapter 2), the emerging picture of greater agricultural intensification and nascent forms of urbanism at sites such as Althiburos, Mdidi, Bagat, and Garamantian settlements further to the south like Zinkekra and Jarma, fits well with contemporary trends in western Eurasia. Although the true character of these centres remains enigmatic, what we do know suggests plausible comparison materially and culturally with the Hallstatt and La Tène *oppida* of central and Western Europe. It is entirely realistic to imagine an African hinterland by the mid-to-late first millennium comprised of numerous autonomous agro-pastoral communities (the 'tribes' of Herodotus and later writers), dominated by an elite buried in impressive monumental tombs – as David Stone's carefully argued paper shows (Chapter 4) – and centred on fortified proto-urban sites, many of which later evolved into towns in the Roman period. That these communities were in touch to various degrees with the Punic towns and *emporia* along the North African littoral is highly probable, particularly those nearer to the coast (was olive cultivation found at Althiburos in the early eighth century a by-product of this contact?). There seems no reason to believe that Carthage or any of the Punic coastal enclaves exerted the deep and substantive influences on African urbanism once attributed to them.

A number of papers in this volume investigate the contribution of Punic influences in North Africa, particularly in the architectural realm. This used to be more settled scholarly terrain, but as the nuanced papers by Stefano Camporeale, Patrizio Pensabene, and Niccolò Mugnai reveal,

[1] I would like to thank Julia Nikolaus, Nick Ray, and Niccolò Mugnai for kindly inviting me to write a concluding paper.
[2] http://ancienthistory.about.com/library/bl/bl_text_sallust_jugurth_1.htm

a true middle architectural ground is present, combining local Punic, Hellenistic, and Roman traditions. Camporeale (Chapter 5) demonstrates that while *opus quadratum* may have Phoenician-Punic antecedents, a hybrid African variant quickly emerges. A Punic origin for *opus africanum* is even less certain, with south Italian and Sicilian antecedents a distinct possibility. But, as with *opus quadratum*, it is in Africa in the Roman period, rather interestingly, that *opus africanum* takes true hold.

This architectural heterogeneity is highlighted by Mugnai at Sala (Chapter 16), a Punic *emporium* in Morocco, where the capitals in the area of the forum again show Punic, Hellenistic, and native influences emanating not just from Carthage and the Mediterranean, but more directly from nearby Volubilis and, to some extent, from Caesarea (Cherchel). The continuity of Punic-Hellenistic architectural traditions well into the Roman and Late Antique periods is an important theme of Pensabene's thematically wide-ranging paper (Chapter 17). But as he reminds us there was a divide between architectural developments in the coastal cities and the urban centres of the interior, the former being more deeply connected to Mediterranean trends than the latter, a topic to which we will return below. Pensabene also draws attention to the crucial role played by African municipal aristocrats and later bishops in monumental and domestic building in the cities, indicative of the continuing power of local headmen. David Stone's monumental elite tombs are replaced by the legitimizing Roman-style symbols of prestige and authority.

If the Africa prior to and under the imposition of Roman power is at last coming into fuller view, a number of papers in this volume remind us, to borrow the title from David Mattingly's book on Britain, that Africa was very much an '*Imperial Possession*'. Rome's blatant will to rule everywhere, even to the edge of the Sahara, is likewise captured eloquently in Andy Merrills' insightful study of Cornelius Balbus' triumph (Chapter 9) with its chaotic list of conquered towns and toponyms deep in the African interior. It was not enough to annex the rich agricultural plains of Punic Africa and Numidia; the piling up of new conquests as far as the Garamantian oases was the unquestioned objective of Roman power to be authenticated through a triumph before the Roman people.

Yet Rome had cast an envious eye on the Maghreb's agricultural richness well before Balbus' triumph. As with Sicily after the first war with Carthage, Punic Africa and the new client kingdom of Numidia following the Second Punic War were exploited by Rome for the much-needed grain they could provide to its armies in Greece and Asia Minor. And as Matthew Hobson forcefully argues (Chapter 8), once Carthage was destroyed, Rome's heretofore informal practice of Empire (epitomized in the maintenance and exploitation of a client Carthaginian state prior to the Third Punic War) was replaced by formal mechanisms: provincial government, troops, colonists, investors, and centuriation in the former Punic territory (excluding local cities allied to Rome). We may not be certain of the pace of this process, but of its ultimate intent, as Hobson shows, there can be little doubt.

The history of the African economy under the Empire is well known. That Africa, particularly the Proconsular province and Numidia, was deeply and productively integrated on both Mediterranean-wide and regional levels into the imperial economy is illustrated in Elyssa Jerray's detailed analysis (Chapter 12) of the recently discovered amphora production centres at Zitha and other locations along the southern Tunisian and Western Libyan coast active under the Empire. The amphorae, chiefly Africana I and III imitations, were probably used for the storage and transport of locally-produced fish sauce, olive oil, and perhaps wine in a region, once formally thought to be agriculturally marginal, but which now appears to have been connected both to the northern coast of Tunisia and the broader Mediterranean trade network.

While we know much about African exports, Ben Russell's paper (Chapter 13) focuses on two heretofore understudied imports: brick and tile, and fine stone. Long thought to function chiefly as ballast for the return journey of grain and oil shipped from Italy, Russell makes a convincing case that bricks and tiles were a profitable commodity used chiefly in the construction of baths and basilicas in coastal and immediate hinterland cities. And it is a particularly salutary reminder of the degree to which the adoption of Roman building types extended not just to their design and purpose, but to the level of building materials employed. The existence of a similar market in imported stone from Italy, Greece, Egypt, and Asia Minor, serving the same cities and same types of buildings including houses, shows how this incorporation of foreign

building materials continued well into the imperial period as symbols of what constituted evolving 'Roman' cultural forms. However, there were limits to this process of cultural adoption as the relative absence of foreign brick, tile, and fine stone in Roman-style buildings in the cities of the interior makes clear. This reminds us that, as with other provincial hinterlands, Roman (and Punic for that matter) influences were perhaps as much proscribed by factors of distance and difficulties of transport as by the forces of local culture.

Burial practices reflect the impact of both local and foreign forces at work on cultures. Julia Nikolaus' careful study (Chapter 15) of more than 130 Roman-period mausolea in Tripolitania reveals a remarkable blending of native, Hellenistic, and Roman influences. Most surviving examples, consisting mainly of tower and temple tombs in the interior and especially the pre-desert, display Punic and Numidian inspiration in the case of tower tombs and Hellenistic traditions in temple tombs (hypogea, although less numerous, were more prevalent along the coast). Agricultural motifs predominate throughout, characteristically reflecting the intensive agrarian development and consequent social hierarchy of the region under the Empire.

Meseret Oldjira and Susan Walker (Chapter 14) undertake a close investigation of funeral practice in Cyrene from the Archaic Greek through Roman periods. Unlike elsewhere in Africa, where native cultural factors are at work alongside external ones, here the cultural process involves the development of a particular colonial Greek, partially aniconic, burial tradition emphasizing busts and half-figures of female deities as early as the fifth century BC, followed by the introduction of a distinctively Roman-style portrait busts of individuals under the Empire – at first alongside the Greek tradition – and then ultimately replacing it. The influence of Rome is equally apparent in the introduction of a sarcophagus tradition modelled on the change to inhumation and the employment of sarcophagi at Rome in the second century AD, but as the authors make clear, the Roman-ness of these forms clearly retains a Cyrenaican character.

The case of Cyrenaica as a sort of cultural enclave in Africa emerges again in Eleonora Gasparini's discerning study of the residential quarters in the Agora and Gymnasium of Late Antique Cyrene (Chapter 7). Tribal attacks and climate change beginning in the third century AD transformed the monumental core of the city into an elite residential quarter complete with Christian basilicas looking less like a town than an increasingly isolated outpost of Graeco-Roman culture. Indeed, Gasparini argues for its reduction to village status over the course of the fourth and fifth century AD, perhaps not wholly different at that point to the character of the original Greek colony at its foundation.

Anna Leone's analysis of imperial statues in late urban contexts (Chapter 18) reflects the continuity across time of the ideology of Roman power in Africa even after the demise of the imperial cult. Images of emperors may have been displayed less ubiquitously, and re-cut and reused where necessary, but they continued to be displayed, though now more commonly in the public spaces of fora as well as baths, as opposed to temple precincts. A clear end to this practice comes with the Vandal period.

Gareth Sear's perceptive analysis on the multiple religious and ethnic identities found in Late Antique Tipasa in Mauretania (Chapter 10) reminds us that the acute religious dichotomies that scholars have argued for in Africa in this period do not always bear up to careful scrutiny. Looking closely at the texts relating to the troubled Christian community of Tipasa in Late Antiquity, he sensibly contends that it makes little sense to polarize African towns into either Catholic or Donatist or, more fundamentally, as Christian or Pagan or Roman or African, but to see each as comprising communities with multiple simultaneous identities.

Sallust's theme of the intermingling of peoples and cultures in Africa is no less applicable to Egypt in the three papers by Robert Morkot, Leonardo Bigi, and Gabriella Carpentiero. Morkot (Chapter 3), surveying past and more recent work on contacts between the Libyan peoples of the Eastern Sahara and Egypt during the Bronze Age, argues for a period of Libyan hegemony in Egypt between 1000 and 700 BC, though as yet he sees no clear connection between the emerging Garamantian state and developments in the Nile valley. He dispels the older notion of a deep connection between the Libyans' arrival in Egypt and the so-called Sea Peoples despite evidence of contacts between the Libyans and the Aegean, Western Asia, and Nubia.

In contrast to the Ancient Maghreb, where native cultures prior to the late first millennium BC remain less well known, the civilization of Pharaonic Egypt is richly documented both

textually and archaeologically. It is thus sometimes difficult to discern how Egyptian cultural traditions engage with imported foreign cultural institutions and structures. This is the case with Carpentiero's good discussion of Dionysias (Chapter 6), a Ptolemaic urban foundation in the Fayum. Geophysical survey has revealed evidence of an urban grid typical of Greek orthogonal planning, but Carpentiero argues that the town exhibits a blend of both Egyptian and Greek urban traditions in its plan, as well as its mix of public and private buildings. The complexity of this engagement is also illustrated in Bigi's close study (Chapter 11) of the production and export of various oils, including olive oil, in the Ptolemaic and Roman periods. Bigi notes the impact of imported pressing technologies and Mediterranean market forces at work in creating a highly developed and diversified oil-producing economy in Egypt, under the Ptolemies and especially under the Roman Empire.

If there is an overarching theme common to all of the papers, it is their disposition to challenge conventional wisdom. Too much of what has been written and said about this part of the ancient world has been embedded within narratives of Punic, Roman, and even Byzantine and Arab exceptionalism, all too often manifested in publications entitled: '*Africa under...*'. Such perspectives have left the investigation of the societies and cultures of Africa in a perennial state of asymmetry in which concepts like dominance, resistance, and subordination have held too much interpretive sway. But this has also given rise more recently to equally asymmetric attempts to reimagine the history of ancient Maghreb as one in which the contribution of the local, however distinctive and powerful it may be in its own right, risks being overstated much in the way foreign influences have been in the not too distant past. Sallust was right to speak of the intermingling of the original habitants and of the settlers who later joined them. North Africa was not isolated; its history was one in which the cultures of the Mediterranean and Middle East coalesced with the native to produce a distinctive, multi-faceted and complex cultural space, a historical pattern of engagement that remains intact even to this day.